The Potent Image

FREDERICK S. WIGHT

The Potent Image

ART IN THE WESTERN WORLD FROM CAVE PAINTINGS TO THE 1970s

Collier Books

A DIVISION OF MACMILLAN PUBLISHING CO., INC.

NEW YORK

Library of Congress Cataloging in Publication Data

Wight, Frederick Stallknecht, 1902–
 The potent image.

 Bibliography: p.
 Includes index.
 1. Art—History. I. Title.
N5300.W615 1976b 709 76–13199
ISBN 0–02–000970–4

Macmillan Publishing Co., Inc.
866 Third Avenue, New York, N. Y. 10022
Collier Macmillan Canada, Ltd.

First Collier Books Edition 1976

Printed in the United States of America

For J. B. W.

ACKNOWLEDGMENTS

I wish to express my gratitude to the scholarly friends who read the manuscript of this book, and generously gave me their time and advice. Miss Agnes Mongan, Curator of Drawings at the Fogg Art Museum, Harvard University, and Martha Davidson were especially helpful, as were Mrs. Jean M. Moore, then Librarian of the Art Library at UCLA, and Catharine Bock. I am indebted to Professors Karl Birkmeyer, Shirley Blum, Susan Downey, Beatrice Farwell, Stephen Kayser, Eugene Kleinbauer, Carlo Pedretti, Marcel Rothlisberger, and Otto-Karl Werckmeister; to Robert R. Wark, Curator of the Collection, the Huntington Library, Art Gallery, and Botanical Gardens, San Marino, California; and to Henry Hopkins, Director of the San Francisco Museum of Art, for reviewing the section on the twentieth century.

I am especially grateful to the many collectors, galleries, and museums who gave their permission to reproduce their paintings, drawings, and sculptures, and in particular to John Swope for the use of his photographs. Numerous photographs appear through the generosity of the Bing Foundation and the UCLA Foundation.

CONTENTS

The Potent Image

1

THINGS TAKE SHAPE

Man is the creature who makes things. He made tools and weapons as aids to his unspecialized body. These aids were made out of his dawning intelligence, and in turn they developed his intelligence, and gave it practice. Intelligence took the place of specialization, and kept man adaptable, so that he has survived in the most varied climates and circumstances. This has been fortunate, for he began as a hunter, roving after his prey, and eventually he roved all over the earth.

He came out of Africa into Asia in pursuit of the herds that fed him, and so into Europe. He crossed at the Bering Straits and roamed on down to the tip of South America. The Northern Hemisphere was in the grip of the Ice Age, so when he could he huddled in caves.

At one time he made fire, at another he built his own shelter. He changed from roving hunter to agriculturalist and he domesticated animals. The plants and herds over which he watched immobilized him; they became property. His settlements grew: his artificial caves became towns or cities and he created political life. These changes required thousands of years, but they took place at an ever-increasing pace. He stepped into history out of the eternity of his childhood.

His tools and artifacts and his artificial shelters were somehow adapted to his own shape; they supplemented, extended, projected his anatomy, and took on a living quality from his life. He realized a new self in his handiwork.

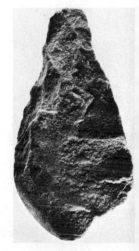

Paleolithic handaxe from South Africa, ca. 600,000 B.C. (UCLA Museum of Cultural History, gift of the Wellcome Trust.) [Suzy Einstein.]

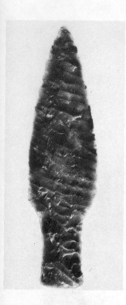

Neolithic dagger from
Denmark. ca. 7000 B.C.
(UCLA Museum of
Cultural History, Los
Angeles, gift of the
Wellcome Trust.)
[Suzy Einstein.]

The arrows and axes he chipped or honed, the skins he sewed, and the fabrics he wove broke forth into shapes and patterns. They were designed; along with his huts and shelters they took on form. Man invested energy in them far beyond the original demands of utility. Being man-made, they were mysteriously man-related, or man-like.

Since these forms reflected their maker, they hypnotized him. Once established, they have had an unreasonably long life. We still cling to the forms we have created, and repeat them long after new inventions or circumstances invite change. Walk down a street and put dates on the architectural forms that you pass: some classic column or cornice or pediment may take you back over two thousand years. Is this lack of courage, an unwillingness to be our twentieth-century selves? Or is it part of ourselves, embedded in the culture that we brought with us out of the past? New forms come hard, often take genius, more often take inventions to make them possible. There are fewer forms than we had thought, and more variations upon them. But since we are in an inventive age, we are form-conscious; we pursue forms.

If we collected, or recorded, only practical, invention-based forms, we would end up with a one-sided, materialistic account of ourselves. We would be missing out on the hopes, beliefs, and perhaps illusions by which we live. We have only to look over what man has cherished and preserved to see that a good half of these things have no practical use whatever. Why does such great value attach to certain sculptures and paintings? What makes a masterpiece; why is a particular building considered a monument? Why are such objects singled out? We are asking a two-word question: why art?

Our search for an answer takes us back deep into prehistory. Such an ice-age event as the Lascaux Caves presents us with man, the artist, with his painted bison, bulls, and horses bursting with life and action. What they meant to him we cannot yet say; the word *magic* tells us something, but not as much as we need to know. One thing we sense at once: the painter is giving importance to life. He is offering us some story, myth, communication which we can only halfway read. It is sobering that the Lascaux Caves are later by thousands of years than the earliest man-made marks, many more years than lie between these painted caves and ourselves. They are late, not early.

Yet as we look across fifteen thousand years to this Ice-Age artist, we at once find something else to digest. The artist engraved horn or bone with dog-tooth markings in groups, parallel lines in series that look like tally marks— and that apparently is what they are, for they fit the phases of the moon with a mark for each day. In other words, his markings are calendars. His animal figures may well be seasonal to mesh with such time notations; they may signal the time of the foaling of mares or the dropping of calves.

Two bison from Lascaux Caves, France. ca. 15,000 B.C. [Archives Photographiques, Paris.]

If true, his abstract marks say when, and his recognizable images say *what*.

Here we have the ingredients of two kinds of art: marks that represent and marks that record. Marks that record take on a special importance. They count, so they measure. Man, as it turns out, has a flair for calculation. This way lies building, construction, manufacture, and trade.

Marks that represent have a different function. They take on the potency of the life they show. Animals and men, strong in the hunt, share their prowess not only with the artist, but with the beholder. With the passage of time man will be creating figures that stand for great powers, gods and kings: figures that strengthen, protect, and console.

This image-making leads to an enormous accumulation. It now includes photographs and, for good measure, images that move. In the face of such multiplicity of images we must classify and fall back on prime examples, or persisting forms.

A man who is producing a useful work is bettering existence, and we should be grateful; but a man who produces a useless work may fill us with awe, for he is offering us his life, his hope, or his history.

2
―――――

INTO HISTORY

Egypt

The Nile Valley can serve as a hyphen between prehistory and history. Here events flow through time at a pace that seems to us oppressively slow. Here both a grand geometry called architecture and a stylized representation shaded off into hieroglyphs, or writings. Egypt entered history at an advanced stage of development and on a tremendous scale. The Old Kingdom was the age of the pyramids, among the largest structures made by man.

The pyramid of Khufu covers thirteen acres and contains some 2,300,000 blocks of stone weighing on an average two and one-half tons. These limestone blocks fit perfectly. They were quarried on the opposite side of the Nile and ferried across, and they were piled up sometime between 2900 and 2650 B.C. This effort was made to protect and preserve the bodies of a king and his queen, a task the pyramids utterly failed to accomplish.

Such tombs are pure geometry. They resemble nothing in nature. They are abstract events and witnesses to human conception. But the Egyptians also provided the perfect organic contrast, that of another kind of art: hard by the pyramids lies the Sphinx. The stylized lion with a royal head is on an equally tremendous scale. It too is a witness to the existence of humanity, for people *are* animals with human heads. The "riddle of the Sphinx" presupposes that his head could think.

The Egyptian believed in another life. By preserving his mummified body he assured himself of immortality. And he had a further protection in case mischief befell his

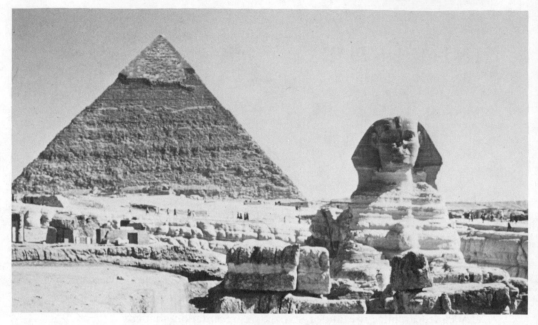

Pyramids in Giza, Egypt. ca. 2600 B.C. The Sphinx. ca. 2530 B.C. [Scala.]

mummy, for he believed that sculptured images served as well. Hence recognizable sculptures were hidden in the tomb. Thus the Egyptians replaced the duality of two worlds, this and the next, with the duality of life and art—a fact of the greatest importance to them and to us. Two permanent ways of life, the real and the pictorial, had to be provided for the soul. This soul was an individual, a man who refused to die.

But there is a gulf of centuries between then and now. Men were an army, a swarm, a centipede with one head. The king, the pharaoh, was at once every man and a god. He was the apex of the pyramid. His battles and hunts, his tomb, and his final triumph over death were recorded and carved into history. Such visible events gave significance to every man's life. Only gradually did freedom come to be shared. Only in modern times has every man even begun to think of it as part of his definition. We may generalize and say that the expanding of the percentage of free individuals is the measure of the progress of history.

The images the Egyptians carved were often much larger than life. Frontal, symmetrical presentations, they looked

unblinkingly straight ahead, standing with one foot forward, or they sat enthroned. Images of state, they were stately. Subsidiary figures lining the walls of tombs or temples were not merely semblances of servants or slaves; they were slaves provided for eternity.

About 2100 B.C. the Middle Kingdom brought in a more feudal state which was to last a thousand years. A new capital, Thebes, arose further upriver. If there were no more pyramids, there were great temples: their walls rich in recorded history—whether carved, painted, or written—their dim roofs upheld by massive columns with lotus capitals, their courtyards leading to ever more sacred precincts. Temples, palaces, and tombs recreated the life of the pharaoh in sport and in war. Wall figures were carved in low relief or incised with a sharp shadow-catching edge: fine lines contrasted with great blocks of stone. Since reliefs were also painted, wall painting came in naturally enough.

Such reliefs or paintings made use of a conventionalized anatomy. The figure is side view, the shoulders and the eye are front view. The drawing is not in perspective, that projection of three dimensions onto a flat surface which came in with the Renaissance, and which the camera has tended to confirm as a way of seeing. Instead, Egyptian drawing is a description of salient facts, and it works well. In our time Picasso has explored such combinations of the most characteristic appearances. Out of the hardest of stones came elegance; out of imitation came a miasma of stylized monotony.

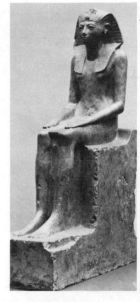

Queen Hatshepsut. Egyptian, Eighteenth Dynasty. ca. 1485 B.C. Thebes. From the temple of Hatshepsut. Indurated limestone. (The Metropolitan Museum of Art, New York, Rogers Fund and contributions from Edward S. Harkness.)

The master artist made models for others to copy: *this* is how you make a bird, *this* is a man. But it is not true that nothing changed. A pharaoh became absorbed in a religious idea: a single god. The king's name was Ikhnaton, his wife's was Nefertiti. The artists who preserved their features for us seemed to grasp at once the new—if brief—triumph of individuality over ritual. It was a new evaluation of personality, a false dawn, and soon convention, both religious and aesthetic, returned.

Egyptian art was not merely sculpture, relief, and wall painting. It was furniture (chairs, beds), woodwork, metalwork, glass, ceramics, and especially jewelry. Everywhere objects were decorated with animal and plant motives. One great hierarchy reached down from the sublime head through stages and classes into substrata that included all living things.

Offering bearers from El Bershel. Wooden model. Egyptian, Twelfth Dynasty, Middle Kingdom. (Courtesy Museum of Fine Arts, Boston.)

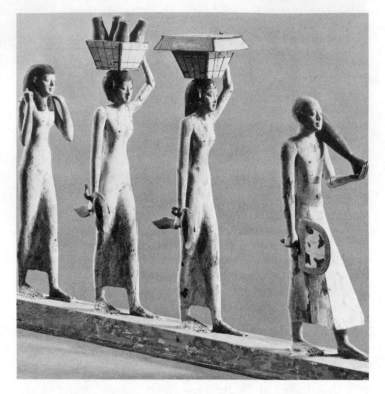

Mesopotamia

Although Egyptian influence reached out to Mesopotamia, the region had its own culture, or rather its many related cultures. The earliest culture, that of the Sumerians, occupied the lower valley from the beginning of history. The most famous city of this region was Babylon on the Euphrates. Far to the north and somewhat later in time, Nineveh on the Tigris was the capital of the territory of the Assyrians. The whole region was given over to war and conquest. The Chaldeans overthrew the old kingdom of Babylon. The Assyrians were eventually overthrown by the Medes and Persians, who overreached themselves when they undertook to invade Greece and were demolished in their turn by the Greek, Alexander the Great.

The first limitation on the arts of Mesopotamia was the absence of stone in the lower reaches of the plain. Building was generally of brick which could be glazed with brilliant colors. In consequence, the art of Mesopotamia tended to be a wall art, an art of color and low relief, a translation

of weaving and fabric into something more permanent. This does not mean that it was easier to be a slave in Mesopotamia than in Egypt. Since there were no natural strong points to defend, whole cities were built on man-made platforms and surrounded with high walls. A central square tower or ziggurat, climbed by a ramp that wrapped it round, dominated the citadel. These massive structures, a town surrounding a palace, have now moldered into mounds that await the archeologist.

The art of this region was singularly vital and ferocious. Its reliefs deal with lion hunts, war, and the slaughter of prisoners, and glory in the death of almost every living thing. These themes reach their peak with the Assyrians, one of history's most warlike peoples. The effect is of men as animals of prey hunting in packs. A marvelous sense of design pervades these expressive descriptions: a deity or king symbol—a winged bull with the bearded head of a monarch—conveys overwhelming power. Interlarded with hieroglyphs, these reliefs are pages of history.

Dying Lioness. Nineveh. ca. 650 B.C. Limestone. (The British Museum, London.)

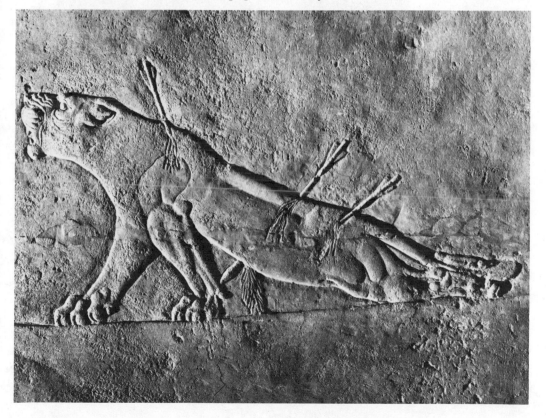

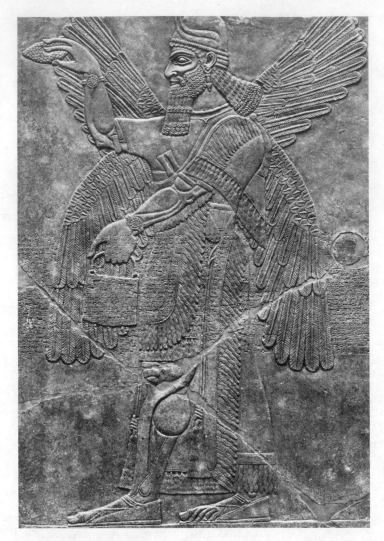

Winged Genius. Assyrian. ca. 850 B.C. Gypseous alabaster. Relief (panel 3) from Nimrud palace of Ashurnasirpal II. (Los Angeles County Museum of Art, funds donated by Anna Bing Arnold.)

The Middle Sea

The kingdom of Egypt, the kingdoms of the Middle East, with their ravenous armies, paused at the water's edge. The Mediterranean itself was their rival, with its invitation to mobility and trade and the opportunity it offered for small city-states to create their own cultures, each a separate variant on the overall culture of the region. For a while each city-state established its identity. Of these early coastal or island cultures, that of Crete is the most haunting, with its far-off reminder of playful elegance, its bull-baiting, its svelte beautiful figures—hundreds of years condensed into the poetry of a few murals on its palace walls.

We must move on to two cultures that had the all-important capacity to survive. The Hebrews and Greeks had nothing in common, apparently, other than their rejection of the oppressive idea of a king-divinity as the living em-

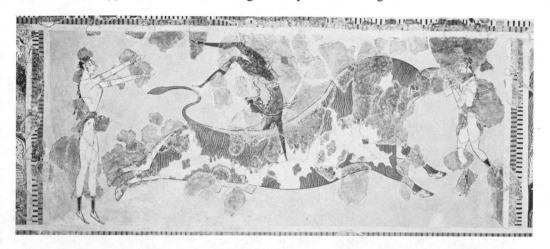

Bull Leapers. Palace of Knossos. ca. 1500 B.C. (Archaeological Museum, Heraklion, Crete.) [Scala.]

bodiment of humanity. The Hebrews replaced a king by a priesthood kept in check by prophets. The bond between God and man became solely spiritual: a conceptual God raised up man instead of treading him down, and a father-and-son metaphor for such a relationship had a vitality that eventually acted itself out. This belief in man's private significance as child of God was to live for centuries. In art it has inspired man's most significant flights.

The Greeks replaced the idea of monarchy with democracy, popular government tainted at times with dictatorship. Their defeat of the Persian armies under Darius and Xerxes in the fifth century B.C. resulted not merely in a triumph of nationalism but in an immediate triumph for man himself. A sudden expansion in art, literature, philosophy, and invention took place as the Greeks saw a new significance in man and became intoxicated by it. As we reenter their time —and we have never quite left it—we find ourselves surrounded by front-rank minds and talents. In Athens we meet individuals who talk and write, build and carve endlessly, and we have the impression that there were as many works of art as there were pairs of hands, and as many ideas as there were heads. This high period produced some of the world's greatest dramas—by Aeschylus, Sophocles, Euripides, Aristophanes; some of the greatest sculptures— by Phidias, Lysippus, Myron, Praxiteles. It is significant that

we know the names of these creative individuals even though their sculptures are now lost. These men were not locked in a continuing style or mode of thought; each accounted for radical change. The transition from the idealist philosophers, Socrates and Plato, to the more scientifically inclined Aristotle resembled the changeover from eighteenth-century political philosophy to nineteenth-century science.

During this brief period, the Greeks perfected an architecture that was a monument to all that is human, for even their gods were humanized with passions, weaknesses, and tumultuous lives. The Greeks created symbols of themselves in stone and bronze, figures that appeared natural, yet were really abstract, for they were under the control of ideas of proportion. Their drive toward perfection was balanced by restraint, and what they created remained strictly within

Demeter, Persephone, Iris. ca. 438–32 B.C. Marble sculptures from east pediment of Parthenon. (The British Museum, London.)

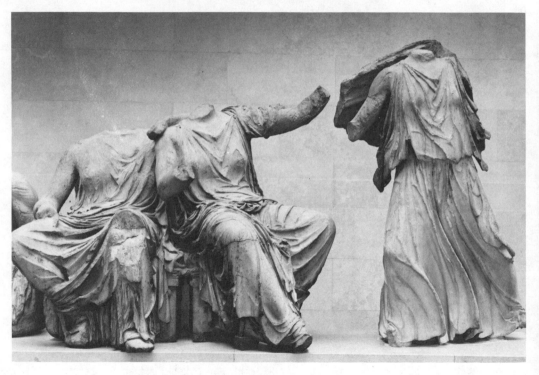

bounds. Basically they only built one building, their temple; and their art centered on anatomy. There was a moment when sculpture and architecture fused, when figures were architecture, and the temple itself was sculpture: such a moment would not return until the raising of the cathedrals in the Middle Ages.

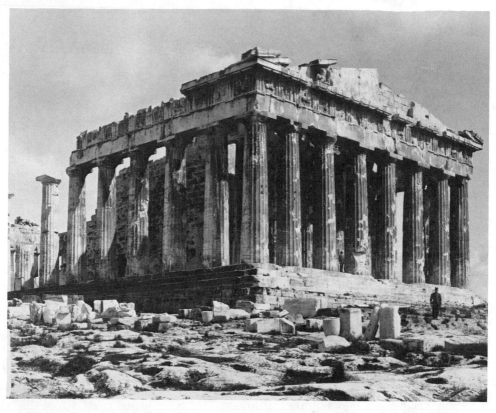

We must now accept a notion of architecture that is quite alien to us. Throughout most of history until recent times, when men chose to build they had quite a different goal from shelter as we know it, concerned as we are with housing mankind in tolerable comfort. Architecture, building at the highest level of imaginative effort, whether palace, tomb, temple, or capitol, existed to house an idea or a symbol. Shelter was quite a secondary matter.

When the Greeks built the Parthenon they lived in hovels; a similar contrast existed in Imperial Rome, and in the thirteenth century when the cathedral rose over the jumbled town. Even today we expect a public building to be larger than life, with higher ceilings and doors than we need; it houses some social or spiritual concept taller than ourselves.

The Parthenon, Acropolis, Athens. 448–32 B.C. [Alinari.]

3

THE COLUMN

AND THE ARCH

We can take the Parthenon as the perfect realization of a
persisting form. The building still stands on the flat top of
a rock, the Acropolis, that dominates the city of Athens.
And at some remove it stands wherever the European tra-
dition has reached. Pericles, the political leader of the
Greeks for the generation that followed the defeat of the
Persians, rebuilt Athens and brought the great temple into
being with the organizing help of the sculptor Phidias. We
know the names of the building's architects, Ictinus and
Callicrates.

The Parthenon displays every subtlety of taste and pride
that the Greek mind could bring to it. So timeless is its air
that we must remind ourselves that the building had a long
development behind it. Temples in wood certainly pre-
ceded temples in stone. The roof beams of the Parthenon
were wood, and Greek columns in wood still existed when
it was built. Back these columns went into wood again,
painted white as marble, all over colonial and nineteenth-
century America. A form can have a longer life than a ma-
terial, even if the material is stone.

The Parthenon at once confronts us with the subject of
the Greek "orders," or the designs of columns and their
capitals that the Greeks developed. These orders, in their
pure form, are three: the Doric, the Ionic, and Corinthian.
Like so many architectural forms, the orders, once estab-
lished, persisted. They are distinct and separate composi-
tions; like music, the relations of the parts are unpredict-

able, being utterly abstract. They develop from the ground
upward, each in a harmony of its own.

The builders of the Parthenon chose the Doric, the sim-
plest and most massive, with a Greek preference for under-
statement and sobriety. They introduced certain Ionic over-
tones; the more delicate and ornate Corinthian was a later
development, beloved of the Romans. The Greek orders
have no structural meaning for us now, with our new tech-
nical resources, and they live on—so it has been for cen-
turies—simply as symbols of measured dignity, private or
public. They have been used so long that they speak to us
from a whole sequence of pasts: Greek, Roman, Renais-
sance to Baroque, and finally as symbols of democratic gov-
ernment. This last use of the classical orders, found so com-
monly in our country, was based on a simplified view of
history that equated modern democracy with the democra-
cies of Greece and with "republican" Rome. Our country
still houses political and legal procedures (and the speeches
and declamations that accompany them) behind classical
porches: this style provides the form of our statehouses
and courthouses far and wide. The French Revolution, too,
assumed the classical style (long a symbol of the monarchy)
as a symbol of republican life.

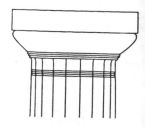

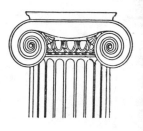

If we disregard the sculpture of the Parthenon, its basic
architectural form is no more than a shed with a low-pitched
roof. Structurally, the Greek temple was entirely post and
lintel, two posts and a header; it was as simple as a door-
way. From a distance the Parthenon looks as if it could be
entered everywhere between its free-standing columns, but
this was not the case: inside the columns was a window-
less wall. In its secretiveness the building was like a tomb,
and it existed for one single purpose: to house a statue of a
deity, the goddess Athena. This statue was of heroic pro-
portions; seated and enthroned, it occupied the whole dark
interior, the cella. The only light came stealing up it from
the one outer door.

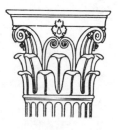

Top to bottom: Doric,
Ionic, Corinthian.
Greek orders.

Outside the blank walls of the cella ran a narrow walk,
the ambulatory, and then came the parade of surrounding
columns, the peristyle, that sustained the wooden-beamed
low-pitched roof. The headers that went from column to
column, being of stone, could not be long, so the columns
marched in close formation, a procession of lights and darks
subtly repeated by the flutings of their Doric shafts. If there
was no provision for a congregation, the great hidden statue

had a host of attendants in stone. Gods and goddesses, men and women, they acted out myths and ceremonies that provided a dramatic and poetic background for the life of the state. The pediments, the gables of the low-pitched roof, were filled with sculpture that reached a high central point under the peak and then subsided. The west pediment, the approach, was given to the *Combat Between Athena and Poseidon for the Land of Attica*. The east pediment showed the *Birth of Athena:* the goddess emerged fully armed from the forehead of Zeus—as the guardian of Athens she was born of the mind.

Classic architecture has so long held civic implications for us that we can all too easily forget that the Parthenon was a religious edifice. But for the Greeks, and for the Romans after them, civic life was a religion. If the Greek lived in a hovel, he lived in sight of the Parthenon. He rose in the morning and wrapped himself in his one woolen garment under which he had slept and he stepped into the open ready to discuss, vote, and dispute. His delight was in the play of ideas, regardless of consequences, and altercation and war were his folly.

Although the Greeks destroyed themselves politically with their endless local wars, they lived on in their structures and concepts. They became schoolteachers to the Romans who methodically carted off their statues and adapted their architecture. To experience Athens from a position of strength was the privilege of the educated Roman, who looked eastward toward civilization, just as in the seventeenth and eighteenth centuries the young Englishman made the grand tour on the continent of Europe, and in the nineteenth century the American artist made a pilgrimage to Europe in search of his ideal.

The Romans were heavy-handed imitators, and to imitate is a discouraging occupation at best. But they had virtues of their own. They were able to impose order upon themselves, and to impose their organization upon others, and to find symbols for their great composite act of will. Seekers of power, they expressed it on an impressive political and architectural scale. When they built, they boldly enclosed great blocks of useful space with throngs of people in mind. Their intention was so different from the Greeks' that they might well have left the Greek orders behind as a poetic diagram in history. But they adapted them and stretched them like rubber over their buildings regardless of

size. Just as they expanded the Greek orders, the Greek *aspect,* they expanded a republic to the size of the then-known world. Perhaps Greek life was an art life because the Greek city-state was so small that you could actually see it—you could climb a mountain and look down upon it. By contrast, the Roman state grew the size of a political idea, and this invisible idea was Roman law. On both counts, the political and architectural, the Romans achieved the gigantic.

Succeeding cultures did as the Romans did, and adapted Greek, or now Roman, architecture to their own purposes, quite untroubled by the original scale, which had once been part of the original form. The Renaissance competed with the Roman flair for size and expanded and adapted Greek architecture in its turn; so did Louis XIV, the builder of the seventeenth-century Palace of Versailles as a symbol of the entire ordered state of France; and so did the builders of modern cities whenever it suited them to use a classical surface. Greek art was so condensed, abstract, and orderly that it almost invited this expansion and dilution.

If Greek architecture was based on the post and lintel, Roman architecture was also based on a simple form, the arch. Its possibilities were limitless. If you prolong an arch in depth, you have a tunnel vault or barrel vault. If you rotate it halfway around, you have a niche or apse. If you rotate an arch all the way around, you have a dome. If you cut one tunnel vault with another at right angles, you are able to light the vault from the sides.

Characteristically, the Romans did not invent the arch. It came out of the East. The Greeks knew it; the Assyrians used it. The Assyrians began with a wall with three arched portals, the highest in the middle. Such a three-arched portal recurs with the Roman triumphal arch. The form lived on to become the three-arched entrance to the Gothic cathedral.

A popular architectural form, original or not, presupposes the support of a technical advance. The Romans could bevel the stones of an arch, and slip in a keystone to lock it; but they also had mortar and brick, their favorite building materials, out of which they constructed arches, piers, and walls that were solid blocks. Still more important, they knew how to make cement and achieved large cement castings, and here they had our modern methods almost within reach.

The Roman adaptation of the Greek temple can be seen at Nîmes in the south of France in the Maison Carrée or

square house. A columned porch or portico has been kept
as a Greek front; the rest of the temple is walled up. In this
way the Romans used a Greek approach to a Roman in-
terior for a gain in space.

Thomas Jefferson, an architect as well as a statesman (he
built Roman fashion, visibly and invisibly), saw the Maison
Carrée when he was ambassador to France, and he used it
as a model for the statehouse in Richmond, Virginia. His
statehouse, to be sure, has more than one floor level—here
was the old problem of the expansion of a style—but Jeffer-
son was equal to this, and spent much of his inventive en-
ergy disguising two or three floors as a single classical story.

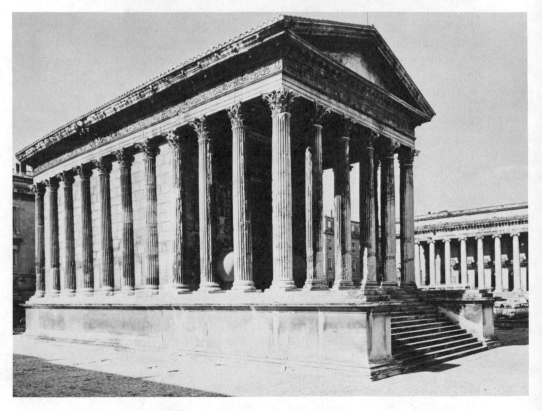

Maison Carrée, Nîmes,
France. Completed
16 B.C. [Alinari.]

The Richmond statehouse set a pattern that was repeated
on the strength of its reasonableness, its simplicity, and its
Classical prestige.

Roman building dates from the Empire. The Romans had
little important building to their credit in Republican days.
The Emperor Augustus, who organized and established the
new Empire that Julius Caesar had bequeathed him, said

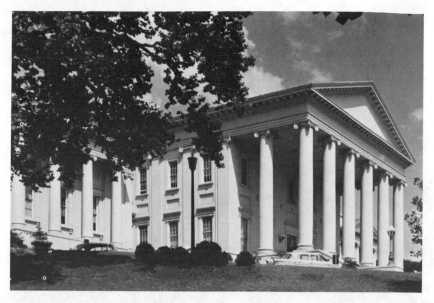

that he found Rome a city of brick and left it a city of marble. But it was really of brick with a marble veneer. Sheets of marble were fastened on with bronze pins, only to be stripped away later to leave the crumbling brick we now see; for Rome, the plunderer of the world, in her turn became the world's most plundered city. It was a preview of our own unfortunate habit of pinning a formal façade on a steel structure with which it has no functional connection.

THOMAS JEFFERSON. Virginia Capitol, Richmond, Virginia. 1785–96. [Sandak.]

The Rome of the Empire seethed and sprawled with a million and a half inhabitants. Like many modern cities, ancient Rome had a small core; the Forum was a semi-sacred place from the city's earliest beginnings, with a cowpath Sacred Way that wandered from one shrine to another down a valley between hills, past the home and temple of the Vestal Virgins and the temple of the civic heroes Castor and Pollux, and on toward the rostra where the orators spoke. Close by was the senate house, which still stands, where parliamentary government was once made to work through a series of checks and balances resembling our own, restraining majority with seniority.

The Romans, being orderly and thorough, were concerned with city planning, but as so often today, the need of planning was not felt until it was too late to change the city's heart. New buildings simply jostled their way in as the emperors who erected them came to power, for regardless of plans, prestige thinks first of itself.

The Empire relied upon spectacle, and civic life itself

fed on theatrical form. The Colosseum still stands as the
hard heart of the spectacular. Built by the Emperor Ves-
pasian for the diversion of an idle and restless populace
(A.D. 70–82), the enormous building was 620 feet on its
long axis, 157 feet high, and seated 40,000 spectators. To

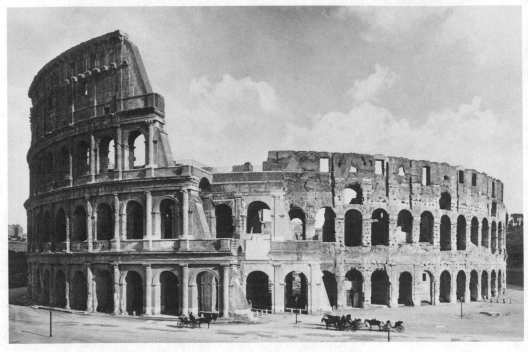

Colosseum, Rome.
A.D. 72–80. [Anderson.]

this day it remains one of the world's largest structures. Ex-
ternally, it solved its vertical problem with a series of super-
imposed arches flanked by columns, first the Doric order,
then the Ionic for the second story, and for the third the
ornate Corinthian which the Romans loved best. The result
was a form peculiarly Roman: aesthetically unjustified, yet
effective, a combination of arbitrary imitation and grandeur.
Engaged columns and pilasters do little or no work, but they
serve as floor demarcations for a multi-storied building, a
clarification that lived on into the Renaissance—and for that
matter, until now.

An extensive cement footing which has stood the test of
time was not the least achievement in this marvel of en-
gineering. Passageways beneath the arena permitted wild
beasts to be brought in from a distance; they were on store
in an ever-changing stockyard which the Empire was
scoured to replenish. The Colosseum could also be flooded

for naval games, and for shade it was covered by enormous awnings that unfurled from the summit of the wall high above the free top seats. Guy lines ran to a central iron ring suspended in the sky, and the spreading or furling of these awnings was one of the duties of the Roman navy.

The Greeks had constructed hillside theaters that leaned into the landscape with a logical grace. The Roman Colosseum was a stronger act of will, a complete, free-standing bowl. It served as a pattern for other oval theaters throughout the Empire, and became the prototype of sports arenas to this day.

Power likes to dramatize itself, particularly if it is declining, and there were other vast public works and monuments to come. The Baths of Caracalla (A.D. 211–17) can serve us for a series of great enclosures. Americans who. have passed through the now destroyed old Pennsylvania Station in New York have experienced this building in free restoration. The Baths housed a complete Roman way of life, for which they supplied a controlled climate.

Here the Roman instinct for order translated itself into symmetry so that every room or court had its counterpart on the opposite side of the main axis. One moved from hot rooms to tepid to cold, through gymnasia, past pools: the central hall, 184 feet long by 72 feet wide and 108 feet high, was nothing less than an enclosed public square. The Romans spanned this great space with cross vaulting that gathered the downward thrust at the four corners. Four tall decorative columns, placed as a footing at each corner of the descending vault, appeared to do the work that was actually transferred to the walls. The Baths were a city man's club, and they provided for every interest and diversion, including libraries. Statuary in marble and bronze, often of colossal size, appeared as a light and dark population of athletes, a reminder of Athens for those who had traveled. The walls were faced with variegated marble for which the Mediterranean basin had been ransacked.

Black mosaic images of Tritons and Nereids quivered on the bottoms of the pools. The floor was warm to the bare foot. Steam and smoke coiled underneath, hidden, and passed up through the hollow walls; the Romans had radiant heating and warmed themselves with the sweat of slaves. To service all this restless nonproductive life, prisoners of war toiled, carts of firewood came from farther and farther away, grain barges were towed up the Tiber, and aqueducts

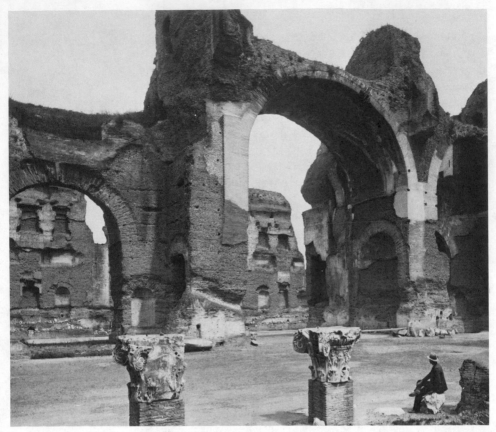

Baths of Caracalla, Rome. ca. A.D. 211–17. [Alinari-Scala.]

brought water from hills twenty miles distant—the brick arches of the aqueducts still stand today like remnants of troops converging on the city.

All this slave labor cost nothing, and was held in contempt as it had been in Greece. The artist too was held in contempt, for he also worked with his hands. Although his work was prized, condescension was to be his reward until the Renaissance, when the notion of genius rescued him. But the Romans respected architects as men who worked with plans and ideas.

No European ever again used such needlessly huge blocks of stone as did the Romans—another instance of their contempt for labor. By preference, Roman walls were unbroken, and the few windows placed high; they were for lighting and not for viewing. They did not invite the outside world or break the centralized, symmetrical, domineering control. Such enclosed space was not unique with the Baths of Caracalla. The Baths of Diocletian were on just such a scale, and so was the Basilica of Maxentius (A.D. 310–20)

with its great hall 261 feet long, 195 feet wide, and 120 feet high. Roman basilicas functioned as civic centers, and in particular housed the law courts. We shall meet the word *basilica* again a little later when it will mean a church.

In the midst of such monuments, how did the populace of Rome actually live? Idly and uncomfortably enough in brick tenements. The more fortunate lived in five-story apartment houses with courtyards, communal kitchens, and heating far from adequate. Quite in the modern fashion they complained with good reason about endless noise and the housing problem. The rich lived in houses that faced an inner court or atrium, which might have a statue or two and a pool; the court was surrounded by a roofed colonnade for shade, and the blind dark rooms of the household opened upon it. Much of this one-story, flat-roofed house with its inward turn toward privacy has survived throughout all Mediterranean culture and on into "modern" architecture. We can recognize it through all its changes.

The Romans liked to locate a house or villa in the open country or at a seaside resort, for the countryside had long been pacified (through the Pax Romana or Peace of Rome), and the sea cleared of raiders. The Romans had farming and country life in their blood. To live luxuriously in such fashion, turning from poetry or history to the account book and back, with a glance at the calendar and a thought for the crops—immediate interests sobered by political speculations based on practical experience in office—such was Cicero's idea of existence. It was also the way Washington and Jefferson lived in a later day. They knew that they were living like Romans and felt the better under the porches that dignified their homes.

As we look back on the Roman Empire, we are struck by the spectacle of a practical people endowed with courage, discipline, and reasonable minds, who got out of their depth through their tremendous success. Technicians, they were beset with technical difficulties: no matter how many problems they solved, the great scale of the Empire confronted them with more. They managed transportation and roads wonderfully well, and they achieved extraordinary speed in communication. Their frontiers were only weeks away. They lacked modern accounting and the decimal system and they lacked modern sources of energy. Slavery, the machinery of the state, laid the state to waste.

People left the land for the cities, where an unemployed

populace got out of hand. Administration broke down and
the function of an emperor ever on the march with his
army ceased to be governing and became troubleshooting.
All this is expressed in Roman architecture: space and civic
probity were its goals and its enclosures were overwhelm-
ing. But it was built for idleness out of slavery, and we read
the unbearable effort in the crushing mass. If it is neces-
sary to underline the fact that the Romans expressed them-
selves through mass, we have only to turn to an architec-
tural form as distinctly Roman as the Parthenon was Greek,
the triumphal arch. The Roman arch is a military symbol,
the yoke under which prisoners of war marched to their
deaths. Prisoners were literally sent under the yoke, *sub ju-
gum,* which gives us the word *subjugate.* The arch is a build-
ing with no inner life, mass for its own sake. In America,
triumphal arches are rare.

Our voyage through the past is to gather significance for
the present, and time and again we shall cross years to point
to inherited or persisting resemblances. When classical
forms reemerged with the Italian Renaissance, they were
used very freely; architects employed classical orders to pro-
vide their buildings with a familiar surface. The Renaissance
passed and Baroque art came on the scene, again with quite
new forms, and these in turn made free use of classical or-
ders. In Renaissance forms, classical orders clarified actual
divisions; in Baroque forms, divisions disappeared, and
classical forms packaged large unbroken units. The Italian
Baroque traveled through Europe quite as widely as the
forms of the Renaissance. It was severely refined in France
where it changed to some degree with each royal reign down
through the seventeenth and eighteenth centuries; it was
freer and more casual in England, until it finally acclima-
tized itself as an elegant and practical eighteenth-century
architecture, the Georgian. Both these French and British
styles had their influence in America, especially the British,
for here the Georgian made itself so much at home that it
was given a looser term, the Colonial. The Baroque style
was much more fantastic when it reached Germany and
Austria, where it took on an extravagant if beautiful form
which failed to reach the New World; and it was equally
fantastic in Spain in a form which did reach Latin America.

To generalize, a restrained classical architecture flour-
ished in France, England, and America through the seven-
teenth and eighteenth centuries. Colonial in this country, it

provided classical orders, columns and pediments, pilasters, and more rarely a Roman dome, for statehouses, courthouses, and whatever buildings symbolized the republic. And for those who could afford it, it symbolized a spacious dignity in their way of life.

Perhaps the most vital and least orthodox display of classic design was the typical church produced by the English architect Christopher Wren. After the Great Fire of London he not only built a new Saint Paul's Cathedral (discussed in chapter four, "The Dome"), but he filled London with new parish churches. These, incongruously, were classic buildings with spires. Historically spires were Gothic, but Wren's were not, although they came into existence to satisfy Gothic heavenward aspirations. His spires were a strange vertical medley of classic forms; in effect Wren had

Arch of Titus, Rome.
A.D. 81. [Anderson.]

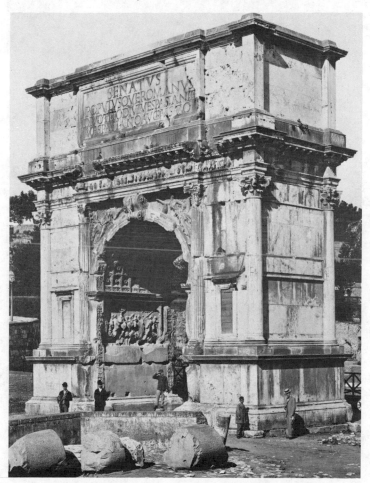

the temerity to put such a superstructure on a Parthenon.
Yet the bold measure was successful, and these buildings
give joy to this day and seem neither strange nor quaint.
Wren's churches and spires set a pattern that was repeated
at one remove throughout America. A follower, James
Gibbs, built Saint Martin's-in-the-Fields that now looks
down on Trafalgar Square in London. Gibbs wrote one of
the architects' guides that influenced New World builders,
and it was the spire of Saint Martin's that became a pro-
totype of so many American spires that stand as a collective
monument to the country's beginnings.

JAMES GIBBS. Saint
Martin's-in-the-Fields,
London. 1722.
[Louis H. Frohman.]

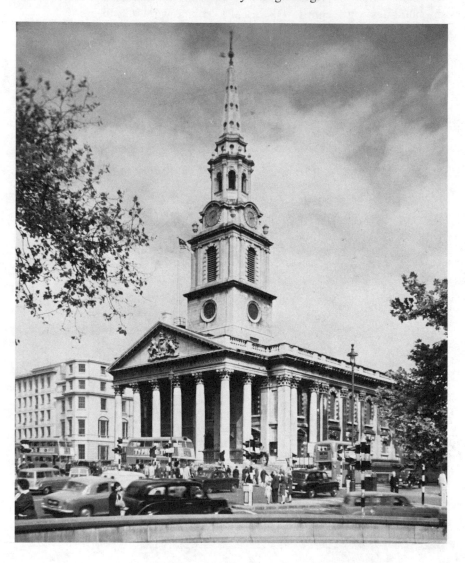

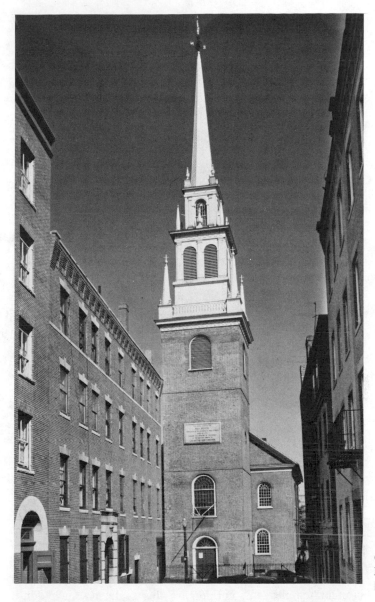

Old North Church,
Boston. 1723.
[Sandak.]

In the late eighteenth and early nineteenth centuries, Roman classicism gave way to a Greek Revival, a needed purification, if purity was the goal, for classicism had been tainted (emotionalized) by the Romantic movement that was then in the ascendant. Finally in our own century classicism became a mere veneer of formal respectability spread over the surface of modern steel buildings. But if the classical is now structurally meaningless, it still lends its name to a sense of order, of rationality, and of history.

4

THE DOME

To conclude with Roman architecture on the positive side, we have reserved one building which sums up the Roman virtues of order, power, and grandeur: the Pantheon, a place for all the gods. Built in the second century A.D. (120–24) while the Empire still had its strength, the Pantheon is a vast round temple crowned with a dome. The rotunda is 142 feet across, the dome 142 feet high, so the building could exactly contain a sphere of that diameter. The Roman zeal for symmetry was perfectly satisfied.

A Greek porch with Corinthian columns and pediment provides a front for the building. A single portal is the only entrance and exit, and its great bronze doors still swing on their original hinges. The inner space is lit by one large circular *oculus* or eye in the center of the dome, and lies open to the weather. The Pantheon is not a ruin. One of the early popes made the temple a church (in A.D. 610) and so saved it from vandalism. The Romans had a liking for circular temples, but nothing on this scale, no such dome, had existed before. The complete centrality of a dome imitates the vault of the sky, at once exalting and overawing the beholder standing beneath, and here the *oculus* in the center becomes a real sun pouring down actual sunlight. The Pantheon was bound to challenge the imagination and abilities of later builders. Its dome is a solid cement casting around vertical ribs of brick. The drum has walls twenty feet thick to contain the thrust.

In the past, architects or master builders could not calcu-

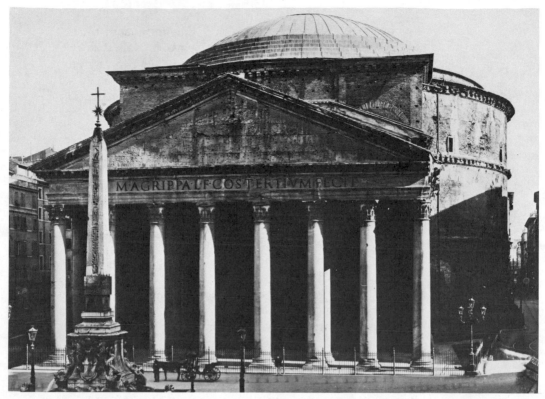

Pantheon, Rome. A.D. 118–25. [Anderson.]

late stress and worked out of experience. The margin of safety was uncertain. To underestimate the thrust of an arch was a misfortune, to underestimate the thrust of a vault was worse, to underestimate a dome was catastrophic. Because its construction was so difficult, the history of the dome is

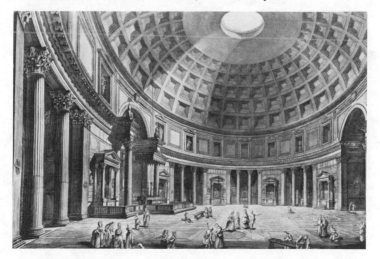

FRANCESCO PIRANESI. *Pantheon, interior.* 1786. Etching. (UCLA Grunwald Center for the Graphic Arts, Los Angeles.)

simple, and a few examples will bring us to modern times.

The Roman solution relied on a massive wall that precluded the development of adjacent space, and in any case it is not easy to fit rooms to a circle. A square may be added to, but then it is hard to fit a dome on top of a square. The problem had to be faced, however, and faced at some height, for no domes before the modern geodesic dome (if we except the igloo) start from the ground. In an early solution, four arches are sprung from four corner piers, and then the corners are cut with smaller arches to produce an octagon. These smaller arches, known as squinches, do not fit too comfortably to the larger arches they accompany and modify. A handsomer and later arrangement is a curvilinear triangle between the arches called a pendentive, which leans in against the dome. Either way, thrust is now concentrated on the four corner piers, but we still have by no means eliminated it. To meet it, we can set up solid walls of masonry at right angles to each other with the supporting piers in the corner between them. These buttressing walls

Hagia Sophia, Istanbul (Constantinople). A.D. 532–37. [Viollet.]

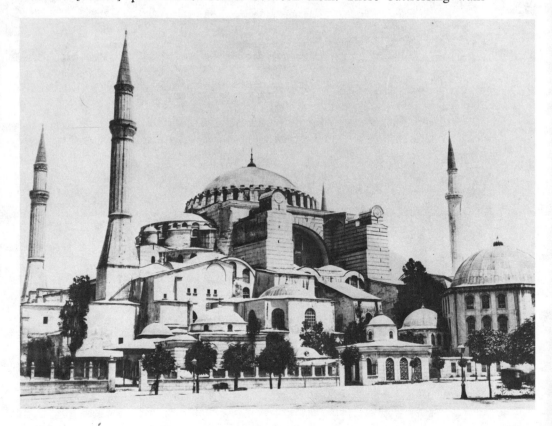

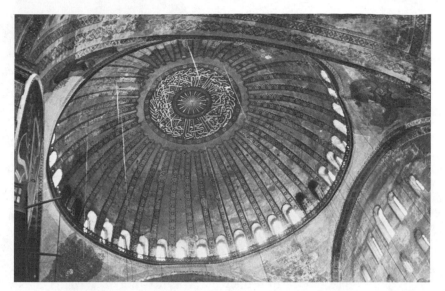

divide the thrust, and since they are in the planes of the large arches beneath the dome, they can act as walls for adjacent halls.

Such a solution prepares us for our next great dome some four hundred years after the Pantheon. Hagia Sophia (532–37) was built in Constantinople for the Emperor Justinian. At first a cathedral, for much of its life it has been a mosque. Its central dome is smaller than the Pantheon's, 108 feet across, but it is hung higher in the sky. The space

Hagia Sophia, Istanbul (Constantinople). A.D. 532–37. Interior of dome. [Professor Thomas F. Mathews.]

Head of Christ, Pantocrator, Daphne, Greece. Eleventh century. Mosaic in monastery dome. [Viollet.]

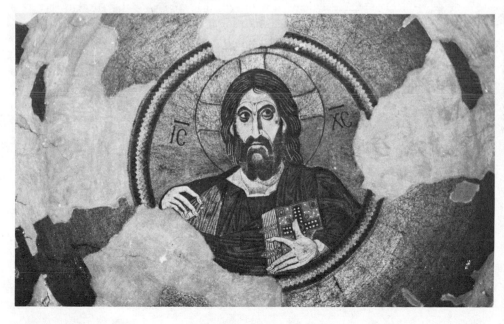

below is rectangular, extended on the long axis by two great apses that lean in against the thrusting dome.

The mood Hagia Sophia evokes is different and new; we are in another culture and the classical world is behind us. In place of clarity, simplicity, and force, we have the mystical and indefinite; a central dome hovers in air above outlying chapels, heading up a hierarchy of spaces large and small. The dome of Hagia Sophia is penetrated by a circle of windows—structurally a rash procedure—and this high circle of light cuts the dome adrift and leaves it apparently floating, as though suspended from heaven.

This hovering aspect, a looking down from above rather than a building up, is the perfect setting for Byzantine mosaics. These images in small stone or glass, aloof, transfixed and severe, peer down out of eternity with a spiritual authority that can neither be measured nor resisted. Hypnotic eyes in the face of a Christ more just than merciful single out each beholder, and the eye of the sun in the Pantheon now becomes the eye of God.

The next great dome rose in the city of Florence after a wait of nine hundred more years. By this time the whole adventure and triumph of Gothic architecture had taken place—a north European development that became classicism's greatest rival. In Italy Gothic architecture was qualified and muted by the continuing presence of the classic achievement: it is the compromise with the Roman past that Italy offers. Nevertheless, the Duomo (*Domus Dei* or House of God), as the cathedral in Florence is simply called, is a Gothic building. The plan is in the form of a cross, as is usual with medieval churches, and an exceptionally large dome was needed to span the space at the crossing. The cathedral had been under construction for a century and still no one had any idea how this space could be closed.

The task was offered as a competition. Brunelleschi, a young man who was not then even an architect, won the prize in the year 1418, at the very beginning of the Renaissance. He raised a tall, steep dome based on a polygon. Its profile is a high-pointed Gothic arch. Such an arch, being considerably higher than it is wide, sends more thrust downward and less of it outward. There were other drives behind the Gothic arch, with its spiritual upward-pointing gesture, but this was a realistic structural one.

Yet Brunelleschi still had an almost insuperable problem with thrust, short of introducing masonry buttresses at an

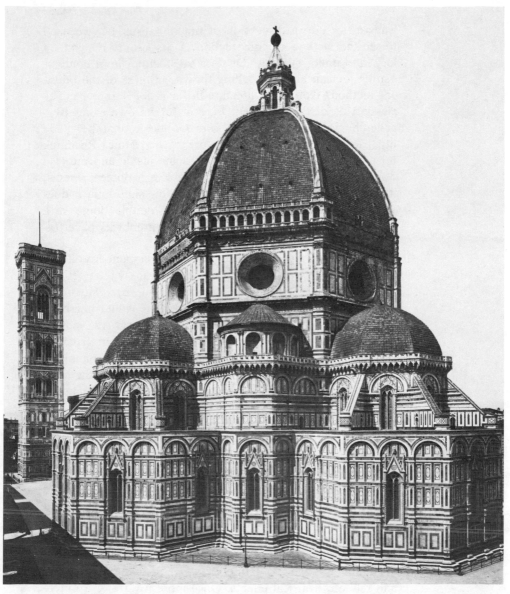

equal height. He dealt with this thrust in summary fashion by wrapping a chain around the base of the dome to keep it from spreading. This is like curing a headache with a hatband, and it has worried architects ever since, yet they have continued to tie their domes together in this fashion. It is an unpleasant fact that if the chain gave way the dome would collapse.

Architectural purists believe that it is cheating aesthetically to chain a stone building together, a point of view that

Duomo (cathedral), Florence. Dome designed by Filippo Brunelleschi. 1420–36. [Anderson.] (See also page 339, painting of dome by Kokoschka.)

leads directly to a discussion of functionalism. Do we need
to see the method of construction? Does beauty depend on
logic and understanding? Or does satisfaction lie in contem-
plating a clean and compelling form regardless of the build-
er's method? Gothic architecture had a visible structure. The
classic side of the argument is form for its own sake. Bru-
nelleschi was more classical than Gothic in that he made
little aesthetic use of the structure of his dome. Reaching
for a grand form, he smoothed his dome inside and out. He
was sensitive to a basic aesthetic problem a dome presents:
it looks higher from the inside, the hollow side, than it does
from without. Accordingly, he built a double dome with
blind space between the shells, and most architects have fol-
lowed his example.

Over a hundred years later Michelangelo undertook the
dome of Saint Peter's in Rome in a frankly competitive
mood, with the Duomo in Florence in his eye. He never
lived to see Saint Peter's completed and he would not have
been happy with what we now see. The church was length-
ened, so that the dome is lost when we stand in front of
the great façade, and in the interior it comes as something
of a surprise beyond a long barrel vault. Only from the back
of the church can we see what Michelangelo had in mind.
Yet the dome is his own, lofty and superb, with an upward
sweep as though it were modeled by a sculptor's hand.
Michelangelo chose to construct a dome with a single shell,
and it is almost too high—390 feet—viewed from within,
and almost too wide—a 138-foot span—seen from without,
and it has an ominous amount of thrust. It, too, is held
from bursting open by a chain.

Saint Peter's now set a pattern, and Rome was soon to
be filled with domed churches. Dating from the Baroque pe-
riod (following the Renaissance), these churches seek the
maximum lift and exaltation of which a dome is capable,
and rely on theatrical effects. Once more we are in a differ-
ent time which had its own ideas to express. The Baroque
church with its unifying, centralizing dome appeared at the
time of the Counter-Reformation, an anti-Protestant revival
that marshaled drama and illusion to reinforce faith. If a
dome is mysteriously the vault of the sky, the Baroque
architect left nothing to suggestion, and painted heaven and
its angels right into the dome in the most realistic terms
possible. That the painted drama overhead fell into proper
perspective only from a single point of observation troubled

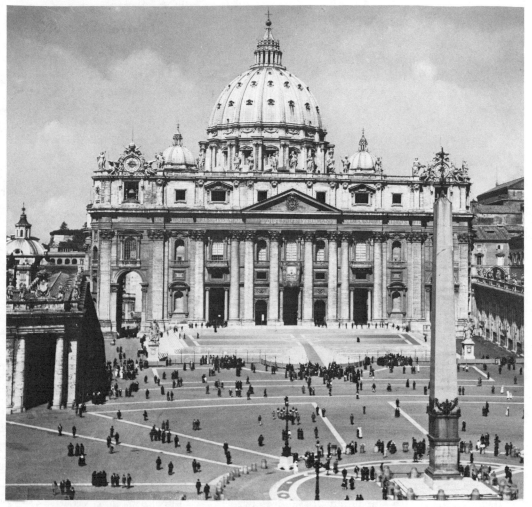

no one. The spot was marked on the floor with a stone, and when the observer stood *there* he was right with his faith.

As noted earlier, the Great Fire of London of 1665 left the medieval Saint Paul's Cathedral a ruin, and a great architect, Christopher Wren (1632–1723), undertook a new cathedral in the image of the Italian Baroque. Begun in 1675, it was completed in 1710. Wren had the good fortune to see his masterpiece finished. He had created not only a national monument, but a national symbol, an achievement reserved to great builders. Saint Paul's rises in white and gray, as sober and silvery as the weather, and possesses an almost unaccountable dignity, blending the kingdom of heaven and a kingdom on earth without embarrassment.

Wren sat his dome on a high drum that gains more height

Saint Peter's Cathedral, Rome. Dome designed by Michelangelo. 1546–64. [Alinari.]

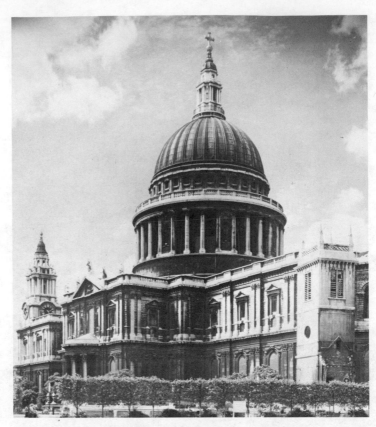

from the columns that surround it; the inner dome, seen from below, is much shallower. In fact, both are illusory; the strength of the structure resides in a hidden cone that rises from the drum and carries the weight of the large lantern on the summit of the structure. Like most things British the dome of Saint Paul's is a compromise. The clergy wished for a Gothic spire, such as they had lost in the old cathedral gutted by the fire. Wren, who was equal to devising Baroque spires for his new parish churches, wished to create a new Saint Peter's. At least he gave the clergy height, and the tall lantern and cross, rising above his dome, make do for the spire. Actually the great dome and surrounding colonnade are drawn from a small building in Rome, the Tempietto (1502), by Bramante, the Renaissance architect who first planned the Saint Peter's that was to employ Michelangelo's old age.

While Wren was building his cathedral in London, in Paris Jules Hardouin-Mansart, architect for Louis XIV, built a domed church for the Invalides, an old soldiers' home and hospital. He began after Wren, in 1680, and

finished before him, in 1691. His dome is much more Italian-Baroque than Wren's and still more dependent on Michelangelo. It is lofty, slender, and supported by not one drum, but two. This church's claim to fame came later: it is the tomb of Napoleon.

Nearly a century passed before Paris had still another important dome, that of its own Pantheon, built by the architect Jacques Germain Soufflot. It took nearly half a century to build, from 1755 to 1792, and was finished just at the time of the French Revolution. If Mansart was indebted to Michelangelo for his dome, Soufflot was indebted to Wren. The Pantheon dome with its surrounding colonnade resembles Saint Paul's. The rest of the building is quite classical, with a Corinthian porch and austere windowless walls, for the late eighteenth century was a time of classic revival. This Pantheon had an influence on American civic architecture, on the national Capitol, and on many a statehouse.

Now America was to have a dome of real distinction. The architect Charles Bulfinch built the Massachusetts state-

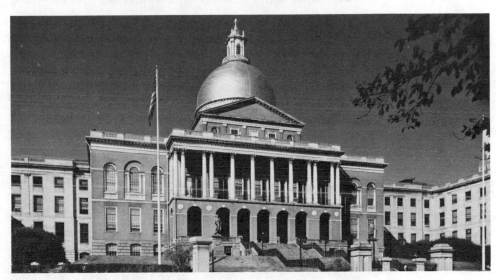

house with a golden dome that has dominated Boston Common since 1795. A sharp rise of ground supports a building that once overlooked the entire city, and the statehouse still holds its own although the tall office buildings that surround it jolt the skyline. Wide wings have been added to the original structure which now flows out from under the dome and no longer sustains the vertical composition (the same misfortune overtook the national Capitol). Bulfinch's build-

CHARLES BULFINCH. Massachusetts statehouse, Boston. 1795–98. [Sandak.]

ing, British Georgian with French overtones, possesses all the charm and warmth of colonial brick picked out with white columns, pediments, and pilasters, before the time when classical marble statehouses became the order of the day.

Thomas Jefferson, mentioned earlier for his Roman architecture that he designed as an eighteenth-century amateur, spent his last years building the University of Virginia. He conceived of a central library as a rotunda based directly on the original Pantheon in Rome. The building, like most colonial adaptations of the classical, was of brick with the classical orders white as plaster. It was less than half size with a drum higher in proportion than the Pantheon's. The original building burned and was replaced early in this century by a somewhat larger building closer to the Pantheon's proportions. This rotunda is very far from Rome in effect, with none of the Pantheon's blind weight—for there are windows—and none of the sense of power of ancient Rome. It has great charm, nonetheless, as it presides over its setting at the head of a lawn lined with long brick-and-plaster colonnades and houses fronted with classic porches that Jefferson built for the professors. The building carries out

THOMAS JEFFERSON. Present rotunda (library), University of Virginia, Charlottesville. Original building 1817–26. [Sandak.]

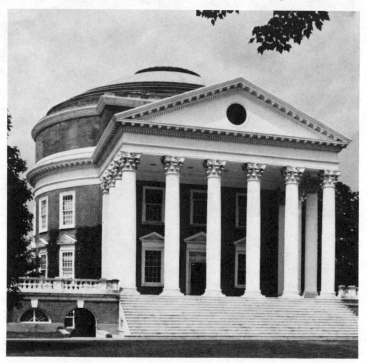

the original intent: to make visible the aspirations of the new republic.

The dome most central in the American imagination is that of the national Capitol. The building underwent many changes before the dome we now see came into existence. The city of Washington itself was a classical fantasy, an Athens of America laid out along Goose Creek by Major L'Enfant, a Frenchman who had served General Washington as an engineer. L'Enfant established an axis between a capitol and a monument, and another axis leading north to a president's house. He planned a series of avenues converging on plazas as an overlay to a rectangular grid of streets, and all this materialized. These converging avenues are entirely baroque: they hark back to the converging alleyways between the great trees in Louis XIV's park at Versailles: the hunters came together at a rallying point and then dashed off after game in every direction; and now the taxis of Washington can follow the same procedure.

A design for the Capitol was more difficult to come by. The scheme of a Steven Hallet and William Thornton found favor, but unfortunately these two men developed different notions of a dome. Then President Jefferson brought in Benjamin Henry Latrobe, an architect with a clearer plan, and the work progressed; but only the two separate wings were in existence when the British burned them down in the War of 1812. The Capitol, completed a decade later, had a façade much as we see it, if we except the two end temples for the Senate and the House of Representatives. The building had the now familiar high basement and broad steps leading up to a classic porch and pediment, but the dome over the rotunda was very shallow.

A generation later Thomas U. Walter took over. He added the Senate and the House of Representatives chambers, which extended the façade so widely, and planned a dome 300 feet high. This final dome was still incomplete, like the nation itself, by the time of the Civil War. It is made of cast-iron plates that simulate marble, for by then not only cast-iron supports but whole cast-iron surfaces were in existence. Thus the Capitol is not the work of any one individual; we must see it as the product of the neoclassic ideal as it undertook to express republicanism. The national Capitol literally rises above its limitations: the dome lifts above a rambling building as though in triumph after a long struggle.

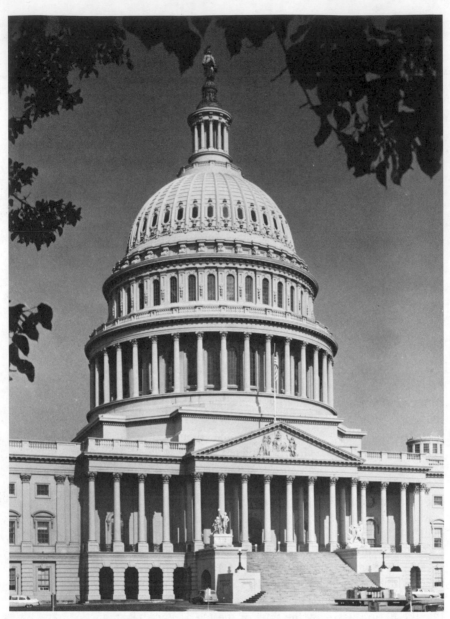

Capitol, Washington,
D.C. Dome and Wings
by Thomas U. Walter,
1851–65. Central block
by William Thornton
and others, 1792–1828.
[Sandak.]

The dome as a form has managed to maintain itself even after the coming of modern architecture; the American architect Frank Lloyd Wright liked this swelling, circular shape. A dome is a self-centered composition, and Wright was a singularly self-centered genius. He imagined Aladdin-like pleasure domes, but his most spectacular achievement in this general design is the Guggenheim Museum in New York. His building is actually a drum, with a long spiral

ramp for exhibition space. Yet standing within it, looking up at the circular glass overhead, we are reminded of the Pantheon in Rome. It is not a practical building in terms of its purpose; but we must remember that these buildings are monuments.

What can be said of these domes in general terms? That they are all singularly unserviceable if they are judged by

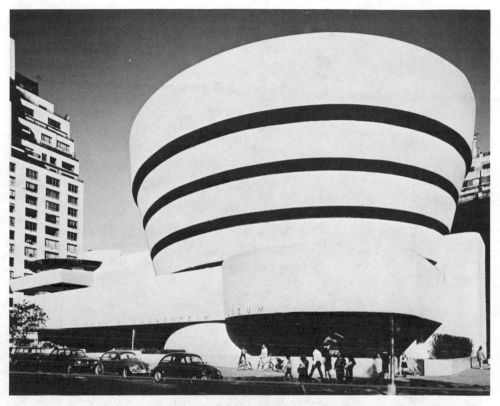

reasonable standards. Their function is spiritual. They survive as if to stress once more that architecture has a civic-religious core. They are the primeval caves; they are shrines.

Nothing dramatizes more effectively architecture's break with its past than the geodesic domes of Buckminster Fuller. These domes are no longer monuments, beautiful objects though they are. They are controlled space, and whether they are architecture or engineering seems no longer a valid question. The formula by which they are structured varies with their size, and these mathematical variations are said to exist not on paper but in the extraordinary brain of their inventor. The geodesic dome put in a long-delayed appear-

FRANK LLOYD WRIGHT. The Solomon R. Guggenheim Museum, New York. 1943–59. [Photograph courtesy of The Solomon R. Guggenheim Museum, New York.]

ance, winning its way into reality as a great economy. And then suddenly it was put to use by the government as a housing for radar installations, and as such has appeared all over the world. These geodesic domes have sprouted like mushrooms, thickest in a magic ring around Russia, as their inventor has observed.

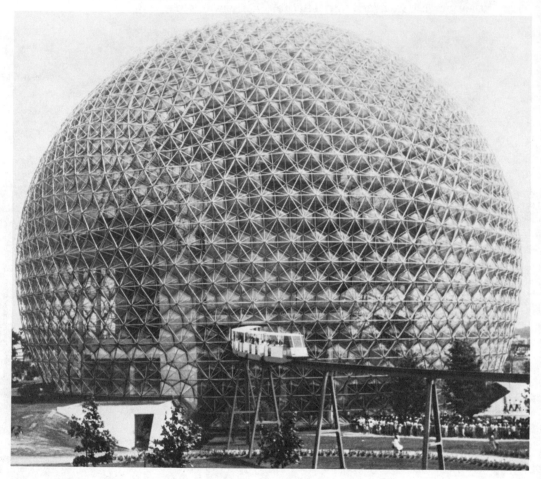

BUCKMINSTER FULLER.
Geodesic Dome,
Expo '67, Montreal.
[Ilse Friesem.]

5

CLASSIC SCULPTURE

AND PAINTING

Hera of Samos. ca. 570–60 B.C. Marble. (Louvre, Paris.) [Cliché des Musées Nationaux.]

If the architectures of the Greeks and Romans, however different in spirit, were long confused, this is even more true in the case of their sculptures. The ancient sculptures we possess are time and again Roman copies of Greek originals. The question keeps arising—is it only Roman, or it is good enough to be Greek?—until the greatest of Greek sculptors become figures of fable. What evidence of surpassing performance do we have?

We at least have the evidence of consistent growth, and to follow this, we must turn back to a time before the Parthenon. As a point of departure, the *Hera of Samos* dates perhaps from the sixth century before our era. The goddess is now a headless shaft clothed in a long mantle—there were to be no nude Greek statues of women for several hundred years. Her erect dignity is quite Egyptian, and her pleated garment makes her into a fluted column. Greek maidens with pleated garments will actually do the work of columns, carrying the cornice of a small building on the Acropolis, the Erectheum. They have a title when they are so employed; they are called caryatids. To this day, columns are swathed in hangings, as we can see in cathedrals on occasion, notably in Saint Peter's in Rome.

At much the same time as the Hera, appeared kouroi, naked figures of young men, whether athletes or gods. They all stand in straight set poses, one foot advanced, arms at their sides, the shoulders much wider than the hips. The shoulders being the full width of the marble block, the arms

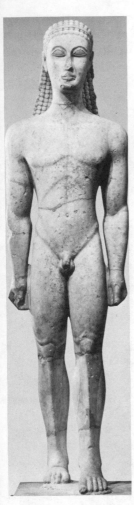

Standing Youth (Apollo
Type). Greek. 615–600
B.C. Marble. (The Met-
ropolitan Museum of
Art, New York,
Fletcher Fund.)

must hang straight and the hips have to be narrow. Broad
shoulders, a set frontal posture with a foot advanced, are
quite Egyptian. And as there is a typical anatomy, there is
a typical expression: the eyebrows are arched high and the
eyes are unnaturally wide open, while the mouth has a set
smile. We possess a number of these figures. They have a
serene youthful splendor that seems to depend on their de-
liberate stylization.

We move nearer to the age of the Parthenon. The *Birth
of Aphrodite,* a relief carved on the back of a throne, shows
the goddess rising from the sea from which she came. Two
attendants in long, rippling costumes lift her with identical
gestures while they raise a cloth to shield her nudity. She is
vaguely Egyptian in her expression and features and in the
turning of her head in profile. But she is pure poetry. On the
side panels are two perfect lyric figures: one a seated, veiled,
and shrouded figure as she guards a lamp which is of course
her chastity; the other a contented naked nymph, her hair
in a snood, who sits comfortably on a folded cushion and
plays to herself on a double flute.

We come now to a sculptor whom we are invited to
take on faith as one of the great artists of all time. We have
nothing of Phidias to which we can point, yet he looms as
one of the great names of a great age, the sculptor of
Greece's two most revered statues. It was he who carved
the gigantic Athena that the Parthenon housed and the Zeus
in a similar temple at Olympus. Both were of ivory plaques
fastened on a wooden frame and both were embellished with
gold ornamentation. They were so large that minor figures
could be introduced by way of supporting decoration, and
Phidias was said to have carved his own portrait on Athe-
na's shield. Both statues have long since vanished, but we
have some inkling of their appearance from coins and from
what may be smaller replicas. They had royalty's rigid task
of imposing their presence, and we have to imagine them as
lofty gleams hidden in deep dusk.

We come to the unanswerable question, what part did
Phidias play in the carving on the Parthenon, the two fig-
ured pediments or gable ends and the two processions that
follow round the building high under the eaves? Obviously
no one man could have made all these sculptures, for the
Parthenon was created too rapidly. Just as obviously the
same imprint is upon them all. The figures from the pedi-
ments now in the British Museum in London are among

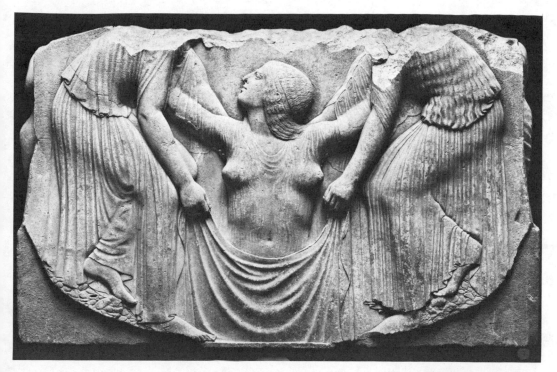

the world's great sculptures. We praise them as studies in
pure formal relationship. Out of this perfection of relation-
ship comes a strange detachment and dignity. The figures
are both alone and individualized, and together and assured.
They have managed individuality and freedom without the
particularity of portraiture. They are presences and divin-
ities.

We must remember that these gray figures once were
colored and once glowed in the sun. Greek color was dec-
orative rather than naturalistic; it made the figures not more
real but more abstract. Hair was black; there were red ac-
cents of outline; blue was introduced as a background to
pale, ivory-colored marble.

Most characteristic of the next generation are the sculp-
tures of athletes, typically runners in the Olympic games.
In the figures by Polyclitus and Lysippus an arbitrary for-
malism is in control. Anatomy is articulated muscle by
muscle. By now originals were likely to be in bronze; the
marbles we possess are Roman copies. The more fluent
bronze invited the artist into a new freedom of movement,
and figures became ever more lifelike and less sculptural
in the process. The most famous in this kind is the *Disc
Thrower* by Myron. Although we only know this work from

Birth of Aphrodite
(Ludovisi throne).
Greek. ca. 470–60 B.C.
(National Museum,
Rome.) [Anderson]

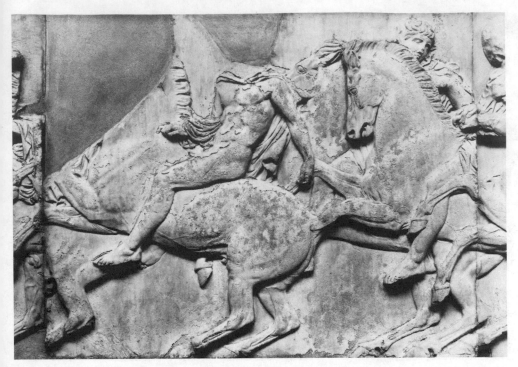

Metope sculptures from the Parthenon. 448–42 B.C. Marble. (The British Museum, London.)

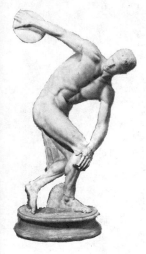

MYRON. *Discobolus.* ca. 450 B.C. Roman marble copy of Greek original in bronze. (National Museum, Rome.) [Scala.]

copies, we possess a number, and through comparison we can come close to the original source. The *Disc Thrower* is an exercise in organization. Sculptor and athlete work together, as though the artist were a coach.

From this point movement and subtlety are taking the place of grandeur and the Golden Age is now autumnal. Praxiteles is the ultimate Greek sculptor among the great who, like Raphael, can use facility without loss of dignity. The *Hermes with the Infant Dionysos* was once believed to be by his hand. Then seen as a Roman copy, it nonetheless possesses the sensuous nobility of an effortless talent, a skill handed to the sculptor by the genius that went before. Greek sculpture has become an assured organization of ideas that resembles life. In this it echoes Plato's notion of a generalized form which each separate member of a species resembles. According to Plato, each of us is a hit-or-miss copy of a living idea of man and it is this idea that the sculptor, and nature too, pursues. As though to sum up the idea of woman, Praxiteles carved the *Aphrodite of Knidos,* a nude, for by now nude female figures had entered history. She was the most famous sculpture of her time and her sanctuary was a place of pilgrimage throughout antiquity.

An ever-increasing facility now led to a greater restless-

ness, an appetite for the violent and the grandiose, a change sufficient to justify a new name, the Hellenistic. Great spectacles could still be achieved, and there were still great recollections to lift the level of performance. We are leading up to the *Victory of Samothrace*. The colossal stone figure beats its wings and its garments float and flap as it alights on the prow of a stone galley that rushes forward at speed. The figure presumably was blowing a trumpet. Other monuments in violent action contain a certain lurking embarrassment, but the *Victory of Samothrace* does not. It sums up an irrational battle feeling that is like first love, when a moment sweeps all of life together.

Then a little later comes the *Venus of Milos*. This is not

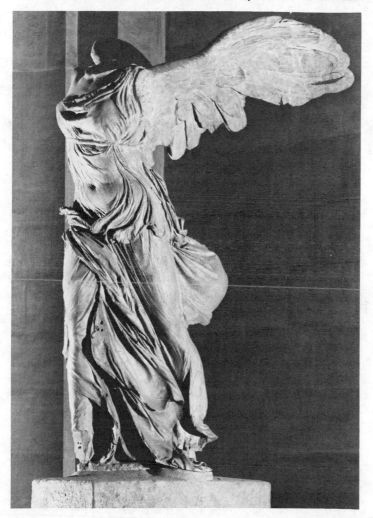

Winged Victory (Nike of Samothrace). Greek. ca. 200–190 B.C. Marble. (Louvre, Paris.) [Cliché des Musées Nationaux.]

the greatest sculpture in the world, but it is one of a very
few sculptures that seem so when we are in their presence.
The figure appears to be very simple, but it is mannered,
and would probably seem more so if it were complete. But
there is nothing trivial about the goddess; she is marvelously
at ease and nobly unconcerned.

Still later are the *Laocoön Group* and the *Apollo Belve-
dere*. Laocoön and his two sons came to light in Rome dur-
ing the Renaissance. Michelangelo saw the marble hours
after it was discovered. Its animation was greatly admired
and it certainly contributed to the freedom of expression of
the Renaissance. But the horror it depicts is highly theatrical
and the serpents tie up the composition as if Laocoön and
his sons were posing in the midst of an old grapevine. La-
ocoön was the Trojan priest who warned his people not to
trust the wooden horse in which the Greeks were concealed,
and Athena sent two serpents out of the sea in support of
the Greek deception, both to discredit and to destroy him.

The *Apollo Belvedere* was discovered still earlier than
the *Laocoön Group*. It was long admired, and never more
so than in the eighteenth century when the classic revival
was at its height. The god has a Byronic air, with something
of the spoiled dilettante about him—or so it seems now. It is
named for the Belvedere, a court in the Vatican. Here it
long stood, and here in earlier times it was a privilege to be
taken through the Vatican at night to see it by torchlight,
when the marble shone ruddy as flesh. Tastes change.

This late or Hellenistic phase of Greek sculpture is typi-
fied once for all in the great altar at Pergamon carved a
little earlier than the *Apollo* in the second century before
our era. This grandiose sculpture celebrates a battle with a
king of Syria who was unwisely pressing into Asia Minor,
and its theme is the combat between the gods and the giants.

The rectangular altar once supported a roofed colonnade.
What remains of the base is a continuous marble frieze, 400
feet in total length, eight feet in height. This frieze, carved
in high relief, presents an extravaganza of violence and tur-
moil. Nothing breaks the animation of this Wagnerian com-
position. Violent without respite, the Pergamon altar offers
us the last scene of Greek art, when all the actors appear on
stage and, as we suddenly realize that they are only actors,
the curtain falls.

In Rome, beginnings were more mundane. The seasoned
heads of statesmen, orators, and soldiers went over into

marble or bronze. The Roman had a very strong and cal-
loused grip on reality and these portraits are gnarled and
unrelenting. Apparently much of this vital and early Roman
art was the work of Etruscans, a people living to the north
of Rome. The Etruscans had thriven off a provincial Greek

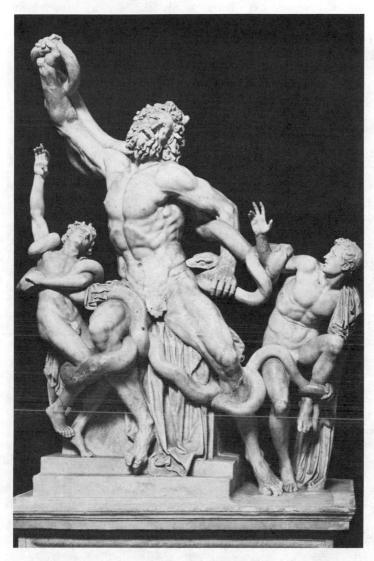

Laocoön Group. Late
second century B.C.
Marble. (Vatican Mu-
seum, Rome.)
[Anderson.]

culture, for the Greeks had scattered colonies all over the
Mediterranean in their day. We are reminded of early
Americans copying European artists and more than making
up with intensity what they lacked in sophistication.

By the time the Roman republic became a vast empire

the city was a forest of statuary lugged in from Asia Minor and Greece, and stonecutters were copying for all they were worth, which was often little enough. Roman sculpture itself became political illustration. No one could have been more bland and cool than the great Emperor Augustus, and his images must have been exactly like him, at once official deity and politician. From now on a curious thing happens:

The Emperor Caracalla. A.D. 215. Marble. (Capitoline Museum, Rome.) [Alinari.]

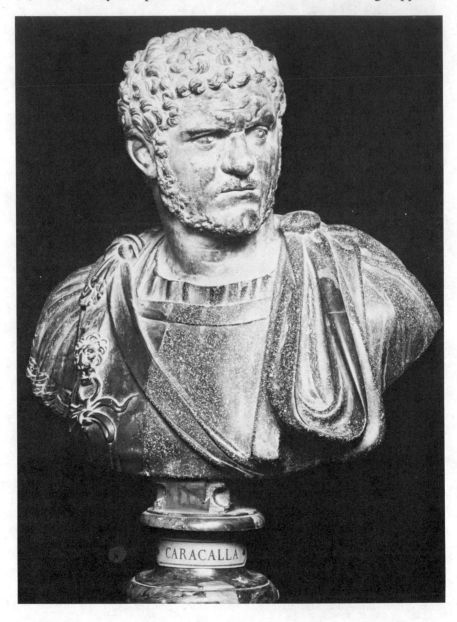

CARACALLA

everyone resembles the current emperor as if by a mass decision. There is only one portrait for each reign, and in the faces of the emperors we can watch the state disintegrate, face after face, as control and self-control become more difficult. We go from genius to brutality to madness. The emperors may show the extreme of asceticism or the extreme of self-indulgence. Among them are idealists like Marcus Aurelius and men of taste like Hadrian, whose urbane fantasies drew literally on the ends of the earth. But more and more they are musclemen, uncontrolled, like Caracalla. And increasingly, sculpture, manly art that it is, becomes rude as a soldier's life.

The story of classic painting is much simpler for lack of evidence. The Greeks admired their great painters quite as much as they admired their sculptors. We have names, of Apelles and others, and anecdotes which suggest that naturalism carried to the point of deception was either the painter's goal or the aspect that impressed the innocent.

Vase painting, a fascinating if minor art, tells much of what we know of the simplicity and vitality of Greek life and of the intimacy with which the Greeks lived with their myths. Their drinking bowls and jars came in three or four characteristic patterns, beautiful shapes in themselves, covered with figures in simple outline.

In its first beginnings vase decoration was geometric, but by the sixth century B.C. the Greeks had taken the human figure for their visual language and their vases showed animated black figures on a red ground. A little later this contrast was reversed and red figures on a black ground allowed for more internal drawing. Finally we have white figures on black, or red figures for weather-exposed men and white for house-bound women. The technique was linear; the effect was of simple theater in shallow space. This free and flowing language of line, which also served for engraving metal, has survived to inculcate elegance wherever there has been drawing or engraving; it was boldly and frankly imitated by Matisse and Picasso.

Roman painting survived both in Rome and in the excavated cities of Pompeii and Herculaneum. Painters divided walls into panels; a small vase or plant appeared in the center of a panel, a decoration that gradually expanded —in the course of years—until it became a scene. Later, the Romans enjoyed opening up the space of a room with a

jumble of painted architecture that tells us much of the congested appearance of classical cities. All too often the quality of the work sank to the level of wall decorations by journeymen intent on covering space.

Yet on occasion Roman painting achieved breadth and vision. Especially in landscape painting we find a real feeling for sweep of territory and a capacity to organize space that is in the Roman character. These landscapes usually

Flagellation scene (detail, murals from House of Mysteries, Pompeii). ca. 50 B.C. [Alinari.]

contain small animated figures in the foreground busily acting out myths. The Romans had no grasp of the mathematical perspective that came in with the Renaissance, so there are no vanishing points. Distant objects are relatively

smaller and higher, and space is loosely accounted for by the objects it contains.

The Romans also illustrated myths with large sculptural figures in contrast to the figures subordinated to landscape. Perhaps the best in this kind that has survived is the series of murals sweeping the walls of a room in the so-called House of Mysteries in Pompeii. This series shows a remarkable control of pictorial elements: drawing, foreshortening, adequate handling of space, and a forward-moving composition. The theme is an initiation, apparently of a young woman into marriage, yet the series seems vaguely morbid and oppressive, perhaps because of the muted red background, the Pompeiian red which became fashionable in neoclassic revivals.

If the edges grow hard in these larger figurations, we must remember that the painter was not only competing with sculpture but with the linear patterns of mosaic. The Romans used mosaics liberally for whole floors and for the bottoms of pools. Mosaics, if they escape destruction, suffer little change with the passage of time, and here at least we are face to face with classical reality. We must judge this handsome art by its decorative intentions and above all by its successful subordination to architecture.

THE MIDDLE AGES

From Roman to Romanesque

Roman architecture enclosed great space, but with the disintegration of the vast single state, such building was a thing of the past. Construction on such a scale was too costly. The labor, the materials, the organization were unavailable. For hundreds of years all that was feasible as a public building was a shed of modest proportions, and in such buildings the early Christians gathered when Christianity, an underground movement, could safely come into the light of day. The early restraints upon the new faith were removed in 313 by the Emperor Constantine, who later became a convert, and by the end of the century Christianity was the religion of the state.

A church began as a very small temple without its surrounding columns. Instead, it had lean-tos set against the long sides for greater width; and the long walls were soon supported on colonnades and arches, throwing the spaces together. This was the Christian basilica, a design that survived until it ultimately accounted for the great cathedrals.

The lean-tos had roofs lower than the central building, whose side walls therefore came into the open above their supporting columns, and on these side walls a line of windows sent down abundant light. This was the clerestory, and this too was to survive to light churches all through the Middle Ages. Windows set high in a wall, for light, not

for seeing, was quite Roman—and for that matter, quite
Egyptian.

Finally the Romans had a way of setting a semicircular
apse in an end wall, a half-cylinder with a half-dome above

Basilica, Torcello
Cathedral, Venice.
Cathedral founded 639,
rebuilt 864, altered
1008. [Anderson.]

it, and this too survived. The basilica had a door at one
end and an altar at the other before the apse. The rows of
columns on either hand gave a sense of progression; to walk
the length of the church was to progress from this world to
the next.

In early examples, the columns are not always of a size.
Pagan temples were plundered for their stones as they were
shut down, and often columns of uneven height were assem-
bled from more than one building. The basilica was not
only a Roman design reworked, the actual stones were used
again.

Mosaic survived too. The side walls above the columns
and arches and below the clerestory carried religious his-

tory; and the apse displayed more sacred and timeless images or symbols of the central figures of the faith.

Mosaics, Interior of the church. Daphne, Greece. Eleventh century. [Alinari.]

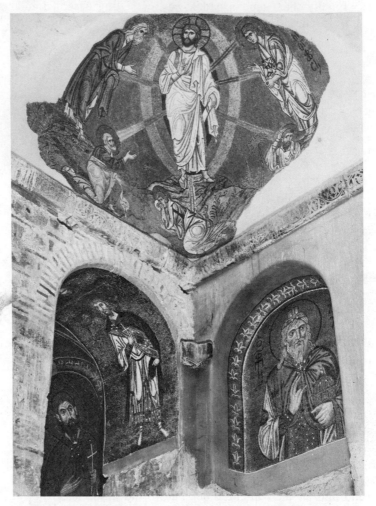

By now the Roman world empire had divided into two sections like some overgrown cell. Constantine had moved the capital from Rome to Byzantium; it became the city of Constantine, or Constantinople. This left a vacuum of power in Italy, and by the fifth century northern tribes that the Romans had never conquered began pouring down into the peninsula. There was a fiction that the Roman emperor ruled the West from the East, but he only retained a temporary outpost of power at Ravenna on the Adriatic, where important Byzantine basilicas still remain.

The story of the West was now one of endless violence

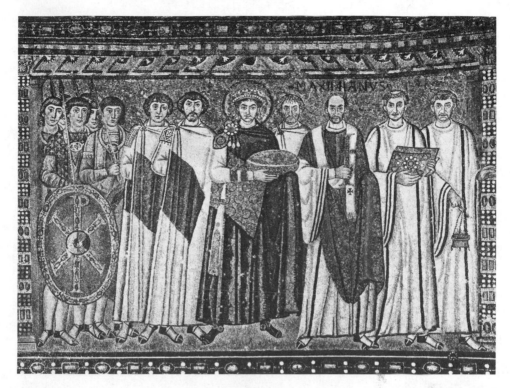

held at bay in a few religious sanctuaries. The churches of
the Middle Ages were more than churches; they were spirit-
ual strongholds. Monasticism as a spiritually dedicated way
of life had arisen in Egypt before the year 400; it spread to
Constantinople and thence to western Europe, where able
religious leaders succeeded in creating effective organized
societies out of the monastic orders they founded. The earli-
est, the Benedictines, was established by Saint Benedict
about 529. Its original headquarters at Monte Cassino, on a
small conical mountain on the road from Naples to Rome,
survived until World War II when it was fought over and
heavily damaged. Such a community was ruled by an abbot,
and here the order not only sheltered a tradition of learning
as a university would later do, but it carried on much of the
daily work that preserved society. Tilling fields and harvest-
ing, it accounted for more than its share of the food supply
in a desperate hand-to-mouth economy. Eventually the mon-
asteries grew fat, as successful organizations will, and the
Benedictines built a vast monastic headquarters at Cluny in
Burgundy (908–1130) that came to wield important politi-
cal power.

Possessed of such spiritual support, the church remained

Justinian and His Nobles. ca. A.D. 547. Mosaic. San Vitale, Ravenna. [Alinari.]

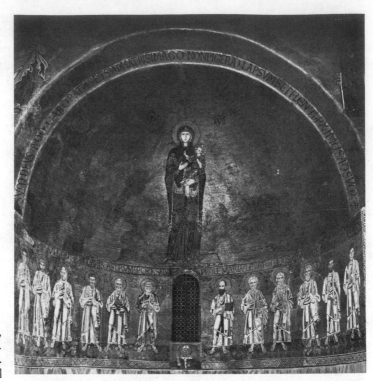

Virgin and Child.
Mosaic in the apse,
Torcello basilica.
Eleventh century.
[Alinari.]

Portrait of Saint
Matthew, *Book of
Lindisfarne.* ca. 700.
(The British Museum,
London.)

the unifying principle in western Europe under the bishop
of Rome, or pope. The Christianizing of Europe not only
followed wherever the Roman Empire had extended, but it
was even more successful in outlying unconquered regions,
notably in Ireland. The monastic orders and their leaders
became missionaries, and to a remarkable degree unified
Europe from the Atlantic to the Middle East.

In sheltering religion the monasteries preserved history.
The scribes copied manuscripts endlessly; in effect the mon-
asteries were publishing houses. Parchment manuscripts,
embellished with illustrations and illuminations, drew no dis-
tinction between the written word and the pictured image. A
capital letter was reason enough for a tangle of pictorial de-
design. For several centuries these manuscripts were the ma-
jor art form, and the best that remain are some of the most
beautiful objects that man has made. Linear, cursive, in-
finitely complex and brilliant in color, they have none of
the simplicity of classical art; they resemble the delight of
childhood in a story embroidered over and over again.

The name of these complex patterns is the interlace. It
has been associated with Ireland for the remarkable exam-
ples that have survived in that country, both in the manu-

scripts and on the characteristic stone crosses; but in origin it is an adaptation of a primitive linear tradition of great vitality that often expressed itself in carving and jewelry.

The manuscripts come between this primeval design out of northern Asia and the linear sculpture and architecture that was to follow from them. Skilled in pattern-making so complex that it cannot even be comprehended at first glance, the scribes preserved and passed on this dazzling linear art. The greatest work in this kind that we now possess is the Book of Kells, dating from about 800. A further memorial to the skill of the unknown scribes is the Utrecht Psalter, or Book of Psalms, where the artist—for so he was—broke out of the interlace tradition to illustrate his text with figures and events. He created a monument of Carolingian art, named

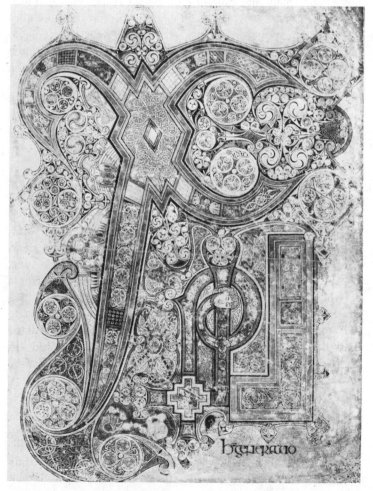

The monogram page, Gospel of Saint Matthew, *The Book of Kells.* ca. 800. (Trinity College, Dublin.) [The Green Studio.]

for Carolus the Great or Charlemagne, king of the Franks,
a northern prince both German and French, in terms of the
territory over which he ruled.

On Christmas Day of the year 800 in the old Saint Peter's
basilica in Rome the pope placed an imperial crown on the
head of Charlemagne, thus re-creating a Roman Empire in
the West. The new emperor had the power to bring a fresh
unity to western Europe, and to create a revival in the
arts. If he did not open a new epoch, he preserved a con-
tinuity with the past that had worn thin. He employed
scribes to multiply texts of manuscripts that had nearly been
lost, and dispersed them like so many branch libraries.

But when the pope crowned Charlemagne, he raised a
never-answered question: did this mean that the new em-
peror was really the emperor of Rome returned, the abso-
lute ruler of the world, or did he owe his power and alle-
giance to the pope? Through the Middle Ages the struggle
for supremacy between pope and emperor became a source
of endless contention and even warfare. In the long run, the
pope, with his central position and spiritual authority,
proved the stronger. The emperor, a German prince, fell
back on his own territories in the north and could only
make forays into Italy. In a Western Europe under a divided
authority, or none at all, the millennium was running out in
the midst of general discouragement and disorder.

Meanwhile, the Eastern, or Byzantine, Empire continued
to lead a life apart. Its art came in separate outbursts, the
first two divided by a long period of iconoclasm that de-
stroyed almost all of Byzantium's first golden age. From
the first age, however, we inherit one of the world's great
churches, Hagia Sophia in Constantinople, which set a type.
Many of the churches that followed were as small as Hagia
Sophia was large, but the type persisted: three aisles and a
central dome. In our discussion of the dome we referred to
a Byzantine style that was grand, imposing, and transfixed
like the society it represented. Figures of Christ and his
apostles, of the Church fathers, or the emperor, looked
down from the vaults or stood together on the walls, elon-
gated figures of authority. Height, verticality, inspired awe.

Not only Christian theology but also Greek philosophy
was seen as leading upward to the Absolute. For Plato,
ideas were living realities: a word such as *man* had a con-
ceptual existence of which individual men were only
shadows. It was early realized that the concepts of Greek

thought were close to the eternal verities of Christianity. Thus the official faith only reinforced authority, and God, Christ, and the emperor were related spiritual and political absolutes that hung aloft above mankind.

The Romanesque

The West was subject to these same vertical concepts. Byzantine mosaics of elongated proportions were already to be seen in Italy from the fourth century, to be followed by religious works in the same style both in Sicily and farther north in Rome and in the city of Venice, then young. Small Byzantine religious images carved in ivory exhibited the same elongations, and such devotional objects were easily transported. Their vertical exaggerations were in the mood of the illuminations that poured out of the monasteries. If the ideal of universality was never achieved as political fact

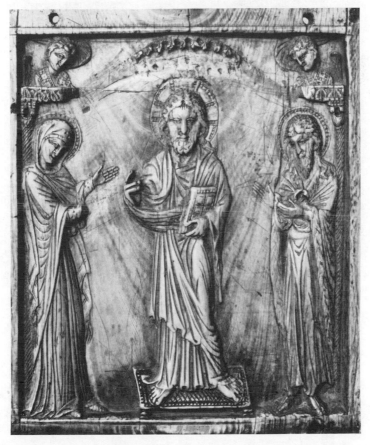

Christ in Glory between the Virgin and St. John. Byzantine ivory plaque. Tenth to eleventh centuries. (The Metropolitan Museum of Art, New York, gift of J. Pierpont Morgan.)

in the West, the longing for a single authority was redirected toward religion and art, and found its expression in an upward sweep toward a single source of spiritual power.

Some time after the year 1000 the reawakened aspirations of humanity, already provided with their vertical metaphor for hope, began to express themselves through architecture, and everywhere new, larger, loftier churches appeared. This architecture, the Romanesque, as it has come to be called, was at once Roman, with its fortresslike solid walls and round-headed arches, and Christian, with its new lift into the sky. These very buildings symbolized the body of Christ crucified, with their transepts for arms, their nave for a body, their choir (the most sacred part of the church, containing the altar) for a head. The nave belonged to the people, the more sacred choir was the territory of the priests, and the sermon was preached where nave and choir

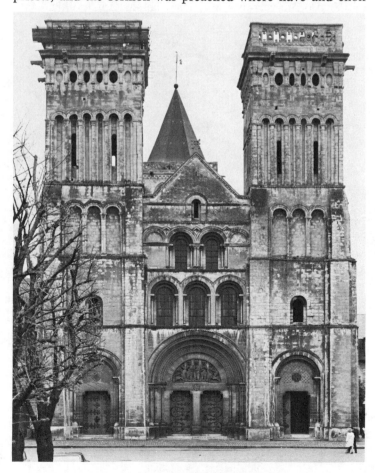

La Trinité, Caen, France. [Giraudon.]

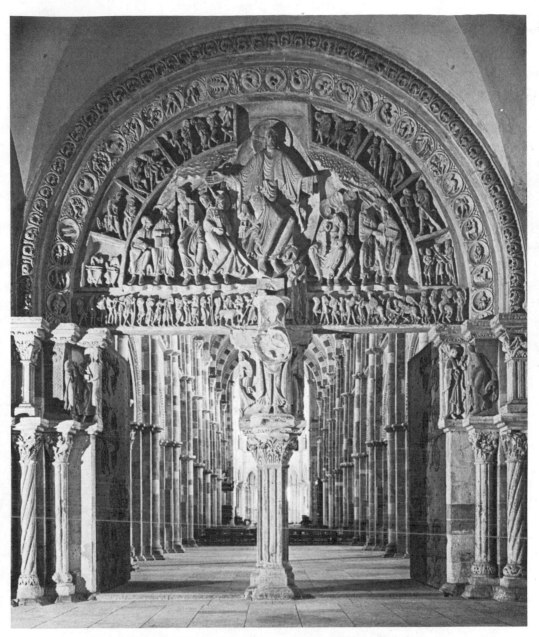

met. The western portal of the church now became a sep-
arate composition, a triple gate guarded by two towers, as
towers had long guarded the gate of a city or castle.

This fortress of faith was locked to the ground as a citadel
for the faithful. And here the faithful materialized in sculp-
ture; here Christ appeared in stone to welcome humanity at
the main portal; and here the saints and the saved popu-

Tympanum, Sainte
Madeleine, Vézelay,
France. ca. 1120–32.
[Scala.]

The Prophet Isaiah.
Notre Dame, Souillac,
France. Early twelfth
century. [Giraudon.]

lated the buildings. They retold their stories through gesture and attribute, they sprouted on the capitals of columns; where a classical column flowered forth in leaves and tendrils, the Romanesque capital sprouted people or souls.

Structurally, the builder's new goal was a fireproof roof, for fire regularly gutted out an appalling number of wooden ceilings. Wooden roofs were replaced by stone barrel vaults, which were at once segmented into bays by stone arches arising above each pair of columns. This barrel vault was heavy, and needed to be braced against thrust, so walls were thickened or else strengthened by buttresses extending outside the building. An effort to make the vault lighter led to a reliance on the cross vault or groin vault.

Here we must be technical. To supplement the arch that goes directly across the ceiling from column to column, arches were sprung on the diagonal across the bay. These diagonal arches obviously spanned a longer distance and in consequence were higher than the transverse arches, so the ceiling now becomes a series of shallow domes. The areas of stonework between arches were also made slightly convex, each a little shell-like dome, which accounted for a gain in strength. This was about as far as the Romanesque went in the design of ceilings.

Immediately beneath the ceiling both in the transepts and the west end great round windows began to appear with spokes like a wheel. In such windows, the round arch had gone full circle and became a symbol of the universe. In the Gothic, it would take on a complex splendor of its own.

This round-arched, massive form varied from region to region. It came out of northern Italy, where the outer surface was brilliant with variegated stone and animated with blind arcades. The south of France had its own type with a central tower. Normandy had its type too, much what the Normans took to England, with square-headed towers on the west end.

The cathedral at Durham, England, with its massive round columns and round arches, is an example of Romanesque, but here as elsewhere the later Gothic overlies these massive beginnings.

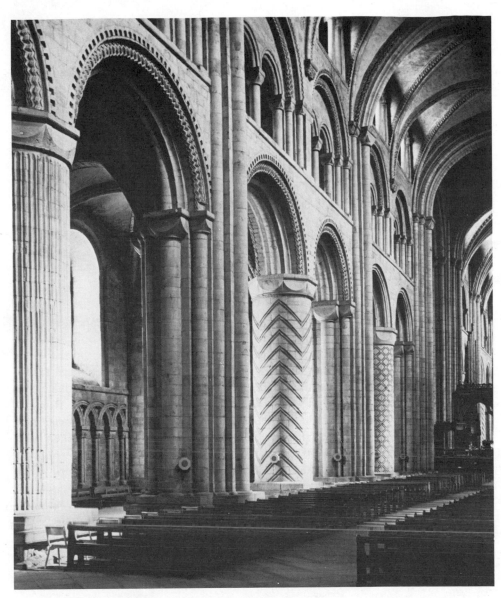

Interior, cathedral,
Durham, England.
1093–1130. [Alinari.]

CATHEDRALS AND TOWNS—
THE GOTHIC

In the eleventh and twelfth centuries, the years when the Romanesque came into its own, Europe not only revived, it doubled its population and had the energy for the Crusades. Such energy, put to better use, realized new architectural forms as though stone could blossom. The thirteenth century was the century of the great cathedrals. Romanesque art had come out of the life of the monasteries. The cathedrals had a different source: they were largely the work and pride of the new towns they dominated.

A cathedral adds up to so much that we can hardly appreciate it without some notion of the society it represented. East or West, the Middle Ages believed in authority, whether over earth or heaven. We have already spoken of the clash between emperor and pope, each the head of an organization conceived vertically. To begin with the authority from heaven: beneath a triune God came the pope, his vicar on earth; under the pope were bishops; and under the bishops, priests. The religious orders were even more closely knit to papal authority. They were headed by abbots with monks at their command, and humbler still were lay brothers. This religious hierarchy reflected a supernatural organization from God to Christ above a heavenly host of archangels, angels, saints, and prophets with dominion over a vast population of saved souls.

On the secular side, that of time and the world as opposed to eternity: beneath the emperor came kings; then the echelons of nobility, dukes, marquises, counts (earls in Eng-

land), barons, and the king's knights. Below them came free men, and all men were not free. At the lowest level were the serfs bound to the land. This hierarchy was the feudal system, organized on the principle of duty, where every man owed allegiance to someone above him.

This fealty as from son to father survived on a basis of mutual obligation. A personal relationship served to reinforce the authority of emperor or king. At the same time, what with appalling communications and a thin and scattered population, the system itself was weak enough to be adaptable. It had the pliability without which society atrophies.

Under these circumstances a king struggled endlessly to assert his authority and to force his will upon a restless and unruly nobility. This centralizing process took hundreds of years, and only replaced anarchy with tyranny as a new unified state or nation emerged. The church provided a refuge from this turmoil, but the saving factor was the rise of cities in which an artisan and mercantile class could shelter.

The meagerness of existence in such far-off times is difficult for us to realize. The hilltops of Europe are crowned with the ruins of small castles. Here windows were mere slots, without glass and open to the winds; the building was as dark as it was cold. The lord in his stone hall might have a chair with a high ecclesiastical back, but more probably he sat on a bench beneath a wall to remove the risk of being stabbed from behind. A table of long boards on trestles was placed in front of him for his feast, and after the meal the table was taken away. Lesser figures in the hall sat on little benches and three-legged stools and still others sat crosslegged on the floor. The dim scene was lit at night by the open fire in the middle of the stone floor and not all of the smoke escaped through a hole in the roof; fireplaces came a little later.

The castle sheltered a village and the villagers could come inside the walls and be safe from a passing raider. The lord owned these people, as he owned the land. They lived in huts made of mud plastered over rushes, and their good fortune or hope was to possess a leather coat.

Compare this existence to the life of the town. Here, if a man lived a year and a day he became free—free to join a guild. Organized by trades, whether weavers, carvers, or carpenters, the guilds protected their members, determined con-

ditions of work and length of apprenticeship, set wages and
prices, and kept out strangers. Their primary concern was
not wages but the quality of the product with which their
membership was wholly identified. These were craftsmen.

The craftsmen, the artisans, developed specialties for
which they and their sons after them were known; artists
were those exceptionally gifted in the family business. Such
men and their families could head up whole industrial units
with their apprentices living under one roof. Although cer-
tain crafts inevitably called for working together in large
sheds, wherever possible men lived where they labored.
Their way of life was based on refectory eating and dormi-
tory sleeping. The master's bed had a central position in the
one heated living space. Separate bedrooms came later. A
maid slept in a trundle bed across the master bed's foot. No
one was very far away. The ribald fantasies of the Middle
Ages were concerned with mistaken identity at night and
people stumbling over one another. One thing the Middle
Ages lacked utterly was privacy.

Such was the creative life in the town or small city. During
Romanesque times hundreds of towns were founded all
over Europe. There were few large cities, and a population
of 30,000 was large. When a city grew larger, another town
was likely to appear nearby. Hence a secular sequence, from
town to manufacturing to trade to communication to freedom.

The Middle Ages had one great overriding urge—a long-
ing for spiritual certainty. What is the meaning of existence
and what is transcendently true? For the intelligent man of
the Middle Ages every event was an act of God. The
spiritual goal was a summation that took account of all
things: man could not afford to stumble on his way to salva-
tion.

The great figures of the Middle Ages worked on these
summations. The Spanish Saint Dominic (1170–1221) estab-
lished his order of preaching friars. Teaching and preaching,
he strove to assure the universality of the faith, and under-
took (mildly and tearfully at first) to terminate the Albigen-
sian heresy in the south of France, an anticlerical doctrine
foreshadowing Protestantism that was eventually healed by
fire and sword. Saint Dominic's order grew rapidly, flourish-
ing in university towns. Discipline was strict; neither the
Black Friars themselves nor their order possessed any
property. The Italian Saint Francis of Assisi (1182–1226)

preached another universality, that of love. He conceived
with a childlike literalness and intensity that God could be
loved and not feared and that everything that God created
could be loved too. This unity of living things through love
was new in the experience of the Middle Ages, as was the
humanity of Christ that Saint Francis preached. His fol-
lowers became a new order, the Franciscans. Preaching
poverty and humility, the Franciscans softened the harsh
climate of the times. They too took no thought for the
morrow or for themselves.

Saint Thomas Aquinas (1225–74) was born the year
before Saint Francis died. He was a professor at the Uni-
versity of Paris, then new, and he spent a lifetime on a
synthesis of all knowledge and philosophy in his *Summa
Theologica*. He undertook to reconcile Christian theology
and the philosophy of the ancients, Aristotle and the Chris-
tian fathers, and in the view of the age he reached his goal.
His philosophy rose like a cathedral of the mind.

Saint Louis (1214–70) and Saint Thomas lived at the
same time. Saint Louis was the ornament of the feudal
system, who lived like Saint Francis and like a king, for he
was Louis IX of France. He was not a wise king, but he
lived out the ideal of knighthood; he was a crusader and a
saint.

The man who summed up the Middle Ages, Dante Ali-
ghieri (1265–1321), did so with a universal poem. He
pursued a lifelong vision of idealized love that he realized in
the *Divine Comedy*. His synthesis of this world and the
next organized man's fate along an astronomical concept, a
spiral that led through hell and purgatory up to heaven.
People who live in two worlds must work out a philosophic
harmony between them.

A universal of the time that drew the faithful together was
the pilgrimage. Men set out across country in organized
cavalcades to famous shrines. Their established routes were
the tourism of the period; the pilgrims had the experience
of a lifetime and came home with a sacred souvenir. The
man who went to Rome was a Romeo; the man who went to
Spain—to Santiago de Compostela—was a Pilgrim; to the
Holy Land was a Palmer. Chaucer's assorted characters in
the *Canterbury Tales* went to the cathedral town by the
Pilgrim's Way. These goings and comings gave a larger unity
to Christendom.

Another universal that drew on spiritual energy was the

Crusade. Great military ventures across Europe and into the Holy Land repeated themselves through the twelfth and thirteenth centuries. They had as their aim the liberation of the sepulcher of Christ. They appear in retrospect as a brutal waste of strength—but so wars eventually do appear. Yet the Crusades aroused a sense of European unity, broadened horizons, and released more energy than they squandered. They widened the flow of trade, flushing out the old east and west trade routes with outright plunder.

We are ready now to see such universals realize themselves in the Gothic cathedrals. These amazing structures originated in the small territory, with Paris at its center, that the king of France could call his own. Their design, with much else of French influence, traveled outward across Europe, and in general terms we can say that a cathedral was more provincial or more eccentric in proportion as it was distant from Paris. But here follows a curious thing: there was little time lag as the design traveled. These great buildings went up almost at the same moment in France, Spain, Italy, Germany, and England. Either the idea behind them was coming to life everywhere or it met no barriers. Nationalism as we know it did not yet exist.

In the Romanesque churches round arches were the sinews of round stone roofs, and they headed windows and doors, the forthright openings that pierced solid stone walls. In a Gothic cathedral, by contrast, arches were generally pointed, and there were really no walls to be pierced. The concept of the cathedral is quite modern; we are in a stained-glass cage, in the midst of a structure of thrust and balance.

No one person invented the pointed arch. It had already appeared in the Romanesque, just as the round arch continued into the Gothic. It is really the vast windows that most truly represent the Gothic, for as the pointed arch reached for height, the great windows reached for light. For a Middle Age that rejected the earth and sought heaven, both height and light were symbols and goals.

The pointed arch minimized outward thrust, and then it could be raised to any desired height regardless of its width, which allowed the builder to create a stone ceiling all of a level. But thrust remained, and the new builders dealt with it in a new way. Along with the pointed arch, they developed the flying buttress. Until now high walls threatened by the thrust of a vault had been braced with solid buttresses set behind the piers that supported the arches—which cut up

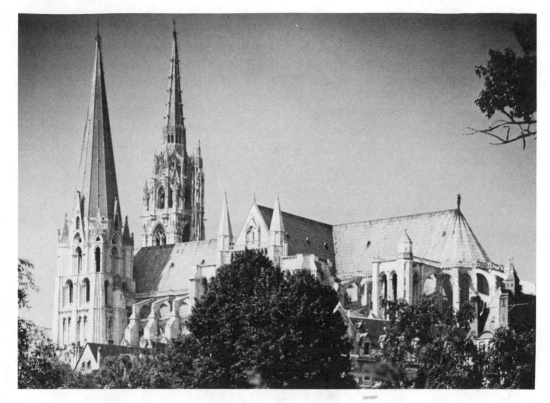

the side aisles into so many chapels. The final solution, the flying buttress, began outside the lower walls and arched over the side aisles to brace the upper reaches of the main wall with an open scaffolding of stone.

Cathedral of Notre Dame, Chartres, France. 1194–1220. [Alinari.]

The result was an amazing structure of visible stone rafters, the vault thrusting out, the flying buttress thrusting in. Looked at from the east, a cathedral resembles a vast tent only partially enclosed. The enclosure is the central portion immediately under the peak with walls brought close together for the sake of height—over a hundred feet of height for some forty in width.

These structural elements that compose the cathedral are by no means static. The pointed arch, the flying buttress hold each other in equilibrium, and the force of gravity moves down from arch to buttress like lightning flowing in a lightning rod. We are dealing with a delicate interplay of forces which frees us from mass.

Pointed arch, flying buttress, and a third element, the groined vault. The simple transverse arch of the Romanesque barrel vault had proliferated, until the new Gothic vaults looked like veined leaves. All these ribs, structurally for

strength and lightness, are implicit in the clustered bundles of columns that rise from the floor. The lines lead ever upward. Lines have taken over in place of the wall. In the Gothic building the linear instinct of the Middle Ages comes into its own. When we see pointed arch, flying buttress, and groined vault working together we may be sure we are in a Gothic building.

With height as an ideal, the builders were not content with their triumph of one-hundred-foot vaults. Cathedrals asked for towers to guard the western portal. At Chartres,

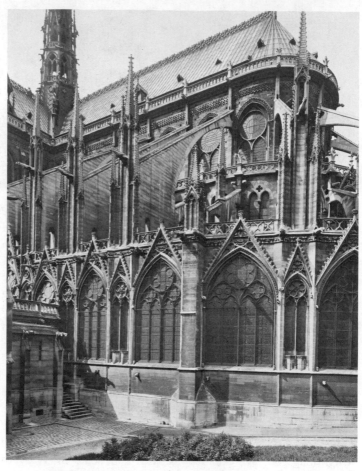

Flying buttresses, Cathedral of Notre Dame, Paris. 1163–1209. [Alinari.]

the lower south tower is early, simple, and perfect, moving subtly from square to octagon as it rises. By contrast, the taller north tower is very late and full of thorny complexities. In these two towers we have the beginning and the end of Gothic architecture before our eyes, and this is no

imperfection, for cathedrals took their time to mature. It is their virtue that they display the growth of a form.

The master builders of the cathedrals relied on experience, daring, and chance. The stones out of which their soaring piers were stacked had to be small enough to be manhandled by very few workmen. The beveled blocks in their vaults were hoisted aloft with tongues. If the cathedrals were built out of stones that were mere fragments, the great windows were built out of fragments too. Large panes of glass were not then possible, yet vast walls became windows. They glowed in a patchwork of color. The patterns were meaningful; they were pages from medieval manuscripts all over again, now literally illuminations. These windows preached to the illiterate. By the time the cathedral reached its highest development it had become both a house and a legend of many-colored glass. Chartres had perhaps the finest glass of all; its earliest windows shine like blue jewels in the west end. But the most resplendent compositions in glass were the great rose windows, one in each transept and one high above the entrance portal. As we know, these windows were braced with stone spokes in the Romanesque, but in later Gothic their flowing vine-like compositions were carved in stone.

As a symbol of a structured society in this world and the next, the cathedral had hundreds of stone inhabitants. Foremost were the Virgin and Christ, he seated in majesty enacting his final judgment and she in the scene of her coronation. Below Christ, sustaining him, on either side of the central portal, stood the prophets of the Old Testament. These figures surrendered their anatomy to architecture. Man, the vertical being, became more vertical when built into columns. He was transformed vertically into his own aspirations. In the figures on the west portal of Chartres every ascending and descending line was seized upon and exaggerated; horizontal movement disappeared.

Yet these figures, obedient as they are to the demands of architecture, are not solely its products. We have seen them before, wrapped in their sinewy folds as they existed in manuscripts for five hundred years past; we recognize them, recall them from the Byzantine ivories recently brought into western Europe. It is understandable that they are motionless and transfixed for they have arrived at their destination. They are among the blessed and their cathedral is heaven upon earth. Their portal is the gate through which

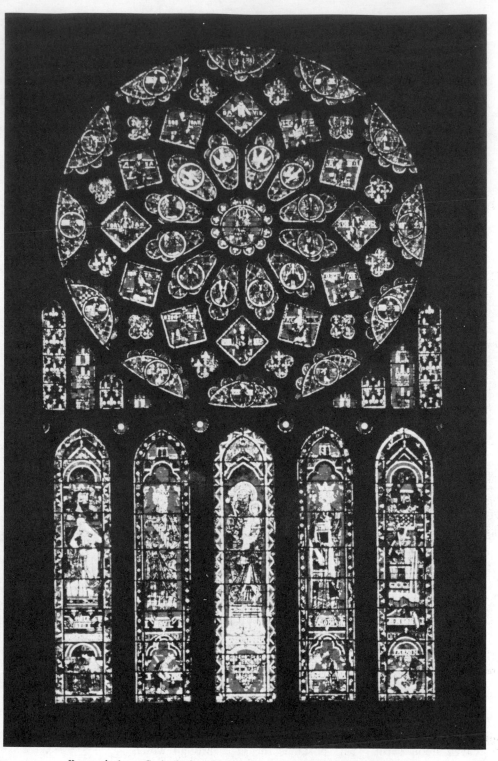

Rose window, Cathedral of Notre Dame, Chartres, France. [Alinari.]

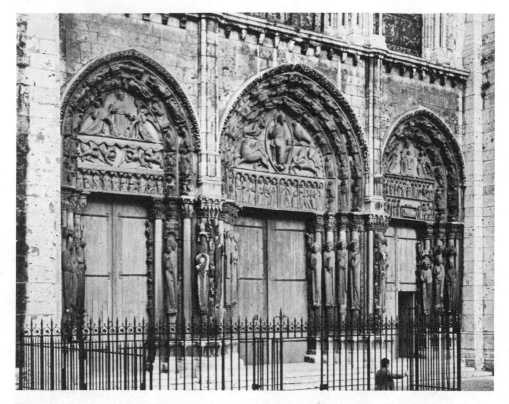

humanity may hope to pass, and the drama of judgment, redemption, and salvation is rightly to be found on the tympanum or half-circle that surmounts the central door.

West portal. ca. 1145–70. Cathedral of Notre Dame, Chartres, France. [Alinari.]

Chartres was built by society as a whole and people of every level of life literally took hold of the rope and helped drag the blocks. Men were building a shared hope and this hope itself became personified. The Virgin, the mother of Christ, will intercede for man. If man looks for love, let him look to woman, to the Queen of Heaven. The great cathedrals were dedicated to the Virgin, Notre Dame of this or that city. This worship of the feminine had a secular counterpart in the role of women; a protective instinct, to counter or redirect an aggressive one, was the measure of an expanding urbanity.

It was also the measure of the new role in life played by architecture. For the sake of simplicity, in dealing with the least simple of buildings, we have dealt with the Cathedral of Chartres, one of the earliest of the great churches, but others have their splendors: Notre Dame in Paris has a more massive Roman feeling with its square towers; the cathedral in Amiens, somewhat later, has its perfect interior;

the cathedral at Reims, later yet, is more elaborate and complex.

Nor should the English cathedrals be neglected. They were almost as early—Salisbury Cathedral is coeval with Amiens. The English cathedrals in general are more rambling, less logical structures, and no less beautiful for that. Their ceilings are less high; they appear surrounded by lawns; they are not, as in France, the expression of the towns around them.

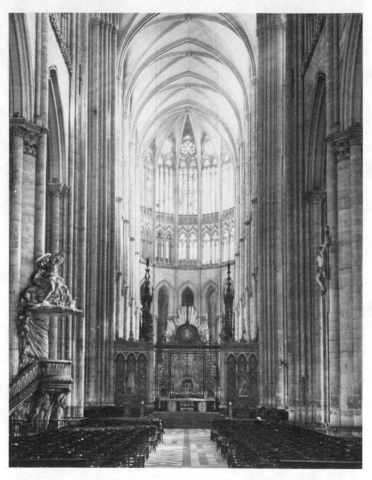

Interior, Cathedral of
Notre Dame, Amiens,
France. ca. 1220–36.
[Giraudon.]

THE GOTHIC TRADITION

The outburst of building that raised the great cathedrals was not sustained. The following century, the fourteenth, was a time of troubles, of completing what had been begun. For the first three-quarters of that century, from 1309 to 1375, the papacy left Rome and removed to Avignon in the south of France. It had fallen under the sway of the French king and for the time being it lost its universal character. A much more disturbing event was to follow, the Great Schism, which divided the papacy between two rival popes, and with this the unity of existence was undone. Meanwhile in the 1340s Europe was visited by the most severe pestilence in history, the Black Death (the bubonic plague), which carried off half the population. Slowly, history had to begin again.

In place of a mass outpouring of spiritual energy we now come to more private exertions. But the loss of universals was the gain of individuality. When the Middle Ages first produced great men they were great as they stood for a summation of their times. Europe was now steadily moving into a new age when men could represent their time by being themselves. The change ushered in the modern spirit in presupposing that individual men had something to live for here and now. If we look forward from the Middle Ages we meet faith of a new kind, hope coming down to earth and men beginning to believe that a rewarding life was here to be gained. Gothic architecture, which we have seen as religious architecture, was also to become civic.

Gothic forms, now superficially applied, decorated both the ancient castle and the city home of the merchant, who had come to fancy himself a merchant-prince. The guilds built elaborate Gothic headquarters that stood in bold contrast to the great barns or halls that had sheltered their workmen. All these structures were an adapted Gothic. Little by little, with the pacification of the countryside, castles and towers were no longer needed for defense, and they were updated into Gothic palaces or country houses. And Gothic forms grew like vines as they lost their strength.

In France this extravagant and decorative late Gothic won the name Flamboyant, an art wrapping itself in a dream and corresponding to thirteenth-century Gothic as Surrealism corresponds to reality. Fantasy and whim now compensated for loss of power. The meaningless overflowing of Gothic architecture finds a parallel in the meaningless overelaboration of military armor.

Guild halls, Quai des Herbes, Ghent, Belgium. *Left to right,* twelfth to sixteenth centuries. [Viollet.]

The knight's serious business had been to fight, and armor and horse had given him an overwhelming advantage, while foot soldiers were slaughtered in droves. But now a drastic invention, gunpowder, arrived on the scene, and it was no respecter of persons. Under this democratic pressure, knight-

Chapel, King's College, Cambridge, 1446–1515. Print. (Collection, James C. Green, Pasadena, California.)

hood grew mythological, the knight obsolete. Suits of armor became objects of display glittering with gold inlay. They were costumes for sport, for the tournament.

While the late Gothic grew elaborate and diffuse on the Continent, in England by contrast it became stiff and austere, and here the name for its ultimate form was the Perpendicular. We can see it in the universities of Oxford and Cambridge. As the name suggests, the Perpendicular was based on vertical straight lines and the effect was of a lofty grid. We find the Perpendicular in its perfected form in the King's College Chapel in Cambridge or Henry VIII's Chapel in Westminster Abbey in London.

In the course of the Puritan civil war, almost all of the old medieval glass in England was destroyed. The plain glass that replaced it gave a cool Protestant severity to the earlier buildings. The white light harmonized well enough with the bleak, perpendicular style and together they really created a new form, an appropriate background for a new and commerce-directed time; these buildings were now far from the Middle Ages.

To come down out of the Gothic age is like descending the spiral stair of a Gothic tower, with an occasional slotted glimpse of an earth below coming ever nearer. It is a very gradual transition toward a populated earth and toward the light of day, but altitude is being lost. When we compare the figures on the twelfth-century portal of Chartres Cathedral with the figure of a Virgin on the cathedral in Amiens carved more than half a century later, and then turn to a Virgin in the cathedral in Paris, later still, we see an obvious change in

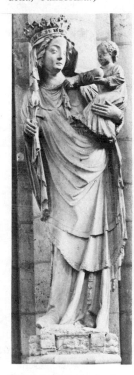

Virgin. Cathedral of Notre Dame, Paris. ca. 1330. [Scala.]

the direction of naturalness. We can take this change as the
flowering of personality and a new mastery of anatomy, or
as a betrayal of spiritual values—and both views are right.
The vertical lines of drapery now speak of elegance rather
than exaltation. An altarpiece will soon be a portable object
designed to focus a single individual's prayers.

With the end of the Gothic age, we might expect that an
architectural form the age created, above all a form expres-
sive of a faith, would withdraw into history. Instead we
witness the survival of an art form as a tradition, a cultural
habit, a source of spiritual security, an educated indulgence.
We have seen the classic gather strength intermittently over
centuries, and Gothic architecture had a similar future. We
can say with Macbeth, "The time has been/That, when the
brains were out, the man would die. . . ." Gothic architec-
ture's ghost was to walk again.

We must remember, too, that the revival of the classic
really was a rebirth, a renaissance. In the north of Europe
the Gothic was on the scene. Long after Italianate archi-
tecture had made its way north as a court architecture
in France and then England, cities and towns remained as
Gothic as they always had been. Steep roofs persisted, and
windows were still small with leaded diamond-shaped panes
—still mere fragments of glass. In England such houses were
half-timbered, which meant that the heavy oak beams were
allowed to show on the outside. Instead of sheathing them
over, the builders simply filled the spaces between them with
brick and plaster. The Pilgrims built similar houses in New
England except that they were now all of wood and had
clapboard facings. But such wooden buildings existed in
England in the region from which the Pilgrims came.

After classic architecture had had its turn in the seven-
teenth to eighteenth centuries, the Gothic revived. The ro-
mantic impulse rescued it; it came back as an affectation.
Soon it reasserted its claims as a religious, Christian art, and
of course it had a princely, aristocratic ancestry as well.
One way or another, this was either consoling or flattering.
In our country the Gothic church reappeared in the nine-
teenth century, and the men who had amassed great fortunes
after the Civil War built adaptations of the French châteaux
complete with Gothic turrets and pointed roofs. Such pres-
tigious dwellings have either been torn down by now or have
taken on some public function. They were exercises in ele-

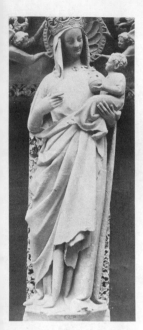

La Vierge Dorée, south
transept portal, Amiens
Cathedral, ca. 1280.
[Scala.]

Half-timbering, Leycester Hospital, Warwick, England. Fourteenth century; rebuilt late fifteenth century. [Royal Commission on Historical Monuments.]

CASS GILBERT. Woolworth building. New York, 1913.

gance (or perhaps only arrogance) a century ago; men who wanted absolute luxury imagined themselves feudal princes.

This was not the end. When we come to the early years of the twentieth century with its new tall buildings, the Gothic was seized upon as an expression of height. It is unfortunate that so many designers of high-rise buildings had no vision of an appropriate form for them—such a form had indeed appeared, as we shall see, but it soon became lost to sight. For lack of a form, builders dressed up their "skyscrapers" with decorative elements gathered at random out of architectural history, and what more appropriate for height than the Gothic? The most spectacular example of this way of thinking was the Woolworth building in New York; long the tallest in the world, it appeared as a Gothic spire sheathed in white terra-cotta. Such buildings were spoken of as cathedrals of commerce.

Meanwhile the Gothic put in an appearance on American university campuses where academic vanity and tradition yearned after Oxford and Cambridge. The result was a compromise between perpendicular Gothic and a more open practicality, a Gothic genteel that mocked history. Such buildings can be seen at Princeton or Yale; there used to be an academic quip that they were not *Gothic* but *Gothin*.

The most familiar image of latter-day English Perpendicular may well be the British Houses of Parliament (1840–60). The vast building appears on a pound note and is still a symbol of beleaguered free government. A nineteenth-

century revival on its own territory, it has the vitality, or perhaps only the charm, of old political habit.

Gothic Painting

During the last years of the fourteenth century a duke of Berry, brother of the king of France, ordered a number of beautiful books, among them the *Très Riches Heures,* a book of hours (religious observances), a personal prayer-book which contained a calendar. It was still unfinished when the duke died in 1416. The illustrations were by the

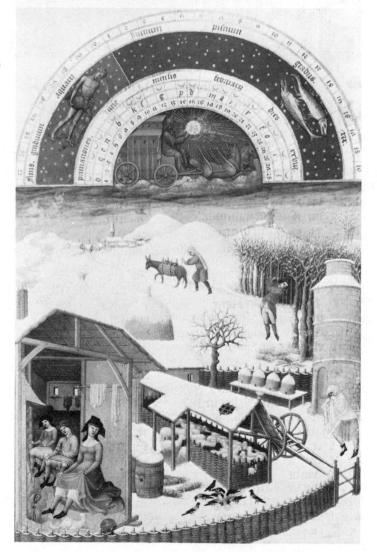

Les Très Riches Heures. 1413–16. (Musée Condé, Chantilly, France.)

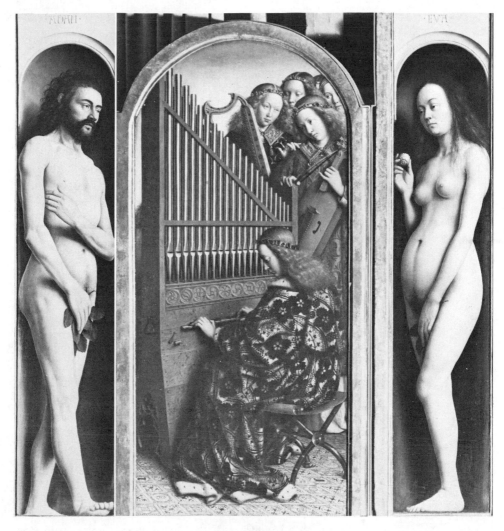

JAN VAN EYCK. The
Ghent altarpiece, de-
tail of Adam and Eve.
Completed 1432. (St.
Bavon, Ghent, Bel-
gium.) [Giraudon.]

Brothers Limbourg, and we can see their northern work of art as the end product of medieval bookmaking, or as the recapture of landscape painting. Its chief characteristic is a delight in the real world that redeems the trivial. Here every man deserves and receives attention as he goes about his daily life. These colorful miniatures are the equivalent in spirit and spectacle of Chaucer's *Canterbury Tales,* then newly written. Gothic painting had arrived.

The great master of this new pictorial vision was the Flemish painter Jan van Eyck. The Limbourgs were caught up in the small pages of a book, but van Eyck, working a generation later, created the great *Ghent Altarpiece,* also

Jan van Eyck
(1390–1441)

known as *The Adoration of the Lamb,* which still functions
like a prayerbook: to this day its large panels are swung at
intervals (like pages turned) to allow us to see, or read.

Van Eyck has long shared credit for this masterwork with
a presumptive older brother Hubert. The altarpiece is on
two levels and it is quite possible that we are faced with
separate works. The lower panels present a crowded scene
complete in itself, the life of this world and the next organized
as an assemblage for the worship of the mystic lamb as it
pours out its blood in a chalice. In this heaven-and-earth
spectacle, we enter a deep idyllic landscape; we have a
Middle Ages concept of a spiritual environment that sculp-
ture could never have given us.

In the upper panels of the altarpiece the figures loom
large as life. We look up to God the Father, the Virgin, John
the Baptist, and our first parents Adam and Eve, together
with two panels of choristers. The naked figures of Adam
and Eve are the first in this kind, and firsts have a way of
being greatest. They must have been a startling experience
for the contemporary worshiper.

Van Eyck is the master of things seen, of organized space
that we are invited to enter, and finally of figures that look at
us quite as we look at them. This grip on the reality of the
visual image, set in perspective and aglow with a new bril-
liant color, is here to stay. Van Eyck not only introduced a
new mastery over the visible world but he perfected a new
technique, oil painting. This was not precisely oil painting
as we know it, but a rather gluey procedure that could
not easily be changed or erased and required infinite pains
and assurance.

With such a rendering of the living world, portraiture was
inevitable, and Jan van Eyck entered the field with one of
the most famous paintings in its kind, the double portrait of
Arnolfini and his wife. Arnolfini was the Florentine repre-
sentative of the Medici banking house in the Low Countries,
and as we see him the weedy little man is presenting his
wife to us. In the back of the painting the artist has signed
his name; he states that he was here, as though he were
being called as a witness. As we look around the room that
the artist records we can add up the new luxuries at the close
of the Middle Ages. Such intensity through precision filled
a great need. It recalled the zeal for all-completeness of an
earlier time and it rewarded the merchant reveling in his
possessions.

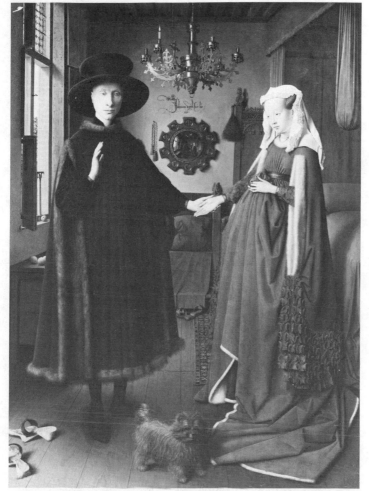

Van Eyck was not alone. The Master of Flémalle from Tournai, a town then in France and now in Belgium, produced the Merode Altarpiece, presumably four to six years before the Ghent Altarpiece was completed. Here we have a typical religious scene, the Annunciation, with donors on one side panel, Saint Joseph on the other. The vision is solemn yet tender, the draftsmanship equal to all demands, whether in the foreshortening of the figures or the perspective of the room. The meticulous details carry conviction; they are all chosen for their meaning for the Middle Age mind. This comfortable well-being is less than the elegance of Arnolfini's interior. The crisp folds in the garments suggest that the Gothic Middle Ages attached importance to laundering, but everything else is fresh and clean too; the color is brilliant, and the artist's eyes intoxicated with seeing.

The Master of Flémalle, possibly Robert Campin (d. 1444)

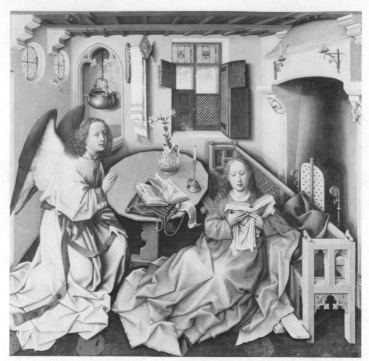

ROBERT CAMPIN. *Annunciation.* ca. 1425-28. Central panel, Merode altarpiece. (The Metropolitan Museum of Art, New York, Cloisters Collection.)

Rogier van der Weyden (ca. 1400–64)

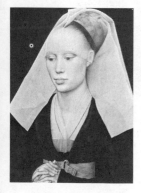

ROGIER VAN DER WEYDEN. *Portrait of a Lady.* ca. 1450–60. (Courtesy of the National Gallery of Art, Washington, D.C. Andrew Mellon Collection.)

A long line of painters in this new spirit followed, and they produced many masterpieces; it is remarkable that this outburst could be sustained for three or four generations. If van Eyck was the greatest, the next to follow was Rogier van der Weyden. He too achieved a large masterpiece carried out in meticulous detail in his *Descent from the Cross.* The painting has the quality of sculpture in an architectural setting, so to this degree it is a step back; but on the other hand, it has a sense of drama, of pathos, and the figures act out their parts in a kind of medieval passion play. Van der Weyden's involvement with the persons presented, as well as with the scene, makes his portraits even more modern, more sympathetic than van Eyck's.

Perhaps the next most important name in this series is Hans Memling (1430–94). Now the brilliance and precision is beginning to show a little Italianate mellowing and rounding. Typically the Virgin has a high forehead, small mouth, and a sweet candid expression as she holds her child, who often appears rigid as though his tight swaddling clothes had just been removed, as was doubtless the case. The sharpness of portraiture increases as we turn to saints, priests, nuns, and donors who attend reverently at the scene as they hope to do after death. And as though denying death, all is clarity and certainty in a shadowless light.

A late masterwork in this meticulous style is the *Portinari Altarpiece* by van der Goes, a nativity with donors in side panels. The altarpiece was ordered by an Italian resident in the north, who sent it home to Italy where it has remained ever since. Hanging among great Italian Renaissance paintings, it nonetheless demands attention. It seethes with hope, such an explosive desperate hope, pinned on the spectacle of one small spiritual prince, as presupposes a lifting of a universal dread.

Hugo van der Goes (d. 1482)

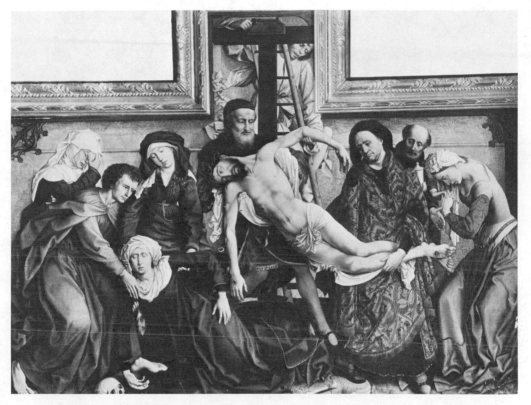

Gothic painting is an exhausting art of accumulated detail. At first we fall under the spell of endless events and possessions, and it is true that a miser's commercial instinct is at work, a ravenous gathering in of things. But there is more than this: every detail of life is seized upon in an effort to reinforce belief; the things of this world *prove* the things of the next in a kind of double-entry bookkeeping. In the medieval faith nothing can be omitted or the whole edifice crumbles.

ROGIER VAN DER WEYDEN. *Descent from the Cross.* ca. 1435. (Prado Museum, Madrid.) [Anderson.]

And such a crumbling of universal faith was taking place under the pressure of worldliness. We see the tension in the

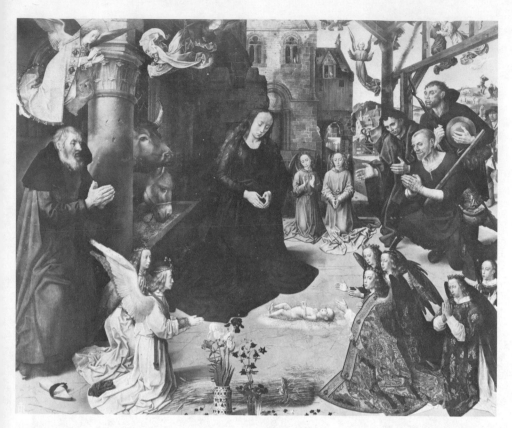

HUGO VAN DER GOES.
Portinari Altarpiece
(central panel). ca.
1476. (Uffizi Gallery,
Florence.) [Alinari.]

transition from the devout to the indulgent; it appears in
northern art as a resistance to the Italianate, to the Classic, a
digging in of heels against the Renaissance that the Church
was embracing. The Gothic carried conviction: what we
have is submitted evidence, whether in the gentle humanism
of the theological scholar, Erasmus, or the violent argumenta-
tion of Martin Luther. A dark day of religious conflict had
arrived, a fanatical burning of heretics, a war between in-
dependence and loyalty, a loyalty for eternity.

Much of this drama was played out in the Low Countries,
for by accident of history they were inherited by the Spanish
Crown, and the Spaniards undertook to stamp out heresy in
the very territory of this late Gothic painting which we have
been examining. And Gothic painting recorded the ordeal.

Hieronymus Bosch
(1450?–1516)

Hieronymus Bosch opens the theme of religious anxiety,
setting the stage for the trauma to come. His paintings are a
medieval contrast, on the one hand salvation, acted out in
lyric terms in an Eden on earth, and on the other, damnation
replete with all the horrors that a witchcraft-haunted mind

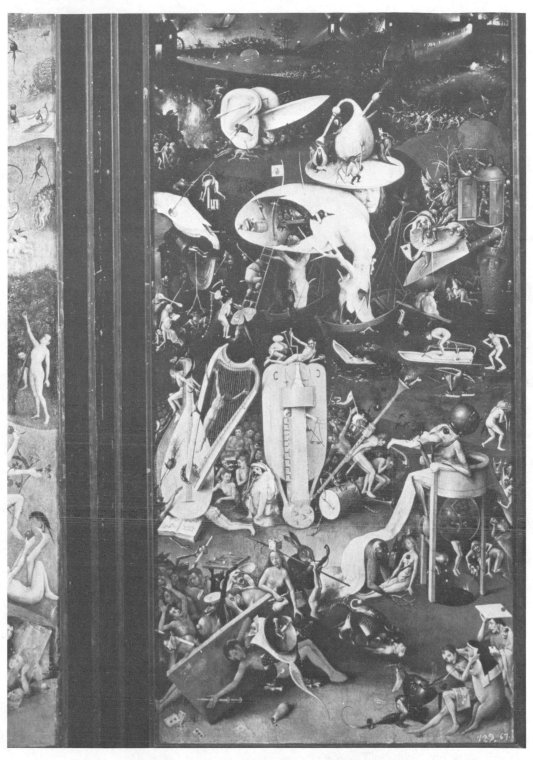

HIERONYMUS BOSCH. *The Garden of Earthly Delights* (detail).
ca. 1505. (Prado Museum, Madrid.) [Alinari.]

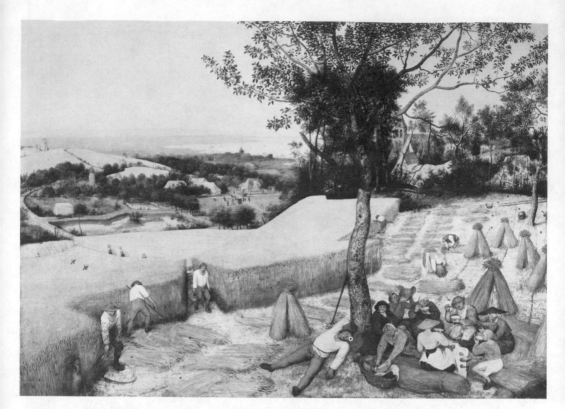

PIETER BRUEGEL THE ELDER. *The Harvesters.* 1565. (The Metropolitan Museum of Art, New York, Rogers Fund.)

could conjure up. His imagination was inexhaustible. Insect and animal forms with a Freudian significance of their own prey on the mind. His *Temptation of Saint Anthony* theme comes close to the trouble.

Pieter Bruegel (1525?–69)

Bruegel followed Bosch by more than two generations, but he worked in the same horrific field. He did not have to imagine his nightmares; they were all around him. He

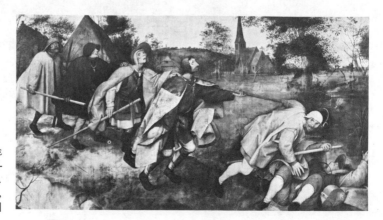

PIETER BRUEGEL THE ELDER. *The Blind Leading the Blind.* 1568. (National Museum, Naples.) [Anderson.]

painted fables of desolation drawn from the Spanish wars, which were waged with both fire and sword. He found his subjects in the downtrodden peasantry, and his wooden-faced little people, desperately following their instincts, act out sermons on the nature of life, and go to their unrecorded deaths. Their few days of happiness, dancing at a marriage feast, or harvesting the grain in the sun, are Bruegel's scenes of salvation on earth. He is one of the great masters, and one of the great spokesmen for humanity.

The Gothic anxiety was widespread north of the Alps. We see it in the greatest German artist, Albrecht Dürer. He was a little earlier than Bruegel, just early enough to escape the impending violence but not early enough to escape the preceding uncertainty. From Nuremburg he made two trips to Venice, late in the fifteenth century and early in the next, Albrecht Dürer (1471–1528)

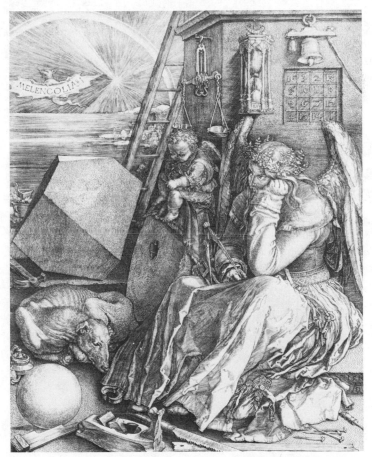

ALBRECHT DÜRER. *Melancholia I.* 1514. (UCLA, Grunwald Center for the Graphic Arts, Los Angeles.)

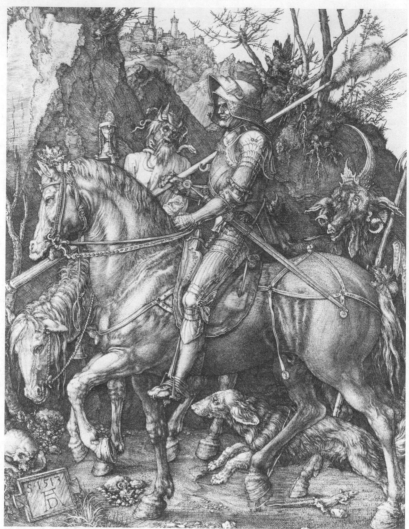

ALBRECHT DÜRER.
Knight, Death, and the Devil. 1513. Engraving.
(Los Angeles County Museum of Art, Graphic Arts Council Fund.)

where he steeped himself in the Renaissance, but to no avail. He painted with a Gothic factual intensity, as though he were saving a soul in recording a personality, and it is not surprising that he painted himself more than once. And now with Dürer Gothic detail found its true and precise language in engraving. Dürer's *Melancholia* is an image of troubled conscience that can take no comfort in the new gifts of science strewn about, and his *Knight* is a hero of the Middle Ages whose faith is beset by demons brewed out of a new-found personality. Dürer was a great master and a troubled one. For Dürer, printmaking was not merely a method that made possible multiple works of art, it was an open road to communication. His prints are fables; they carry a message and are meant to be read.

Out of such tensions now came one of the world's great masterpieces, a work that stands out as an achievement even beyond the strength of its creator, as though it were the last will of a dying Gothic age.

Matthias Grünewald, or Mathis Gothardt Neithardt, painted the Isenheim Altarpiece, now in Colmar on the borderland between France and Germany. The great painting unfolds chapter after chapter, as ambitious altarpieces do;

Matthias Grünewald
(d. 1528)

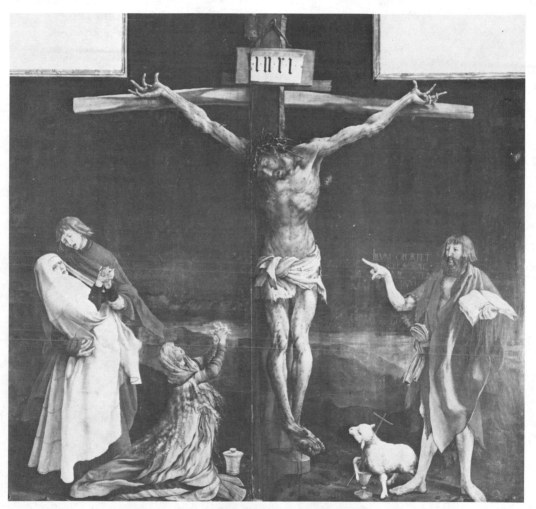

but the central theme, the crucifixion, is the artist's overwhelming triumph. The livid figure of Christ on the cross against a dark sky is populated with wounds that are festering sores, for the painting was created for a hospital of lepers. Christ shares their fate as they share his hope. The monumental scene is a Gothic work created almost in terror

MATTHIAS GRÜNEWALD. *The Crucifixion* (panel of Isenheim altarpiece). ca. 1510–15. (Musée Unterlinden, Colmar, France.) [Giraudon.]

before the new significance of man. Here the agitation in the Portinari Altarpiece reaches the breaking point.

Hans Holbein
the Younger
(1497–1543)

By now the Italian Renaissance has been a century in the making and we have yet to see what was crowding and alarming the medieval spirit. There remains, however, one more genius of the Gothic tradition, who recorded his age: the south German Hans Holbein, who lived a generation after Dürer. Holbein was haunted by images of the dance of death—a universal subject serving like the skull paperweight as a reminder of man's fate. He created a series of woodcuts showing a skeletal figure of death seizing men and women of every rank.

Holbein was one of the great portraitists in both his paintings and his drawings. He lived for a while in Basel, Switzerland, and went to England on the introduction of Erasmus where he became court portrait painter to Henry VIII. Here he is at his best in his masterly drawings that rely on a sensitive outline surrounding a modeling often too faint and subtle to reproduce; most of them are in the British Royal Collection, and taken together they are a dazzling chapter in the history of art.

As Gothic survivors, Dürer and Holbein came to terms with a new age. By now Germany was filled with Renaissance-haunted art and princely art patrons in love with splendor—while an uneasy conscience was calling to prayers.

HANS HOLBEIN. *Cardinal Fisher, Bishop of Rochester.* 1527–28. Drawing. (Windsor Castle, England, collection of Her Majesty the Queen. Reproduced by gracious permission of Her Majesty Queen Elizabeth II.)

THE RENAISSANCE

AND FLORENCE

If Dante summed up the Middle Ages with his *Divine Comedy,* he also opened a new age: he created the Italian language. In the arts, another great man was able to lead that same age into the future. Giotto di Bondone did more than record his epoch, he gave it a new significance. He left us the Arena Chapel in Padua which he built and decorated —for there was little distinction between architect, sculptor, and painter in his time—and his murals in the Church of Santa Croce in Florence. If the decorations in the Church of Saint Francis of Assisi are not his, his stamp is upon them. But his great legacy is the Arena Chapel.

Giotto di Bondone (1267?–1337)

Here Giotto projected the life of the Virgin and of Christ on the walls in a series of scenes in three superimposed bands. The figures are simplified and set in dramatic gestures that tell the story with an epic finality. Properties are introduced in these scenes only as needed. The scenic architecture is so small in scale compared to the figures that we are forced to believe we are witnessing a miracle play, the simple informative spectacle that acted out scripture for medieval audiences. But Giotto was able to give his figures a new three-dimensional reality, and their dignity is overwhelming.

At that moment in Italy, late medievalism was still producing altarpieces steeped in a Byzantine mysticism, or the "Greek Manner." High points were an altarpiece in Florence by Cimabue (d. 1303), and another by Duccio di Buoninsegna (1250?–1319) for the cathedral in Siena, a

GIOTTO DI BONDONE. *Flight into Egypt.* ca. 1304–6. Arena Chapel, Padua, Italy. [Anderson.]

GIOTTO DI BONDONE. *Lamentation Over the Body of Christ.* ca. 1304–6. Arena Chapel, Padua, Italy. [Anderson.]

conservative city where an earlier gold-ground style was to linger. Duccio, one of the last and greatest medievalists, brought his figures to life with glowing color and significant gestures, but they are still small in scale, and seem closer to

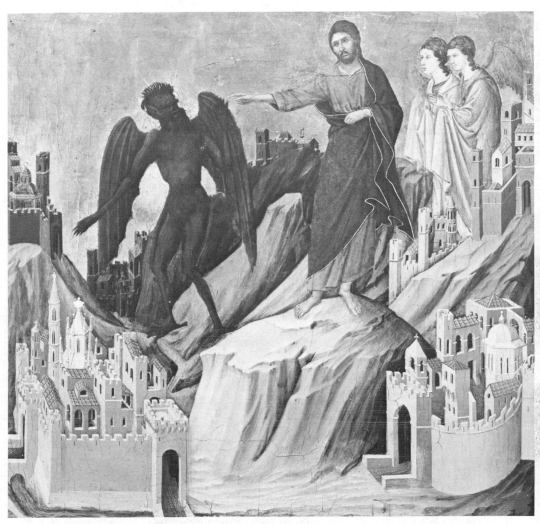

the illuminated manuscript than to architecture. By contrast, Giotto opened up a new world that drew on the new energies of Florence: no figure of his vitality was to appear for a hundred years.

DUCCIO. *Temptation of Christ on the Mountain.* Panel from back of altarpiece, Siena Cathedral. 1308–11. (Copyright the Frick Collection, New York.)

Donatello
(1386–1466)

The next great Florentine name is Donatello, a sculptor who brought in the Renaissance. With Donatello, all that remains of the Middle Ages is his delight in line. He loved low reliefs in bronze that were almost paintings and his work in this vein is gentle and perfect. He has an assurance that is

DONATELLO. *David.* ca. 1430–32. (National Museum, Florence.) [Anderson.]

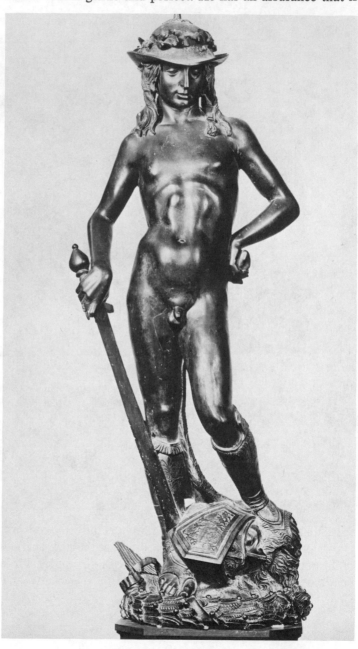

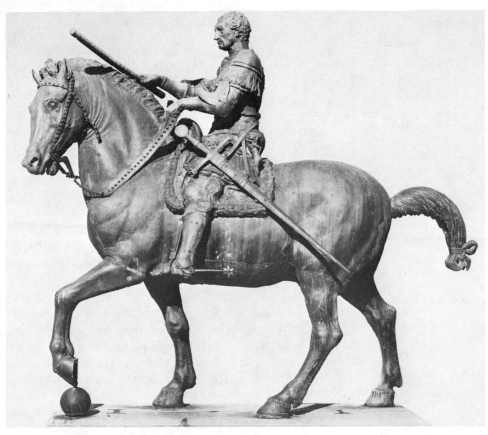

DONATELLO. *General Gattamelata.* Padua, Italy. 1445–50. [Alinari.]

quite decadent, as though he were working at the end of a period and not in its forefront. His sensuous figure of the boy *David* (1430–32) was the first bronze nude since ancient times. Nor had there been a bronze equestrian statue until he cast the *General Gattamelata* (1445–50), or "honey cat" as he was known to his troops, a mercenary in the employ of Venice. It is the greatest of all horse-and-rider sculptures, marked as it is by an air of philosophic serenity, of calm purpose. His young *Saint George* typifies the adventurous youth of the Renaissance. Donatello is in no sense a preparatory figure. He did things that had not been done before, and were not to be done better.

Ghiberti, living at the same time as Donatello, created the famous bronze doors for the Baptistry in Florence. This octagonal building sheathed in varicolored marble stands opposite the cathedral or Duomo. Much older than the Duomo, it already boasted the finest bronze doors in existence, the work of an early Pisan, Andrea Pisano, who had

Lorenzo Ghiberti (1378–1455)

tempered Gothic art with recollections of classical carvings
on Roman coffins or sarcophagi. Pisano worked within a
pattern of medieval quatrefoils, or four-lobed medallions.
Keeping to this format, Ghiberti entered a competition with
Filippo Brunelleschi (1377–1446) for additional doors. We
can still compare the panels that each submitted. Ghiberti
won a lifetime commission, as it proved. The panels he now
created were rectangular, and he treated them as pictorial
narrative descriptions. Near figures stand out boldly while
distant objects fade into low relief, and the organization of
perspective (this new intelligent seeing) gave him no trouble
at all. Even Michelangelo was to speak of these doors as
worthy of the gates of paradise.

The loser, Brunelleschi, won a commission to build the
dome of the unfinished cathedral in 1418. His daring under-
taking, the great dome that dominates his city to this day,
has been treated elsewhere. His other buildings, a foundling
hospital, the Pazzi Chapel, and the Church of San Lorenzo
(created for the Medici family) have an airy simplicity, re-
finement and assurance which are Donatello in architecture.
Their classicism is still somewhat tentative; they retain the
Gothic linear delicacy. The Florentines moved away from
Gothic art with infinite grace.

Rising palaces attested the new prosperity of the city. The
nobility had their architecture; the new rich merchants had
theirs. The nobles, called Ghibellines, originally lived in
castles on their hilltops, and their mercantile adversaries,
called Guelphs, were entrenched in the city. The castles of the
nobility had medieval crenelated battlements, and when the
Ghibellines built in the city they brought their skyline with
them. The Guelphs, as a newer successful commercial class,
built in less military fashion. They lived in great square
palaces capped with overhanging roofs. The walls of these
buildings were soon decorated with classic orders piled one
above the other in the Roman fashion. We may observe the
smooth arrival of the Renaissance in the Riccardi Palace
built in 1444–59 by Michelozzo for the Medici, and the
Rucellai Palace built at almost the same time—1446–51—
by Leon-Battista Alberti. Both buildings have double win-
dows grouped under a Romanesque arch, but Alberti intro-
duced the classical orders and they came to stay. Alberti
was a courtier, scholar, and a writer on classical art. He
expounded Vitruvius, the recently rediscovered Roman au-
thor who wrote of ancient architecture. His endorsement of
classical art was to have a wide and long-surviving influence.

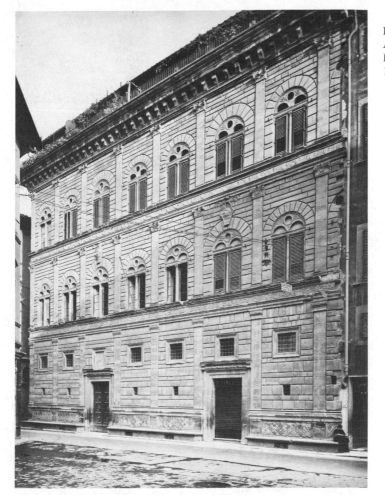

We find two distinct trends among Florentine painters: the first, weighty and sculptural, fulfilled what Giotto had forecast; the second, linear and lovely, had a wayward sensibility of line that recalled the Gothic past. The first was the highroad: the artists who followed it had the future before them. Of these, a young man named Masaccio takes his place among the great. He was born with the fifteenth century—the century of Florence—and lived to be only twenty-seven. He painted frescoes in Florence that take up where Giotto left off. He set his figures squarely on the ground in believable space relationships and could make them move when he chose. He gave them an air of solemn grandeur. They are actors in major roles in the drama of humanity.

Masaccio's masterly fresco of the *Trinity* in Santa Maria Novella in Florence, painted in 1426, was followed the next year by his frescoes in the Brancacci Chapel in the Church

Masaccio (1401–28)

of the Carmine. Here his famous Adam and Eve in the *Expulsion from the Garden of Eden* are fleeing in anguish. His figure of Christ in *The Tribute Money* is altogether noble. In his *Saint Peter Baptising,* the nude shivering figure of the boy waiting for baptism introduces a new naturalism dependent for its power on a new and stronger light and shade. Here Michelangelo and Leonardo stood and admired when Masaccio's work was half a century old.

Piero della Francesca (1420–92)

Andrea Mantegna (1431–1506)

Two more sculptural painters lead us toward the heights of the Renaissance. Piero della Francesca painted frescoes that are ennobled by simplification. His great *Resurrection* recalls Masaccio; his *Queen of Sheba before Solomon* has a splendor that foreshadows Raphael. His forms are simplified and sculptural; his figures move solemnly: they have spiritual weight. His color is luminous, as though the Italian sky had been invited down.

The other great painter, Mantegna, who really drew sculpture in space, worked at a moment of fascination with perspective. He had the Florentine virtue of structural dignity, of being caught up in conceptual space for its own sake. His line was so incised that atmosphere was out of the question. Actually Mantegna lived nearer Venice, and was related to a Venetian family of artists, the Bellinis, father and sons: he married the sister of the painters Giovanni and Gentile Bellini, and spent most of his productive life in Mantua.

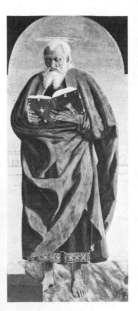

Above: PIERO DELLA FRANCESCA. *Saint Simon the Apostle* (?). 1454–58. (Copyright the Frick Collection, New York.)

ANDREA MANTEGNA. *Dead Christ*. ca. 1501. (Brera Museum, Milan.) [Anderson.]

ANDREA MANTEGNA. *Bacchanal with Silenus*. 1490. Engraving. (UCLA, Grunwald Center for the Graphic Arts, Los Angeles.)

Fra Angelico
(1387–1455)

On the Gothic side, the delicate and reminiscent side of Florentine painting, Fra Angelico (1387–1455) cannot be forgotten. He was cloistered in his life and in his art. Here vision and reality blur gently. He decorated the walls and private cells of the monastery of San Marco in Florence with the tenderest of frescoes, which float on the walls like realized prayers.

His numerous easel paintings, large and small, are crowded with the congregation of the blessed, ivory-pale figures, beautifully drawn and set off with the clearest of blues. They exist beyond death, in a world where there is neither shadow nor doubt.

FRA ANGELICO.
Annunciation. 1438–45.
Cloisters of San Marco,
Florence. [Alinari.]

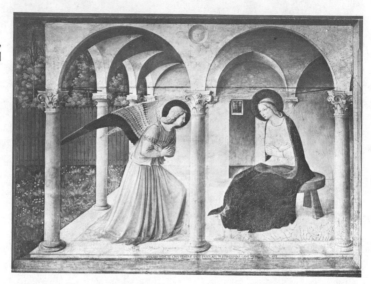

Sandro Botticelli
(1445–1510)

Botticelli, as a child, must have seen the work of Fra Angelico. Together their lives more than span their century. The Florentines were great draftsmen committed to sharp, clean edges, and Botticelli (before the days of Leonardo) was the greatest draftsman of them all. He looked back rather than forward, with his medieval, linear suavity, his troubled spirit, his yearning temperament loose in a sensuous world. On the other hand he represented a new subtle school of philosophic thought which came out of the very heart of the Florentine Renaissance.

There was no contradiction here: the Renaissance man was steeped in the past. He was building a future out of rediscovery. In the fifteenth century the classical past seemed to reveal itself daily. New classical sculptures were continually being found, ancient coins, everything classical was

collected, and although the remains of ancient architecture had never been hidden, now they were examined and measured accurately in a spirit of scholarship. The emperor of Constantinople visited Florence in 1439 with a number of classical scholars in his train, and they stimulated the study of Greek philosophy. A few years later this exciting contact with Eastern scholarship was to be permanently reinforced. The Turks captured Constantinople in 1453, bringing the Eastern Empire to an end, and the scholars of Byzantium came pouring into Italy as refugees.

In this cultural climate, Cosimo de Medici, the first in his rising and astute banking and mercantile family to dominate the city of Florence even as he paid lip service to the Republic, planned an academy where the ideas of Plato could be expounded and his works translated. Cosimo selected one

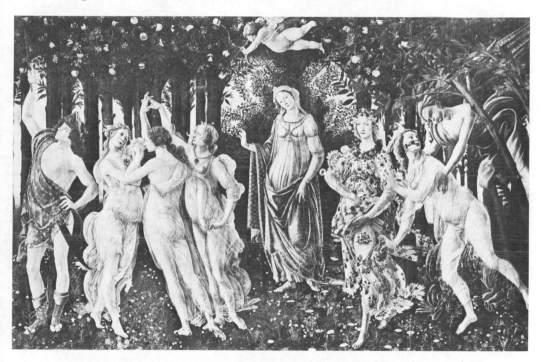

Marsilio Ficino as the future head of this scholarly project while Ficino was still a child, and had him educated for his life's undertaking. The young man grew smoothly into this assigned career and did in fact spend his days expounding Plato. Like Alberti, Ficino exerted an immense influence, not only on his own age, but on later European thought. The Renaissance was addicted to acting out its ideas, and the

SANDRO BOTTICELLI. *Primavera.* ca. 1478. (Uffizi Gallery, Florence.) [Anderson.]

purposeful and ambitious men of Florence lived out the
Platonic ideal under Ficino's tutelage, in a garden-party
fantasy of scholarship and urbanity. It is this ecstatic pause
in the midst of violence, this essential humanism, that we
read in Botticelli.

His *Primavera* and *Birth of Venus* are steeped in this
atmosphere. In the *Primavera,* each nymph seems pregnant
with a mystical love; even the earth itself is in this happy
state. The fantasy recalls the ritual of devotion to woman
that contrasted with the military ideal of the feudal system.
The *Birth of Venus* was related to the story of an aristocratic

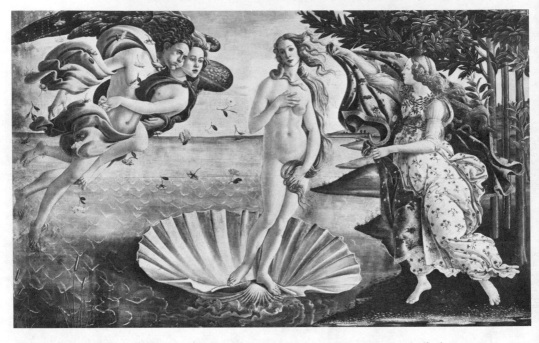

SANDRO BOTTICELLI. *Birth of Venus.* After 1482. (Uffizi Gallery, Florence.) [Anderson.]

young lady who was the delight of Florence and died young.
There is something touching in this tearstained yearning
when we contrast it with the scheming brutality and hyper-
activity of the Renaissance man.

Another Florentine painter and sculptor, Andrea del Ver-
rocchio—Andrea of the true eye—(1435–88), would have
shown as a front-rank talent in any less competitive cir-
cumstances. He produced the world's other great equestrian
sculpture. It now stands in Venice, the grand and arrogant
portrait of another mercenary general, Colleoni. Verrocchio
had still a further claim to fame. He had as a student or
apprentice Leonardo da Vinci (1452–1519).

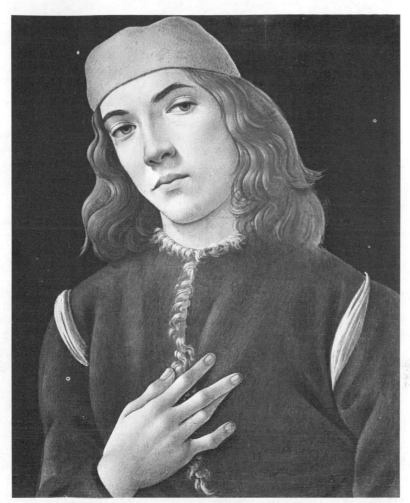

Sandro Botticelli.
Portrait of a Youth.
1483–4. (Courtesy of
the National Gallery of
Art, Washington, D.C.,
Andrew Mellon Col-
lection.)

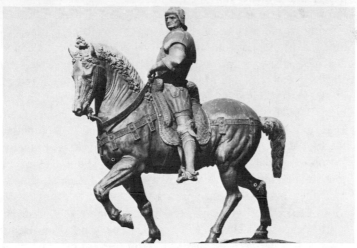

Andrea del
Verrocchio. *Colleoni*.
ca. 1482. Completed
after sculptor's death.
Venice. [Anderson.]

MEN OF GENIUS

Individuality now takes on a new value. Men are encouraged to see themselves as exceptional and indeed to become so. With the Italian Renaissance we are in the presence of major figures on every hand. History becomes biography as they put their stamp on an epoch. Leonardo da Vinci (1452–1519), Michelangelo Buonarroti (1475–1564), and Raphael Sanzio (1483–1520) were all breathing the air of Florence at the same time. They are major figures in world history.

A little later we shift our attention to Venice, and here the dominant figures are Giovanni Bellini (1437–1516), Giorgione (1478–1510), Titian (Tiziano Vecelli) (1488/90–1576), and Tintoretto (Jacopo Robusti) (1518–94). This is to pass over a host of figures of only slightly less altitude, all living within a century. As we leave the Renaissance behind, the Mannerist and Baroque periods are upon us, and once more there is an outburst of genius. We have to deal with the greatest of the Mannerists, El Greco (1541?–1614) and the first of the great seventeenth-century Baroque figures, Peter Paul Rubens (1577–1640). El Greco came from Crete to Venice as a young man and took the late Venetian style to Toledo, in Spain, where he found a mystical religious environment that exactly suited him. Peter Paul Rubens, a Flemish painter of overwhelming vitality, almost single-handedly carried the Baroque mythology north. Before the close of their lifetimes came two great painters of the seventeenth century, Velasquez (1599–1660) and Rembrandt (1606–69), figures we must see as the peaks in a mountain

chain. To follow this figure of speech, we again lose altitude until we come to the solitary volcano named Francisco Goya (1746–1828), and then in the second half of the nineteenth century we find a whole new chain of major figures in France.

To deal with history as a sequence of great men is to distort it, but the fact is that history distorts itself as minor men and events become lost in the past. Yet this selective distortion has its virtues. Now when mere numbers force us to classify, to deal with groups or movements, it is good to be reminded that individuals make a difference. In the arts, later events are not necessarily better, and in this range of peaks that we are to survey the highest come first.

Leonardo was more than an artist. In his own lifetime he was thought of as a scientist, an engineer. When he left Florence in mid-career and went to Milan to work for the tyrant Ludovico Sforza, Leonardo wrote a letter of self-recommendation. It is not a very modest letter, but it is nonetheless an understatement, and is worth quoting at some length:

Leonardo da Vinci (1452–1519)

I have plans for bridges, very light and strong and suitable for carrying very easily, with which to pursue and at times defeat the enemy. . . .

I have also plans for making cannon, very convenient and easy of transport, with which to hurl small stones in the manner almost of hail. . . .

And if it should happen that the engagement was at sea, I have plans for constructing many engines most suitable either for attack or defense, and ships which can resist the fire of all the heaviest cannon, and powder and smoke. . . .

Also I can make armoured cars, safe and unassailable, which will enter the serried ranks of the enemy with their artillery, and there is no company of men at arms so great that they will not break it. . . .

In time of peace I believe that I can give you as complete satisfaction as anyone else in architecture in the construction of buildings both public and private, and in conducting water from one place to another. . . .

Also I can execute sculpture in marble, bronze, or clay, and also painting, in which my work will stand comparison with that of anyone else whoever he may be. . . .

Leonardo was a tireless experimenter. He kept notebooks that dealt with every subject that caught his imagination. In his day our modern sources of energy were out of reach.

LEONARDO DA VINCI. *Studies for a Painting of Leda.* ca. 1509 or later. (Windsor Castle, England, collection of Her Majesty the Queen. Reproduced by gracious permission of Her Majesty Queen Elizabeth II.)

Because of the lack of power, of precision machinery, and of advanced mathematics, his ingenuity was often pathetically blocked. He was obsessed with the mechanics of flight and labored to no avail over contraptions that would allow a man to soar and to beat mechanical wings. With these limitations his greatest achievements were inevitably in the comprehension of the world about him.

Gravity as a force aimed at the center of the earth, the

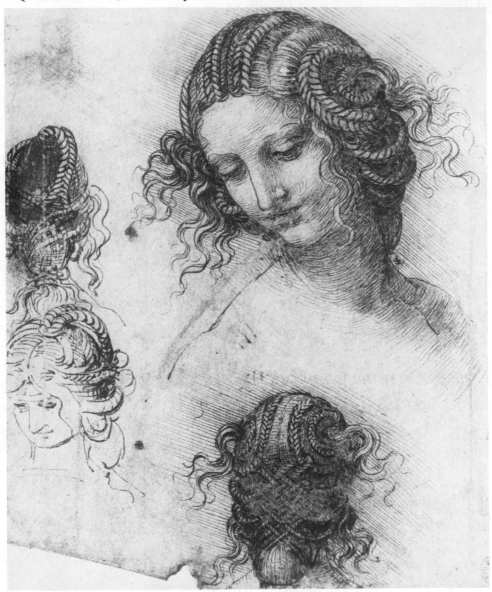

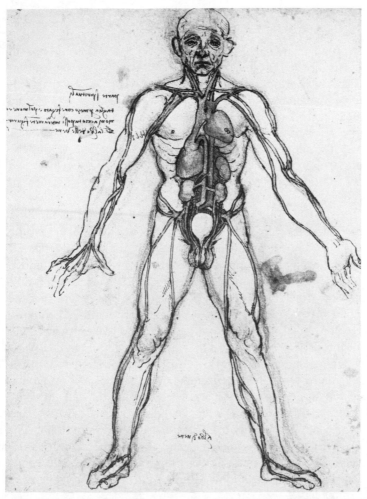

LEONARDO DA VINCI. *Anatomical Drawing.* ca. 1494. (Windsor Castle, England, collection of Her Majesty the Queen. Reproduced by gracious permission of Her Majesty Queen Elizabeth II.)

acceleration of falling bodies, the sun as the center of the solar system, the earth traveling in an ellipse with its axis inclined to the plane of revolution—he understood these matters ahead of Galileo or Newton. He speculated on basic units such as the atom, on waves as a means of projecting energy, and on the propagation of light. The motion of water concerned him; he struggled with the patterns and mechanics of waves.

His anatomical investigations were extraordinary, and it was here that he brought art and science together. He dissected. He understood the leverage of muscles and the balance of forces between muscles acting against each other on either side of a limb. He did not stop at these grosser aspects of anatomy; his curiosity led him to dissect the eye in the hope of understanding the mechanics of sight, and he

tried to find out how sound was created in the throat. He tried to discover the processes of generation and birth.

His notebooks are wonderfully illustrated. His beautiful anatomical drawings are unique. Even when he was diagramming machinery, human figures crowded on the page, for the great central subject of the Renaissance was man. His drawings were based on infinite subtlety of observation and they had a wide aesthetic range. On one end of the scale was the perfection of beauty and youth; on the other, he dwelt on the grotesque, the deliberately ugly, and the extremes of age.

Leonard wrote a treatise on painting, whose function he saw as the capturing of the third dimension. His scientific organization of space was supported by the new understanding of perspective, and he reveled in foreshortening and a bold yet tender manipulation of light and shade. Since painting or drawing normally commands a far more limited range of values than we experience in nature, Leonardo recommended working from the model in twilight when light and dark were closer together.

Unfortunately Leonardo left very few completed works and these few have been singularly ill-fated. His *Madonna of the Rocks* (1485) is a masterpiece of the late fifteenth century. A Madonna with attendant angels bestows her benign attention on two infants, Christ and Saint John. The Christchild gives his blessing, and the infant Saint John receives it for the humanity he represents. A strange rocky landscape fills the middle distance, a cave that leads to a distant light.

Then follows one of his greatest efforts, *The Last Supper* (1495–98). This painting was disaster-ridden from the beginning. Leonardo projected it on the wall of a large refectory in a convent church in Milan. He wished for greater precision than fresco allowed and he undertook to seal the plaster and work in oil. The painting was faded and blotched in a few years. Time and again it was restored, and when the eighteenth century was through with it little of Leonardo's hand was left. At one time a door was cut through the painting, and Napoleon used the room as a stable. In World War II, the church was hit by a bomb, and three of the refectory walls were destroyed. Miraculously the wall with the painting was spared. Despite the depredations of time it still retains its power to move us through the grandeur of its conception.

Leonardo chose the moment when Christ announces that

one of the assembled apostles will betray him. Each reacts in a different way. Each protests. It is a moment of self-revelation for everyone present. Many artists have painted the

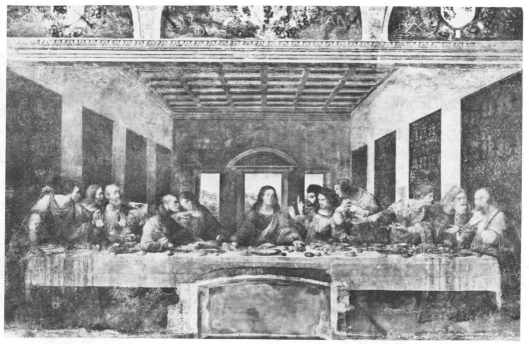

Last Supper but this painting became by common consent the archetype of the scene.

LEONARDO DA VINCI. *The Last Supper.* 1495-98. (Santa Maria delle Grazie, Milan.) [Anderson.]

The Virgin and Saint Anne (1506–10) is a very strange work. The Virgin sits on the lap of her mother, Saint Anne, while she reaches for her son who plays with the mystic lamb. This image of the relationship between the Virgin and her mother does not originate with Leonardo, but we cannot escape the uneasy feeling that he allows the two women to merge—or perhaps one woman plays a double part. This struck Sigmund Freud who saw in this painting a fusion or confusion of mother images in Leonardo's life.

Then there is the *Mona Lisa.* Actually painted somewhat earlier (1503–06), it is a conclusive image, a portrait as detached and singular as its audience is spellbound and universal. Her "smile" is simply Leonardo's hypersubtle modeling pursued into twilight. Leonardo introduced a shadowy lineless modeling, a "soft focus" effect, where before all had been hard and sharp. This form-without-line through the subtle manipulation of tone was to have a long future.

In *Mona Lisa,* the light is soft, but still clear: our eyes penetrate the canvas, and her eyes penetrate us in return. They reflect Leonardo's personality. The "mystery" is not hers alone, it originates with him.

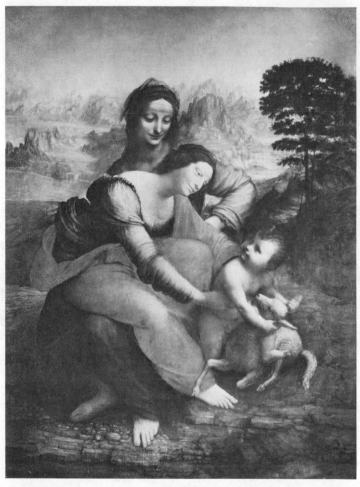

LEONARDO DA VINCI. *The Virgin and Saint Anne. ca.* 1506–10. (Louvre, Paris.) [Cliché des Musées Nationaux.]

Leonardo seems to have been untouched by the love of women. Prodigiously handsome, he lived in narcissistic splendor. He evaded the world of Michelangelo and Raphael, and left Florence for Milan where he squandered the best years of his life in the employ of Ludovico Sforza, a singularly unadmirable prince even for those times. As his military and inventive chores allowed, he worked on an equestrian statue of his patron's ancestor, Francesco Sforza. The world's greatest equestrian statues, by Donatello and Leonardo's teacher Verrocchio, were already in existence, so this statue

had to surpass them and perhaps it did. But by the time it got into clay Sforza's days were numbered. Before it could be cast into bronze it was used for target practice by French troops in Milan, and was shot to pieces.

Ultimately Leonardo accepted an invitation from François I, king of France. He took his voluminous notebooks with him and lived out the remainder of his life, now unproductive, near the château of Amboise in Touraine.

All other men of genius, even Michelangelo, appear as men of their time. Leonardo seems to be up ahead of us. Living now, he could well have been a kinetic artist, or a manipulator of light. He would certainly have been in electronics. Flight to the moon would have been no more than an appropriate preoccupation.

Yet much as he gave, he also withheld. He was left-handed, and his notebooks, difficult to decipher, are written in reverse. His weakness, the low heat of his emotions over against the white heat of his ideas, is a twentieth-century vice.

Leonardo had an open-ended genius that reaches over centuries. Raphael, on the contrary, had the ability to sum up the Renaissance. Without any apparent effort, he fulfilled the efforts of others. He broke no molds; he simply was the epoch and this was instantly understood. His life was short yet it seems complete.

Raphael Sanzio (1483–1520)

For Raphael there were no delays. He came from the mid-Italian town of Urbino where he worked four years. He was pupil of a sweet and tender religious painter, Perugino, who produced calm provincial paintings, and sweet and tender Raphael was to remain.

The young man went up to Florence where he stayed for another four years seeking and finding his fortune. Here he painted a series of Madonnas with one or two children—the young Christ and Saint John. These Madonnas are serene, blonde, and far from tragic. They were greatly prized from the day they were painted. Raphael had the limpid nature of a lyric poet; his self-portrait shows no lines.

Suddenly Raphael was summoned by the pope to come and work for him in Rome and here he spent the last twelve years of his life. He was asked to decorate a series of small. groin-vaulted rooms in the Vatican. His first frescoes are semicircular, some thirty feet across the base. Raphael began with the great *Disputa,* so-called, as the doctors of the church seem to be in discussion. But the actual subject is

the endless miracle of the mass. The monstrance is in the center at the vanishing point; a semicircle of church doctors surrounds it, a convocation of saints drawn from the history of the Middle Ages. About their heads sits a second semicircular tier, a balcony of figures drawn from the Bible. Higher yet on the central axis is the figure of Christ; the dove is below him and above his head appears God. Still higher come angels floating, and beyond a spread of golden rays the sky appears as a dappling of transparent blue cloudlets, each a cherub's head. The form of the whole work is semicircular in depth, so that it opens up the low-ceilinged room as if with an apse. And of course a similar opening up was called for on the opposite wall.

Here Raphael painted the *School of Athens*. The philosophers of ancient Greece are depicted as a throng caught up

RAPHAEL SANZIO. *Alba Madonna*. ca. 1509. (Courtesy of the National Gallery of Art, Washington, D.C. Andrew Mellon Collection, 1937.)

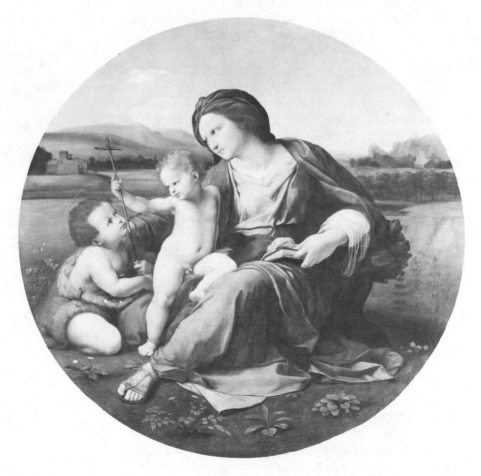

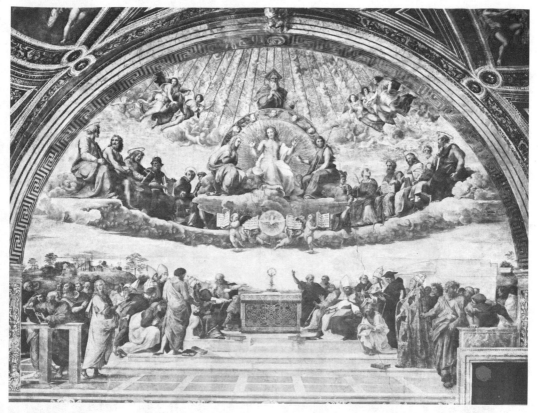

in solemn speculation. The central figures are Plato and
Aristotle: Plato, the idealist, points upward, while Aristotle,
realist, points to the earth. Pythagoras, in the left foreground,
is the old man writing. On the right, Raphael has introduced
his own portrait. The setting is a grandiose presentation of
the architecture of his friend Bramante. It is in fact a glimpse
of the dream that Bramante had had of the new Saint Peter's.
Diogenes lies sprawled on the steps.

RAPHAEL SANZIO. *Dis-
puta.* ca. 1509. Vatican,
Rome. [Anderson.]

These two great murals sum up the spirit of the Renais-
sance, that fusion of Christian theology and classical philos-
ophy only recently recaptured. On the wall between them,
if we look we can see Apollo playing on his lyre. Such all-
inclusive spiritual harmony could hardly be repeated. As the
series continues through other rooms, the later murals are
more dramatic and strain for effect. The artist had already
deployed his great and special gift, his benign serenity.

Raphael was the victim of his own efficacious skill. Since
everything that he touched succeeded he was loaded with
commissions and responsibilities. The pope placed him in
charge of whatever was afoot in Rome in the way of art,

RAPHAEL SANZIO. *School of Athens.* ca. 1510–11. Vatican, Rome. [Anderson.]

architecture, or archaeology. Overwilling, he was overtaxed and unexpectedly grew ill and died. He lies buried in the Pantheon.

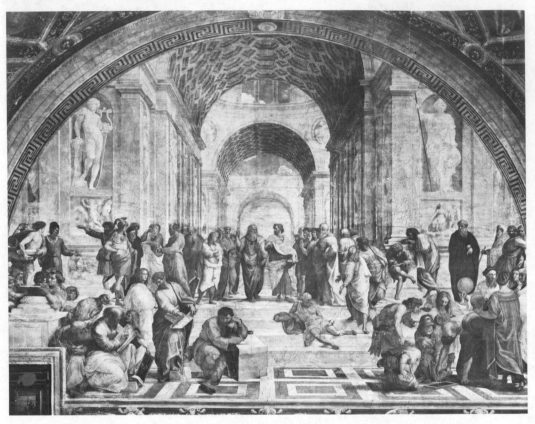

Michelangelo Buonarroti (1475–1564)

Michelangelo and Leonardo, both Florentines, were living at the same time for a span of forty-four years. If we raise the rather foolish question of who was the world's greatest artist, there is only one possible answer: Michelangelo. It would be hard to argue against Leonardo's claim for second place. Wherever Leonardo looked he cast an uncanny light of comprehension, but it was a chill light. Michelangelo by contrast had the power to project his burning emotions. His art often seems to crumble under pressure, as he pursues some impossible goal.

In his old age he brushed aside his art as a small matter compared to his desperate religious needs. He was tortured by conscience in a world devoid of compunction. He saw the worldly and resplendent Renaissance of the papacy receive shattering blows. In 1527 Rome was barbarously sacked

by Spanish and German troops under the Emperor Charles
V. The papacy lost Germany to Luther, Switzerland to
Calvin, and England to Henry VIII. Michelangelo lived into
the Counter-Reformation, when fanaticism took the place of
Renaissance humanism. Yet these blights were only an ac-
companiment to the darkness in his soul.

He, too, was somehow denied the tempering love of
women. He was small of stature, broken-nosed from an early
fight, bitter, and impossible to befriend. He existed in
squalor. He was perennially unwashed and filthy. The pro-
jects he undertook at once assumed overwhelming proportions,
yet amazingly he completed most of his labors of Hercules.
If he left other works unfinished, they too remain acts of
genius.

He was sculptor, painter, architect, and poet. He certainly
created the world's greatest sculpture; we have only to
choose. As certainly he created the world's greatest single
painted wall. He was utterly modern in offering his per-
sonality along with his art, and indeed as part of it. His life
and art were one long struggle with mortality, and one
long search for someone to love. In the end he found the
answer to both torments in the love of Christ. He cried out
about the whole tragedy of man, that he is only given his
life to have it snatched away and is born condemned.
Habitually he would defy authority, work himself into an
impossible situation, and run away.

Michelangelo studied in Florence when young, came to the
notice of Lorenzo de Medici, and carved a *Battle of Centaurs*,
a relief that echoed the violent and congested sculptures on
late classical sarcophagi. Sometime before 1500 he was in
Rome, where he carved a *Pietà*, the dead Christ lying in his
mother's arms. The Madonna appears as a young girl and
we do not immediately notice that she is on a larger than
life scale, cradling the figure of Christ as though he were
still a child. It is always in Michelangelo's exaggeration
that the emotion lies. This sculpture, now in Saint Peter's,
has been to America, was recently vandalized (1972), and
has been restored.

Between 1501 and 1504 Michelangelo, still in his twenties,
was back in Florence where he carved his *David,* his most
unified and perfect work. The *David* was cut from a block
that an earlier sculptor had abandoned; Michelangelo was
obliged to work within limits and the pose is restrained. But
in the *David* a bold gesture is imminent. An intense vitality

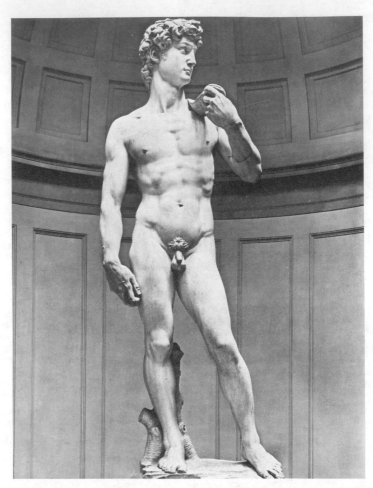

MICHELANGELO. *David.*
1501–4. (Accademia,
Florence.) [Alinari.]

runs all through the sculpture, animating the whole body.
Michelangelo stresses certain disproportions, the gangling
wrists and overlarge hands of youth.

The *David* is on a colossal scale, eighteen feet tall. No
observer thinks for a moment what Goliath would be like.
David is a giant-killer but he is also the giant. He is set to
conquer himself.

There was an immediate political relevance to the sculp-
ture. The Medici were always being thrown out of the city of
Florence and always returning. The resolute *David* was
carved during republican years when the Medici were out.
What with relevance, scale, and sheer genius the acclaim for
this sculpture was immense. For centuries it stood in the
city square before the Palazzo Vecchio, where a replica
stands now. The original has moved into the Accademia,
amidst other of Michelangelo's sculptures early and late.

Pope Julius II now sent for Michelangelo to work on his tomb, but as both sculptor and pope shared instincts for the impossibly grandiose, the project ended in failure. The tomb was to have been a monument to an extravagant ego on three levels: figures of victories and slaves at the base, four great figures on a plane above, of which only a *Moses* was ever completed, and on the third level the pope was to be carried into heaven in his papal chair. Of the slaves that Michelangelo carved, only two were finished. These two swooning young men are of great beauty; the others are obscure figures still struggling to free themselves from the marble. The *Moses,* an exalted Renaissance leader of men, sits enthroned and wildly roused. His full beard coils, his

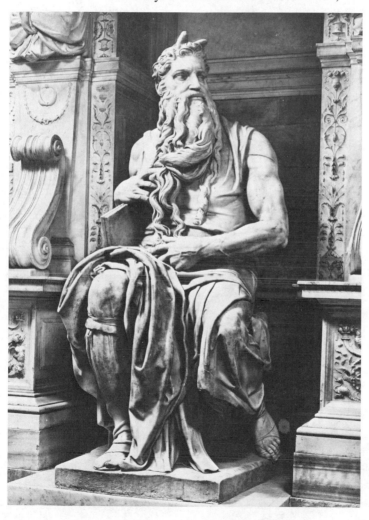

MICHELANGELO. *Moses.* ca. 1513–15. San Pietro in Vincoli, Rome. [Anderson.]

eyes blaze. The *Moses* was not finished until after the pope's death and only long years later was it used for a much smaller tomb that diminishes the great sculpture.

Meanwhile this whole undertaking hung heavily on Michelangelo. He had bought the marble, and he made off to Florence and refused to return. The pope now wanted him to paint the ceiling of the Sistine Chapel. Michelangelo stormed, yielded, and came back to Rome. He was a sculptor and he believed that Raphael and the architect Bramante had conspired to persuade the pope to misdirect his energies.

He painted the whole Sistine ceiling, all seven hundred square yards, in four years, He worked lying on his back under the wet plaster and it was shattering to his health. The surface is so great that Michelangelo felt obliged to create an architectural format within it. He painted images of prophets, sibyls (prophets or soothsayers of pagan mythology), and young decorative figures as a setting for a series of central panels that deal with nothing less than the Creation: of light, of the world, and of man. The Temptation and Expulsion follow, and the Old Testament unfolds down to Noah, the flood, and the second beginning for mankind.

The masterpiece in all this amazement is the bringing to life of Adam as God touches him with a finger. No one but Michelangelo has been able to create an image of God, a figure with the vitality to account for his own existence without explanation or cause. By comparison all other images of God are simply pictures of old men.

MICHELANGELO. *The Creation of Man* (detail). 1511. Ceiling, Sistine Chapel. Vatican, Rome. [Anderson.]

The *Medici Tombs* were the sculptor's next great achievement. He designed the new sacristy in San Lorenzo in Florence, where they are placed. Beneath opposite walls stand identical tombs, each raised on supports and covered

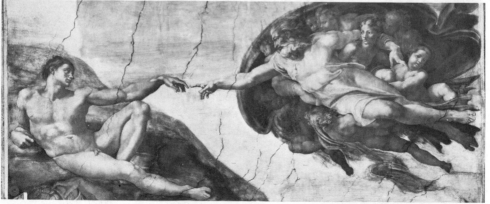

with a low broken arch. In each wall a central niche contains a seated figure poised above a tomb. Presumably they are images of the Medici dead, but actually they are representatives of those Renaissance ideals, the man of action and the figure of grace. A helmeted warrior broods above one tomb, and above the other a golden youth sits casually, listless.

At this point genius intrudes. Two gigantic presences recline on each tomb to form the base corners of a triangle whose apex is the figure overhead. Called *Night, Day, Morning,* and *Evening,* they are some of the greatest carvings of all time. Brooding, somnolent, or suddenly roused, they disturb profoundly. Out of scale with the scene they haunt, they rest most uncomfortably on the slanting lids of the tombs and hang into space. It is often pointed out defensively

MICHELANGELO. *Day* 1524–34. Medici Tombs, San Lorenzo, Florence. [Anderson.]

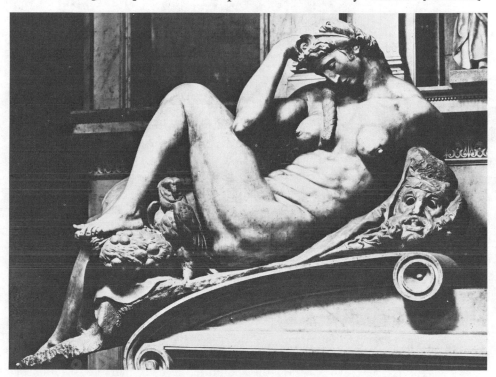

that four more figures were planned for floor level to extend the triangles downward, yet it is hard to conceive how this would have helped. Something still more massive would have been needed; Michelangelo has created works out of scale with their environment, even though he made the environment himself.

None of this matters. The room does not have the air of

a chapel, but of a scene of creation, and the ultimate presence here is Michelangelo himself. The four figures overtax any normal conception of humanity. The unfinished figure

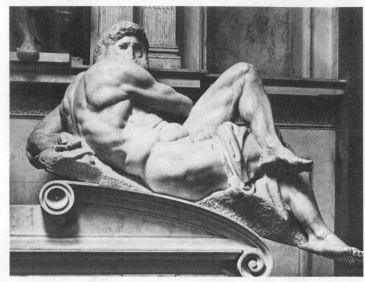

MICHELANGELO. *Night.*
1524–34. Medici
Tombs, San Lorenzo,
Florence. [Anderson.]

MICHELANGELO. *Pietà.*
1555–64. Castello
Sforzesco, Milan.
[Anderson.]

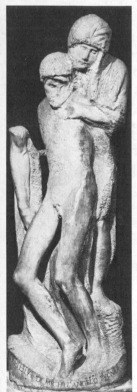

called *Day* may be greater than the *David*. Thirteen years had gone by before the tombs reached their present stage, and by then Michelangelo was fifty-nine.

Then there is the great end wall of the Sistine Chapel, the *Last Judgment*. Michelangelo undertook it a generation after the time of the ceiling. This is his great Mannerist-to-Baroque achievement. Here every limiting dimension is swept away. We have an entirely new kind of space without coordinates, simply an endless continuum so that separate souls can exist, which they do between a hope and a fear that is to be justified at once and forever. We are looking at strange anatomy, at torsos that are square, at figures that spiral unbelievably. Yet these very impossibilities carry conviction and animation at a distance. These are anatomies of struggling souls.

There was still sculpture, a final marvelous unfinished *Pietà,* a skeletal diagram of suffering. Here Michelangelo utterly repudiates the flesh, and is caught in the act of chiseling it away.

For his last years Michelangelo played architect. He undertook the task of the unfinished Saint Peter's. He wished for a central dome and we can see something of the Saint Peter's that he envisaged if we look at the cathedral from

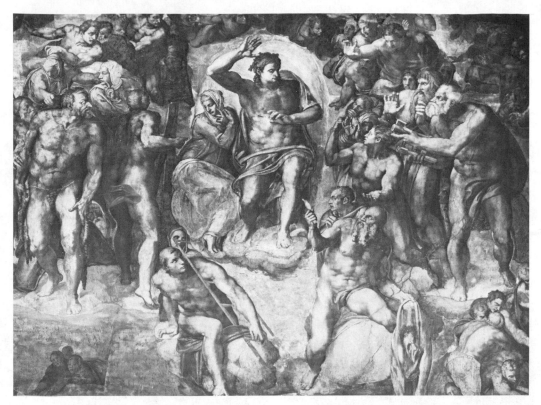

the rear. The dome rises enormous, serene. For the outer walls of the building Michelangelo produced heroic pilasters that organize the surface from top to bottom in one sweep. No classic order on this scale was ever seen before. For Michelangelo architecture was sculpture, worked out with models so that he could study the fall of light.

MICHELANGELO. *Last Judgment* (detail). 1534–41. Sistine Chapel, Vatican, Rome. [Alinari.]

If this were not enough, Michelangelo designed a group of buildings on the Capitoline Hill in Rome. The hill forms the backdrop for the ruins of the old Roman Forum and the architect had the opportunity to front up the whole classical past. He approached the hill from the other side, leading a long, wide ramp up to a level summit, a pavement backed by a towered palace with a supporting palace façade on either hand.

As one faces the trapezoidal pavement at the top of the ramp the façades on either side each verge away to counteract the natural closing-in of perspective. In the center of the court stands the ancient and rare bronze statue of the Emperor Marcus Aurelius on horseback. The pavement surrounding the statue is filled with an abstract pattern of mosaic arcs that keep the space from remaining void.

As on Saint Peter's, Michelangelo provided these buildings with a "colossal" order of pilasters that goes from pavement to cornice. This vertical device is excellent and if it calls for a proportionately heavy—too heavy—cornice he had a solution here, too. He lightened the building with a balustrade along the edge of the roof and for good measure placed decorative statues upon it, one above each pilaster, so that the vertical line carried through to the sky. This roofline balustrade has been a boon to architects from that day to this, whenever they were caught with a classical disproportion or needed to disguise a roof.

Everything about this total design was successful. Its most remarkable aspect was the enlargement of the single composition to include three buildings on an axis. This essentially Baroque achievement, an exercise in city planning, was a lesson soon to be well studied and well learned.

MICHELANGELO. Buildings on Capitoline Hill, Rome. ca. 1545. [Alinari.]

11

MANNERISM IN FLORENCE, VENICE, AND SPAIN

The so-called High Renaissance, when genius was in serene balance, lasted no more than two decades, the first twenty years of the sixteenth century. A period of uncertainty followed, of hypersensitivity. The artist no longer emulated classic works; he tended to rely on his own inner moods. The subtle art that he produced, called Mannerism, stemmed in part from Michelangelo's temperament with its component of deep despair. Mannerism had an early and late period. In general, its early phase came out of Florence; its second, late, phase can be associated with Venice, with Tintoretto and then El Greco.

Mannerism was an art of yearnings, of pathos, of the kind of reality the theater best expresses. Its figures became actors, its movements became gestures. It delighted in studied contortions, twists and turnings, in acid bitter colors and forced lights and shadows. Figures became impossibly tall, an effect conveyed by giving them unnaturally small heads. Mannerism was tinged with private confession. Its artists were trivial, lustful, or exalted. It has a special appeal to twentieth-century man.

Fiorentino (1494–1541)

Francesco Parmigianino (1503–40)

The first, or Florentine, phase of Mannerism, a strange self-conscious art of elegant posturing, was a young man's movement: Il Rosso Fiorentino, Parmigianino, Pontormo, and Bronzino were all much of an age. The *Madonna of the Long Neck* by Parmigianino expresses the general exotic mood. The gifted Pontormo employed similar attenuations.

Pontormo (1494–1557)

Angelo Bronzino (1503–72)

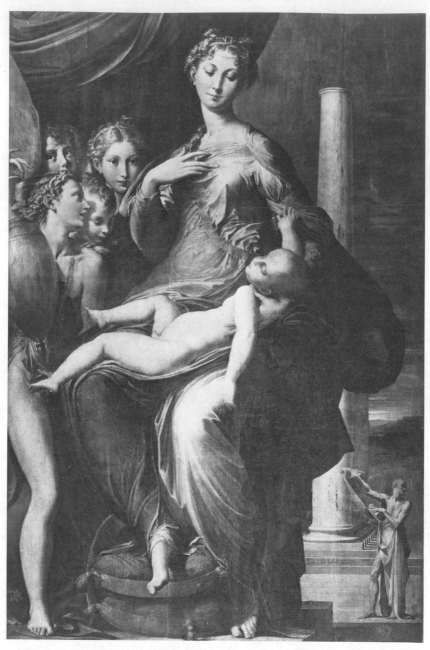

FRANCESCO PARMIGI-
ANINO. *Madonna of the
Long Neck*. ca. 1535.
(Uffizi Gallery, Flor-
ence.) [Anderson.]

His canvases are finished to the last detail, and his subjects seem under hypnosis; they seem to have a "high fashion" distinction.

Correggio
(1489/94–1534)

More tender, and altogether more living and wholesome is Correggio. A north Italian artist, his great work is the painted dome in the cathedral in Parma, filled with figures

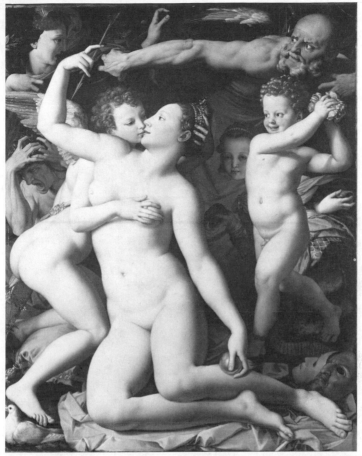

able to swim happily in the heavens. In his relatively few easel paintings Correggio makes use of Leonardo's soft shadowy modeling; his nymphs float in a sensuous dream. He was ahead of his time: too personal, too private for the Renaissance, too wholesome for Mannerism. He resists classification—a fact which annoys historians.

Mannerist Sculpture

As though overwhelmed by Michelangelo, Mannerist sculpture lacked grandeur. So many formal lessons had been learned that the sculptor was drowned in facility. The sixteenth century was a time of engaging little figures, beautifully made, actors for a pocket-sized mythology. Hundreds of small bronze Venuses appeared in Italy, smooth and glossy. An equal number of wooden figures appeared in Germany, brought to a high nut-brown polish. They are too sleek, too nimble for the nobility of the life-size image.

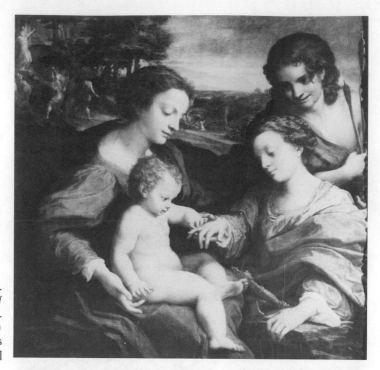

ANTONIO CORREGGIO.
The Mystic Marriage of
Saint Catharine. ca.
1523. (Louvre, Paris.)
[Cliché des Musées
Nationaux.]

Two sculptors represent perfectly this ironic lack of importance through an emphasis on skill that approaches sleight of hand; and both undertook large-scale sculptures that show up their limitations: Benvenuto Cellini, an Italian, who had a high-flying career in France; Giovanni da Bologna, a northerner (from Boulogne, France) who had a successful career in Florence.

Benvenuto Cellini
(1500–71)

Cellini assured his future with an autobiography so egotistical, so exuberant, that it is excellent reading to this day. It is a success story presenting the man of talent whom princes delighted to honor. He provided what was wanted, and what was wanted was the classical image as an object of luxury. He created a saltcellar for François I of France that features two nude figures who contemplate each other at leisure. One is the king's mistress, Diane de Poitiers, as the goddess for whom she is named; the other is the king as Neptune. As king of the ocean he provides the salt; she provides the pepper (the spice). This profoundly philosophical work is in gold.

In Florence, in the midst of the great sculpture of the recent past, Cellini came nearer to rising to the occasion. He

created a life-size sculpture of Perseus as he kills the Medusa. Sword in hand, Perseus stands on her body and holds aloft her head. Cellini tells in his autobiography of the turmoil attendant on the casting: how there was not enough bronze and how he threw in all the extra metal, silver and other, on which he could lay his hands until he had just enough. In short, he provided his own publicity.

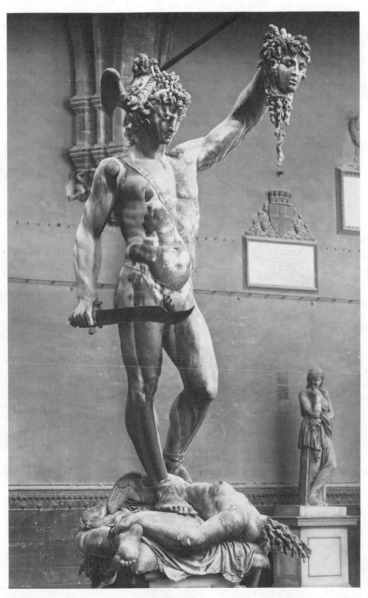

BENVENUTO CELLINI.
*Perseus Slaying the
Medusa.* 1545–54.
Loggia dei Lanzi,
Florence. [Scala.]

The Venetians and Paint

The Venetians were exuberant wholesome painters in love with color and life. For those who love paint for itself there are no artists like the Venetians. They lived in a world of light reflected off the sea. Their color glows in the shadows and their lights are bleached. Venetian painting began with tenderness and ended with splendor.

There are so many gifted Venetians; to pass over such men as Carpaccio or Gentile Bellini takes hardness of heart. We must settle for Giovanni Bellini (1431–1516), younger brother of Gentile (brother-in-law of Mantegna), for his sweetness, his faith, his luminousness, and his long struggle. Certain artists open up an age and have difficulty doing what other men will soon do easily—yet not so well. Bellini was

GIOVANNI BELLINI. *Saint Francis in Ecstasy.* ca. 1485. (Copyright the Frick Collection, New York.)

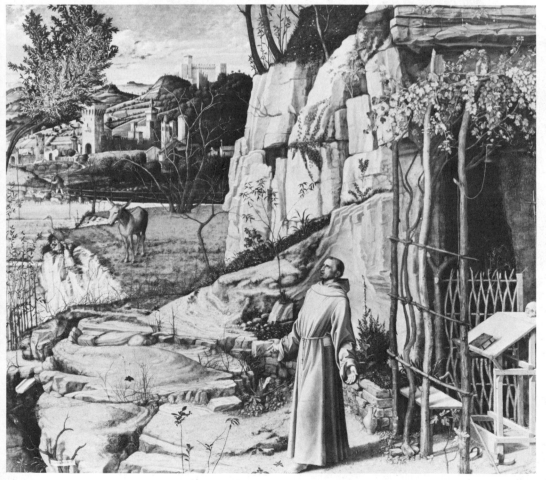

still Gothic, with the appetite for detail of the northern artists, and his paintings are almost all religious. They have a colorful quietude that invites prayer and they smell of the warm wax of altars. He was the first of the great Venetians to turn to oil paint, that northern technique at which the Venetians were to excel.

Giorgione (Giorgio Barbarelli) (1478–1510), the earliest of the Venetian sensualists, left a few great paintings, done with grace and apparent ease. He introduced the theme of

GIORGIONE. *Fête Champêtre.* ca. 1510. (Louvre, Paris.) [Alinari.]

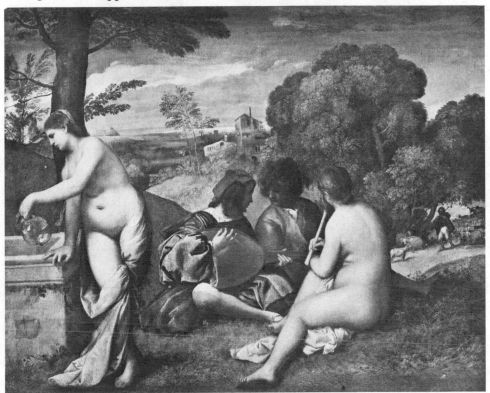

the Venetian reclining Venus, classic in her repose, Gothic in her elongated seal-like suavity. Like Raphael he seems never to have matured, and yet he suddenly matured Venetian art. He died young.

Giorgione leads us at once to the great figure of Titian. Both men shared equal talents, but Titian was an immensely productive and commanding figure throughout a long life.

Titian (Tiziano Vecelli) (1488/90–1576)

He, too, has been acclaimed as the world's foremost painter. Michelangelo remarked sourly that Titian could not draw, but he drew with light, suppressing detail, and he

created great somnolent living forms. The Venetians offered flesh, and Titian was famous for his female nudes. He created a series of bacchanals, exuberant rustic happenings involving gods and goddesses, fauns, satyrs, nymphs, and mere Venetians who qualified. These paintings are resplendent decorations. The Venetian painters with their high-keyed palette, their delight in color, approached Impressionism; Titian has been thought of as the first Impressionist. He

TITIAN. *Bacchus and Ariadne.* 1522. (Reproduced by courtesy of the Trustees, The National Gallery, London.)

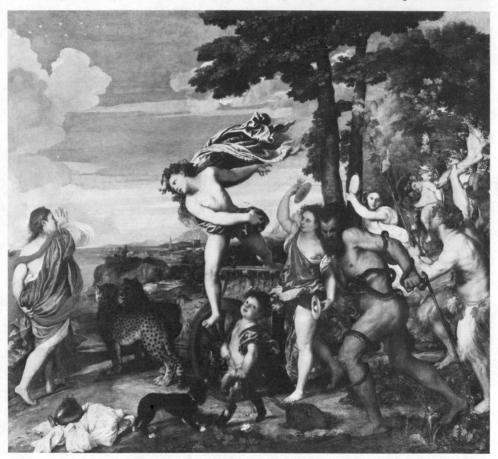

did not manage an Impressionist sunlight; instead he spread a golden glow over flesh to contrast with an intense blue sky, an approach to outdoor light if a small cloud filters the sun on a deep blue day.

Titian made a formula of Giorgione's reclining Venus. His nudes are heady, pungent, and expensive. No matter, he associated with men who could afford them. In *Venus and the Organ Player* the pleasure of music adds to the pleasures

of the eye. We can hear Shakespeare's prince reciting, "If music be the food of love, play on."

His portraits of men are even greater than his paintings of women. Both men and women are untroubled, with seamless brows and steady eyes. Their consciences are calm, and if they live in dangerous times and have cause for fear they do not show it.

Titian was a prince among princes, a friend of the greatest, the Emperor Charles V. His royal portraits have a dignity calculated to impress. In the Middle Ages the king had his "dignity" which was almost a physical shadow, a solemn transformation of his individual self. At his funeral a stylized

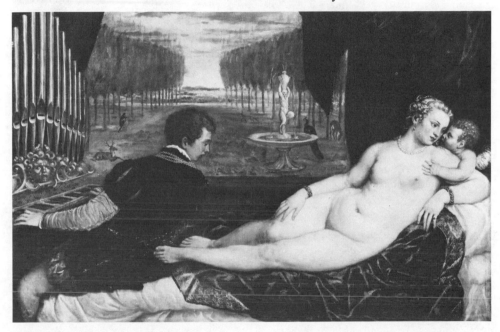

symbol of his body was carried in state, and it was understood that this was neither the image of his body nor of his soul. It was a state presence. The same idea produced a solemn mien in portraiture. Such a presence seemed especially appropriate to donors who were introduced at their prayers in the corners of altarpieces for which they had paid. Titian was master of this princely image and his noblemen appear genuinely noble.

TITIAN. *Venus and the Organ Player*. ca. 1548. (Prado Museum, Madrid.) [Anderson.]

Early and late, Titian produced religious paintings, some of them imposing church decorations, others great with a sense of profound drama. The finest in this kind is his last canvas, a Pietà that he did not live to finish. Here at last this

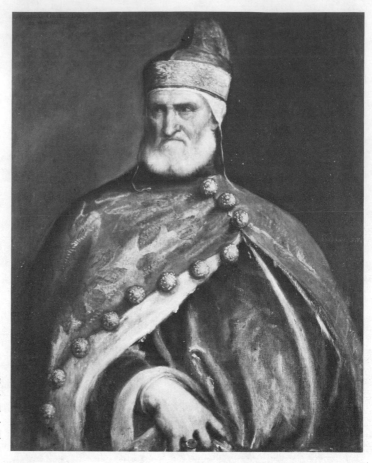

TITIAN. *Doge Andrea Gritti.* 1535–40. (Courtesy of the National Gallery of Art, Washington, D.C., Samuel H. Kress Collection.)

most worldly of painters confronts his own death in his extreme old age. The dead Christ lies across the Madonna's knees, but our attention gravitates to the old man prostrate at the Virgin's feet, more self-portrait of the aged Titian than saint.

Tintoretto
(1518–94)

Tintoretto was born late enough to be energized by the stupendous achievements already accomplished during the Italian Renaissance. He aspired to the color of Titian and the drawing of Michelangelo. If he fell short of both goals, he is full of generosity, action, and life. He is so rich in vitality that we hardly notice how his figures move in a quite artificial choreography, posturing, bending, and swooping. This of course is Mannerism. Much of it comes directly from Michelangelo, whom Tintoretto so greatly admired.

Since Tintoretto was inexhaustible and never paused, his vast paintings show best in sequence when he creates a world

of his own. In Venice he took twenty-four years (1564–88) to cover the walls and ceilings of great rooms upstairs and down in the *School of San Rocco,* patron saint and consoler of those stricken with the plague. His subject is the life of Christ. Although building and setting are palatial, his Christ stands totally apart from the surroundings of Venetian opulence, a figure of spiritual purpose and of humility in a city whose sin was pride.

Like other Venetians, Tintoretto loved to launch figures into the sky with or without wings. But only Michelangelo

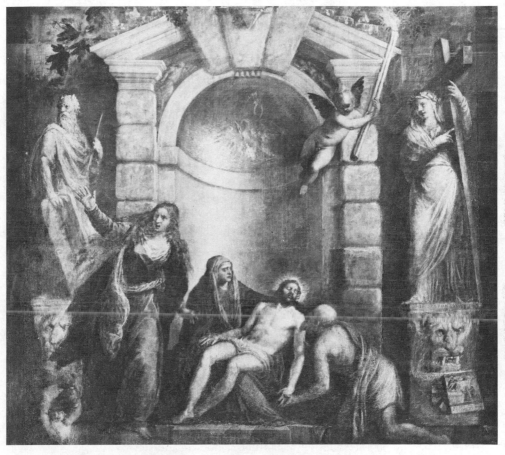

and Tintoretto are really successful in freeing figures from the pull of gravity. Michelangelo's figures move like bodies in orbit in airless space. Tintoretto, being a Venetian and living on the sea, allows his figures to float in blue atmosphere or swim in it with skill and speed. In his early *Miracle of Saint Mark,* the saint comes flying down with tremendous

TITIAN. *Pietà.* ca. 1576. (Accademia, Venice.) [Anderson.]

authority. In the *Marriage of Bacchus and Ariadne* (1577–
78), one of a series of smaller decorations painted for the
Ducal Palace, Venus comes swimming through the sky to
approve the occasion, and she moves with all the immediacy
of love.

An earlier characteristic painting, the *Presentation of the
Virgin in the Temple* (1552–56), shows us what goes on

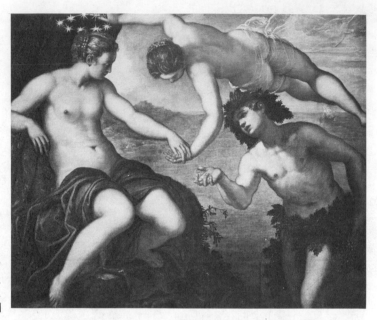

TINTORETTO. *Marriage
of Bacchus and
Ariadne*. 1577–78.
Ducal Palace, Venice.
[Anderson.]

when a major Venetian is at work. The artificial manipula-
tion of light to reinforce composition or drama is a charac-
teristic Venetian procedure, and Tintoretto uses this re-
source with quite arbitrary abandon. The way in which
light is turned on or off to direct our interest is not merely
theatrical, it is cinematic. Light silhouettes the loneliness of
the little Virgin at the top of the steps, ennobles the high
priest, and picks out a mother in the foreground who directs
her child's attention—and ours—to what is going forward
overhead, while arbitrary shadow drapes the Michelange-
lesque figures sitting in line on the steps.

This manipulation of light grew upon the Venetians. Fig-
ures were studied by torchlight for the massing of light and
shadow. Painting in which light and dark became the ma-
chinery of the composition, even its subject, was to sweep
Europe. It lent three-dimensional conviction to the fact of

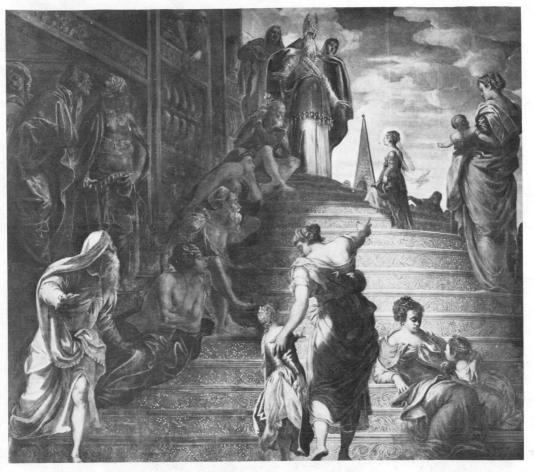

man's existence, however temporary, and painting once more became a religious art.

Tintoretto was buried near his *Presentation of the Virgin* in the church of the Madonna dell'Orto. The legend on the stone exhorts us to consider the accomplishments of this man and to go away the happier.

Other great Venetian painters were inexhaustible in their zeal to decorate their city. Veronese was one of the most resplendent of large-scale painters. He covered entire walls with mass portraits and he set scenes for the great festivals where the love of food and drink competed with the love of women. The subject may be either religious or civic—to Veronese it was all the same. The result is a spectacle of the beautiful and proud throwing themselves into the pageant of

TINTORETTO. *Presentation of the Virgin in the Temple*. 1552–56. Church of the Madonna dell'Orto, Venice. [Anderson.]

Paul Veronese (1528–88)

Venetian life. If Christ is present, the occasion is biblical; if Venus is of the company, it is mythological.

A comparison of Tintoretto and Veronese helps us to distinguish between Mannerist and Baroque. Mannerist is in-

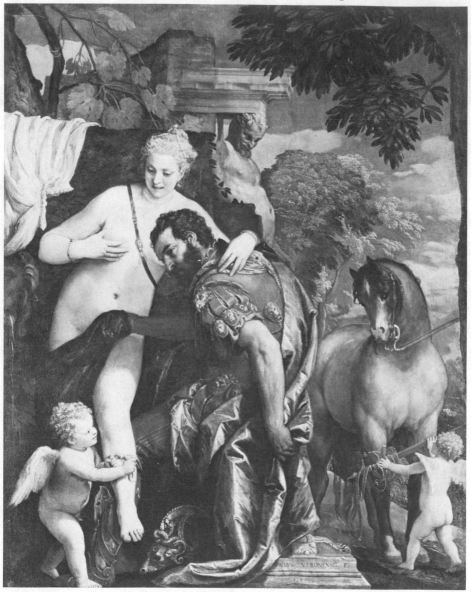

PAUL VERONESE. *Mars and Venus.* ca. 1576. (The Metropolitan Museum of Art, New York, Kennedy Fund.)

ward-looking, subjective; Baroque outgoing. No Venetian is very inward, but Tintoretto provides a stylized choreography for mystical happenings, whereas Veronese is singularly literal, and content with the spectacle before him—if only it remains spectacular.

Mannerism: From Venice to Spain

In El Greco we have late Mannerism in its purest form. El Greco came from Crete, visited Venice long enough to become a Venetian painter, saw Rome, and accepted an invitation to go to Spain when he was about thirty years old. Here he lived out his life painting in Toledo. We know very little of the spiritual baggage he brought with him when he came to Venice, and can only surmise that he was influenced by a world of exalted Byzantine elongations. With Venetian Mannerism as his new equipment, he became a painter of religious experience when he reached Spain. All the tenuous elongated proportions of Mannerism now took on spiritual meaning for him. Coincidentally these elongations were Gothic: El Greco was suddenly more Spanish than the Spanish. His paintings breathe exaltation and faith.

El Greco
(Domenikos
Theotocopoulos)
(1541–1614)

Spain visualized its own world of absolutes, a transcendent world, barren below (during life), triumphant above (during eternity—for where is death?). This eternity is the real territory of El Greco and its land and sea are white ice floes of cloud drifting in an ocean of black sky. His greatest canvas, painted ten years after he arrived in Spain, is the *Burial of the Count of Orgaz,* in San Tomé in Toledo. The crowded scene describes an old, legendary miracle. Saint Augustine and the young Saint Stephen appear at the funeral of the good knight to lay him in his grave. The body of the count, in steel armor with gold damascene inlay, simply floats before them. Immediately behind, Spanish gentlemen in black with white ruffs stand astonished yet impassive while a great supernal drama takes place above their heads. Here the whole host of heaven appears to welcome the birth of a new soul among them, which moves upward as a vague embryo through the shell-like clouds. We witness a literal second birth. John the Baptist, on the right, kneels to intercede for this soul with the Virgin, on the left, who in turn will intercede with her Son who sits far above in the height of heaven. Saint Peter attends, and angels hover. This salvation through petition is court procedure. The petition will assuredly be granted and all will be well forever.

El Greco also painted a masterpiece in his *Saint Martin of Tours,* the soldier saint who is cutting his cloak in two with his sword to give half to a naked beggar. The white horse, the black armor, must have fascinated the artist, who dealt with this subject more than once.

He also painted one of the world's great landscapes in his *View of Toledo.* The painting owes its mystical, haunting quality to its dark and light sky that is neither of day nor night. Toledo was a sacred city, and religion was its chief concern. El Greco created a habitation for spirits, a citadel remote from the world, only to be reached by its guarded bridge. This is a Mannerist scene, but it is far from Venice.

EL GRECO. *Saint Martin of Tours.* 1604–14. (Courtesy of the National Gallery of Art, Washington, D.C., Andrew Mellon Collection.)

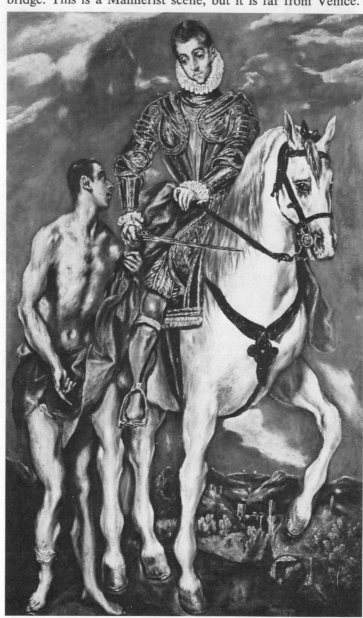

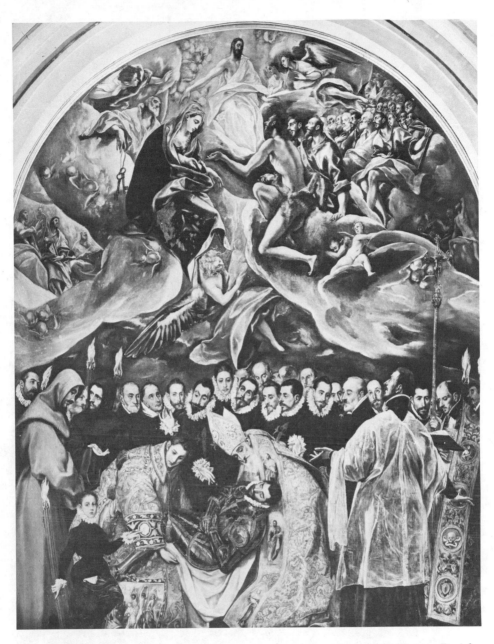

Later Venetians

EL GRECO. *Burial of the Count of Orgaz.* 1586. San Tomé, Toledo, Spain. [Anderson.]

Venetian painting lasted down into the eighteenth century, when Venice herself had lost her power and had become the tourist center she is today. The last of the Mannerist-Baroque decorators, Giovanni Battista Tiepolo (1696–1770) painted with flair and brilliance, spreading mythology

over ceilings and walls. He painted the ceiling in the palace in Madrid which was to influence the young Goya. Then there were splendid painters of the pageant of the city, Antonio Canale, called Canaletto (1697–1769), and Francesco Guardi (1712–65). Canaletto's scenes of Venice are superb documentaries—paintings which British tourists of the time bought and took home. Eventually he went to London, where he of course painted the city. Guardi, only a few years his junior, was much closer to modern times, that is, to the nineteenth century. His fluent Venetian scenes have a wateriness that approaches Impressionism. The activity within his canvases—the figures, the gondolas—is written in with touches of white that provide an artificial animation and glitter.

EL GRECO. *View of Toledo*. 1608. (The Metropolitan Museum of Art, New York, bequest of Mrs. H. O. Havemeyer, the H. O. Havemeyer Collection.)

THE BAROQUE

The richness of the Renaissance, the triumph of sculpture, and the parade of color all suggest opulent well-being and we assume a sudden softening of living conditions and a farewell to the austerity of the Middle Ages. Yet this was only partially true. The cities of Italy and to a lesser extent those of Germany and Flanders had wealth to spare. Renaissance to Baroque paintings present scenes of festivity and great banquets; but if we look closely we will see the bare stone floors and trestle tables. It is the clothes that are ostentatious, rich and padded against the cold, and the hangings for blocking drafts or shielding a bed create a misleading sense of luxury. Interiors of the time resemble stage sets. They contain just enough equipment to make the drama possible, nothing more.

Yet if living was meager in our view, for the actors everything was better than what they remembered. The men of the period lived in a world of expanding ideas and the actual extension of habitable space. On the one hand the New World had been brought into European experience. Within the century after Columbus' voyages, gold was being wrenched out of Mexico and Peru. Spanish ships were bringing merchandise from China to Acapulco, where it was transported overland to Vera Cruz and reshipped to Europe. Francis Drake waylaid such Spanish cargo ships in the Pacific. The geographic world was discovered and in hand.

On the side of the expansion of ideas, the fifteenth century had brought in printing. The use of movable type, an

epoch-making invention that revolutionized communication, came out of Germany. Nuremburg, Basel, Mainz, then Antwerp, Lyons, and Venice were centers for this most cosmopolitan skill. Printed books were to ideas what gunpowder was to warfare, and engraving accomplished for art what movable type did for literature. The images of art could now travel. Engraving broadened experience. It had formerly been necessary to go to see a work of art, but now the smaller change of reproduced forms could pass from hand to hand.

In one way or another Italian influence, freighted with its classic recollections, had spread all over Europe. The vulnerability of Italian cities had lured both the French and the Spanish to invade the peninsula. These invasions were tragic for Italy, but for the invaders, who were restless with their new nationalism, such excursions were rewarding. The French brought home their experience of Italian architecture, and Italian artists were imported, beginning with the great Leonardo himself.

Renaissance forms were applied quite innocently and gaily to the older Gothic castles and palaces. It was not long, however, before a French sense of order, of logic and refinement, took over. The Gothic yielded to a sober, restrained classicism that became a new architectural language, a French national expression that has survived to the present day.

The French were also fortunate in their adaptations of the Italianate when it came to their sculpture. Mannerist figures spiral, twist, and posture as we have seen in Michelangelo's great Medici tomb figures or on the wall of his *Last Judgment;* we see them swooping and bending in Tintoretto, and in El Greco they become figures of unearthly exaltation. These elongated figures with their Gothic proportions did well in a new environment. As El Greco put his famished figures at the service of religion, the French put their long willowy nymphs at the service of love. But it was a cool love. Mannerist figures—again like Gothic figures—emphasized elegant line.

Meanwhile a further, later, architectural influence came out of sixteenth-century Italy. The name of the north Italian Andrea Palladio (1518–80) is associated with the country villa, the château in France, and the country house in England. Palladio's villas were built in the general Venetian area; perhaps the most perfect example is the Villa Rotonda

JEAN GOUJON.
Triton and Nereids.
1548–49. (Louvre,
Paris.) [Alinari.]

in nearby Vicenza. Here he chose to set a square building on a high basement and to cap it with a low-crowned dome. To this he added classic porches on all four façades, complete with columns, pediments, and broad flights of steps. The result was an exceedingly stylish and impractical building that had an appeal for stylish people for many years.

Palladio was important not only for what he built but for what he wrote. Like the Renaissance Alberti, his writings on classical architecture had an enormous influence. When the British, like the French before them, turned whole-

ANDREA PALLADIO.
Villa Rotonda, Vicenza,
Italy, ca. 1567–70.
[Alinari.]

heartedly to the classical tradition, they fell under the spell of Palladio, with the result that he had a special influence on colonial America.

Palladio was a purist in a century when the classicism of the Renaissance was undergoing great changes. A time of organized planning had arrived: buildings no longer competed with each other but took their places in a larger civic

composition. The new harmony, dressed in classical orders larger in scale, corresponded to larger political units. Michelangelo's group of buildings on the Capitoline Hill conveniently date the coming of this expansive concept. The individualism of the Renaissance was past—unless the individual were a prince.

This new mood, or style, the Baroque, could be restrained as in France, or flamboyant as in Germany. Either way it was on a scale to express the state, the statesman, or the prince. In Italy, whence the Baroque came, the great princes represented the Church and churchmen made excellent use of this impressive new architecture.

The sixteenth century had brought in the Counter-Reformation, a holding of the line against the Protestant revolt. Humanism gave way to fanaticism under stress; it was a time to purify and defend the faith. The arts were now called upon to bring support to religious conviction; as a result, painting and sculpture became theatrical, and the new churches rising in Rome became spiritual forums. What was needed was a space that the fervent voice of a preacher could fill: the call for this centralized pulpit came from the Jesuit order. The new Baroque churches were their churches. These buildings had a shortened nave, the shortest of transepts, and the merest remnant of side aisle. They could be filled with exhortation, and to dazzle the faithful their interiors were ablaze with gold, with sculpture that gesticulated freely, with angels swarming into the zenith. It was of little moment whether the images were in marble, bronze, plaster, paint, or a combination of all four.

These Roman Baroque churches had a two-story façade unrelated to the interior. The roof was buttressed with masonry designed in a curious S-scroll. The pediment over the entrance might be capped with a low curve that echoed the roof of the building. Classically this was outrageous, but if Michelangelo could build for effect, composing with sun and shadow, others could and did. Vignola's church, Il Gesù (1568–84), prepared the way; the influential façade was by della Porta (1573). Such vital if incongruous forms also transplanted well: they appeared in France, in England, and in Spain.

Caravaggio
(Michelangelo Merisi)
(1573–1610)

When the new theatrical intensity called for a forcing of the painter's values, Caravaggio, a north Italian, a Lombard, singlehandedly transformed the art of his time with a

strong three-dimensional modeling, a bold use of lights and darks. He heightened plausibility by finding a natural setting or circumstance for his intense contrasts. His figures congregate in cellars where a shaft of day spears down upon them. His low-life models came from just such an underground setting: they were the city poor sequestered in their dens. Such a grimy factualism, brought to bear on religious subjects, shocked his public. His *Death of the Virgin* is simply the death of an unfortunate woman.

He had a short tumultuous life. He worked in Rome where he influenced a group of visiting northern painters who were intoxicated by this dark, forceful method and car-

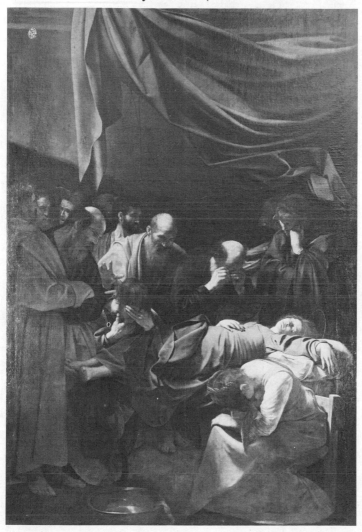

CARAVAGGIO. *Death of the Virgin.* ca. 1605–07. (Louvre, Paris.) [Cliché des Musées Nationaux.]

ried it home. At one remove the method reached two northern painters who raised to great heights this art of light object looming out of shadow: Georges de la Tour in France and Rembrandt in Holland. Caravaggio stabbed a man to death in Rome, which prompted him to travel to Sicily and Naples, then Spanish territory, and here his influence not only strengthened a stark Neapolitan school but spread to Spain. Clearly his art spoke for a universal need of his time, the need to find a convincing realism for imagined events. His subjects were not solely religious; he also painted fortune-tellers and cardsharpers at their work.

Giovanni Lorenzo Bernini (1598–1680)

Two generations or so after Caravaggio opened the Baroque period, it was still in full spate with a great and spectacular Italian sculptor, Bernini. Sculptor, architect, superintendent of art in Rome, he carried the theatrical gesture of the Italian Baroque to its ultimate pitch, and his histrionics were matched by his ability. He carved and modeled as fluently as if he were sketching. He set his stage with smiling and winsome angels flapping their marble wings, and with church fathers gesticulating while their bronze robes thrashed in the wind. Once we adjust ourselves to this pageantry, other sculptured images seem frozen and prosaic. Leaving aside whether we find Bernini's sculpture in good or bad taste, we are forced to admit that there is no other sculptor of such ability between Michelangelo and Rodin.

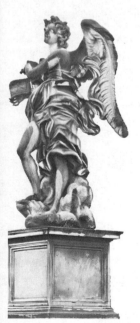

School of BERNINI. *Angel with the Emblems of the Passion*. 1667–71. Sant'Angelo Bridge, Rome. [Alinari.]

Many men poured their talents into the creating of Saint Peter's in Rome, but the unforgettable names are Michelangelo and Bernini. Michelangelo's enormous space called for a tremendous effort to bring it to life and save it from the airless void. To this Bernini proved equal. Right under the dome and over the altar he constructed the Baldacchino, a bronze canopy held aloft by four spiral bronze columns. The enormous object, half architecture, half jewelry, is no more than in scale under the lift to the great dome overhead. These spirals are not the invention of Bernini: similar spiral columns go back to the original basilica and can still be seen in the present building. But Bernini's writhing columns, with their decorated surfaces, are the essence of the Baroque.

Behind the Baldacchino Bernini animated the apse with bronze figures of the church fathers surrounding the throne of Saint Peter. These figures too are on the great scale of

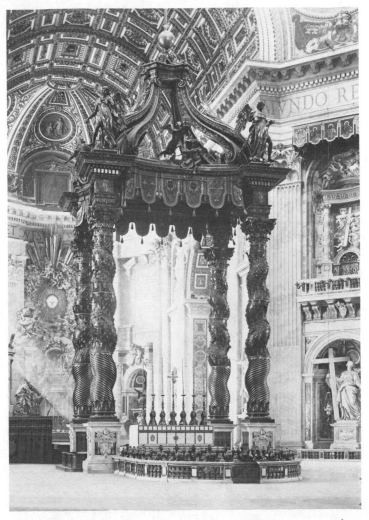

the building, not the human scale, and they convey an impression of tremendous fervor and power. Behind them, a high oval window brings a sunburst to focus, to provide both a real and symbolic illumination.

Then Bernini took on the problem of the approach to the cathedral. The great façade faces a vast pavement that slopes gently down toward the Tiber. Bernini designed two curving colonnades that open like arms to embrace the whole multitude that often fills this area. The colonnades are a brilliant conception—it is hard to imagine Saint Peter's without them —and again Bernini had the courage to work on the great scale the scene demanded. He topped the cornices with figures of saints, swirling against the skyline, one above each

column, as Michelangelo had done for his cornice at the
Capitol. The colonnades date from 1656 to 1663; the an-
cient Egyptian obelisk had been standing in the center of
this arena for half a century.

The ultimate in Bernini's art is the *Ecstasy of Saint The-
resa* that he carved somewhat earlier, in 1646, for a chapel
in Santa Maria della Vittoria. Here every canon that might
control or restrain sculpture is flouted. The marble saint
floats swooning on a marble cloud as a joyous young angel
prepares to lance her to the heart with a golden arrow. A

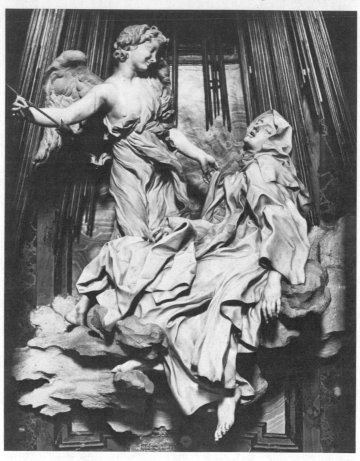

GIOVANNI LORENZO
BERNINI. *Ecstasy of
Saint Theresa.*
1645–52. Cornaro
Chapel, Santa Maria
della Vittoria, Rome.
[Anderson.]

sunburst of gilded rods pours down over her, lit by outdoor
light that comes through a hidden pane of yellow glass. If
there were any doubt that this is theater, the donors are
carved on each side of the altar, sitting snugly packed in two
theater boxes as they watch the production that they have
sponsored.

Bernini remains the most extravagant sculptor of the late Baroque, as though facility and abandon could go no further. But the seventeenth century was an age not of sculpture but of painting, of exuberant decorators of churches and, far above them, men such as Rubens, Rembrandt, and Velasquez.

The Baroque and the North

If we credit Caravaggio with creating the Baroque in paint, then Rubens was its great fulfillment. His exuberance, his expansive occupation of acres of canvas, his feeling for the lack of limits to life are in the Baroque spirit. Rubens was a Fleming, and paintings of or by Flemings show us scenes of an overindulgence that was actually characteristic of the whole period. In an age of shortage and misery it is an unlovely circumstance that those who have crave too much. Rubens lived in a season of excess when to stagger from the table and die of apoplexy was thought to be quite as heroic as to die in battle. In the midst of war and death princes flattered themselves and amused their subjects with extravagant pageants and ornate floats that made up in vitality for what they lacked in taste. Architecture was massive and clumsy, furniture heavy, and the table needed to be strong. Rubens lived and painted this life. He was not merely equal to it, he embellished it. From his youth he knew how to associate with princes; like Titian, he was elevated to the nobility, and was twice granted ambassadorial rank.

Rubens went to Italy as a young man, and the experience completed his training. His painting owed its largest debt to the Venetians; it is rich in color, limpid and clear. Soon he was court painter to the duke of Mantua and able to live as a gentleman-at-large in the then-known world, and as he lived, so he painted. He was animated but not impulsive; his painting is controlled and organized even when it is almost instantaneous in execution. His figures hunt and fight, and if they meditate it is on love. Blood flows; a crucifixion moves the congregation as the theater moves its audience. He dealt with every possible subject: altarpieces, mythological dramas, portraiture, landscape. One of his triumphs was the cycle of decorations for the Luxembourg Palace in Paris (the cycle is now in the Louvre) that glorified the life of Marie de Medici, queen of Henry IV. The

Peter Paul Rubens (1577–1640)

grandiose spectacle offers history steeped in mythology and allegory.

His vast productivity required a team of assistants, one for the animals swarming along in the hunt, another as an expert in painting velvets and silks. He himself could be counted on for the creamy flesh which was never in short supply. He invented a type of rapid oil sketch, both a working out of a composition and a delight in itself. These limpid little canvases are his most modern things in the sense that the plastic idea is their justification.

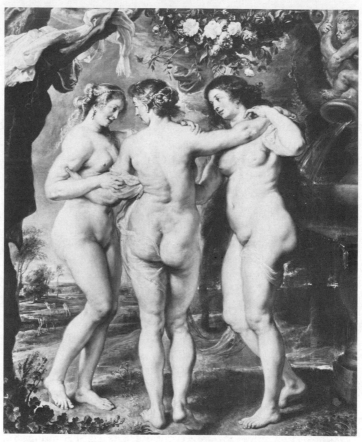

PETER PAUL RUBENS. *The Three Graces.* ca. 1636–40. (Prado Museum, Madrid.) [Anderson.]

He was twice in Madrid at the court of the king of Spain, and went to England as Spanish ambassador. To this day many of his finest works must be seen in Madrid.

Rubens painted with a vitality impervious to questions of taste. In our time there is talk of a gap between art and life. This is a gap that Rubens could not have imagined, any more than he could have comprehended the virtues of

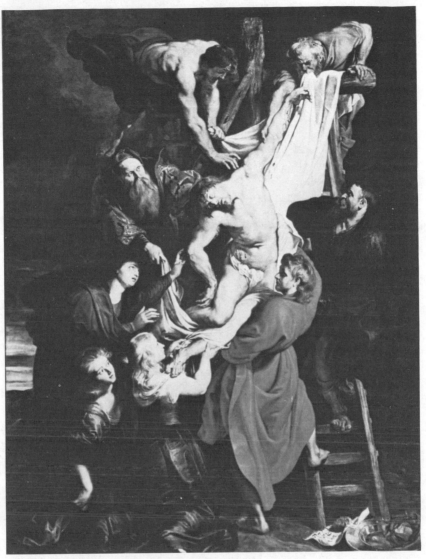

understatement. He seems to pick up the whole of European art and move it forward. He had a personal success only equaled by that of Raphael, Titian, or Picasso.

Rubens had a young assistant, van Dyck, who became a painter of resplendent court portraits. He possessed all of Rubens' facility but none of his strength. Instead he had elegance. As a young man he was in Genoa and the portraits he painted there were his finest. Later he had a brilliant career in England as court painter to Charles I. Equally popular and fluent, he wore himself out over his commis-

PETER PAUL RUBENS. *Descent from the Cross*. 1613. Central panel of triptych. Antwerp cathedral. [Alinari.]

Anthony van Dyck (1599–1641)

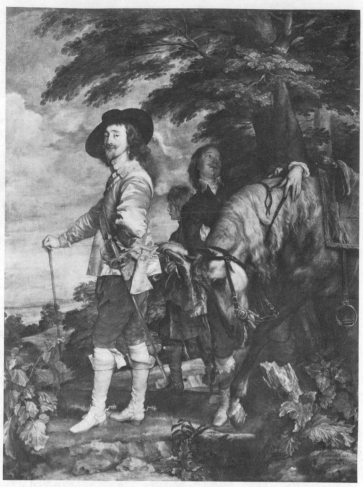

sions and died relatively young, but not before he had established a style of portraiture in England that lasted down through the eighteenth century.

Jacob Jordaens
(1593–1678)
Van Dyck refined Rubens; another Fleming, Jordaens, provided Rubens with competition on the side of animal spirits. It comes home to us that Rubens' earthiness has its gentlemanly limits when we sit down to a feast with Jordaens. Not only does the table groan, the guests guzzle, shout, and sing. Mere eating reaches a sensuous pitch that recalls the Romans. It has been difficult to take this innocent mass uproar seriously, and only in recent years has Jordaens, long overshadowed by Rubens, been recognized for the splendid painter that he is.

13

RESEMBLANCES

The Triumph of the Dutch

In the seventeenth century Holland was newly independent. The Dutch were rapidly acquiring wealth and as rapidly producing—and acquiring—paintings. A mass market came into existence. Dutch painting was an innocent response to the vanity of a whole new mercantile society. The Dutch wanted portraits, domestic scenes, seascapes and townscapes, and above all landscapes. They wished to be remembered as they lived, and this was granted them. Whether of high life or low, Dutch paintings are spectacles of well-being. They are animated by a detailed northern tradition, soon to be jostled by the influence of Caravaggio, and above all by the overwhelming influence of Rubens.

Portraiture with a new zest, brushwork with a new freedom, and life-size images: in Hals, this art of living likeness, at once brilliant, instantaneous, and casual, reached a candid-camera triumph. Eyes twinkle puffily and a genial animation is simply smudged across a face with extraordinary sleight of hand. A millstone ruff with all its folds intact is boldly kneaded into shape. At a little distance everything falls miraculously into place. When sober and industrious, Hals could paint with infinite detail and precision. He used this skill to produce companion portraits, family groups, and mass portraits of military organizations, commemoration pieces greatly in demand.

Frans Hals
(1580/5–1666)

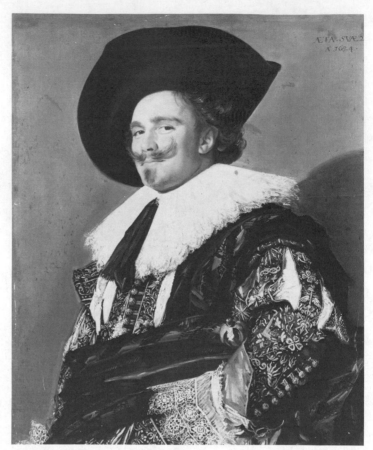

Hals had better control over his brush than he had over
his life, but he managed to work into a bleary old age. His
paintings astonish with their boldness. His subjects are aglow
with vanity and self-indulgence, but they have independence
and self-respect. One of his last and greatest canvases, *The
Women Regents of the Old Men's Home in Haarlem,* is a
group portrait of the five old women in charge of the
poorhouse; they are looking as deep into Hals as he looks
into them.

The Dutch Environment

The Dutch of the seventeenth century wanted small paintings
for small rooms and a cautious purse. If some are portraits,
more are glimpses of the world about them. These works
can be classified on the basis of social strata. At the top of
society is Gerard Terborch (1617–81). His full-length fig-
ures resemble Spanish court portraits in miniature. The

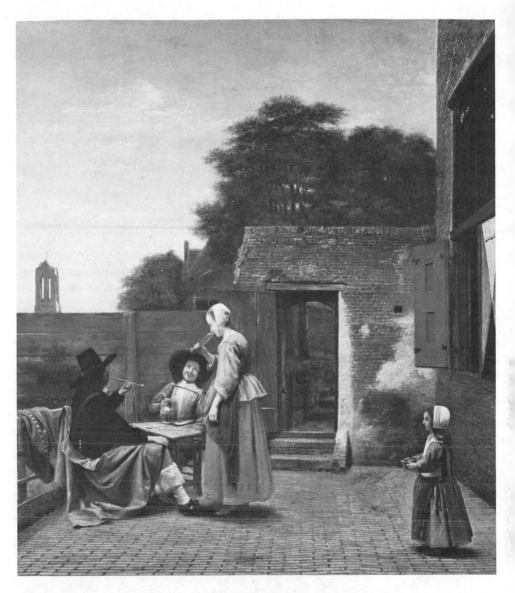

gentlemen merchants are in sober black with lace cuffs and ruffs. Their ladies are in silks and satins. The recent Spanish influence lingers even to the black frames that the Dutch favor.

For middle-class well-being there is Pieter de Hooch (1629–84?). He painted conversation pieces; scenes of conspicuous leisure include well-polished children and record an orderly complacent life. He liked to open up his compositions; a room may look out on a passageway softened by an arbor.

PIETER DE HOOCH. *A Dutch Courtyard.* ca. 1660. (Courtesy of the National Gallery of Art, Washington, D.C.)

For the lowest stratum of society we come to more re-
laxed and unbuttoned subjects. Adriaen van Ostade (1610–
85) and Jan Steen (1626–79) recorded little pothouse spec-
tacles: men drink, women encourage their appetites, and
children squall. America contributed to these scenes, for
the men are often smoking tobacco.

There were specialists for harbors and ships and naval
battles. There was Albert Cuyp and Paulus Potter if you
wished for cows. There were excellent landscapes by Ruis-
dael and Hobbema. And finally there was the greatest of
all the "little" masters, unfairly so called, Jan Vermeer of
Delft.

Jan Vermeer Vermeer resembles Pieter de Hooch in subject matter.
(1632–75) For his interiors, intimate portraits, and one magnificent
townscape, he achieved a photographic realism that is quite
uncanny. Girls look at us out of animated faces with button-
bright eyes, or women apparently unaware of the painter go
about their household chores with a quiet faithfulness that
is deeply moving. Paintings and figures are by no means on

JAN VERMEER. *Officer
and Laughing Girl.*
ca. 1657. (Copyright
the Frick Collection,
New York.)

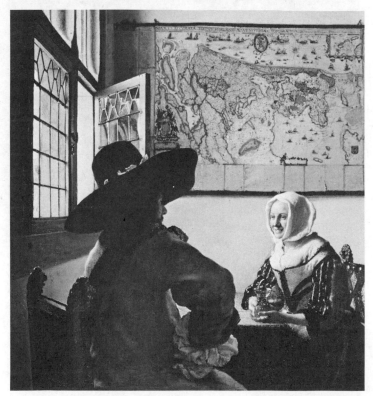

a miniature scale, but still they are small compared to their monumental effect. Vermeer's control of values seems effortless—it is like perfect pitch. He has a special surface all his own, combining a rather velvety texture with a sharp focus. To this surface, rich yet clear, he adds animation with little white touches that make the scene flicker as though with confetti.

This total success in representation disturbs, as though he had foreseen colored photography. Yet it is quite clear that his subjects are a means to an end: he leads us through representation to the threshold of the abstract. The precise spatial adjustments of a Mondrian are equally Vermeer's concern. A few closely observed relationships somehow open up the whole wonder of sight and consciousness. Vermeer's painting bridges centuries from the time of van Eyck to our own. He is one of the great masters.

It is amazing that Vermeer was for long lost to sight in the welter of Dutch anecdotal painting. But so it was: only in the last hundred years has his work been seen as a totality, thanks on occasion to the spotting of his initials that he liked to smuggle into the scene.

Rembrandt, the miller's son, is in complete contrast to the extrovert painters whom we have been discussing. Yet the contrast was not immediately evident. With his great talent Rembrandt came forward rapidly to take his place among the portrait painters who pleased. He too made money. He married well and set himself up in a townhouse in Amsterdam, where he indulged a rather vulgar desire for splendid and ornate things: he had an opulent, Eastern taste for brocades, turbans, jewels, and glitter.

Rembrandt van Rijn (1606–69)

Then something went wrong. The people whose portraits he painted were not his real subjects and at midpoint in his career they came to realize it. In their view, the tragedy of existence had passed from them when they escaped the Spanish political nightmare. But for Rembrandt their prosperous, commercial life was only a corner of existence and a moment of self-contentment in eternity. Rembrandt lived in universals: for him every beggar's skull was a cosmos, and in each man he saw all of life, and all of death too. He became the greatest of all the illustrators of the Bible and his Christian simplicity makes other religious art seem either overwrought or cold.

In seventeenth-century Holland the Reformation was as

new as the state. It was a source of freedom and its teachings
were taken to heart. Rembrandt was a Calvinist, and if he
was not a Mennonite he looked with favor on this faith
which turned directly to the Bible. Yet his mother was a
Catholic, and all through Rembrandt's work there is a feel-
ing of something august taking place, often in shadowy
scenes with pencils of light descending, as though in a vast,

REMBRANDT VAN RIJN.
*The Anatomy Lesson
of Dr. Tulp.* 1632.
(Mauritshuis, The
Hague.) [Alinari.]

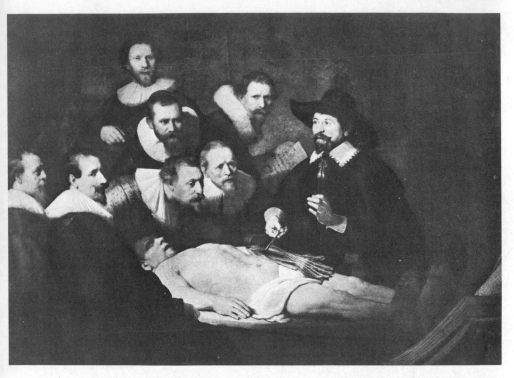

religious interior. He could create a serene cloistered atmos-
phere with nothing more than a dim wall as a quiet back-
ground to the rainsoaked dark days of a northern European
winter.

Rembrandt's popularity left him more quickly than his ex-
pansive way of life, and he went into bankruptcy when he
was no longer young. His wife had died early. They had lost
four of their five children; only his son Titus grew to man-
hood. As Rembrandt sank back into poverty he took in a
young girl, Hendrickje, who became his common-law wife,
an arrangement which brought on social and legal difficul-
ties. Titus and Hendrickje became an art firm that em-
ployed the old man, presumably to avoid his old debts. Both
of them died a year or two before Rembrandt himself, but

this did not break him; he worked on alone. He was his own subject. No one has painted his own portrait as persistently as Rembrandt, or with such soul-searching self-examination.

Every loss enriched Rembrandt. Solitude enriched him.

REMBRANDT VAN RIJN. *Portrait of the Artist's Son, Titus.* 1653–54. (The Norton Simon Foundation, Los Angeles.)

Poverty enriched him. In the prideful, commercial city of Amsterdam he discovered the poor. The Dutch were relatively decent to the Jews who flocked to Amsterdam. In their faces Rembrandt read the Bible: he was the first artist to search among the Jews for a face for Christ. He painted many Jews and his personal use of subdued light seems almost an expression of their submerged existence.

Rembrandt's life reads not like a biography but like a great timeless drama that a genius has imagined. It presupposes a naive, childlike man arrested by any glittering object, yet one who could look into human nature with steady wisdom. It presupposes also a simple, innocent man, humble and religious, who was yet defiant toward all conventions

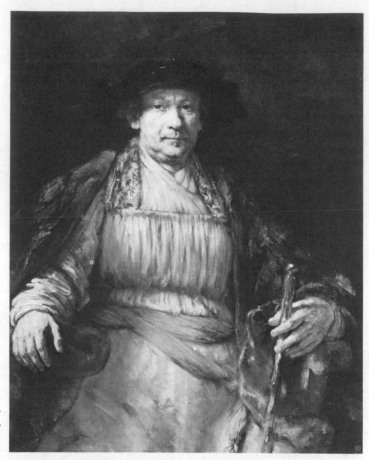

and restraint, and a modest man with an indestructible be-
lief in himself. He saw himself as a revolutionary among
painters.

As we consider Rembrandt's formal development we have
difficulty in seeing contemporary influences in such timeless
work. Yet they are present. Rembrandt had a choice be-
tween the boldly three-dimensional modeling of the Manner-
ist-Baroque tradition exemplified by Caravaggio, where the
light is lowered to force contrasts, and on the other hand,
the airy, pearl-gray atmospheric art of the Dutch painters
around him with their luminous renderings of detail. It was
the more dramatic, Baroque influence, with its strong model-
ing and bold contrasts that Rembrandt embraced. He created
a conviction of three dimensions by means of the subtle
manipulation of light. Light was not only his means but his
subject, his formless form.

Rembrandt's light chooses its object and descends upon it

as a benediction, yet it goes softly everywhere, neglecting
nothing. It subsides so gently into shade that even when
nothing is visible we imagine that we see on and on. It is
like the departed sound that we still hear as long as the
pianist's hands remain on the keys. To go with this quiet
pervasive light there is a mood of acceptance on the faces on
which it falls, a brooding in reflective eyes. These eyes are
Rembrandt's own but he lends them to others.

This fall of subdued light and the look of the eyes that are
bathing in it is strangely charged with moral significance. In
one of his great canvases the naked Bathsheba is seen hold-
ing the all-too-significant letter from King David, while a
kneeling old woman washes her feet. Bathsheba broods in

REMBRANDT VAN RIJN.
Bathsheba. 1654.
(Louvre, Paris.)
[Alinari.]

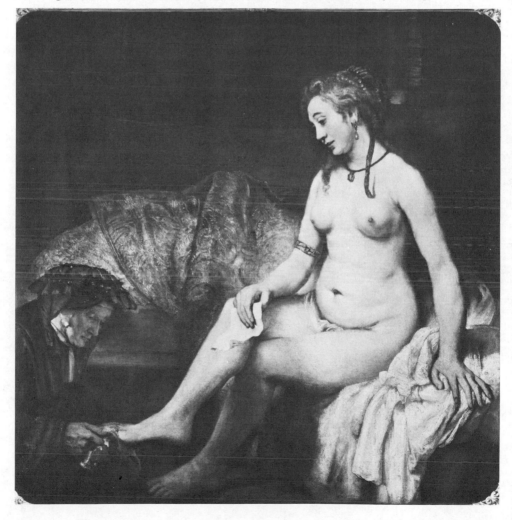

silence over his summons, as she considers her destiny, adultery, without the will to reject it. The light itself seems to forgive her as like the quality of mercy it seeps everywhere without strain.

Rembrandt was not born with this subtlety in hand. His beginnings were painstaking and often awkward. He labored over the detail characteristic of the Dutch vision and undertook to organize and mass this detail in baroque light and shadow. Only later did his brushwork broaden. A turning point is his vast canvas, *Frans Banning Cocq's Company of the Civic Guard,* often called *The Nightwatch* (1642). It was said to be a turning point in his fortunes, in that some of his subjects were clearly lighted and delighted, while others were confined to shadow and resentment. What we see now is an uncomfortable masterpiece, too large a canvas painted in too great detail. Thirty years later, he has worked out a balance in interest between the individual portrait and the group—it is after all the problem of society itself—in his great painting of *The Syndics,* or the *Sampling Appraisers of the Drapers' Guild.* The group around a table, the secretary with papers, the treasurer with a money bag, all is quite conventional. But the harmony of lighting and the harmony not of action but of purpose are inseparables.

The discipline in Rembrandt's handling of light controls his etchings. Here we enter a world of distinction where there are no competitors. In his etchings Rembrandt is able to develop such hazy, sensitive tones as we can hardly expect in paint. His lines flow together and surrender to each other like individual notes in music. Blank paper takes its quality of space from the regression of the few objects that flee away from us. Here Rembrandt turns to portraits, and then to the life and death of Christ. When he calls on the drama of the Baroque it is never an empty Baroque, he fills it with compassion. And always light, continuous and consistent, is the unifying principle. Rembrandt's relationship to light itself is mysterious. The emotion that he seems to convey is the rare one of gratitude—gratitude for sight. There would have been more etchings if Rembrandt had had the benefit of a modern oculist. He was forced back into painting in his old age.

His late paintings are generalizations on a lifetime of seeing. Color is subdued and unimportant. There is no source of color in Holland but the flowers. What matters is form cre-

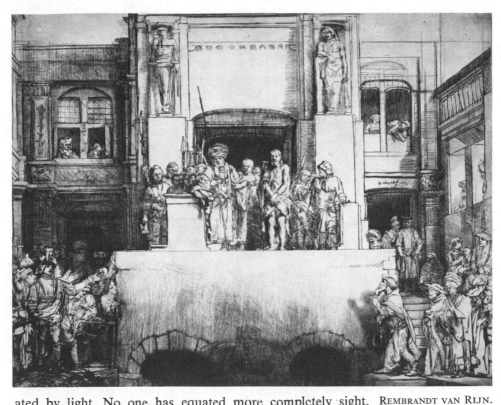

ated by light. No one has equated more completely sight, light, and personality. In his endless self-portraits the fortitude of spirit in its body-prison grows agonizing. As we look at this bulbous, sea-lion head blearily peering into itself, we wonder how deeply our faith in our own personality is indebted to the mirror.

REMBRANDT VAN RIJN. *Ecce Homo* (Christ Presented to the People). 1654. Drypoint etching. (Los Angeles County Museum of Art, Mr. and Mrs. Allan C. Balch Fund.)

Spain

Spain, in the time which we have reached, was still largely medieval, although there is hardly a chapter in its history that could not open with such a statement. It was scarcely touched by the Renaissance, a culture of cities, and entered directly into Baroque art, a church-and-state expression well-suited to the Spaniard's trust in a higher power. Here the feudal system had survived almost unchanged as an economic and spiritual force.

That this medieval ideal was now an unrealistic fantasy mattered little. The Spanish writer Cervantes (1547–1616) reduced this ideal to absurdity in his one great book, *Don Quixote*. His hero was the old gentleman gone mad, who

lived in delusions of knight-errantry. But his folly did not
deprive him of greatness of soul.

This might suggest that Spain in its remote peninsula was
sealed away from the whole gradual development of modern
Europe. Yet, paradoxically, Spain had an enormous impact
on Europe and the world, and was a source of great political
energy.

Spain had conquered the New World: most of South
America, Mexico, Florida, what is now Louisiana, and all
the Southwest of the United States. Gold was wrenched out
of Mexico and Peru in such bulk as Europe had never seen
before, but it never turned into national wealth. It was
squandered in misguided military enterprises, in efforts to
conquer the Low Countries—a dynastic acquisition through
the Hapsburgs—and to stamp out Protestantism in England.
Philip II had married Mary Tudor, older half-sister of Eliz-
abeth, and when the Protestant Elizabeth became queen, he
had the misfortune to mount the Armada against her.

Spain provided the military sinews of the Counter-Refor-
mation, and the intellectual sinews as well; the Jesuits were
established by Ignatius Loyola and served as troops of per-
suasion under the command of the pope. Their art was Ba-
roque art.

Spanish Baroque architecture is heavy, massive, and
prisonlike; even churches are fortresses. It soon developed
an ornate style peculiar to the country. The new archi-
tectural form became so covered with images of saints that
it could hardly be deciphered. This art of encrusted surface
was called the Plateresque, as though it were the work of
silversmiths. Formally it is a degeneration, yet it suggests a
great surging together, a congregation of the blessed, that
must be seen in effective contrast to the wide, bare spaces
of the country where it originated.

Baroque and the Plateresque were forms that took root
easily in Latin America. Inflicted on an alien world, they
made themselves at home. The Spaniard treated the Indian
horribly, yet they worked out together a certain stoic har-
mony. They shared a taciturn dignity, courage, and ascend-
ency over death. Both understood a hard, agricultural or
pastoral life, and the Indian quickly adopted the Spaniard's
cattle and horse. This Latin America composite culture
made good use of the overwhelming unity of the Baroque
and accepted it as its spiritual hive. There is a curious kin-
ship between great pre-Columbian temples and vast Baroque

buildings. They both have an atmosphere of menace now past.

Spanish art was created for the church and court. Painting rather than sculpture was its form of expression, for court art was portraiture, and Spanish religious art concerned itself with miracles and visions and populated the sky. Yet visions and figures afloat were no contradiction to the most intense realism; for the Spaniard this transcendent world was reality.

The painter Zurbarán (1598–1664) typifies this forthright rendering of a world that cannot be questioned. The religious paintings that came from his shop went out not only over Spain, but over Spanish America as well. An absolute faith called for absolute naturalism.

FRANCISCO ZURBARÁN. *Agnus Dei.* 1638–39. (The Fine Arts Gallery of San Diego, California.)

The greatest of the Spanish naturalists was Velasquez. He was quite simply the greatest of all portrait painters. His was the art of giving a subject importance because of the importance of the subject's position. He painted his sovereign all his life. Artist and king were much of an age; we first see Philip IV as a candid young man and watch him grow pasty with sensuality. A king must be presented as a pivot around which the world revolves. He is a horseman, so there can be equestrian portraits; or he can be shown hunting, or at his prayers.

Diego Velasquez (1599–1660)

Velasquez came to Madrid from Seville, and brought with him a literal rendering of concrete objects against a dark ground. His rather meaty brushwork soon thinned down into a much more fluent technique. He was greatly influ-

enced by the Venetian paintings in the royal collection that contained many of the finest Titians, and he became more of an Impressionist that Titian himself. Then the deluge of the greatest of Rubens' paintings had its impact.

Velasquez had little imagination, but he could compose and arrange by suppression, for he had taste. This taste never weakened his work (as it did for van Dyck) for he also had dignity and so did his subjects: they were Spaniards. The color black, loved in Spain, provided solemnity. Where Venetian paintings are blue and gold, Velasquez' are black and rose. He is a great colorist, although color is most sparingly used. He painted like a scientist. His canvases were washed in the first day, receiving heavy enough paint on the features the next to provide a third dimension. This minimal procedure has given us paintings that have aged marvelously well.

The pageantry of the court included dwarfs and fools who provided a traditional diversion. These unfortunates were a resource for the painter, and their various mental and physical deformities are as pathetically legible now as they were diverting then. Even here the artist's glance falls as calmly as the light.

Left: DIEGO VELASQUEZ. *Philip IV of Spain.* 1644. (Copyright the Frick Collection, New York.)

Right: DIEGO VELASQUEZ. *Court Jester, "El Primo."* 1644. (Prado Museum, Madrid.) [Alinari.]

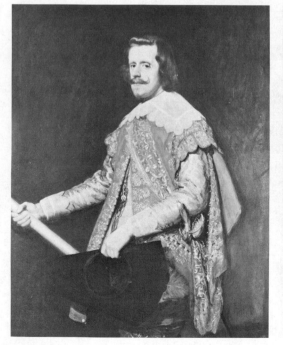

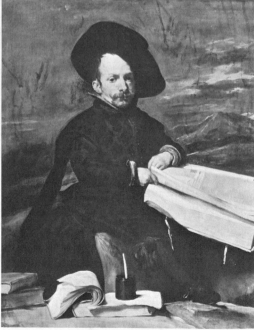

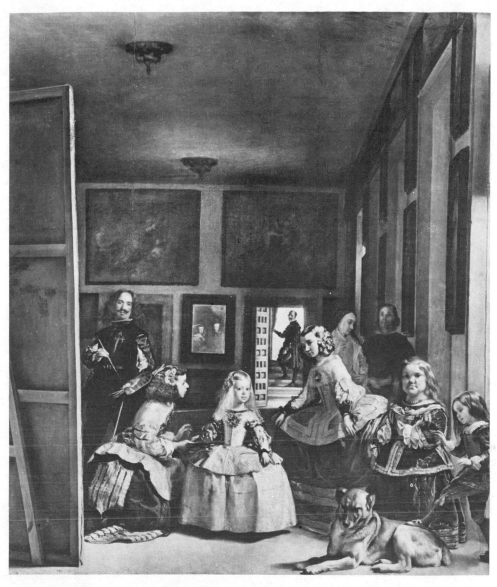

Velasquez went to Rome where he painted Pope Innocent X. The portrait is quite frightening in its vitality, and brilliant in its interplay of reds on reds. Actually Innocent X was an anxious man tyrannized over by his sister, but Velasquez managed to make him commanding; he could see men in terms of their walks of life, which is after all seeing them as they visualize themselves. It is a curious ability. Literal atmospheric painting does not show at its best in sculptural Rome, but this portrait is one of the greatest works of its

DIEGO VELASQUEZ. *Las Meniñas* (The Ladies-in-Waiting). 1656. (Prado Museum, Madrid.) [Alinari.]

kind. Incidentally, it provides the theme in our day for the series of hysterical popes by the English Expressionist painter Francis Bacon.

Velasquez' masterpiece, however, is *Las Meniñas* (The Ladies-in-Waiting), not because he never painted better but because it sums up his own entire life at the service of his king—and because no other painting is like it. It is a court scene as viewed by the king and queen who are looking down on the painter as he peers around the corner of his great canvas, his head aslant looking at them. In the foreground a little princess is being offered a glass of water by a kneeling lady-in-waiting. Another child playfully prods with a foot the flank of a drowsy hunting hound. Other attendants fill in the domestic scene, and in the far background a courtier leaves the big, dusky room through a bright, open door, and looks back—he cannot leave without facing the king. Finally, in the center distance, a mirror dimly shows the king and queen side by side so that we know what the painting is about.

Down the wall to the right, windows admit slabs of light that divide the distance like so many past decades of the lives of the artist and his king. The painting gives us the special privilege of seeing through the king's eyes. This is almost sacrilege, and one must suppose that Philip requested Velasquez to paint the scene before him.

At present the great painting is exhibited in a room of its own in Madrid, and faces a mirror so that we can see an illusion of an illusion. This is a superfluous trick, emphasizing the magic. Velasquez never emphasized.

ERA OF NATIONALISM:

THE SEVENTEENTH AND

EIGHTEENTH CENTURIES

IN FRANCE

Baroque art could be exuberant and extravagant, and by turns it could be orderly, classical, and disciplined. All these contradictory qualities had their appeal for the possessors of power. As the Baroque moved across Europe a new nationalism brought in national differences. Italian Baroque was as extravagant as Bernini. German and Austrian was, if possible, still less restrained, and we have had a glimpse of the general northern flamboyance of Rubens. In France, by contrast, the orderly disciplined aspect, the classical Baroque, represented a new centralized control. France had become the first authoritarian state in Europe, a dictatorship in the modern sense, and its architecture grew cool and formal.

The monarchy had won out over feudal anarchy. In the first third of the seventeenth century the nobility was brought to heel by a great and relentless statesman, Cardinal Richelieu. The absolute state he did so much to create was the Baroque state, the *unlimited state,* haunted by the history of Imperial Rome. Absolutism decreed a total way of life, accompanied by an art of manners, of urbanity and intelligence. Under such circumstances genius shifts for itself.

Richelieu had his portrait painter, opposite number to a van Dyck, in Philippe de Champaigne, who painted the cardinal from three sides, and indeed he was justified, for no man in France was more visible. Simon Vouet and Eustache Le Sueur were painters of a restrained classical sensibility.

But in general, the great figures in the French seventeenth century still worked outside the establishment, while those of the eighteenth century worked within it, because there was nowhere else to be.

Nicolas Poussin (1594–1665)

Claude Lorrain (1600–82)

Nicolas Poussin, the painter of classic scenes, was so filled with a zeal for order, for a composed art, that he made structure an end in itself quite as we do in the twentieth century. Claude Gelée, called Lorrain for his native province of Lorraine, was the first French painter to give himself over entirely to landscape. However different their styles they were lifelong friends. Each man had the good fortune to represent a dominant interest of his century, and both lived and worked in Rome.

NICOLAS POUSSIN. The *Birth of Venus.* ca. 1638. (Philadelphia Museum of Art, George W. Elkins Collection.)

Poussin had a slow-maturing genius. After disappointing beginnings in Paris he moved to Rome as if by instinct. Here the wealth of the past crowded in upon him, and he was to build a new art on this old foundation. He turned first to the example of Titian and then to that of Raphael, and then there was all of antiquity. He began again as a student, al-

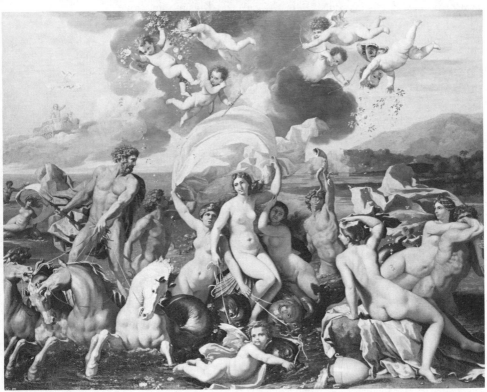

though he was past thirty. Gradually his scholarly tempera-
ment asserted itself, and he created a sculptural, classical art
out of the past revisited. He drew his themes from mythol-
ogy, adapting the *Metamorphoses* of Ovid. He painted bac-
chanals with the sensuous decorations of Titian in mind.
When he turned to biblical subjects these too were handled
as classical scenes. This would suggest a borrowed art, lack-
ing the breath of creation, and borrow he did, whether
themes or figures, but he created works that have maintained
a following from that day to this. He is a painter's painter.
He holds a position apart for all subsequent French artists,
who see in Poussin the qualities a great painter should have:
the taking thought, the preoccupation with structure, the
organizing of space. He lost none of his authority when
painting became abstract.

Poussin had more to offer than studied composition. As
his figures act out his pagan themes they convey an inescap-

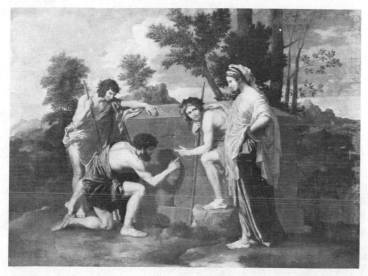

NICOLAS POUSSIN
Et in Arcadia Ego
(Arcadian Shepherds).
ca. 1655. (Louvre,
Paris.) [Cliché des
Musées Nationaux.]

able feeling of great sensuality. No matter that their gestures
are frozen, their faces masks and their bodies colored shells,
their eroticism persists. The artist's intellectual interests only
bank the fire.

His practice was to create little sculptures on which he
stuck clothing, either of paper or cloth; he then positioned
these figures on a stage and worked from them. As a result,
each stands as a sentinel guarding the space it occupies. He
needed this spatial clarity, for one of his major sources seems
to have been the figure-crowded surfaces of ancient sar-

cophagi, where limbs so interlace, whether in love or combat, that we must unravel our way through the composition. As a result of this influence of classic high relief, Poussin's figures tend to crowd the foreground. As in football scrimmages, the activity is central and the outlying figures carry the play (or composition) around the corners.

Poussin used classical architecture freely in his background, and in the last decades of his life he went over into landscape painting. Figures are still present—the change is simply a change in scale. The action is small, the setting now large, and since the treatment of the scene is architectural rather than atmospheric, a hypnotic sense of airless trance comes through to us.

Poussin the scholar was under the spell of Stoicism, a pagan philosophy that called for dignity in the face of fate. In his paintings, gods and goddesses must be taken as personifications of the forces of nature, and they not only act out a myth, they symbolize natural history. This curious blend of ancient poetry and philosophy and a then-modern scientific turn of mind appealed to sophisticated scholarly men. It takes a certain temperament to love Poussin. He not

CLAUDE LORRAIN. *Sermon on the Mount.* 1656. (Copyright the Frick Collection, New York.)

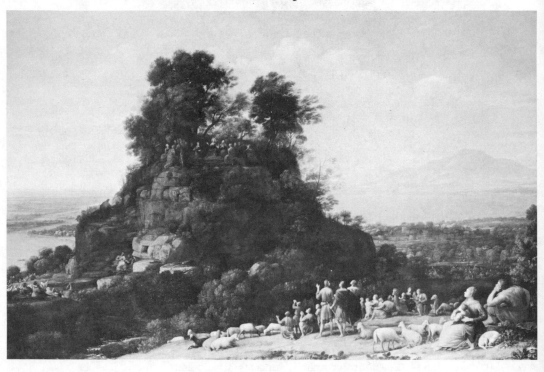

only throws a spell over artists, he attracts the educated man whose dignity is secretly harried by erotic fancies.

Claude caught the new interest in man's surroundings. In the view of many, he remains the greatest of all landscape painters. He came to Rome when he was very young so that his whole art was a product of that environment. His territory lay within a few miles of the city. He liked to paint imaginary harbor scenes in which the familiar buildings and temples of Rome rise up at the water's edge, and a soft sunlight filters through the spars of ships. He was able to paint the sun in the sky, simulating its direct glare with a white-gold haze, an effect often reinforced with a track of glittering sunlit water. His Roman landscapes of woods, fields, and streams are inhabited by little figures that convert the scene into a pastoral poem, or a mythological drama, or an event out of biblical history. He had a feeling for haunting presences in silent groves.

Claude's wash drawings are remarkably free. He produced a book of drawings that served as a catalogue of his works, the *Liber Veritatis* or *Book of Truth,* which had the further purpose of discrediting his imitators. It accounts for nearly two hundred of his canvases, or a life's work, and in itself is a collection of masterpieces.

To Poussin and Claude must be added another French figure of outstanding talent, Georges de La Tour, who like Claude came from Lorraine. He was practically unknown before this century. Like Vermeer he has been reconstructed by scholarship and research and his reputation now rests on some thirty-one works. He lived out his life away from Paris or Rome and his subsequent obscurity was the obscurity of the provinces.

Georges de La Tour (1593–1652)

La Tour perfected the night scene lit from a single artificial source, whether lantern, candle, or torch. In this he was a follower of Caravaggio. Lesser painters of lamp- or candle-lit scenes brought the Caravaggio manner north, but it is possible that La Tour went to Rome and experienced this influence directly; we do not know.

La Tour, however, made special and personal use of this artificial light. In his hands it became a psychic force allowing him to evoke a close and secret nighttime communication, or an awesome sense of discovery. And this controlled light served to establish highly stylized, precise

forms. The light source, often hidden behind a hand, or-
ganizes the composition. Darting shadows come alive, and
intensify experience. We are reminded how closely darkness
pressed upon humanity before the twentieth century.

When he painted daylight scenes (only connected with his
name as late as 1927) he again followed the Italian painter,
this time in subject matter: Caravaggio painted card players
and cardsharpers and so did La Tour.

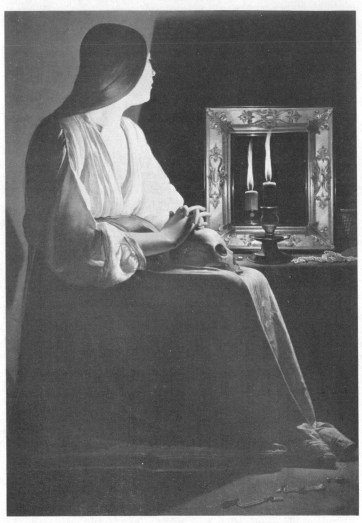

GEORGES DE LA TOUR.
Penitent Magdalene.
ca. 1628–40. (Private
collection, New York).

Louis Le Nain Here we should add the three Le Nain brothers, Louis,
(1593–1648) Antoine, and Mathieu. Insofar as their works can be sepa-
rated, Louis is the most gifted. His subjects, or their sub-
jects, are generally peasants in their rustic environment. A

Le Nain painting bears a family resemblance to the Little
Dutch Masters, but it shows us a less hopeful world. The
color is generally of a gray-green cast; the peasant farmers
in their tattered protective coloration can scarcely be dis-
tinguished from the land they till. These bleak canvases,
vital and moving, forelay for the peasant paintings of Millet,
and of the young van Gogh.

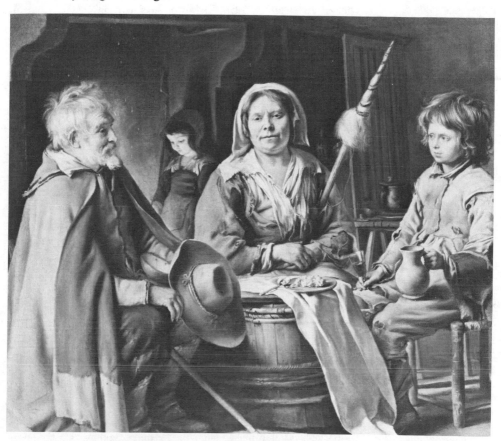

The Mirror of Monarchy

With the age of nationalism, the great sovereign states were
in perpetual rivalry with each other. France, England, and
Spain wasted their energies in a three-cornered game. The
strongest always found itself faced with the other two and
no one won. Spain was the first to draw off in exhaustion
and the rivalry was then between France and England. From
the late seventeenth century under Louis XIV, it dragged on
into the early nineteenth century of Napoleon.

Louis Le Nain.
A French Interior.
(Courtesy of the
National Gallery of
Art, Washington, D.C.,
Samuel H. Kress
Collection.)

The two countries were by no means as cut off from each other as this would suggest. The temper of the times was cool, intellectual, and international. Cosmopolitan ideas knew no boundaries, and taste was international too. This taste was classical, if by classical we envisage an increasingly restrained and refined Baroque, an architecture making tireless use of the classical orders. The style was more advanced in France, more urbane, less provincial, more unified, for taste was autocratic; a monarch now absolute was able to dictate the national image.

Beneath this self-conscious world the mass of mankind, those who were thought not to exist if they caused no trouble, were still living in their old Gothic cities and towns now overcrowded and squalid. The narrow streets were the original narrow streets. The inhabitants of these decrepit dens were overworked, undernourished, and represented an invisible threat. They were remote from the people who had enough wealth to introduce change. Form—art form—comes from those who are free to express their lives and they were still a glittering few.

With political centralization, the castle in the wilderness began to be replaced by the private palace with its well-ordered park, where even nature could be taught its manners. Early in the reign of the young Louis XIV the minister of finance entertained the king at the magnificent château that he had just completed, all in a formal new style with vast gardens. The king was so impressed by the expenditure that he put his minister in prison for life. He was also impressed by the achievements; he took over his minister's architect, Le Vau—soon to be followed by Mansart—as well as his gardener, the famous Le Nôtre, and he began to build Versailles out of his father's hunting lodge. Louis also had his painter, Charles Lebrun (1619–90), who could paint very well indeed, but his primary task was to design, organize, and direct, as a sort of minister of the arts. With such helpers, the king had a life's work as an alternative to the waging of war. Both activities were an investment in prestige, and both went far toward bankrupting a kingdom.

The vast structure of Versailles was fifty years getting its growth. Its 2,000-foot façade fronted on a park one-fourth the size of Paris. The windows of mirror-lined state rooms overlooked sheets of water, fountains, statuary, formal plantings, and great flights of steps leading down from terrace to terrace to a mile-long canal. Woods were laid out

in precise alleys that converged on circles where the hunts-
men gathered. Here were outdoor theaters and summer
houses. The scene was set for all the urban satisfactions:
music, dance, art, and a theater that boasted the playwrights
Racine and Molière.

Here the king kept his nobility on a silken leash directly
under his eye. He offered his nobles a sumptuous routine
of pleasure in place of a bygone power. Life was feminized;
women played a new dominant role in a world that seemed
especially designed for them. They were upgraded as men
were downgraded. Swords had become rapiers; a man's life
as well as his fortune depended on dexterity rather than
strength. Conversation was rapierlike; the scene was one of
glitter and beauty.

Behind such a well-ordered social façade, Louis worked
at government. Versailles housed his ministries. The château
with its great park became a setting for a way of life ac-
cepted by all of Europe, by the king's enemies and allies
alike. This forcing of order upon nature, the preference for
long vistas and straight lines, was essentially political. The
king ruled by vision, by lines of sight; what was imposed on
nature at Versailles was also imposed on human nature. The
king took the sun as his emblem. Golden suns and sunbursts
appeared everywhere. The king shone.

JULES HARDOUIN-
MANSART. Garden
façade, Versailles.
1669–85. [Alinari.]

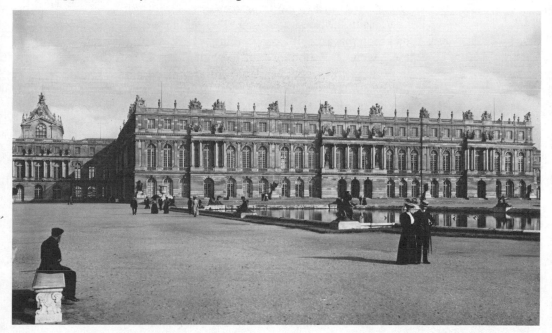

The royal bedroom was the absolute center of the composition; with Baroque precision it faced the long avenue into Paris. It doubled as a cabinet room; the king was surrounded by nobility and ministers of state from the moment he woke until he went to sleep. He was ever an object of watchful care and veneration. Since everything and everyone focused on the image of the king, mirrors were in order as symbols of self-preoccupation. Large plate-glass mirrors were a French technical monopoly of the time. There could never be enough light for a sun king, and at night the mirrors captured the thousands of candles already multiplied in the prisms of chandeliers.

Large, light rooms called for new furnishings. Upholstered chairs and sofas now had straight severe lines subordinate to architecture. Furniture was lavishly gilded—over-gilded— and set off by pale gray walls. Desks, bureaus, called for inlaid wood or marquetry. Chiseled bronze ornament was profuse, and silver (to be melted down in the hard times ahead) was lavishly used. Chairs had the scale of thrones.

This ornate scene was as crowded as a convention; all but the most exalted lived in cubbyholes. Anyone stepping back into the Versailles of three hundred years ago would have a startling experience. Fear would be his lot. Fear of his own awkwardness, of slander, or loss of favor, of poisoning, of sudden arbitrary imprisonment.

Versailles was filthier than the Middle Ages. The place had little that resembled plumbing. There was little heat, and the region can be bitter cold in winter. The king liked ladies in evening gowns; he also like to dine with the windows wide open, and with reason: a crowd at Versailles was no treat for the nostrils. Silks, satins, brocades, and furs were only clean once. Only the king had ironclad good health and nothing was more dangerous than a doctor.

The king's ambition had another form of expression, war, and as the reign dragged along bankruptcy and defeat came on like old age. Louis was crushingly beaten by the duke of Marlborough—the ancestor of Winston Churchill. A trance of despair settled on Versailles. Louis outlived his century and most of his family; his great-grandson was his successor.

The evils of his time survived him. The new child king, Louis XV, proved weak and neurotic. Country life palled, and Versailles ceased to be the center of gravity of France. Power was slipping back to Paris, the capital city.

The Rococo

Feminine influence was now still more strongly in the ascendant, and grandeur, the palatial, ceased to be an ideal. In Paris, smaller houses and small snug rooms that a fireplace could easily heat became fashionable. Feminine taste, feminine design: Louis XV furniture has graceful curves. Sofas had sinuous backs and curved legs that flowed into a rippling front. There were endless cushions, stools, and ottomans. The same swimming forms embellished wardrobes, bureaus, writing tables, and cabinets. Rooms were tastefully paneled in natural wood or painted in light gray picked out with gold. The carved moldings on the wall echoed the flowing curves of the furniture. A carved shell became an omnipresent design element and signature, and gave a name to this dominant style, this classicism grown cozy, the Rococo.

This setting was animated by a sprightly lounging; the great art of society was not love, but conversation. And what was the talk about? When it was serious it was about man himself, his nature, his history, and his destiny; about the current political anxiety; about the marvelous new world of science, or universal knowledge. It touched on freedom, change, and a possible democracy, but not quite yet on revolution. These conversations took on styles of their own. Part love-in, part seminar, they were presided over by ladies who had *salons* that differed according to theme.

The radical philosopher Voltaire was the ornament of the time. But conversation was not a French monopoly; Benjamin Franklin was there to talk with the best.

There was a new mobility. But for a few lumbering coaches, people had gone about on horseback or on foot. Now came a new form of transportation, the carriage, and suddenly everyone was on wheels. These light new vehicles brought in a frantic desire for speed. Injuries and deaths from driving accidents were on a par with automobile accidents today. Only the new avenues in Paris could accommodate such traffic.

City planning on a monumental scale was in large part the Baroque concepts of Versailles come to town. Paris was opened up with squares (*places*) that remain some of the most beautiful civic centers in the world: the Place Vendôme was built by Louis XIV, the Place de la Concorde by Louis XV—it was then named for him. In the eighteenth century many more such centers were planned for Paris than ever

were built. The great new streets became avenues of trees. Paris was not the only city to be so transformed. A similar parceling out of squares was occurring in London, and behind this development lay the Baroque piazzas of Rome.

The widening gap between this urbane, animated comfort and rising industrialism in the wretched cities left room, or opportunity, for revolution. Government, ever in search of money, increased its burdens on industry. Impossible demands were made on the ministers of finance and it was not understood that beyond a certain level taxation destroys what it lives on and returns grow less as rates go up. The government of France in the seventeenth and eighteenth centuries was a firm believer in monopolies (which could be sold) and did everything possible to choke free trade. An industrial base was either lacking or insufficient; and even agriculture, sustained by the natural fertility of the land, was taxed to death.

With such a basis or lack of basis, it is not surprising that official art under Louis XIV and XV was decorative, and content with a refined sensuality. Portraits and Baroque sculpture on a high level of competence took care of royal and public needs which were one and the same. France enjoyed or suffered the advantages of government in art. Louis XIV had established the French Academy in Rome, to put talent through its paces, and young artists competed for fellowships to the Academy for the next three hundred years.

It was inevitable that such a self-conscious time should find artists to mirror it. Three men, representing three succeeding generations, reflected the pleasure-seeking taste of their century, and as often happens the greatest came first. Watteau offered his age more distinction than it deserved; Boucher, brilliant performer on a lower decorative level, was the favorite painter of Madame de Pompadour; Fragonard, born too late, outlived the Rococo, and survived into the dangerous times of the French Revolution.

All three painters devoted their art to women, the young Watteau with all the tenderness of first love. The sensualist, Boucher, had a working arrangement with classical mythology which provided him with endless obliging nudes. Fra-

Antoine Watteau
(1684–1721)

François Boucher
(1703–70)

Jean Honoré Fragonard
(1732–1806)

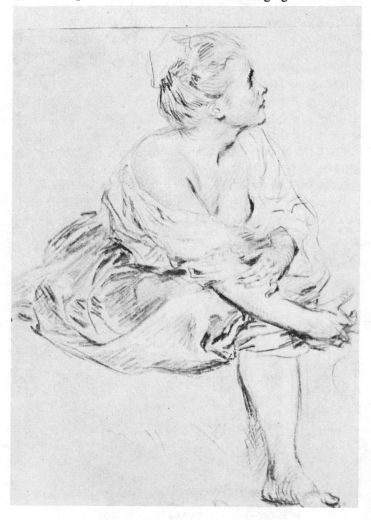

ANTOINE WATTEAU.
A Woman Seated.
Drawing. (Collection
of the Pierpont
Morgan Library,
New York.)

gonard was a magnificent handler of the brush. In his paint-
ings he never tired of infidelity, of little notes being passed;
love had become a prank.

Watteau's life was short. He was tubercular. He painted
during the last years of Louis XIV. His subjects were *fêtes
galantes,* the outdoor picnics in the park of Versailles trans-
lated into lyric fantasies. The high point of this theme is his
Embarcation for Cythera (1717). He also found a perfect
subject in the strolling Italian musicians who sang, played
mandolins, and offered the stock diversions of buffoonery.
His hero was a lovelorn Harlequin.

Watteau lent a certain glory to this urbane folly. He was
one of the great draftsmen, and no artist was more sensitive
to feminine charm. He came from the northern Flemish side
of France and owed a great deal to Rubens as a colorist, but
his figures have none of the drive and monumentality of
Rubens; they are small and steeped in a tubercular pathos.
With this reduction in scale he introduced the mannered in-
timacy of the eighteenth century.

The art of Boucher was not expected to interrupt the con-
versation. In Rococo interiors, overdoor panels added height
to doorways and provided the room with a visual incidental
music. Such pieces poured out of Boucher's studio: his pro-
ductions were diluted with the help of many assistants. But
when he worked for Madame de Pompadour, his patron, the
painting was by his own hand and the quality climbed back.

FRANÇOIS BOUCHER.
Summer. 1755.
(Copyright the Frick
Collection, New York.)

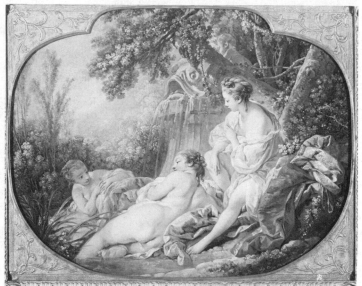

His art has the resource of being right for its period. His nymphs are pink around the edges, and have a Lolita charm.

Fragonard was a superb handler of paint. He only lacked the poetry of Watteau. He is sensuous and filled with fire, and his amazing brushwork provides his figures—the sitters for his occasional portraits—with a haughty impatience, with blaze and dash.

JEAN HONORÉ FRAGONARD. *The Swing.* 1766–7. (Reproduced by permission of the Trustees of the Wallace Collection, London.)

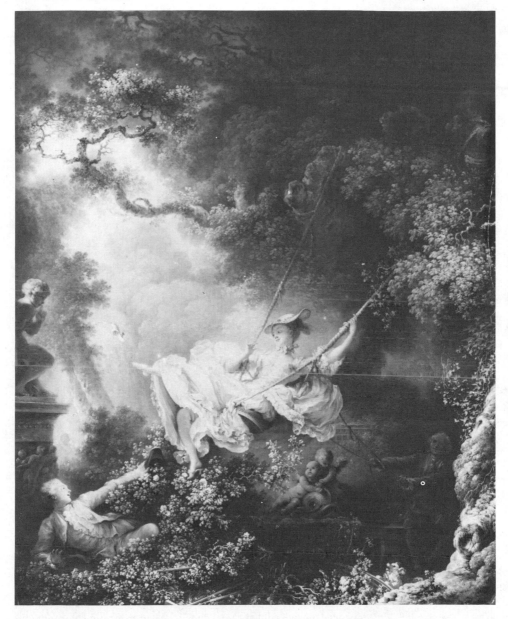

The eighteenth century was an age of portraiture. People worked on their personalities, and were famous for them, and they have been preserved by many excellent, if lesser, portraitists. But there was one, Maurice Quentin de Latour (1704–88), who caught the likeness of the century in a fresh and entirely appropriate medium, pastel. His portraits have no weight, but they tingle with sensibility. They look at us with penetration, and probably consider us dull citizens, but they conceal their opinion and smile. These are the people who pursued pleasure and ideas and who started more than they bargained for—such were the heads that were lopped off in the Revolution.

Such a sensuous age had its sculpture, all of it elegant and fluent, much of it on a small scale. Terra-cotta, a gray or red clay, was an ideal medium for much of this work. The best in this kind is by Clodion who produced figurines of graceful little nymphs and satyrs, carefree companions for the population of Boucher.

Jean-Antoine Houdon (1741–1828)

Carrying such fluency over into stone, the eighteenth century produced one great portrait sculptor, very late. Houdon could create speaking portraits out of marble, lighting up the

JEAN-ANTOINE HOUDON. *Diana, the Huntress.* ca. 1780. (Copyright the Frick Collection, New York.)

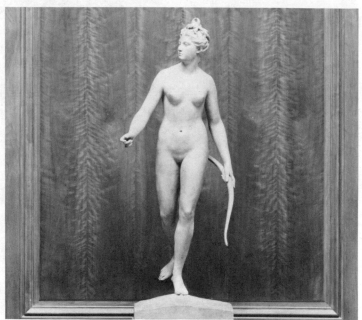

eye and opening the lips. Nothing comparable, nothing so unlike the nature of stone, had been seen since Bernini. He captured the haughty loveliness of aristocratic women; he

was equal to the grinning, aggressive face of the philosopher Voltaire; he did a full-length statue of Washington, making him very French in the process. He modeled the sea fighter of our Revolution, John Paul Jones. The eighteenth century had its own face, an attitude held, the chin raised, the haughty glance looking down the nose, rather like a dog pointing. With the passing of the century of manners, Houdon and Fragonard ran out of subject matter.

In the midst of this art for the establishment, one eighteenth-century figure stands apart, the painter Chardin. In outlook he resembles the Little Dutch Masters of the century before; but none of them equals him in quality, with

Jean-Baptiste Siméon Chardin (1699–1779)

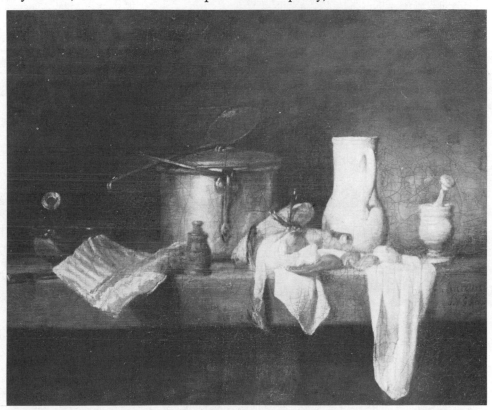

JEAN BAPTISTE SIMEON CHARDIN. *Still Life: Kitchen Table.* 1733. (Courtesy Museum of Fine Arts, Boston, gift of Peter Chardon Brooks.)

the exception of Vermeer. He looked with sympathy on the world of domestic well-being, on the children of the family who were so carefully taught their manners. Kitchens were his studios, and he was equally content with food for theme or with copper pots. But he offered far more than subject matter: his concern was with the quality of color under a certain silvery light.

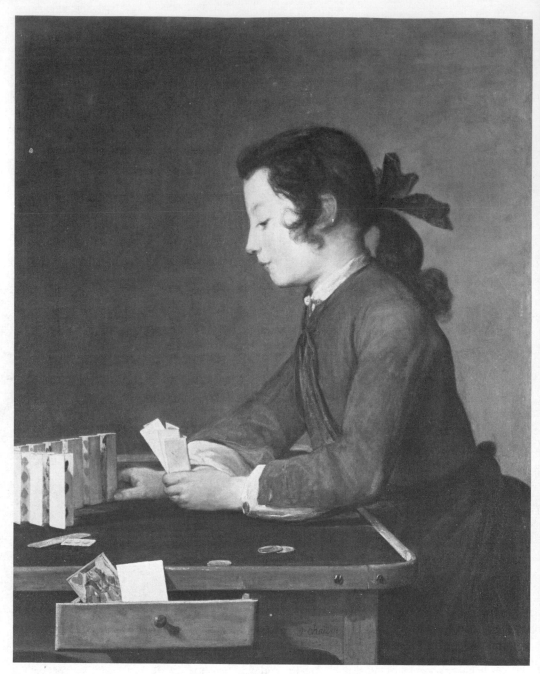

JEAN BAPTISTE SIMEON
CHARDIN. *The House
of Cards.* ca. 1735.
(Courtesy of the
National Gallery of
Art, Washington, D.C.,
Andrew Mellon
Collection.)

THE SEVENTEENTH AND EIGHTEENTH CENTURIES IN ENGLAND

In seventeenth-century England, Puritanism and Civil War were harsh to the arts. But in one way England was ahead of France: it passed through the political revolution for which France was waiting. The great Tudor sovereigns Henry VIII and Elizabeth had known how to live with their subjects and to have their own way. With the Stuarts, the crotchety James I, the stubborn Charles I, the popularity of the crown faded. Charles I undertook to have his own way in spite of his subjects and it cost him his throne and his life.

When the monarchy was restored, Charles II was able to set a happy, even uproarious national mood and became immensely popular. To be sure, he had no more love for Parliament than his father, and since Parliament controlled appropriations, he was willing to scrape along with secret subsidies from his cousin, Louis XIV. His brother, James II, destroyed in short order the new royal popularity. James had all the old ideas of the divine right of kings; he was a Catholic and the country had fought and bled for Protestantism; he had to go, and the remaining power of the throne departed with him.

The difficulties of the Stuart kings are an indication of the changes in society. An aristocracy had grown increasingly out of touch with the mood and aspirations of a new mercantile class and contempt from above destroyed loyalty from below. The conflict was visible in many ways. A lingering Tudor Gothicism, a native medievalism (or isolationism)

persisted stubbornly in the face of a French-Italianate style that beguiled the court. The new imported style, the Jacobean (for James I) remained transitional—although transitional imprecise styles are very British. Renaissance to Baroque in intention, the Jacobean had a heavy-handedness about it. Furniture was ornate. Tables had bulbous legs and beds had heavy spiral-carved posts. Oak paneling sheathed the walls as in Tudor days and fireplaces were still vast. If the intention was classic, the forms remained Gothic.

There was little building under Charles I's strained economy. Often a classical-Baroque addition was no more than a gesture of urbane intention. A semiclassic gate, a doorway, a false front on an earlier building had to do. The important architect of the reign, Inigo Jones (1573–1652) had introduced a sophisticated style to London in the Whitehall Palace Banqueting Hall. A classical building derived from Palladio, the Banqueting Hall was actually finished three years before Charles came to the throne. Twenty-four years later he stepped through one of the upper windows onto a scaffold to be beheaded.

It was cheaper to assemble paintings than to build, and Charles amassed a great collection—many of the masterpieces today in the Louvre belonged to him; they went to France when he needed money to defend his throne. He welcomed the two great Flemish painters of the age, Rubens and van Dyck. Rubens came briefly as an ambassador, but

INIGO JONES. Whitehall Palace (Banqueting Hall), 1619–22. (National Archives, London.)

van Dyck (1599–1641) stayed to paint portraits until his early death.

Oliver Cromwell was no patron of the arts. Much was to be repaired after the Civil War, and more was beyond repair. Most tragically, the war (or fanaticism) destroyed almost all the medieval glass in the cathedrals and churches, and much medieval sculpture as well. With the restoration of Charles II the arts suddenly revived, but they were tawdry. The theater returned, and painting was in demand once more; but the best of the new painters, Peter Lely (again a foreigner), was far inferior to van Dyck, and the ladies who sat for him were not like van Dyck's ladies; they were bold and disheveled. Taste was far below the level of Versailles.

Then came the Great Fire of London in 1666 that destroyed the old Gothic cathedral and half the city. Fortunately, a great builder (he had not even begun as an architect) was on hand to take advantage of this grim opportunity, Christopher Wren (1632–1723); we recorded his name in our earlier account of the history of the dome and spoke of his London parish churches with their Baroque spires.

The seventeenth century in England had laid the groundwork for great change. A long step in the direction of democratic government had been taken and the national wealth was building up. A scientific turn of mind had arrived and with it the spirit of progress. Whereas in France the newly formed Royal Academy was charged with guarding the purity of the French language, in England the members of the new Royal Society read scientific papers to each other. If Wren was the artist of the seventeenth century in England, the great mind of the century was Isaac Newton (1642–1727); and strangely, the anti-art Puritans produced the century's great poet, John Milton (1608–74).

The British eighteenth century chose an orderly classical architecture of its own, and shied away from the extravagant Baroque. The Georgian expressed a new comfortable way of life for more people, an urbanity (an urban or town culture) based on industry rather than on land and agriculture. The period extended from 1720 to 1830, covering the reigns of four kings named George; for Americans it is associated with the reign of George III, the monarch who lived too long. Democratic this eighteenth-century existence was not, but it was within reach of sufficient numbers to create a life

style based on the Renaissance man. To be aware of the deep past and disciplined in the classical languages (with travel in Italy if it could be managed) remained a goal in British education that has lasted down to the present century.

Georgian architecture expressed this classical ideal, and not only in the mansion, the country seat, or city house of the nobility or men of great wealth; it housed (in brick) a whole class of prosperous people of more limited means.

A square, three-story house with a classical doorway, a central hall through to the back with two ample rooms to the right and left and easy-flowing stair leading to an upper hall; over the main door a triple window taken from Palladio, the center section taller with a round arch head—it was all practical and dignified. When the scheme was more pretentious, delicate plasterwork embossed frail classical patterns on ceilings, while vaguely Pompeiian designs animated walls that were white, gray, or pale green; the general refinement suggested that the great architect-designer, Robert Adam, had passed this way.

Robert Adam (1728–92) was the most famous of a Scotch family of designer brothers. After a trip to Italy and to Dalmatia, he became an enthusiast for Roman architecture, and between talent and an instinct for success he created an overall design for the British eighteenth century. He had to his credit public buildings and whole streets and squares, as well as private houses complete with the furniture they contained. His detailing made use of delicate classical emblems caught up in a circle or ellipse, the whole molded in stucco. Similar imagery focused on fireplaces. The strength of this style lay in Adam's tireless attention to every aspect of design. In the most imposing houses, stone took the place of brick and plaster, and niches in walls contained statues, for how could a gentleman feel at home in the classical past without sculpture to contemplate?

Adam was not the only designer of furniture. The British eighteenth century was famous for its cabinetmakers and their designs were perhaps the finest expression of this matter-of-fact age. The eighteenth century fairly invented furniture, if we think of it in terms of tolerable comfort. In England the great cabinetmakers were Chippendale, Hepplewhite and Sheraton. Chippendale chairs were elaborately carved in mahogany. The legs and back had an easy graceful sweep like the forms of growing wood, forms that interlock in the openwork carved splat in the center of the back.

Hepplewhite's chairs, like his other furniture, have frail, straight legs, and chair backs center on a circular or shield-shaped splat. Sheraton, the youngest of the three designers, was closer to Hepplewhite. He was famous for his book of designs.

Georgian architecture expressed a way of life and it transformed whole towns. City houses and whole city streets appeared in the country. When such blocks of houses curved gracefully they were called crescents. The most spectacular developments in this manner emerged in the resort city of Bath in the west of England, where people went to gamble and to drink the health-giving waters by day and partially recover from their attacks on their health by night. Conversely, the eighteenth century saw beautiful parks and squares turn the west end of London into a garden city. A darker architectural brew was in preparation: the slums, the east end of London, the manufacturing towns of the North.

English Painters

The English eighteenth century sat for its portrait and its most important portraitists were Reynolds and Gainsborough. Reynolds saw his art as a development in a living tradition, and his canvases owe something to the Venetians and more to van Dyck, with hints of Raphael or Correggio,

JOHN WOOD I. Circus at Bath, England. 1754. [Louis H. Frohman.]

or even Michelangelo for good measure in his portrait of the actress Mrs. Siddons. This appealed to his continuity-minded public. A recorder of manners, he shows us the men who dominated society, and their ladies and children.

As a bachelor clubman, Reynolds typified the masculine society over which Samuel Johnson presided, men drawn

JOSHUA REYNOLDS. *Miss Nelly O'Brien.* 1760–62. (Reproduced by permission of the Trustees of the Wallace Collection, London.)

together in the pursuit of discussion and ideas. Fittingly, he was the first president of the Royal Academy. His fifteen *Discourses* provided a dogma for the English School, and in his last discourse he brought himself to do justice to his rival Gainsborough.

Sir Joshua Reynolds (1723–92)

Thomas Gainsborough was everything that Reynolds was not, an engaging man, with a sketchy, undisciplined way with a brush. His portraits are luminous and brilliant. No painter, not even Watteau, was ever kinder to women than Gainsborough; he appears to be in love with them at the

Thomas Gainsborough (1727–88)

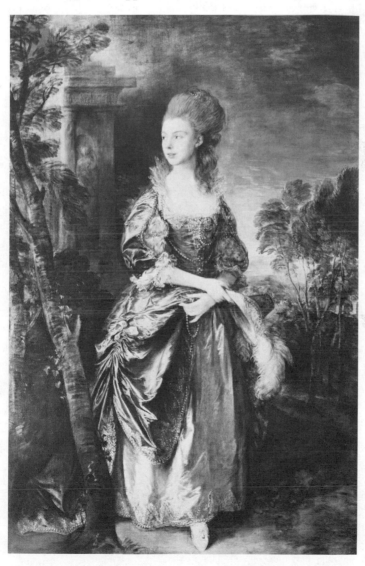

THOMAS GAINSBOROUGH. *The Honorable Frances Duncombe.* 1777–78. (Copyright the Frick Collection, New York.)

moment, and they look back at their portrait painter with a limpid sexuality held in check by their special blend of chastity and condescension. Gainsborough too made his art out of van Dyck, but he was far more sensitive. He did not draw very well, but then not too much anatomy was made visible to him—he could lose himself in laces and ribbons. More invitingly than Reynolds, he projected the sloped-shouldered elegant stance of his century.

He also painted feathery landscapes; he would have been a landscape painter, given the choice. He was a romantic individualist but he lived just before the Romantic era and he did not revolt against the establishment. There was no revolution to join.

William Hogarth Hogarth was nearly a generation older than Reynolds and
(1697–1764) Gainsborough, and if we place him after these great portrait painters, Hogarth takes his place as the head of a separate and later profession: he had the eye of a journalist. He was an excellent painter of portraits, but he chose as his primary subject a series of narrative canvases which could be read like eighteenth-entury novels. His *Rake's Progress* and *Marriage à la Mode* unfold relentless plots that mark out the path to madness, perdition, and the gallows. *Beer Street,* where all is well, *Gin Lane,* where all is disaster, and the *Seven Stages of Cruelty* need no further commentary. Unlike Reynolds and Gainsborough, he painted his age without its permission. He also engraved these novel-like themes; in effect, he published them.

Since literature was the dominant art in England, it is not surprising that the English artists should turn to printing to reach a wider public. They produced engravings, mezzotints, and later steel engravings, and their wares were avidly bought in a time before photography. There were as many aspects to this profession as there were techniques. Engravers produced prints in series that pointed a moral. Single engravings might show a well-known character or well-publicized event, and books could be illustrated. This material was realistic in imagery, although it could grow satirical and slop over into caricature.

The Industrial Substructure

We are approaching the time when our account of art would be unrealistic if we did not give some attention to the

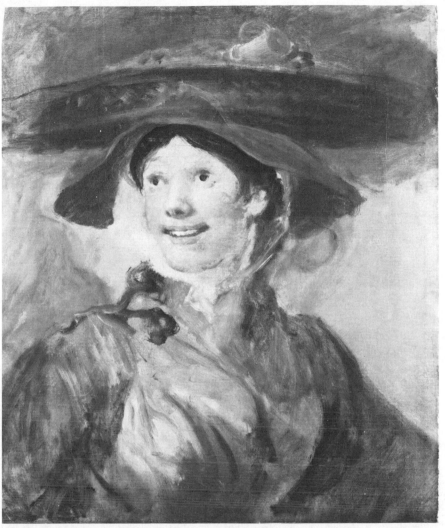

economic substructure that increasingly affected it. This hard matter-of-fact age, with its appetite for a realistic record of the lives that dominated it, was soon to lose touch with the creative spirit. The painter, like the man of letters, revolted in the name of sensibility. He turned to nature, to the past, to more human ideals, and his revolt had an all-inclusive name, Romanticism. What was his revolt *against?*

The late seventeenth century and the eighteenth century were times of discovery, invention, and the beginnings of science and its practical application. By the nineteenth century the new technology of the Industrial Revolution brought on a crisis. This development was essentially British. The will of practical men to experiment and the convenient

presence of iron and coal had been the essential ingredients, and manufacturing, credit, and trade transformed the scene. Industry existed elsewhere, but the early successes, or excesses, were in England. We can generalize and say that in the eighteenth century France was interested in form—architecture, city planning—and built from the top down; England was interested in content—trade and manufacture —and built from the ground up.

Before this time iron had never been much used. It was the armorer's material. Much fuel was required to work it; iron was waiting for coal. In England the forests were seriously depleted by the beginning of the eighteenth century and coal was the new form of heat. When the new fuel took the place of charcoal, it was suddenly realized that iron could be mass-produced. Cast iron became the new product: iron cast first as pig iron and then into the form desired. But almost half a century went by—the eighteenth century was well along—before there was a large-scale use of the new material. It was first employed for bridges, for spans of great width that led from one stone abutment to another in ever flatter, more daring arcs. For this, separate castings were fitted together much as stones had been used in masonry. At the same time that roads were able to span rivers, a new system of canals appeared in England, and more bridges made possible the interplay of roads and canal networks.

Then by the end of the century came Watt's steam engine. First it was a stationary engine used for pumping, but soon enough it was placed on a cart to pump itself along on tracks and trail a carriage after it. Iron rails now came into existence; the railroad era had arrived. With easier transportation for manufactured goods the new cotton mills became larger and busier, brick and iron prisons for the laboring poor. The new frantic pursuit of trade, the new pace, was offensive to those who relied on a landed economy with its long-established loyalties. Not only did the artist, the poet, and the man of letters look back to "unspoiled" nature, so also did the conservative squire.

THE SEVENTEENTH AND EIGHTEENTH CENTURIES IN AMERICA

The earliest need of the colonists was obviously for shelter. A New England winter must have impelled the settlers to pile logs together as best they could, and to stop out the drafts between them with anything handy. But it is wrong to see the country as a whole moving from log cabins to comfortable homes as in some national success story. In surprisingly few years the colonists built such homes as they knew before. Cottages or cots, farmhouses, and village or town houses providing an astonishing amount of comfort sprang from the ground simultaneously as men somehow created what they remembered and thought they deserved. The log cabin, which exists to this day in Appalachia, goes back to the Swedish colonists, and thus had a Scandinavian ancestry. Men stayed with the forms they knew.

The sharp gables of medieval towns reappeared, and the second-story overhang above medieval streets survived too, even though the new houses stood in open fields. Windows were a problem: at first oiled paper served for glass, but soon the small diamond-shaped lights of the late-Middle-Age casements became familiar. Such windows were small and interiors were dark as caves. But rooms were small; half the house on the ground floor was a dining-living space with a great fireplace taking up most of the interior wall. Here the inhabitants could sit close to the embers, happy to watch their dinners simmering at their feet.

At night the fire lit the room and candles provided an extra glimmer. People went to bed with the sun and with

the first light they were up to begin the struggle for existence again. Those who read, read the Bible, and the aged labored over their salvation with a reading glass in hand.

An example of these developments, still medieval in design, is the House of Seven Gables in Salem, Massachusetts. Building on this scale soon summoned the new classical pretensions in the mother country. Square blockhouses, formal doorways, and new, larger windows spelt more comfort and light. The Jacobean, still squat and heavy, gave way in its turn to a passing Dutch influence that had invaded

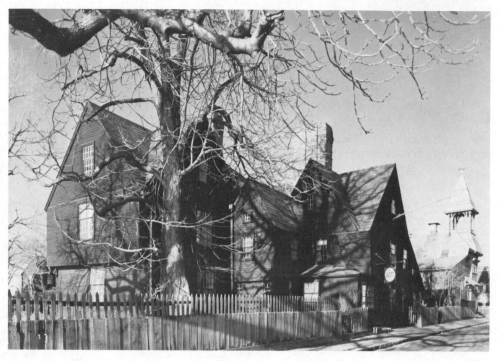

House of Seven Gables, Salem, Massachusetts. 1668. [Sandak.]

England at the end of the seventeenth century during the reign of William and Mary—we see it in Williamsburg, Virginia.

By the eighteenth century, the typical Georgan (Colonial) dwelling was a two-to-three-storied clapboard house. It had a simplified classic frieze under the eaves, pilasters at the corners or cornerboards imitating masonry, and classical surrounds to give dignity to the front door. These forms were generally wooden adaptations of English brick, but soon brick took over in the young cities. For a long time brick was imported from England, although it could easily have been baked here.

The eighteenth century was town-and-city oriented, but we should remember that America was largely rural; rural life underlay the social and political life of our country until modern times, and people lived in a fashion that had hardly changed since the seventeenth century. In New England, for instance, the so-called Cape Cod house was a standard design antedating the Georgian. It was a simple, squat house with a central chimney and a long low roof like a hat pulled well down over the eyes. A central front door (rarely used) led to a room on either hand, a bedroom to the right and to the left a parlor reserved for weddings and funerals. A stair steep as a ladder went up against the chimney to the open attic where the children slept. In back, a central room with a large fireplace served for cooking, eating, and general living. It was flanked by a pantry to one side with a root cellar under it, and on the other, a small bedroom gathered in the central warmth for some chilly and privileged elder member of the family. With the coming of stoves, a "summer" kitchen was built on the back and the fireplace was soon only for heat. Later, dormer windows sprouted in the low roof and partitions divided up the attic. These forms together with the way of life they contained are a medieval survival functioning within living memory.

Towns and cities stood in complete contrast to this hard-working democracy of the countryside, monuments as they were to the uneven distribution of wealth. The towns grew rapidly along the Atlantic seaboard and here the rich identified themselves with the privileged in England and imitated their way of life. In the northern colonies the concentration of wealth making this comfort-to-ostentation possible came from trade. Even before machine manufacturing, when actual handwork or piecework accounted for everything of value, shipping concentrated wealth and a single shipload could be worth a fortune.

An even greater division between wealth and poverty soon existed in the South. In Virginia, the large plantation houses built along the rivers—which served for roads—resembled luxurious English country houses, while the poor grew still poorer, tied to the land as they had always been, or as slaves they were owned outright. Inequality is not dependent on cities, it is based on a very old attitude toward life. Cities merely show up social intentions.

What we look back on now is the visible luxury of the time: exceptional eighteenth-century Colonial houses and

churches; a few "unspoiled" New England towns; Newcastle, once the capital of Delaware, a colonial town on the Delaware River, still practically intact; and, more synthetically, the restored colonial capital of Williamsburg. In the next century, American towns of wooden houses all gleaming in new paint looked to Charles Dickens like so many toy towns set out afresh each day.

Such construction was the work of builders leaning on their past experience or following plans that had been freshly imported, in "how-to" pattern books (see p. 26) generally written by British architects. The eighteenth cen-

Westover, Charles City County, Virginia. 1730–34. [Sandak.]

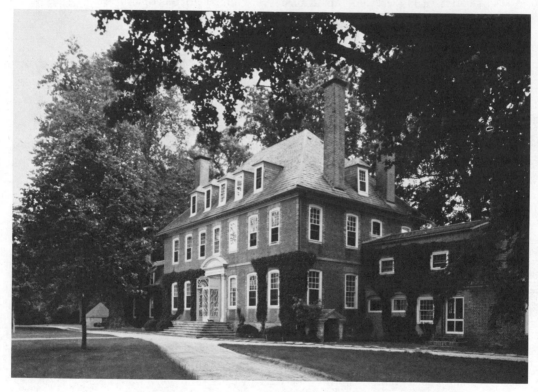

tury was a time of versatility, and a gentleman-owner would study these plans and guide his builder step by step. Nor did he confine himself to his own home. Jefferson, the universal man of the century, designed the statehouse in Richmond (1785–92) (see p. 18), and not only his own mansion of Monticello (1793) but the University of Virginia (1817–26) (see p. 38), the handiwork of his old age. Even Independence Hall in Philadelphia was the work—the only work—of an amateur, a lawyer by profession.

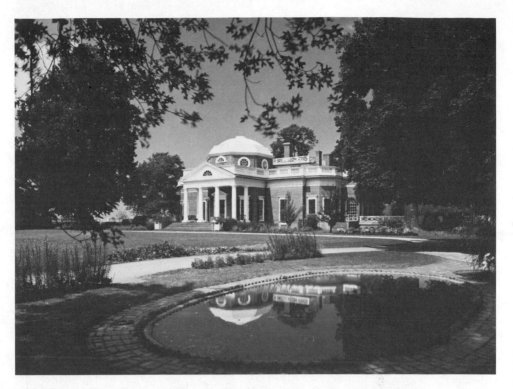

The professional architect was hardly needed or wanted, but two must be mentioned. New England had Charles Bulfinch (1763–1844) who built the domed statehouse in Boston (1795–98) (see p. 37), the statehouse in Hartford a little earlier, and many a handsome foursquare private house and an occasional church, with for good measure the Charlestown jail and the Massachusetts General Hospital in Boston (1818), the last two in granite.

Bulfinch was a Georgian architect with a taste for delicate proportions and subtle, slight decoration that stems from Robert Adam. Out of the Southern colonies came a protégé of Jefferson, Benjamin H. Latrobe (1764–1820), who worked in the purer classic style, the neoclassic that Jefferson favored. He had to his credit the Baltimore Cathedral (1804–18) and the National Bank in Philadelphia (1799–1801), now destroyed, a building of compelling elegance, with portico and shallow dome. He had a hand in the composite design of the national Capitol and of the White House.

If we take the roof off a colonial home and look inside, the early oak, then pine, then maple, then later mahogany furniture holds our attention as does the glass, china, and

silverware. In the beginning Jacobean furniture had been simplified to come within the capacities of local cabinet-makers, but the Queen Anne was much better managed, and continued in America until the middle of the eighteenth century. Then an American Chippendale flourished with local styles coming out of Boston, Philadelphia, and Newport, Rhode Island, or out of Virginia and the Carolinas. After the War of Independence, a Federalist style emerged, based directly on Sheraton design. Pieces by the best cabinet-makers of the time now find homes in museums. The work of Samuel McIntyre of Salem was outstanding; the Scot, Duncan Phyfe, located in New York, worked both before and after the Federalist period, designing furniture well into the nineteenth century.

Leaving aside the most prestigious creations of the cabinet-makers, the bulk of American furniture, from colonial times down into the nineteenth century, represented rugged and forthright simplifications of European design, often of an appealing honesty, and such pieces constitute what the twentieth century has bought and treasured as "antiques." The best in this kind was Shaker furniture, with much to be said for the furniture of the "Pennsylvania Dutch." Of the more linear adaptations of English design the most successful item was perhaps the Windsor chair. The men who labored on the Constitution in Philadelphia sat in Windsor chairs and were comfortable enough to pay attention to their work. The Hitchcock chair mass-produced in Connecticut was a remote descendant from Sheraton design. The ladder-back chair that seems so essentially American came from a long line of European ancestors.

Silverware was as handsome in America as in England; no silverware is more desirable than that of Paul Revere.

Painting in the Colonial Centuries

But what of the walls? What of painting? Here as in England, a family portrait over the mantel or man-and-wife companion portraits over the sideboard was the social goal, however difficult to realize. In England portrait painting for the wealthy looked back to van Dyck, and since the aim was elegance, the fluency of a skillful hand was essential. In the early colonies such a pretentious product could only be obtained from professional painters who had reached America as dropouts from the competition at home. But the need was

more likely to be filled by native itinerant journeymen or limners who quite innocently undertook to paint whatever was wanted from a tavern sign to a likeness, and who jogged through the countryside hacking out resemblances of men, women, and children who were overjoyed to see themselves at last. The painter struggled, and the client was amazed. Such home-grown artists were conforming to an ancient tradition, where the goal was a detailed linear clarity; a medieval spiritual earnestness, so appropriate to the mood of the colonists, had survived too.

In short, there were two kinds of art, imported and native, top-down and ground-up. Of names that survive, the best of the first generation to arrive was John Smibert (1688–1751) who reached Newport in 1729—he had been

RALPH EARL. *Portrait of Chief Justice and Mrs. Oliver Ellsworth.* 1792. (Courtesy Wadsworth Atheneum, Hartford, Connecticut.)

on his way to Bermuda—and settled in Boston. A generation younger, Joseph Blackburn appeared in 1753. Such painters were imbued with a zeal for the Baroque-palatial. They could labor over brocades and silk that they made to shimmer like aluminum, and with the flowing draperies they threw in classical columns. In contrast to these imitators of the Baroque, the self-trained native painters struggled to preserve faces much as men of religion strove to save souls. Robert Feke (1706/10–67) was as eager to satisfy the so-

cial pretensions of his sitters as the European artists he fol-
lowed; but the more remarkable Ralph Earl (1751–1801),
the strongest of the hewers to the line, set men before us as
though before the bar of justice. Earl came out of Connecti-
cut and years in London did nothing to soften him. He
sensed, and salvaged, the special quality of the New England
personality.

John Singleton
Copley
(1738–1815)

Copley presents the spectacle, often to be repeated, of a
talented man lacking the experience of a tradition and sweep-
ing together whatever help he could find. He grew up in Bos-
ton. His stepfather was an engraver who could at least offer
him the sight of prints of European older masters including
a secondhand glimpse of van Dyck, and the boy had the
Smibert and Blackburn portraits before his eyes. Yet by the
time he was twenty young Copley was painting finer portraits
than had ever been seen in America, with a power that lay

JOHN SINGLETON
COPLEY. *Paul Revere.*
1768–70. (Courtesy
Museum of Fine Arts,
Boston, gift of Joseph
W., William B., and
Edward H. R. Revere.)

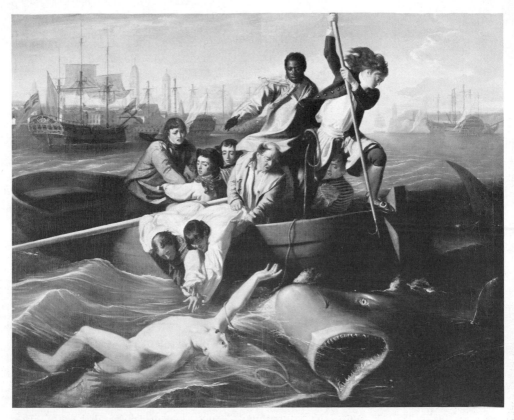

in his uncompromising truthfulness. His subjects were carved and colored like the figureheads of ships. But this intense grasp included their personalities; thanks to Copley we have before us the generation of the Revolution, men and women who seem absolutely sure of themselves, who have a firm grip on the past and the present and who are ready for the future.

It was a future that Copley was not to share. While still a young man, he sent a painting to the Society of Artists in London and wrote to Joshua Reynolds and to the American painter Benjamin West, then in England, asking for criticism. Both men answered Copley and West urged him to come to study in Europe "before it was too late." Eventually, in 1774, Copley left for Europe and made the grand tour through Italy. The American Revolution found him in London, and he never returned.

As a portrait painter in London where a smooth urbanity was desired, his stubborn integrity was at a discount and he was permanently eclipsed by Reynolds and Gainsborough. Adapting himself to the taste of the times, he undertook

dramatic and historical compositions for which his precision-ist art was ill-suited. He painted the *Death of the Earl of Chatham in the House of Lords* (1779–80) and several versions of *Watson and the Shark* (1778) in which we see the future Lord Mayor of London as a youth swimming in Havana Harbor: he is about to have his leg taken off by a shark while a boat stands by to rescue. We know that the shark got the leg, but Copley does not make us believe it.

Benjamin West (1738–1820)

West was the same age as Copley. He migrated even sooner to Europe, when he was twenty-one, and had a brilliant career in London where he too spent the remainder of his life. He grew up in Philadelphia and, like Copley, learned what he could from such portraits as he could see. He, too, had powers that his predecessors lacked. But there the resemblance between West and Copley ends. Copley treated reality as though seeing were a duty, while West was essentially impulsive and fluent and his painting rapidly became theatrical. A romantic at heart, he moved out into the world with an instinct for success. A group of Philadelphia merchants staked him and he sailed for Rome.

At this moment Rome was the center of classicism or neoclassicism. A famous German art historian, Winckelmann, was introducing the idea of classical beauty. For Winckelmann, classical sculpture and Raphael and (strangely) Michelangelo were the basis of great art. Such a view, or faith, carried conviction, and it was not long before the remarkable excavations at Pompeii and Herculaneum made classicism fashionable. Young West came under the spell of history and Rome, and the result was historic narrative painting on a grand ambitious scale. After three years he went to London intent on his new ideal. Without choosing to compete with such portrait painters as Gainsborough and Reynolds, he launched into his exalted theme and had an immediate success.

An aesthetic battle between this neoclassicism and a new Romanticism was in the making and by the end of the century the lines would be drawn. But West was able to throw the driving force of a Romantic temperament into his neoclassicism and have the best of both worlds. His subjects were drawn from Roman or recent history or from the Bible —no matter, as long as they were grand. Thus he suited every taste, for here was historical integrity, and here were

drama and religion. The range is to be read in his titles: *Agrippina with the Ashes of Germanicus* (1767); *The Death of Wolfe* (1771)—the hero of Quebec; *Saul with the Witch of Endor* (1777). These paintings were simply not good enough to make history of their own, for West had no such talent as Copley, but the English School made slight demands on drawing or color and West survived and flourished on the strength of his themes. He inherited Reynolds' mantle as the second president of the Royal Academy, and he was endlessly generous to young American artists who besieged his studio.

What his young American students needed most was sober advice. Fired by his success, they went home intent on painting vast scenes for which there was neither market nor wall space, and they ate their hearts out—or painted portraits. The experience of the successful West, the less successful Copley, posed a problem that was to beset the American painter for a century and a half. To what degree should he surrender to Europe? Is art national or international? The answers have been based largely on temperament. Most American artists have had some experience of Europe and of European art. Some have chosen to live out their lives in Europe, but with the exception of Copley the greatest have not.

Stuart came from Rhode Island; he was gifted and precocious with a flair for catching a likeness. A Scottish painter who happened to be in America took the boy artist to Edinburgh to study. Stuart's patron then promptly died, and the boy worked his way home only to return to Europe when he was twenty years old. But after a decade in England he ran casually into debt, for which a man could be imprisoned in those days, and he took refuge in Ireland for another five years. Then he returned to America—it was 1792—to paint George Washington as he announced. Paint Washington he did, many times over, in the general's old age, and the sober, paternal image of Washington that lives in the national mind comes from Stuart: nose massive, eyes tired, lips compressed —Paul Revere had constructed dentures for Washington out of elk's teeth and the general was undoubtedly well advised not to smile.

Where Copley's people show a tough integrity, Stuart's breathe an easy assurance. The paint is fresh and thin on a

Gilbert Stuart
(1755–1828)

heavy-grained canvas, the drawing adequate, the color, like the complexion, rosy and flushed—a good wine was a weakness of the century and of Stuart as well.

Stuart was long thought of as the great American portrait painter, and only in recent times has the overwhelming veracity of Copley come to the fore, to leave Stuart's portraits a thin social commentary in comparison.

Charles Willson Our fourth Colonial figure offers an utterly different tem-
Peale perament and history: Peale represents the spirit of experi-
(1741–1827) ment and invention that was to flourish so unhampered in

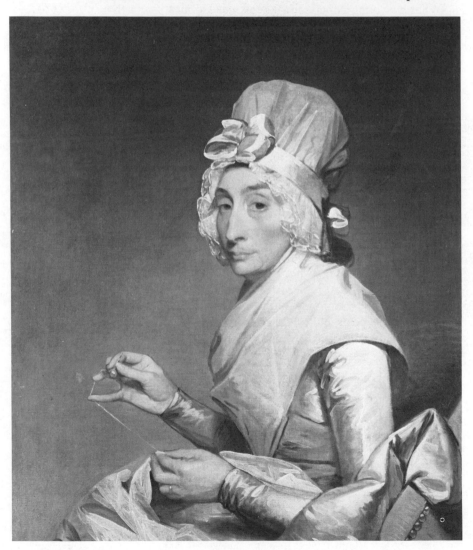

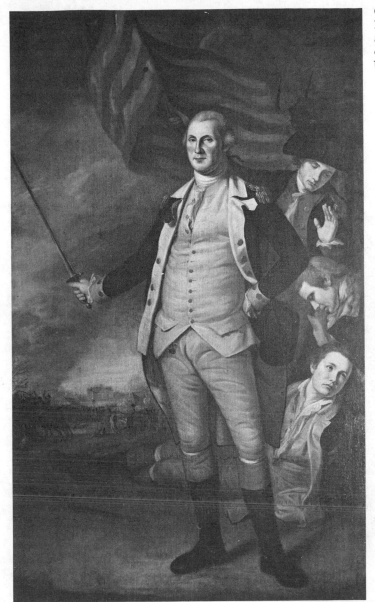

America. He approached painting as a craftsman and saw it simply as something he could do to advantage. As a boy he was apprenticed to a saddlemaker, and he added a whole series of crafts from watch and clock repair to working as a silversmith or as a caster of brass. It was not until he was twenty-one that he saw a painting or two that prompted him to feel that he could do as well. He bought a "how-to" book in Philadelphia (he had grown up in Maryland) and devel-

oped a natural flair. When he was paid ten pounds for a por-
trait and saw what easy money it was, he settled for this
craft in preference to all others.

He went to Boston and made a copy of a painting by Cop-
ley; friends raised money to send him to London where he
spent the years from 1767 to 1769, and like all young
Americans he was welcomed by Benjamin West. On his re-
turn he became the leading painter in the colonies, with
Stuart and Copley away. His portraits of Washington, much
younger than when Stuart painted him, tell us of the actual
appearance of the wartime general. Peale had an outgoing
temperament and his studio became something of a public
showroom, a museum of his own in the making. The next
step was his creation of a natural history museum in Phila-
delphia, filled with stuffed birds and whatever oddments
aroused his curiosity, and his great achievement was the

CHARLES WILLSON
PEALE. *The Staircase
Group.* 1795.
(Philadelphia Museum
of Art.) [A. T. Wyatt,
Museum staff
photographer.]

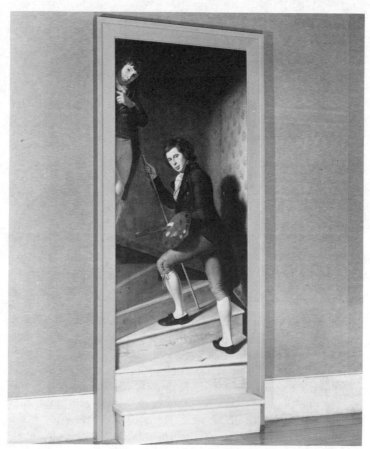

digging up of a mastodon. With natural pride, Peale painted his own portrait in the entrance to his collection with the mastodon skull at his feet. He had gone far beyond the eighteenth-century notion of a cabinet of curios, and made an approach to scientific classification that foreshadowed Darwin. His museum was in Independence Hall, and here he exhibited another classification, a gallery of portraits of the country's great men.

This museum took up half his time: he found no conflict between his painting and his museum chore, as he was far from entertaining the romantic belief that an artist was a man apart. In fact, he was so committed to the craftsman attitude toward art that he brought up his children to be painters as a matter of course, naming them after artists to give them a running start in their trade. But of Raphaelle, Rubens, Rembrandt, and Titian, only Raphaelle and Rembrandt gave much of an account of themselves as painters, and Raphaelle and Titian were never better employed than when they were posing for their father in *The Staircase Group* (1795) where the painter shows a delight in deception that prefigures one of the twentieth-century pleasures.

Peale in his old age achieved a new dimension. A painting of his brother, James Peale (1822), reaches a concern with that essentially nineteenth-century interest, the mysterious quality of light.

A fifth figure cannot be lost to sight. John Trumbull falls into the gifted amateur status, a son of a governor of Connecticut, aide-de-camp to Washington, and after the war a diplomat in London. Trumbull knocked out portraits, but his dream was of a great epic, a record of the Revolution on a heroic scale. He produced the preliminary studies. It is a wonder he got so far, for he could not even sell his compositions in the form of engravings. Not until 1817, a generation later, was he commissioned by Congress to paint four large panels for the Rotunda for the Capitol, and there they are to this day.

John Trumbull
(1756–1843)

ROMANTICISM: A VIEW

OF LIFE

Like classicism, conceived as the past of civilization itself, the Romantic movement was essentially international; it hungered after faraway times and places, and it took an expansive view of the spirit of man. It involved all the arts; it emerged and throve in Germany, England, and France; it has been happily at home in America. The Romantic movement was an active force to reckon with for a hundred years, from the mid-eighteenth to the mid-nineteenth century, and in America its mood has lingered on.

Historically Romanticism throve in opposition like a political party. It had an establishment to attack in the politics and philosophy of the Age of Reason in England and France. In the arts, this Age of Reason had found expression as an age of classicism: classical architecture, classical myth as subject for the artist, and with the coming of the French Revolution a harking back to great events in the history of Republican Rome. In France, classicism thus became identified with republican patriotism, and took on a new political life complete with a new austere style.

But Romanticism had been gaining strength for half a century, and it blew like a warm wind on this long, cold, classical trend. The result was confusion—a mixing of terms. Even the intense classicism of the French Revolution can be seen as Romanticism in disguise, for what else was it but an escape, a fantasy of a heroic age? And what is classical about revolution? The conflict between classicism and Romanticism was based on temperament. Romanticism was

warmer, more alive. Romanticism was a cry for freedom and adventure, for a reliance on emotion, intuition, and mood. The Romantic movement could be tender and violent; it spoke to vanity, it offered hope.

In England Romanticism gathered strength as a literary movement and we can see it emerge most clearly in poetry. Robert Burns (1759–96) was a romantic figure by temperament, singing with the voice of the people. Walter Scott (1771–1832), a poet before he became a popular novelist, was the professional celebrator of a romantic Celtic way of life: he was a perennial best seller, widely read in America, especially in the South, where squire and planter saw themselves as successors to Scottish chieftains. Byron (1788–1824) was the archetype of Romantic poet, a rebel in his short and squandered life, dying as a would-be liberator of Greece. He composed long dramatic poems set in the Middle East on themes of violence, plunder, and love. By contrast, what could be more romantic than the brooding *Rime of the Ancient Mariner* by Coleridge (1772–1834)? Then Wordsworth (1770–1850) became the tender romantic poet: a yearning love of nature, a mild liberalism, a nobility of spirit saw him through a long, peaceful life. All these figures were born well back in the eighteenth century. The novel itself came out of the eighteenth century from the pens of Richardson (1689–1761) and Fielding (1707–54) and what they wrote were romances. It was not altogether a classical time.

This British Romanticism grew out of strong British sentiments: a liberal concern for humanity (overriden by the demands of business and success), and a love of nature and the countryside. It brought in a change of taste, replacing the European formal garden with the British informal park that imitated nature; here a yearner for living beauty could linger, here a lady might safely roam—are not the paintings of Gainsborough romantic? Such an escapist wildwood taste easily became an antiquarian taste and brought in the Gothic Revival in architecture and the enjoyment of haunted Gothic ruins either real or artificial. This escapist longing in the presence of the visible past became a literary hankering for imagined scenes far away and for whatever was rugged and untamed. Wild mountains were suddenly objects of veneration and awe; up until the Romantic period they had simply been obstacles to travel to be avoided. Cataracts and storms aroused solemn meditations for solitary and melancholy spirits with suicide in their hearts.

The major Romantic painters of this period were three in number: Blake, Constable, and Turner.

William Blake
(1757–1827)

WILLIAM BLAKE.
Creation of Eve
(*Paradise Lost* Series).
1808. Watercolor.
(Courtesy Museum of
Fine Arts, Boston.)

A troubled and exalted mystic, Blake had a flair for moving easily from one art to another: poet, engraver, and painter, he was able to mingle his talents in the creation of books that fused image and text like medieval manuscripts. His sympathies were with the downtrodden: he was fiercely antiestablishment. He created a strange social-religious mythology of his own: a troupe of guileless figures, draped or naked, acted out his myths of innocent happiness in a celes-

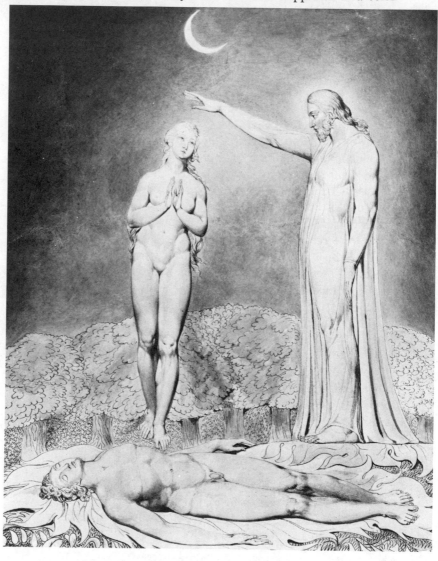

tial dance. He was at his best in dealing with stories from the Bible. He found visual language for the grief in the Book of Job and the joy of the Psalms.

Blake's plastic conceptions were Mannerist, if we choose to look back. That his anatomy is academically bad is no ground for reproach. Blake lived in a spiritual world of his own devising and his unschooled drawing seems related to some childlike sexual unawareness. His figures are only equipped for exaltation and despair.

Constable is the Wordsworth of British art, a detached brooder over the loveliness of nature. He is unlike Blake and utterly unlike his great contemporary Turner, yet all three are essentially Romantics. Constable stayed close to his territory, a region of quiet streams, fields and green trees. A distant spire, a wooded hill, a moist landscape with its gentle waterways controlled by locks, and Constable was at home.

John Constable (1776–1837)

The remarkable achievement of Constable is not that he embraced nature like a Romantic poet. Familiar scenes led him to a new way of seeing. He realized that what he had before his eyes was color: he saw that the sky was a watery, luminous blue and he discovered that the land was green, not the gray-brown of an imagined background behind a fig-

JOHN CONSTABLE. *The White Horse.* 1819. (Copyright the Frick Collection, New York.)

ure. And he went further. He stumbled upon broken color, and animated his canvas with little flecks of white paint that became light, an effect known at the time as "Constable's snow." In these inventions and advances Constable antici-

JOHN CONSTABLE. *Salisbury Cathedral from the Bishop's Garden.* 1826. (Copyright the Frick Collection, New York),

pated the French Impressionists by half a century. It was unfortunate that all this new freedom tended to be confined to his sketches. His finished paintings are weighted down with detail and the spell of the first impression is broken.

J. M. W. Turner (1775–1851)

The same age as Constable within a year, Turner was a romantic painter closer to an earlier literary spirit. He has grown steadily in critical estimation, and now stands as the greatest British artist. As a young man he took walking trips and brought home sketches and watercolors. Where Constable closed in on a small target as an object of love, Turner preferred the monumental prospect as an object of wonder, with an old castle or ruin in distant focus. He was a

painter of the sea and ships; he loved wild mountain sce-
nery and invaded Switzerland. Like other Englishmen he en-
tered Italy in search of the past, the past of great painting,
as though he were seeking a major rival. In Claude Lorrain
he found a worthy one (so popular with British collectors)
with whom he could contend. Claude had painted Italian
landscapes, sea scenes, ships, and imagined ports with clas-
sical architecture coming down to the water's edge, in effect
theatrical sets for classical myths. Turner did likewise, and
remarkably he made thrilling and successful use of such re-
worked material. His Italian subjects are as much English
poetry as Shakespeare's Italian plays.

J. M. W. TURNER.
Mortlake Terrace.
ca. 1826. (Courtesy of
the National Gallery of
Art, Washington, D.C.,
Andrew Mellon
Collection.)

The poetry in Turner seems related to his great spacious-
ness, his instinct for the wide angle that leads him into the
sky. In effect all is sky in Turner unless it is sky and sea.
Everything becomes unsubstantial and the dark values of
ground simply evaporate. It is understandable that Venice
was Turner's ideal subject matter, where pale buildings meet
the water.

Claude, as we saw, had a habit of placing the sun directly in the center of his canvas and making this immediate source of light believable. In his hazy, glittering effects, Turner took on his rival with a surer grasp of reality, and more imagination. He allowed himself exceptional liberties. A Turner tree has a poetic part to play, floating lacily before the visible sun, part tree, part feather. His air and water compositions, his storms, calms, surgings, and shimmerings, contribute a poetic response to nature that is essentially British.

J. M. W. TURNER.
Fighting Téméraire.
1838–39. (Reproduced by courtesy of the Trustees, The National Gallery, London.)

Turner was one of the first artists to enjoy the diligent support of a critic. John Ruskin devoted much of his literary life to Turner, and he gave Turner's achievement a moral dimension. According to Ruskin, that painting is the great-

est that has the greatest number of the greatest truths to offer, and here he found Turner to excel.

Francisco José Goya
(1746–1828)

Romanticism cut across all frontiers; we are following its mood from England to France and then to America. But the greatest Romantic painter of all for sheer ability was the

Spaniard Francisco Goya. So remote was Spain from either England or France, so broken were communications, that Goya had little influence upon his time outside his country. The Romantic period was over before he achieved his rightful place.

Goya came from a town in the north of Spain. He descended on the capital, Madrid, married the sister of a lesser painter, was taken up by the aristocracy and began painting pastoral scenes as designs for tapestries: he represented picnics and frolics of the upper classes or fleshed out their visions of the happy poor. Goya dashed off these charades with a late Venetian lightheartedness. Then came portraits, and so up the ladder of preferment until he was court painter for the royal family. Portrait followed portrait: his rival was the long-dead Velasquez.

It is almost unbelievable that his subjects enjoyed what Goya showed them. They were looking at some of the great-

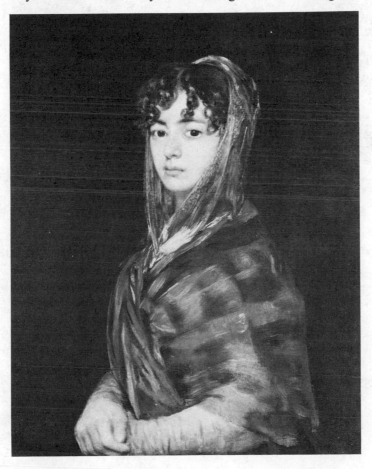

FRANCISCO JOSÉ GOYA. *Señora Sabasa García.* ca. 1806–07. (Courtesy of the National Gallery of Art, Washington, D.C., Andrew Mellon Collection.)

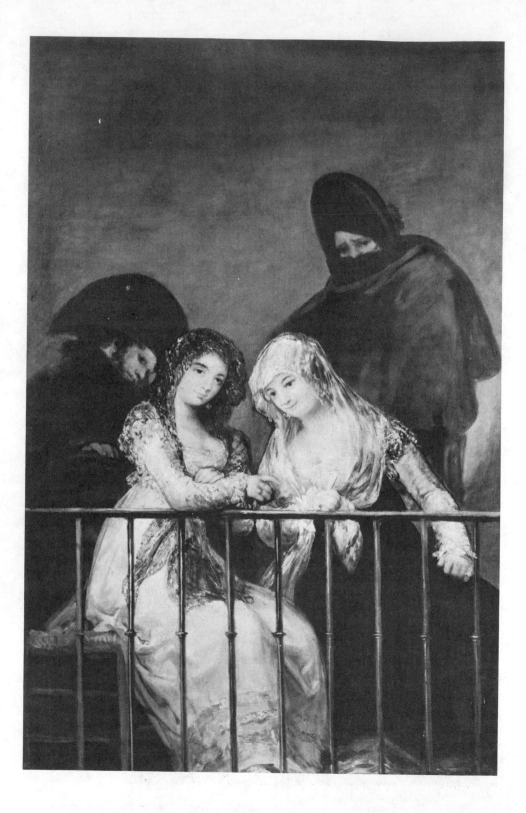

est paintings in the world, but they were also looking at themselves. The king was a bloated simpleton who lived for the hunt, the queen a virago who spent her nights much worse employed, and they set a tone of folly and debauch. None of this was lost on Goya, and his brush revealed his thoughts. The decadent scene, the tottering government, was not lost on Napoleon either. He invaded the country, and needless bloody war tore Spain for a generation.

While Goya continued with his portraits he found a more effective outlet in his sardonic etchings. Of these he produced four series, beginning with the social satire of the *Caprices*. After a pause came the *Disasters of War,* then the *Art of Bullfighting,* and finally the *Proverbs*. The *Disasters* are the most savage indictment of war ever drawn, in all its torture, horror, and stupidity. The bullfight series is an enthusiastic account of the national sport. The *Proverbs* is a repetition of the *Caprices* on a deeper psychological level: here Goya creates dark fables that probe into the obscure and overwhelming impulses of mankind. These etchings are a far cry from eighteenth-century portraiture. They shocked, they were cloaked in censorship; half a century went by before they were all published.

The etchings coincide with the agony of the Napoleonic

Left: FRANCISCO JOSÉ GOYA. *Majas on a Balcony.* ca. 1810–15. (The Metropolitan Museum of Art, New York, bequest of Mrs. H. O. Havemeyer, The H. O. Havemeyer Collection.)

Below: FRANCISCO JOSÉ GOYA. *Young Woman on a Bucking Horse.* ca. 1818. Etching from the *Proverbs.* (Collection of Mr. and Mrs. Edgardo Acosta, Beverly Hills.)

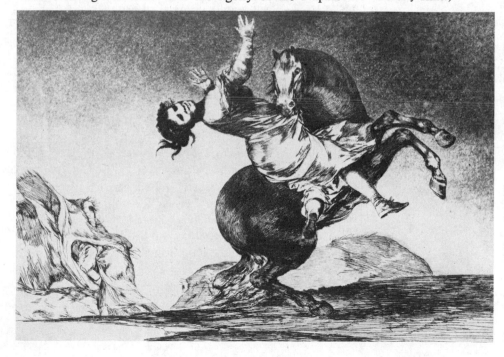

wars, but they also reflect a private agony. Goya was afflicted
by some heavy obscure illness which left him stone deaf.
This personal blight coincided with the bitter end of a love
affair of sorts with the duchess of Alba who died prema-
turely. His deafness cut him off from the surface of society
and his powerful morbid etchings tell us what it was like for
Goya to live with himself.

In his final alienation he painted a late series of morbid
visions as decorations for his home, his retreat for his old
age. These sinister and irrational "dark paintings" deal with
witches, with goats preaching to a gullible and idiot human-
ity. He conceived of such paintings as two men fighting with
cudgels in a mountain wilderness: they stand anchored in
the ground up to their knees just near enough to strike each
other. In another canvas, a dog's head looks up with long-
ing and loyalty at some vague suspicion of a human hand.
Perhaps the dog sees more than we.

Goya bore a resemblance to his great contemporary, Bee-
thoven. They looked much alike, and they harbored the
same resentments against the aristocrats with whom their
ambitions brought them in contact; they were equally defiant
and uncouth, and in old age both were cut off from the
world by their deafness. In spite of his withdrawal in his
later years, Goya ran into political difficulties and fled into
exile, finishing his days in Bordeaux.

Romantic Classicism

Jacques Louis David The French painter David lived through the almost identi-
(1748–1825) cal span of time as Goya: he was two years younger, and
died three years earlier, and he too died in exile. A lesser
talent (which could be said of every painter then living), he
left his mark on the history of France as a dictator of the
arts, whether of painting, costume, furniture, or design. He
thought of himself as a classicist, and classicism was cer-
tainly his language, but the French Revolution itself was a
crisis in Romanticism—we have contended—for its view of
itself as the Republic of Rome come back to life.

The young David studied in Rome. He brought home a
painting *The Oath of the Horatii* (1785) to be followed two
years later by *The Death of Socrates,* the first a conspiracy
in a just cause, the second the unjust death of a good man.
These canvases introduced a new cold style appropriate to
a Roman courage. They had a revolutionary impact—patri-

otism made visible, although the painter had innocently dedicated *The Oath* to the king. Here figures were smoothly rounded and colorless to suggest classical sculpture. David on occasion took Roman statues for models.

By these means he became the Revolution's official artist. He painted a masterpiece of the death of the revolutionary extremist Marat (1793), who was assassinated by Charlotte Corday as he soaked in his tub. Marat had a skin disease that left him happier submerged, and here, with a board across the tub for writing, he was to be found.

Time went on, the Revolution calmed into the years of the Directorate, and David was still omnipotent in the arts. He was responsible for the fashions of the period, for the whole visible way of life. In his portrait of Madame Récamier the charming Directoire gown, the Roman couch, the

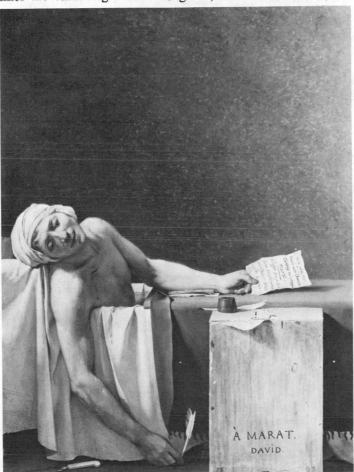

JACQUES LOUIS DAVID. *Death of Marat.* 1793. (Royal Museum of Fine Arts, Brussels.)

Roman lamp, were all conceived, or dictated, by David. He
set the style or tone for exhibitions. The word *salon,* mean-
ing a public exhibition, was already in existence in the days
of the monarchy, but in those days showings had been held
by an artists' guild, with a membership based on a long
apprenticeship. Now salons were to be open to a more dem-
ocratic range of talents, or such was the intention. (Un-

JACQUES LOUIS DAVID.
Madame Récamier.
1800. (Louvre,
Paris.) [Cliché des
Musées Nationaux.]

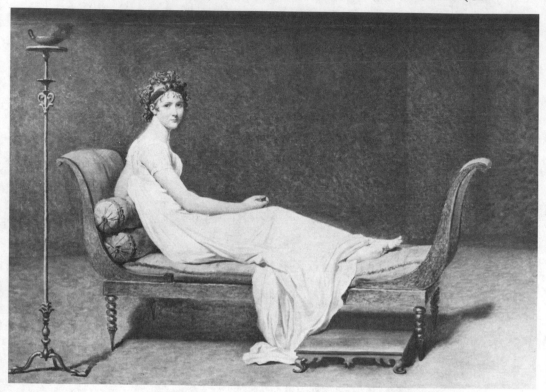

happily, the worst artists kept the best out all through the
nineteenth century; juries blocked the door.)

When Napoleon took over from the Directorate and be-
came emperor, as the smoke cleared, there was David still
maintaining his ascendancy, for no change of style was
needed; the shift was only from the Rome of the Republic
to the Rome of the Caesars. His monster painting of the
coronation of Napoleon as it took place in Notre Dame
shows the cathedral with its Gothic interior classicized as far
as possible for the reappearance of a Roman emperor. But
neither the event nor the painting was classic: each was a
cardboard fantasy.

The downfall of Napoleon was fatal to David as it was to

many lesser men. David had been too identified with politics; during the Revolution he had voted for the execution of the king, and when the Bourbons were restored he fled, and ended his days in exile in Brussels.

Was this classicism, or Romanticism in disguise? David was an austere Romantic who made war on the Romantic impulse and he had a follower who continued his cult of austerity in his pupil Ingres.

Ingres came from Montauban in the extreme south of France. As a precocious young man in Paris he was a student of David, and he carried his master's severity through an even longer life. Although he was not the undisputed dictator of the arts that his teacher had been, he wielded great conservative authority. It was the good fortune of the Romantic painters that he was out of the country in Rome for so much of his life.

Jean Auguste Dominique Ingres (1780–1867)

Although Ingres saw himself as a classicist he too painted highly romantic myths and histories. He looked to the Renaissance rather than to classical Rome, and Raphael represented his lifelong ideal; Poussin as well—for all French artists believe in Poussin. Ingres said that "drawing was the probity of art." He had infinite facility with a pencil, and he could organize detail with the clarity and assurance of a

JEAN AUGUSTE DOMINIQUE INGRES. *Odalisque with Slave.* 1839–40. (Fogg Art Museum, Harvard University, Cambridge, Massachusetts.)

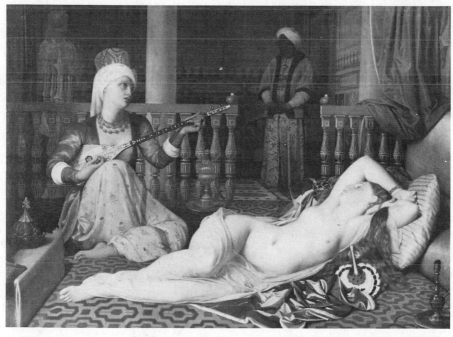

master. For Ingres color was a secondary matter, a mere tinting of surfaces. His mythological figures, in other words his nudes, tend to be boneless and they have an inescapable cold sensuality.

He won the Prix de Rome like his master before him, and left for Italy in 1806 when he was twenty-six. He stayed on after his scholarship expired and only returned twenty years later after the whole Napoleonic era was over. Eight years more and he was back in Rome again as head of the French Academy, the institution created under Louis XIV. He returned to France in his old age where he lived on in the midst of honors, consoling himself by making existence miserable for his arch rival the Romanticist Delacroix.

Ingres surely is the arch classicist, yet he lived in the heyday of Romanticism, was infected by it, and his Romantic virtues are the source of his vitality.

Théodore Géricault (1791–1824) The romantic side of French Romanticism is not simple, but we can simplify it by staying with two outstanding figures. The first had a tragic brief life, the second, a longer ailing one. Géricault and Delacroix were friends.

Géricault was a wealthy, dashing young man with a powerful and assured talent and the brushwork to project it. He had a passion for horses, for racing. He painted with gusto the race of riderless horses down the thoroughfare of the Corso in Rome; the horses were urged on by spurs fastened to their sides and the event had something of the brutality of the bullfight. Géricault later painted a number of extraordinary portraits of lunatics, and a head of a dead man is characteristic. There was a dark, satanic side to his nature. His favorite sport cost him his life; he was a hard rider and a fall worsened a spinal trouble or injury, obscure but fatal.

The high point of this short dramatic career was a salon painting of 1819, *The Raft of the Medusa*. This large canvas, some 16 x 23 feet, was a monument to Romanticism. The subject was contemporary. The ship *Medusa* was lost near the Canary Islands, and the few survivors were adrift on a raft for days before they were rescued. The raft, a scene of the dead and the living dead, was Géricault's perfect subject. The whole tragic circumstance had a congenial dimension of political scandal and proved an almost fatal embarrassment to the government.

The powerful painting was carefully studied from nature

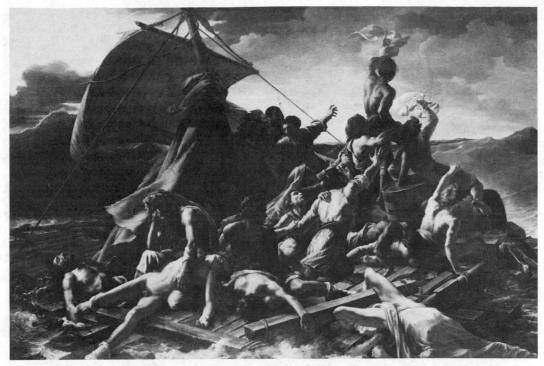

—we cannot say from life, for the corpses were studied too. With strong Baroque diagonals as guidelines, the composition lurches from lower left to upper right in a progression that begins with death and moves up through despair to frenzy, as the highest figure waves in wild hope for faraway help. The painting caused a sensation. Géricault took it to London, put it on display, charged admission, and showed it to throngs.

THÉODORE GÉRICAULT. *The Raft of the Medusa.* 1818–19. (Louvre, Paris.) [Cliché des Musées Nationaux.]

We come now to a brilliant figure with the energy of genius in a frail body. Delacroix had a brooding, misanthropic nature, and he was responsive to the painful introspective mood of his generation. He was well born, presumably the illegitimate son of the great statesman Talleyrand. He managed to lose what fortune he possessed; he lived in society, was addicted to the theater, and never married. Like Poussin he has cast a spell over succeeding French artists of every stripe. He had a typically romantic feeling for the interrelation of the arts. He was conscious of music: he loved the music of Mozart, and was a close friend of Chopin.

Eugène Delacroix (1798–1863)

Romanticism was a literary movement in France as well

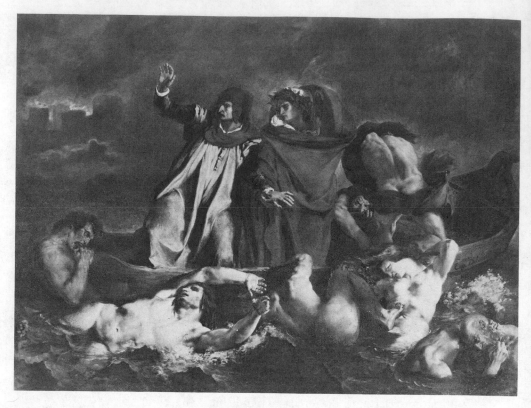

EUGÈNE DELACROIX.
*Dante and Virgil in
Hell.* 1822. (Louvre,
Paris.) [Cliché des
Musées Nationaux.]

as in England. First and foremost there was the romantic firebrand Victor Hugo (1802–85), but other poets, typically Musset and Lamartine, were romantic to the core. Then there was the romancer George Sand, female friend of Delacroix and Chopin. The times produced two exceptional critics whose subject matter was, of course, Romanticism: Sainte-Beuve and the poet Baudelaire. In this self-conscious period men nursed their wounded ambitions and wrote diaries. Châteaubriand (1768–1848), friend of Madame Récamier, was the archetype of romantic author weeping into a memoir: Delacroix himself wrote a diary that reveals both the artist and his time. In its pages we find a modern man who delved for the meaning of art in states of mind.

Delacroix looked to Rubens and the Venetians for color and action. He found romantic subjects in literature, in Dante, Shakespeare, Scott, and Byron. He was under the spell of the romantic Middle East; Napoleon had revived this theme with his ill-fated Egyptian campaign. But for a Frenchman the Middle East was also across the Mediterranean in Algiers and Morocco. Delacroix went to Morocco briefly to see for himself, and after this firsthand experience

his Islamic subjects became more realistic, but they were still theater.

He had a taste for violence, for the hunt, for the horseman attacking the lion. Such turbulent scenes recalled Rubens but in Rubens the violence of the hunt focused on the act; in Delacroix, violence tended to remain a neurotic fantasy.

Delacroix began his career with a major bid for attention in the salon, his *Dante and Virgil in Hell*. Dante and Virgil stand in Charon's bark crossing the Styx, while snarling figures alongside in the murky stream claw at the gunnel. These figures are adaptations at some remove from Michelangelo via Rubens. By curious chance Delacroix, in his pursuit of color, was indebted to Constable, who sent his *Haywain* over to the salon of 1824. Delacroix saw the painting and reworked his next major canvas, the *Massacre at Chios*. He was now ready for something with the scale and tumult of Rubens: *The Death of Sardanapalus* drew its subject from Byron.

A defeated oriental monarch is about to die on a couch which will be his funeral pyre, and his harem and steed are being slaughtered to accompany him. In keeping with this wild turmoil, Delacroix goes over into the throb of reflected,

EUGÈNE DELACROIX. *Death of Sardanapalus.* 1827–28. (Louvre, Paris.) [Cliché des Musées Nationaux.]

prismatic color. It is very mild compared to what the Impressionists have in store, and mild compared to the color of his mentors the Venetians; nevertheless Delacroix brought color back as it had not existed since Watteau.

A series of mural commissions occupied much of the rest of Delacroix's life. For all his accumulated skill, they are not his greatest works. There is something plaintive in Delacroix, a feverish wistfulness, that calls for smaller scale: it is part of his spell.

Romanticism in America

In America Romanticism was still more pervasive, part of the very culture and scene. If Romanticism meant freedom, here freedom rang; if it meant a human concern for mankind, here was democracy; if it meant an attack on the wilderness, here was nature at its wildest waiting to be discovered and tamed. In America, Romanticism meant the expansion of all dimensions, the improbable come true. It did not have to lurk in literature, it existed in life. Artists who simply drew on experience were inevitably romantic. Romanticism permeated the American nineteenth century.

We dealt with Benjamin West as a figure of the eighteenth century, but he was a forerunner of Romanticism in his historical compositions. His *Death of Wolfe at Quebec,* his *Witch of Endor,* are spectacular romantic subjects. These paintings drew attention like great films.

Washington Allston (1779–1843)

Allston came from South Carolina and lived in Boston. He was abroad for seven years from 1801 to 1808. He could paint a good portrait but he did not care to do so; instead he produced poetic scenes. In the *Rising of a Thunderstorm at Sea* (1804), he has much of the sweep and power of Turner. In the *Moonlight Landscape* (1819) he is quietly haunting. Technically, he had mastered the underpainting, the glazing, the building up of color tone characteristic of English art. But the end result is luminous rather than colorful, and this emphasis on light in place of color—sensitive gradations of light *because* color is lacking—is to be characteristic of the best of nineteenth-century American Romantic landscape. And the cool light lent itself to engraving.

John Vanderlyn (1775–1852)

As a young man, Vanderlyn was sponsored by Aaron Burr who paid for a year's study with the aging Gilbert Stuart in Philadelphia, then sent him to Paris and Rome. Vanderlyn's romantic ambitions and disappointments parallel Allston's; he too longed to create monumental paintings of history and myth and scorned portraiture. But Allston

went to London, and Vanderlyn was the first American to study in Paris, where he worked with a follower of David. Being trained on the French neoclassic side, his drawing was better than was customary, his color colder. Vanderlyn's best work, *Ariadne* (1814), was the first nude in American art.

WASHINGTON ALLSTON. *Moonlight Landscape.* 1819. (Courtesy Museum of Fine Arts, Boston, gift of Dr. W. S. Bigelow.)

With Audubon we are suddenly outside of the studio atmosphere, even free of the desire to be a professional painter. Audubon was an adventurer, explorer, and naturalist, who pitched on a wild goal and managed to reach it: his ambition was to study and depict the birds of America. His birthplace was on the island of Haiti; he was educated in France. He came to the United States when he was nineteen and traveled all over the then-known country; he made his way down the Ohio and Mississippi Rivers on a raft to New Orleans. Everywhere he observed and drew his favorite subject.

John James Audubon (1785–1851)

To find a market for his drawings he journeyed to England, and here he succeeded in bringing out a vast collection of color engravings: *The Birds of America, from Original Drawings with 435 Plates Showing 1065 Figures.* These

JOHN JAMES AUDUBON. *Passenger Pigeon.* Drawing made 1824, published 1829. (Courtesy Museum of Fine Arts, Boston.)

plates were "double elephant folio" in four volumes with five volumes of accompanying texts. The *Birds* appeared between 1837 and 1838. There were bird lovers in England to pay for all this; the plates were prized at the time and are prized to this day. They are superbly decorative, remarkable as early science and quite dazzling as art.

A young portrait painter in Philadelphia happened to see a delegation of Indians and the spectacle provided him with his life's mission. Catlin was off to the Great Plains where he lived with the Indians and painted them. He brought home a record that he saw as a memorial to a culture and race passing from the scene. He took his paintings to Europe to exhibit them as though he were a P. T. Barnum, the pioneer of the circus, or a missionary from the Indians to civilization. His paintings have their limitations, but they are brimming with vitality. His success was such that most other painters of the primeval Indian were Catlins secondhand.

GEORGE CATLIN.
A Chief of the Missouris. 1832.
(Collection of Carl Dentzel, Los Angeles.)

George Catlin
(1796–1872)

Thomas Cole Cole was born in England and came to America at seven-
(1801–48) teen, to Philadelphia, then to Ohio, and back to Philadelphia
again to learn to paint. He went abroad, first to England,
then to Italy. At twenty-eight he was considered America's
foremost painter—why not the world's? He was caught be-
tween a naturalistic rendering of the American scene and
an instinct for the Romantic allegory.

In winter he painted landscapes from sketches made in
the summer on treks through the Catskill Mountains. He was
the founder of the Hudson River School. By contrast, he
also painted epic accounts of man's fate. In his *Moses on
the Mount,* created before he left for Europe, the minute
prophet stands on a promontory in a scene for which the
Yosemite Valley in a hurricane would hardly qualify. On
his return, he produced the sequences *The Course of Em-
pire* and *The Voyage of Life.* In the former, a fantastic city
rises only to be destroyed. In its prime, in *Consummation of
Empire,* the city is Babylon, Rome, Venice—and rather like
a vision of the first Chicago World's Fair at the end of
Cole's century. In *The Voyage of Life: Manhood,* rocks,
grottoes, storms, blasted trees, and hidden streams describe
and symbolize man's brief passage through life. Such dark
meditations lit by gleams of hope sobered and fortified
Americans five generations ago. These were sermons, and
not only in paint. They were engraved and distributed far
and wide.

Asher B. Durand Engraver and then painter, Durand left a harvest of tender
(1796–1886) luminous landscapes. His *Kindred Spirits* (1849) shows
Thomas Cole and the poet William Cullen Bryant standing
John Frederick on a high rock above a mountain stream as they survey
Kensett from this vantage point the beauties of nature in the Cats-
(1816–72) kills. The painting shows, too, how remote such a vision
was from a sense of plastic form. The poet worships nature,
and nature proves to be an endless catalogue of details.

Is it enough for the artist to be simple and devout in the
presence of nature? Should he rely on himself and the wil-
derness, or should he go abroad and seek the great painters
of the past as his mentors? Nature is beautiful and at hand;
nature is her own reward. Durand belonged to the Hudson
River School; so did the more important Kensett.

The Connecticut-born Kensett carried further the qualities
of illumination without color that we met in Washington
Allston. He was trained as an engraver, which reinforced an

instinct for line and detail that was at once the charm and burden of a period. He went to England for two years, made a sketching tour across Europe, and spent two more years in Rome. Serenity is the special quality of his paintings, the mood that of a windless and luminous morning. His paintings are saturated with light. The mellow pantheism that pervades his landscapes made him the most popular painter of his day.

ASHER B. DURAND. *Kindred Spirits.* 1849. (The New York Public Library, Astor, Lenox, and Tilden Foundations.)

George Caleb
Bingham
(1811–79)

GEORGE CALEB
BINGHAM. *The*
Trapper's Return.
1851. (The Detroit
Institute of Arts,
gift of Dexter M.
Ferry, Jr.)

Of far more importance, Bingham is the natural artist triumphant, successfully self-taught. He grew up in Missouri, had a job painting signs, and went on to hack out portraits of an innocent intensity. He too went to Philadelphia and saw what had been accomplished in America to date. For a while he was painting portraits in Washington, and then he went home to Missouri. The year was 1844.

He now created a chronicle of his time and place. He shows us a river culture of canoes, rafts, boats, and trading posts; of frontier government focused on a general store— he had a zeal for local politics. He worked from drawings, putting scenes together by composing with figures that appear

as character actors. His drawing is hard and strong, and his details are held together with a remarkable breadth of vision; an atmosphere in green and rose tonalities fuses his facts as he lifts anecdote into national legend. He left behind monuments to a period that are far more than records; he caught the mood of the frontier, at once wilderness and republic.

Late in his life he went to Europe and painted in Düsseldorf, an experience that softened and clouded his reminiscent vision.

Düsseldorf and the Romantic American

London had its influence on the Americans in the eighteenth century, and so, always, did Italy. French influence was to come much later. Meanwhile, early and late in the nineteenth century, American painters were likely to go to Germany, to Düsseldorf in Westphalia. Here they found the conflict that existed elsewhere between an official classicism and a Romanticism bubbling underneath. As a compromise, local artists painted historical subjects that could taper off into the anecdote popular in America, or they could paint landscapes that resembled the Hudson River School. In 1849 a Düsseldorf Gallery opened in New York and sold Düsseldorf artists in bulk for a number of years, so the Düsseldorf practice was familiar.

Behind this German Romanticism was a painter of real merit: Caspar David Friedrich (1774–1840). His paintings of the Bavarian woods had much to offer the American painter of romantic landscape. Poles apart from Friedrich, a German-American, Emanuel Leutze (1816–68), cut a figure in Düsseldorf for his painting and teaching. He produced one of America's most famous paintings, *Washington Crossing the Delaware*. In fact he accounted for more than one *Crossing*. One, on the German side, was destroyed by American bombers in World War II.

Church has a place among the painter travelers and adventurers. He was a pupil of Thomas Cole and it is not surprising that he had an instinct for the vast, for the significance of some cosmic scene as a commentary on man. He had the capacity to master a great deal of realism, to grasp facts and set them in order.

Frederick E. Church (1826–1900)

Church had read a book that influenced him profoundly. The aging German naturalist and early traveler Alexander Von Humboldt drew on his memories of a South American journey to write his *Personal Narrative of Travels to the Equatorial Regions of America*. It was published in 1852. The book inspired Church to make two trips to Ecuador which produced such records as a view of an active volcano,

Cotopaxi (1862). He then tempered the tropics with a trip
to Labrador, and went to the Middle East and to Greece
where he painted the Parthenon: he produced a romantic
travelogue in paint.

Albert Bierstadt Bierstadt was much of an age with Church. A native of
(1830–1902) Germany, he was brought to America as a child; he returned
to Germany to Düsseldorf to learn to paint, and spent a
year in Rome. When he came home he had a chance to join
an expedition to the West that took him to Wyoming—the

ALBERT BIERSTADT. year was 1858. He moved off on his own for the summer
Thunderstorm in the and sketched in the mountains, and brought back enough
Rocky Mountains. material to keep him painting for four years.
1859. (Courtesy Mu-
seum of Fine Arts, His scenes of the West met with instant spectacular suc-
Boston.) cess. He made the wilderness his own, and his smaller
canvases are handsome and effective documents to this day.
Unfortunately his subject urged him on to the largest
scale. Such vast spectacles appeared at the time as acts of
patriotism. He was able to build a palace on the Hudson
River and lived like a prince. But he lived too long: his great
house burned, his "westerns" became a drug on the market,
and he died in difficulty. As a Romantic he came late.

Ryder is a still more belated Romantic, a solitary recluse who seemed to be living in an earlier time. Spiritually he was coeval with the transcendental New England poets, and with the Melville of *Moby Dick*. He had grown up in New Bedford, and there was something of the timeless sea in his rhythms. He moved to New York when he was twenty-one and the rest of his life was a changeless story of nocturnal brooding on the sea and on music. He made more than one trip to Europe simply for the spell of the sea that he watched over and back.

He produced profoundly haunting canvases, free of detail, reduced to a few basic components: sky, sea, land, a dark sail. His scenes were moonlit; even when his paintings were not night scenes they were hardly day. His forms reached out and found each other in dusk; he was a mystic. He remains one of America's great painters, and our greatest Romantic.

Albert
Pinkham Ryder
(1847–1917)

ALBERT PINKHAM
RYDER. *Moonlit Cave.*
ca. 1890–1900. (The
Phillips Collection,
Washington, D.C.)

THE DEVELOPMENT

OF POWER

We saw the ground laid for the Industrial Revolution in eighteenth-century England: cast-iron bridges, new roads, new canals, then railways; manufactured goods out of new factories for new towns that needed produce and fuel; cotton mills multiplying and growing larger, new looms being invented; pottery made wherever there was the right clay. More mines, as more iron and coal were needed to make and turn wheels, created a whole new unhappy life underground. Such activities made possible the larger cities and ports that lived off trade. The British population increased rapidly and soon the countryside could not feed it. Food had to be imported—in the form of grain, for lack of refrigeration.

This grain, together with raw materials, such as cotton, were paid for by manufactured exports. But grain and cotton were bulky and the manufactured exports were not. What to add to the smaller cargos in outward-bound ships? British coal. Such was the basis of British prosperity in the nineteenth century. It followed that customers for this trade, who could provide the raw materials and absorb the manufactured products, were an absolute necessity. They were the remaining colonies, for the American colonies were lost and were now competitors. Such was the British Industrial Revolution as we move from the eighteenth into the nineteenth century. The continent of Europe showed far less energy and drive.

America, meanwhile, was large and empty, and the economy had its transportation problem too. But the rivers of

New England all had their cotton mills that manufactured the raw product brought up from the South to be shipped overseas in competition with England. Cotton became suddenly cheap, thanks to the invention of Eli Whitney's cotton gin for removing cotton seeds, and in the South the growing of cotton became a slave-labor product forced and sweated.

The country now had to be developed in depth. Canals spread westward through Maryland and Pennsylvania and the Erie Canal connected the Great Lakes and the Hudson River. Railroads pushed west and steamers appeared on the great rivers as North and South competed for the new territory.

What has this to do with art? Better ask what have Classicism and Romanticism to do with iron and coal, railroads and factories, or how it could matter whether the escape was to the Middle Ages or to Greece and Rome when so much was happening to change the face of the world. Even the men of the industrial age had a new appearance to go with new habits. Colored silks and velvets, knee breeches and silk stockings were gone. All men now wore the long trousers of the workaday world. Clothes were dark and practical. Luxury appeared as a new cleanliness, and at last linen was fresh and white.

In France and the young United States, revolution had been stabilized. The people at the top had lost but those at the bottom had not won; the winners were in the middle. Business and industry had taken the place of rank and land. In England, where aristocracy survived, the new men took titles out of vanity but capitalism was their strength. The vitality lay where business, planning, and engineering were at work.

The Nineteenth Century: Forces at Work in Architecture

When we search the nineteenth century for new architectural forms we find them coming out of the new materials, iron and then steel, glass, and by the end of the century reinforced concrete. French engineers were early in producing elegant and successful iron trusses in the first third of the nineteenth century. They used them to span unsupported ceilings in large public buildings, and they had to their credit wide market sheds and theaters on a new ambitious scale. Later,

department stores needed such spans. But whatever the build-
ing, the trusses that made unsupported roofs possible were
actually bridges hidden indoors. French engineering also
created the suspension bridge—a span hung from wire
cables was thrown across the river Rhone as early as 1824
and is still in use to this day. This practical invention for
sustaining a long roadbed across space has spread all over
the world and eventually came to the rescue of some of our
larger cities, notably New York and San Francisco.

Iron and steel frames that could stand alone invited an
extensive use of glass: a building that is certainly one of the
ancestors of our own steel office buildings with their hanging
glass walls was a large municipal greenhouse built in Paris
in 1833 in the Botanical Gardens. The glass cage made
possible the new buildings for world's fairs, a nineteenth-cen-
tury phenomenon then largely associated with Paris. Since
these structures were temporary they escaped challenge from
a conservative taste. They had to house vast crowds, and they
became forcing beds for new engineering experiments.

By exception, the building in this kind that was a structural
revolution in itself was British: the early and enormous
Crystal Palace built for the Great Exhibition of 1851 held in
London. Prince Albert, the consort of Queen Victoria, was
the driving force behind this whole endeavor: it was his hope
that this international event would introduce an era of
world trade and world peace.

The Palace was designed and built by Joseph Paxton, a
landscape gardener who had constructed greenhouses, and
it was nothing more nor less than a greenhouse on a tre-
mendous scale. The building was 1,851 feet in length, a num-
ber deliberately identical with its date. It had a ground area
of 800,000 square feet. The remarkable aspect of its con-
struction was the fact that it was prefabricated. The thousands
of glass units of which it was made were farmed out to
factories all through England and assembled at the site. A
building far larger than a cathedral was erected in a matter
of months.

America was not far behind with its own Crystal Palace
Exhibition in New York in 1853, and then came the Uni-
versal Exhibition in Paris in 1855 with its great arched halls,
only to be outdone by the Paris fair of 1867, just before the
Franco-Prussian War. Finally we come to the Paris Inter-
national Exposition of 1889, with a gallery for machinery
some 1,378 feet in length that had a span of 377 feet, a

prodigious cage of glass. The most spectacular structure in this exposition was the Eiffel Tower, which still stands. For half a century it remained the tallest structure in the world. The engineer, Eiffel, was a great builder of bridges, and his tower was a vertical bridge to nowhere, to the future. Most of these buildings are long gone, but a more permanent by-product of these experiments was the semicircular glass roof employed as a railway terminal, a practical design that was to spread around the world like the suspension bridge.

Among all the products and patent devices at the New York Crystal Palace Exhibition was a contrivance destined to revolutionize the appearance of cities, the work of Elisha Otis. It was only a platform hoisted by a rope between verti-

JOSEPH PAXTON. *Crystal Palace, London.* Engraving. 1851. [National Monuments Record, London.]

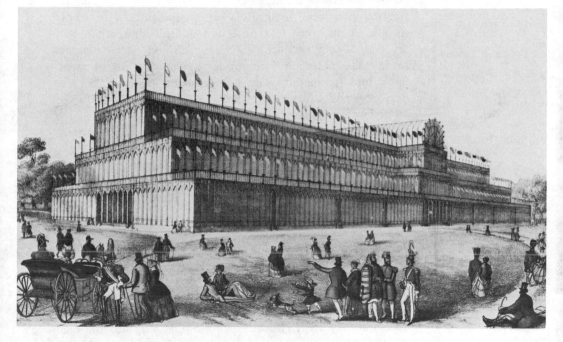

cal tracks, but it had a built-in safety device. As Otis was lifted above the heads of the crowd he called to a man to cut the rope with an axe. Two hooks flew out to prevent the fall of the lift and Otis called, "All safe, gentlemen." The elevator was to enlarge horizons and to allow a concentration of population never seen before.

At this time another American named James Bogardus became spellbound by cast iron and undertook to cast the whole outside of buildings. He did it successfully. Almost all of these pre-elevator iron buildings have disappeared, but a

few still remain on the waterfront of Saint Louis. They had vaguely classical designs and made possible an increased amount of glass.

Wood, Stone, or Steel

Chicago, the modern city, had been the scene of a new radical design that was to make possible thousands of new American wooden houses. The balloon frame is credited to George Washington Snow of New Hampshire, although there are other claimants. It came into use about 1830 and it serves for wooden house construction to this day. Previously houses had been framed by mortising sills, plates, and heavy horizontal beams into corner posts equally heavy. Balloon framing introduced light studs set close together, the whole thrown up in much less time and at little more than half the cost. The procedure was dependent on cheap factory-made nails that came into production at just this moment. Snow took his method with him when he moved to the site of what is now Chicago.

A few years later, and Chicago was to be the scene of a struggle between fact and appearance between the new steel structure that was engineering and a surface of stone, brick, terra-cotta, and glass that clothed the steel and called itself architecture. The high-rise buildings, or skyscrapers, which first appeared in Chicago—not New York—in the 1880s, brought this problem or conflict to the fore. The early skyscrapers were successfully designed, with structure and surface accepting each other. But with the coming of the first World's Fair, this logical development was all but forgotten. Spurious detail, classic or Gothic, dressed up the new buildings, or perched on their summits. Richardson, the Chicago architect, had died before the coming of these vagaries in taste, but they badly afflicted his followers, Sullivan, and then Wright.

Henry Hobson Richardson (1838–86) The American architect who maintained the integrity of masonry—asking stone and brick to do what they appeared to do—was Henry Richardson. He was a Southerner who found himself at Harvard unable to return home at the opening of the Civil War. He went to France where he studied architecture and fell under the spell of the Romanesque. To Richardson this rugged early architecture was right for a rugged new country, and he brought the style home with him.

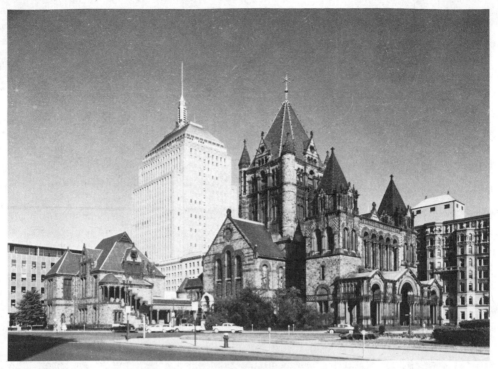

He achieved a major Romanesque monument in Trinity Church in Boston (1872–77), and other less imposing buildings in this style came from his drawing board. Then he moved to Chicago where he built the Marshall Field Warehouse (1885), an adaptation of the Romanesque to modern commerce. This structure, which no longer exists, was much admired by his fellow architects as an honest statement. Here, almost for the last time, a commercial city building on a block-large scale was exactly what it claimed to be, a masonry structure held up by its own walls.

HENRY H. RICHARDSON. Trinity Church, Boston, 1872–77. [Sandak.]

This Romanesque revival did not die with Richardson; instead we have the spectacle of the persistence of a form once it is brought to life. During Richardson's last years in Chicago the young Louis Sullivan was employed in his office, and Sullivan, a greater architect, adopted Richardson's Romanesque. He did so in spite of his own architectural philosophy, for his contribution was in the logic of his construction. No matter, Sullivan was in love with the low Romanesque portal with its semicircular arch. And this was not the end. An architect still greater than Sullivan, Frank Lloyd Wright, was working as a young man in Sullivan's office, and he too found a use for the low, round arch of the Romanesque.

Louis Sullivan Sullivan's name is associated with the skyscraper. It must
(1856–1924) be said at once that he did not invent it. No one did. Chicago
was ready for this development. All the ingredients were
assembled: steel, glass, concrete, and the elevator, as well as
a dense population and high real estate values. Chicago had
a whole galaxy of creative architects at this fortunate mo-
ment. William LeBaron Jenny was one of the forerunners
with his Leiter building of 1879, and his more advanced
Manhattan building of 1891. Then there was the famous
firm of Burnham and Root with its Monadnock building, also
of 1891, and Holabird and Roche with the Marquette build-
ing of 1894. These structures with their grids of masonry as
mere frames for glass grew increasingly open. Walls, "curtain
walls," no longer supported the building, and the glass itself
developed into the "Chicago window," a composite consist-
ing of a large fixed pane with narrow panes on either side
which could swing. On occasion this was designed as a bay
window, a step forward into space and light carried almost
to the modern ultimate in the Reliance building of 1894.

In the midst of all these advances, Sullivan was one
builder among many, but he gave the skyscraper form. The
weakness of skyscraper design then as now was the indef-
initeness of the height; tall buildings could be pulled longer
like licorice. Sullivan conceived of a building that had the
qualities of a classical column. It had a horizontal base, a
shaft or rise in which the lines move vertically, and a capital
or cap sustained by some form of ornament. The result was
a building simple yet varied, with strength and a structural
logic about it. It came into existence as the Wainwright
building, not in Chicago but in Saint Louis. Other Sullivan
buildings followed with a similar stamp of finality upon them,
but in the Wainwright Sullivan came up with a complete
architectural idea.

At this point we have suddenly reached the peak and end
of the whole native adventure in skyscraper design. The
first Chicago World's Fair, that of 1893, appeared as a
series of neoclassic temples surrounding an artificial lake,
thanks to the influence of the Academy of Fine Arts (Beaux
Arts) in Paris. The earlier world's fairs in Paris had offered
opportunities for experiment; this was a turning-back of the
clock. Seductive appearance had won out over the logic of
design. Architecture ceased to be a problem to solve and
became once more a choice of styles to imitate regardless
of the supporting structure.

Sullivan, almost alone now, maintained the integrity of his vision. The triumph of his development was the Carson, Pirie, Scott building (1889–1904), a department store in Chicago. Here the same logic produced a different solution. The base, wall, and cap remained; the surface was a simple grid framing Chicago windows, but the building is relatively low and the composition is horizontal. The level lines of the grid now carry heavier accents than the verticals, providing stability, for a department store is not a skyscraper.

Sullivan was the victim of inner conflicts (as we would now

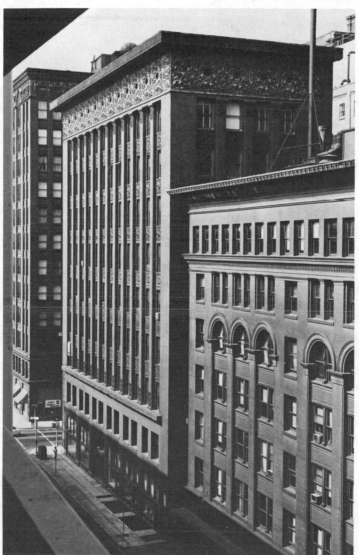

Louis SULLIVAN. Wainwright building, St. Louis, 1890–91. [City Art Museum, St. Louis.]

say), and if he was an intensely logical builder, he had a
Celtic poetic streak that overlaid the logic with curious, highly
personal decorations in bronze or iron, abstract designs drawn
with a compass or based on floral motives. This tangled over-
growth resembles the Irish Interlace, but it can be associated
with an exuberance of personality: in his latter years Sullivan
was neglected and disappointed, and became an alcoholic.

Defensively, he wrote a book, *The Autobiography of an
Idea,* that consolidated his accomplishments. He reduced
the theme of a life's work to three famous words, "Form
follows function." This simple and logical idea, even this
phrase, was not original with him, but he acted upon it and
made functionalism his own.

If we must leave Sullivan waiting for the return of better
days that he was not to see, it is all the more tempting to
reach for the name Frank Lloyd Wright as our next heading,
for Richardson, Sullivan, and Wright were a dynasty in
American architecture. But Wright will lead us deep into the
twentieth century, not only in his life span but in his
thought. A concern with the structure of the new city archi-
tecture has carried us too quickly into modern times. *Struc-
ture* is a twentieth-century word; the corresponding nine-
teenth-century word should be *surface.* We must pause, and
turn back.

The Surface of America

We stressed at one point the length of time that America
remained rural; a city culture was hardly to be trusted—a
city man was a city slicker. America as a countryside was
full of wooden houses, two-story, stove-heated boxes with no
more engineering to hide than balloon framing. There was
no new house to correspond to the new office building; the
choice of appearance remained strictly between older styles,
and we must look with gratitude at the late eighteenth- and
early nineteenth-century Greek Revival that followed happily
on the Colonial. Its whole intention was, of course, to adapt
and imitate, but we have to be grateful for simplicity. As
Greek architecture became the subject of archeological ex-
amination, the Greek was seen as the *pure* classic, and
Greek Revival buildings, public or private, large or small,
were very pure indeed. In America these smooth-sided
white buildings seemed simple even compared to the Co-
lonial, and yet they could join forces with the stately planta-

tion style of the Deep South. The alternative was a steep-gabled Gothic with scrollwork fascia boards along the overhang, or Italianate villas with capped roofs, or no style at all with trimmings of mill-work moldings with neither a past nor a future.

If we look indoors in the nineteenth century we are surprised that the exteriors could remain so plain. Interiors were choked with new cheap products that clamored to be seen. It was the age of ornaments, and the typical piece of furniture to display them was the whatnot, a triple-deck mahogany stand with a curved front leg and mirrors in the back. Here stood the precious objects, mostly china, that only the most trusted person could dust. But dust did not matter much, the draperies were so heavy, the carpets were so deep, the "real" oriental rugs were so mottled. Furniture was heavily upholstered, chairs were as fat as beds, and tassels and fringes hung to the floor. The style was covered by the name Victorian. Better furniture was black walnut or mahogany intended to reproduce Louis XV with its flowing curves; but subtly or blatantly it missed the elegance of Louis XV and was rather dumpy, bulging in the wrong places like the ladies who sat on these things.

It was a time not of distinction, but of accumulation.

THE SECOND HALF OF THE NINETEENTH CENTURY: PAINTING IN FRANCE

All through the nineteenth century, popular taste equated the ornament on the mantel with the anecdote on canvas— art was a silent literature. The photograph had arrived, but not the film. However, in France, where a great art period was in the making, the serious painter began to look with a fresh eye at a new, variegated world. Romanticism versus classicism no longer held his interest. He sat down to paint neither legend nor story nor myth, but arresting fact.

He was, to be sure, a little cautious in his choice of fact. For a long while he lingered over the old familiar environment that nature offered. All through the nineteenth century landscape was his laboratory.

A group, the "men of 1830," set out into the countryside and chose a landscape some sixty miles southeast of Paris near Fontainebleau. Here was the village of Barbizon, and here they painted old oaks and grazing herds and flocks. They became the Barbizon School. Théodore Rousseau and Charles-François Daubigny, to name only two, share a certain humility in the presence of nature, with recollections of the Dutch landscape painters still fresh in their minds. Their canvases seem rich, solid, and innocent, and above all dark. They could not know that a luminous Impressionism would bring in color and the light of day. They were seeing landscape before dawn.

Jean Baptiste Camille Corot (1796–1875) A painter of far greater importance, Corot shared the humble rustic philosophy of this Barbizon group. As unas-

suming as Constable, he went his solitary way content with a pearl-gray or white-gold atmosphere. His early landscapes have a disarming integrity. He takes us on a trip to Italy in small canvases mellowed with parched ground and the warm brick of ancient buildings. Such simple factual studies are among his finest works. As his other great accomplishment, he painted figures, studies of young women that are modeled like sculpture in a gray light. Their silvery aspect is related to photography—one more instance of a new concern with objective scientific fact.

Finally, Corot took a step backward into Romanticism. He developed a pastoral mythology, typically scenes of woods, pool and nymphs, a world of smoky foliage in a watery atmosphere. These moist paintings are monotonously alike

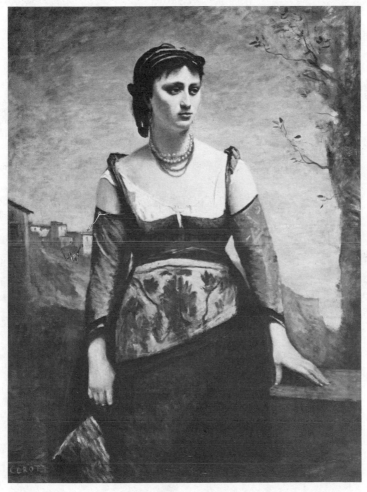

JEAN BAPTISTE CAMILLE COROT. *Agostina.* 1866. (Courtesy of the National Gallery of· Art, Washington, D.C., Chester Dale Collection.)

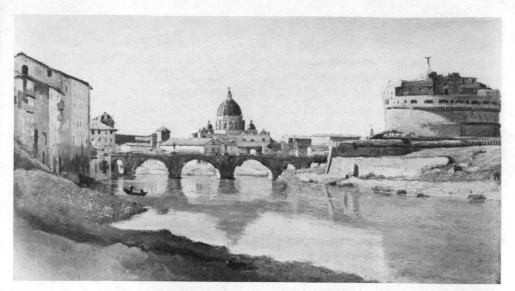

JEAN BAPTISTE
CAMILLE COROT.
*View of Rome: The
Bridge and Castle of
San'Angelo with the
Cupola of Saint Peter's.*
1826–27. (The Fine
Arts Museums of
San Francisco, The
Palace of the Legion
of Honor, Collis P.
Huntington Memorial
Collection.)

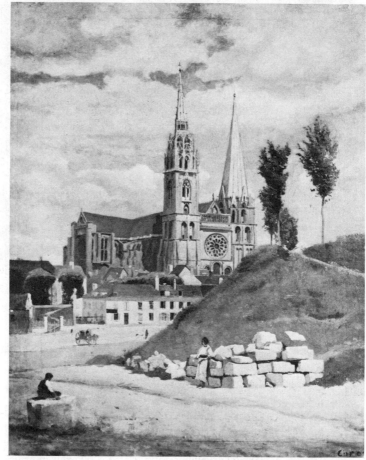

JEAN BAPTISTE
CAMILLE COROT.
Chartres Cathedral.
1830. (Louvre, Paris.)
[Cliché des
Musées Nationaux.]

and they soon became monotonously sought after, a pleasant change for Corot, for his parents had supported him until after he was fifty. For a long time these pastorals *were* Corot; only later was he discovered through his earlier canvases and through his figure pieces to be a clear and great painter.

JEAN FRANÇOIS MILLET. *The Angelus.* 1859. (Louvre, Paris.) [Cliché des Musées Nationaux.]

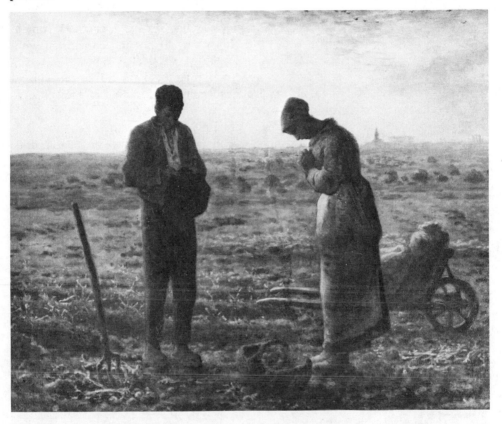

Millet was even closer to the Barbizon painters. He came from Normandy, from a peasant background, and took the worker in the fields as his subject matter. He too chose Barbizon, where he spent the rest of his life.

Jean François Millet (1814–75)

He was a powerful draftsman, with a plastic, shaded drawing which had arrived with photography, as opposed to the outline drawing which recalled the eighteenth century. His paintings of sowers and reapers were to become famous, and *The Angelus* became the most famous of all.

Realism

Gustave Courbet
(1819–77)

It remained for Courbet to coin the term Realism, which made him one of the few painters to come up with his own label. For Courbet, reality was simply what he saw, no more, no less. He said if anyone showed him an angel he would paint it.

Courbet had a sensuous feeling for experience. He was a naive man with little philosophy to put in competition with appearances. He had a healthy, physical response to nature; he came from a wealthy farmer background in the village of Ornans in eastern France in the foothills of the Alps, a countryside he was often to paint.

Showing existence precisely as he saw it, and above all admitting that this was his aim, made for rejection and trouble, for critics protect their own views. The artist's colossal egotism made him all the more vulnerable to ridicule and attack. When his paintings were refused at the Universal Exposition of 1855 in Paris, he hired a building opposite the fairgrounds and hung up his own exhibition of "Realism" that was roundly condemned by critics and public alike. The most famous canvas that he showed was his *Burial at Ornans* (1849), a twenty-foot representation of a country funeral. Everything was found unacceptable about this painting: the fact that common men were presented on a heroic scale, the spectacle of routine unconcern rather than grief, the crude clumsy figures of the country people, the prominence of the grave diggers. Actually it is a masterly and sober report on

GUSTAVE COURBET.
Burial at Ornans.
1849. (Louvre, Paris.)
[Cliché des
Musées Nationaux.]

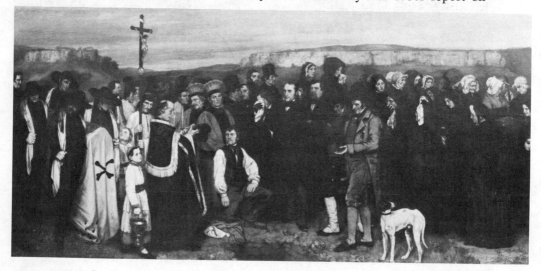

mortality. The composition is a band of verticals, of standing men and women in black, and the long frieze is tied together by the high skyline of white-gray cliff typical of his home countryside. In such a painting Courbet was paving the way for the novels of realism, for a view of the world in which science and fact are accepted and myth and illusion renounced.

His other famous painting is his large *Artist's Studio (A Real Allegory of Seven Years of My Artistic Life)*. Here he is seen at his easel in the midst of a numerous throng, presumably gathered to pay him homage or to watch him paint. A nude model stands beside the artist as though she were his muse. On the right side Courbet has packed in the celebrities he had come to know through his talent—the poet and critic Baudelaire is seated in the right-hand corner. These people are quite distinct from the crowd on the left, representatives of the common humanity that drew his sympathy. According to the painter, those on the right are here to live, those on the left, here to die. The circumstance is, of course, impossible, however realistically painted, and thus a complete denial of his theory, but egotism demands its own myth.

Courbet created splendid nude figures. Rich and sensuous, their flesh glows in the Venetian manner. An alternative to this posed studio painting, his landscapes have a factualness in heavy paint that lives like thick foliage. He had a feeling for light filtered through trees, an awareness not only of green but of all the tones of competing greens, all the forest's subtleties. Paintings that include game and hunting dogs in this woody life are especially fine. He also painted sea and surf in canvases that pack power; but he knew the hills better than the sea.

Courbet finally won the battle of Realism and he became famous. His identification with the common man led him to fancy himself as a social philosopher and disaster overtook him when he became enmeshed in politics at the time of the Franco-Prussian War of 1870. The immediate sequel to the defeat of France was the establishment of the Commune in Paris, a preview of a socialist state that was doomed at the outset. Courbet was involved when the bronze column that Napoleon had erected in the Place Vendôme (in imitation of Trajan's Column in Rome) was thrown down, and he received the blame for this act of sabotage. When the government was restored he fled to Switzerland to escape

GUSTAVE COURBET. *Rock of Hautepierre.* 1848–50. (Courtesy of the Art Institute of Chicago, Emily Crane Chadbourne Fund.)

arrest. The entire cost of re-erecting the column was charged against him, an impossible sum to meet, and the paintings he had left behind were confiscated. It was a blow from which he never recovered.

The great apostle of Realism simply brought in another kind of illusion, the illusion that reality is a surface. Yet Courbet had not only a sense of things seen, but of things touched, of tactile qualities. Presumably he was the first to paint with a palette knife.

Honoré Daumier (1808–79)

With Daumier we come closer to modern times. He was a cartoonist, a newspaperman. He looked out at the tradesmen and shopkeepers around him, the citizens of a Paris that was a nation within itself. He recorded and caricatured the world of middle-class pretensions, the rapacity of doctors, the venality of lawyers. He had an eye for the nameless collectors who cull through portfolios of prints, the haunters of bookstores, and the old men who play chess. He showed us the restless, cosmopolitan mind that was the very life of the city.

He was born in Marseilles in the south of France and was brought to Paris when he was eight. He grew up ap-

prenticed to a lithographer—the lithograph was then a new method of printmaking, a printed drawing—and lithography became his language. He began as a political cartoonist at the time of the middle-class Revolution of 1830 that brought in Louis Philippe, the "Citizen King." The new regime was not as liberal as Daumier supposed, and he was jailed for half a year for one of his cartoons lampooning the king—which taught him to turn from politics to social satire.

His lithographs have a directness, freedom, and power that go over into the grotesque to make a point. His expressive free handling somehow resembles the free brushwork of Fragonard. Daumier wished to be a painter and sculptor but the endless demands of his journalistic career held him back. By 1848 (at the time of the next revolution) he attempted to find an audience for his paintings but he met only discouragement. In his old age he made a final break with cartooning and gave himself over to painting with no financial success at all. Most of his great paintings, including *The Third-Class Carriage,* were done in the short period between 1860 and 1863. He would have starved but for his

HONORÉ DAUMIER. *The Third-Class Carriage.* ca. 1862. (The Metropolitan Museum of Art, New York, bequest of Mrs. H. O. Havemeyer, The H. O. Havemeyer Collection.)

friend Corot, and he lived in the retirement of poverty out-
side of Paris.

His paintings have his usual bold freedom. They deal with
his familiar subject matter: a washerwoman at the river
embankment, a barker at a circus, rioters in the city. He
painted Cervantes' *Don Quixote:* in these canvases the gaunt,
mad Don and his squat attendant Sancho Panza become
grotesques—but grotesques as states of mind.

He looked at humanity with compassion in spite of carica-
ture. His overview of human nature brought him as close to
the great novelists of his time as he was to his fellow painters.
He was one of the masters of the great French century.

Edouard Manet Manet was almost a generation younger than Daumier. He
(1832–83) belonged to a whole cycle of major artists born in the 1830s
and 1840s. In his early phase Manet owed a debt to Cour-
bet, and a greater debt to the Spanish masters, especially to

EDOUARD MANET.
*Picnic (Déjeuner sur
l'herbe)* 1863. (Jeu
de Paume, Paris.)
[Cliché des
Musées Nationaux.]

Velasquez. What the Spaniards had to offer him was an over-
whelming factualness and a palette dependent on black. The
great Spanish painters were not easily seen in Paris, but they
were not unknown. There was a vogue for things Spanish in

the 1830s, and by the time it had died down the Emperor Napoleon III married the Spanish Eugénie, so the vogue returned.

Manet simplified the Spanish factual vision to produce a bold personal style that denied the convention of a detailed scene in the graduated light and shadow of the studio. He

owed a debt to photography: his flat underexposed vision allowed a few simple facts to overwhelm, and for this he was vilified until almost the end of his days. He spent his life being rejected by the juries of the official salon.

EDOUARD MANET. *A Bar at the Folies-Bergère*. 1882. (Courtauld Institute Galleries, London.)

The first fruits of this procedure were two early masterpieces, his *Picnic (Déjeuner sur l'herbe),* and *Olympia*, both of 1863. The *Picnic* was refused by the salon and appeared in a Salon for the Rejected that Napoleon III ordered into existence, where it was singled out as an object of ridicule. The nude woman with two clothed men in a relaxed country setting is much in the mood of Giorgione's *Picnic (Fête Champêtre)* in the Louvre, and actually owed its composition to Raphael, but no matter, Manet's canvas had an im-

mediate impact that shocked. So had *Olympia,* who was neither a goddess nor a nymph but a recognizable nude woman accepting a bouquet brought to her by her maid.

By degrees Manet became involved with the contemporary Impressionists and lightened his palette. He spent the decade of the 1870s painting Paris as a passing scene. His late masterpiece in this vein is *A Bar at the Folies-Bergère.* Here the barmaid, in her glittering territory, is observed with the detached vision of the man about town. It is interesting that the scene is factually impossible for all its literalness: the girl could not show in the mirror behind her as we see her reflection; nor could the man, presumably the onlooker, nor could the bottles be reflected as they are. Manet worked in his studio in a one-to-one relationship with each object. He pressed reality against the eyeball, and doubtless this contact, this immediacy, was one of the reasons he was so furiously resisted.

IMPRESSIONISM

AND RODIN

The last thirty years of the French nineteenth century brought into focus a whole new way of seeing. The change affected everything before the artist's eyes: landscape, cityscape, still life, and man. The artist went beyond this total environment as subject matter; he painted the intervening light and air. As this translucent vapor became his real concern, he grew at home with the intangible, and painting grew subjective as atmosphere became mood.

It began quite simply. A group of young painters who were studying together as students in a studio in Paris found themselves exploring color and painting in a lighter and lighter key. This was not an accident. It coincided with a new scientific awareness of the prismatic nature of light that suggested that colored lights could be separated and combined as well as pigments. A red and a blue stroke set side by side created purple at a distance, a far brighter purple than if the paints were mixed. In effect the colors were mixed, but they were mixed in the air. This procedure led not only to a new illumination, it led to animation: the whole canvas began to vibrate.

We do not have to look far to find a circumstance in nature that invited this dappling of paint. The Impressionists found it in the reflections in water, shimmering river water in gentle motion that broke up the color reflected from a bank above. Small towns on the Seine near Paris, Chatou, Bougival, where artists painted in the summer, provided just such color-scattering effects.

But do we *ever* see anything other than spots of colored light? Our optic nerves respond to light waves, experiencing various colors as those waves are longer or shorter; if the waves are too long or too short, we see nothing. In painting colored light the Impressionists believed themselves to be scientists. Just at this moment new bright chemical colors were becoming available: piercing yellows, purples, reds, and greens replaced the dull old colors of earth.

Yet this surrender to colored light destroyed, in principle, all the art that had gone before. Suppressing edges and boundaries destroyed objects. It was as though the artists had no lenses in their eyes and could recognize nothing. If the Impressionists did not go this far, they saw like lovers: a blurred soft focus captured the throb and glow of life.

Impressionism, being a way of seeing, the work of an organized group, was a composite. The Impressionist painters have a strong family resemblance. Hostile criticism held them together, and they put on group exhibitions every few years through the 1870s and 1880s, exhibitions that were milestones on the road to modern times. Little by little the contempt and derision that greeted them subsided and color and light began to win their way. One painter and then another was accepted and eventually venerated, and such justification had to compensate them for a neglected life.

From the oldest to the youngest the Impressionists were all within a generation, and many were much of an age. Claude Monet, born in 1840, was the central figure and pioneer. His name must at once be bracketed with Alfred Sisley, one year older, and Camille Pissarro, ten years older (b. 1830). Paul Cézanne, who began as an Impressionist, was one year older than Monet and the same age as Sisley. Among Impressionists at one or two removes, Edgar Degas (b. 1834) was six years older than Monet, and Pierre Auguste Renoir was one year younger (b. 1841). The American James McNeill Whistler was the same age as Degas; Mary Cassatt, American friend of Degas, was born in 1845. Not since the Renaissance had so much talent been brought so close together. In only a few years came the Post-Impressionists' names: Paul Gauguin (b. 1848), Vincent van Gogh (b. 1853), Georges Seurat (b. 1859), and Toulouse-Lautrec (b. 1864). The sculptor Auguste Rodin (1840–1917) adds to the splendor of the time.

Monet, born in Paris, grew up at the port of Le Havre, and here when he first began to paint he knew the gifted painters of shore and harbor scenes, Jongkind and Boudin. They were of Corot's generation; and their canvases, even when sunlit, were pearl gray. Monet was to go forward from their cloudy day and capture sunlight.

The young man went to Paris to study, met Courbet, and came to know as fellow students Renoir and Cézanne, and then Sisley and Pissarro were in the group. They gave each other courage, but Monet was the furthest out into an external environment, and the least confined to the studio. Monet's shadows in the sun were real color, not mere dimness. The surface was broken everywhere into a mosaic of separate strokes and vibrant touches. The name "Impressionism" came from a hostile critic's derisive reference to a Monet painting of 1872, *Impression: Sunrise,* a watery scene drowned in mist.

In *La Grenouillère* (1869) (The Frog Pond), everything now takes on the same ripple of wateriness. In his *Gare Saint*

Claude Monet
(1840–1926)

CLAUDE MONET. *La Grenouillère (The Frog Pond).* 1869. (The Metropolitan Museum of Art, New York, bequest of Mrs. H. O. Havemeyer, The H. O. Havemeyer Collection.)

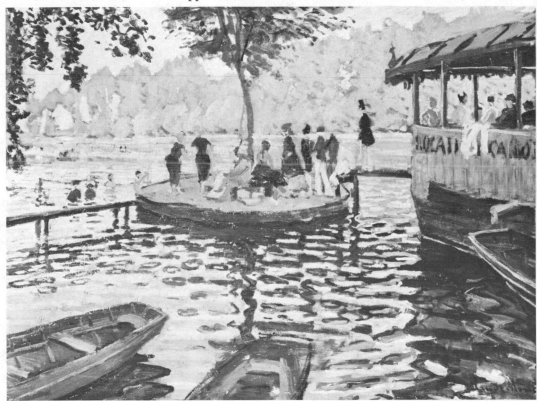

Lazare (1887), a railroad station in Paris, the new train shed
is no more than a container for smoke. With this dissolving
of subject matter, this expanding of quiver and blur, Monet
becomes a painter of optical experience. He made this clear
in paintings in series, the same subjects repeating themselves
under different lights, poplar trees by a river bank, hay-
stacks, and then the façade of Rouen Cathedral, a late
Gothic surface of infinite detail impossible to render except
in generalizations. All these renderings changed radically
with the time of day, with effects of sun or shade or dusk.
And toward the end of his life came the *Water Lilies* series.

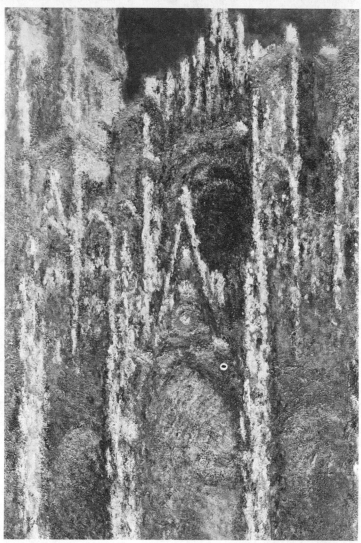

CLAUDE MONET.
*Cathedral of Rouen,
Sunset.* 1894.
(Courtesy Museum of
Fine Arts, Boston,
bequest of Hannah
Marcy Edwards, in
memory of his
mother, Juliana
Chesney Edwards.)

They were painted at his home in Normandy where he could finally afford a Japanese garden with its lily pond. We look down on green smudges for lily pads, lavender reflections of hidden trees, and the punctuation of floating blossoms.

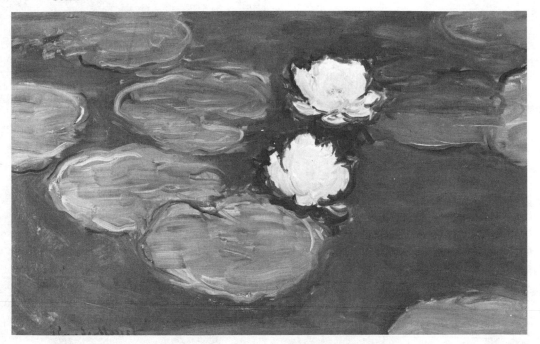

CLAUDE MONET. *Water Lilies.* 1905–07. (Los Angeles County Museum of Art, bequest of Mrs. Fred Hathaway Bixby.)

With the coming of atmosphere a painting became a window, an outdoor event that competed with the reality of the room; and finally Monet felt the need to blot out altogether the architecture and frame, and to allow nothing to exist but the all-engulfing scene. His late canvases of water lilies were now a half-circle, or even a full panorama creating a transcendent total experience.

By the 1920s Monet appeared as a survival from the nineteenth century. No one could foresee that this struggle to make painting an uninterrupted reality, drowning all architectural borders, was opening the theme of the late 1940s and 1950s, when his late water lilies paintings—the ultimate in representation when they were painted—were recognized as forerunners of those loose gestures in swimming paint called Abstract Expressionism.

Monet had a long life. In French artists we often find a heartening spectacle: a man stubborn in poverty and detached in success, his lifework calmly fulfilled.

Alfred Sisley
(1839–99)

Sisley greatly resembles Monet. It is like the family resemblance between a gifted relation and a great man. Both men used the same technique in recording the same subjects. No one can blame the Impressionists for resembling each other; they believed they had discovered the truth behind appearances. Sisley reminds us that they worked as a group.

Camille Pissarro
(1831–1903)

Pissarro shows less dependence upon Monet. At one point in his life Pissarro went beyond Monet's Impressionism to translate light into a vibration of its color elements. We shall soon come to this deliberate technical venture, Pointillism, with its fabric of colored dots, that Pissarro took over from another master, Seurat. But then Pissarro fell back on Impressionism. Among his associates he appears as a kindly parental figure, a humanist with a sensitive eye and a gifted brush.

PIERRE AUGUSTE
RENOIR. *La Loge.*
1874. (Courtauld
Institute Galleries,
London.)

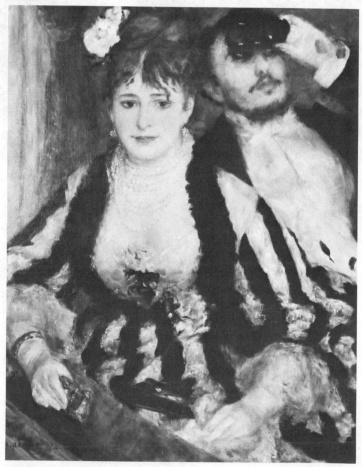

The Impressionism with which Renoir began underwent changes as he strove for form, but all his life he was faithful to a single subject, woman. In the early *La Loge*, the opulent woman's figure takes over the canvas. Impressionism brings an engaging sensuality to the relaxed *Boating Party* of 1881. But now Renoir made a trip to Italy and experienced the formal solemnity of the great Italians. When he came home he undertook to discipline himself and for a while his painting seemed to be colored statuary; he even built paintings out of historic sculptures as in his *Bathers* of 1884–87.

Pierre Auguste Renoir (1841–1919)

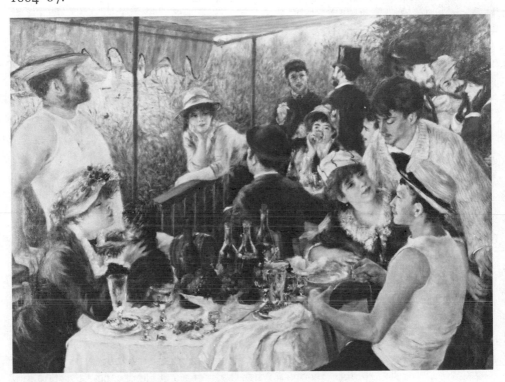

From now on he strove for a synthesis between form, color, and atmosphere. He translated form into massive symbols of the feminine, and his late nudes become overpoweringly maternal. At the same time his color grew symbolic. These late figures are of a deep rose color brimful of their blood, while their outdoor plant environment becomes a complementary green. At times rose-colored stems radiate out into this greenery as though they were arteries nourishing the whole canvas from a central throbbing heart. There are admirers of Renoir who see only the Impressionist paint-

PIERRE AUGUSTE RENOIR. *Boating Party*. 1881. (The Phillips Collection, Washington, D.C.)

PIERRE AUGUSTE
RENOIR. *The Bathers.*
1884–87. (Philadelphia
Museum of Art, Tyson
Collection.)

ings and put out of their minds these later symbols of flesh and earth. Others see these late paintings as his greatest. They are immensely human myths, and Renoir wrapped them up in themes of mythology.

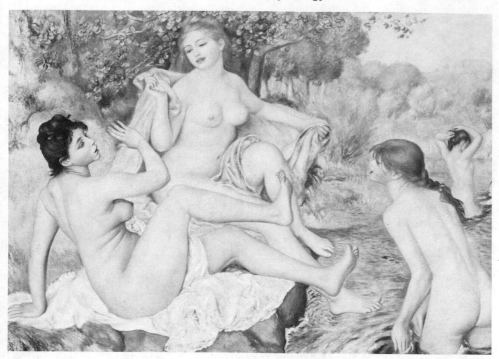

Edgar Hilaire
Germain Degas
(1834–1917)

Degas associated himself with the Impressionists, exhibited with them, and borrowed and developed Impressionist effects of light. Yet in many ways he represented a point of view at the opposite pole from Impressionism. He was a traditionalist at heart. He was a great draftsman, an admirer and follower of Ingres. The Impressionists dissolved drawing; all Degas did was to soften his edges. He was an indoor painter. When he painted a landscape he sat in his studio with his back to the light, and when he painted a woman on a beach the model actually sat on his camel's hair vest on the studio floor. His whole mood was counter to that of the Impressionist confraternity. He was aristocratic in his tastes and background; he had private means; he seems to have disliked most men and more women.

Yet he possessed great resources. He had the detached vision of a scientist and his studio was his laboratory. He was a photographer. His rather candid-camera compositions draw on the old masters, photography, and the off-center,

clean-line effects of the Japanese print that was just beginning to exert an influence in the West.

Degas had perfect taste as a musician can have perfect pitch. While still a young man he painted a series of great family portraits, of his father and of his Italian relatives. After this his art was segregated in themes. In the late 1860s and 1870s he devoted himself to racetrack paintings: horses, jockeys, silks and blankets, seen against soft green landscape. This is not really Impressionist painting, it is toned drawing. The remarkable new feature is his capturing of the movement of the horse. Before the invention of the camera, the motion of a horse was only visible when one movement was arrested and another about to begin, the legs far out front and back like a hobbyhorse, or all four feet together like an image of the pony express. Degas had the skill to seize the actual motions in all their immediacy. He had a gift for gesture, human or animal, fast or slow.

EDGAR DEGAS. *Carriages at the Races.* 1872. (Courtesy Museum of Fine Arts, Boston, Arthur Gordon Tompkins Residuary Fund.)

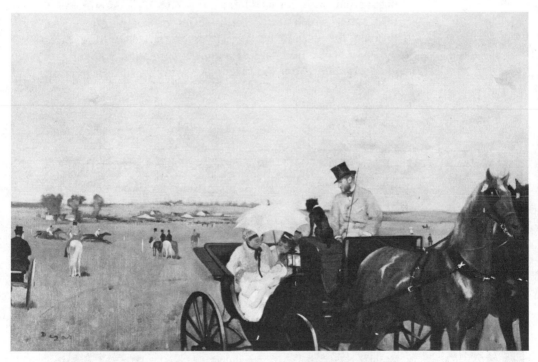

In the 1870s he turned to still more specialized subjects, the opera and the ballet. In place of racehorses milling around, young girls are practicing at the barre, but Degas' interest was much the same. The evanescent quality of the subject turned him to a softer, more brilliant and instanta-

neous technique, from oil to pastel. Lighting in the theater was very different then; the hard stimulus of electricity had yet to arrive and gaslight was more mysterious.

Then came the endless bathers, not sylvan nymphs but women enjoying the ritual of the bath attended by a maid, or reduced to scrubbing themselves. Degas, the invisible bachelor, is not exactly contemptuous of his models, but neither is he tender. He is like a doctor who cares for research, not for his patients.

In his old age there is a change. His subjects, ballet dancers again, remain the same, but the scale increases to near life size, and the pastel color is suddenly resplendent. He comes close to his subjects at last, close enough for them to blur, to be out of focus. He seems to have outlived the dread of women. So sensuous a taste, so late, has its pathos. Eventually he went blind.

Degas was also a sculptor, a fact that underscores his preoccupation with form. Understandably, his sculptures fall into series which parallel the series of his paintings. All through the decade of the 1870s he modeled little racehorses. These objects are of a superb animation and subtlety of observation. After the racehorses, with his shift in interest,

EDGAR DEGAS. *The Rehearsal.* 1878–79. (Copyright the Frick Collection, New York.)

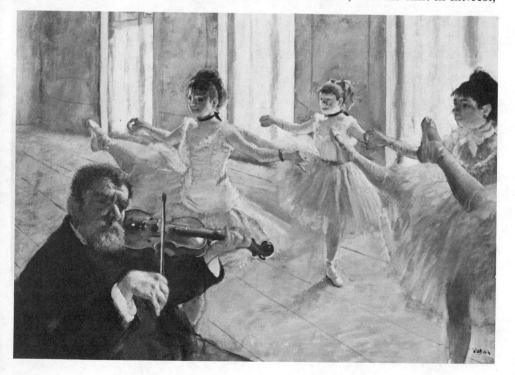

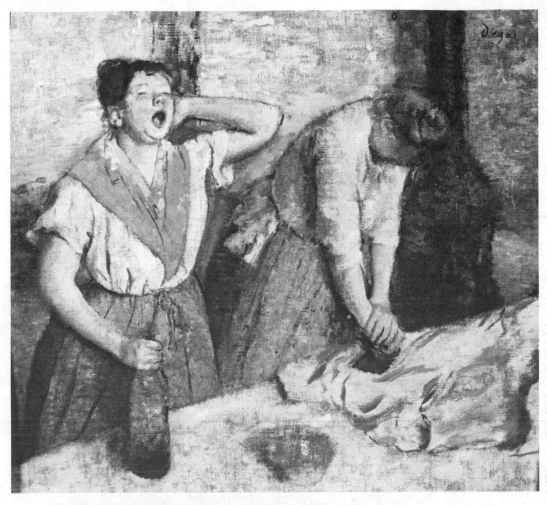

EDGAR DEGAS. *The Laundresses*. ca. 1884. (Jeu de Paume, Paris.)

come the small sculptures of his ballet dancers and his bathers. This interest continued through the 1880s and on to the mid-1890s. These little figures are great sculptures; Degas the sculptor was never below his level as painter and draftsman.

Some seventy such works exist and originally there were more. They were made in wax, and were cast in bronze after the artist's death. We can see the artist only carrying them as far as his exploration of form demanded.

One exception stands out: the *Little Dancer Aged Fourteen* (1880–81). Three-quarters life size, this sculpture is actually dressed in a real ballet skirt (tutu), has a real ribbon in her hair and at one time wore real ballet slippers; Degas had made a preliminary nude study. This figure is finished to the furthest degree of factualness and the mys-

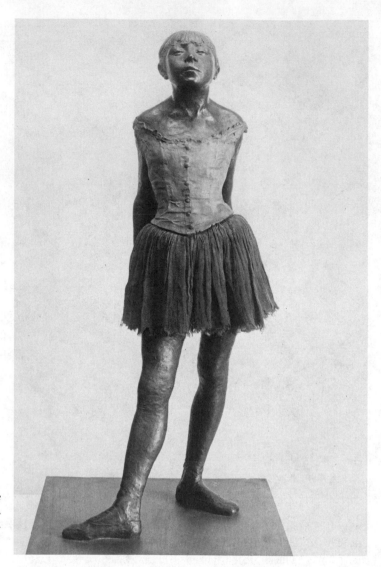

EDGAR DEGAS. *Little Dancer Aged Fourteen.* 1880–81. Bronze. (Courtesy Museum of Fine Arts, Boston.)

teriously beautiful object with its faded clothes nearly a century old appears as a prank of genius even more moving, in its sardonic way, than it could ever have been when new.

We must remember that the arts are now changing and developing very fast. Degas died toward the end of World War I. Much younger men who represented a later development, van Gogh, Gauguin, Toulouse-Lautrec, Seurat, had long been dead. Together with Cézanne, these men are grouped as Post-Impressionists. They modified Impressionism to give painting a more assertive turn toward emotional expression and to rescue form.

Sculpture

The period that produced such great French painters pro-
duced one great sculptor, Rodin. There had been no sculptor
of his stature since Michelangelo, not even Bernini. Rodin
leaned deliberately on the famous Florentine and made a
pilgrimage to study his work. He recalls Michelangelo in his
contortions, in his command of the language of muscles.
The other major influence upon Rodin comes from the
unknown carvers of the Gothic cathedrals.

Rodin's figures are in the grip of strong emotions; they
are tense with anguish; they strive and they triumph. They
dramatize Rodin's own struggle. Like the Impressionists,
Rodin spent most of his long life fighting the entrenched

Auguste Rodin
(1840–1917)

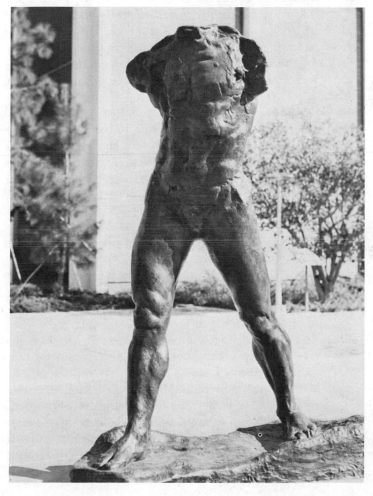

AUGUSTE RODIN.
Walking Man. 1905.
Bronze. (UCLA,
Los Angeles, given by
the UCLA Alumni
Association from an
anonymous donor as a
tribute to Franklin D.
Murphy, Franklin
D. Murphy Sculpture
Garden.) [Courtesy
of John Swope.]

official art of his time; for half his days he had to work as an assistant to other men, hacking out their commonplace conceptions for them to sign. Rodin's major monuments were few, and the greatest was not cast in bronze in his lifetime. He was a superb modeler on a small scale; his hands had an instinct for infusing life into clay. These small works grew large with the help of assistants, when he had helpers in his turn. His marbles were carved for him while he hovered over the work. He was a modeler, not a carver. He had the ability to locate an emotion in anatomy, and he gave us an art of intense fragments.

His early *Age of Bronze* (1876) stands in anguish; his next great work, *Saint John the Baptist Preaching* (1876–80), strides into the future in a state of spiritual exaltation translated into motion. This stride, with a torso placed upon it, exists as a separate study, the *Walking Man*. Rather typically, this torso was from another source, and presumably placed upon the legs at a later date, perhaps not until the work saw the light of day in 1907. The end result is more than a fragment, it is vision of purpose. Rodin had difficulty finishing, like Michelangelo before him, as though the creative temperature alone kept his work molten.

In 1880 he was given a commission to create a portal for the Museum of Decorative Arts, and he conceived of a comprehensive work, the *Gates of Hell,* a tribute to Dante's *Divine Comedy.* The *Gates* dragged on through the remainder of Rodin's life and was not cast until after his death. It cannot escape comparison with Ghiberti's doors for the baptistry in Florence—the earlier work compartmented, lucid, and episodic, Rodin's work all one diffuse scene, his figures, over two hundred of them, floating and swarming over the surface in a tormented composition that is Wagnerian in its quality of tense flux. The *Gates* were to provide Rodin with a vocabulary of figures for a life's work. They are all here, waiting to be isolated and enlarged. *Adam* (the *Three Shades*) surmounts the *Gates.* Below him the *Thinker* broods. He is the poet, the creator of all the rest; he is man in the role of Dante.

Rodin was commissioned in 1884 to do a monument for the city of Calais, to celebrate the six burghers who volunteered to give their lives to save the town when it was captured by the British in the Middle Ages. The unconventional work was a long time reaching completion, and a longer time before it was accepted. The six men walk forth, man-

acled, in their shirts, carrying the key to the city. Many studies exist as potent as the finished work. Whenever Rodin created clothed figures, he began with a nude that he later draped.

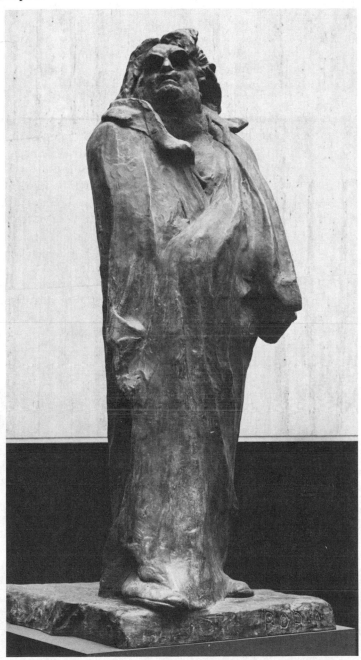

AUGUSTE RODIN. *Monument to Balzac.* 1897. Bronze. (B. Gerald Cantor Collection, Beverly Hills.)

By now a Rodin had a gnarled surface with exaggerated dents and bosses that allowed the sculptor to model with shadow and light. This fluid luminous surface came close to a painter's vision. Rodin lived in a time of great painters. He was exhibited with Monet—they were the same age within forty-eight hours; he seems closest to Daumier among his contemporaries. If his bronzes have light painted over them as though with a brush, his marbles—most of them given over to feminine subjects—appear to be melting, as though carved in snow. He is the great Impressionist sculptor.

His final major work was the *Monument to Balzac*. This figure brings together all his Michelangelesque qualities: intensity, contortion, exaltation. Commissioned by the Society of Men of Letters, it was years in progress and ultimately rejected. It too was never cast in the artist's lifetime. Balzac, the writer, worked and practically lived in his bathrobe, a costume which allowed Rodin to wrap him in a waking dream.

All his life Rodin harped on anatomical "truth." Vitality would have been a better word. He updated the great European tradition that had languished since the Renaissance. In his old age he became deified, with a reputation hovering far above his detractors. After his death this reputation collapsed. For the artist of a new time, concerned with structural concepts, Rodin was simply in the way. Now he has been rediscovered as a figure of colossal proportions. He provided his century with its sinews, and the new century has made room for him.

POST-IMPRESSIONISM

The Impressionism of Monet, Impressionism in its pure state, often seems no more than a happy outdoor basking. It offered too little scope for a passionate personality. Inevitably painters who followed the Impressionists would demand more than mere appearance; a triumph such as Monet's could hardly be so important again. We cannot call these following painters the next generation, for now the time allotted to a movement, or development, grows shorter. If Impressionism ripened between the years 1875–80, Post-Impressionism can be seen at its peak at about 1895.

Why were so many men rejected out of hand by late-nineteenth-century taste? First and foremost, the artist's new sense of reality came as a shock. We can hardly imagine how disturbed people were a hundred years ago by a new way of seeing the world around them. For a comparable situation, we must turn to the radical conflict in beliefs that led to the religious wars. It is not sufficient to say that a new middle class had no taste and knew no better.

A glance at history suggests that artists in all previous times had been doing much as they were told, and were seeking their patron's satisfaction. The first great artist to be rejected was Rembrandt. If he disappointed expectations, he did so deliberately, in pursuit of truth, as a man testifying to his beliefs.

Monet, Renoir, asked for an acceptance of heightened color. With Cézanne we come to a larger gap between artist

Paul Cézanne
(1839–1906)

and public. His struggles spoke of internal difficulties only resolved through the support of a simplified scaffolding—a structure that sustained the artist's emotions as well as the

PAUL CÉZANNE. *Self-portrait*. 1878–80. (The Phillips Collection, Washington, D.C.)

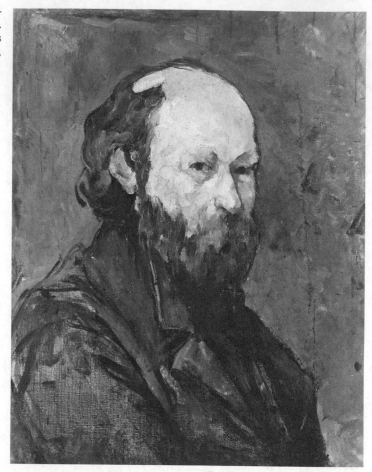

composition. Cézanne was timid: he avoided the nude model much as he wished to paint it. He approached the human figure with an awkward feverish longing. He seemed to visualize anatomy with the half-misled curiosity of a child. Yet he wanted to paint bacchanals like the Venetians, figures in sensuous movement in blue and gold. Time and again this project broke down in agitation, and he fell back on calmer themes; on stubborn portraits or self-portraits, and above all on still-life compositions totally under his control.

This range in tension between feverish nude and controlled still life resolved itself in still lifes steeped in sensual richness—a richness of form and paint. He wished to rival

the formal splendor of the Italian masters, and he did. He wished to understand and surpass their sense of structure—and this too he did. He wished, he said, to create an art like the art of museums, and he is in the museums now. His paintings are conceived like sculpture, like architecture; they are carefully, deliberately built. In this sense, Cézanne alone takes the place of Poussin, and he inherits all of Poussin's restrained sensuality. His still lifes, his landscapes, have the splendor and passion of nudes.

PAUL CÉZANNE. *Mont Sainte Victoire.* 1886–87. (The Phillips Collection, Washington, D.C.)

He lived in a dry area of low mountains; tawny or cement-colored rocks lent themselves to compositions of arranged

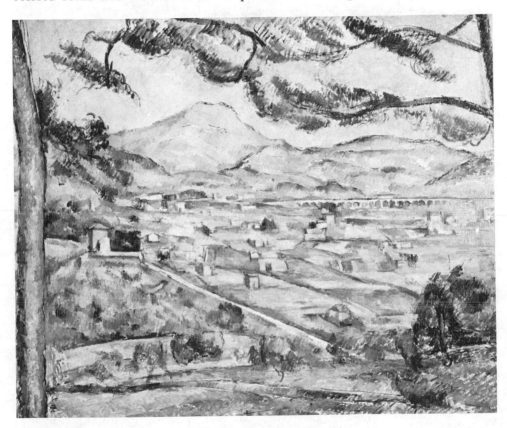

forms. Mont Sainte Victoire dominated the scene for Cézanne as a natural altar. A deep Mediterranean sky and the sea not far away nourished his response to infinite blues.

He wished to save what Impressionism had to offer. Impressionism called for the vibration of broken tones achieved with many quick strokes, and Cézanne applied this nervous, vibrant surface to his calm, sculptural forms. In doing so, he

created a tension between color and form that is distinctly his own.

Other artists, Titian for example, have offered painting as colored sculpture. But Cézanne succeeded in relating color to form as it had never been done before. He realized that color could function as form (so it was form); that yellows came forward, that blues retreated, that slabs and washes of different colors could assume formal relations to each other on the basis of their color alone.

He also realized that forms could be simplified. Where a Degas particularized drawing, Cézanne could do the oppo-

PAUL CÉZANNE. *Still Life with Basket of Apples.* 1890–94. (Courtesy of the National Gallery of Art, Washington D.C., Chester Dale Collection.)

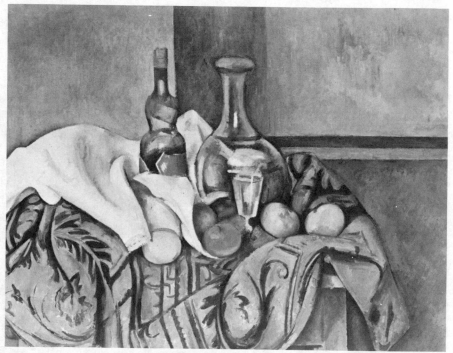

site through geometry. He could reduce accidental forms to typical forms, and create a profound act of recognition. An egg-shaped head, a columnar torso made its point awkwardly, powerfully, like broken ancient sculpture. Cézanne knew what he was accomplishing, and he had the wisdom to draw off for self-protection while he developed this timeless art. He saw that he was ill-adapted to living in the world—he was "frail in life," he said—and he gave up the struggle in Paris where he must have felt he had more to lose than to gain. He went back to Aix, his home in the south of France.

He now labored stubbornly at his painting as though he

were recreating existence—which he was. Certain subjects repeat themselves indefinitely, whether they are an apple or the local mountain, Mont Sainte Victoire. As they repeat themselves their basic form emerges. Existence is not merely

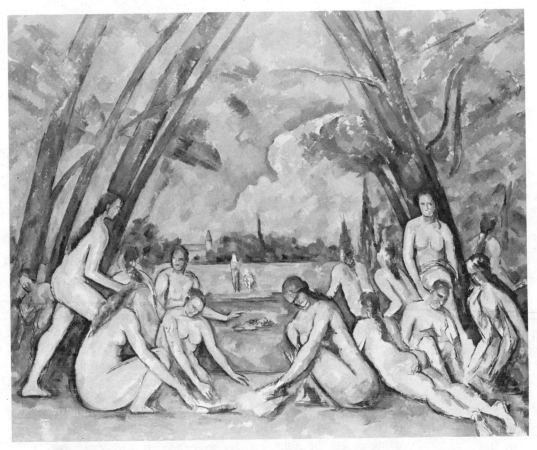

something to be observed, it has to be *made*. Hence painting should display a man-made geometry which roughly fits our environment. We are back in the thought of Plato, of the Greeks.

This constructive formal role for the arts was Cézanne's gift to the twentieth century. We see him at his most impressive in his last years, as in *The Large Bathers* of 1898–1905, where the human figures and the alley of trees become transformed, flattened in the interest of pattern. Here he prepares the way for both Matisse and Picasso. We go on to other painters, but this does not leave Cézanne in the distance. He keeps reappearing, rising like a mountain as we

PAUL CÉZANNE. *The Large Bathers.* 1898–1905. (Philadelphia Museum of Art, the Wilstach Collection.) [A. J. Wyatt, Museum staff photographer.]

move away. Later inventions in art have a way of reminding us of his.

Vincent van Gogh (1853–90) Van Gogh's life marks the beginning of a twentieth-century phenomenon, an artist whose very existence is his subject matter. His art is inseparable from an internal tragedy. His genius gave him what sanity he possessed. He grew up in the home of a clergyman in a village in Holland, and here the young van Gogh struggled with a Protestant overload of guilt versus desire, and with self-abasement versus the vanity of sainthood. This troubled family had art-dealer connections which made it possible for Vincent's brother Theo to became a dealer in Paris, and Vincent was to become one too. In this profession he dismally failed; no man was less equipped by temperament to sell to the rich. He fell back on his family, the very scene of his problems, and vacillated between art and religion. For a while he became a missionary in the fearfully depressed coal-mining region of northern Belgium. Here he began to paint, and here too he effectively destroyed the image expected of him as a missionary. His paintings in these days were dark as the winter climate, rugged portraits and drawings under the influence of Millet, the painter of peasantry.

Letter writing was one of his few forms of immediate relief from his tensions and inner conflicts. He wrote endlessly, all his life, to his dealer brother, pressing the responsibility for his existence on Theo. Finally he took the great step of joining his brother in Paris. Here existence speeded up intolerably; it became a short, three-year blaze. In Paris van Gogh met the Impressionists, he met Gauguin, and he entered a colorful Impressionist phase. Having arrived as the humblest of the humble, he now quarreled with everyone, and finally flew off by himself to Arles in the south of France, in the general territory of Cézanne. Here for him too Impressionism became something different as colors acquired meanings, even moral meanings. His brush strokes took on power and direction, and became slashing and hurried swirlings, the handwriting of anxiety.

He painted his room and its furniture; he painted in the fields and in the town. He discovered a foster family, and nestled into it, painting portraits of all the members. Having abandoned the world of the artists in Paris, he planned an art colony in his retreat and persuaded the impoverished Gauguin to join him.

This visit of Gauguin proved fatal. To linger in a prolonged childhood had been van Gogh's only safety. Gauguin taunted van Gogh back into ways for which he lacked the emotional stamina. An attack on Gauguin was followed by a self-wound, a hacking of his own ear as an ironic present

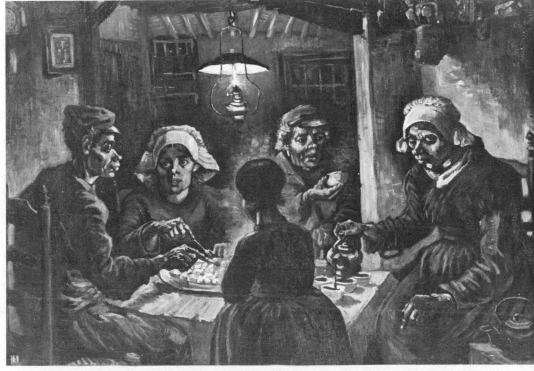

VINCENT VAN GOGH. *The Potato Eaters.* 1885. (Collection of V. W. van Gogh, Amsterdam.)

to a prostitute. Gauguin fled, Theo came to the rescue, and van Gogh was hospitalized in an asylum. Yet all through this turmoil and confinement his biography of paintings poured forth, self-portraits with a bandaged ear, the asylum and its surrounding landscape. His paintings take on new wild gyrations to express his inner turmoil. Cypress and olive trees writhe under a great, blistering, yellow sun, and stars spin in a night sky.

Finally after a year he was freed from the asylum and came north to his brother, who found a home for him near Paris in the care of a doctor-collector named Gachet. Van Gogh painted as furiously as ever but he was not ready to reenter the world. His anxiety built up again and he shot himself.

Through all this he knew what he was doing in paint. His sharp, bleak colors expressed the menaces that only he felt.

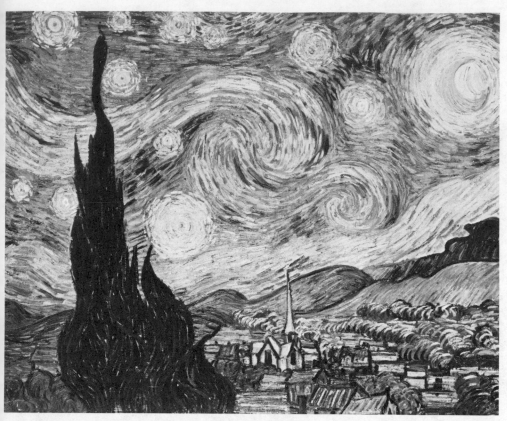

VINCENT VAN GOGH. *Starry Night*. 1889. (Collection the Museum of Modern Art, New York, acquired through the Lillie P. Bliss Bequest.)

His gyrating forms spelled exaltation as well as anxiety, and lifted him giddily off the earth into the sky. His brush strokes hurried like frightened steps. His great strength lay in his capacity to use paint for an autobiography. Fortunately for us, his suffering is not ours, but we can share his joys. He did not *paint* the inward art of the twentieth century, but he created the inward subject: after van Gogh, reality could become a psychic reality.

Paul Gauguin (1848–1903)

Among all rejected artists, Gauguin assumes the stellar role of arch rebel. In his sweeping view, art symbolizes the great underlying impulses and becomes the summation of the experience of mankind. Hence his primitivism and his concern with mythology. This was far from the goal of Impressionism, that realistic reading of an actual moment of air and light.

Yet Gauguin began as an Impressionist disciple. Color was his language, broken color at first, but not for long. Soon his color came in large pools. His color shapes fit together with some common purpose like organs inside a living torso.

His paintings have a deeply felt sensuality. He strove for liberation: he was an antimoralist and against inhibitions; hence the violence of his confrontation with van Gogh.

Gauguin had Peruvian-Indian blood in his veins, and he had the tropics in his eye. Born in France, he lived in Peru for a while as a child. In adolescence he entered the merchant marine and again saw South America. Later he put his life in order, became a stockbroker, married a Danish girl, and had a family. All went well until he developed an interest in painting, first as a collector, then as a painter and a friend of Pissarro. He even exhibited in the Salon (in 1876) and with the Impressionist group (in 1881 and 1882). The next year he gave up his job and shortly after gave up his family. From then on he led a life of desperation and defiance.

For a while Gauguin lived and painted in Brittany to save money. Here his early Impressionist painting became overheated as though the light and color of the tropics were burning through. He made an unfortunate trip to Panama and Martinique that can be blamed for the first inroads on his health. He returned to Brittany, then went briefly to Arles for his disastrous partnership with van Gogh, and came back to Brittany again.

By now his whole view of the nature of painting had undergone a change. He abandoned Impressionist landscape and painted the religious beliefs of the Breton peasants, beliefs that he did not share. His *Vision After the Sermon* (1888) throws away fact and turns to emotional communication through nonrealistic color. Praying peasant women, painted without any concern for a light source, experience a vision of Jacob wrestling with the angel, a mystical event which takes place on a field of uniform clear red. This unbroken arbitrary color became at once a new resource offered the liberators of painting. Gauguin provided a philosophy under the title of *Synthetism* to justify his procedure, and although it was conceived largely in the hope of dominating a following it did sum up a belief in color and shape as symbolic language.

Gauguin appeared in Paris to finance his first trip to Tahiti, and after two years was back in Paris with his new exotic paintings to raise money again for his second voyage to the South Seas, a voyage from which he never returned. Illness, poverty, and misery lay in wait for him. As though to escape fate, he moved from Tahiti to the Marquesas Islands where he died in 1903.

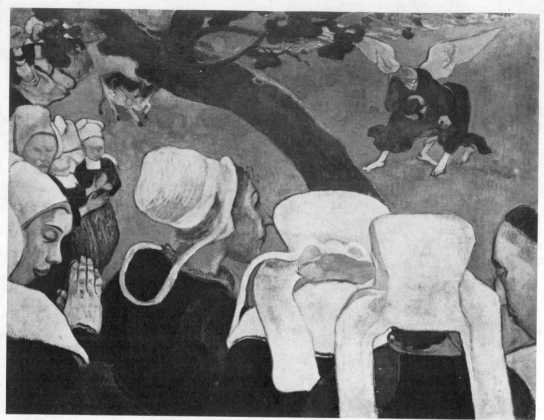

PAUL GAUGUIN. *The Vision After the Sermon.* 1888. (National Galleries of Scotland.)

Gauguin's glowing paintings on these two trips are the works primarily associated with his name. The tropics blossomed for him. He saw the Tahitians as guileless children, and he threw in his lot with them, reveling in a life of simplicity and impulse. But the French colonial administration made life miserable for him and the Tahitians were not free in the terms he sought for himself; primitive life is closely bound by its own taboos and fears. Curiously, he began by illustrating a Madonna-and-Child theme, *Ave Maria* (1891), as though Tahiti were Brittany. It compares with a later, wiser view, *The Spirit of the Dead Watches* (1892) that comes closer to a comprehension of this simple yet haunted people. He even tried to recreate for them the gods they were just beginning to forget.

He simplified anatomy to compose with his flat, colored shapes. Transitions are minimized, a foot is directly attached to a leg without too much concern for an ankle and a hand joins an arm without a wrist. The effect is of simplicity, strength, and an awareness of form. He used Indonesian sculpture as a direct source for a mannered Orientalism that

he introduced in his figures. His few colored woodcuts were to leave their influence upon a new generation of printmakers.

His great achievement was his orchestration of tropical color in large, flat areas, as though the paint had been spilt. He said that a lot of green was greener than a little green. For Gauguin colors took on a life of their own; images of one thing, they are obscurely symbols of another. (Symbolism, an idea to which other artists were responsive, came from the poets of the time, the Symbolists.)

In primitive man Gauguin was seeking a clue to man's real nature. Soon artists would turn to man's nature as their subject without pursuing it halfway around the world in search of its primal beginnings. Our unconscious natures are primitive in themselves.

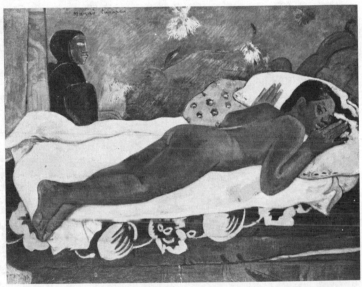

PAUL GAUGUIN. *The Spirit of the Dead Watches.* 1892. (Albright-Knox Art Gallery, Buffalo, New York, A. Conger Goodyear Collection.)

Seurat was under the spell of formal art from the great Italian masters down through Ingres, but he was also under the spell of science, believing that knowledge and precision should take the place of intuition. He wished to produce a logical, controlled Impressionism in which colors would have their roles planned and their intensities determined. He approached light as a physicist and pigment as a chemist, steeping himself in all that was then known about the relationships of colors. The resultant procedure that he developed was called *Pointillism,* technically an exhausting assembly of colored dots. He produced by hand the result obtained

Georges Seurat (1859–91) and Pointillism

by the dots in colored or black-and-white photoengraving—
and his dots were almost as innumerable. To offset the fuz-
ziness that such a method invites he went on to develop pre-
cise and stylized forms as crisp and controlled as Egyptian
low reliefs. In a Seurat painting the light vibrates but the
forms and figures are clean-cut and locked in a trance.

Such a painstaking procedure would suggest an art of
endless experiment and tiresome restraint. But in the work-
ing-out, Seurat perfected his technique almost at once and
pressed through to a series of magnificent performances. The
great achievement of his very short life lay in six large
masterpieces supported by a great many preliminary studies;
and to these we can add a score of exceptional landscapes.
Of the major six the greatest was the second, *A Sunday
Afternoon on the Island of la Grande Jatte* (1884–86).

GEORGES SEURAT.
*A Sunday Afternoon
on the Island of la
Grande Jatte.* 1884–86.
(Courtesy of The Art
Institute of Chicago,
Helen Birch Bartlett
Collection.)

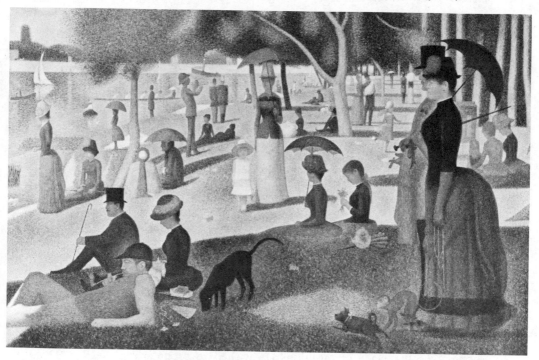

This large and famous painting presents a scene of trees
and grass in sun and shadow inhabited by men, women, and
children who have come out to enjoy the cool summer air
off the Seine. Foreground figures stroll or sprawl and bask;
others, diminishing, animate a pale green distance. Five
parasols create a fugue in design. Two dogs and a monkey
on a lead enliven the scene and boats go by on the river. But

the total impression is static calm as the endless Sunday hours bear down. The timelessness of the scene is in perfect balance with the overwhelming technique. Seurat had achieved one of the great paintings of the nineteenth century.

The canvases that followed, *The Models, The Sideshow, The Burlesque,* and *The Circus,* are to some degree less successful, if only because Seurat undertook to use the whole apparatus of his technique for motion, when it is in the special quality of trance that his poetry lies.

His landscapes are mostly harbor scenes dealing with the Normandy coast. His pointillist technique works well with the animation of water surface: the paintings vibrate from yellow to a steely blue and the painter often brings his complementary color dots out on the frame. This great outpouring was shortly over. Seurat died at thirty-one, having literally worked himself to death. He had his colors labeled on his palette so that he could paint night and day.

His black-and-white crayon drawings are of the greatest elegance. They produce the same vibrant effect, as of an infinite peppering of dots and marks, although here the minute transitions from black to white are due to the tooth of the paper over which he dragged the crayon. Seurat in his lifetime appeared as a curiously stilted Impressionist; it was only later that the full significance of his formalizations was appreciated. His rational artificiality made painting an end in itself. He was a twentieth-century artist, and he *could* have lived deep into our time.

He had followers, but only Seurat used his method to build monumental paintings without apparent strain.

Sex and tragedy arrest attention, and everyone knows the story of Toulouse-Lautrec. In childhood he broke his legs and they never grew. He remained dwarfish, and his sportsman father had no further interest in him. Even as a child he drew with amazing skill; he went to Paris to art school and became an admirer of Degas. The same subject matter, the life of the theater, appealed to both. Toulouse-Lautrec's passion was not for the ballet, however, but for the music hall. He painted in oil or in gouache, often on cardboard, and posters were his specialty.

Henri de Toulouse-Lautrec (1864–1901)

The lithograph was the vehicle from which Daumier had longed to escape into painting. Toulouse-Lautrec turned from his oil paintings to the lithograph, and his posters were soon appearing on Paris billboards. He had a singular ca-

pacity to capture the vitality of the night life of the city. His subjects are fiercely alive, and even more vicious and flamboyant than they were in reality. His sinister line portrayed a sexual ravenousness that went to the heart of character.

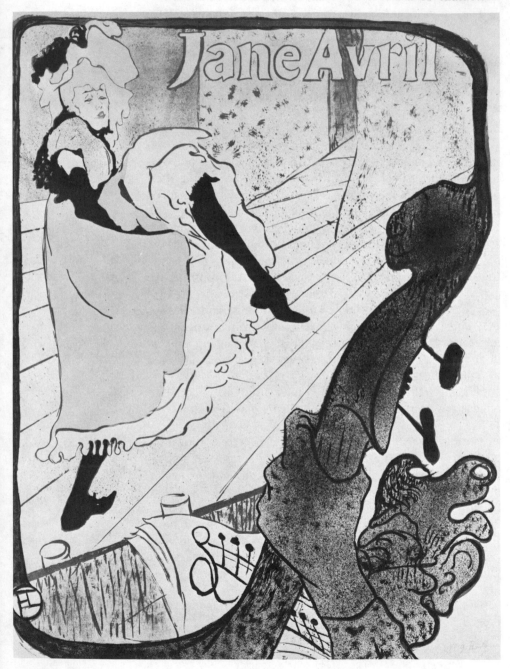

HENRI DE TOULOUSE-LAUTREC. *Jane Avril*. 1893. Lithograph in colors, poster, first state. (Los Angeles County Museum of Art, gift of Mr. and Mrs. Billy Wilder.)

Of the music hall singers he celebrated, two names survive with his help, Yvette Guilbert and Jane Avril.

Toulouse-Lautrec's life ended tragically. He drank himself to death at an early age.

HENRI DE TOULOUSE-LAUTREC. *At the Moulin Rouge.* 1892. (Courtesy of The Art Institute of Chicago.)

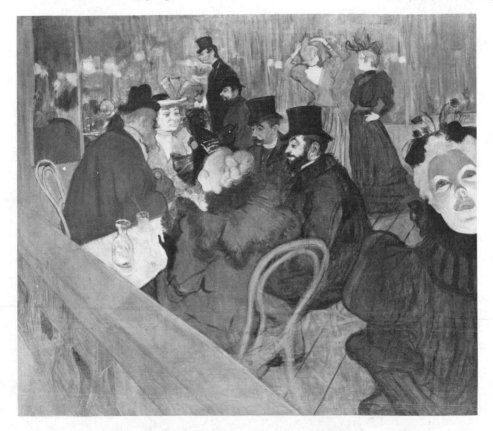

Living at the time of the powerful Impressionist and Post-Impressionist attack on reality, Redon was a visualizer of the fantastic, a man with a sense of myth. His subjects were his morbid, mysterious imaginings. He drew on the poets for sustenance; he was close in spirit to the poet-critic Baudelaire and the Symbolist poet Mallarmé. He was influenced by the late nightmare prints of Goya. At a time when color was the source of the new excitement, Redon worked in black and white; he was a printmaker, a lithographer.

He shifted his attention to color late in his life, working in pastel as well as in oil. It was beautiful, sensitive color that had little to do with Impressionism. "While I recognize the necessity for a basis of observed reality," he said, ". . . pure art lies in a reality that is felt." His sensitive

Odilon Redon (1840–1916)

flower pieces, often accompanied by the ghostly head of a
woman, were central to this reality. His dreams were not
always pleasant dreams. He was troubled by an image of a
single, exaggerated eye, the cyclops myth. He foreshadowed
the Surrealist movement of the 1920s.

ODILON REDON. *Silence.*
1911. (Collection of
Mr. and Mrs. Donald
Winston, Los Angeles.)

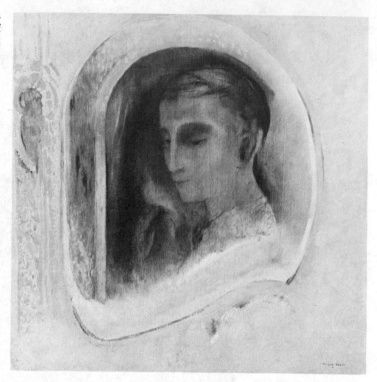

The Nabis

As we approach the end of the nineteenth century we must
round out the French scene with still another group, inspired,
at least, by the Post-Impressionists, the Nabis. They thought
of themselves as a brotherhood. The name they chose comes
from the Hebrew word for prophet. They were essentially
followers who synthesized what had gone immediately be-
fore. They drew on, and publicized, the paintings of the
Impressionists and Post-Impressionists, in particular those of
Gauguin, Cézanne, and Redon. Their closest contact was
with Gauguin: a Nabis spokesman, Paul Sérusier, had lis-
tened to Gauguin in Brittany. When he painted a small panel
(from a cigar box) under the master's direction, this became
his "talisman" for transmitting the Gauguin vision.

The Nabis strove to bring the various arts together: they had a hand in illustration, bookbinding, and stage design, and produced their own publication. One of their leaders, Maurice Denis, was writer and theorizer as well as painter. "A picture—" said Denis, "before being a battle horse, a female nude or some anecdote—is essentially a flat surface covered with colors assembled in a certain order." Such a sophisticated view of painting was to have its influence in the twentieth century.

Three names stand out among the Nabis—the painters Pierre Bonnard and Jean Edouard Vuillard and the sculptor Aristide Maillol. In the nineteenth century Maillol was not a sculptor; he was concerned with weaving and with tapestries in those years. Bonnard and Vuillard were intimate painters, with a marvelous sense of color. Both drew on a domestic environment, Vuillard creating quiet, cluttered interiors around an image of his mother, Bonnard painting color-drenched nudes in bedroom or bath. Bonnard liked dining-room tables invitingly loaded, or windows opening on gardens, for he lived in the south of France. Both artists carried their rich, past-century art well into later times.

ENGLAND AND AMERICA: THE LATER NINETEENTH CENTURY

An age that trusts the miracles of power and "science" may have an uneasy conscience, and its artists may prefer a poetic or spiritual yearning to brutal fact. This may come to seem Victorian hypocrisy, but at the time it was idealism, a tempering of Romanticism with morality.

England: The Pre-Raphaelite Brotherhood

Dante Gabriel Rossetti (1825–82), a British-born painter and poet, chose sublimated love as his theme, typically that of Dante and his poetic ideal, Beatrice—was not Rossetti named Dante? Add the names of William Holman Hunt and John Everett Millais: Hunt was twenty-one, Rossetti twenty, Millais nineteen when they formed the Pre-Raphaelite Brotherhood, and signed their paintings PRB. The year was 1848.

Art, they said, had become conventional since the Renaissance, so they would go back to earlier times, to early Florence for the sake of sincerity and Christian piety. They had four aims:

1. to have genuine ideas to express;
2. to study nature attentively, so as to know how to express them;
3. to sympathize with what is direct and serious and heartfelt in previous art, to the exclusion of what is conventional and self-parading and learned by rote; and
4. most indispensable of all, to produce thoroughly good pictures and statues.

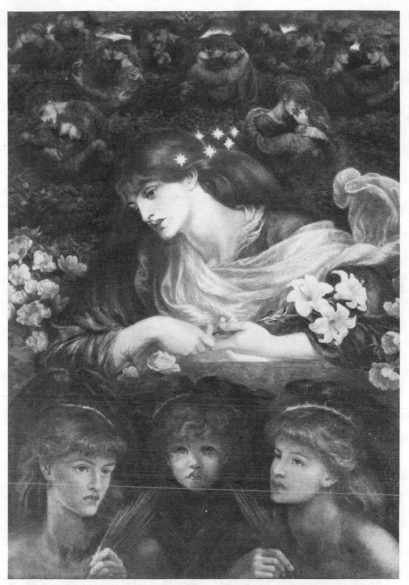

DANTE GABRIEL
ROSSETTI. *The Blessed
Damozel*. 1871–77.
(Fogg Art Museum,
Harvard University,
Cambridge,
Massachusetts,
Grenville L. Winthrop
bequest.)

EDWARD BURNE-JONES.
*The Angels of
Creation—The Second
Day.* 1875–76. After
stained-glass windows
of same subject, 1873.
(Fogg Art Museum,
Harvard University,
Cambridge,
Massachusetts,
Grenville L.
Winthrop bequest.)

William Morris
(1834–96)

Graded on this basis, they would get a low passing mark on point 3; on the other counts they would fail miserably. Yet they became widely known. The critic John Ruskin was vigorous in their support for their piety and their sensitivity to Italian art. The English yearning toward Italy had long been intense: witness Shelley, Byron, Ruskin, and Robert and Elizabeth Browning. Art lovers went to Italy. The Pre-Raphaelites were painters of religious scenes. Hunt painted *The Light of the World,* in which a sorrowing Christ with a lantern knocks at a closed door overgrown with briars; in its day the painting was incredibly famous.

The Pre-Raphaelite Brotherhood took on a new life in the 1860s with two additional recruits, Edward Burne-Jones (1833–98) and George Frederick Watts (1817–1904). Their figures were less clothed and their theme was more frankly love. But it was a literary love. Burne-Jones made a drawing of Sir Galahad at the very moment that Tennyson wrote his poem on the knight whose heart was pure. Altogether Pre-Raphaelite painting must now be seen as a materializing of literature, but like the literature of its day, it had a humanizing effect. It was part of the turn from the materialism of the eighteenth century.

The Pre-Raphaelite group possessed one member of a different order of ability, William Morris. He made the field of design his own, an overall design that was to transform all the visible equipment of living: furniture, utensils, fabrics, wallpapers, painting, books, and typography, as well as his wife's clothes. He was appalled by the appearance of the new machine-made products that were pouring out at the time. Urged on by Ruskin, he turned back to the Middle Ages, to the probity of handicrafts, and his studio became a guild. The woodblocks he created allowed him to project large pallid flower forms over draperies and wallpapers. His papers in particular are still greatly admired.

He was an important influence in the English renaissance in printing at the end of the nineteenth century. The Morris chair preserves his name, although he did not actually design it. The heavy chair with its movable back began a concern for posture; for a generation it combined dignity and comfort for the heads of families. Morris hardly affected the industrial march of the nineteenth century, but he did create a style, and he helped to make human well-being a matter of conscience. Morris was also a poet, and produced pseudo-Norse epics.

Realistic Painting in America

In France we saw romantic painting yielding to a new concern for realism. In America the romantic drive was far stronger, but here the romantic and realistic drives lived happily together. Romanticism bore witness to an American faith, an article of which was a reverence for fact. The recording of fact had its own romantic appeal, from the landscape painted in minute detail to reporting or illustration.

George Inness was stirred by the innocent spectacle of domestic America set against the empty wilds, the farm lying in its valley. American painting had been precise and thin; by contrast Inness' brush was loaded, as though the paint itself were a rich crop ready to harvest. He had modeled himself on the Barbizon painters. His canvases can be almost too rich; his *Peace and Plenty* (1865) is an earthbound Turner.

Few painters of America as a spectacle have been equal to their subject. We can offer at least three: Winslow Homer

George Inness
(1825–1894)

Winslow Homer
(1836–1910)

GEORGE INNESS.
Peace and Plenty.
1865. (The
Metropolitan Museum
of Art, New York,
gift of George A. Hearn.)

in the last century, and Edward Hopper and John Marin in ours. Homer grew out of America and it spoke through him. He began as a lithographer's apprentice in Boston and worked for years as an illustrator for *Harper's Weekly*. He comes to life for us as a recorder of the Civil War. His *Prisoners from the Front* (1866), the best in a series of such paintings, made him famous. The confrontation of standing figures breathes with the same assurance as Courbet's *Burial at Ornans*. The painting was shown in Paris in 1867. Homer himself went to Paris, saw the Louvre, and came home with no trace of contamination. His early, solid figure scenes, masterly in their factualness, now gave place to larger, heavily brushed landscapes and seascapes melodramatic in their power. These paintings may contain hunters or fishers, but sea, wind, land and space are their subjects. He created an epic out of fog and salt, weather and courage. The *Fog Warning* (1885) and *The Lookout—"All's Well"* (1896) are somehow national monuments. His own life became a venture in solitude: he made Maine his home and lived with the ocean.

WINSLOW HOMER. *Prisoners from the Front*. 1866. (The Metropolitan Museum of Art, New York, gift of Mrs. Frank B. Porter.)

His best work, however, is in watercolor. Here the immediacy of execution allows his sheer ability to gleam through. There is no trace or hint of Impressionism, or of the raising of a key, since he sees the full range from white

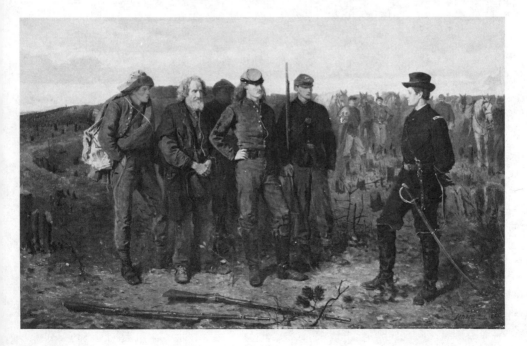

to black. Edges are hard and all is clear. Late in his life he painted a series of watercolors in the Bahamas and here the muscular figures of black Bahamians cut into tropical light like so many keyholes. The whole Impressionist struggle with illumination proves no problem at all.

WINSLOW HOMER. *Rum Cay*. 1898. Watercolor. (Worcester Art Museum, Worcester, Massachusetts.)

If Homer has a limitation it lies in his great virtue, his objectivity. There is no struggle with form, as in Hopper or Marin. Form (on which we have harped without too much philosophizing) is man-made and artist-made. In Homer we should not speak of the form in things but of the shape of things. He relies on his sure grip on actual shapes.

We cannot compare Homer and Eakins; the word must be "contrast." They only resemble each other in stature and in devotion to fact. For Eakins fact takes on a moral dimension as though he were testifying under oath to the events he has witnessed. His stubborn literalness adds dignity to his statement.

Thomas Eakins (1844–1916)

Yet there is much more in Eakins than visual observation. He is filled with a new scientific attitude and he has the confident draftsmanship of the man who has dissected the human body and understands the mechanism he sees. He is not content to observe; an intelligent man, he goes on to explain.

Eakins lived and painted in Philadelphia. He studied at the Pennsylvania Academy and went to Paris right after the Civil War. In Paris he worked with men who were given to hard draftsmanship and detail for its own sake,

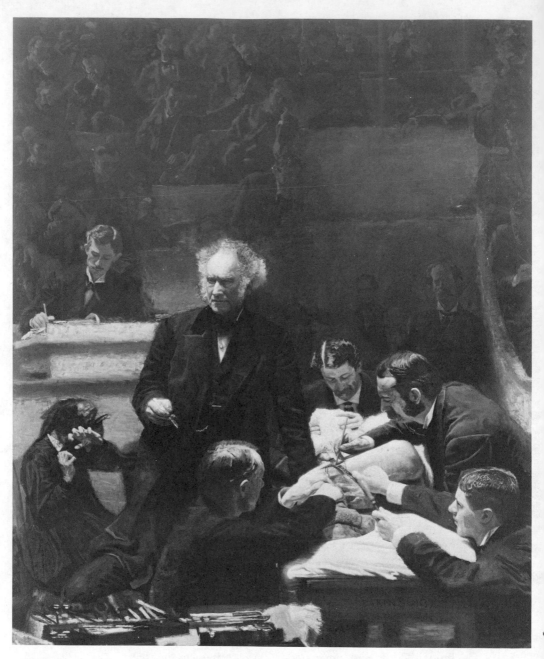

THOMAS EAKINS. *The Gross Clinic*. 1875. (Courtesy of Jefferson Medical College, Thomas Jefferson University, Philadelphia.) and he added his own fanaticism of observation. Then he took a trip to Spain and saw the great Spaniards, Velasquez, and above all Rivera, the greatest of the Neapolitan painters when Naples belonged to Spain. At a time when the French painters were lifting their values into color, Eakins joined up with the Spanish masters and solemnly lowered his key.

His dark palette provided him with dignity and intensity.

Back in America he painted sportsmen and athletes for the sake of their anatomy and became interested in medical schools for the same reason. One of the high points of his lifework is *The Gross Clinic* (1875) with its accent on scientific awareness. The portrait of a surgeon lecturing as he operates might be Eakins himself holding forth on anatomy.

Eakins painted a long series of portraits, a sequel to Copley's in their airless sculptural power. The greatest of these is the portrait, *Miss Amelia Van Buren* (1891), in which the refined, dry angularity of the sitter perfectly harmonizes with the severe painter's devotion to structure.

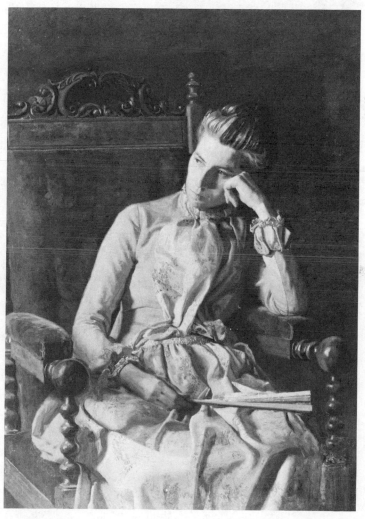

THOMAS EAKINS. *Miss Amelia Van Buren.* 1891. (The Phillips Collection, Washington, D.C.)

Even her fan seems to be an extension of tendons and knuckles.

Eakins taught drawing and painting at the Pennsylvania Academy, where he introduced an extraordinary change in instruction. Young ladies who looked forward to painting flowers were given the opportunity to dissect a dead horse that had been soaking in formaldehyde during a summer of pre-air-conditioned days. The life class was Eakins' laboratory. A moment came when he was explaining the structure of the pelvis of a male model and exasperation led him to make the facts plain. Several young ladies lost consciousness. It was the end of Eakins as a professor. The year was 1886, a little early for such a passion for form. Eakins was neither appreciated nor loved, and the rest of his life was a withering away.

James A. McNeill
Whistler
(1834–1903)

In contrast to a Homer, an Eakins, or a Ryder, Whistler was the American expatriate, the cosmopolite artist at home everywhere and nowhere. He was a deliberate eccentric, and a life that began as showmanship deepened into bitterness. At once hypersensitive and superficial, he built a brilliant and distinguished art out of a trivial existence. He signed his thin-washed canvases with a stylized butterfly.

His father was an army officer and engineer later employed abroad, and Whistler was born in America and brought up in Saint Petersburg in Russia. He returned to America to become a West Pointer. He was proud of this experience but it was not right for his temperament. Whistler returned to Europe to become a painter, and at twenty-one he was a student in Paris, in the same studio that later nourished the young Impressionists. He was nearer to Degas in manner and in refinement than to the sunlit Impressionists, preferring a dim studio light or twilight or the atmosphere of a city at night. He was influenced by Velasquez and above all by the Japanese, not only for their odd-angled compositions in their prints, but even in terms of the objects, the properties he introduced. He made use of Japanese screens, fans, and blue-and-white porcelain. He had a tenuous elegance and relied on simplification and understatement.

Whistler chose to live in London rather than Paris, and here he thrived for a while on his capacity to seek the spotlight through his style of life, his wit, and his capacity to insult. Eventually he was brutally criticized by Ruskin, and he answered with a libel suit. Whistler won the suit with a

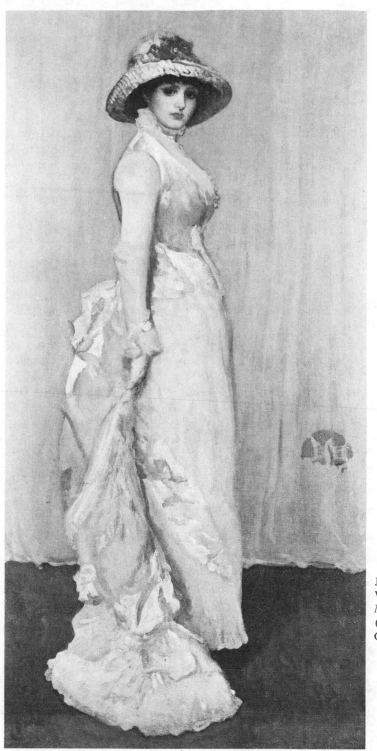

JAMES A. MCNEILL
WHISTLER. *Lady
Meux.* 1881.
(Copyright the Frick
Collection, New York.)

farthing's damages, but he bankrupted himself on costs and became the butt of a conservative public. The experience thrust him deeper into arrogance, bitterness, and a lonely old age. He was the apostle of the creed that the artist is a special person bound to be misunderstood by a "bourgeois," or stupid, middle-class public.

Whistler liked to describe his paintings in musical terms to emphasize his concern with composition as opposed to mere subject matter. He painted "harmonies" in blue, gold, or gray, or "arrangements"; above all, there were "nocturnes" —and indeed his art has the silvery quality of Chopin. Perhaps the most memorable of his night paintings is his *Nocturne in Blue and Gold, Old Battersea Bridge* (1872–75) where the high, curved bridge is quite Japanese and the simplified composition is set off with something as momentary as fireworks in the sky. As dim silhouettes with sky above and water below were right for Whistler, Venice proved to be an ideal subject; for Venice his tenuous smoky etchings were the perfect medium.

His portraits, his chief work, have the subdued air of rain-soaked Velasquezes. Two stand out both for distinction and fame. They are really the same composition or solution to a problem: *Arrangement in Gray and Black #1,* the artist's mother (1872) and *Arrangement in Gray and Black #2,* his portrait of the Scots historian Thomas Carlyle (1872–73). The first possesses a moving elegance and understatement, and rises above a rather self-conscious taste. It is one of the most famous paintings of its century, and for not always the most sensitive reasons: it has been on a stamp and has grown dear to the hearts of florists come Mother's Day. The painting belongs to the Louvre, and the French government lent it to this country at the same time that it lent Leonardo's *Mona Lisa;* oddly enough the two paintings once passed each other in trucks going in opposite directions on Route One. American art is nonexistent in the Louvre, except for the portrait of Whistler's mother, which is well concealed in the attic.

Mary Cassat (1845–1926) Mary Cassatt is quite simply one of the best and certainly the best known of women painters. She came from a wealthy Pennsylvania family, and lived in France from the time she was twenty-one. She was part of the Impressionist scene, but she has a greater resemblance to her friend Degas. Like Whistler, she was influenced by the Japanese print, especially

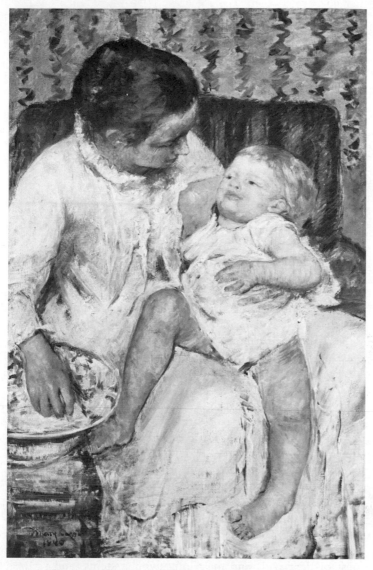

MARY CASSATT. *Mother About to Wash Her Sleepy Child.* 1880. (Los Angeles County Museum of Art, bequest of Mrs. Fred Hathaway Bixby.)

in her own superb printmaking. When we compare her with the French painters of her generation there is a certain modest Victorianism, a blandness in the experience she offers. Her subjects are mothers and children in nursery or domestic scenes, and somehow doubly touching as the vision of a spinster who found this intimate contact with humanity.

She gave good advice to her American collector friends, which in due course made American museums the richer.

ART NOUVEAU

The last years of the century brought in a universal style which involved the widest range of objects: books, illustrations, posters, furniture, draperies, and clothes, as well as painting, sculpture, and architecture. It flourished from 1890 to 1905, and lived on until about 1920. The style was Art Nouveau, New Art, *Jugendstil,* depending on the language, and everywhere it was exotic, fashionable, and vaguely foreign. The term "Art Nouveau" comes from the Maison de l'Art Nouveau, a shop in Paris run by a German, S. Bing, but the source of the style is primarily British; the designs of William Morris and an arts-and-crafts movement in England and Scotland pointed the way.

The style was essentially linear and flowing. Plant forms were characteristic, with a preference for tendrils and vines. So were birds: the peacock for the pattern of its tail, swans for their sinuous necks. Pond lilies were used for the roundness of their pads and their long twining stems, and stylized reflections were a welcome complexity. Finally, flowing hair provided weaving lines by the thousands. Art Nouveau was a feminine style.

The style spread rapidly via posters, illustrations, prints, and books. The Japanese print, too, made its contribution. As the print became known to the general public it was widely adapted, and its rigorous lines grew wayward and weak. In Holland, Art Nouveau was influenced by another oriental source, the batik, which came from Java, then a Dutch colony. The French Art Nouveau picked up the frail

linear elegance of the Rococo style. In Paris, the posters of Toulouse-Lautrec, with their insistence on compelling line, led directly into the style. The 1890s saw William Morris, by now an older man, designing and printing books. There existed an extensive background for a linear style, for before Morris the Pre-Raphaelites, Rossetti and Burne-Jones, had already designed books, these, in turn, recalling the linear book designs of Blake. Morris had a hankering for the medieval, and medieval manuscripts, with their elaborate letters, provided just such linear entanglements as book designers affected.

Suddenly in England a young illustrator of extraordinary talent appeared, one whose drawings and designs were at the very center of the new style.

Aubrey Beardsley (1872–1898)

Beardsley was just nineteen when he showed his drawings to Burne-Jones. Soon he had produced more than 300 illustrations to Malory's *Morte d'Arthur*. The next year (1893) he illustrated Oscar Wilde's *Salome*. Japanese prints, the work of Whistler, and especially that of Toulouse-Lautrec had their influence upon him. His erotic, "sick" illustrations had an immediate international audience; everyone was attempting to draw like Beardsley and failing utterly to achieve his cold, morbid sensuality. Being tubercular, he had no time to lose, and his work was mature from the beginning. He died at the age of twenty-six.

Beardsley, as a figure of the British "Decadence," was the very opposite of the socialist William Morris. Yet both represented attitudes that were at the heart of Art Nouveau. In Morris, the style took a humanist turn; in Beardsley it was self-conscious and affected.

The style made its appearance in several exhibitions held in Belgium. A series of important exhibitions called *Les Vingt* (The Twenty) had been seen in Brussels beginning in 1884. Seurat's *Grande Jatte* was shown in 1887, Gauguin's *Vision After the Sermon* in 1889; in addition there were canvases by Cézanne, Redon, and Ensor. But significantly for Art Nouveau, the decorative arts had their turn in 1892 and 1893, and in the latter year the first Art Nouveau house was built in Brussels by the architect Victor Horta.

Other exhibitions spread the influence of the style: the Decorative Arts Exhibition held in Dresden in 1897, the International Art Exhibition in Munich in that year (where a whole Art Nouveau movement was on display), and

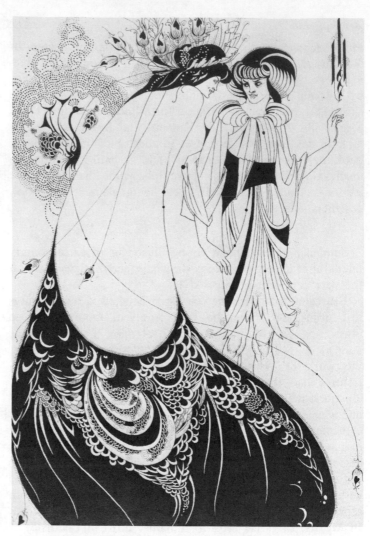

finally the Exposition Universelle in Paris in 1900 where Art Nouveau dominated the scene.

Henri van de Velde
(1863–1957)

In the propagation of the new style, the Belgian artist-designer van de Velde took up where Morris left off. A designer, educator, writer, and architect, he gave up painting to turn to the decorative and industrial arts. He too saw the house as a design unit in which everything was to harmonize. He shared Morris' sense of social obligation: the artist was now best employed offering humanity a total environment. He designed four rooms for S. Bing to be shown in his Maison de l'Art Nouveau in Paris, where Bing sold whole rooms as a unit. Van de Velde's philosophy of

social service through design was inherited by most of the major architects of the twentieth century, notably Gropius, Le Corbusier, and Richard Neutra. A wall hanging, a chair, a desk, a candelabra, a set of table flatware, all uniformly designed, define the house as van de Velde would have it. Unlike Morris, he accepted the machine and was willing to design for industry and even to create industrial advertisements. He also designed jewelry, and (here like Morris) he too designed his wife's clothes. Art Nouveau, a composite of many arts, remained strongly influenced by van de Valde.

The Architecture of Art Nouveau

In the Middle Ages (for which both Morris and Ruskin longed) a house contained very little. By the eighteenth century wealth and vanity had produced a great deal of equipment for domestic comfort, but it was not until the nineteenth century when machines began to hum that random possessions crowded interiors. Previously, a house had been furnished; now furnishings were demanding a home. It was something new in the world when the style of the objects in the house dictated the architecture. In the house that Victor Horta designed in Brussels in 1892–93, the snarl of lines completely destroys any sense of architectural structure, and the building becomes an ornament. There is no wall, no ceiling, hardly a floor, only lines in a jungle overgrowth.

Such an interior should not be visualized as empty, it should be seen inhabited by the willowy women of the period; each lent the other grace, and the architect Victor Horta's designs are a costuming for architecture. Horta can be studied in a more serious mood with his Maison Du Peuple, the socialist headquarters in Brussels (1897–99). Its curvilinear breakfront design is really late Baroque.

Similar glass boxes were being designed in Vienna by the architects Otto Wagner and Joseph Hoffmann, but the Art Nouveau building deservedly cited again and again is the Atelier Elvira, built in Munich in 1897 by August Endell. Such an extravaganza of applied design is pure theater.

These exotic flourishes lead us to an architect still too little appreciated, and too fantastic to imitate. He lived in Barcelona, a city that has produced more than its share of the greatest talent. As an architect he has to his credit a vast, unfinished church of cathedral proportions, several private houses and apartment houses, and a large hillside

Antoni Gaudí (1852–1926)

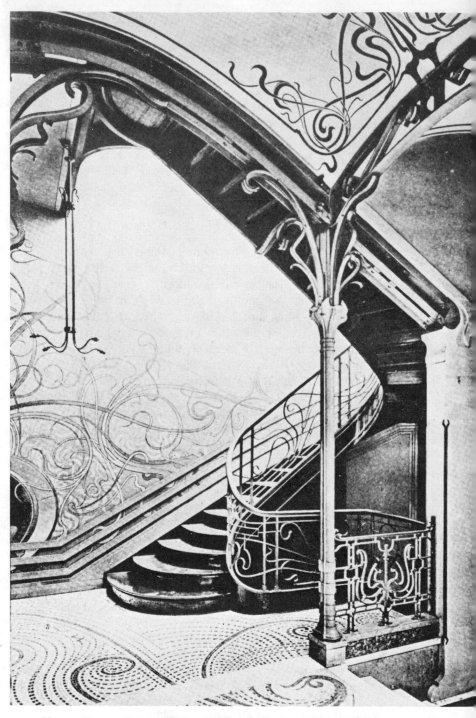

VICTOR HORTA. Stair hall, Tassel house, Brussels. 1892–93.
[Photograph courtesy of The Museum of Modern Art, New York.]

park with its various buildings and coiling terraces. In all these structures there is hardly a straight line, and the few that exist are deliberately out of plumb. Gaudí fused reminiscences of classical columns, of late Baroque curved façades, of Moorish buildings and minarets, and of the late ornate Spanish Plateresque. He inherited the building that became his great church, the Sagrada Familia, or Holy Family, and furthered it both in reality and in ultimate plan,

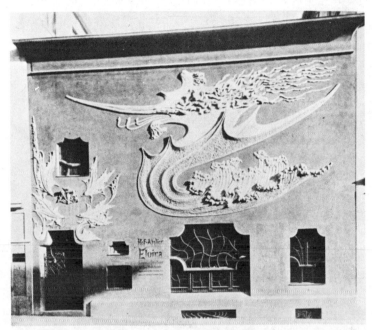

AUGUST ENDELL. Façade, Atelier Elvira, Munich. 1897. [Photograph courtesy of The Museum of Modern Art, New York.]

for it is still unfinished. Here he threw up walls which outline the apse, and he built the towers of the north transept (1903–26). These soaring towers with their pinecone shapes are only vaguely Gothic. The warm stone bursts out in color from embedded tiles, and the great finials on the summits of the towers glitter like stars. A green tile Tree of Life grows to a great height out of the enormous steep peak above the central transept portal.

If we look at the model of the church as Gaudí planned it, the building is even stranger. He threw away the problem of buttresses that plagued all other cathedral builders by simply tipping the supporting columns off the vertical to line them up with the direction of thrust. Presumably this shattering effect of lurch will eventually be realized. The present pace of construction is relaxed: cathedral churches took

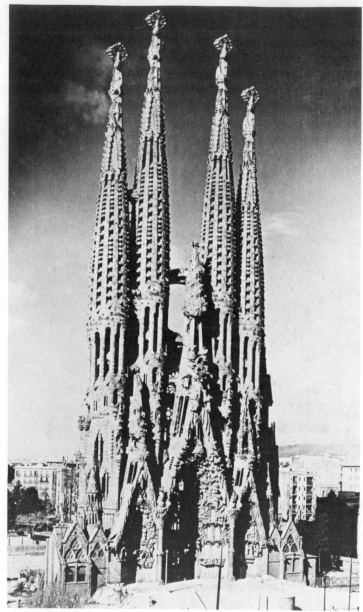

hundreds of years to get their growth and were often un-
finished in the end.

The same principle of columns leaning in the direction
of thrust is to be found in the Park Güell. Here Gaudí
carried his effect to the ultimate extreme. Columns simply
shore up the weight overhead and lean into it like workmen
carrying a load. Benches plastered with fragments of shiny
tile curve and coil like great scaly serpents. After the strange

anatomy of the Park and its buildings, Gaudí's apartment houses seem almost normal. Yet windows are shaped like so many great mouths or eyes, and the forms of the chimneys and ventilators on the roof are swirling abstract sculpture. Gaudí will certainly be turned to by architects in the future, for living forms once realized cannot be banished. But so much time has gone by—and will go by—that the return to Gaudí will probably be made in entirely new materials, plastic or metal.

Art Nouveau Painters

Among painters, Munch rises high above the weak Art Nouveau style, to play a historical role in the development of Expressionism, an early twentieth-century movement in Germany given to the ardent projection of emotion. Yet Munch worked with loose lines that lassoed forms, quite in the Art Nouveau vein, and he was well employed when he used these restless lines in his prints. For his colored woodcuts surpass his impulsive paintings.

Edvard Munch (1863–1944)

His great achievements, and his contribution to the century ahead, came in the 1890s. He grew up in a Bohemian world in Norway at the very moment when the older playwright Ibsen was having a liberating influence upon the new generation. Then the young Munch went to Paris, and here, in 1890, he was writing in his notebook a creed for himself that reminds us of van Gogh, and could serve for all the Expressionists to come. "No longer should you paint interiors with men reading and women knitting. There must be living beings who breathe and feel and love and suffer. I would paint pictures in a cycle. People would understand the sacredness of them and take off their hats as though they were in church."

If his paintings were sacred to him it was because passion was sacred. His two subjects were love and death. A sickly sensuality was characteristic of the time, but for Munch both subjects came close. In his own early experience they were intermingled and confused. His sister and mother had died of tuberculosis when he was a child, and his father reared the remaining children in a disturbed and remorse-ridden atmosphere. All his life Munch dreaded love as much as he longed for it, and his solutions were either pathetic or tragic.

His morbid attitude toward living and dying, strongly

presented, brought Munch an instant success in Germany. He
was invited to show in an exhibition in Berlin in 1892, and
the tumult that his paintings aroused caused the exhibition
to be closed after the second week. He was at once scan-
dalously famous, and he became something of an opposite
number to the playwright Strindberg in the Bohemia of
Berlin.

EDVARD MUNCH. *The Shriek*. 1896. Black-and-white lithograph. (Collection of The Museum of Modern Art, New York, Mathew T. Mellon Fund.)

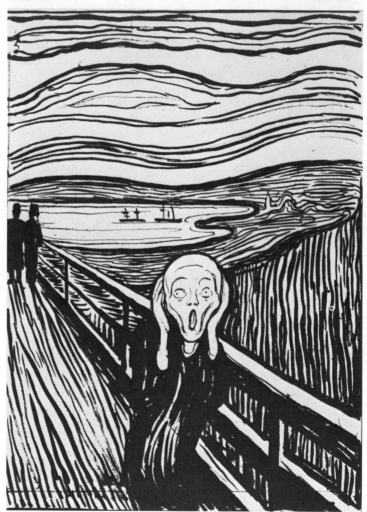

The strenuous and troubled life that followed this liberated
emotionalism led to a breakdown about 1907. It was not to
have a fatal termination, as the break in the life of van
Gogh, but it was a retreat. Munch then went back to Norway
and produced larger, calmer, and less interesting canvases
for the remainder of a long career.

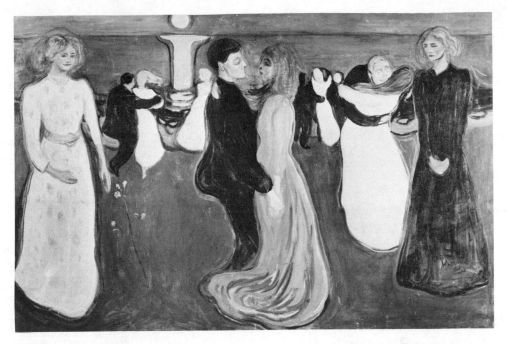

Obviously, Munch did not need details to dramatize such general themes as love and death. He needed figures that could personify moods, and he isolated them with sweeping dark outlines, or set them afloat in a sea of color, a procedure that he had found ready at hand in the painting of Gauguin. From van Gogh came plunging distances and swirling compositions, and to these Munch added such obvious symbols as white for chastity, red for love, black for death. The *Dance of Life* is a painting that sums up his saga. Its typical progression from left to right (as though it were written) leads us from innocence to love and on to inevitable grief in the appropriate colors. It also sums up Art Nouveau with its outlined figures, its decorative interest, its symbolic message.

Munch associated an abundance of hair with love or desire and tangles of red hair had a way of swarming through his compositions. Time and again this symbol carried over into the landscape background, and red sunset cirrus clouds streaming like hair across the sky fill the scene with Nordic twilight yearnings.

In his woodcuts with their strong decorative lines, the Art Nouveau aspect of his work is even more obvious. Munch introduced color, a procedure that comes from the few important woodcuts of Gauguin. These prints of Munch's redoubled the artist's influence upon younger

artists in Germany, and led directly into an outburst in printmaking that updated the great German print and engraving tradition of the fifteenth and sixteenth centuries before and after Albrecht Dürer.

Gustave Klimt Even more than Munch, Klimt was the essential Art
(1862–1918) Nouveau artist. He lived in Vienna, and women were his subject, fashionably dressed or—in his murals—either nude or hidden in patchworks of many brilliant colors from which three-dimensional heads and hands emerged. His line was as frail as it was sensuous, and he often strengthened the composition by crowding it: he liked to cluster nude figures in the hope of adding to the physical impact, and actually he was rewarded by a certain amount of scandal. He was a transitional figure and not, like Munch, an influence upon the future. He provided a pause between centuries, and in this he resembled Vienna itself.

Egon Schiele A Viennese a generation younger, Egon Schiele had a
(1890–1918) harder, more assertive art. He drew provocative women, naked, or in partial undress that only increased their sexual impact. Theirs is no mere flirtatiousness: they look out with a transfixed, haunted glance.

Schiele painted little and drew much, but he often heightened his drawings with color. He depended on wire-taut outline, as though the hard edge between bodies and the world around them were a zone of fear. Most characteristic are his gnarled arthritic hands.

His nine active years from 1909 until his death place him either as a belated Art Nouveau talent, or among the Expressionists; either way he must be seen as one of the century's great draftsmen.

James Ensor The Belgian, James Ensor, was swept away by fantastic
(1860–1949) imagery. He provided a preview of Freud and German Expressionism. His morbid subject matter also takes us back to his Flemish predecessor, Hieronymous Bosch.

Ensor was born in Ostend on the Belgian coast (his father was English) and his mother kept a curiosity shop. At carnival time she sold grotesque, brightly colored masks that must have had an alarming impact on the young Ensor. Masked figures and skeletons are his obsessive subjects. They act out unwholesome pranks that contrast with a delicacy

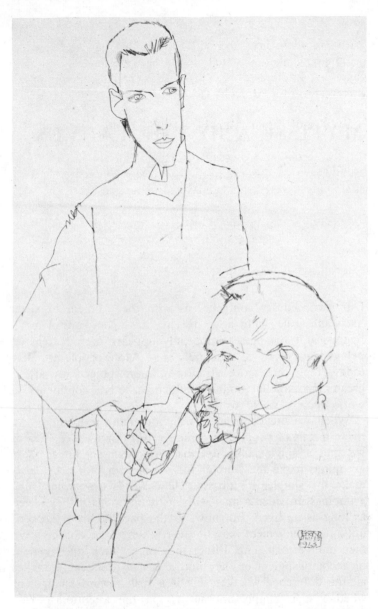

EGON SCHIELE. *Zentralinspector Benesch and his Son Otto,* 1913. (Fogg Art Museum, Harvard University, Cambridge, Massachusetts.)

of handling and cheerful color: Ensor is an Impressionist with an addiction to clear red set off by pale blue. His canvases, at once morbid and infantile, gave courage to the Expressionists to come.

MATISSE AND THE FAUVES

Our own century confronts us with the problem of sheer mass and scale. Until now, distance has taken care of lesser figures. But the present not only appears more extensive, being right before us, it actually is so. More people are alive today, there are more structures, more objects of art, a greater cross-pollination of influences, more continents at work upon a single world.

When we are confronted with too many individuals, we make a unit of people who share a form or an idea, just as we find a single color for them on a map. But if these groupings make life simpler for *us,* they do not necessarily make life simpler for artists. There was a time when such groupings provided a man with his definition, for they lasted as long as he lived. But now, as the pace of history speeds up, an art movement may be over in ten years, and creative men outlive their time. Either they repeat their one moment of accomplishment or they find a new expression. It makes all the difference whether this is a real, inward change, or whether it is simply another try at the attention of the public. A movement which takes over a personality does not always return it.

Yet as in the past, a few dominant figures stand out while movements come and go. Four figures whose contribution was made early in this century have maintained their significance. Two are architects, and of these one was an American, Frank Lloyd Wright (1867–1959). The other was a Swiss whose work centered on Paris, Le Corbusier (1887–1965).

Wright we will deal with separately as part of the history of our country; strong in his Americanism, he had little to do with Europe and actually gave it more than he took from it. Le Corbusier, the younger man, accounted for the greater change in the appearance of the world. He was the most significant single source of architectural ideas in our century, although he actually built very little until late in his life—the opportunity was denied him. World War I delayed the development of the coming architecture in Europe, so Le Corbusier too must wait. We turn to the two remaining forerunners, two painters who were sculptors and printmakers only to a lesser degree, the Frenchman Matisse (1869–1954), the Spaniard Picasso (1881–1973), the dominant creative figure of the century. Of these four, the three Europeans were active in Paris for the better part of their lives.

Matisse, the great colorist, must be seen as an innovator who provided a conclusion for the half-century that went before. Along with Cézanne he returned nineteenth-century painting to *painting*. He made it clear that the Impressionists and the Post-Impressionists were not merely imitating nature. He was the keystone of their arch; a keystone has a shape all its own and without it there is no arch. Matisse was responsible for the movement in France called Fauve, which will lead us into Expressionist painting in Germany.

We must keep Picasso waiting until these outbursts are over, for he is to offer the new century a whole new structure and open up a new world.

Fauve Painting

The style which the young Matisse now made his own was bolder and simpler than the Post-Impressionism out of which it grew. Simplified forms called for simplified vivid colors. Such color-forms, subtly related to each other, fused in a new unity that brought the whole canvas to life. The new painting balanced precariously between two realities, that of art and that of the visible world.

In Paris, the new Autumn Salon was the advanced scene: in the autumn of 1905 Matisse was hung in the same gallery with his younger associates, Rouault, Derain, and Vlaminck among others. A critic was said to have labeled this colorful and uninhibited group the *Fauves,* or wild beasts; whoever came up with the name, it stuck. The years 1905 to 1908 were the heyday of the Fauves. Fauve painting existed

before 1905; but art movements, like people, are usually born before they are named.

Henri Matisse
(1869–1954)

The young Matisse explored his way cautiously into painting. He copied the older masters in the Louvre, he studied the methods of Impressionism, and mastered the atmosphere of Monet. He became a colorist. He discovered the color of Turner when he made a trip to London, and he experienced the live color of the Mediterranean in Corsica. He passed through an early phase when he was painting with colored spots like Seurat. Then he flattened his canvases with large areas of two-dimensional color like Gauguin. When he became a sculptor, he adapted the blocky, gnarled forms of Rodin. All these influences coalesced into his own Fauve style, bold and fluid. Ultimately, he said that Cézanne was the great influence upon his life.

HENRI MATISSE. *The Joy of Life.* 1905–06. (Copyright 1976 by The Barnes Foundation. Merion Station, Pennsylvania.)

The canvases of the Fauve group grew vivid in the Mediterranean sun at a small port, Collioure, near the eastern end of the Pyrenees. Drawing on his liberating Fauve experience, Matisse produced a special canvas, *The Joy of Life,* sometimes called the first masterpiece of the twentieth century.

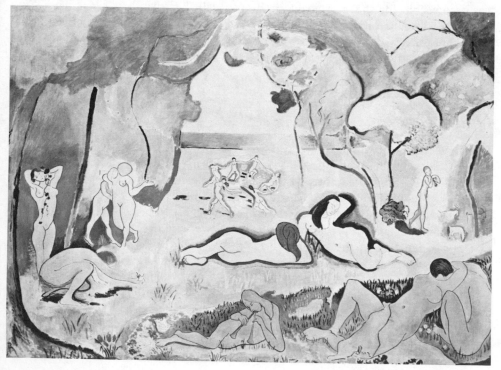

The Joy of Life not only summed up a lyric acceptance of pleasure, it announced a life's work. Matisse had already taken possession of the flat color surfaces of Gauguin, which allowed him to use color for mood. He now introduced the female figure as an impersonal symbol for the happiness Gauguin failed to find. Matisse's acceptance of the impersonal is his most twentieth-century characteristic. His figures live for us as musicians in an orchestra who make it possible for us to be alone with the composer. They are bounded by a

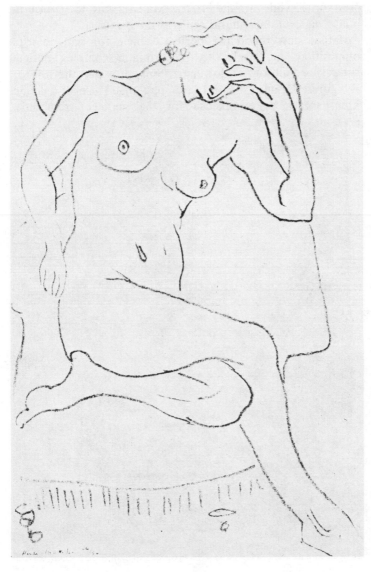

HENRI MATISSE. *Nude Seated in an Armchair.* 1922. Lithograph. (UCLA, Grunwald Center for the Graphic Arts, Los Angeles, Norton Simon Foundation.)

vital continuous line that does not so much describe anatomy as the motion for which anatomy exists.

The little ring of dancers in the middle distance of *The Joy of Life* became a central theme. Matisse painted this subject twice over on a mural scale, whipping the dancers into motion in a swirl of sun-darkened flesh on Mediterranean blue. A series of such paintings, vaguely classical, whose innocent figures may be dancers or musicians playing plaintively to themselves, or bathers as inquisitive as children, are among his most telling creations. They held the stage for a brief while around 1910. Matisse was to return to similar dancers on a mural scale in the 1930s.

Matisse now found the perfect vehicle for flat, colorful compositions in Islamic art. A brilliant, complex design, abstract, or built out of flower patterns, provided the foil for his figures. Delacroix and Ingres had made use of Islamic harem scenes as an excuse for the nude or seminude,

HENRI MATISSE. *Nude on a Blue Cushion.* 1924. (Private collection, Los Angeles.)

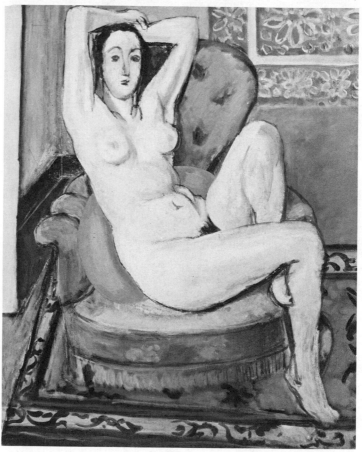

and so did Matisse. Veiled, in Turkish trousers, seen against a Moorish screen, the harem inmate had a name: she was an odalisque. Matisse was tireless in depicting her.

Delacroix had not been content to base his orientalism on literary allusion; he made the pilgrimage to North Africa, and so did Matisse. The intense light, with its black shadows, the vivid opaque color, gave Matisse some of his most sumptuous paintings.

He could no longer be considered a Fauve. His bold statements had always been deliberate; he was committed to endless discipline. Like an athlete or a musician he dazzled

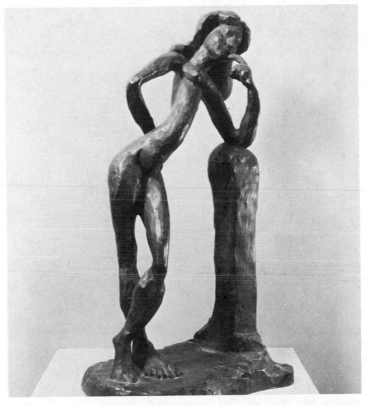

HENRI MATISSE. La *Serpentine.* 1909. (Collection of The Museum of Modern Art, New York, gift of Abby Aldrich Rockefeller.)

with his skill and concealed the practice on which it depended. His constant theme was a nude figure in a chair, a French window open on a balcony, a southern sun, sea, and flowers.

Matisse's early Fauve sculpture, his *Slave* (1900–03), has the gnarled and clobbered surface of Rodin. Once it had arms, but Matisse broke them off to clear up the image of the torso quite as Rodin himself might have done. Of his many small figures, *La Serpentine* (1909), is pure linear

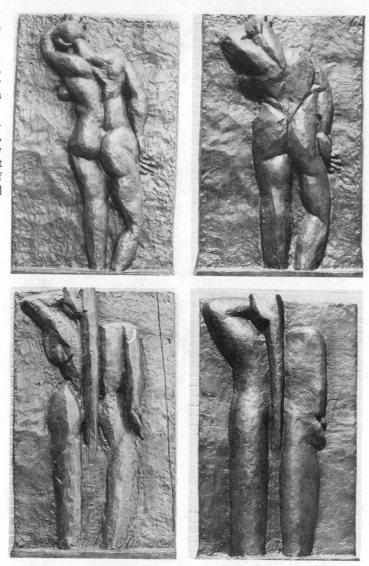

Matisse. A transition from a Fauve naturalism to an Expressionist-abstract image took place in a sequence of five busts, each a *Head of Jeanette,* modeled between 1910 and 1913. In another sequence of four great panels, each shows a woman's figure back-to, and here again there is a transition from the naturalistic to the abstract. Modeled over the years from 1909 to 1930, they are deliberate studies in progressive simplification, as Matisse spent his life condensing form.

In his old age Matisse, confined to his bed, created large decorative surfaces, colored paper patterns cut out and pasted

on canvas under his direction. These *découpages* (cutouts), abstract or floral, are the triumph of his maturity. It is matter for reflection that Matisse, who had found in the nude figure a form of expression for a life's work, ultimately gave it up and reconciled himself philosophically to the interplay of colors and shapes. In the process he closed his account with the nineteenth century and came to grips with one of the major interests of our time.

Compared to Matisse, the other Fauve painters, and especially the Expressionist painters, their counterparts in Germany, were violent and impulsive. If these men seem enormously creative, they did not always realize that a great artist does not indulge emotion, he has the will to guide it. This is what sets the Fauves and Expressionists at a distance from this mind-controlled century. They were content to trust to their strong and innocent feelings, and they now have the air of a lost youth.

After Matisse, the second Fauve painter of importance in the Paris group was Georges Rouault. He changed very little once the Fauve pattern had been set, and we know his work if we become acquainted with it before World War I. Rouault shared with Matisse a drive for essentials, but their essentials differed. Matisse offered joy and entertainment and he was as great as an artist can well be without becoming involved with man's aspirations and fate. Rouault, on the contrary, was a religious painter and moralist. In contrast to Matisse, who lived in the sun, Rouault remained cloistered. What happens in religious observance, being ritual, gains through repetition. What would be monotony in another painter was dedication in Rouault. He dealt with man's shortcomings and his redemption, with evil and with good.

Georges Rouault
(1871–1958)

While a young man, Rouault found his subjects in prostitution and vice, and he painted scenes that had been congenial to Toulouse-Lautrec. But he painted them not with relish, but with horror, and his revulsions provided the agitation and violence in his style which made him a Fauve.

When he turned to the shortcomings of men, he chose the clown as a symbol. The suffering clown who must make others laugh is a well-worn literary device (the opera *Pagliacci* is built upon it), but in Rouault's hands the implications are deeper. Our happiness is a mockery. If we

think that a little make-believe will give us happiness, we are clowns.

His next figure of human limitation is the judge. For Rouault, God is the only judge of man, and the man who

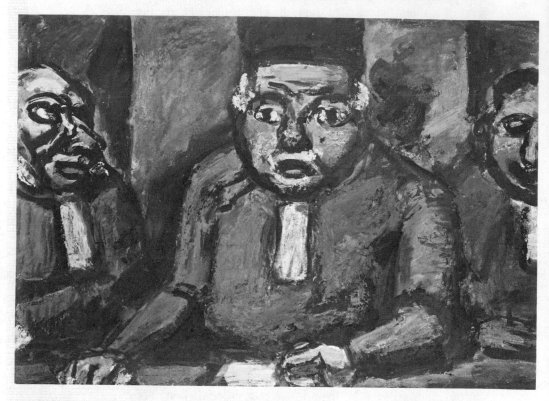

GEORGES ROUAULT. *Three Judges*. 1913. (Collection of The Museum of Modern Art, New York, Sam A. Lewisohn bequest.)

sets himself up to judge others is overweening. Rouault's judge is a man unaware of his limitations, who overestimates himself in his ignorance, and takes evil advice. Finally, Rouault turns to the image, or theme, of a king, like the judge a tragic figure not fit for power over men. But the king is born to his inescapable role and is thus a figure of tragedy. Hope lies in salvation alone, which comes to man not because of his power but because of his weakness, and this leads Rouault to illuminate the life of Christ.

The Fauve Rouault inherited from Daumier, the French moralist of the generation before. But his submissive, if spiritual, attitude toward life harks back to still earlier ages. During his adolescence Rouault was apprenticed to a stained-glass maker and repairer, and perhaps too much has been made of the resemblance of his painting to medieval stained-glass windows. But the resemblance is there—his

slashing dark outlines surrounding brilliant areas of color, reds and yellows, clear blues and deep greens, recall the dark lead outlines that surround luminous colored glass in cathedral windows. As in stained glass, the light in a Rouault painting appears to come out of these clear areas and not

GEORGES ROUAULT. *Miserere*. Published 1948. Plate 35, etching and aquatint. (UCLA, Grunwald Center for the Graphic Arts, Los Angeles, Harold P. and Jane Ullman Collection).

to be reflected off them. The light comes through to us from another world.

It is understandable that these powerful darks surrounding clear color lent themselves to lithography. So too does Rouault's instinct for dramatic black-and-white images, where black and white are death and salvation. Printmaking is one of the great dimensions of twentieth-century art, and Rouault, along with Matisse, Picasso, and the German Expressionists, is in the forefront of the great printmakers.

André Derain
(1880–1954)

André Derain produced a number of early Fauve paintings of spectacular brilliance. Later he became involved with Cubism and went over to an art of structure. Caught between two opposed approaches, that of Matisse and that of Picasso, he retreated from both, and turned back to figure pieces that have a kinship with the nineteenth-century artist Courbet. These paintings have flashes of great power, but they remain remote from our interests and time.

ANDRÉ DERAIN. *London Bridge.* 1906. (Collection of The Museum of Modern Art, New York, gift of Mr. and Mrs. Charles Zadok.)

EXPRESSIONISM

AND GERMANY

Expressionism, an outburst in German painting, followed closely upon Fauve painting in France. Both France and Expressionist canvases displayed bold forms and heightened colors. Both Expressionist and Fauve artists clamored for personal freedom, and shared a limitation, a belief that to be muscular is to be free. But while Fauve painting is bold, compared to Expressionism it is deliberate. In Germany turmoil in paint conveyed anger as well as joy and made a moral pronouncement. Expressionist painting was closer to the German temper than Fauve painting was to the French, and it was to have a longer life.

There is more than one link between the Fauves and the Expressionists. Certain influences were immediate: the German painters saw or learned what was happening in Paris about 1905 and were stimulated to assert themselves in turn. But there was also a less direct connection, and we must turn back a little to trace it.

Before Rouault, the Post-Impressionist van Gogh was also motivated by moral protest. Van Gogh was the Reformation all over again, and it is not surprising that his high moral seriousness reached into Germany. The man who bore his message was Edvard Munch, the young painter from Norway who was working in Paris in the 1890s. Munch was in Germany for the first seven years of this century, where he had a strong, releasing influence upon the younger men. After his breakdown and retreat to Norway, Expressionism went on without him.

KÄTHE KOLLWITZ. In Germany itself, there were other seminal figures besides
A Woman Entrusts Munch. Käthe Kollwitz (1867–1945) had a powerful
Herself to Death. 1934. influence as a printmaker. Her etchings and lithographs were
Lithograph. (UCLA, charged with an Expressionist fixation on death and the
Grunwald Center for suffering of the poor and oppressed. She clamored for
the Graphic Arts, Los social justice, but she was a reformer and not an explorer.
Angeles.)

The Brücke or Bridge Group (1905-11)

German Expressionism was charged with a sense of mission. It was launched as a conscious program, complete with publications, plans, and hopes. The Brücke or Bridge Group was founded in Dresden in 1905 by a few earnest young men. It survived for only a brief moment of brotherhood, but it liberated an expression that was quite national. The leader of the group, and the strongest figure as an artist and personality, was Ludwig Kirchner.

Kirchner was a young student of architecture in Dresden in 1901, but he was soon painting, and during the next four years a number of friends gathered around him. His first significant confederate was Erich Heckel. More important was Heckel's friend and schoolmate, Schmidt-Rottluff. In the next year, 1906, two more joined the group, Emil Nolde and Max Pechstein. There were others, but as fast as the Brücke grew it dissolved, either through resistance to the dominance of Kirchner, or because Berlin, the art capital, drew various members to it at different times.

Kirchner in his early subject matter ranged from city night life or street life to the biography of the studio. Generalized yet brittle forms and heightened color are his characteristics, and time and again the mood sinks from exuberance into the depths of anxiety. *The Street* (1907) and another *Street* (1913) show him at his early best, and to these we can add the symbolic *Bridge* (1914), actually the bridge over the Rhine at Cologne. His style, easily recognized by its splintery angularity and an exaggeration of the vertical, creates a sense of discomfort even when the scene is sensuous and lyric: Kirchner's happiness, like Munch's, was tainted.

Kirchner was caught up in the First World War from 1914 to 1917 when he suffered a collapse. He was tubercular and he went to live in Switzerland. In 1938 he committed suicide. Both his art and his broken life remind us of van Gogh.

By the time we have absorbed Kirchner's spiky and uncomfortable art, lending itself so well to translation into powerful woodcuts, we have a measure of the others in the Brücke Group. Schmidt-Rottluff was perhaps the next most imposing figure. He sacrificed everything to impact and force, and for all the violence of his color he was still finer

Ludwig Kirchner
(1880–1938)

Karl Schmidt-Rottluff
(1884–)

Erich Heckel
(1883–1970)

Max Hermann
Pechstein
(1881–1955)

Emil Nolde
(1867–1956)

LUDWIG KIRCHNER. The *Street*. 1913. (Collection of The Museum of Modern Art, New York.) in his strong black-and-white prints. Where Schmidt-Rottluff was dramatic, Erich Heckel was more quietly lyrical, and Pechstein softened into the decorative and suave. Nolde, who was only with the Brücke for a year, was an exception to the whole group, an older man of provincial background caught between the Impressionist influence of his own time and his surrender to a younger generation that attracted

him. Nolde never did complete his adaptation, but he was saved from his transitional position by his simple rustic nature and the coarse breadth of his art. He was by instinct a powerful painter among men who were sacrificing all for power.

As an Expressionist, Kokoschka came late. Like Klimt and Schiele before him, he was also from Vienna, and he typified the flamboyant love of life associated with that city. His expressive art is filled with a greater tenderness and joy of living than we find in the Brücke artists. But if there is more love, more empathy, Kokoschka made no such warm impression on the Vienna of Strauss and of the Hapsburg Empire. His immediate success was due to the scandal that his early paintings and a few early writings (a juvenile play, *Murder, Hope of Women*) brought down upon him. The paintings he showed in Vienna in 1908 and again in 1909 were too strong for his audience, but he had staunch adherents in the intelligentsia, whether they were critics, art historians, or the advanced architect Adolf Loos. When the smoke cleared, Kokoschka retreated from Vienna to Switzerland. Here he found the noble landscape that he needed, at once calming and exalting. He returned again and again to the Alps for inspiration, and in his old age he lived with the mountains.

Oskar Kokoschka (1886–)

KARL SCHMIDT-ROTT-LUFF. *Peter's Draught of Fishes*. 1918. Woodcut. (UCLA, Grunwald Center for the Graphic Arts, Los Angeles.)

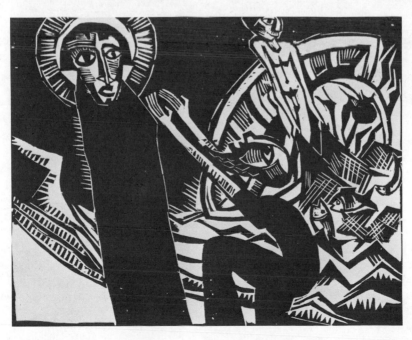

With the coming of the First World War, Kokoschka sold a great canvas dramatizing a spectacular love affair in order to purchase a cavalry mount, and rode off to the Russian front as a hussar. He received a head wound and was captured and rescued, an experience that left an emotional scar. At one time Kokoschka's alienation was such that he had a life-size doll constructed for him (the surface was suede), as a substitute for humanity. He painted this

OSKAR KOKOSCHKA. *Self-portrait.* 1913. (Collection of The Museum of Modern Art, New York.)

simulacrum, and drew from it some sort of unwholesome companionship.

His endless travels now began, his flights from one capital of Europe to another, as he sought to escape the coming political darkness. He was singled out in Hitler's Exhibition of Degenerate Art that bore down on the Expressionists. He took refuge in Vienna and then in Prague—although he had been born in Austria, his father was a Czech—and he reached England for the years of the Second World War.

Kokoschka's earliest paintings are his finest. He began with some of the great portraits of the century. His distorted images of raw sensibilities in thinly brushed paint allow for many scratched lines that relate these canvases to the tradition of German printmaking. It is only in the 1910s, in the war years, that the paint grows loaded and moonlit blue-green tonalities take over. These tonalities recall the sixteenth-century Spanish painter El Greco who was just then beginning to be valued as a master.

OSKAR KOKOSCHKA. *Il Duomo* (cathedral in Florence). 1948. (Mr. and Mrs. Donald Winston, and the Minneapolis Society of Fine Arts.)

In the 1920s, Kokoschka retreated from Expressionism to something more serene. His favorite subjects were now cityscapes painted from a height. His wide prospects have two vanishing points: we retreat into the distance in each upper corner rather than down the center. These cityscapes are literally above humanity: they are hurried, loose and brilliant in execution, with a touch-and-go, migrating vision. Increasingly we miss his early intensity.

George Grosz
(1893–1959)

Max Beckmann
(1884–1950)

The Expressionist scene changed with the defeat of Germany. Untrammeled as the Expressionists had been, they now grew more disorganized, like men who were still fighting without any clear view of their enemy. George Grosz and Max Beckmann had fought the military establishment, and when it collapsed they fought the devil-take-the-hindmost pessimism in the highly cannibalistic postwar society they saw around them.

Grosz was a revolutionary filled with a ferocious crusading spirit and he used a line that cut like a whip. His drawing is not solely Expressionist; by now the irrationality of Dada and the morbid perceptions of Surrealism (both subjects up

GEORGE GROSZ. *Fit for Active Service*. 1918. Pen brush and India ink. (Collection of The Museum of Modern Art, New York, A. Conger Goodyear Fund.)

ahead for us) were ready to his hand and appropriate to his bitter subject matter. It seems clear that the hate and sadism he castigated were churning in his own breast—but this is the fate of revolutionaries. His ferocity often took a sadistic sexual turn when the subject slipped away from politics.

If his fierce social satires drawn and painted during the 1920s reach the emotional heights, later when he came to live in America he found himself reduced to a reminiscent animosity. His line slackened and became entangled in illustration: he painted little windswept nudes in the sands of Cape Cod.

Beckmann had a greater and still darker talent. He also castigated the First World War and its sequel, and in due course Nazi tyranny—he had much to protest. He, too, produced an art quite as sadistic as the scene he attacked: it is hard not to see his endless mutilations and bloody stumps as an expression of his own hate. His strong black outlines delineate frantic figures caught in political spasms. Beckmann, too, moved to America but in his case neither the ferocity nor the ability died down. Animosity was rooted deep in his powerful style, and he had no thought of a cease-fire.

In his early paintings Beckmann began with scenes of

MAX BECKMANN. *Departure*. 1932–35. (Collection of The Museum of Modern Art, New York.)

crowded domestic horror that set the stage for all that was to come. Here a small but aggressive child-Beckmann blows his own symbolic trumpet in circumstances that remind us of Oskar in *The Tin Drum* by Günter Grass. Such scenes are previews of his later triptychs that deal with lust, brutality, and power. Hard black lines, as final as death, separate flesh from flesh. His highest peak in this manner is *Departure* (1932–33), a triptych describing the embarkation of an infant prince in a fisherman's boat. A king and queen accompany the child; the boatman, who is hooded, may be Charon, the boatman on the Styx, or an executioner, or perhaps Fate. In the midst of all these symbols, we can see the princeling as the artist's own genius in exile on earth, or simply the artist himself sailing into exile. It is a rich blue painting in which fate leaves room for hope, but the mayhem in the side panels that accompany this scene is fodder for the psychiatrist.

Chaim Soutine
(1894–1943)

Not all Expressionism is German, just as not all German Expressionism is moral protest. There is also an expressionism of the brush, a desire to break through the limitations of art with blazing and extravagant statement. Such a desire drove the Russian-Jewish painter, Soutine. His distortions, whether of the features or of the general anatomy, or the diagonal lurch he gave to buildings as though they were running from the destruction of their town, are more intense and extreme than any we have yet encountered. Even in looking at Soutine in black and white we sense that he is a violent colorist. His flesh is in a high, ruddy key and his landscapes are a gold-green that is quite his own.

Soutine came out of provincial Russia like the sculptor Lipchitz and the painter Chagall, both of whom he met when he reached Paris. He was a friend of the Italian painter Modigliani and the French painter Utrillo, and they are often grouped together, not for their way of painting, for they differed greatly, but for their poverty-stricken, disorganized lives.

Soutine's most characteristic works are his solitary figures. Although they are pinched, gnarled, and twisted, their images are colorful, their spirits burning and free. His little bellhops and kitchen helpers stand out for their pathos, their animation, their vitality.

An equal intensity goes into his still lifes. Most of them

are of food, for the artist is ravenous. He sets before us plucked fowls and dead fish, and a whole *Side of Beef* (1925) that he painted in imitation of Rembrandt. It is a gory resplendent work.

Soutine did not offer ideas to the future. He harvested in splendid fashion what the Epressionists had sown.

CHAIM SOUTINE. *Pastry Boy.* ca. 1927. (Private collection, Los Angeles.)

Fauve and Expressionist Sculpture

We find no equivalent force in French sculpture to set over against Fauve painting. The whole French nineteenth century had only one great sculptor, Rodin, a figure of renewal rather than advance. Degas created major sculptures but only Matisse, in our century, created sculptures that are in any sense Fauve.

Rodin discouraged the liberation of form from anatomy.

Another still more conservative sculptor, Maillol, prolonged this calming effect.

Aristide Maillol
(1861–1944)

Maillol was somewhat older than Matisse, but he lived more than half of his long life in the twentieth century. It was only then that he became a sculptor; earlier he had been a designer of tapestries.

ARISTIDE MAILLOL.
La Nuit. 1902. Bronze.
(Private collection.)

His sculptures are of full-bodied women. They belong to the classical tradition and are as timeless as the Mediterranean. Having set a simplified, somnolent form, Maillol never changed. The lack of individuality in his blank and opaque figures gives them a spurious authority. The best of them have a certain pythoness grandeur which has arrested twentieth-century taste. They deny the Fauve impulse.

The Expressionist distortions of Lehmbruck convey a tender self-pity rather than indignation. For such an unassertive temperament the influence of Rodin was lying in wait. He went to Paris and modeled several handsome, if academic, female figures that are pensive and remote under a blurring of features characteristic of the French master. Later, just before the First World War, he produced two heroic-sized figures of infinitely thin and tenuous proportions, his *Kneeling Woman* (1911) and *Standing Youth* (1913). These are magnificent works, medieval in their vertical attenuations. Like the Blue Period figures of Picasso, they have an emaciation that portrays a starvation of spirit. Lehmbruck was not long on the heights; he committed suicide right after the First World War.

Wilhelm Lehmbruck
(1881–1919)

WILHELM LEHMBRUCK. *Standing Youth*. 1913. Bronze. (Collection of the artist's family.)

Ernst Barlach
(1870–1938)

Chief among German Expressionist sculptors was Barlach, who produced strong defiant gestures, such as the *Avenger* (1923). They appear as overpowering protests: Barlach relies on Gothic reminiscence for pathos and power, and on folk art—as in *Singing Man* (1928)—for the common touch.

In Germany anger has often proved a spur to art. But anger and art do not mingle well unless the artist has the ability to reach the depths of human nature, for political turmoils are all too quickly forgotten. Barlach escaped this pitfall, through talent, and through dignity. His work was strong and proud.

Gerhard Marcks
(1889–)

Gerhard Marcks appears to be a follower of Maillol, but in fact the dominant influence upon him is Greek art of the great period. In his old age, he found a second home in Greece. For Marcks, all Europeans are Greeks, in their culture, their art, and their fratricidal wars. But there is more. His figures also breathe a Gothic austerity and chastity.

He is a sculptor of animals as well as of people. His animals, at once humorous and quaint, come close to folk art. Here he taps something deep in the German temperament; in Marcks it is a resource, not a limitation. Marcks closes the door on Expressionist sculpture, a door that Maillol had declined to open.

PICASSO

Whether the times changed of themselves or were dislocated by the first genius of the age is beside the point. Pablo Picasso (1881–1973), more than any other artist, accounts for the twentieth century. He seems occupied solely with his own biography whether in paint or sculpture, prints or ceramics. But through a miracle of fitness it turned out to be the biography of the time.

With Picasso a new era began. In Cubism he gave the early decades of the century their structure. When artists turned to a new emotional inwardness (Surrealism), as opposed to the out-the-window look of Fauve and Expressionist painting, Picasso was in the forefront of the change. But he escaped altogether the illustrative limitations of Surrealism; he found bold, intense forms for emotion and his art can be seen as providing the century with both its geometric structure and its inward release.

Picasso is a multiple personality containing many contradictions. He was the boldest and freest of experimenters, yet his disciplined art was submitted to years of organizing and structuring. He began with paintings quite sentimental in mood, were it not for their elegance. Yet he could find an idiom for any emotion, whether it were of personal anguish or based on obscure archetypal drives. The most original man of the century, he took over the inventions of others without compunction, knowing that whatever he touched became his own.

Picasso was born in Málaga in the south of Spain. He was

a youthful prodigy. His father, an art teacher, surrendered to the genius of his son and himself stopped painting. The family moved and Picasso grew up in the large industrial city of Barcelona, the one Spanish city which offered some encouragement to the arts and to progress. It even had a restless life of cafés where ideas could bloom at night. But this was only a dim reflection of the art world of Paris toward which the young turned their hopes. Picasso, age nineteen, first arrived in Paris in 1900. He made several

PABLO PICASSO. *Woman Ironing*. 1904. (The Solomon R. Guggenheim Museum, New York, Thannhauser Collection, courtesy of the Thannhauser Foundation.)

returns to Barcelona before he detached himself for good. Then Spain saw Picasso no more; he lived in France, in Paris, for the better part of his life. There he brazened out the years of German occupation, too important a figure to molest.

His first five years in Paris were given over to an art of

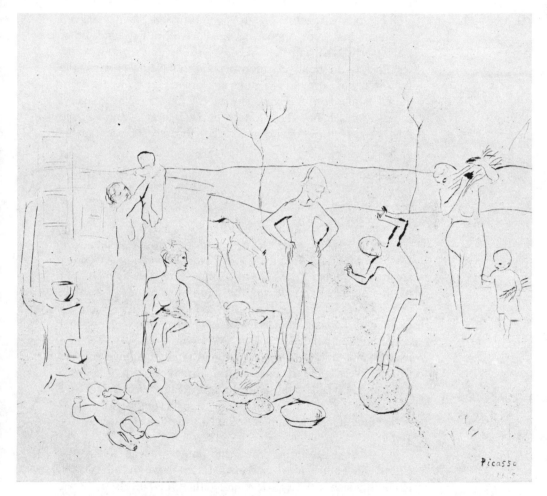

nostalgia and moodiness. He imitated Toulouse-Lautrec, or he recalled a night life of poverty in Barcelona. He adapted a linear Art Nouveau style for his mannered sinuous images, progressing from a Blue Period to a Rose, via a Circus Period of strolling acrobats in harlequin suits. These wan, inward, and self-indulgent canvases are steeped in pathos; they dramatize the inner solitude that to Spaniards is the tragic mystery of being a person.

PABLO PICASSO. *Les Saltimbanques (The Tumblers).* 1905. Drypoint. (UCLA, Grunwald Center for the Graphic Arts, Los Angeles, Fred Grunwald Collection.)

Suddenly Picasso woke up and discovered himself in the forefront of the twentieth century. A time of synthesis was at hand. He drew a new order out of his endless imitations: from classical art, whether Greek vase painting or the art of Pompeii that came out from under the ashes of Vesuvius; from the exalted art of El Greco, and finally from the African mask.

Picasso was not the first to be impressed by the African carvings that were appearing in Paris. Matisse and other Fauve artists had already been struck by their quality. But for Picasso the bold yet smooth planes of Negro carving, the hollow forms, provided a new anatomy. Here was no individual confession or Expressionist cry but a tribal imagery. Picasso himself had the strength of a tribal artist, and as the African carver represented his tribe, Picasso represented his age.

Arrival of Cubism

It is characteristic of Picasso to employ a large canvas either for the introduction of a program or for its conclusion. *Les Demoiselles d'Avignon* (*The Young Women of Avignon*) (1907) announced a whole new procedure. It was made out of Negro art, yet in reducing the sculptured planes of African images to a flat surface Picasso was already hitting upon the method of Cubism, the translation of forms into planes that could be manipulated at will. *The Young Women of Avignon* grew from the left. As we cross the canvas the figures become progressively more strange and distorted. To this day it is hard to say whether the painting is a heated expression or a cool invention. *The Young Women of Avignon* was ahead of its time and it remained rolled up in Picasso's studio for years.

As Picasso advanced from this point, we can follow the Cubist adventure as it becomes fined down into thin triangulations that flutter over each other like sheets of paper on a desk. These abstractions never quite lose the image that lurks at the heart of the puzzle that Picasso created. But the puzzle-like forms and not the hidden image soon become his obvious subject. This was Cubism, and in its development from 1907 to 1912 Picasso had a co-worker and co-inventor, Georges Braque.

The two Cubist pioneers could look back to a further source in Cézanne. They could consider that they simply took

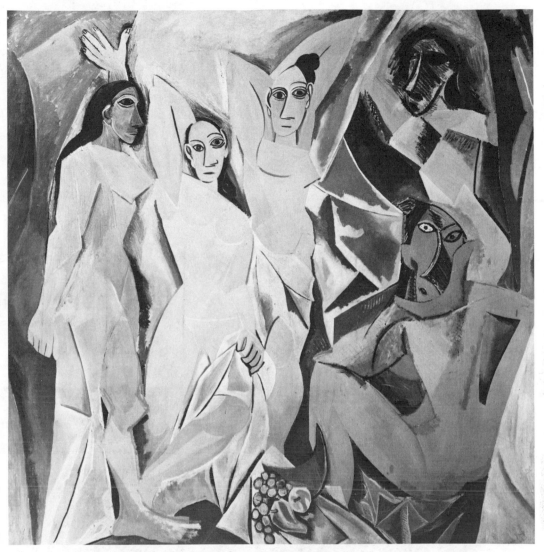

Cézanne's vibrant little planes one step further. Late in his life, Cézanne wrote a letter in which he stated that art (his own art) could be made out of the sphere, the cone, and the cylinder. A great deal was made of this pronouncement. It served to authorize a conceptual art and to make Cubism orthodox. But behind both Cézanne and Cubism, we should remember, were the age-old box forms of Mediterranean architecture. Some of the late, piled-up townscapes of Cézanne are almost Cubism, and similar scenes in Spain, towns that look like lump sugar, lent themselves to Picasso's early Cubist experiments.

It is almost incredible that a temperament such as Picasso's

PABLO PICASSO. *Les Demoiselles d'Avignon.* 1907. (Collection of The Museum of Modern Art, New York, acquired through the Lillie P. Bliss bequest.)

could work so closely with Braque in developing Cubism; one can only assume that Picasso gained from the collaboration. Although Cubism was to become an art of construction, it began as exploration, disintegration, and the clearing of the ground. The first five years were understandably called Analytical Cubism. From then on Picasso and Braque began to

PABLO PICASSO. *Accordionist*. 1911. (The Solomon R. Guggenheim Museum, New York.)

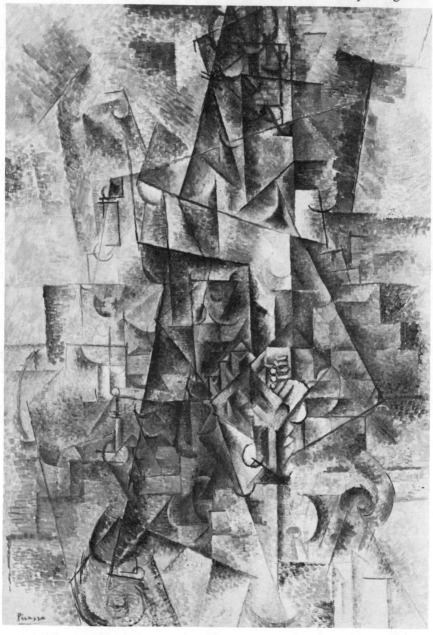

rebuild, and the new reconstruction—the way back—received the name Synthetic Cubism. Then Braque went to war, and Picasso carried on alone.

Picasso made a discovery in 1912: if the relationships within a painting were its subject matter, then actual objects could be made to serve quite as well as copies of them. So he applied newsprint directly and printed oilcloth served as an image of itself. He was soon attaching rope and blocks of wood to the surface of a "painting." Such ready-made patterns and instant content provided a shortcut to construction: in effect, such stickings-on or *collages* gave a "painting" a new concrete existence. Fauvism and Expressionism exaggerated, but Cubism, and the abstraction to which it led, translated images into symbols, and symbols could be based on concrete facts.

Independent fact involved a real third dimension and was a move toward sculpture. And a three-dimensional approach fused more than one view of an object. For instance, a head could be shown from more than one angle, in profile and full face. In profile a nose *looks* like a nose, and two eyes are made visible because they exist. Picasso clung to this descriptive procedure well past his Cubist days. It was not exactly new to history, as this was only a continuation of Egyptian drawing, but it freed Picasso from imitation, and allowed him to describe what he knew instead of showing what he saw.

To offset the obscurity inherent in these works Picasso stayed with simple and obvious themes. Figures gave way to still lifes which made use of musical instruments—often enough the typically Spanish guitar—or objects that might be found on a studio or café table. He painted fruit dishes and fruit (adapted from Cézanne), bottles, glasses, a newspaper, and an occasional sculpture. Such sculptural still life was congenial to Picasso as his paintings usually dealt with nearby objects that required little surrounding space; he was not an atmospheric painter.

If Cubism seemed obscure to the public, to put it mildly, this very fact invited the favorable critic to attach himself to the movement, to provide it with an explanation and a philosophy. Picasso attracted critics. Max Jacob was a loyal friend, and then there was Guillaume Apollinaire, who became the spokesman for Cubism.

An extravagant figure, Apollinaire saw that an art without ready intelligibility (a nonliterary art) was in need of a dynamic literature, and this, with some fanfare, he produced.

He published *The Cubist Painters* before the war. Later he coined the word *Surrealism.* Intuitive and dogmatic, he was a myth-maker, and he offered his own myth. He invented his name, and claimed to be the son of a pope.

He fought in the war, and received a head wound which took a bad turn, and right after the war he died. He turned the twentieth-century critic into the spokesman, creating a role which has flourished ever since.

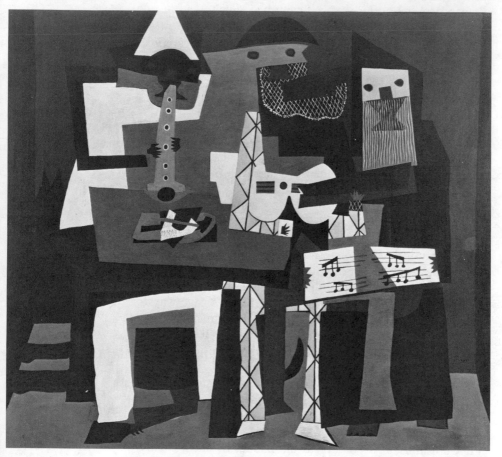

If *The Young Women of Avignon* opened the theme of Cubism without being altogether Cubist, three paintings, variants on a single composition, tended to conclude the theme as Picasso turned in a new direction. *The Three Musicians* of 1921 are Cubist enough in procedure, but they arouse an obscure and troubling mood. Picasso shows us a carnival group: a clown, a harlequin figure, and a musician in the guise of a monk. These figures are only diagrams,

flat areas of color, but Picasso manages to make them ominous precisely because they are disembodied. To use a term more of our time, they are presences. These three musicians would willingly play an accompaniment to an execution, for they have no bodies to lose. The only real restraint they know is the restraint of the composition in which Picasso has locked them up.

Meanwhile, Picasso was painting realistic canvases whenever his own inner tension was sufficiently relaxed to allow a return to surface appearances. Then he was likely to turn to harlequin images recalled from his early circus theme, or to semi-draped classical figures. Here unconscious imagery lay hidden, for the circus or carnival is the topsy-turvy world where concealed impulses get acted out, and the classical figure is no mere opportunity to deal with a semi-draped figure—Picasso needed no such subterfuge. In his drive to reveal emotions he seems drawn toward the infancy of humanity as other artists are drawn toward their own childhood. The classical time is a long way back, in the childhood of Europe, and a pagan age is essentially innocent, being pre-Christian. For that matter, his classic clothes are no more or less than night clothes, and they invite a physical art free of compunction.

By now Picasso had given himself and the century a new method that allowed him to explore those deeper unconscious drives which are one of the compelling interests of our time. This interest came over into the arts, under the name of Surrealism in the 1920s, and Picasso was claimed by the Surrealists, although he quite rightly resisted the claim. If Surrealism illustrated the theories of Freud, Picasso created diagrammatic works that symbolized what Freud strove to explain.

Artists, major artists, often make a single contribution that renders them significant or authoritative for an essential decade. Picasso went on creating until the end of a long life. To follow his life, as we will, and not break it into fragments, inevitably steals the show from other artists and movements, and will force us to give the century an air of cutback. No matter: Picasso did this to the twentieth century. Other artists were obliged to live in the presence of genius, and often to glean where Picasso had reaped.

The *Seated Bather* (1929) will do for a whole series of paintings called the Bone Period, in which Picasso invented a hard-shell crustacean anatomy that takes life back to a

dinosaur age. Such a creature, with its little eyes in a beak
head and its clipper jaws, is able to seize its prey and crunch
it down. It is in the business of survival and to that end it

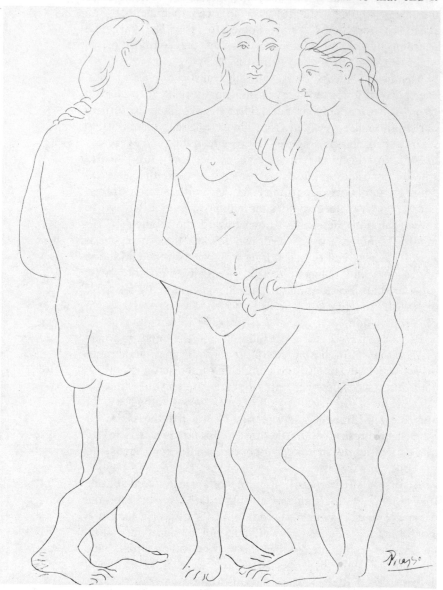

PABLO PICASSO. *Les
Trois Amies*. 1927.
Etching. (UCLA, Grun-
wald Center for the
Graphic Arts, Los An-
geles, Fred Grunwald
Collection.)

has breasts. Picasso has an instinct for an unnatural history
which is our own. Appropriately, the background is the age-
less sea. For Picasso offers an emotional experience in great
depth. He is able to create a time span that really fits the
long history of evolution.

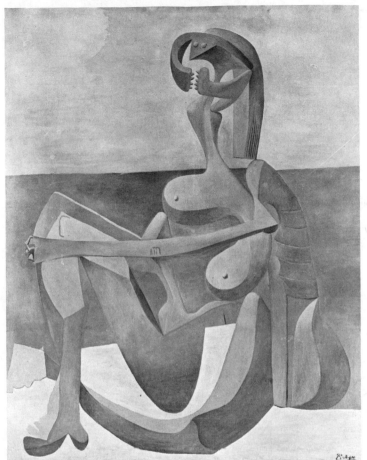

Girl Before a Mirror is a quite violent diatribe on the nature of woman. The girl before an oval mirror is herself a series of ovals that emphasize her femininity: round breasts, belly, and buttocks are offered as an enticing collection rather than a single body. Her head is both profile and full face, so that it seems to turn and come to life. But there is more here. The profile head is white silver, a half moon; the full face is golden, a round sun. So we have night and day, a twenty-four-hour reality. Arms are reduced to mere sweeping gestures as the girl reaches toward the mirror, and here the reflection she sees presents important differences. In the mirror the body is simplified and reduced to breasts and buttocks while the head is at once primeval and stylish; with its hawk's beak it is quite Egyptian. The woman looks back to some earlier essential form lurking within her. This is neither Freud nor Jung, it is again Picasso's intuitive vision, his capacity to see the deep past in the present.

Left: PABLO PICASSO. *Girl Before a Mirror*. 1932. (Collection of The Museum of Modern Art, New York, gift of Mrs. Simon Guggenheim.)

Right: PABLO PICASSO. *Weeping Woman with Handkerchief*. 1937. A study for *Guernica*. (Los Angeles County Museum of Art, gift of Mr. and Mrs. Thomas Mitchell.)

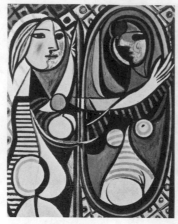 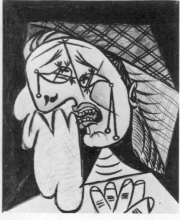

In *Weeping Head* (1937) distortion and desperation are the same thing. But note that the outline of the head is much less distorted than the agitated features. The face serves as a sort of oval corral in which features are turned loose. Tears leave literal tracks or furrows, and teeth biting a handkerchief are a separate subject of momentary observation.

This disorganized way of seeing forces us to lurch from one object of attention to the next, and to keep up with events as they tumble in. It makes us realize that other paintings were completed at some point in the past whereas these paintings seem to be still happening before our eyes. Such a procedure would hardly lend itself to a large, comprehensive canvas, we might suppose, but Picasso used it for a vast scene of chaos in his *Guernica*. The subject of this great painting is the destruction of the Basque town in the Spanish Civil War. Picasso knew better than to illustrate the event:

PABLO PICASSO. *Guernica*. 1937. (The Museum of Modern Art, New York, on extended loan from the artist.)

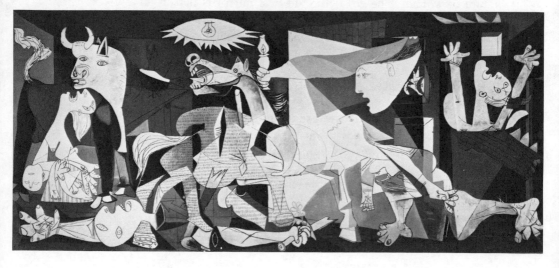

he reduced it to symbols. The bullfight is the symbol he chose for this slaughter. The bull stands triumphant and steaming; the picador's horse is killed. A woman holding a lamp comes swarming down a staircase. How is this expressed? By a hand that comes in from above and a woman's head arriving on a long stem: her head simply swoops out of nowhere. High above the scene is an electric bulb, the eye of God that gathers the evidence.

Toward the Second World War great paintings by Picasso are more rare. *Night Fishing at Antibes* (1939) looms as a major event, a jumbled and distorted spectacle of one of the rudimentary human employments; men get food while women look on. The fishermen spearing fish at night by the light of a lantern are quite as primevally engaged as a large fish eating a smaller one. It is understandable that they are grotesque. This could be the way the fish see them while

PABLO PICASSO. *Night Fishing at Antibes.* 1939. (Collection of The Museum of Modern Art, New York.)

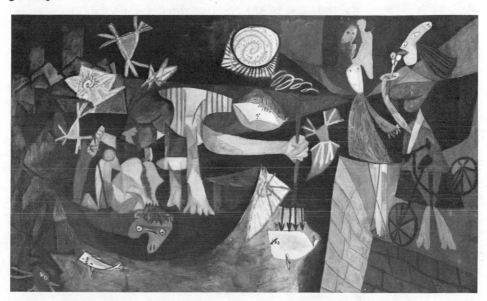

they watch the fish. Limbs are little more than a record of motion and Picasso does not count fingers.

Picasso possesses a saving sense of caricature that allows him to distort to an incredible degree without losing either action or personality; rather, both gain in the process. As a result, he never abandons subject matter or representation. Yet he can be as far-fetched as he chooses. Ultimately he devises figures in which front and back are deliberately confused, so (if we look into the matter) we must see the image rotating before our eyes.

This freedom has lured him into the broadest range of techniques. He branched into printmaking, then into sculpture, then into ceramics. Some of his finest works are his prints, for his strength is in his living line. His dealers have turned his sculpture concoctions into bronze because of their value, often depriving them of their original whimsicality, as Picasso pursued resemblances hidden in materials at hand, whether wire, wood, cloth, or glass.

When Picasso translated Cubism into sculpture, he diagrammed space. Later he created a series of monumental heads, typically *Bust of a Woman, Boisgeloup,* that possess a curious anatomy of their own as forehead and nose swell out like shoulder or thigh. These heads are entire bodies. Is not this as reasonable as a separated head? Having achieved these forms, Picasso did not repeat them.

His most famous sculpture, *Man with Sheep,* is, almost by accident, one of the great spiritual ventures of the century. Once the self-pity of the artist's Blue Period is past, Picasso's primeval art is hardly noted for tenderness. Yet here his unsentimental image of man in relation to his animal (they live off each other) sums up man's relationship to life itself.

His ceramics are an artist's frolic in terms of caricature, whim, and arresting form. And much of his late painting after the war deals with sardonic adaptations of the masterpieces of the past; it is genius being impertinent to genius. He has diverted himself with such nymphs as Matisse was enjoying in 1909, but Picasso makes much wilder use of distortion which allows them more leeway to romp. In his late prints the romp becomes a self-indulgent orgy. This is the work of a man who lived to master that dangerous opponent, his unconscious. The casual works of his old age seem to come out of an erotic euphoria; nothing now required his full strength, and his only opponent was death.

CUBISM AND

ORGANIZED FORM

When we turn back to Cubism to see how it fared, we must at once admit that it was only a part, if a major part, of a twentieth-century zeal for organized form. And even Cubism was not all due to Picasso. It is to Picasso's credit, however, that he sensed his twentieth-century zeal, and pre-empted a creative position in the midst of a dominant trend. Leaving Picasso his central position as a leader among leaders, we must go back to build the environment that he so strongly affected. And we must begin by doing justice to Braque.

Braque and Picasso worked together for four or five years during the early development of Cubism. For a while their canvases are deceptively alike—sufficiently close to fool Picasso on occasion, it is said, and many of the more subtle Cubist inventions during this time should in all probability be credited to Braque. The variety of surface effect, the differences in texture from smooth to sanded, the tan and gray tonalities, the introduction of letters in the composition, all these aspects of Cubism are also characteristic of Braque's later work. Braque's father was a house painter or decorator who could be relied on for such effects as the graining on wainscoting or doors to be found in the cheaper hotels and restaurants of the time. Presumably Braque acquired these skills in creating illusory surfaces during his house-painter's apprenticeship as a young man. He is a painter of infinitely refined textures, and in a not unkind sense a decorator. Picasso delved under the surface of existence following where

Georges Braque
(1882–1963)

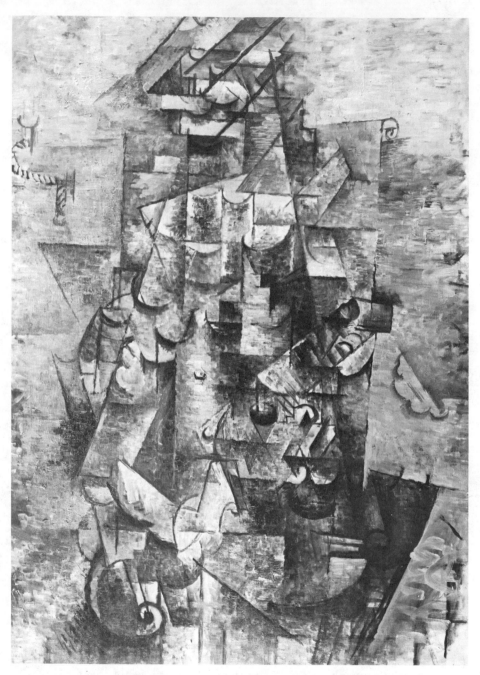

GEORGES BRAQUE.
Man with Guitar. 1911.
(Collection of The Museum of Modern Art, New York, Lillie P. Bliss bequest.)

emotion led, while Braque stayed with the surface and its delights.

After the war, Braque produced a studio-laboratory art untroubled by deep emotion: his concerns were aesthetic. A willingness to create a profile in black as the shaded half of

a full face or figure is all that is left of a Cubist double vision. Braque's endless still lifes are infinitely harmonious and sophisticated: he is a painter's painter.

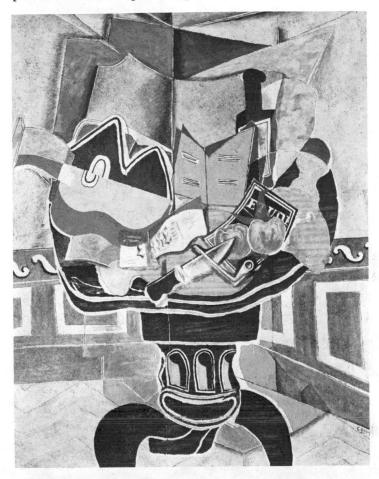

GEORGES BRAQUE. *The Round Table*. 1929. (The Phillips Collection, Washington, D.C.)

After Braque, Gris comes closest to Picasso during the Cubist days, the only days Gris was to know, for his creative life only covered some fifteen years. He reflected Picasso's light, a moon to his sun. On his arrival in Paris he began as an illustrator, but when he turned to Cubism it proved more important to him that he had been trained as an engineer. His paintings are as precise as though they were produced by a straight-edge and triangle, and a shimmering metallic surface such as we see on the doors of bank vaults is characteristic of his steely grays. Like moonlight, his painting is utterly without heat. One of his earliest canvases is a masterpiece, his *Portrait of Picasso* (1911–12).

Juan Gris
(1887–1927)

From then on Gris showed no great change. Typically, he stayed with Cubist subject matter: his still lifes offer us musical instruments, bottles, plates, knives, and an occasional chessboard for the sake of its pattern—all the Cubist table-top material. We even encounter Picasso's harlequin, but Gris' figures, except for his *Portrait of Picasso,* remain diagrams.

JUAN GRIS. *Portrait of Picasso.* 1911–12. (Courtesy of The Art Institute of Chicago, gift of Mr. Leigh B. Block.)

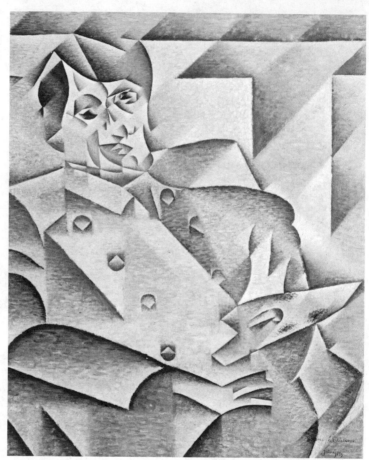

Fernand Léger (1881–1955)

Very different is Léger, although he is even more metallic than Gris. He began with a Cubism related to architecture, with primary colors for animation. His environment was soon as firm as structural steel and when figures appeared they were metal automata. He had one overriding idea, the mechanized quality of contemporary life. For Léger, life was urbanized; the driving force in his crowded compositions is the modern urban pressure. His heavy outlines and his emphatic colors, pure red, yellow, blue, and black and

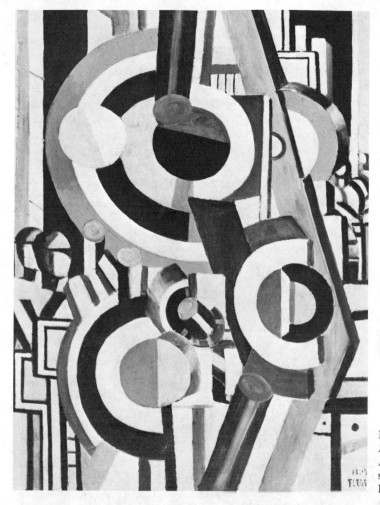

white, clear up the scene, and then there is the simplification that comes from the persistence of a single idea.

Such persistence can be counted on for more than one masterpiece, but Léger was never more effective than in the 1910s and 1920s or finer than in his well-known *Le Grand Déjeuner* (1921). In this canvas he invests three mechanized women with an extraordinary vitality. They fit harmoniously into their geometric environment; they seem to have insisted with unrelenting willfulness on this interior of the 1920s that is so becoming to their arbitrary anatomy. Characteristic are clarity, brilliance, and a feeling for the throb of the new century.

Delaunay is a somewhat lesser figure, but he made his contribution to Cubism: he introduced color. Picasso was

Robert Delaunay (1885–1941)

colorful during his Synthetic Cubist phase to be sure, and
Gris and Léger used color assigned to particular surfaces—
we are shown that a tablecloth is red. Delaunay used color at
an earlier date as an abstract element, as part of the form,
and he devised circular color patterns that made his forms
gyrate and the eye dance. His spinoff from Cubism had a
name, Orphism.

FERNAND LÉGER. *Three
Women* (*Le Grand
Déjeuner*). 1921. (Col-
lection of The Museum
of Modern Art,
New York.)

He painted the Eiffel Tower more than once, treating it
chaotically in a quite disorganized nonperspective. His Eiffel
Towers have a lurch characteristic of German Expressionist
painting, and it was no accident that it was Delaunay who
was the most influential in the transplanting of Cubist ideas
into Germany. It was the color and chaos which got through,
and not the discipline of the Cubism of Picasso and Braque.

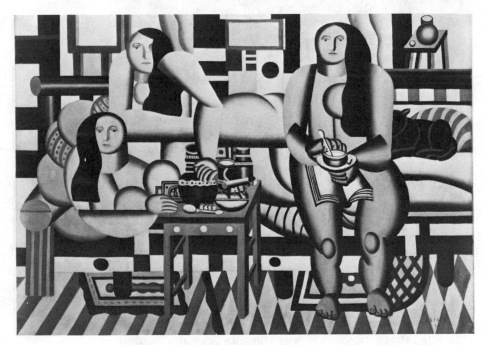

Cubist Sculpture

We come to the intrusion of Cubism into sculpture. It takes
more courage to flout anatomy in three dimensions than to
reduce it to a diagram on canvas. Picasso created a *Head of
a Woman* that was quite an exceptional event in Cubist
sculpture in 1909. But soon the usefulness of Cubism to
sculpture was to become apparent.

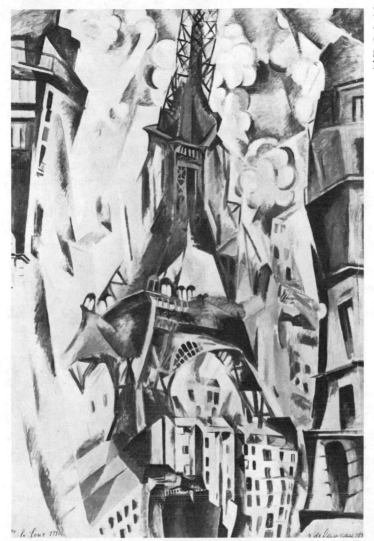

Archipenko, one of the earliest Cubist sculptors, was making use of Cubism before the First World War, a suave curvilinear Cubism such as Picasso would use in the 1920s. As a Russian, he knew the simplified flowing forms of the Byzantine-Russian icon and it was natural to him to describe a figure in suave, highly simplified curves.

Alexander Archipenko (1887–1964)

He arrived in Paris at a crucial moment, when Cubism provided structural opportunities. It was his invention to translate convex swelling surfaces into concavities, and pushing this to its logical conclusion, to create voids which had a positive formal existence. His concavities and holes led di-

rectly into the concept of volume without mass. *Woman Combing Her Hair* (1915) is an early instance. It is more liberated by Cubism than Cubist, and certain Art Nouveau recollections linger on.

Archipenko came to America in 1923, so that he spent half his life as an American. It was not the more creative half. He turned to an endless refining of his own forms, although it is also true that he experimented ceaselessly with new materials. By the late 1940s, he was making figures of plastic lit from within, sculptures no longer dependent on changeable, reflected light. In the 1950s, he was working in plastic high reliefs in variegated colors, the outcome of a lifelong interest in polychrome sculpture. Late in his life he achieved a few impressive symbols, more Surrealist than Abstract, such as his *Solomon,* or his *Queen of Sheba* (1961). He was cruelly unappreciated in America in his lifetime, per-

Above: ALEXANDER ARCHIPENKO. *Woman Combing Her Hair.* 1915. Bronze. (Mrs. Frances Archipenko Gray.)

Right: ALEXANDER ARCHIPENKO. *Queen of Sheba.* 1961. Bronze. (UCLA, Franklin D. Murphy Sculpture Garden, Los Angeles, gift of Donald H. Karshan and anonymous donor.) [Courtesy of John Swope.]

haps because his forms create an ingenious rather than a compelling effect.

The major Cubist sculptor was also a Russian, Jacques Lipchitz. In Paris, he assimilated rapidly the simplifications and the structurings that Cubism implied. Like Picasso he clung to the living image, but he knew how to carry this living quality over into forms that could become symbols of life. Although he kept pace with the changes that Picasso

Jacques Lipchitz
(1891–1973)

JACQUES LIPCHITZ. *The Bather*. 1923–25. Bronze. (UCLA, Franklin D. Murphy Sculpture Garden, Los Angeles, gift of David E. Bright.) [Courtesy of John Swope.]

initiated, he thought as a sculptor, and he gave Cubism sculptural solemnity and monumental scale.

For Lipchitz, Cubism was the discipline that sobered a highly expressive temperament. Expressionism was to come to the fore in his later work, but by then his acquired Cubism was still on hand as a method. When the Cubist restraint is

upon him, while a sense of life is filling the slab forms into swelling, muscular surfaces, he is at his finest, as in his *Bather* (1923–25). He too was early in opening up his sculpture, first by boring a hole, then by devising larger apertures, then by using outlines of metal.

Lipchitz had an instinct for a central place in the modern European tradition. His successful, rigorous Cubism—as well

JACQUES LIPCHITZ. *Song of the Vowels*. 1931–32. Bronze. (University of California, Los Angeles, Mr. and Mrs. Norton Simon and the UCLA Art Council.) [Courtesy of John Swope.]

as the coiling, gesticulating, Expressionist aspect of his work
—did not cancel each other out; they supplemented and
augmented each other, and his Cubist structure kept his
Expressionist animation from becoming too feverish.

Since Lipchitz' work remained recognizable, however
stylized, he was dependent on subject matter. He often turned
to classical mythology but he was better served by themes
that obviously came closer to him, subjects drawn from the
Old Testament. The story of David was especially reward-
ing to him; it gave him an often-repeated symbol, the harp,
which he brings to life as both instrument and player, a meta-
phor for an artist at one with his work.

Lipchitz came to America as a refugee in 1941. He had
a studio and home at Hastings-on-Hudson, but in his last

RAYMOND DUCHAMP-
VILLON. *Large Horse.*
1914. Bronze, cast
1968. (Los Angeles
County Museum of Art,
gift of Anna Bing
Arnold.)

years he lived much of the time in Italy, near Carrara—although he worked almost exclusively in bronze.

Jacques Villon
(1875–1963)

Raymond
Duchamp-Villon
(1876–1918)

Marcel Duchamp
(1887–1968)

Three brothers and a sister of a Norman family named Villon were all artists. The sculptor brother, Duchamp-Villon, only lived to create three or four major works. His two most famous sculptures are his *Baudelaire* (1911) and his *Horse* (1914). The first is quite Egyptian in its formal simplification and power. The second work is relatively abstract: its resemblance to a horse must be seen in an impression of a pawing hoof, of a foreleg in action. The *Horse* is already beyond Cubism in its use of abstraction to convey the essence of character. It is a great, even a crucial work. After this brief glimpse of an outstanding talent we have nothing more.

Jacques Villon, the elder brother, was a painter content with a colorful realism seen through the structural simplifications of Cubism. His forms tend to be softly blurred by an Impressionist atmosphere. He was an accomplished printmaker.

Finally, the youngest brother, Marcel Duchamp, was both painter and guiding influence on two generations of artists. He soon left Cubism behind—his *Nude Descending a Staircase* (1912) is not precisely Cubism—to take up a life in which personality became an art form in itself. We shall return to him when we come to Dada and Surrealism.

THE FORMAL TREND

Futurism in Italy

Cubism crossed frontiers easily. We shall see it taking on new and more extreme manifestations in Holland, Russia, and Germany. Italy had its own formal movement, a counter-movement to Cubism, based on the diagramming of motions; in the working out, where Cubism was architectural, Futurism was operatic.

Futurism began with a manifesto, a protest and a clamor that came from a Milanese poet, Marinetti. The Futurist idea in Marinetti's mind dated from 1908; the first manifesto appeared a year later and the next a year later still in 1910. These manifestos were calls to arms: museums were to be burned and art freed from the dead hand of the past. "Dynamism" was the new, releasing word. Italian art had been quiescent and unimpressive all through the nineteenth century and now action was needed: "a roaring motor car, as though running on shrapnel" was of greater beauty than the sculptures of the past. If action was the goal for the Futurists, the greatest and most liberating action was war itself. Futurist praise of war was to be satisfied all too soon. Meanwhile there was nothing really dangerous in an art movement sustained by the work of four or five artists in Milan.

Balla was the eldest of the Futurist group, by exception a Roman. His most famous painting, probably the most famous Giacomo Balla (1871–1958)

Futuristic work, was the *Dynamism of a Dog on a Leash* (1912), an exercise in multiple positions that resembles a stroboscopic photograph. He also had to his credit a fascinating *Flight of the Swifts* (1913)—successive images of the birds that enliven the sky of Rome toward evening. These multiple-position paintings should be compared with the more famous *Nude* of Marcel Duchamp, itself an exercise in a sequence of positions.

GIACOMO BALLA. *Dynamism of a Dog on a Leash.* 1912. (Albright-Knox Art Gallery, Buffalo, New York, courtesy of George F. Goodyear and the Buffalo Fine Arts Academy.)

Gino Severini (1883–1966)

Severini was living in Paris just before the rise of Futurism. In consequence he was the closest to Cubism and its techniques. To Cubist forms he added a brilliant dazzle of color. *Dynamic Hieroglyphic of the Bal Tabarin* (1912), celebrating a nightspot in Montmartre, gives us a joyous response to raucous subject matter that recalls Toulouse-Lautrec. The crowded forms and images are gay and high-keyed and clash with one another. Actual sequins are spattered over the work to add to the animation. By 1914 Severini was producing quite abstract paintings of triangles formed of pointillist dots, with dazzling color ranging through the spectrum from red-gold to purple and blue. A little later he was celebrating the war in good earnest which led him back to a form of realism under a Cubist discipline: he chose an armored train with all its cannons belching away.

The central figure of the Futurists, the one artist of major talent in the group, Boccioni, was both painter and sculptor. The Futurists were in love with riots, demonstrations, and trouble in the streets, and *The City Rises* (1910–11) achieves the Futurist intent, with political action and violence conveyed through a throbbing light. The painting is powerful, if dated in terms of its heavy symbolism: two massive draft horses lunge toward each other, and for all the claims of twentieth-century technique we are back in the days of tournaments.

Umberto Boccioni (1882–1916)

As a sculptor, Boccioni was more important. His *Development of a Bottle in Space* (1912) is a major contribution to the progress of art in this century. This small object is a study of a bottle as a cylinder that has been carved into, unwrapped, and spread out into its environment, and the end result is a monumental form that could well be a majestic centerpiece for a city square. Boccioni successfully denies the division between environment and object; here the two are inseparable.

UMBERTO BOCCIONI. *Development of a Bottle in Space*. 1912. (Collection of The Museum of Modern Art, New York, Aristide Maillol Fund.)

Boccioni then goes on to do the same thing for the human

figure in his *Unique Forms of Continuity in Space* (1913),
only now it is the separate muscles of the animated figure that
uncoil and flutter and flash away into their environment. The
figure somehow fuses with the flowing metal of which it is
composed and has an air of a knight in armor in violent
action. If the object does not go over into its environment
as successfully as the *Bottle in Space,* it is nonetheless
electric.

Boccioni was killed in the war and Futurism, the move-
ment he dramatized, was strangely temporary if we con-
sider how arresting it was when it was new. Its "dynamism"
was somehow hollow and self-defeating, for once an explo-
sion has taken place nothing is left but an echo.

De Stijl and Neo-plasticism in Holland

The structural discipline took on a new look when it reached
Holland. It became static; in place of motion it had tension.
It moved inexorably toward architecture.

Holland was cut off by its neutrality during the First World
War and its artists were thrown together in their isolation. In
consequence the movement that developed here had an un-
usual amount of cohesion. Painters, sculptors, and architects
worked together, with a singularly long-lived art publication,
De Stijl (The Style), to cement their interests. The move-
ment centered on two painters, one a creator and innovator,
Mondrian, the other a firebrand, van Doesberg, theorist,
artist, and editor of *De Stijl.*

Piet Mondrian
(1872–1944)

Theo van Doesberg
(1883–1931)

Mondrian must be recognized as a twentieth-century
painter of the first rank. He dedicated his life to the search
for absolutes and he achieved an absolute in his total life's
work. A religious temperament intensified his drive toward
unity of composition. He was a mystic and a theosophist.

Mondrian began as a naturalistic painter in his generation.
He was looking over the horizon toward a new world by
1908, and he went to Paris in 1911. Here he was soon
translating landscapes into segments of line, at first frag-
mented curves and then a series of short horizontals and
verticals. The flat Dutch scenery he knew provided hori-
zontals, but verticals had to be sought. He found them in
tree forms and the masts of boats in harbor. Soon the
horizontals and verticals won out as events in themselves and
he was painting tight patterns of what amounted to plus and

minus signs. Having reached this point about 1914, Mondrian made a trip home to Holland where he was caught by the outbreak of war.

His problem from then on was to use color without disrupting the flatness of his canvas. Cézanne had given half a lifetime to creating three dimensions with color, his yellows pressing forward and his blues retreating; Mondrian devoted no less energy to reversing or restraining this effect. Finally he held down color with heavy black bars, horizontal or vertical—in effect he jailed his color. This procedure called for precise widths of black to balance exact amounts of color. In choosing between colors he found the primaries a necessity—a red that contained no blue, a blue free of red, a yellow that was pure. Thus his colors stayed forever separate, while his lines, being at right angles, could only

meet once. In a special philosophic sense, a Mondrian is a unique event.

Mondrian gave the name Neo-plasticism to his rarification of Cubism. It could hardly have taken place without an attendant dogma and theory. He put his ideas into words in the magazine *De Stijl.*

He was to have a broad influence, not only on painters,

PIET MONDRIAN. *Composition in White, Black, and Red.* 1936. (Collection of The Museum of Modern Art, New York.)

but on architects and designers. Architectural lines also tend to be vertical and horizontal, completely so if the pitched roof is abandoned, as it was in the new architecture of the 1920s. The Schroder House designed by Rietfeld (1923–24) and Café d'Unie by J. J. Oud—two major names in Dutch architecture—compete in their adaptations of Mondrian's compositions.

Toward the end of his life Mondrian moved to New York and the rectilinear grid of the city must have made him welcome. His last works were explorations of more complicated patterns, laid out experimentally with colored Scotch tape. But his life's work was more than experiment or exploration; it was an achievement. He was the purist of the century.

As editor of *De Stijl,* Theo van Doesberg promoted all abstract movements: Cubism, Neo-plasticism, Constructiv-

ism. He had a brand of his own: Elementarism. He was a propagandist. As a painter he stylized "real" objects until we can just make out the source if we have a clue. The resulting abstractions are far from Mondrian's philosophy, purity—or taste.

Suprematism and Constructivism in Russia

One only has to look into any of the nineteenth century Russian novels to encounter the desperate longing with which the intellectual Russian looked toward western Europe. Leningrad itself was built by Peter the Great in order to open a door on the West. Marxism was not a Russian idea; but in adapting it the Russians provided it with whatever was extreme. So it was with the ideas that made the journey from Paris and back. They returned to the West in a more extreme form, made over into philosophic absolutes.

Young Russian artists were not then cut off from the West as they have been since. They traveled to western Europe and they had the opportunity to see what had been brought home by Russian collectors. Right in Moscow they could get to know Cézanne and the Post-Impressionists as well as the Fauves. Some of Matisse's greatest canvases, all dated before 1914, were in Russia.

Kandinsky is the foremost name among Russian painters of this century, but he turned to western Europe early. He was to work and live in the West except for the war years and a brief moment of aborted hope right after the Revolution, and we must hold him for another context.

Malevich stands close to Kandinsky in liberating art from imitation. He made a sweeping contribution that he labeled Suprematism. He placed a black square on a white square ground in *Basic Suprematist Element* (1913). His achievement is in the creating of a painting that had no sources in experience: a square on a square is a geometric conception. Malevich, a religious man, saw this as a spiritual event materialized.

Kasimir Melevich (1878–1935)

He took his own conception one step further in 1918 with *White on White*. This is a tipped square drawn in outline on a square. We have here at one stroke the twentieth century's delight in conception or invention as art. The logical sequel—although it took fifty years—is an artist

picking up the telephone and ordering a cube to be delivered
to him instead of making it himself.

Constructivism

Vladimir Tatlin Tatlin was in Paris in 1913, the year before the outbreak
(1895-1956) of war. He saw Picasso's constructions and on his return
to Russia he was inspired to produce similar objects. His
constructions, in wood, metal, or glass fragments, unlike
Picasso's, were apparently unrelated to a specific source;
in any case they no longer exist. What does exist is his
remarkable model of the *Monument to the Third Inter-
national.* This work can be seen as a sizable sculpture, a
leaning spiral that vaguely reminds us of a transparent
Leaning Tower of Pisa in structural steel or a fragment of
the Eiffel Tower. But Tatlin thought of it as a model for
a construction 1300 feet high, a building-sculpture of metal
and glass with usable spaces, the whole designed to revolve

VLADIMIR TATLIN.
Model of the *Monu-
ment to the Third In-
ternational.* 1919–20.
(Photograph from plate
in book: *Tatlin,
Against Cubism,*
Nikolay Punin, St.
Petersburg, 1920,
photograph courtesy of
The Museum of Mod-
ern Art, New York.)

at varying speeds—once a year, once a month, every day—
in short, a giant clock large enough to contain time-bound
man. Understandably, this monument was never built, but
it deserves to be taken seriously as an example of the Russian
willingness to attack the gigantic and to push toward the
ultimate, a willingness which has taken the Russians into
space.

In contrast to Tatlin, two brothers, Gabo and Pevsner, were the theoreticians who transformed Constructivism into a precise and intellectual art in three dimensions. The elder brother, Pevsner, began as a painter. He, too, was in Paris before the First World War, from 1911 to 1914. He was familiar with Fauve painting and Cubism and was in contact with the advanced Russian sculptor, Archipenko. Meanwhile the younger brother, Naum Gabo, was in Germany studying medicine, until he gave this up in favor of engineering; only later did he become a sculptor. Both Pevsner brothers tided out the war in Norway until the Russian Revolution in 1917, when they went home. Three tumultuous years followed for the younger Russian artists including the Pevsners—the junior, Naum, changed his name to Gabo to avoid confusion—and for Malevich and Kandinsky. They all hoped for a revolution in the arts, but their hopes were soon frustrated. The new government saw the arts as a vehicle for propaganda and demanded a naturalistic imagery legible to the masses.

Anton Pevsner
(1886–1962)

Naum Gabo
(1890–)

Gabo and Pevsner issued a manifesto in 1920 which talked
of "realism," by which they meant their own philosophic
reality. They soon left Russia, Gabo going to Germany for
the decade of the 1920s and Pevsner returning to Paris.
Gabo was the more inventive and the more active of the
two brothers. Typically he used transparent plastic frames
as scaffoldings for meshes of plastic thread. With these
threads under tension, he built beautiful curved surfaces
out of infinite adjacent straight lines. These objects are of
exquisite lightness and beauty. They resemble the models
constructed by mathematicians to translate higher equations
into three dimensions. Though we seem to be off the earth,
we are still in a universe obedient to the laws of physics.

Pevsner's constructions followed the same principles that
guided his brother's. He, too, created beautiful curvilinear
forms out of an infinite series of straight lines. In his work
the lines are brass rods welded together so the sculptures

NAUM GABO. *Linear
Construction No. 4,
Variation 2*. 1963.
Phosphorous bronze,
brass, stainless steel.
(Collection of
Mr. and Mrs.
Frederick R. Weisman,
Beverly Hills.)

are opaque. It is temperament and not a difference in
theoretical approach that allows us to tell the brothers apart.

The Claim of the Mystical

Constantin Brancusi
(1876–1957)

There is more to existence than construction; there is a
religious, mystical view of life. Such a view came from the
East and had permeated Byzantine art. Brancusi brought this
mystical sense with him out of his native Rumania. He had
a peasant background; he possessed the strength of the
rudimentary. He had an instinct for a single, curved, all-
containing form: an egg, a shell, a skull, out of which
hatched mind, or soul. His simplified oval images, whether
in stone or brass, contained the essence of existence. His
singlemindedness was physical as well as spiritual; as a
young man he walked from Rumania to Paris.

In Paris he carved an early naturalistic head that might
have been by Rodin. He declined to be Rodin's assistant.

"Nothing grows in the shade of great trees," he said. As early as 1908 he created a sculpture, *The Kiss,* that can be instructively contrasted with Rodin's sculpture of that title. Brancusi's sculpture was made as a gravestone: two rectangular stones fuse sensuously together. After this Brancusi turned away from rectilinear forms once and for all and began to carve his ovoids. The features on his detached heads disappear little by little until nothing but an egg is

CONSTANTIN BRANCUSI. *The Kiss.* 1908. Limestone. (Philadelphia Museum of Art, Louise and Walter Arensberg Collection.)

left; life goes back into its embryo. He translated these smooth heads into a long series of portraits of an actress, Mlle. Pogany—a theme that he pursued for the better part of twenty years with only the slight variations that were so important to him.

As we watch, egg becomes bird; the form simply elongates. The original oval has an end sliced away; and the flat

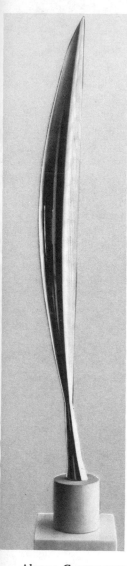

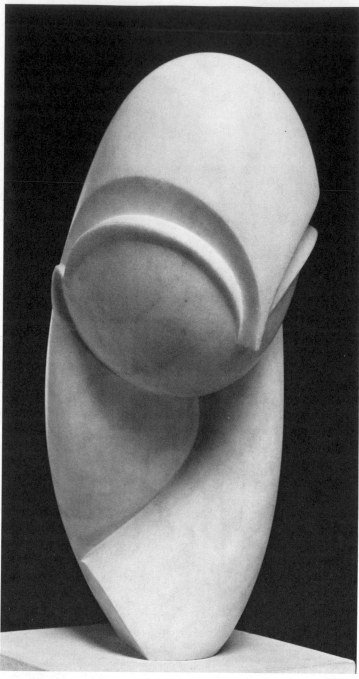

Above: CONSTANTIN
BRANCUSI. *Bird in
Space.* 1925. Bronze.
(Rita and Taft Schrei-
ber Collection, Beverly
Hills.)

Right: CONSTANTIN
BRANCUSI. *Mlle.
Pogany.* 1931. Marble.
(Philadelphia Museum
of Art, Louise and
Walter Arensberg
Collection.)

elliptical plane that results often seems to stand for a mouth.
In his pear-shaped *Young Bird,* this plane, slicing on the
bias, mysteriously creates an impression of pert awareness,
and in Brancusi's final masterpiece in this theme, *Bird in*

Space (1925), the form is greatly elongated, yet the slanting plane is still there, sharpening the upper end into a beak. The total form, more tenuous than the body of a heron, is as much the image of flight itself as of a bird. The term "streamlined" comes to mind, but the sculpture is older than the term. Brancusi must be forgiven if other artists seemed trivial to him, men who failed to see through to the significance of things. He set himself up as a lifelong rival to Picasso.

An art object reaches us via a frame or a pedestal. Brancusi made the pedestal part of the work of art. If the sculpture were marble the pedestal could be rough-hewn wood, and for his featureless brass heads he had a still more interesting solution: he simply served them on a circular, flat, brass disc, equally highly polished. This based the head on its own reflection, allowing it to double itself or reproduce itself through reflection (or introspection). By instinct he made himself at home with the oval: here life began.

If Brancusi came so close to the heart of things, why had he so few followers? We reflect that a man who acts on a strong belief has little to offer those who do not share it.

Modigliani, the Italian painter of twentieth-century portraits, hardly belongs to his time and is difficult to place. He was a form-conscious artist with a definite relation to Brancusi, with whom he worked in the days when he was a sculptor. He was obsessed by a recurring sculptured image, a kneeling female caryatid, a composition of ovals.

Amedeo Modigliani
(1884–1920)

Modigliani was born in Leghorn and came to Paris as a young man, where he carved for some five years, until about 1912, when his worsening health forced him to give up sculpture for painting. He was tubercular, beautiful, and hopelessly dissipated, and a nightmare to women. Only eight years of creative life remained to him, but during this time he painted an extraordinary series of figure pieces and portraits. His nudes have an extreme stylized elegance and splendor. Their elongated anatomy seems entirely convincing, though they would be hard put to use it. But then no figure of Modigliani's ever walked—he never painted a foot.

He was an Italian Mannerist come to life. His extreme, elongated, oval heads are from Brancusi and the African mask.

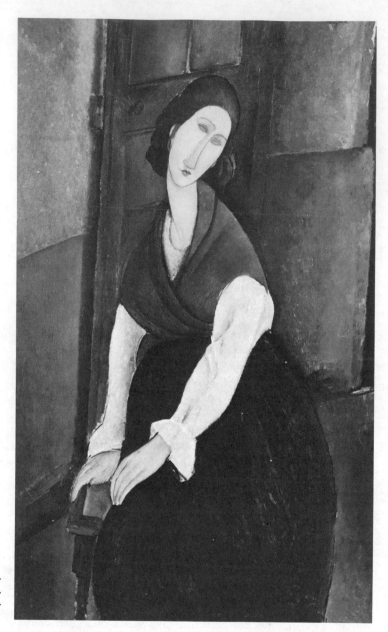

AMEDEO MODIGLIANI.
Jeanne Hebuterne.
1919. (Pritvate collec-
tion, Los Angeles.)

FREEDOM, FANTASY,

AND ORDER

The Blue Rider Movement

In the winter of 1911–12 a group of artists put on an exhibition in Munich. They took their group name, *Der Blaue Reiter* (Blue Rider or Blue Knight), from a painting by Kandinsky. This was a more cerebral group than the Expressionists in Dresden of a few years earlier. The two most important figures were the Russian, Wassily Kandinsky, and the Swiss, Paul Klee, who had come to Munich to find his own modest and sensitive way ahead. Then there were Franz Marc, soon to be killed in the First World War, the French painter Delaunay, with his colorful Cubism-derived abstractions, and the musician Arnold Schönberg, who was briefly a painter.

Historically, Kandinsky was on the verge of an important breakthrough that would lead to non-objective art. Klee, half a generation younger, took longer to find himself; he used the current concern with form as a base for a world of fantasy he never abandoned. Both artists came from countries that had active folk art traditions—Russia and Switzerland. Folk art offered Kandinsky brilliant color and provided Klee with a feeling for grotesque subject matter. Both men were musicians; Klee's father was a conductor, and music was to have been his profession. After the coming First World War, both artists were to find themselves together for many years on the faculty of a famous school of design in Germany, the Bauhaus.

The Non-Objective

Wassily Kandinsky
(1866–1944)

Kandinsky had traveled in western Europe from an early age. He studied law in Moscow, gave it up to paint when he was thirty, and went to Munich. In this art center he kept ahead of the times, shifting from one advanced group to the next.

He painted landscape of a toy-town vividness. As his scenes became increasingly generalized and abstracted he grew less and less dependent on representation, and the time came when he freed himself altogether from this support. If we set the date for this liberation between 1911 and 1913 the question whether he was the very first to produce non-objective work is moot. Mondrian was moving in the same direction, the American Arthur Dove was growing abstract by way of symbols, and Malevich was creating abstractions which he thought of as religious statements. But the fact remains that Kandinsky saw the inevitability of an art without object, obliterated the object, and created a theory to justify his accomplishment.

His theory emerged as a small, early, and significant book, *Concerning the Spiritual in Art,* published in 1912. Here the words *spiritual* and *soul* frequently recur. Kandinsky saw the dissolution of the material world as a scientific fact. He was greatly impressed with the disintegration of the atom which was scientific news at the time. He believed his abstract art was actually closer to "reality" than imitative images; it was representative in a cosmic sense. He devoted four years to his progression from imitation through abstraction to the non-objective. The change was based on an act of faith.

Kandinsky was part western man of the world, part an oriental mystic. Like Mondrian he was involved with theosophy. His theories go far beyond the scientific; they tell us how his mystical mind worked. He saw special qualities in colors, and different directions had different meanings. Being a musician, he made much of an analogy to music, an art that depends on the relationship of sounds and not on imitation. His simpler paintings were "melodic"; they could be incorporated into more complex "symphonic" arrangements.

His theorizing led to a series of exceptional paintings. He was sustained by a rich Eastern folk art instinct for color. During his last four years in Munich from 1910 to

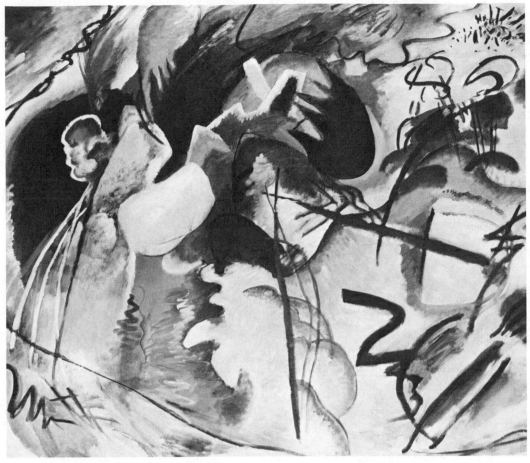

1914, his canvases, now grown increasingly abstract, were
tumultuous and operatic. There is little sense of gravity. We
are loose in the empyrean and witness dynamic outer space
events. In proportion as his paintings detached themselves
from recognizable objects, and became inventions, he graded
them from Impressions, to Improvisations, to Compositions.

WASSILY KANDINSKY.
*Painting with White
Form*. 1913. (The
Solomon R. Guggen-
heim Museum,
New York.)

Kandinsky returned to Russia in 1914 with the beginning
of war. He painted very little during the war years, but a
shift from a expressive romantic art to a geometric intel-
lectual one could already be seen. He may have been subject
to Russian Constructivist influence; but given his tempera-
ment an intellectualizing of his art seems inevitable.

Right after the war, at a time when advanced Russian
artists had a moment of revolutionary hope, Kandinsky
became a professor, a bureaucrat. Then the arts were
assigned a political propaganda role, and this hope was
dashed. So Kandinsky went back to Germany, to Berlin,

WASSILY KANDINSKY. *Green Accent, No. 623.* 1935. (The Solomon R. Guggenheim Museum, New York.)

and was soon appointed, along with Paul Klee, to the faculty of a new school of design, the Bauhaus. Since the school had Constructivist interests of its own, it could only have encouraged Kandinsky's transition from the expressive to the geometric. In any case, his loose, impulsive gestures became ruled diagrams. But free or ruled, Kandinsky produced his own astronomy or cosmos based on nothing but an inexhaustible imagination. Years passed before the tension went out of these colorful configurations, and an equilibrium of forces took over.

This equipoise may have been due to a later stage of life, or perhaps to a change of scene. The Bauhaus had been a stimulating, tumultuous environment. Eventually the school disintegrated under Nazi pressure, the faculty members left one by one, and Kandinsky spent his last years in Paris.

Paul Klee
(1879–1940)

Klee was subtle, allusive; his surfaces existed to conceal larger subjects hidden below. It is possible to see all sorts of

evasions at work in his aloof, witty, sardonic art. He began with a series of etchings, satires based on gnarled nude figures that were advanced cases of Gothic distortion. Although he was aware of the Cubist inventions of Paris and of the beginnings of Expressionism in Germany, his tentative yearnings for perfection, his self-abasement, left him at a loss. Munich and the Blue Rider group at least cured his isolation.

He worked on a small scale, and watercolor, often merely tinted drawing, suited his low-keyed expression. *The Holy One* (1921) or *The Twittering Machine* (1922) are typical whimsical drawings steeped in mockery with a tang of heartache. Here emotion is controlled by mechanism; joy can be turned on with a crank. Is this the new phonograph? And what are tears for? A handkerchief.

Klee made a trip to Italy when he was quite young. With all the art to be seen in Italy what apparently impressed him most was the Aquarium in Naples. But Klee's art was always luminous and submerged and he painted fish more than once; they served him as a symbol of man's origins. His famous *Around the Fish* (1926) is an example of much in little. All zoology and anthropology lie served on a platter. We start with an Adam or Eve fish under a sun and moon. As we go round the platter clockwise we meet a series of mysterious symbols, beginning with a cross and the Trinity. Finally plants emerge, and then man himself, celebrated by an arrow pointing to him and an exclamation mark.

PAUL KLEE. *Around the Fish*. 1926. (Collection of The Museum of Modern Art, New York, Abby Aldrich Rockefeller Fund.)

Klee had an interest in weaving. He liked patterns of water plants with twining stems. He liked to drop objects onto a web of horizontal lines producing an effect that vaguely resembles a sheet of music, and he often used the form of the clef. For Klee the human eye was a familiar,

PAUL KLEE. *The Mask of Fear.* 1932. (Collection of Dr. Allan Roos and Mrs. Mathieu Roos.) [Photograph courtesy of The Museum of Modern Art, New York.]

oft-repeated image, appearing almost as it does in Egyptian art. A circle and crescent as pupil and lid took many forms, as in *Around the Fish,* where they are sun and moon. They could as easily be seed and leaf.

At the Bauhaus, Klee wrote a syllabus for his teaching, his *Pedogogical Sketchbook* (1925) that describes the development of a point into a line or a line into a plane in fairy-tale terms. The revealing aspect of the book lies in his search for compromises that resolve the conflicts he sets up. The forces of nature, a heart as it beats, or the

PAUL KLEE. *Boats in the Evening Sun.* (Collection of Mr. and Mrs. Charles E. Ducommun, Los Angeles.)

interaction of muscle and bone, all are subject to personification. It is only his whimsicality that saves him from the depths of quaintness.

Life at the Bauhaus did not escape the deteriorating political situation. *The Mask of Fear* (1932) is not a simple drawing. It seems to be Mussolini. Are the people walking behind the mask trying to frighten us, or are they giving themselves courage? Is the real dictator the crowd?

When the Bauhaus days were over, and Klee had to retreat from Germany to his homeland, he spent the short remainder of his life in the south of Switzerland. He left us a major art in a minor key.

Franz Marc
(1880–1916)

A third Blue Rider painter, Franz Marc, produced relatively few paintings in his short life. Perhaps the best known is his *Blue Horses* (1911). There were also by contrast red horses, and deer in the woods. The colors are artificial, the forms exaggerated and flowing, the effect decorative and romantic. The animal world appealed to Marc for its innocence when compared to the world of men.

The three most important Blue Rider artists veer away from images of people. Kandinsky achieved this detachment by escaping from representation altogether. Marc went over to the animal kingdom. For Klee the figure was no more than a diagram to carry a load of satire, and he was most satirical in his images of women.

The Bauhaus (1919-33)

The school of design where Klee and Kandinsky taught must be presented as the ultimate in a philosophy of form, just as Kandinsky offered a formal absolute in practice. The Bauhaus, the Place of Building, was an updated art school in Weimar. Its significance dates from the postwar moment when Walter Gropius, one of the century's outstanding architects, became its director and gave it both a new curriculum and a philosophy. Gropius was a many-sided man, but perhaps his greatest achievement was his school, where he shone as organizer, teacher, and philosopher.

Understandably, Gropius placed the arts under architecture as a parent discipline. He believed in the arts as services to society, and not as self-expression in a garret. For Gropius, an artist was a craftsman and should be trained as one. But handicraft was not the goal—that was a nineteenth-century illusion. The artist-craftsman should welcome mass production for the masses, and design for the machine.

Gropius was concerned with mass production in housing, and any art that was reproducible had a high priority at the Bauhaus. This included not only furniture and furnishings but printing and photography. The Bauhaus produced im-

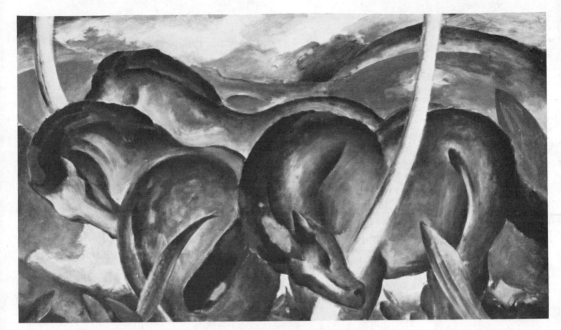

FRANZ MARC. *Blue Horses*. 1911. (Walker Art Center, Minneapolis, gift of the Gilbert M. Walker Fund.)

portant designs and designers and its publications were outstanding. We owe to the school much of our environment today that we now take for granted, particularly in layout and typography as we see it around us in advertising.

The Hungarian, Moholy-Nagy, next in importance after Gropius on the faculty, was almost universal as designer, painter, writer, and theoretician. He stated that "the man without a camera is the illiterate of the future." Later Moholy-Nagy took the Bauhaus to Chicago where it became the New Bauhaus and then the Chicago School of Design. The architect Marcel Breuer came out of the Bauhaus and was later an associate of Gropius in America. Breuer was the first to create a chair made out of bent, chrome-plated steel, in effect a metal variant on the last century's bentwood chair. Presumably the idea came to Breuer when he was bicycling and looked down at his handlebars.

When Gropius undertook to fuse the arts he had to admit that the artist-craftsman he needed did not exist. This was the man the school would create. For the time being the artist-craftsman would have to be two individuals, one a man with a sense of form, the other a technician. The first was the artist, the "form-master," the second was the "work-master." The form-master was an artist-in-residence who served by example. Gropius was aware that the form he sought was a mystery locked up in the imagination of the artist.

Success in such a synthesis of the arts could only be achieved by a creative act of will. Under Gropius' direction the Bauhaus survived for a dozen desperate years. It was driven out of the conservative city of Weimar as a radical organization, and Gropius took it to Dessau in eastern Germany on invitation of the mayor. Here he was able to build for it one of the most advanced and important structures in Europe. We will come to it when we turn to twentieth-century architecture.

The school lived through the years of inflation in Germany and the collapse of the mark, and was finally destroyed by the Nazis. Its faculty left under pressure. Gropius went to England, and another major German architect, Mies van der Rohe, took over briefly and shifted the school to Berlin. When all was over, Gropius and Mies van der Rohe came to America in the same year, both to lead careers as architects, and Gropius to teach at the Harvard School of Design.

The faculty that Gropius had assembled was extraordinary; he had an affinity for talent. He brought together Oskar Schlemmer, Moholy-Nagy, and later Joseph Albers—who spent a second useful life at Yale University—as well as the sculptor Gerhard Marcks, who was in charge of ceramics. His three painters, Kandinsky, Klee, and Lyonel Feininger, his artists-in-residence or form-masters, were hardly such men as the utilitarian philosophy of the school required, and their presence is greatly to Gropius' credit. Feininger was Gropius' first recruit for his faculty. He had come to Germany as a young man; if we wish to think of him as an American, he is one of our finest painters.

Lyonel Feininger
(1871–1956)

Feininger, like Klee, was trained as a musician, the son of professional musicians. Born in America, with a German background, he was sent to Germany to study, and rather casually shifted from the pursuit of music to cartooning, which became a first career. Eventually he produced a full-page comic strip (comics were then called funny papers) for the *Chicago Tribune*. Cartooning had liberated Feininger from a literal naturalism, and when he began to paint it was an easy step for him from the linear grotesque to the geometric. His liberation into painting took place in Paris at about the time of the Fauves and the beginning of Cubism. He developed a structured art entirely composed of straight lines, a geometry that never obliterated the

object. Gropius expressed the view that this geometry of Feininger's was not Cubism, that his straight lines were lines of light or sight.

Feininger was a violinist. It is interesting that he was at great pains to make his ruled lines vibrate as though they were violin strings: he dotted them intermittently with ink, which created an effect of throbbing tension. Granted such a rectilinear method it is understandable that Feininger's subjects were often houses and towns. He also had a passion for ships and here his straight lines allowed him to open up enormous skies and establish far horizons. Lines were his poetry.

LYONEL FEININGER. *The Steamer Odin II.* 1927. (Collection of The Museum of Modern Art, New York, acquired through the Lillie P. Bliss bequest.)

When Feininger abandoned the Bauhaus like the others, he returned to America. Fifty years had passed but he had never given up his American citizenship. His return opened a new last chapter in his work. The tall buildings of New York were a congenial subject for his highly structured art.

THE RANGE OF EMOTION

We have been following the constructive side of art from Cézanne to the Cubism of Picasso and Braque, to the non-objective art of Kandinsky and Mondrian. A zeal for structure, as its own reward, is surely the great original contribution to the art of this century. Yet such a formalizing interest was bound to architecturalize art and the creative temperature was due to drop. We have had enough experience of the temperamental alternatives that beset the arts—the old conflict between Romanticism and Classicism updated as the conflict between the Fauves and Cubism or Expressionism and Abstractionism—to expect to find some emotional outburst gathering its competitive forces.

Such competition was already under way. It was not to come from more Expressionism, but from violent, irrational impulse. Emotion itself was to become subject matter. This in turn led to a twentieth-century concern with the sources of feeling, and to a new awareness of the primitive, the naive, the fantastic. For such an art the writings of Freud served as a handbook.

We can take our cue from Picasso. By 1930 he was no longer a Cubist. He was a *user* of his Cubist discipline and experience. He was off and away in pursuit of imagery that could unlock evolution-old responses. He did this by instinct. He did not have to ask the century what interested it; he knew very well.

Naive Art, Myth, and Fantasy

"Primitive" has two meanings. It refers to two kinds of art, both ill-served by the word. On the one hand, it has been applied to the sophisticated art of non-European, non-Asian peoples; on the other, it has been given to the work of naive artists, unschooled in the accumulated disciplines that are actually the residue of a Renaissance way of seeing. These artists, nothing daunted, simply answer a call to create and set to work. They are in the grip of something innocent in their own natures. We now realize that innocence, the childlike, can be precious when it shelters talent.

The greatest of the artists who seem utterly dependent on their innocent vision was Henri Rousseau. He led a long, simple, unstrenuous life with a modest employment in a customs house, one of those small buildings that at one time guarded the roads into Paris. He had leisure, and he painted. As subjects he chose such memorable events as weddings and football matches. His interest lay in the event, and he recorded endless detail for its own joyous sake, organizing his material with exquisite sensibility.

As his art progressed through the end of the last century and into the first ten years of this one, his poetic imagination asserted itself and he began to paint jungle scenes. His

Henri Rousseau
(1844–1910)

HENRI ROUSSEAU. *The Sleeping Gypsy.* 1897. (Collection of The Museum of Modern Art, New York, gift of Mrs. Simon Guggenheim.)

exotic plants and the wild animals he placed in their midst
—monkeys, lions, buffaloes, and an occasional serpent—
came out of his visits to the botanical garden with its zoo.
Or was he in Mexico as a soldier (when France endeavored
to set up a Mexican emperor) and did Mexico account for
his dense tropical greenery? Whatever his sources, his many
masterworks are triumphs of muted color, of detail balanced
with voids, of inexhaustible entertainment. His *Sleeping
Gypsy* (1897) and his *Dream* (1910) rank with the great
canvases of his time. They are naive, they are fantasies,
they are private myth, and they are magical. Is the lion
really sniffing the gypsy or is the gypsy simply dreaming
of the lion? Commenting on the *Dream,* Rousseau actually
stated that the nude on her sofa was dreaming the jungle
around her into existence. In such a reality, waking and
dreaming fuse.

Marc Chagall.
Birthday. 1915–23.
(The Solomon R.
Guggenheim Museum,
New York.)

Rousseau stubbornly exhibited his paintings to a chorus
of ridicule. In his last years he became a celebrity for a
small group, including Picasso and his friends.

Chagall came out of a Russian-Jewish community in Vitebsk, and as he followed the road toward art, to Leningrad and then to Paris, his childhood of Jewish folklore stayed with him. He painted a world of Russian-Jewish myth, of barnyards where people and animals converse on equal terms and gravity is no obstacle: people, birds, and fish simply take off into the sky.

<div style="text-align:right">Marc Chagall
(1887–)</div>

When he reached Paris he produced a number of large canvases celebrating love, and love has remained a constant theme. His lovers soar into the air like their spirits. This lyric art, so steeped in childhood recall, has inevitably lost some of its freshness, but he has been able to strengthen it with the solemnity of Old Testament subjects, as they appear in a series of noble canvases and in impressive prints. His prints, solemn or joyous, are an important dimension of his art.

Chagall has produced brilliant stained-glass windows now in Israel, and in a Christian church in Zurich, and he has redecorated the ceiling of the Paris Opera House. Childhood in Chagall is much less innocent than the childhood in the art of Rousseau. Chagall used his childhood; Rousseau never left his.

We now come to an early essay in Freudianism, of childhood recollected in anguish. If Chagall realized a folklore dream, Chirico projected a nightmare. His life is a tale for an amateur psychoanalyst. His engineer father died when he was young and his mother brought him up. He was influenced by a last-century German painter, Böcklin, famous for his scenes of death; he found his subject matter in a fantasy of old Italian cities deserted as though ridden with the plague. His haunted towns are lit by the half-light of a partial eclipse. Black shadows from unknown statues offstage dominate silent piazzas; an ancient little train puffs away into the distance, leaving us behind. Endless arcades baffle and confuse us; a young girl rolls a hoop close by an empty van that doubles as a hearse. This is an art of psychic fixation. Even a shudder is impossible.

<div style="text-align:right">Giorgio de Chirico
(1888–)</div>

Chirico began a series of such trance-like paintings before the First World War. A few years later, and he was painting two lay figures such as were once used in art schools. He surrounded them with easels, straightedges, and triangles, and the floor beneath them tipped like a drawing board. These deaf-and-dumb figures with blank oval heads, helplessly muffled as they are, seem to love each other. The

amateur analyst needs no more clues. These are Chirico's parents; the painter is having his revenge.

Time has had its revenge on Chirico. In the 1920s he undertook to paint movement. He depicted galloping horses with flowing manes that resemble Delacroix's Arabian steeds. These canvases are deplored by common critical consent. Chirico, however, has persisted in repudiating his remarkable earlier work.

Dada to Surrealism

With Paul Klee we possessed a recollected childhood under control, an imagination under discipline. We now come to wilder, rougher scenery: the unconscious made visible; the irrational. We are asked to view it as the heartland of creation. Artists now searched through nineteenth- and twentieth-century literature for whatever light they could find on the nature of personality. Above all they turned to the recent writing of Sigmund Freud. Myths, fairy tales, and the beliefs of childhood, they now learned, were reservoirs of stark desires. Hidden raw impulses stood revealed on every hand, urging creative artists to make the most of them. Would they have to experience and indulge the irrational before they could hope to understand it?

The first general indulgence of fantastic behavior with art as a by-product was called Dada. It began in Switzerland in 1916 as an antiwar protest movement, an attempt to be still more irrational than Europe at war. Some dozen refugees, artists, and writers from Germany and Rumania in the ascendant, had found a meeting place in Zurich where they could unburden themselves and they named it the Café Voltaire. Here they staged what would now be called happenings or demonstrations. They composed and recited meaningless poems for the sake of the sound, poems made more meaningless by being chanted simultaneously by their various authors. For Dada, noise was an expression in itself: *bruitism* or *noisism* was a recent inheritance from the theatricality of the Futurists. The walls of the café were hung with works of art appropriate to the random tumult.

Dada was the first blast of anti-art. With Dada what mattered was shock. Dada was the questioning of an activity —art—that had been taken for granted up until then, like civilization itself. In place of cause and effect Dada substituted a reliance on chance, and for logical sequence it substituted simultaneity with its total impact. The name, Dada, was a product of chance. In French the word means hobbyhorse, and presumably it was found by opening a dictionary at random. The Dada artists excited through their very rejection of logic and the lack of embarrassment in their behavior.

Dada introduced an attitude toward life that is still with us; we have seen it on campuses and universities the world over. We speak of a new Dada, or neo-Dada. Happenings are really Dada, and so was much of the antisophistication of Pop Art.

It is not surprising that this way of life drew a response out of all proportion to the talents of the original Zurich group. The only figure in Zurich with survival power was the sculptor-poet Jean Arp. For another major Dada figure we must look to New York where Marcel Duchamp, who was to be the philosopher of the movement, was tiding out the war. Duchamp lived in New York for the latter half of his life, but at the time he was a European phenomenon in an alien land. His own more subdued and sardonic performance actually preceded the goings-on in Zurich. A lesser talent, the Spaniard Picabia, was in New York with Duchamp, and Picabia left to join the Dada group in Zurich as its fame grew.

To these men we must add two major German artists who did not enter the Dada picture until after the war, Kurt Schwitters and Max Ernst. Schwitters was essentially Dada not only in his work but in his life and temperament; Ernst had Dada beginnings but he was soon to become a major Surrealist figure. Then there was the German painter and caricaturist, George Grosz, powerfully expressive in his early work, and seething with political anger; and the gifted American painter and photographer-around-Paris, Man Ray. Of these the essential names are Arp, Ernst, Schwitters, and Duchamp.

Jean Arp (1886–1966) Arp was an Alsatian from Strasbourg, borderland city that had belonged to Germany when he was born, only to be returned to France after the First World War. In his later years Arp lived in Paris and in Switzerland. A life experience on the demarcation line between two cultures set him singularly free from nationalism, and perhaps it is this that makes him so much a man of the future.

He began as a poet and drew on a highly developed poetic imagination as an artist. By 1916 or so, when he joined the Dada group, he was making small collages based on random patterns of torn fragments of paper. Here chance was invited to set the form, but it was chance ruled by taste. His collages were soon being translated into tapestries, for he married the gifted young weaver and dancer Sophie Taeuber.

After the war Arp joined Max Ernst in Cologne for two years, but then he gravitated to Paris along with his fellow Dadaists. By this time his paper patterns had solidified into wooden cutouts he called reliefs, one board laminated on another, and he often gave each slab a separate color

as well as shape. His early work had tended to be rectilinear, but his wooden reliefs were rounded and flowing. He often cut holes through them which he labeled navels. It was not until 1930 when Dada had given way to the more sophisticated movement, Surrealism, that Arp turned to sculpture in the round and began to work in stone, usually white marble, and in bronze.

His three-dimensional sculptures continued the vaguely fetus-like formations of his earlier reliefs. He kept his forms undefined so that they suggested multiple sources, whether plant, animal, or human, and his poetic titles stressed this ambiguity. He often used the word "bud," re-

JEAN ARP. *Pagoda Fruit.* 1949. Bronze. (UCLA, Franklin D. Murphy Sculpture Garden, Los Angeles, gift of Mrs. Dolly Bright Carter.) [Courtesy of John Swope.]

JEAN ARP. *Ptolomy III.*
1961. Bronze. (UCLA,
Franklin D. Murphy
Sculpture Garden, Los
Angeles, gift of the Hal
Wallis Family.) [Cour-
tesy of John Swope.]
ferring to a latency in his sculpture suggesting blossoming,
growth, and youth. Yet he gravitated toward the human, and
he said that all his sculptures were torsos. He avoided the
word abstraction, preferring "concretion." "Concretion
designates solidification. . . . Concretion is something that
has grown." Arp dealt with the core of the organism. There
are torsos, even heads, but no features and no hands or feet.

The end result was an art central to our century. No other
artist has come so close to the process of living, to the
mystery of forms unfolding their structures in growth. He
was never so sure of himself as when he trusted to the child
within him. He outgrows Dada, outgrows Surrealism. He is
close in spirit to the late Miró.

Duchamp was the philosopher of Dada, and much more. Marcel Duchamp
Most of the experiments and advances of our century owe (1887–1968)
a debt to him, and to his laboratory-research approach. He
was an individualist, aloof, yet in the center of ideas, like
Diogenes in his tub. He had shared a Cubist background with
his two gifted brothers, but Cubism was behind him even
before the First World War. Ten years more, and his
creative life had gone over to restless experimentation,
apparently guided by whim. He said that artists did their
early work in order to reach their good work, and it was
not his fault if he did his best work first. He gave himself
to the game of chess.

America had made contact with modern European art
when the Armory Show opened in New York in 1913, a
major event in American art history to which we must
come. Duchamp had the most celebrated painting in the
show, his *Nude Descending a Staircase* (1912). It was seized
on by the press as the prime example of the preposterous
in the exhibition. Actually it was a study in simultaneity
based on a multiple-image photograph. Only superficially
Cubist, the painting was disturbing to the Cubist fraternity
when it was new; they sensed that Duchamp had subtly
changed their subject, and they must have felt that he was
mocking them in his sardonic way. For Duchamp, it was
only a step from multiple imagery to multiple aspects of
personality, and he was soon satirizing accepted emotion.

In the *King and Queen Traversed by Swift Nudes,* also
of 1912, king and queen are chessmen, and these automata
appear to be connected with tubes that serve as a parody
of a circulatory system and reduce love to plumbing. Other
variants on this theme were to follow, and finally between
1915 and 1921 he produced a summation work, his *Bride
Stripped Bare by Her Bachelors, Even*. Here his images
are caught between two large plates of glass, so that we
see his tubular parodies of anatomy in a translucent plane,
and look through to a background of reality that changes
as we move. Ultimately the glass was badly fractured in an
accident, and this pattern of fracture (chance) was the one
thing needed, as Duchamp considered, to complete the work.

Duchamp was never more Dada than when he sent a
urinal to an exhibition labeled *Fountain by A. Mutt* (it was
rejected, of course), or when he exhibited a bottle rack as
a work of art in 1917. This was the beginning of the cult
of the found object and of the notion that a work of art
exists when an artist sees it as art. Duchamp was early

MARCEL DUCHAMP. *Nude Descending a Staircase. No. 2.* 1912.
(Philadelphia Museum of Art, Louise and Walter Arensberg Collection.)

in kinetic art: he rotated discs to create patterns or experiences that did not exist when the movement ceased. He created an interior for a gallery by crisscrossing the space with miles of string—an early happening, and for that matter

MARCEL DUCHAMP. *The Bride Stripped Bare by Her Bachelors, Even.* 1915–23. (The Wilstach Collection, Philadelphia Museum of Art.) [A. J. Wyatt, Museum staff photographer.]

a three-dimensional Jackson Pollock. Perhaps the most Dada thing about Duchamp was his ability to live for years as an influence on art and artists whether or not he produced any art. He said there were two kinds of artists, idea artists who only painted when they had ideas, and olfactory artists who painted when they smelled paint. Duchamp reveled in ambiguities and double meanings. He expressed himself through paradoxes and puns, and his final whim was to leave a large secret work behind him when he died, a sexual fantasy presented as a peep show.

Duchamp possessed the vice of his age to an extreme degree, a great richness of ideas to cover over a lack of genuine emotion. For the artists of the twentieth century he was the professional coach, and his critical role put him ahead of his time. He seems to have sensed that the making of art was no longer the top job—this job had been taken over by the idea man. Accordingly he played the creative critic while at the same time he offered criticism little to criticize. This cool shrug, this beating of publicity at its own game, demanded more self-confidence than most artists have to offer.

Kurt Schwitters Schwitters lived completely in the spirit of Dada. For
(1887–1948) Schwitters the irrational or absurd was normal life and he never put away childish things. Whatever caught his eye he picked up with a magpie gleam, notably colored ticket stubs lying in the street. His home-studio was a scene of trash-into-art, with relationships that struck his fancy dependent on the gluepot. He also patched together words into humorous extravaganzas. He invented a title for his inventions, *Merz* or *Merzbau,* his equivalent for Dada. The word comes out of *Commerz:* in his hands the fragments of commerce and industry became art.

Like Arp also, he allowed his collages to take on three dimensions, mostly by way of objects attached to the plane surface. "I nail my paintings together," he said. Instead of moving toward sculpture in the round, his bent was constructivist. He created in his own home a random structure of pieces of wood that bore much the same relation to architecture as a treehouse that enterprising boys concoct. This structure reached the ceiling and then grew on through into the second story like an architectural cancer. Schwitters had to retreat before the Nazis and he built a second similar structure in his refuge in Norway. When the Nazis invaded

Norway he escaped again, this time to England, where a third structure (that has been preserved) grew up through a house.

Guided half by chance, half by instinct, Schwitters found in collages of either two or three dimensions the very pattern of experience itself. His ever-varied arrangements could be dazzling or amusing; no one has been so successfully inventive with collages. He was a poet to whom chance was kind.

KURT SCHWITTERS. *Construction for Noble Ladies.* 1919. Mixed media: wood, metal, paint. (Los Angeles County Museum of Art.)

SURREALISM

Naturalistic Surrealism

Dada moved to Paris after the First World War. Since it was simply an invitation to unconscious expression it could not be programmed. It subsided in 1924 when Surrealism was born.

By contrast, Surrealism proclaimed that the Freudian world of interpreted dreams allowed the unconscious—the very depth of our natures—to be described, diagrammed, and projected on canvas. Man's mind in all its extravagant obscurity could now be traced and understood. Thus the Surrealist artist became an amateur psychoanalyst, whereas the Dada artists had been behaving like the analyst's patient. The Surrealist evinced a cool and haughty control over his material and his paraphrase of psychiatry invited the formation of a cult.

Here was the perfect opportunity for a critic to become an impresario, to launch a movement with a manifesto, to edit a magazine that would be the movement's house organ, and in general to dominate the artists involved and inflict his dogma upon them. The critic who seized this opportunity was André Breton. He wrote the *Surrealist Manifesto* in 1924 and spent the next decades heading up the Surrealist organization that he had helped to found and using it as though it were a club (in both senses of the word), recruiting and expelling Surrealists as he chose.

The artists who stayed closest to their avowed purpose

were sometimes distinguished as Naturalistic Surrealists. They invented dreams and painted them with a literal conservative technique. Thus their paintings were only modern in subject matter. Ernst was certainly the most gifted of this group, which also contained Salvador Dali, Yves Tanguy, and René Magritte, among the major figures.

By contrast, the title Organic Surrealists was offered to artists of far greater talent who had similar subjective concerns, to name only Picasso, Miró, and the Swiss sculptor Giacometti. Men of such caliber did not illustrate unconscious imagery so much as allow their unconscious to paint or model. It was their work itself that was their dream.

Yet the narrower, more literal group represented Surrealism to the public on the strength of their bizarre photographic imagery, and the publicity-gathering capacities of Salvador Dali with whom the movement became identified. Dali, however, was a latecomer on the Surrealist scene. Ernst had been painting Surrealist canvases since 1924, and Dali was not in Paris to stay until 1929.

For Ernst, Dada had been a brief experience; he was to be primarily a Surrealist painter. He had not known the Zurich group during the war but he made contact with them soon afterward and he and Arp worked together in Cologne from 1919 to 1921. Previously Ernst had nourished his art on the dark Gothic fantasies of the Middle Ages, when devils warned of damnation and the dance-of-death theme was a sober reminder to rich and poor alike. These morbid dreads lived on into the time of Protestantism, and their shadow lay over the Romanticism of the nineteenth century.

Max Ernst (1891–1976)

Ernst absorbed this anxiety-haunted Gothic tradition, and he found his taste encouraged when he came to know the painting of Chirico and the sardonic if whimsical satires of Paul Klee. He produced a series of collages out of nineteenth century wood engravings in which sadistic acts were suddenly revealed in claustrophobic Victorian interiors, a horror out of harmless material achieved with no other means than a pair of nail scissors, a paste pot and a heated imagination. These objects marked out Ernst's future: by 1921 he went to Paris to take part in a larger scene, the changeover from Dada to Surrealism.

Typical of Ernst's mature art is *Woman, Old Man, and Flower* of 1924, the year of the *Surrealist Manifesto*. The old man appears to be the artist, a shell of a man cherishing

a sculptured image of woman in the void within him, whereas
the larger female figure, presumably his muse, is all vanity
with a fan for a head and mere diagrams for arms. She
turns away from us; in place of breasts she has two large
openings that let through the light of day. She can neither
embrace nor nourish.

MAX ERNST. *Woman,*
Old Man, and Flower.
1924. (Collection of
The Museum of Mod-
ern Art, New York.)

All artists who use subject matter have their own vocab-
ulary of images. Ernst, given to scenes of decay, is drawn
toward insect life, such beetle and worm forms as are found
under a large leaf in a festering garden, or under a plank,
turned over and gently but hastily replaced. He has an image
of a large bird, Loplop, which also seems to be a plant
and in any case is inescapably a self-portrait. Since Ernst
likes birds he likes forests, moonlit forests not free from
danger.

Ernst's color is as personal as his imagery: his soft greens
or garish reds and yellows create a dream atmosphere that is
far from the light of common day. More than the other
Naturalistic Surrealists Ernst has achieved the very quality
of dreams and that is his strength, for dreams have been im-
portant to this century as a clue to our natures. Remarkably,

considering his bent, he has achieved important sculpture, even the monumental, and it is interesting to see him bring off his strange effects without support from his special atmosphere and color.

Dali came from the Barcelona area as did Picasso and Miró. When we see Gaudi's Surrealist architecture in Barcelona with his extraordinary command over the fantastic in his great unfinished church, we have before us a complete dictionary of Dali's effects. For Dali's art is one of brilliant adaptation. With cool indifference he borrowed the precision of the French nineteenth-century academician, Meissonier, and the convincing tonalities of the great seventeenth century Dutch painter Vermeer. We cannot blame him for taking what served his purpose, for with these borrowings his mature style appeared whole and at once. He brought his extraordinary abilities into focus on Freudian subject matter and he became the century's illustrator of psychoanalysis.

His temperament was brittle and theatrical and he seemed born to command an audience. As to methods, he was capable of jumping through a store window for the sake of publicity. We have to turn to the theater for careers in any way comparable; he did take part in an early and remarkable Surrealist film, *Le Chien Andalou,* and he has created

Salvador Dali
(1904–)

SALVADOR DALI. *Illuminated Pleasures.* 1929. (Collection of The Museum of Modern Art, New York, The Sidney and Harriet Janis Collection.)

theater sets and opera sets of great elegance. He has also
designed jewelry, a by-product of painting of a miniature pre-
cision.

In his early *Illuminated Pleasures* (1929) and *Persistence
of Memory* (1931) he is at his best. In the first, in center
stage a woman in a hallucinatory seizure is being sustained
in the arms of a fatherly psychiatrist as she reaches toward
a breaking wave. The background is taken up by three
shallow boxes that look like frames for honey in a hive.
The central one has slotted holes that allow us to see insect
life inside, while the figure of a woman peers into it. The
box to the left shows a man pointing to a series of Roman-
esque arches and rose windows while a large, deformed skull
takes up the foreground. The frame or box to the right shows
bearded men on bicycles in endless procession, presumably
psychiatrists. Both boxes represent an endless and daily
monotony, one of religion, the other of psychiatry. On the
far, bare horizon a great, deformed skull lies broken open
as though it had just hatched. There is more: a hand and
dagger, a lion's head.

The *Persistence of Memory* has a popular title, *The Tired
Watches*. A stone quay in a black and windless Mediter-
ranean has a watch hanging limply over the side like weary
laundry. There is a fly on this watch; the back of another
watch close by is aglitter with insects that resemble the
jewels that twinkle in a watch's works; time is either sick
or dead. A dead tree has another watch hanging limply over
a limb. In the foreground is a dead head, apparently sub-
merged and of a peculiar flat deformity, its tongue protrud-
ing; and a limp watch wraps it round. All at once it is clear
that these watches have the shape of tongues—which have
probably said their last word. Tongues are repeated Dali
symbols. These are very small paintings of a dental drill
technique, intense, suggesting an inexhaustible imagination.

Much of his later painting is given over to double imagery.
To see two contradictory images at once is a pictorial pun.
This is by no means new in art but Dali has made it a
specialty. It stands for the substitution of ideas, as the more
acceptable take the place of the less tolerable, which was a
basic discovery of Freud's. The Surrealist held an exhibition
in London in 1939 and Dali appeared in a diving suit as an
explorer of the depths.

When he moved to America in 1940, Surrealism was
largely over as an activity. Accordingly, Dali abandoned it,
and transferred his skills to adaptations of the art of the

Renaissance. He produced a full-scale *Last Supper* for the National Gallery in Washington, and a *Crucifixion* for the Metropolitan. These works are art for mausoleums; they have the whiff of embalming. Yet Dali has a wizardry that is beyond the reach of criticism, much as Houdini was beyond explanation.

The Belgian Magritte offers scenes in which he introduces objects that have no connection with their environment, reminding us that we live somewhere between our perceptions and the memories that intrude. He never changes either in style or mood, and we can only admire the ingenuity with which he invents and maintains the implausible. Rocks float in air, locomotives appear out of fireplaces, paintings on easels neatly fit the reality behind them. What is real, what is unreal, is the eternal question. Typical is a paraphrasing of David's portrait of Madame Récamier, *Perspective: Madame Récamier by David* (1951). In the original she half reclines on her *chaise longue*. Magritte shows us a coffin on the identical piece of furniture, but the coffin too makes a right angle: like the flirtatious and frustrated lady it refused to lie down.

Through many of Magritte's paintings we find a little deadpan figure in a derby hat, the popular image of the detective, and this, we are led to assume, is the artist himself.

RENÉ MAGRITTE. *Perspective: Madame Récamier by David.* 1951. (Private collection, Washington, D.C.)

René Magritte (1898–1967)

Organic Surrealism

It is misleading to fragment Picasso's long and continuous development, or to associate him too closely with a movement he did not create. Nevertheless, through the 1920s, 1930s and 1940s his painting and sculpture were concerned with finding images that projected the deepest drives of the unconscious, and for this he was remarkably equipped. He was able to distort without ceasing to represent, and to condense many levels of communication into a single symbol. As we have said before, he offered the working of the unconscious, he did not need to interpret it.

JOAN MIRÓ. *Painting.* 1933. (Collection of The Museum of Modern Art, New York.)

Joan Miró (1893–) With Miró, we turn to exuberant impulse, whim, and fantasy; we enter a joyous world where color and shape are both means and ends in themselves. Like Picasso, he seems unconcerned with explanations. He is simply, often humorously, indulging himself. It is an arresting spectacle that he offers.

JOAN MIRÓ. *Head of a Woman*. 1938. (Collection of Mr. and Mrs. Donald Winston, Los Angeles.)

Miró also came from Barcelona. His early paintings are naturalistic landscapes in a blaze of heat and portraits in fierce light. Edges are baked hard and details are emphatic. The most famous of these early works, *The Farm* (1921–22) belonged from the beginning to a lifelong lover of Spain, Ernest Hemingway. In *The Farm*, the painter, like the writer, has a style made to order for the factual and intense.

Miró came to France the year following the end of the First World War and for a while divided his time between Paris and his home in Spain. He knew Picasso well, was impressed by Matisse for his color, by the Dada group, and by Paul Klee. He went over to a Dada or Surrealist fantasy and his inventions grew whimsical, his figures mere toys, his forms related to the humorous organic outlines of Jean Arp. His canvases were now as populous as a country fair with jumbled, living images and his line spiderweb thin.

Gradually Miró's forms take on a life of their own quite independent of their original sources, although he allows us to recognize them. He needs very few symbols to set up his miracle plays: a woman, a sun, a moon, a star will do.

When he is quite abstract—typically in *Painting* (1933)—Miró seems under the spell of the shapes he has imagined. If we cannot recognize these shapes the scene is nonetheless vaguely erotic as they penetrate each other, exchanging color as they do. In *Head of a Woman* (1938) his image is no compliment: she becomes some gaily plumed angry bird disturbed on her nest.

The time came when these busy symbols took on solider

form. Miró became a ceramist with the aid of a technician. He built large glazed walls populated with his organic images. Finally, his grotesques left the wall and became great horned presences, half human, half bull.

Miró has one of the more restless and creative imaginations of our time. Whereas most of the Surrealists have a sickly mood, he is joyous. Humor is rare in art and Miró and Klee are our great humorists. But Miró can combine those incompatibles, humor and power.

Alberto Giacometti (1901–66)

A sculptor with Surrealist beginnings, the Swiss, Giacometti, lived and worked in Paris. *Woman with her Throat Cut* (1932) gives us the sensation of finding the remains of a bird's skeleton on a beach, comparing it with the flight over our heads, and reflecting (perhaps) how life lives off murder and protein. *The Palace at 4* A.M. (1932–33) is an airy little Surrealist fantasy in wood that makes plain an awareness of Dali, and above all of Ernst. But Giacometti has a persisting grip on personality which eventually condenses into a statement about man that is free from all Surrealist archness. He states three things: that man has a certain loftiness about him, that he is frail, and that he can move, is on his way. In his *Walking Man* (1960), height in every sense—exultation, aspiration—is the most important fact. This total statement is repeated indefinitely; Giacometti seems to feel that it cannot be said too often. His view of man resembles that of Cervantes in *Don Quixote*—*Walking Man* is a spiritual solitary.

Jean Dubuffet (1901–)

Dubuffet is hard to classify or even describe. He is primitive (childlike), and he has Picasso's ability to pour life into the grotesque. His figures, animal as well as human, are gargoyles; they draw their vitality from the depths of caricature. His art appears unsophisticated, except—and it is a big exception—that it demands a sophisticated audience.

His rudimentary characters, dependent on emphatic outline, seem to wear out after the 1940s and 1950s, and become mere abstract areas that interlock. In a sense, they are still figures, now lost in a crowd. Their hard-doodled living shapes eventually take on three dimensions and become sculpture. When Dubuffet finds large three-dimensional forms over which to spread his patterns, he somewhat resembles the sculptural Miró.

ALBERTO GIACOMETTI.
Walking Man II. 1961:
Bronze. (Collection of
Dolly Bright Carter,
Beverly Hills.)

JEAN DUBUFFET. *Bidon
l'Esbroufe*. 1920. (The
Solomon R. Guggen-
heim Museum,
New York.)

434

THE FIRST HALF OF THE TWENTIETH CENTURY IN ENGLAND

In England, a nineteenth-century literary quality persisted, either moral, or lyric, or anecdotal. But there were French influences. Walter Sickert (1860–1942) was a sensitive painter whose subdued, distinguished portraits-in-environments had something in common with the scenes of Vuillard. By contrast, Augustus John worked in a major key; an expansive vitality animated his brush, and he challenged the onlooker with the immediacy of a Manet.

Making the most of unconventional behavior (a very old convention in itself) John discovered the gypsies and their way of life and happily camped out with them. Vitality brought success, and success eventually brought him into the arena, characteristically British, of the establishment portrait. He gave his subjects a certain ardor and vivacity calculated to please. He was Celtic; at this distance he blends with the Irish literary renaissance. He had an arresting, undisciplined talent. His drawings are effective. *Augustus John (1878–1961)*

Spencer offered an illustrative humanism. He recalled the Pre-Raphaelites in his zeal for a morality to be found in the archaic. He painted a huge Resurrection, with the dead climbing out of their graves in medieval fashion. He created a vision of a bygone rustic life. A vague eroticism hangs over his domestic scenes, tempered by a whiff of the nursery. *Stanley Spencer (1891–1959)*

A revolutionary by temperament, Lewis created a one-man movement named Vorticism which was to reform *Wyndham Lewis (1882–1957)*

AUGUSTUS JOHN. *Portrait of Madame Suggia.* ca. 1923. (Tate Gallery, London.)

Cubism and Futurism. He had an influence beyond his performance, and should be seen as an opposite number to such advanced critics of the time as Clive Bell and Roger Fry. He had an international sense; he reminds us that art is something which flows in time and stagnates in place. We know now that what happens anywhere, happens everywhere, but this was not always understood.

Jack Yeats
(1871–1957)

The younger brother of the Irish poet William Butler Yeats had an Expressionist style all his own that recalls, at

some remove, the style of Kokoschka. He painted Ireland
and the Irish with a most sensitive and relaxed brush. There
is little form in his art, but he handles the heavy paint itself
as a poet (that is, an Irish poet) handles language. His
canvases are wildly lyrical. They have all the arresting
quality of Celtic myth and wit.

Sutherland has produced a post-Cubist art based on plant
forms, mostly roots, buds and thorns, chosen apparently out
of reverence for the secret or obscure beginnings of life. His
structural if tangling forms recall the endless twinings of
medieval illuminations. A liking for clear colors, often a
black-on-yellow arrangement, makes these patterns effective.
Sutherland painted a Crucifixion for Saint Matthew's Priory,

Graham Sutherland
(1903–)

GRAHAM SUTHERLAND.
Thorn Heads. 1946.
(Collection of The Mu-
seum of Modern Art,
New York, acquired
through the Lillie P.
Bliss bequest.)

a free translation of Grünewald's masterpiece that is imposing in its own right.

He produced a striking portrait of the aged writer W. Somerset Maugham looking like a Chinese mummy, and of Winston Churchill looking like Churchill, to that statesman's noisy resentment.

The most important British painter of the immediate post-war period is Francis Bacon. His themes are dramatic and horrific. Images or spectacles of madness follow each other— of mad men and even mad dogs. Naked figures sit hunched and crumpled in motionless depression in dark unidentified interiors; asylum or concentration-camp inmates squat furtively in a landscape as though they had just escaped.

Bacon has reinforced his horror with references to the past of art. He combined Velasquez' *Portrait of Innocent X* and a photograph of a screaming woman from an early Russian film by Eisenstein, and the end product was a series of canvases of screaming popes. Bacon's figures often seem to be observed through a transparent curtain, and he has added a piece of compositional machinery that makes an impression of great alienation: the central figure may be enclosed in a box of white lines in perspective. It is such a fantasy of isolation as was acted out in reality during the trial of Eichmann in Jerusalem, where the accused appeared in a bulletproof glass box.

The later Bacon paintings in no way mitigate this mood of revulsion, but his style changes, and becomes more expressive, more colorful, and less transparent. He now contorts his figures, body and face, to give an impression of galvanic motion as the voltage of the irrational shoots through them. These equivocal paintings often display self-tormenting figures sprawled or coiling on couches in dens which have all the desolation of operating amphitheaters. How these actors are really employed is mercifully far from clear: in black, red, and white paint, they seem to have a raw-meat surface instead of skin. For sheer brutality, nothing quite like Bacon's paintings exists elsewhere on canvas.

In utter contrast to Bacon, Nicholson represents a most restrained and distinguished translation of the Cubist discipline. He began as a painter, but eventually went over to panels in gentle relief, hinting of the shift to sculpture as the true expression of twentieth-century British art. He is partial to snuff-colored tans and blacks and thin-washed whites. Exact circles, either drawn or incised, contrast with exact right angles, the whole animated with subtle over-patterns of fine, ruled lines. Such works have a distinction all their own, and an understatement which seems both personal and national. Without in any way resembling Paul Klee, Nicholson calls to mind Klee's self-effacing integrity, quietism, and resourcefulness in composition. His cool architectural exercises keep

Francis Bacon
(1910–)

Ben Nicholson
(1894–)

pace with the great Cubist works that brought them into being.

FRANCIS BACON. *Sphinx I.* 1953. (Collection of Mrs. Robert Rowan, Pasadena, California.)

Jacob Epstein (1880–1959)

With a shift from British painting to sculpture comes a sense that we are out where the twentieth-century "action" is. With Epstein, British sculpture tried its muscles. He was an American who went to live in London when he was twenty-five. Before the First World War he was in direct contact with Picasso and with Brancusi—which called for a divided loyalty. He was like neither; he was an Expressionist who produced figures of a gnarled and rugged vitality. He was influenced by "primitive" art, but it was not so much the elegance, the condensation of primitive art, as the heavy-lidded Polynesian features, the simply designed bodies of Gauguin, to which he turned.

He fell back on portraiture where he could offer great animation and escape the deeper problems. He was a pre-

JACOB EPSTEIN. *Night*. 1929. (London Transport.)

liminary figure, one of those men who realize that great events are in the wind and feel that they must bestir themselves. He strove for dignity, and could always be intense.

JACOB EPSTEIN. *Princess Menen*. 1949. Bronze. (Dalzell Hatfield Galleries, Los Angeles.)

Henry Moore
(1898–)

We come now to one of the major creative figures of the twentieth century. Nearly twenty years younger than Epstein, he did not have the advantage of direct contact with the art of the European continent before the First World War. He came from Yorkshire, the son of a coal miner. His training was relatively academic and he had to find his own way out into modern times. Moore too was impressed by "primitive" art, in his case pre-Columbian sculpture, one of the last areas of art outside of western Europe to be incorporated into a worldwide point of view. This encouraged him to carve simple massive figures that fitted well with a theory current at the time, "truth to materials," which meant that stone should not imitate flesh but be obviously a block of stone.

HENRY MOORE. *Reclin-
ing Figure.* 1960.
(UCLA, Franklin
D. Murphy Sculpture
Garden, gift of David
E. Bright.) [Courtesy
of John Swope.]

Making solid stone represent a human figure that we now think of as a fluid and slippery composite of forms, from organs to blood vessels to networks of nerves, all composed of cells that have mysteriously separate yet interrelated lives of their own—this demands a willing acceptance of the absurd. To be on safer ground, the sculptor may offer selected characteristics. Moore chose to present the organic as an interplay of internal and external forms. The result has

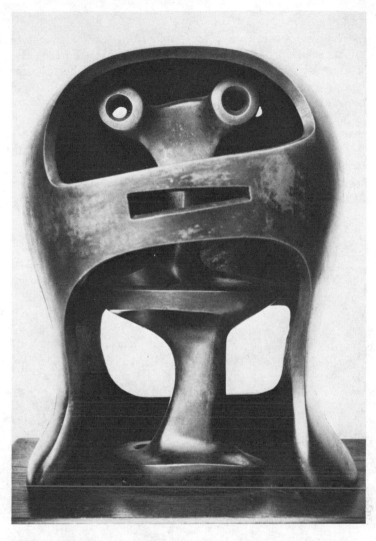

HENRY MOORE. *Helmet Head No. 2.* 1950. Bronze. (Collection of Dorothy and Richard Sherwood, Beverly Hills.)

been a long series of figures that are opened up, penetrated, and reduced to fragments. In his aggressive attack Moore seems instinctively aware of the relative hollowness of the human chest (it reverberates hollow), and like a miner testing rock he goes in there and makes an empty space of the thorax. In his further wearing down of the figure he creates an impression of great age, of rock worn by time, weather, or the pounding sea, and this impression is enhanced by features almost blurred out of existence on unnaturally small heads. Often these worn-down figures closely resemble the medieval sculptures on tombs that are common in English churches. A reclining female figure was an obsession with him for years, as was a mother and child.

The play between outer and inner forms is nowhere more effective and personal than in his bronze helmet heads. By paraphrasing the hollow complexities of a skull he has created a compelling image of two kinds of reality that are closely knit: mind and its bone housing.

When he had beaten stone into submission he shifted to bronze, and the more pliable metal allowed him to be more fluid, more abstract, and less dependent on mass, and to work on a smaller scale. But his most characteristic sculptures are large, static and suited to outdoor sites. They are at their best in open fields where they look like outcroppings of the very bone of earth. And here simplicity becomes noble.

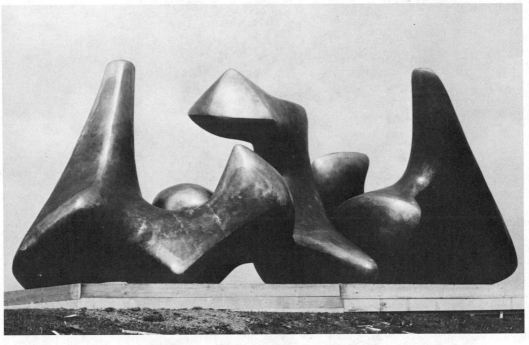

HENRY MOORE. *Vertebrae*. 1968. [Courtesy of John Swope.]

A sculptor who uses the human figure so translated is inevitably the victim of his own style. He must keep up the pressure of creativity so that each new work commands the viewer's response and surrender all over again. This Moore has accomplished, deepening and strengthening his expression as time went on. It is a tribute to him that although he has been able to sustain the vitality of his style, the sculptors of the next generation in England could not live under him. They radically repudiated his amalgam of Surrealism and symbol and turned to purely abstract problems.

Barbara Hepworth worked closely with Moore and is closest to his work when he is more abstract, for she stays on the formal side; she is even less representational than Arp, with whom she also has something in common. She was at one time married to Ben Nicholson; she shared with him a refined elegance. She created monumental sculptures, well-suited to the cool, glazed impersonality of large, contemporary buildings; witness her monument to Dag Hammarskjöld at the United Nations building. Her sculptures are often heightened with color.

Barbara Hepworth
(1903–75)

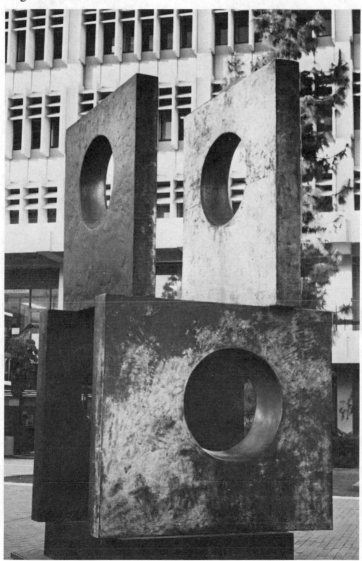

BARBARA HEPWORTH. *Four Square (Walk Through)*. 1966. Bronze. (Norton Simon, Inc., Museum of Art.)

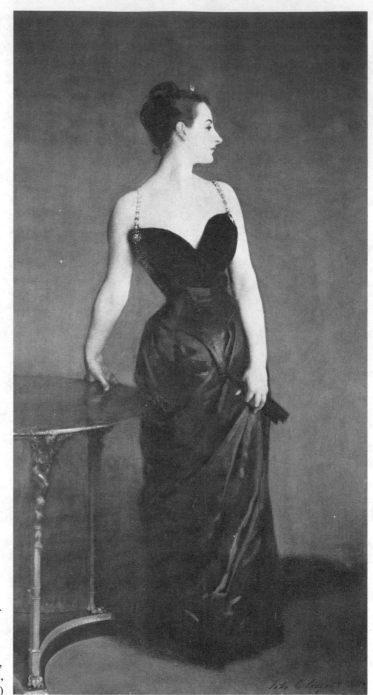

JOHN SINGER SARGENT.
Madame X (Madame
Gautreau). 1884. (The
Metropolitan Museum
of Art, New York,
George A. Hearn Fund,
1916.)

THE FIRST HALF OF THE

TWENTIETH CENTURY

IN AMERICA: I

Official Art

At the beginning of the century three great American painters, Eakins, Homer, and Ryder, were still much alive, but they were the most withdrawn and remote of men. The candidate for fame was the American expatriate portrait painter to the fashionable of London and New York, John Singer Sargent. Like Whistler, Sargent lived most of his creative life in London, and he too leaned on recollections of Velasquez. On occasion the ghost of Hals, or even of Manet, was allowed to intrude. Sargent was a master of free brushwork, and he had a way of projecting an alert vitality. Many of his large, effective portraits are now in museum storerooms, but in his day he was the best of his derivative, dashing kind.

John Singer Sargent (1856–1925)

His watercolors deserve greater respect, for here the medium allows his amazing facility to shine forth. Everywhere the artist is observant and resourceful, as he takes the onlooker through a widely traveled life. But nothing seems to move him, and a bluish skim-milk tonality invades all climates and scenes.

At home, lesser American talents were busy with familiar nineteenth-century themes, with landscape and anecdote. An awareness of Impressionism was beginning to heighten color. The cleanest and freshest of the painters who desired to please was perhaps Childe Hassam. It was still a time of ultrarefinement. An aesthetic chastity determined the standards of good taste.

Reporters at Large

The new century broke in on this illusion of calm and good breeding. A change made itself felt in both art and literature. Artists and authors became burly, two-fisted, and bottleminded, as though they were embarrassed by their professions. An admiration for the muscular brought in a new American ideal and it came to stay. During the Spanish-American War Theodore Roosevelt had created the "rough rider" image; he was the first "Western" hero. This new, tougher facing-up-to-facts came out of journalism, or at least made itself known through the press.

At that date journalism was an art that involved drawing as well as writing. Artists still illustrated newspapers and magazines; photographers were only beginning to compete with them. Winslow Homer had begun as a journalist-illustrator during the Civil War, an opposite number to the great and early war photographer, Mathew B. Brady. Artists as newsmen covered the Spanish War. On assignment with reporters they sketched heroism in Cuba just as they had drawn accidents at home. Some of these men not only drew, they painted. They still chose subjects for impact and stridency and their new blatant attitude toward subject matter appeared to be a revolution in art.

This journalism as art came out of Philadelphia. John Sloan, George Luks, William Glackens, Everett Shinn were young illustrators on the *Philadelphia Press* under the direction of art editor Edward Davis, father of the future abstract painter, Stuart Davis. They had an artist leader, the painter Robert Henri, a young teacher at the Pennsylvania Academy of Fine Arts, who had studied in Paris. They met at his studio for the stimulus he had to offer, and when Henri moved to New York to teach and Ed Davis became art editor of the *Newark Evening News,* the Philadelphia group followed along.

The Ashcan School

In 1907 these painters submitted their work to the National Academy exhibition, and when Sloan, Luks, and Glackens were rejected, Henri withdrew his entries in protest. Henri was now requested by a New York dealer to put together an exhibition of his choice. His selection, *The Eight,* brought together a group soon to be known as the Ashcan School. They were shown not only in New York, but in Philadelphia

and Chicago. Like most objects in an ashcan, *The Eight* had not been together before, and were not to be together for long. Henri, Sloan, and Luks can be seen as related painters, but then there was Maurice Prendergast, one of the few destined to gain in reputation, as well as Arthur B. Davies, who had his helpful social connections, an exotic painter of floating nudes, vaguely Italianate. Finally, a younger man, George Bellows, had a powerful boisterous way of painting. After Prendergast he had the largest talent in the group and for a moment was a leader in a new American art. A number of these men deserve separate mention.

MAURICE PRENDERGAST. *Garden by the Sea.* 1916. (UCLA Frederick S. Wight Galleries, Los Angeles.)

Prendergast chose Boston as the scene of his early neglect. He developed a curious Impressionism all his own. His mottled overall patterns were quite flat; the effect was of tapestry. His figures, and they were numerous in his scenes set on the shore or in parks, were generalized, with blanked-out faces. His color was sensitive and subdued. He produced significant canvases while his contemporaries were reaching for significant subjects.

Maurice Prendergast (1859–1924)

Henri was a teacher of a generation. He came back from Europe with a bold, vivid way of painting based on Manet. His brushwork was free, his effects immediate if sketchy. He painted single figures who look the beholder directly in the eye; there is an impression of personal contact. What Henri

Robert Henri (1865–1929)

had to offer was valuable and refreshing, and he liberated others. He was an important influence, but not an important painter.

George Luks
(1867–1933)

Luks had Henri's direct attack. Here too is something of Manet, but more of Hals in the bold handling, the piecrust-colored flesh, the heightened, simplified effects. "The world never had but two artists, Frans Hals and little old George Luks," said Luks. The vitality in his painting came out of immediate experience. He had been in Cuba as an artist-correspondent; he was staff artist on the old *New York World*; he led a bar-to-bar existence and liked to provoke fights—he believed his fists were for use. Eventually he must have miscalculated, for he was found murdered.

Luks offered a wide range of strong, impulsive feeling, from violence to tenderness. He had more power than Henri, for power was his goal, and a certain physical exuberance still keeps his painting alive.

GEORGE LUKS. *Otis Skinner as Colonel Bridan in "Honor of the Family."* 1919. (The Phillips Collection, Washington, D.C.)

Sloan, painter of scenes and events, never rose far above the level of illustration with which he began. His etchings are appealing documents, and his paintings caught the mood of American city life in a time now gone. He was deeply involved during the 1910s in the Independent exhibitions and was president of the Independents for years.

John Sloan
(1871–1951)

Bellows, the most vigorous and incisive member of the Ashcan School, had a raw, racy way of painting. He forced values and developed a cold, hard coloring all his own. Painter and man, he was in the grip of a self-conscious

George Wesley Bellows
(1882–1925)

athleticism, as though art were a matter of targets to attack rather than problems to solve.

 Waterfront scenes and the prize ring were his favorite early subjects. Unfortunately, it was already late for these simplified bold statements, and what seemed so fresh, strong, and new was suddenly outdated by what was new in Europe —and very strange and different. As a counterthrust, Bellows made a strenuous effort to be an inventive, organized

George Wesley Bellows. *Dempsey-Firpo Fight*. 1924. (Collection of Whitney Museum of American Art, New York.)

painter, and to come up with deliberate structure. He made use of a theory called Dynamic Symmetry, the invention of Jay Hambidge, a structural system based on diagonals and triangulations that pinpointed key locations deemed important in the composition.

To see what came of this we have only to compare the early *A Stag at Sharkey's* (1907) with the late *Dempsey-Firpo Fight* (1924); a naive, vital thrust of instinctive power is replaced by unconvincing posturings. And once the structure was frozen, Bellows forced the color until it grew garish. He had great energy nonetheless, and a will to break into modern times. Unfortunately he died relatively young.

EDWARD HOPPER. *House by the Railroad.* 1925. (Collection of The Museum of Modern Art, New York.)

Edward Hopper
(1882–1967)

The Ashcan School had represented a self-conscious Americanism in its wedding of bold technique and raw subject matter. The death of Bellows was not the end of this drive. An even stronger painter in this raw emphatic manner was Edward Hopper. He was the same age as Bellows and lived exactly twice as long. To make a hare-and-tortoise comparison, Bellows was dashing and Hopper had a stubborn,

strong, and congealed way of painting. He was in Europe before the First World War, but appeared to be quite untouched by what was happening in Paris, and rather pleased to be uncontaminated.

Hopper divided his interests between maritime New England and New York; we could also say between day and night, for his many after-dark scenes are of the lonely city. There are figures in his paintings, even nude figures, but they are subsidiary. A painter of architecture, he concentrates obsessively on buildings—brown stone or brick in the city, in the country gingerbread Gothic (typically the government's style for a lighthouse-keeper's house) or a mansard pavilion. All his buildings have much the same late nineteenth-century date, as though he were on an endless quest for some lost house that was vitally important to him. *House by the Railroad* (1925) contains all of this precious past and projects all of Hopper's future. His theme is an intense loneliness which permeates everything, even entering into the special bleak quality of the light.

The Stieglitz Group

Modern times in America began with a man named Alfred Stieglitz. Although quite un-American in upbringing and outlook, he devoted himself to American art. He was steeped in a belief in the exceptional, in quality; he was ravenous for the uncommon. He was an impresario, a dealer, and he was one of the great photographers.

He opened a gallery, "291" (at 291 Fifth Avenue), before the First World War. It was originally intended as a forum for photography but soon he was showing painters and sculptors—Rodin's drawings as early as 1908, and Matisse, Picasso, and Brancusi. To these he added Americans and finally he was showing Americans only—John Marin, Georgia O'Keeffe, Arthur Dove, Marsden Hartley, Max Weber, and as many others. But his group became smaller over the years until it was only Marin, Dove, and Georgia O'Keeffe—whom he had married. His gallery was almost the only outlet for advanced art before the First World War. He kept moving it, and renaming it, finally calling it "An American Place."

Hartley was an early adventurer into prewar Europe. He was interested in Cubism, and then in Expressionism when he left Paris for Germany. Here, in 1912, he created an im- Marsden Hartley (1877–1943)

MARSDEN HARTLEY. *Evening Storm, Schoodic, Maine*. 1942. (Collection of The Museum of Modern Art, New York, acquired through the Lillie P. Bliss bequest.)

portant series of paintings of German military symbols: flags, iron crosses, and military paraphernalia in the German red, white and black. His curious blend of Expressionism and Cubist structure gave his paintings a strong physical presence. A Cubism adapted to communication was to satisfy a deep American involvement with the factual. It never showed to better advantage than in Hartley's beginnings.

A world traveler, he returned to Maine in his last years, where he painted a cycle of major canvases. His simplistic art suited such New England fundamentals as an ice-blue sky and sea, glacier-scarred rock, mountain and forest. He added the fishermen, whom he saw ennobled by their hard and dangerous life. His *Mount Katahdin* (1939–40) or *Evening Storm, Schoodic, Maine* (1942) compressed a lifetime of cold passion.

John Marin
(1870–1953)

America has had two great watercolorists, Homer and Marin. The medium offers immediacy and brilliance. There is something American in its active abruptness. Marin valued economy of means, and said that painting was like golf—the fewest strokes won the game.

For Marin, watercolor provided a means of creating complex compositions out of interlocking vignettes. Some of his paintings with their multiplicity of views or aspects resemble photographic montages. Marin disliked the rectangular format. He framed his painting with brushstrokes—five, six, any number but four. Condensing what he had to say led him to create his "shorthand," as he called it. A jigsaw line meant trees, parallel lines in the sky could be rain.

Like Hartley, Marin lived in Maine and steeped himself in the wild, remote scene that he painted. But for half the year he painted New York: he had a special feeling for the

lift of great buildings as though they too were acts of nature. Marin's paintings of city or sea are far from literal; they are fields of force, of action and reaction; forms press on forms.

JOHN MARIN. *Maine Islands*. 1924. (The Phillips Collection, Washington, D.C.)

He was a slow starter. He planned to be an architect, gave up the endeavor, and became something of a vagabond. He was abroad from 1905 to 1911 when important things were happening of which (like Hopper) he was hardly aware. His

early etchings of the time were based on Whistler. Only on his return was he struck with the raw, fresh dynamism of the American scene. His violent response began with his jagged etchings of the Brooklyn Bridge. Although his etchings and early paintings have all the air of immediate response, they are based on Cubism at some remove, and are closest to Delaunay. Marin's New York buildings lurched like Delaunay's Eiffel Tower.

He now gained in intensity year by year with paintings that were subtle, bold, complete. When he took to oil paint late in his life, his canvases appeared like rougher watercolors. They were some of his best things, nonetheless, and they led him on to new experiments. His technique became linear. In this last stage Marin would execute his "writings," as he called them, with a paint-laden syringe.

Stylistically he moved much further into this century than Hartley. His combinations of images on one sheet of paper, his staccato discontinuities, and ultimately his linear patterns are all his own. If they are Cubist in source, they are far removed from Cubist intention. They are like musical notations and of this, Marin, who was musical himself, was well aware. He liked to stress the progressive experience of a painting in time as an aspect of its composition. Meanwhile, Stieglitz, his dealer, groomed him as an all-American figure. It is true that he *was* intensely American: there is a bond between his brilliance and brittleness and the very quality of crisp, clean New England.

Arthur G. Dove Dove was still nearer our time than Marin: he was pro-
(1880–1946) ducing abstract paintings as early as Kandinsky. He created his own condensed language, reducing his subject now to a salient aspect, now to a mere symbol. Before the First World War he exhibited a series of such abstractions under the general title *Nature Symbolized*.

He was precocious; he came down to New York from "up state" and became a successful illustrator like any Ashcan School beginner. Then he gave up this career to paint. He went briefly to France, and came home to struggle with farming and with poverty; all his life he was desperately poor.

He had a spell of collage-making in the 1920s: his whimsical concoctions describe an activity in *Goin' Fishin'* or a personality in his *Portrait of Alfred Stieglitz*. He was stumbling on Pop Art ahead of his time. These remarkable

ARTHUR G. DOVE. *Nature Symbolized.* 1911. (Courtesy of The Art Institute of Chicago.)

assemblings were sideshows, however. His paintings were abstractions drawn from the great events of nature—flashes of lightning, wind made visible, hypnotic moons and suns. He lived aboard a boat in Long Island Sound for one period of his life, which kept his canvases small and his effects large enough to fill the sky. He had great resources: he could paint the sound of foghorns swelling and rolling over the undulant surface of water. He was a completely innocent and inventive man with none of the self-conscious defenses that stifle creation. He understood that the artist's business is not to imitate but to create.

Weber was born in Russia and came to America when he was ten. He reached Paris in 1905 when he was twenty-four. In Paris he became a friend of the primitive Henri Rousseau; he knew Picasso (they were the same age) and he studied with Matisse. He went to Spain to see the work of El Greco, Velasquez, and Goya; he visited Italy and he saw the Cézanne exhibition of 1907. Back in America by 1909, he became part of the Stieglitz group.

Max Weber
(1881–1961)

Weber brought home his own variant on Cubism, of which the best known example is *The Chinese Restaurant* (1915). By the 1920s he changed to a style that he was to maintain for the rest of his life, a highly animated Chassidic-Expressionism. His figures tend to be fluent drawings with a brush,

ARTHUR G. DOVE. *Moon.* 1935. (Collection of Mr. and Mrs. Max Zurier, Los Angeles.) [Frank J. Thomas.]

superimposed upon subdued, velvet tonalities that are the very atmosphere of warm, glowing, yet captive lives. It is this quality of tone, rich yet mournful, which is the most original aspect of Weber's work.

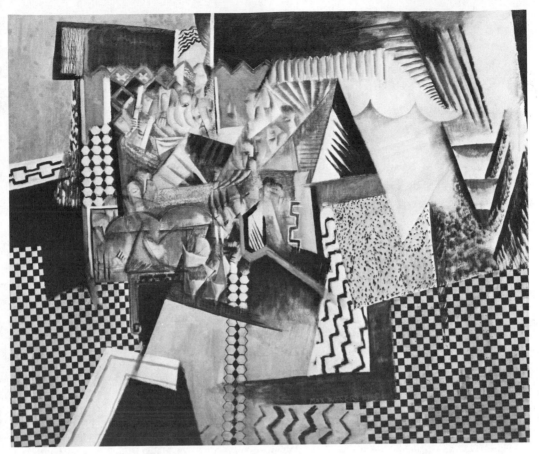

MAX WEBER. *The Chinese Restaurant.* 1915. (Collection of Whitney Museum of American Art, New York.)

The Armory Show

The vast International Exhibition of Modern Art was held in an armory in New York from February 17 to March 15, 1913. It was largely due to the dedication and labor of two artists, Arthur B. Davies and Walt Kuhn. It contained contemporary American work as well as European, and reached back into history as far as Goya. More to the point, it provided the first total immersion in modern art for the American public, and for most American artists: Cézanne, Gauguin, and van Gogh were on display. Matisse and the Fauves were to be seen, and so were Picasso and the Cubists. Marcel Duchamp's *Nude Descending a Staircase* stole the show.

Critics and newspapers had a field day ridiculing the spectacle, and Theodore Roosevelt, turning his hand to art criticism, had his uncomplimentary say and came up with the phrase, "the lunatic fringe." After the Armory Show an

advanced taste came cautiously into being in America, at least in New York. The exhibition was a timely experience for American artists, for soon the First World War broke off their contact with Europe.

The Precisionists

A number of American painters tended to use this new Cubism for the compositional strength it had to offer. They created paintings with a rectilinear organization derived from Cubism without in any way obscuring the reality of their subject matter. Their precise, antiseptic canvases often suggested stage sets or architectural renderings. They were called Precisionists, or (less generously) Immaculates: the most important were Charles Sheeler, Charles Demuth, Georgia O'Keeffe, and Niles Spencer.

Charles Sheeler (1883–1965) Sheeler was also a photographer, which goes far to account for his studied patterns and his unwillingness to intrude upon a realistic image. He reduced a scene to its salient aspects, and eventually allowed an overlay of images that might have come from reflections in glass or double exposure. His

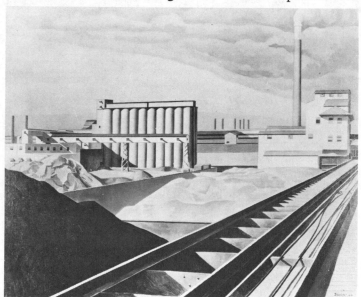

CHARLES SHEELER. *Classic Landscape.* 1931. (Collection of Mrs. Edsel Ford.)

primary subjects were American cities and American industry, but he also painted farmhouse interiors with their furniture; he came from Philadelphia and knew the Pennsylvania Dutch country well. Although he painted a locomotive

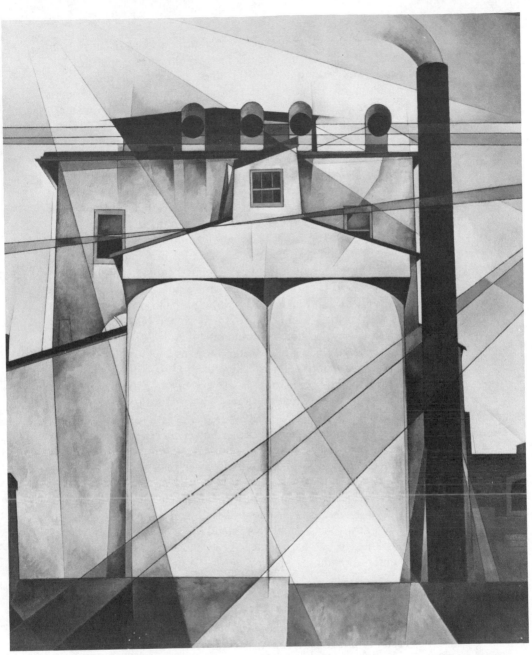

and the Ford plant at River Rouge, his view of industry shows nothing of labor and no grime whatever. He gives us management's view of industry, an architect's view of a building, an inventor's view of machinery. In this he comes closer to rendering the American waking dream than all the Ashcan painters together.

CHARLES DEMUTH. *My Egypt.* 1927. (Collection of Whitney Museum of American Art, New York.)

Charles Demuth Much the same is true of Demuth, who also came from
(1883–1935) Pennsylvania. In his Precisionist architectural paintings De-
muth was willing to project lines beyond the image of a
building to develop a transparent surrounding diagram, a
Cubist scaffolding such as Feininger liked to use. An outstand-
ing work in this kind is *My Egypt* (1927).

He also goes deep into symbolism, as in his well-known
I Saw the Figure Five in Gold (1928), a painting created as a
counterpart to a poem by his friend William Carlos Williams.
The dominant figure five was on a fire engine. The canvas
carried suggestions for later advertising design and it was to
have echoes in the painting of Jasper Johns.

There was another side to Demuth. He was a slight,
elegant person with an interest in night life, and he indulged
a totally different expression related not to architecture,
much less to Cubism, but to literature and the theater. Before
his surrender to Precisionist painting he had produced a series
of watercolors, some of variety-show acrobats, others illus-
trations for the nineteenth-century writings of Emile Zola
and Henry James. These watercolors as a group are dazzling,
slight, and subtly erotic. The best are his illustrations for
Henry James' great story, *The Turn of the Screw*. Judged as
a personal expression, these are his finest things.

Georgia O'Keeffe O'Keeffe produced a series of flower pieces vastly enlarged.
(1887–) They have been viewed as sexual metaphors, projecting an
interest such as the flowers themselves may possess for hum-
mingbirds.

Her chief and ultimate subject matter is drawn from New
Mexico where she has long lived, and here a bleak style
pared down to essentials completely fits the wide, stark scene.
Working in a sharp-focus American way, she became a
painter of what is special in the American West. Animal
bones—skulls and horns or bleached pelvises—are her de-
light. They are crystalline symbols of a great parched world.
Latterly she has produced large canvases of small, round
clouds seen from higher in the sky, an airplane view. These
clouds appear as stepping stones or perhaps an infinity of
gravestones. Her art is beautiful, willful, and cold.

Niles Spencer Spencer's subject matter resembles Sheeler's, but his piled-
(1893–1952) up buildings are more Cubist, more abstract, and more
imposing. Where the absence of inhabitants seems an evasion
in Sheeler, in Spencer it is a source of strength. His images
are too monumental to suggest everyday life. His highly

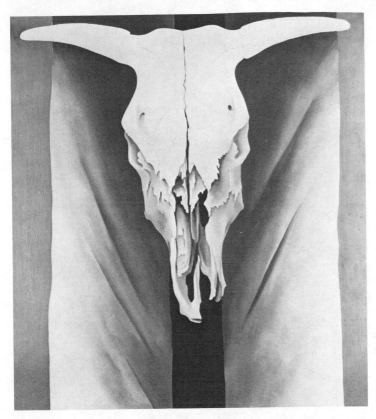

GEORGIA O'KEEFFE. *Cow's Skull: Red, White, and Blue,* 1931. (The Metropolitan Museum of Art, New York, the Alfred Stieglitz Collection, 1949.)

organized canvases gain much from his color sense—rich tans, brick reds, slate blues, blacks, and oyster whites create form without atmosphere. Unfortunately he produced relatively few of these well-studied works.

Precisionist is too limiting a term for Davis. Just as all French painters revere Poussin and Delacroix no matter how they themselves paint, for three or four decades American artists have thought well of Stuart Davis regardless of their own vision. He too is an adapter of Cubism, but his style results from his determination to get to the bottom of a painter's relation to an object. He nailed an eggbeater and glove to a table, and adding an electric fan, sat down to this material for a year. Whatever else may be said of this procedure, it was courageous.

Stuart Davis (1894–1964)

The Armory Show, said Davis, was the greatest single influence he experienced. He exhibited a few watercolors in the show as a student. He threw off early the illustrator's environment in which he had grown up. By the 1920s he was well on his way with paintings that described more than they represented.

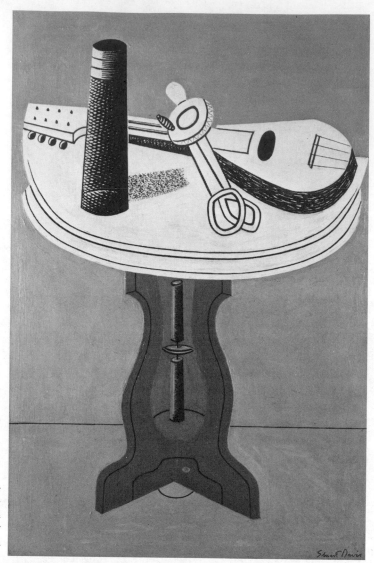

STUART DAVIS. *Egg-beater V*. 1930. (Collection of the Museum of Modern Art, New York, Abby Aldrich Rockefeller Fund.)

Lucky Strike (1921) is close to the advertising that came out of Bauhaus design at a later date. Davis' eggbeater series of 1927–28 was a crisis in self-discipline. Then he went to Europe, taking a painting of his own along, not to lose his personality, he said. He did not lose it. The paintings he produced in Paris were views of the city in flat poster style. He had no use for atmosphere and very little for perspective.

On his return to America, Davis grew progressively more vivid and abstract. Rockport, Massachusetts, or New York might be his subject, but recognition of an American scene gave way to a colorful and intense translation of an American

experience. Canvases that appeared fragmentary and chaotic were actually tightly organized. He had a way of throwing words into his compositions where they functioned as billboards. Sometimes the words were real, sometimes they were his own inventions. They had little resemblance to Braque's letterings, for all Davis' edges were hard as type and words and forms were equally declamatory. The European painter he does resemble for his forms and above all his palette—his piercing yellows, hard greens, shocking pinks—is Miró. But

STUART DAVIS. *Premiere.* 1957. (Los Angeles County Museum of Art, Art Museum Council Fund.)

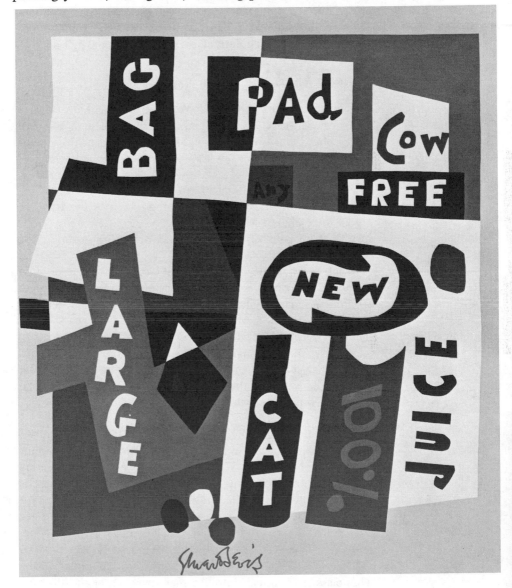

here the resemblance is only in color and complexity of forms. Miró was indulging his fantasy. Davis took an object or idea, a slogan or a theme, and nailed it down, as he had once done with his subject matter.

Much has been made of the fact that Davis was a great fan of jazz music, and that the jarring, throbbing qualities of his paintings come from this source. It is true that he achieved a similar jolting intensity. It is also true that his paintings are a summation of the sign-impact of any one-street American town. But the experience closest to Davis is the throbbing sight of an American city at night as seen from a descending plane. Apparently Davis foresaw neon lighting.

American Sculpture

American sculpture in the first years of the twentieth century has a brief history. In America, even more than in Europe, the emphasis was on painting. Change and experiment themselves favored painting. A sculpture is an actual event; it almost seems to be a contradiction for sculpture to express something as unsubstantial as an idea. Abstract Expressionism, toward which American painting was moving, was not a goal to be shared with sculpture; nor was it easy for sculpture to share painting's trend toward providing an unlimited environment.

What has become of the whole Greek tradition of man as an ideal event, a three-dimensional fact, standing in controlled and restrained splendor, deserving to last as long as bronze or stone? After twenty-four hundred years it has died, apparently; but it has died before.

We have our athletes, our heroes, our representatives, but there are so many, even of them. Who are the unforgettable people who went to the moon? We no longer want stone men and women on rooftops, or in wood on the prows of ships.

Yet at the beginning of our century Rodin was alive, and serious men were making a real effort to make monuments out of anatomy. The best of these monument makers in America was Augustus Saint-Gaudens (1848–1907). His best-known work is the standing sculpture of Abraham Lincoln in Chicago. A lesser sculptor, Daniel Chester French (1850–1931), created the less impressive if enormous figure housed in the Lincoln Memorial in Washington.

The gigantic, the colossal, is often evolution's final effort. The classical-political impulse has twice broken into the

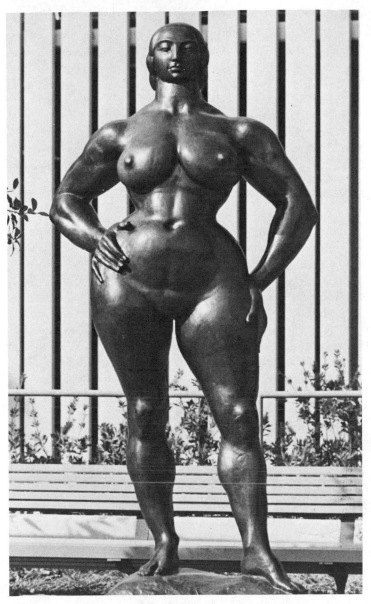

GASTON LACHAISE.
Standing Woman. 1932.
Bronze. (University of
California, Los An-
geles, Franklin D. Mur-
phy Sculpture Garden,
Mr. and Mrs. Donald
Winston, Mr. and Mrs.
Arthur C. Caplan, Mr.
and Mrs. Walter McC.
Maitland.) [Courtesy
of John Swope.]

open in a big way, with the heads of four presidents on
Mount Rushmore in North Dakota by Gutzon Borglum
(1871–1941), and with a Confederate procession on Stone
Mountain in Georgia begun by Borglum, finished by
Augustus Lukman and Walter Hancock. These works simply
underline the failure of naturalism on a gigantic scale. Such
projects still exist as farce in the imagination of Claes
Oldenburg, who is willing to suggest a potato the size of
a skyscraper as a civic monument.

Gaston Lachaise
(1882–1935)

When we look for sculpture with survival power, we are arrested by a sculptor born in Paris, Gaston Lachaise, who attempted and achieved monumental figures, more personal than Maillol's and certainly more massive. Working in America, he gave himself up to one single obsessive theme from the 1910s through the 1920s, a commanding figure of a woman, a sexually charged image of imperious self-consciousness. His later works are an erotic vocabulary of bold, arresting disproportion. Out of all this he achieved at least two masterpieces, his *Standing Woman,* in an early and a late version.

Elie Nadelman
(1882–1946)

Other sculptors, already formed in Europe, brought their mature talents to America early and late. We have already dealt with Archipenko and Lipchitz. Nadelman, born in Poland, developed his art or style in Paris before coming to America in 1917. His figures, mostly carved in wood on a modest scale, are abstracted in the sense that they are greatly simplified. They have a curvilinear suavity. They depend on gesture, and offer us a species of ballet, a theater of their own, and demand admiration in return for delight. In Nadelman we can almost imagine a playful Brancusi.

John Flannigan
(1895–1942)

In utter contrast, Flannigan, active in the 1930s, produced smallish carvings, whether of human or more often animal subjects, that retain a fieldstone simplicity of form. "Truth to materials" was a sculptor's creed at the time, a creed that stressed the stoniness of the carvings of Henry Moore. An unpolished surface came to Flannigan's aid: he achieved dignity by way of the raw and rudimentary.

THE FIRST HALF OF THE

TWENTIETH CENTURY

IN AMERICA: II

Government in Art

The 1930s led into a time of general discouragement, in art and indeed in our national existence. The Great Depression was upon us. Art was thrown back upon its own resources, which were nil. Artists were on relief and the federal government came to their rescue under the New Deal. It launched two projects to salvage the arts: the first employed artists to decorate public buildings; the second employed them as artisans. For a while both programs were a part of the Public Works of Art project; then a Section of Fine Arts was formed under the Treasury Department, and government assistance became the Federal Arts Project under the WPA (Works Progress Administration). Although the project could only assist artists who were already on relief, at one time it employed 5,000. They produced murals, posters, and a visual record of American artifacts, the Index of American Design. There was also an easel project that employed artists to paint in their studios; at one time or another the majority of the artists whose reputations have survived those years were working for the government.

These programs cannot be measured by the work produced. They salvaged a generation of artists who were crossing a financial desert. The project circulated exhibitions and subsidized artists in their home environments, striving to undo the concentration in New York. It served to make

Americans far and wide aware that the arts were not a crank activity, but were integral to a civilized life.

The whole undertaking required political courage. It was not easy to defend artists from the general public—or from themselves. Understandably, artists resisted organization, or chose to organize themselves. That so much was accomplished when so much was needed should largely be credited to the pertinacity and humanity of one man, Holger Cahill.

Ten years after the beginning of the Depression, by 1939, the project had become a political liability and was allowed to die. By then we were moving toward a new world war. Artists hoped that they might share in the national effort (by this time they were used to working for the government) and propaganda, the press, and history had their claims and their need to be made visible. An army program for artists was set up. It was well conceived, but Congress killed it, and then *Life* magazine took it over. The navy, more cautious, had a limited art program which managed to survive.

The Mexican Muralists

American painters had an example to turn to, not in Europe but in Mexico. A long drawn-out revolution south of the border had been a source of political anxiety and a painful contrast to the American way of living. Americans saw the recourse to firing squads, the splitting up of private property, the breaking of the upper-class grip on the land. It was hard to admit that national and social ideals were inexorably at work and that the peon, the American Indian, was violently coming into his own.

This land had an art sense, native and instinctive, and out of the political upheaval came mural paintings intended as communications with the illiterate masses. These murals were painted in the 1920s. They were by Diego Rivera (1886–1957) and Clemente Orozco (1883–1944), and later by a young man, David Alfaro Siqueiros (1896–1974). Rivera and Orozco were enormously productive. They executed vast commissions in Mexico City. They were rivals, and when one was at work in Mexico the other was likely to be out of the country, turn and turn about.

Both Orozco and Rivera were influenced by European painting, Rivera the more of the two, for he had had his youthful season in Paris. For a while he was involved in

Cubism, and then as a muralist he was inspired by Giotto after a trip to Italy. He developed a formula for a stoical Indian head, and created heads in crowds like so many brown buns on a tray.

Orozco was by contrast an Expressionist painter. His finest work is in the provincial capital of Guadalajara. On the ceiling of the staircase in the Capitol he painted a gigantic Father Hidalgo, the George Washington of Mexico, waving a torch. It is an imposing achievement. So is his *Man of Fire* in the dome of the orphanage in the same city.

Both men worked in the United States. Rivera painted murals in San Francisco, most curiously in the stock exchange, and in the Detroit Institute of Arts. The radical message came through clear in Detroit: machinery was literally in the hands of the worker. Rivera was much admired at the time so his politics were tolerated. His next commission was for the Rockefeller Center in New York. The artist worked behind screens and as the huge mural neared completion it was understood that a place in the center was being reserved for a leader of men. Was it to be Lenin? There was a gap in point of view somewhere. The mural overtaxed the Rockefeller public spirit, and as it neared completion it was either destroyed or hidden—in any case, it passed from view. In the United States great

CLEMENTE OROZCO. *Prometheus.* 1930. (Pomona College, Claremont, California.) [Frank J. Thomas.]

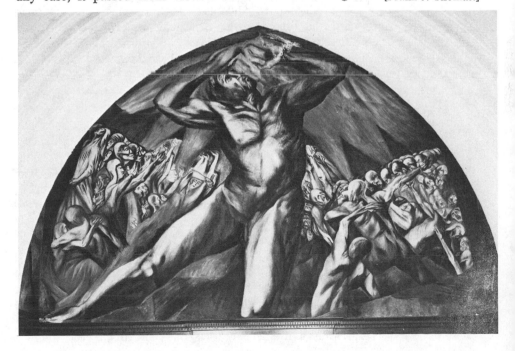

fortunes are not shot down. They settle to earth gently and usefully as foundations.

Orozco painted a powerful mural at Pomona College in Claremont, California, a giant figure of Prometheus; he also depicted the coming of the white man for the library at Dartmouth College. But neither painter did his best work in the United States. The Mexican human sympathy was curdled by a basic hostility to the North American environment. In retrospect, Orozco was a major figure and will be reevaluated. Rivera, colossally mechanical and dull, has grown duller with the passing of time. The violence of Siqueiros rings hollow. But in the 1920s and '30s these men seemed to blend into a general Mexican experience. Only time could separate them.

As an influence north of the Rio Grande, Mexican painters spoke to disappointed liberalism. Even if they spoke in a foreign language, they were Americans too.

Regionalism and Social Realism

What came of this dark period was an art of realism, regionalism, and social consciousness. The ascendency of American-scene subject matter made it possible for government and art to come together.

The affirmative regionalists sought homespun American ideals, and turned to the American past in quest of hardy virtues; they extolled the life of the farm and the frontier. The best of them came out of the Midwest: Thomas Hart Benton, John Steuart Curry, Grant Wood. They painted the heartland: Iowa, Kansas, the Ozarks, the Mississippi valley and the Great Plains. Over against these were the protesters, angry men with much to be angry about. They were the Eastern city liberals-to-radicals, Ben Shahn, Philip Evergood, Hyman Bloom, Jack Levine, and Leonard Baskin, with the later George Grosz of the party. Then there was the Mexican-influenced Rico Lebrun, who dealt with death and resurrection, but more with death than with hope.

Thomas Hart Benton
(1898–1974)

Benton was from Missouri; he was the great-nephew of Senator Benton, the first senator from his state. He studied in Paris, revolted against the experience, and went home to lead a more manly life. With his background he must be forgiven for wanting to take hold where Bret Harte and Mark Twain left off. He painted the Ozarks and Missouri and Kansas in a technique as hard and dry as the country.

He created a lank, grotesque figure who stood for the hard-bitten Western male, and his buildings and landscape were equally lean and gaunt. His canvases appear to be rare early Americana rediscovered, but he did not reproduce the old West, he produced a western. He is the best of the three Midwesterners, nonetheless. His paintings are crammed with life.

THOMAS HART BENTON. *Arts of the West Mural.* 1932. (The New Britain Museum of American Art, New Britain, Connecticut.)[E. Irving Blomstrann.]

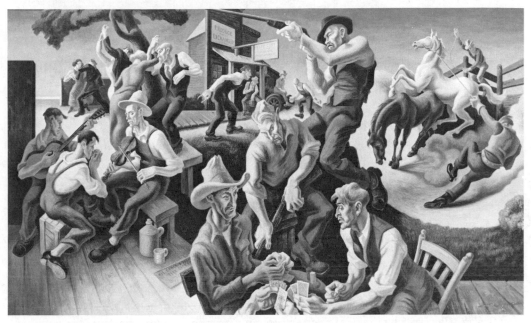

Wood also went abroad to study. When he discovered early Flemish painting, he saw in the precise, intense art of van Eyck and his followers the very method for describing the rural Iowa he knew. Here were the hard lineaments of lives formed by the grip of conscience and the gospel of work. He painted *American Gothic* (1930) in this unrelenting discipline and it made him famous. But *American Gothic* is essentially an anachronism. Once having set this style Wood had only two choices; he could be sardonic-whimsical as in *Daughters of the American Revolution* or *Parson Weems' Fable,* or he could be needlepoint quaint.

Grant Wood (1891–1942)

Curry began where the Ashcan painters left off. He illustrated the life of the plains. He painted John Brown, larger than life, but no larger than Michelangelo's *Moses,* whom he too obviously resembles. His regional art, striving to hold interest, became an art of the picturesque. It is a common fate.

John Steuart Curry (1897–1946)

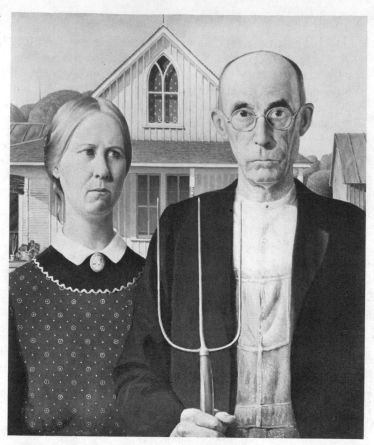

Ben Shahn
(1898–1969)

Shahn was born in Russia; he was eight when he came to America. He grew up in Brooklyn, and worked as a lithographer's apprentice while he went to night school. This training was to stay with him. He was an effective print-maker, and the key to his art is in his drawing. He created eloquent, gnarled images of humanity, or victims of in-humanity. Features indelibly stained by labor are laid in sharp and hard. The color, thinly washed, exists only to turn the drawing into a poster or billboard. Uncomfortable effects of red brick or red construction steel set off a metallic world of black and white. Shahn placed these painful diagrams at the disposal of political protest. With his social-political dedication and his technical resources matching perfectly he only needed a theme—which he found in the Sacco-Vanzetti case. He painted the series called *The Passion of Sacco and Vanzetti* in 1931–32, and these hard, eloquent cartoons created a sensation.

He went on to deal, less impressively, with the Tom Mooney case in San Francisco. By this time he had created

a Tom Paine image of himself, and he put his angry and compassionate art behind many causes. He created posters; he painted murals in public buildings in New York and in the Social Security Building in Washington. Concern for the wartime destruction in Italy produced an exceptional

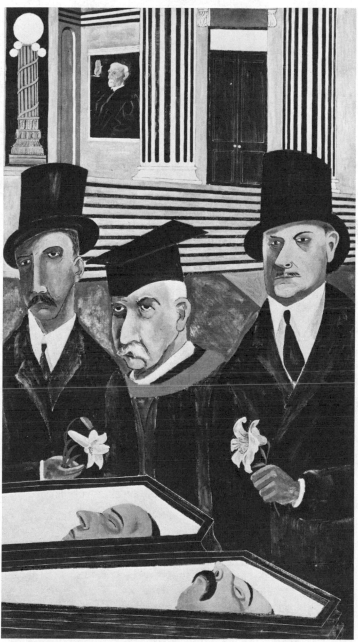

BEN SHAHN. *The Passion of Sacco and Vanzetti*. 1931–32. (Collection of Whitney Museum of American Art, New York.)

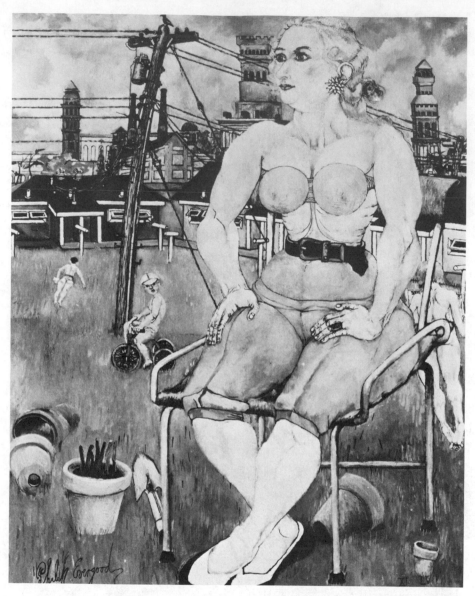

PHILIP EVERGOOD.
Woman of Iowa. 1958.
(Courtesy of Kennedy
Galleries, Inc.,
New York.)

series of canvases: his children playing in rubble are like insects that DDT had missed.

Shahn's art of propaganda raises a hard question: how can we grow indifferent to the theme of justice and injustice? It is a sorry answer to say that lifelong sermons are not in the American mood. But the radical artist has a problem. He must produce a revolutionary art when there is no revolution. He must harp on poverty while his bank account builds up. His professional humility is limited by very human vanity. Whom does he hate on a day when nothing seems

hateful? These are obviously moral or political questions, and moralists and politicians wear out their welcome. Interest has turned away from Shahn. It is hard to do his abilities justice; there is so much injustice in the world.

His father was an unsuccessful painter with a Polish-Jewish background who came from Australia; his mother was British-establishment. Evergood was born in New York and educated in England. He went to Eton, for a while to Cambridge, and to the Slade School when he decided to be a painter. Then he came "home" and lived in and around New York for the rest of his life.

Philip Evergood (1901–73)

He painted figure pieces, either portraits in symbolic environments that described the person, or group scenes that tended to be social protest, or fantasies as social satire. Like Shahn, like almost all social commentators, he developed his own grotesque anatomy. As a young man he had seen El Greco's paintings in Spain, an experience which gave many of his figures a ghostly floating quality. He was also influenced by the tense, contorted drawing of Grünewald. All this was pulled together with an artificial primitivism which stressed detail.

Like other artists of his generation, Evergood had to struggle through the Great Depression, which meant desperate times even in the midst of recognition. Like other moral-protest artists he had to see his view of the nature and purpose of art repudiated and abandoned with the coming interest in the abstract. In his own life, his vivid sympathy for the unfortunate seemed to invite misfortune.

Lebrun was closest to the Mexican muralists. He was born in Naples, and never threw off the dark drama of the Neapolitan tradition that goes back to Caravaggio and before. His most successful work is a vast Crucifixion, a composite of stark black-and-white canvases. His theme goes deeper than poverty and toil. It is the tragedy that man knows he is mortal, and still needs salvation although he has lost belief.

Rico Lebrun (1900–64)

Half a generation younger, Bloom and Levine came out of the slums of South Boston. Levine was born in this country, Bloom in Latvia. They had an identical training, the same dedicated teacher, the same mentor and patron, a professor at Harvard. They both were precocious, and assimilated an influence from Soutine. There the resemblance

Hyman Bloom (1913–)

Jack Levine (1915–)

stopped. Levine, the more facile, launched into canvases of bitter social satire; Bloom, the more meditative, brooded on religion and death. Bloom painted rabbis and torahs. Then he faced up to a materialist mortality and painted corpses. He is an impressive, refulgent colorist. He draws remarkably.

Levine painted scenes of political corruption, gangsters, and the victims of injustice. His figures have a characteristic disproportion: they have the large heads of children or dwarfs (moral dwarfs). By this means he expresses either his hatred or his sympathy. He makes this grotesque disproportion of the cartoonist convincing with great sleight of hand.

LEONARD BASKIN.
Frightened Boy and His Dog. 1955. Woodcut in black and red. (UCLA, Grunwald Center for the Graphic Arts, Los Angeles.)

Leonard Baskin
(1922–)

Baskin, like Shahn, is an imposing and impressive print-maker. His symbolic lonely figures deal with the tragedy of existence, with man, as he dreams, hopes and suffers, and with death. His drawing is stark and arresting, with a vitality that was to call for three dimensions. Baskin is also a sculptor.

He makes us meet his "man" head on, a figure who confronts us as if we were looking in a mirror. The man is stocky, pot-bellied, and has a wide, squat head; naked, he is able to stand firm under pressure. We also see this man dead, as a preview of ourselves.

Baskin's man is often accompanied by a large bird; and on occasion the images fuse: the man has a bird's head, a head that can have more than one beak. These humble-yet-noble images are compelling. They are clothed only in compassion, which is enough.

It is sad to admit that the social realists have had a losing battle in America. They all fought to arouse sympathy, but the sympathy they arouse is for themselves, for they have had more talent than recognition. Though injustice is all around us, we do not easily recognize it in our optimistic culture; we tend to think that every man can be president, and the poor have only themselves to blame.

The Natural Artist

In rural New England there is a term of admiration, a "natural artist." It means a man who has not been defiled by instruction. He has heard a call, and his calling is to paint. We have dealt with the greatest of natural artists in Henri Rousseau. There were many such artists in America. In fact, there was a time in the seventeenth and eighteenth centuries when the term could have been applied to most practitioners. We touch here on three latter-day primitives, who like Rousseau could hardly have been appreciated earlier. They are quite timeless, that is to say, they are outside of art movements. All were born in the last century and worked in ours.

LOUIS EILSHEMIUS. *Afternoon Wind.* 1899. (Collection of The Museum of Modern Art, New York.)

JOHN KANE. *Prosperity's Increase*. 1933. (Collection of Mr. and Mrs. William S. Paley, New York.)

The son of a wealthy man, Eilshemius created a personal tragedy out of alienation. His desire for a recognition that was denied him in his lifetime only deepened the gulf between him and the world. Utter simplicity in his art and his nature led on to frustration; no one—none of his fellow painters—believed in him.

Louis Eilshemius (1864–1941)

He loaded himself with the praises that had been denied him. The self-styled Mahatma Eilshemius was also poet and musician, and wrote short stories and novels, privately printed. He was a poet in paint, and a delicious colorist. He had been to Paris when young and his art harks back to Corot. Nymphs, woods, and pools recur, but these scenes have none of Corot's sensuous fantasy. They are more in the spirit of picnics remembered from childhood. The anatomy of his creatures is not of a prize-winning sort, but it is good enough to keep them in motion. Eilshemius is still better than he is thought to be.

Kane was a Scots laborer, a miner at the age of ten. He came to America when he was nineteen, and worked at blast furnaces in Bessemer. He painted Pittsburgh. He was absorbed in telling how Pittsburgh was. Houses and trees, boats on the river, are of a size to be recognized, regardless of perspective. Objects simply follow each other like days in a year. As in Rousseau, it is the tonalities, quiet, cool, and sensitive, that tie everything together. We are confronted with the poetry in a hard life. It is Kane's own poetry but he sees it outside himself and makes it visible to us.

John Kane (1860–1934)

Horace Pippin
(1888–1946)

Pippin, black artist from West Chester, Pennsylvania, painted what he remembered and imagined. His imaginings are vivid and persuade us that we have real evidence before us. But actually he painted fables, religious paintings, and history—he painted the story of John Brown. His paintings are rich in color, emphatic and childlike, and they say what they mean. They are deeply moving.

Pippin had been a furniture packer and odd-job man. He was in the army in the First World War, was hit by a sniper's bullet, and came home with a paralyzed right arm —hence his leisure to paint. He began when he was forty-two and was "discovered" when he was forty-nine, which left him nine years of success. Success did not spoil his painting, but it sadly disorganized the remainder of his life.

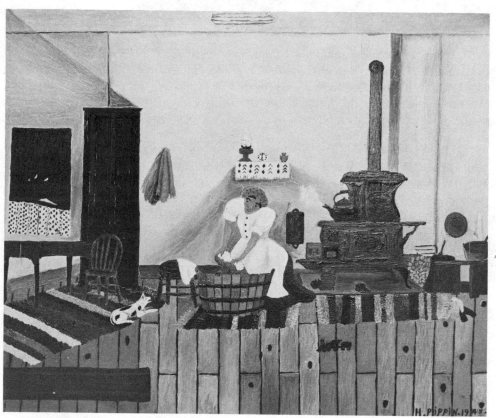

HORACE PIPPIN. *Saturday Night Bath.* 1947. (UCLA Frederick S. Wight Art Galleries, Los Angeles.)

THE FIRST HALF OF THE

TWENTIETH CENTURY

IN AMERICA: III

Private Support

During the difficult 1930s, while government was coming
to the rescue of the painters of the American scene, private
effort was rallying to the support of a more advanced
expression. A sense that art was an international undertaking
revived and gathered strength. With internationalism came
a returning interest in the abstract, as a reflection not of
the place where men live but of the times in which they
live. This respect for art regardless of its origin, a concern
for *now*, rather than *here*, made itself felt in New York,
where Europe and America were in contact. An awareness
of the new century found its expression in two museums
built out of a few modern collections. The Museum of
Modern Art opened its doors in 1929—just in time for the
great Wall Street crash. Two years later the Whitney Museum
of American Art came into existence. The importance of
these events precisely at this time cannot be overestimated.

Before that, very little advanced art had been shown
to the American public. In 1920, the Société Anonyme
(as a French corporation is called) provided a public display
of the private collection of Katharine Dreier. She was
advised by Marcel Duchamp and together they put on a
curtain raiser for a modern museum. By 1927 another
private collection, that of the Philadelphia artist-collector
A. E. Gallatin, went on display in New York. But the
Museum of Modern Art, when it opened in 1929, brought

in an enormous change of emphasis: "It will present the great modern painters—American and European—from Cézanne to the present day, but will be devoted primarily to living artists, with occasional homage to the masters of the nineteenth century." So stating, the museum spread a broad spectrum of American artists in one of its first shows. By 1936 it was mounting two major exhibitions, "Cubism and Abstract Art" and "Fantastic Art, Dada, Surrealism." These two shows were summations that subsequent art history had little need to amend: in terms of experience offered, they completed what the Armory Show had begun. The guiding spirit behind these undertakings was the museum's then young director, Alfred H. Barr, Jr., whose remarkable achievement has been to provide a comprehensive overview of whatever was significant in the century—a great accomplishment in balanced judgment.

The Whitney Museum had a more personal background. It grew out of the Whitney Club, founded in 1914 by the wealthy sculptress, Mrs. Gertrude Vanderbilt Whitney. The club was both a means of entertaining artists and of keeping them alive, as Mrs. Whitney bought out of the club's exhibitions for her collection. The club grew and moved from her studio to a building on 8th Street in New York and developed into the Whitney Museum. Since then the museum has moved twice, first into the shadow of the Museum of Modern Art on 54th Street, and finally into a hard light on Madison Avenue.

Through the 1920s, during the difficult Depression years of the 1930s, and into the 1960s, a dealer, Edith Halpert, ran a gallery devoted solely to American art. Over the years, her Downtown Gallery showed Weber, Davis, Hartley, Sheeler, Shahn, Marin, Dove, and, for a time, O'Keeffe.

The Abstract Trend: Painting

In the 1930s and 1940s painting in America underwent a change. It became more personal, more subjective, and as artists reasserted themselves, and offered themselves as subject matter in place of the scene before them, their expression became increasingly abstract. With this change American artists almost inadvertently won international recognition. And at the same time the outburst which had long centered in Paris became a mere echo of other days, hardly audible in the Second World War. But this change

should not be thought of in national terms as though a reviving American art were pulling ahead of its rivals or competitors. Something more interesting than mere competition was taking place. Thanks to modern communications the world of art was becoming one. National aspects were steadily blending into something larger, an overall international richness, and American art was finding its place in the larger composite. Something similar happened to America politically and economically after the war.

There are always accidental happenings that push history ahead or delay it. A number of gifted Europeans flocked to this country as refugees, either from Germany when the Nazis made their position at home untenable, or later from the countries of Europe that the Nazis overran. From Germany came the architects Walter Gropius and Mies van der Rohe, and the painters Beckmann, Grosz, Albers, and Hofmann. From France we received an international group: Léger, Chagall, Ernst, Miró, Matta, and the sculptor Lipchitz. Mondrian came from Holland. Understandably these men were on the defensive when they arrived, and their presence was not immediately felt. But they were an international leaven. New York now became a world art center such as Paris had been a generation before.

The change began with the abandonment of the Cubist and Surrealist traditions, which had never been too strong in America in the first place. The void was to be filled by a new celebration of personality that would be given the name Abstract Expressionism. This bold expression of individuality was nonetheless a group development with many different temperaments playing a part. We must consider the work of artists who were moving in this general direction, whether or not they realized that they were paving the way.

Having just downgraded regionalism (our history will now tend to center on New York) we must make exception as we find the arts stirring on the West Coast—in the Northwest, in San Francisco, and later in Los Angeles. Mark Tobey was identified with the Seattle area where he was living at an important moment in his development. He had come under the spell of oriental art, an influence doubtless deepened by the oriental collections of the Seattle Museum.

Tobey was born in Wisconsin, and grew up in the Midwest. For a while he was a conventional painter of portraits in

Mark Tobey
(1890–1976)

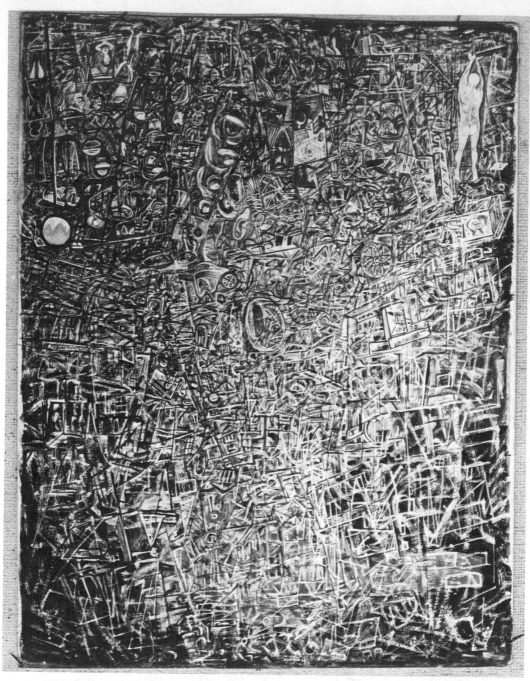

MARK TOBEY. *Flow of Night.* 1943. (Portland Art Museum, Portland, Oregon.)

New York. He managed to travel widely in America, Europe, and finally in the Far East. His concern with the Orient and its art now worked a radical change upon him. He had been converted to the Baha'i world religion; he studied

Chinese brush painting in the early 1920s, and Zen
Buddhism in China and Japan in the 1930s. Out of this
came a whole new attitude toward art, together with a new
technique, white writing, a tangle of white lines on a dark
field. He used his new white writing to convey an experience
of the city at night when events are naturally luminous,
and his traceries add a sense of motion.

Soon his white writing took over without the aid of
subject matter: a beautiful linear entanglement left just
sufficient substance to sustain an artist's personality. The
use of lines in patterns that resemble and evoke written
communication was to have a future. Morris Graves adopted
Tobey's white writing, and Marin in his last phase was
creating "writings" with a paint-loaded syringe. The great
performer with linear patterns was to be Jackson Pollock.

Tobey must be given credit for a major form of expression,
a visual language that looks beyond the separateness of
languages. White writing in his hands also has cosmic con-
notations as though we were watching the traces of particles
that dart in straight lines under their own power only to
change direction as some attracting force wills. This pattern
was to change as Tobey turned in the 1950s to his Sumi
ink drawings. These black-on-white drawings have a much
looser, accidental and curvilinear aspect when we compare
them to the earlier white writing. We see a change from
the geometric to the organic.

Nothing could be less local than such interests, and
having related Tobey to the Seattle area at one formative
moment, we must release him to the world scene. He chose
to spend his latter years in Switzerland.

Graves, more definitely a Northwest painter, knew Tobey Morris Graves
and shared his interest in oriental art and in Zen philosophy. (1910–)
Sharing Zen, Graves and Tobey were to share white writing,
but for Graves this was not the substance of his art, but
simply a pictorial resource; it provided an aura that he could
effectively wrap around the symbols he used. These symbols
are the heart of the matter for Graves. He found what he
needed in bird images to nourish an aloofness of spirit.
He worked out haunting, distorted forms for a strange aviary,
and through these he was able to attach himself to life while
detaching himself from man.

Graves is a poet in paint, which comes through in such
titles as *Little-Known Bird of the Inner Eye* (1941), *Sea,
Fish, and Constellation* (1944), and his *Spirit Bird* series.

MORRIS GRAVES. *Little 476*
Known Bird of the
Inner Eye. 1941. (Col-
lection of The Museum of
Modern Art, New York.)

The Potent Image

Fish, as the victim of birds, and a number of small, shy
animals have also drawn Graves' attention; in these images
he is a naturalist of the unconscious.

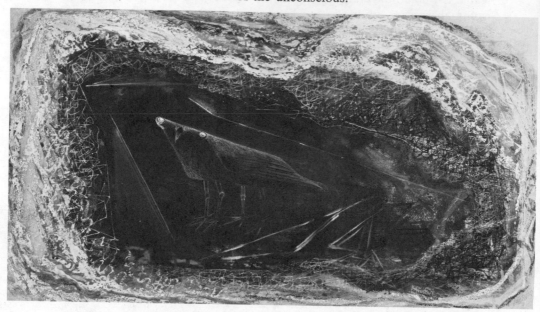

Arshile Gorky
(1905–48)

When we come to Gorky, we could hardly have clearer
evidence of the new internationalism in art that reflects a
moment of time rather than a national background. Gorky
came to the United States from his native Armenia at the
age of sixteen. By the time he was twenty-six the Depression
had cast its blight, and he spent his creative existence in
the midst of hard times. He began with cautious derivative
experiments, influenced by Europeans from Cézanne to
Picasso. He was fortunate in the friendship of Stuart Davis
and Willem de Kooning. He developed his own abstraction
that is alive with sensuous forms and brilliant colors and
hovers just below the surface of recognition. He is nearest
to Miró or to the early Kandinsky, if not in his forms
then in his spirit. Brilliance tends to flatten his shapes which
float about his canvas like so many kites in the sky, and
as kites are held by a barely visible thread, fine black
lines give clarity to Gorky's shapes and connect them with
each other.

Plant forms figure among his sources and often minute
petals or blades of grass appear to have served his purpose,
but the end product is always a broad, abstract statement
about the splendor of experience. *The Liver Is the Cock's*

Comb (1944) is an outstanding, even a summation example. His paintings, small if compared to the Abstract Expressionist sizes ahead, seem nonetheless to expand their material with tenderness as though the artist were cultivating the beauty of existence. Little of their special quality comes through in black and white.

ARSHILE GORKY. *The Liver Is the Cock's Comb.* 1944. (Albright-Knox Art Gallery; Buffalo, New York, gift of Seymour H. Knox.)

Gorky takes us more than halfway along on the Surrealist route to Abstract Expressionism. His work broke off at its peak. He was the victim of an automobile accident, and not long after he committed suicide.

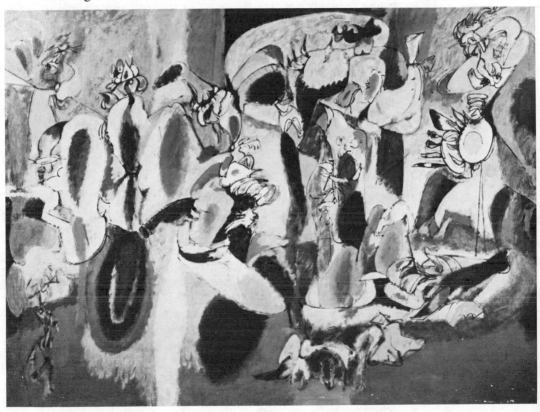

The Surrealist route was not the only one that led to Abstract Expressionism. Tomlin was a Cubist-oriented painter until late in his life. By 1948, he began to experiment with a very free calligraphy, light on dark, a white writing of his own. This led him on to a complex overall pattern, or two patterns of white and dark overlying each other, both based on a single color tone, often enough a soft green. These patterns are composed of short stripes, horizontal, vertical, or sickle-shaped, sometimes interspersed with dots

Bradley Walker Tomlin (1899–1953)

that serve as punctuation. In Tomlin the Abstract Expressionist quality lies in the overall interest and the lack of limits.

Abstract Expressionism

The way was now open for a painting free from the complex geometry of Cubism that had tended to become (in America) no more than a way of seeing objects, and a painting equally free from the obvious symbols of a Freudian Surrealism. It was suddenly possible for an artist to write his personality onto the canvas by surrendering to impulse, by giving his hand permission to perform. This random quality retained all the artist wished to retain, as it was soon discovered: his sensitivity, his concern with color, his will to live through painting. Inevitably paintings created with such freedom differed as the personalities of the artists differed; and yet they had a family resemblance due to an attitude shared. Such was Abstract Expressionism, a style that swept all before it in a flood. As often happens, the first generation, the innovators, produced the memorable work.

Jackson Pollock (1912–56)

Pollock is only one of the major Abstract Expressionists, but the others seem to take their location in the movement from his central position. He is the figure who stands for the movement, quite as Dali stood for Surrealism. Yet the paintings for which Pollock is famous span a very few years. These were his drip paintings, a tangle of lines that he allowed to stream off the end of a stick onto a canvas lying on the floor. As the artist reached out and poured himself on and into the surface, these snarled lines might be strong or bold or so finespun that the end product became a mesh of luminous carpeting.

Abstract Expressionism was given the name "action painting" by the critic Harold Rosenberg. This, of course, identifies these canvases with the way they were created in a choreography for which the painting became the script. But more than that, action painting refers to the energy locked up in the canvas as well as the energy expended in the making.

In the early 1940s Pollock's abstract patterns were bold, rugged, and cluttered and bore some resemblance to the Mexican Orozco in his most abstract vein. By 1947 all this was to change and refine itself as Pollock learned the language (a sort of visual incantation or self-hypnotism)

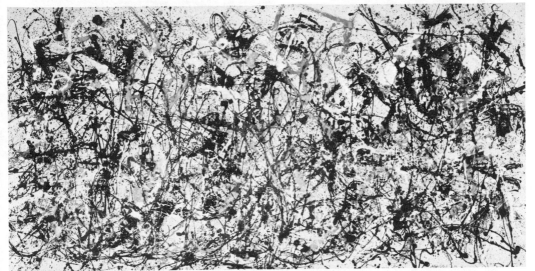

for which he became famous. The more finespun drip paintings have been compared to galaxies and they do have a Milky Way dazzle and a sense of infinity about them. But this is a figure of speech; the real depth or sense of depth in these canvases is shallow. The infinite aspect, apart from infinite complexity, is in their endless extension. These paintings are large and could have been larger—they do not

JACKSON POLLOCK. *Autumn Rhythm (No. 30)*. 1950. (The Metropolitan Museum of Art, New York, George A. Hearn Fund, 1957.)

Ocean Grayness. 1953. (Solomon R. Guggenheim Museum, N.Y.)

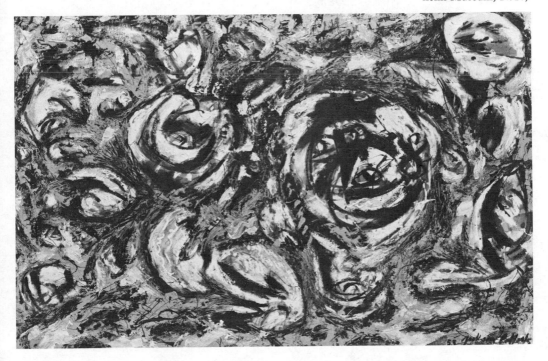

have fixed dimensions. On the contrary, they offer an endless environment. They go on indefinitely like our lives. We can neither know their beginnings nor foretell their ends.

Pollock's last years were a time of quandary as though he were overwhelmed by the limitlessness of his undertaking. He seemed to be infected by the Hemingway virus, an overload of masculine assertion made more intolerable by success. And just as his early work had contained living images before abstraction blotted them out, now recognizable forms, eyes and grotesque heads, began to force their way back in. These late black images may have been for Pollock what the late black paintings of Goya were for him. One wonders if these intruding images were welcome. In any case, this phase was broken off by death. Pollock was killed in a car crash.

Willem De Kooning (1904–) De Kooning is perhaps the second Abstract Expressionist figure for sheer stamina. He came to America from Rotterdam when he was twenty-two. As a painter he went through years of experiment during which he stayed with the human figure as subject. His sensitive surfaces, his refined feeling for color, hardly prepare us for the fierce and triumphant statements to come.

By 1950 De Kooning was in a thoroughly abstract phase, creating preponderantly black paintings laced with white. But the effect is not so much white writing as a scene of crowded and congested dark forms that vaguely suggest human limbs. His black surfaces have solidity and mass and are far from the open fluidity of Tobey or Pollock. De Kooning seems earthbound in comparison, and even bound to anatomy, for he is haunted by the figure, which keeps returning, or reemerging.

This balance between the abstract and physical representation worked itself out in the famous *Woman* series of the early 1950s. Here we have fusion out of violence, a turmoil of ferocious brushwork and writhing forms on a large canvas. All through this turmoil fragments of a figure, larger than life, keep breaking the surface, as though his woman were a champion swimmer in a heavy sea. This figure becomes subject to mayhem, which appears to be both contrived and a matter of impulse. De Kooning apparently separates a diagram of a body limb from limb and rearranges the fragments as a basis for an abstract composition.

Out of all this comes a release of powerful emotion. De Kooning seems to be refereeing a contest between what

physical representation wants to admit, and abstraction tries to deny. But this struggle places him at the very heart of the Abstract Expressionist movement. For here the artist stands in front of his canvas and attacks it, and what he projects is anything but chaos; it is his own personality, his emotional self-portrait. Abstract Expressionist artists are even more easily recognized in their works than are painters of subject matter.

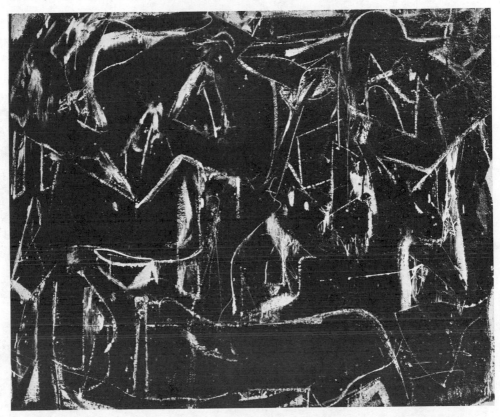

The alternations between the abstract and the recognizable continue for de Kooning. The late abstract canvases have titles that suggest that they are landscapes, and they rely on the color sensitivities he developed long ago in quieter times: blues, yellows, salmon pinks are now savagely splashed together. And when the woman's figure returns it comes back in meaty paint, in fragments of red on white, in a sensuality always verging on a dismemberment that recalls Soutine, but leaves Soutine calm and obvious by comparison.

The one development that seems irreversible is the lifetime

WILLEM DE KOONING. *Dark Pond.* 1950. (Collection of Mr. and Mrs. Frederick R. Weisman, Beverly Hills.) [Frank J. Thomas.]

WILLEM DE KOONING.
Woman I. 1950–52.
(Collection of The Mu-
seum of Modern Art,
New York.)

transition from sensitive uncertainty to violent assurance.
De Kooning created an art which demanded great talent
to be tolerable, and in this he set the limits to Abstract
Expressionism. Here any dimming of a white heat was fatal.

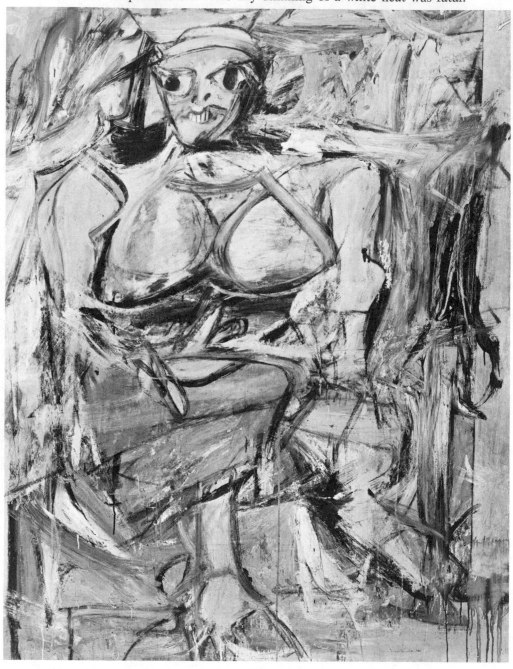

After Pollock and de Kooning the third major figure in Abstract Expressionism was Kline. He came out of the coal-mining region in Pennsylvania and understandably painted the rock-bottom American scene characteristic of the 1930s. We are told that one fine day in 1949 he projected some of his smaller black diagrams and saw at once how effective they could be on a monumental scale. From this came an art of black and white, strong black diagrams and scaffoldings thrown across a white field, and Kline suddenly had a life's work. The resemblance of his diagrams to Japanese or Chinese characters is doubtless accidental, but his paintings have been popular in Japan.

Franz Kline (1910–62)

It is always rash and impertinent to say what an artist means in his unconscious, when even he cannot know, but these craggy canvases can suggest veins of anthracite laced through rock. Kline's paintings have the power of slabs of geology.

It was only in his very last phase, shortly before he died, that Kline liberated himself into color.

FRANZ KLINE. *Harleman*. 1960. (Collection of Mr. and Mrs. Melvin Hirsh.)

A fourth figure among the first generation of Abstract Expressionists, Hofmann is somewhat difficult to fit into the time sequence. He was an influential teacher for half a lifetime before he became a significant painter. Born in Bavaria, he established an art school in Munich during the First World War. His school survived the war, and when he came to America in 1930 (on the invitation of his friends at the University of California) he continued to teach. He reestablished his school in New York and Provincetown and scores of students went through his classes.

Hans Hofmann (1880–1966)

As a painter, he had a long-delayed triumph. He was in
Paris before the First World War when, like so many
of the German Expressionists, he was influenced by the
color of Delaunay. Presumably he left his paintings behind
in Paris; he was to lose still others that he abandoned in
Germany when he came to America between the wars. But
whether he really began to paint in 1940 for the first,
second, or third time, he then moved rapidly from tentative
Expressionist landscapes through Picasso-inspired grotesques
to a fully abstract maturity. In his final phase, he had a wide

HANS HOFMANN. *Embrace*. 1947. (William H. Lane Foundation, Lunenberg, Massachusetts.)

range from thin wash to the thickest paint and from formal
shapes to the wildest Expressionist spatterings and clobber-
ings. His surfaces are drenched in color and are at once
recognizable for his characteristic golden greens, piercing
yellows and vermilions on the orange side. All this powerful
obstreperousness was subject to a discipline or at least
a philosophy summed up in his phrase, "push and pull."
He meant by this that warm colors, the yellows and oranges,
push forward while others, the blues and violets, pull back
into the canvas. This was a fact with which Marin was
familiar and which Cézanne had sensed long years before.
But Hofmann organized the entire surface of his paintings
on this basis, believing that the apparent forward and back-
ward thrust of the paint was far more important than a
movement to right or left. The first was actively dependent
on color while the second was mere dimension.

The idea hidden in "push and pull" worked overtime for
Hofmann. Insofar as it is an idea based on Cézanne, it
marks Hofmann as a somewhat earlier painter, or thinker,
than the other Abstract Expressionists. His concern with

the in-and-out movement on the surface suggests that he did not think in terms of infinite expansion like the others; his canvases are not infinite, they are merely large.

But if he was behind his contemporaries on this score, he was ahead as a colorist, for the trend we can now see was to be toward color, and here he was a forerunner. His contribution was to provide splendid color in bulk.

CLYFFORD STILL. *1965.* 1965. (Courtesy Marlborough Gallery, New York.)

Clyfford Still
(1904–)

Still was born in North Dakota; his parents were Canadian in origin. The family moved to Spokane, and Still spent his youth in the state of Washington and in Alberta. A determined independence is characteristic of the man and his art. On a trip to New York he seems to have given himself all the contact with any previous art, or with museums, that he could stomach. His canvases are large, turgid, and imposing; he sets up an opaque surface built of strong colors: red, orange, blue, brown, and black and white. The forms are tattered and torn, jagged and splintered. It is often difficult to tell whether a colored spot lies on the suface, or is a color showing through a tear.

This grand and abstract art developed rapidly. The paintings seem to be the total statement of a man in a strongly held, isolated position, and as such they apparently include a moral dimension as well as a pictorial one. In the midst of their Modernism they have something of the roar and rumble of Whitman.

ADOLF GOTTLIEB. *Rolling II*. 1961. (Los Angeles County Museum of Art, estate of Davis E. Bright.)

Still taught in San Francisco from 1948 to 1950 (almost at the same time as Rothko) and the two uncompromising

men had a strong influence on the region. He is an imposing artist. He comes down over the canvas like a flow of lava.

Gottlieb had a long development out of symbols or "pictographs" placed in compartments. He remained with symbols, which became progressively larger until finally he was left with a double image: a sun in the upper half of the canvas, a black furry or feathery ball below. The painting lives in the tension of contrasts: in values, bright against black; in outline, smooth against furry; in texture, transparent against opaque. If we choose to read these paintings as a clear sun above a dark troubled earth, the paintings take on a cosmic solemnity.

Adolf Gottlieb (1903–74)

Motherwell is an Abstract Expressionist and something more—an artist who led out of the movement because he had the imagination to see ahead. As a developing figure he was able to survive a transition which left even a painter such as De Kooning an old master of another time. Motherwell's adaptability may be due to his flair for communication. He is an intelligent man in pursuit of ideas.

Robert Motherwell (1915–)

Motherwell was born in the West, in the state of Washington. He studied philosophy at Harvard, turned to aesthetics, and so to criticism; he came to know a number of European artists, mostly Surrealists, who had moved to the United States during the 1930s, Max Ernst and Matta, among others, and by then he had begun to paint.

Abstract Expressionists come in two kinds: there are those who had experienced Cubism, whether in its pure form or as a source of discipline; these artists broke the grip of structure and ended up with looseknit personal gestures in paint. Then there are those who came to Abstract Expressionism from a Surrealist point of view. If these men gave up (or never indulged) the recognizable imagery of dreams, they clung to some central symbol. It became their trademark, growing ever more obscure as it expanded and dominated the canvas. Motherwell came to Abstract Expressionism through such an interest in Surrealism. What seemed to concern him was the new trust in the unconscious with its reliance on chance—really a Dada inheritance. He reached for a few compelling symbols which he wisely never allowed to explain themselves or come into the light of common day.

For a long period, for some ten years beginning in 1949, Motherwell painted a series called *Elegies for the Spanish*

Republic. These are monumental and ominous canvases, a progression of alternating shafts and ovals in black on white, or on occasion an earthy yellow. Taking the overall view of Motherwell's performance, his *Elegies* are at the power or bass end of a scale that reaches up to include a treble of small subtle paintings in brilliant color, often collages. His collages may include labels, or post cards, or fragments of mail (in any case, symbols of communication) and so fall in the Schwitters tradition if with an even greater consciousness of taste.

Motherwell is a painter of unerring taste. Taste, of course, can operate at leisure, eliminating or changing as it chooses; but the effect in Motherwell's painting is of a reliance on chance and on sudden irreversible gesture. Yet no matter how quick the hand, taste is never absent; it appears to operate automatically and instinctively. Now an active sense of taste is usually the enemy of power and flinches away from bigness, yet Motherwell has achieved the monumental easily and power often. He also solved a problem that haunted the Abstract Expressionist who focused on an image: how to present a compelling image and yet achieve an effect of endless surrounding expanse. Motherwell has managed this at least laterally through an extended progression of forms. His

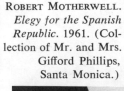

ROBERT MOTHERWELL. *Elegy for the Spanish Republic.* 1961. (Collection of Mr. and Mrs. Gifford Phillips, Santa Monica.)

Spanish Elegy paintings are horizontally infinite, just as is a Greek colonnade.

As a force and portent in contemporary art, Motherwell has also solved the problem of keeping in midstream in very rapid water. To be midstream without being middle of the

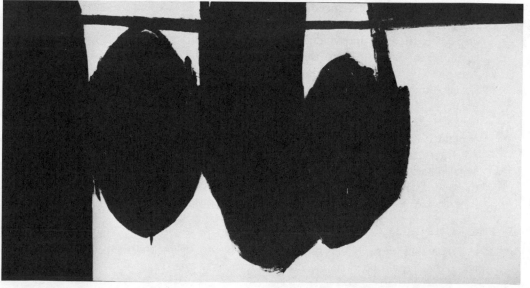

road may seem to be only juggling metaphors, but there is a real problem here, a judgment problem that can beset museums as well as artists.

Rothko does not translate into black and white, and only with difficulty into language. He comes after Abstract Expressionism in that he offers no more than a condition (a color condition) in place of an event. No one should call him an action painter. He is a realizer of moods.

Mark Rothko (1903–70)

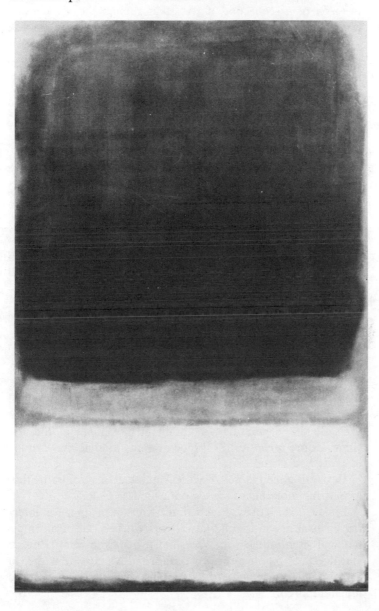

MARK ROTHKO. *Untitled*. 1951. (Collection of Mr. and Mrs. Gifford Phillips, Santa Monica.)

Rothko, like Motherwell, came to painting late as a mature and educated man. He had little or no early contact with art. He was born in Russia, and grew up in the American West outside of the experience of museums. He came East and went briefly to Yale. As a painter he was largely self-educated. He entered the art scene via Surrealism, with an interest in Chirico, Miró and Ernst. But this interest was to prove transitional. Surrealist imagery was soon blanked out. In its place soft blots of color on canvas gave an impression of a scene out of focus, as though the viewer had approached too close to the surface. From now on (about 1947) the canvases grow larger until we are hardly conscious of the borders if we stand as close as the artist wishes us to do. And what we see are soft smoky rectangles of color, without texture, without apparent depth, yet somehow independent of the surface. The large scale is "for intimacy," said Rothko. We are absorbed into color. It is not exactly a sky or a cloud, it is more the experience of color through closed eyelids in the sun.

His range of color is extraordinary. Blacks versus reds and plum colors; blues versus greens, divided by a neutral stripe or margin. Typically Rothko paintings are higher than they are wide, and divide horizontally into an upper and lower color area. The effect is of a window of two sashes that faces on mysterious pulsating dusk. These are some of the most beautiful paintings of the century. They suggest a drugged withdrawal from meaningless events.

Sam Francis
(1923–)

Francis appears as a late Abstract Expressionist. He began with transparent paint, for the sake of clarity and blaze. Loose cell-like forms swarm in contrasting color areas and progressively these cellular forms become richer and bolder. In still more recent work these color stains and spottings tend to draw off toward the edges, leaving a large central area white and open as though the canvas were a title page for Color-Field painting—a dominant movement of the late sixties. More recently still the color spots are back, swarming in great bands and arcs.

He is an effective and vivid printmaker; his colored lithographs resemble his canvases on a modest scale.

Francis, like Tobey, is a painter with an instinct for internationalism in art, and he has always worked out of an international situation. He first became widely known in Europe and lives and paints either in California, whence he came, in Switzerland, or in Japan, where his brilliant canvases are much admired.

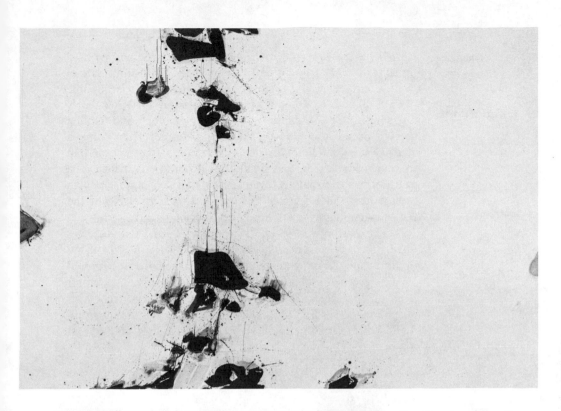

SAM FRANCIS. *Toward Disappearance*. 1957. (Los Angeles County Museum of Art, gift of Contemporary Art Council.)

RICHARD DIEBENKORN. *Ocean Park No. 43.* 1971. (Collection of Whitney Museum of American Art, New York.)

Richard Diebenkorn Diebenkorn was born in Oregon, and has lived and painted
(1922–) in California. He painted and taught at the California School
of Fine Arts in San Francisco (as it then was) at a time
when Still and Rothko were on the scene. His own early
abstraction owed something to Gorky—colors and coiling
lines on occasion confessed a realistic source. Then came a
change: a bold admission of outside fact. Abstraction had
become so current in San Francisco that the emergence of a
group of realistic painters came as a shock. The group won
a name, the San Francisco School. Diebenkorn was not the
first to bring figures back into focus, but he was the strongest.

Diebenkorn moved to Los Angeles in 1966, and with this
move came his current nonobjective phase, not a return, but
a purification of colors and shapes. His large canvases present
a sparse geometry of parallel lines and diagonals that delimit
areas of cool color. An apparent looseness, a sense of at-
mosphere, conceals a rigorous and deliberate architecture.
He is able to maintain a balance between sensibility and
power.

Austerity

We now come to three important figures who must be brought
together for what they are not. Apparently survivors of Ab-
stract Expressionism, they are outside the movement; ap-
parently descendents of Cubism, their interests are entirely
different. They share a tradition of the discipline of restraint.
In this they remind us of Mondrian, and of the "less is more"
philosophy of architect Mies van der Rohe. They have a
monumentality, as much of character as of work, which sets
them apart from the permissive trend in the art of the times.
They form an anchor to the painting of the sixties which
we can trust.

Ad Reinhardt Reinhardt was an abstractionist on the structural side; if
(1913–67) his patterns were at one time loose, his sense of structure, so
contrary to Abstract Expressionism, was to prevail. It was
to prove a hidden structure and its place of concealment was
color itself.

The ultimate development of his work is based on a philo-
sophic understatement that seems quite Oriental. Form is
subdued until it becomes its own ghost. The experience for
the beholder is at first one of overall color, later lack of color
in his black canvases. After a while a pattern of plaited bands
gently emerges, revealing itself as if in response to medita-

tion. This is the event concealed in the tonality that was first red, then blue, and finally, for the most impressive and significant part of his work, a soft black.

These paintings, like the artist himself, appear completely uncompromising and uncompromised. They convey a spiritual chastity—a spiritual kinship to Mondrian. Strangely, they are strong; their willfulness, their total lack of accident, keeps them from being tenuous; taken as a whole they are one of the more exalted events in modern art.

As an abstract painter Newman was also given over to geometry, and ultimately he represented a forward movement into a new synthesis of form and color. On the one hand he led into Color-Field painting, on the other he led to the geometric simplifications in "minimal" sculpture characteristic of the sixties. He advanced the whole theory and aspect of modern art. **Barnett Newman (1905–70)**

In his late powerful paintings, he conceived vast canvases of uniform, strong color set off with a vertical margin of white, or canvases of two tonalities, with a division between them usually roughened or smudged. Or he introduced to one side of the canvas a clear, vertical line, narrow but strong, that he called a "zip." This bold division sets up the tension in the color field on which the painting depends; it cuts through like the artist's personality dominating an environment.

In format, these paintings have a certain resemblance to Rothko's, granted that the divisions are vertical instead of horizontal. If the Newmans are less venturesome than the Rothkos in terms of color, they are stronger and more masculine. He is a painter of strength and authority.

The same verticality carries over to Newman's rare sculptures which are no more than a pole (with a feathered edge, a three-dimensional zip) or impressively an inverted obelisk fragment supported on its point.

Albers taught in Gropius' Bauhaus School from 1920 until it closed in 1933. Then he came to America (in 1934) to teach at the experimental Black Mountain College in North Carolina, and later he became associated with Yale University. He has always been an influential teacher. In a sense he has never left the Bauhaus, for his own work is an uninterrupted teaching and self-teaching. He simplified and intensified his results through a life of experiment and stubborn persistence, and it points to his continuing development that the American years are his important years. **Josef Albers (1888–1976)**

JOSEF ALBERS. *Overlapping.* 1927. (Courtesy of the Busch-Reisinger Museum, Harvard University.)

At the Bauhaus he experimented in "painting" in colored glass in precise, hard-edged patterns of horizontals and verticals. Like Feininger, Albers is insistent on the power of the ruled line as opposed to freehand drawing, which doubtless goes back to the design training of the Bauhaus and a respect for the machine. At times this purity has been carried beyond the ruled line in dark on white to a pattern (in his prints) solely dependent on embossing.

But for all Albers' concern with line, it is color which has become his final contribution. His ultimate form has been an endless series, *Homage to the Square,* in which squares within squares vary primarily in the color of one as it relates to the color of its container. Square shapes allow Albers to calculate the exact amount of color in relation to the contrasting color. Meanwhile the repetition of square forms dulls our response to geometry and it is color against color that survives. Here Albers possesses extraordinary sensitivity; he understands to a nicety the pressure between colors, and the changes that one color inflicts upon another.

In his commitment to hard edge, to geometric simplicity, and above all to the mysterious relation between colors, Albers has reached the goals of the artists of the 1960s. He has done it by following his own undeviating path.

The Abstract Trend: Sculpture

American abstract sculpture took on an early importance with the arrival of Alexander Calder on the international scene. In 1926 he was in Paris where he created *Calder's Circus,* a total toy-town environment that arrested the attention of the advanced art world. He progressed to his mobiles, or sculptures that moved, and from his mobiles to his stabiles, his motionless constructions. The mobile was named by Marcel Duchamp, the stabile by Jean Arp.

Alexander Calder (1898–)

Calder is most American in his successful inventiveness. It took almost a generation for anyone to come up with a sculpture that moved that was not like a Calder. His work was so radical and new, demanding such an expansion of the definition of sculpture, that he was famous before he was appreciated.

Calder was born in Philadelphia. His father and grandfather before him were sculptors, and he was trained as an engineer. He came into art by way of illustration, but soon after he reached Paris he began to work in three dimensions, to draw in bent wire. If we are to relate his caricature be-

ginnings (his *Circus*) to an art source, it must be to Dada, but really Calder was simply drawing on a play impulse. Play and the wind are the two driving forces that activate his mobiles to this day.

In 1929 he created a mobile that worked by hand, and soon he was animating his sculptures with motors, but this was too mechanical and monotonous. Preferring to rely on chance, he went over to constructions hanging in such delicate balance, one metal petal or plaque balancing another, that the passing air would set them in motion. The forms of these petals on their wire or rod stems were generally organic; he liked leaf or lily-pad shapes. They were likely to be painted black, with brilliant red or white for contrast. The range in scale is enormous, from delicate spidery tabletop objects to public monuments. And beneath the scale of the smallest mobile comes the jewelry that Calder has designed.

As Calder's formal interest grew, the element of caricature died down. He is supposed to have been influenced by Mondrian, whom he met in 1930, but he has even more in common with Miró: the color, the playfulness, the drift from grotesque to arbitrary form. Whatever influence played upon him, his mobiles, once invented and liberated, changed remarkably little, so much variety was possible within the original concept. Modern sculpture and architecture want the

maximum space with the minimum mass, and the mobiles admirably fulfill this requirement. They have both visible and invisible form. For the first, actual shapes move before our eyes, and for the second, we have all the possible circular gyrations. At a later date it occurred to Calder to add brass gongs to his mobiles: they clash and clang to mark a high moment of activity.

Parallel to the mobiles, the stabiles have provided Calder with a still broader creative field. Since they avoid the problem of suspension (where freedom is also a limitation) they have a greater range both in form and size and can and do become major architectural events; there are stabiles twenty, fifty, ninety feet high. Formally, they are curvilinear geometry, but then so is anatomy. Calder's constructions are vaguely Surreal. They have the air of alert creatures, sometimes of groups of creatures. They resemble the images in cave paintings in their vitality; his stabiles all seem *capable* of motion.

ALEXANDER CALDER. *Black Widow.* 1959. Stabile, iron. (Collection of The Museum of Modern Art, New York, Mrs. Simon Guggenheim Fund.)

Such is the strange menagerie of Calder: Surrealist insofar as it seems living, architectural when viewed as an adventure in form and shape, but never really mechanical. Calder has been able to tap the dynamism of his epoch and has made an art out of invention with irresistible ease.

Most recently he has been invited by Braniff Airlines to splash his vivid arbitrary colors and forms over a large plane. These "flying colors" somehow fail to update Calder or to catch up with the dynamics of flight.

Theodore Roszak
(1907–)

Roszak left behind constructivist beginnings to produce highly expressive, spiny monsters. They come from an age when living things defended themselves, or defied digestion with hard spiky shells, and in this he recalls Picasso's bone period of the 1930s. His *Specter of Kitty Hawk,* an early example, is one of the simplest, most ominous and most convincing. His sculptures have the air of dying forms in the final stages of their evolution.

Seymour Lipton
(1903–)

Lipton has created a vocabulary of organic forms developed out of metal sheets that wrap around one another. The effect is of unfolding plants, or of shells, or of ear-like

THEODORE ROSZAK. *Specter of Kitty Hawk.* 1946–47. Welded and hammered steel brazed with bronze and brass. (Collection of The Museum of Modern Art, New York.)

formations that guard some secret within. Thin, silvery metal
is countered by a sense of —evolvement, or growth.

Ferber's somewhat similar organic forms have proved
capable of actual growth. In a late development he produced
sculptures of a scale to fill the space assigned them. The
spectator enters the sculpture and experiences it from within.
In this fashion Ferber creates a cosmos.

Herbert Ferber
(1906–)

Born in Los Angeles, Noguchi has an oriental leaven in his
art. To this he added the experience of working as a young
man with Brancusi, a sculptor whose own instinct for subtle
simplifications must have greatly stirred Noguchi's Eastern
sensibilities. The result is a refined abstract art more often
in stone than bronze. Forms interlock, symbols exist in
series, or hypnotize like the rock in a Japanese garden.

Isamu Noguchi
(1904–)

A sculptor who evokes mood out of found (transformed)
objects, Nevelson creates walls out of pieces of turned wood,
such as balusters, arranged in compartments and painted
black or more recently gold or white. The effect, as of an
altar wall, is solemn and compelling. More recently still,
these wall displays have gone over into metal or become
transparent, speaking with light.

Louise Nevelson
(1900–)

David Smith was, quite simply, the greatest American
sculptor to date. He died in an automobile accident as he
reached the height of his development. He had moved from
a long experience of Surrealist diagrams to an incorporation
of tools, farm or other, to constructions in stainless steel that
are as massive as they are dazzling. He had begun as a
painter and was not averse to the introduction of color.

David Smith
(1906–65)

Smith was born in Indiana and grew up in the Midwest.
Since he was presented as a simple, rugged American, much
was made of the fact that he was a riveter and welder at a
Studebaker plant when he was nineteen, and that later during
the Second World War he worked for the American Loco-
motive Company in Schenectady. Thus he can be seen as an
artist emerging out of American industry, who sensed its
relevance and kept its scale. He chose to live and work at
Bolton Landing, on Lake George, north of Albany, New
York, and there he strewed his sculptures over the fields. Like
Moore, he created sculpture that he could relate directly to
nature without the support of architecture. It too looms out

of the surface of the earth as an outcropping of the imagination.

Yet Smith's sculpture was for years primarily two-dimensional see-through patterns intended to be observed from one side only and at least in this aspect related to painting. He presented a progression of diagrams, not so much variants on each other as an alphabet of meanings. By its nature this was hardly monumental sculpture, and it was actually small in fact. His drive, however, was in the direction of grandeur, and like Moore he preferred photographs that silhouetted his work against a skyline. When he went over into colored sculpture, he favored brilliant reds.

DAVID SMITH. *Voltri VII*. 1962. (Collection of Francis K. Lloyd.)

As a next-to-last phase Smith developed his open-work forms and discarded in large degree the old organic or pictographic suggestions. Deliberate form now stood forth on its own to produce an art of extraordinary freedom. And with a gain in strength he moved to his final phase, the *Cubi* series, ultimate works of four-square beams, slabs or columns of welded stainless steel. Mere contact between these welded

elements seems sufficient to hold them together so that they act out an idea of magnetic relationships and appear relatively free from gravity. This lightness is enhanced by their gleaming white steel surfaces. On these geometric faces Smith has scored shimmering patterns, and if they have little to do with the forms they animate, their incongruity appears as one more brilliant flourish of inspiration.

DAVID SMITH. *Cubi XX.* 1964. Stainless steel. (University of California, Los Angeles, Franklin D. Murphy Sculpture Garden, gift of David E. Bright.) [Courtesy of John Swope.]

EUROPE AFTER THE

SECOND WORLD WAR

Meanwhile, paralleling Abstract Expressionism in America, abstract painting in Europe continued to flow out of what went before as Europe recovered from the war. In France there was a whole postwar school or generation of abstract painters whose work was generally colorful and loose in construction. The most imposing name is that of a Russian who grew up in Belgium.

Nicholas de Stael De Stael was in and out of representation, but his memor-
(1914–55) able canvases are abstract. Here he worked in thick, flat areas of muted color that meet together like blocks of masonry. He favored grays, tans, dull blues, and an occasional off-white. The heavy meaty texture offsets the fragility of great taste in the opposition of tones, and the result is solemn, noble, and calming. Surprisingly, de Stael went back to a thin, literal landscape painting toward the end of his life. He died a suicide.

Pierre Soulages Soulages works with broad, dark bands that sweep across
(1919–) a uniform ground. The end result much resembles a canvas of Franz Kline. He has a sleek elegance that Kline lacked— or avoided. His paintings have an arresting density, as of symbols of unknown things.

Georges Mathieu Mathieu is also a painter of gesture. In a handwriting
(1921–) almost Arabic, he squeezes thick paint, red, white, or black, directly from the tube. His technique could well have claimed

the name action painting, for Mathieu has reduced it to a performance to be witnessed. This choreography fails in its purpose. In Pollock we sense the excitement of the method. We are denied this in Mathieu if we miss the act.

Another Paris painter, the Canadian Riopelle, has an impressive vitality. He builds a thick carpet of vivid pigments,

Jean-Paul Riopelle (1923–)

NICHOLAS DE STAEL. *Vue de Marseilles.* 1954. (Los Angeles County Museum of Art, estate of Hans de Schulthess.)

PIERRE SOULAGES. *17 Janvier, 1970.* 1970. (Courtesy of M. Knoedler and Co., New York.)

one smudging over another. The result is a heavy, overall mosaic of prismatic color that creates a sense of splendor.

Riopelle and Soulages came closest to Abstract Expressionism. The name for the style in France is *Tachisme,* a spotting or staining, or *Art Informel.*

Karel Appel
(1921–)

In Holland, the CoBrA group (the letters stand for Copenhagen, Brussels, Amsterdam) offers images that are overwhelmed by a massive smearing on of paint. The best in this crude, colorful style is Karel Appel. Typically, his barbaric subjects, gargoyle-like heads or skulls, match the violence of the attack. He projects a strenuous vitality.

Horst Antes
(1936–)

KAREL APPEL. *Savage Bird.* 1956. (UCLA Frederick S. Wight Art Galleries, Los Angeles.)

In Germany, in the midst of much simplified abstraction, Horst Antes has risen into prominence with his strange, vigorous figures, large-headed dwarfs if they are taken literally, wrapped around in hard, dark outlines that apparently come from Max Beckmann. These human icons are close relations of the grotesques of the CoBrA group. They turn into symbols before our eyes, as though we were wit-

nessing the creation of pictographs for a primitive alphabet. They convince because they are alive. It seems reasonable that the artist has converted them into sculpture.

HORST ANTES. *Figure (Oh Fallada)*. 1969/70. (Collection of John Lefebre, New York.)

Fritz Winter, somewhat older, has an abstract vocabulary that stands the test of time. A still older figure with a relatively new reputation is Julius Bissier. He had an early

JULIUS BISSIER. *5 März 61*. 1961. (Collection of Marion Lefebre Burge, New York.)

Fritz Winter (1903–)

Julius Bissier (1893–)

Marino Marini (1901–)

background of larger oils and of black-and-white prints which he has suppressed in favor of smaller paintings in tusche (a fluid medium used in printmaking), oil tempera, and watercolor. Here all is reticence, the color subdued, the images transparent, the forms abstract. Yet the forms hint of unidentified objects: enough reality remains to create an impression of a flight of fancy. Such phrases could be used to describe the work of Paul Klee, and Bissier has often been compared to him. But his sensitive painting is entirely distinct, and the comparison does Bissier no harm whatever. Although the artist is an older man, these works are of the postwar decades, and are recent in spirit.

After the brief outburst of Futurism, the First World War, and the fascist blight with its drive toward bombast, Italian art came to life again with at least one major sculptor, Marini, and another, Manzú, of lesser impact. Marini owes a certain debt to Picasso, but he has his own capacity to animate the grotesque. He achieves this through a gesture of ecstasy. And

he came up with a theme that he made his own, the horse and rider. In his hands the rider is an anti-hero, understandably a counter to the too-recent heroics of fascism. The rider is the little man who incongruously becomes the man on horseback. He resembles Sancho Panza, the peasant who accompanied (and outlived) the exalted knight, Don Quixote. Marini's horse and rider is an essay in pathos. It is also a triumph of humanity via satire; it is black humor in bronze.

Above: GIACOMO MANZU. *Cardinal.* 1963. Bronze. (Ted Winer Collection, courtesy of Palm Springs Desert Museum.)

Left: MARINO MARINI. *Cavalier.* 1953. Bronze. (Collection of Mr. and Mrs. Harry Lenart, Los Angeles.) [Frank J. Thomas.]

Giacomo Manzú (1908–)

Manzú is weaker than Marini, and he does not over-attempt. He is a literal sculptor, suavely lyric, and very kind to women. He has undertaken an almost impossible task and acquitted himself well in creating door panels for Saint Peter's Cathedral in Rome.

Lucio Fontana Among Italian artists, the most extreme are the best. Fon-
(1899–1968) tana, born in Argentina, was both sculptor and painter. His
characteristic style, due to an accidentally slashed canvas,
dates from the 1940s. From then on he developed a white
canvas that is slashed or wounded with one or two razor
strokes. The edges of the wound curl, turning the canvas
into a species of sculpture. For a showing in the Venice
Biennale he created a small cubicle of such wounded white
surfaces confronting each other; this setting, with its sterile
incisions, created an image combining both operating amphi-
theater and patient.

Fontana's most characteristic sculptures are spherical
events with uneven surfaces; they resemble great wasp nests.
Placed in the landscape, they astonish by their presence and
arrest the imagination. It is the slashed canvases, however,
which are his most personal and significant works. They raise
a vindictive act to the level of art.

Alberto Burri Another Italian penetrator of surfaces, Burri too has pro-
(1915–) duced an art between painting and sculpture. He was a doctor;
he began "painting" in Arizona when he was an American
prisoner of war. He worked at first with pieces of burlap
sewn together and stained with red. Inescapably they suggest
bloody bandages. He has also covered panels with thin strips
of wood, and created patterns by burning the surface. These
opaque, wounded, burnt, and tattered works have an effective
richness. He has gone on to stretch plastic sheets over metal
frames, creating two-dimensional sculptures to be walked
around, in which holes again appear. They are less compel-
ling to an American eye, perhaps because of the disposable
nature of cellophane; we are less hypnotized by the familiar
transparent surface than Europeans. Burri's surfaces all have
an air of wartime devastation.

Antonio Tapiès Spain has produced two protest painters, Antonio Saura,
(1923–) and the more imposing Tapiès, who plasters surfaces with a
paint loaded with sand and marble dust. His walls, of the
general tone and consistency of asphalt pavements, range
from dusty grays to bronzes to gravelly whites. Areas of
color meet in edges that rise in relief. These blind slabs have
great integrity in their oppressive way, turning our thoughts
to barriers, political or spiritual.

Of late he has added an occasional symbolic object,
notably a bureaucratic desk piled high with paper that spells
danger, as though we were political prisoners.

THE FIRST HALF OF THE TWENTIETH CENTURY: ARCHITECTURE

In architecture we no longer find a dependence on past styles, classic or Gothic. Instead we have a living tradition in engineering, and as a point of departure, the work of two major architects, the American old master, Frank Lloyd Wright, and the Swiss Le Corbusier, twenty years his junior. If we add the Germans, Walter Gropius and Mies van der Rohe, we have a half-century in hand.

Wright began his career in Chicago, the first modern city. He was trained in the office of Louis Sullivan, which (as we know) made him the third in a dynasty of distinction: Richardson, Sullivan, Wright. In retrospect, Wright is a figure of world stature. His temperament stood between him and larger commissions for public or industrial buildings, so he was primarily a builder of houses. The Guggenheim Museum was his last great effort, and his only commission in New York.

Frank Lloyd Wright (1867–1959)

During the first decade of this century he built a series of large residences in the Chicago area in a long, low style (to go with a flat countryside) called Prairie Architecture. Typically these houses had low-pitched roofs with wide overhangs, and they centered on a main chimney for which he had a reverent pioneer feeling; for Wright the hearth was an altar. Hearth and massive chimney sustain the hovering roofs, planes apparently free of gravity such as later "modern" architecture will make familiar, while the windows are in long, unbroken banks. Then he had a way of outlining

walls with dark horizontal and vertical stripes, which came
from Japanese architecture as he got to know it from the
Japanese prints in the Chicago Fair of 1893. Later he built
his own Japanese print collection.

Indoors, rooms tended to flow together. In place of the old
compartmentation, we have a preview of the victory of con-
venience over privacy in the modern servantless home. The
Robie house in Chicago was his culminating masterpiece in
this Prairie style.

His next phase centered in Los Angeles. Here he com-
pletely changed his approach, building with precast cement
blocks that caught the sun with their patterns. In a more

FRANK LLOYD WRIGHT.
Robie house, Chicago.
1909. [Sandak.]

vertical geography, he accepted high façades, and in a dry
climate he gave up overhanging roofs. The culmination of
this phase was the Millard house in Pasadena. Meanwhile,
during these same years, he was building the Imperial
Hotel in Tokyo, now destroyed. But whether in Tokyo or
in Los Angeles, a zeal for the monumental led Wright away
from the coming trend of the architecture of the century
which was moving toward lightness and simplicity; in con-
trast Wright was massive and complex and his cast-concrete
patterns led him on to exoticisms that recall the decorated
surfaces of his master Sullivan.

Wright surrounded himself with disciples, and built him-

self feudal encampments where he reigned as a patriarch; the first in 1925 at Spring Green in Wisconsin, the state whence he came, the second in 1938 near Scottsdale, Arizona, a dry-weather complex of buildings with translucent cloth roofs.

His reputation can be entrusted to three masterpieces, all of the greatest originality, all completely realized developments of a long-maturing personal trend. The first is the

FRANK LLOYD WRIGHT. House for Mrs. George Millard, "La Miniatura," Pasadena. 1923. [Photograph courtesy of The Museum of Modern Art, New York.]

Kaufmann house, Falling Water, at Bear Run, Pennsylvania. Here Wright carried to an ultimate conclusion his resolved conflict of cantilevers set at right angles, both hung on the haunches of a central mass of rough masonry, his persistent architectural core. This arrangement already existed in the Robie house, but the earlier structure is no preparation for the freedom that Wright now achieved. His building is set in wooded country where it hovers over a waterfall and pool in a mountain stream. The Kaufmann house is one of those works of art so closely knit to environment, so distinctive

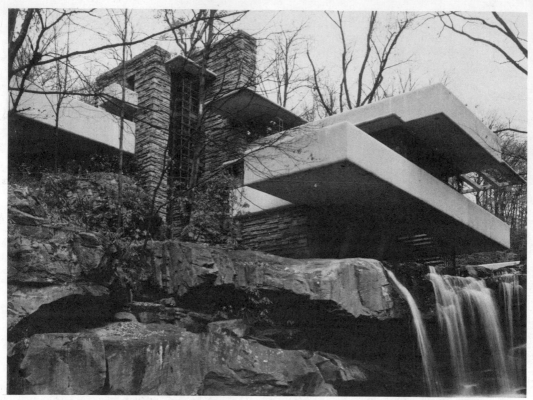

FRANK LLOYD WRIGHT. Kaufmann house, "Falling Water," Bear Run, Pennsylvania. 1936. [Sandak.]

in its form, that successful imitation is out of the question.

The second major achievement we must list is the administrative building for the S. C. Johnson and Son Co., Racine, Wisconsin (1936–39). A horizontal structure with a tower, this complex presents a synthesis of square and circular forms devoid of windows. To sustain the ceiling of a large office space, Wright devised a special form of support, a tapering column flaring at the top into a broad, flat, circular cap. These circular caps almost touch each other, defining the ceiling and allowing light to enter between them. Wright the engineer had produced a unique form, which not many architects are privileged to do.

Finally we come to the Solomon R. Guggenheim Museum, a building we have discussed earlier. The museum presents an extraordinary cylinder of space defined by a spiral deck that swings wider as we mount. As a place for display it presents its problems. Paintings and sculpture must be shown in the compartmented bins that follow each other along the ramp. Here nothing is vertical or horizontal and the rectangle of a canvas must make the best of the situation. Yet either

by magic or accident this turns out to be good more often than not: the modern painter may liberate emotion through the lurch that he imparts to his forms only to have his effect diminished by the rectangular stability of frame, wall, and room. But in Wright's building, the sloping environment reinforces the instability of the painting it houses, and frees, as it unsteadies, the response of the beholder. Everything swims, whether forms or heads.

FRANK LLOYD WRIGHT. Interior, S. C. Johnson and Son Co., administrative building, Racine, Wisconsin. 1936–39. [Sandak.]

The space Wright has achieved here is in the tradition of religious architecture, at once finite and mystically limitless. A work of great art in itself, scornful of its function of housing any other art, it exists to astound and arrest. We ask ourselves what the building is for and immediately have the only possible answer: Wright was building his tomb.

Le Corbusier was Swiss. His real name was Charles Edouard Jeanneret. Le Corbusier was a pen name: by the time he was a successful author he was stuck with it.

Le Corbusier (1887–1965)

Twenty years younger than Wright, Le Corbusier was the great architect of his time, the opposite number to Picasso as an influence in his field. He has done more than any other man to change the look of the world around us. Yet for all his influence he was asked to build remarkably little until late in his life. Frustrated, he wrote and drew plans and published. For lack of commissions he was a successful propagandist for his ideas; and since it costs no more to think

large, he went deep into city planning. He rebuilt, in his imagination, most of the major cities in the world as though he foresaw their destruction. Standing on the Acropolis in Athens, he stated that the composition stretched from horizon to horizon. Imagination so unbounded sees architecture in larger terms than single buildings.

Le Corbusier was at once a moralist in search of a better world and an adventurer in organizing space. He saw solutions with simplicity and seized on the techniques that could produce the desired result. Such a man is educated by the times in which he lives. He worked as a very young man with a builder in Paris, Auguste Perret, from whom he learned the use of reinforced concrete, and he realized at once that this was the new material for the shapes to come. He studied in Berlin with Peter Behrens, an architect who had the chance distinction of having three young men work for him who were all to become great: Le Corbusier, Gropius, and Mies van der Rohe.

Building in France stopped during the First World War, but by 1914 Le Corbusier had drawn a diagram of the house of the future. Vertical supports were set well back from the outer walls and went through to a flat roof. This at once provided for hanging walls, unlimited glass, and space free to be cut in any convenient pattern. It was really American skyscraper construction, and to this basic plan he added an idiosyncrasy: he would have neither attics nor cellars. Accordingly, he placed his building on posts or stilts. The cellar was the open space beneath.

Such boxes were at once new and very old. Mediterranean architecture from the Middle East to Gibraltar is made of little boxes, as we pointed out in our discussion of Cubism. Le Corbusier revived this Mediterranean architecture, the house that preferred windowless outer walls and turned inward on a courtyard. Enclose the court of a Roman villa with glass, use steel for support, and you have a modern house.

When building was possible again, the young Le Corbusier was held down to very modest residences and to cheap housing developments. In Stuttgart, in the reviving Germany of 1927, a modern housing project allowed three advanced architects to build: Le Corbusier, Gropius, and Mies. Their houses were remarkably alike, although Le Corbusier, to be sure, mounted his house on posts. Windows were in banks and the flat roof was a usable terrace. Such buildings were

white plaster over metal contruction: all was practical, anti-luxury, and austere. All was also form: no color, no texture was allowed, and of course no ornament. In Le Corbusier's phrase, a house was "a machine for living."

Over against this modest reality Le Corbusier was envisaging great skyscraper apartments, Y-shaped in plan, that were to be free-standing in the midst of parks. It was many years before he was invited to build such a giant apartment himself, but other architects took over his published ideas, and half a century later there was hardly a major city without a Le Corbusier–inspired housing development. Le Corbusier had realized that if you built high enough you could house the population of the densest city and have green land left over. His plan competed successfully with the suburb, and for a simple reason: since it did not thin down the population it did not reduce the value of real estate.

Meanwhile, Le Corbusier had an opportunity to spend money lavishly and his austerity faded. The Villa Savoye, at Poissy, outside of Paris, was the Le Corbusier box on posts with windows' in banks and a smooth-finish exterior. The roof was capped with curvilinear windbreaks to protect a planting. The ground floor was a triple garage, something

LE CORBUSIER. Villa Savoye, Poissy-sur-Seine, France. 1928–30. [Photograph courtesy of The Museum of Modern Art, New York.]

unheard of; and the second-story area was only partly en-
closed, with a terrace open to the sky. Thus Le Corbusier
provided hardly any living enclosure at all. The building
was an adventure in form.

The Villa Savoye sat in a field like a moored yacht, and
it resembled the bridge of a ship. Le Corbusier had always
been impressed with marine architecture. The modern steam-
ship was far more advanced, he contended, than any con-
struction on land. Like yachts, Le Corbusier's houses could
be moored anywhere. He did not share Wright's concern
with site.

A few years later and he was able to build the Swiss
Pavilion for the Cité Universitaire in Paris (1930–32).
His country had heard of him and gave him the commission.

LE CORBUSIER. Swiss
Pavilion, Cité Universi-
taire, Paris. 1930–32.
[G. E. Kidder Smith.]

He created an oblong box lifted up on heavy posts with an
open roof terrace above that. The long sides were all glass,
the narrow ends were windowless masonry. This form was to
survive. He had a chance to create it again in the Ministry of
Education in Rio de Janeiro (1937–43), in collaboration with
Oscar Niemeyer and others. Its final development was the
United Nations building in New York for which he was one
of the associated architects.

Le Corbusier had great disappointments. In 1927 he won
the competition for the palace of the League of Nations to be
built in Geneva. He designed a large, airy office building for

the conduct of the world's affairs, with a sculpture by Lip-
chitz on the façade. This was intolerable; the world's states-
men buried the building as they buried the League. What
they wanted and got was a pile of masonry with columns and
a pediment. It was a tomb for a hope, and they built a monu-
ment for a mass grave. Le Corbusier was disqualified on
the grounds that his drawings were not in Chinese ink.

He was equally unhappy over the United Nations build-
ing. It has the stamp of his handiwork upon it but although
he thought of it as his own he was only one of a large
group of collaborating architects. He was not a good col-
laborator. When the time came to build, it went up without
him.

Even such a large building was small compared to his
conceptions. He said to New York, "Your skyscrapers are
too small." At last he had his belated chance to erect one
great apartment house in Marseilles after the war, a whole
block or city for communal living in the sky, complete with
shopping center. It is not a very practical building but it
actually came into existence—ideas do realize themselves.
Many of the elements in his design, from the great supports
underneath to the ventilators on the roof, are really major
sculptures.

Le Corbusier's early work was bleak, inspired engineering;
but, if this were all, the times might have left him behind.
When he was older, he changed. Again he moved out ahead,
this time with buildings that were loaded with a new human-
ism, a new psychological expressiveness. His forms became
massive and unpredictable. He built a small, fantastic chapel
on a hilltop, high up where France begins to rise toward the
Alps.

Notre-Dame du Haut, Ronchamp, France (1950–54), is
a mysterious form that speaks of primeval man, a cave
where he might have drawn on the walls in the dark. Like
Picasso, and like no one else, Le Corbusier was able to
summon up the form-memory of mankind. This small build-
ing is one of the great architectural events of this century.
It has no regular angles, lines, or curves. Its thick walls meet
like the prow of a ship; a fantastic overhanging roof hovers
free above the building. Random windows pierce the walls
in no pattern, and appear from without as medieval slits in a
fortress. The beautiful interior is eminently suited to its
function as a small church. Le Corbusier's chapel on its hill
is half spiritual fortress, half primeval den, a place of time-
less pilgrimage, a sculpture as a cave is sculpture.

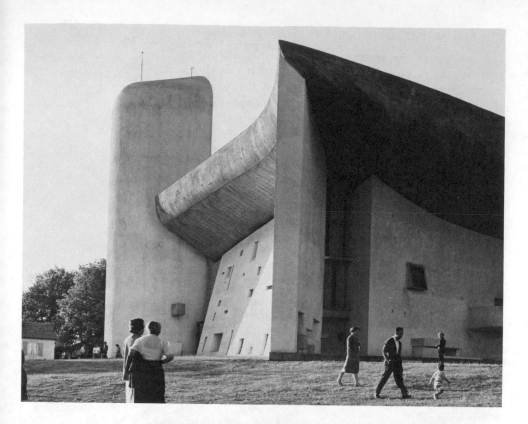

LE CORBUSIER. Chapel,
Notre-Dame-du-Haut,
Ronchamp, France.
1950–54. [G. E. Kidder
Smith.]

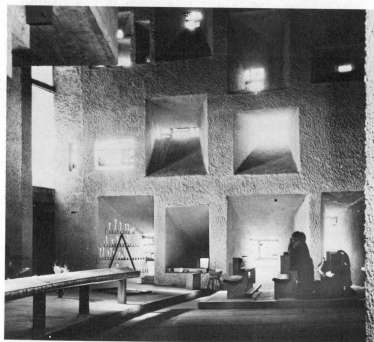

LE CORBUSIER. Interior,
chapel, Notre-Dame-
du-Haut, Ronchamp,
France. 1950–54.
[French Government
Tourist Office.]

Major twentieth-century architects were receiving (at last) their great hoped-for commissions in Asia and South America. Le Corbusier had already had his early building in Rio de Janeiro. And now, in Chandigarh, he was given a whole capital city to build in the Punjab in India. Here his public buildings surround a reflection pool. The Assembly Building (1959–62) is simply tremendous sculpture, with a gigantic double roof held aloft on sharp pylons. The roof is an expansion of the roof at Ronchamp, on a scale to hold off the molten heat. India is the home of great monumental architecture which exists first and foremost for spiritual reasons. Le Corbusier, a lifetime away from his first creations, was undefeated by this challenge.

We have met Gropius before. A great organizer, he cuts across the organization of any history as teacher, architect, city planner. Too modestly, he thought of himself as a man who fought for other men's ideas. First and foremost he was a philosopher of design. He believed that artists should labor for the common good; he welcomed without vanity the help of the machine.

Walter Gropius (1883–1969)

The approach to art via social philosophy meant that he lived with concepts that were developed by others who provided the hands. If this was the evil fate of Le Corbusier, for Gropius it was a chosen method. His collaborators or partners made the drawings. The next partner drew the familiar Gropius buildings, which remained austere, barracks-like structures.

Gropius had a career broken by war and fascism in Europe, with an earlier phase in Germany and a later one in America. The earlier phase was the more creative. The Fagus Shoelast Factory, Alfeld-an-der-Leine, Germany (1911–16), represents the forthright (and literal) turning of a corner in architectural history. Gropius used walls of glass with no corner posts at all: for the first time the glass panes serving as a transparent screen simply meet at the corner. He made the principle of inside support plain, and for him this had the virtue of truth.

After the war, Gropius was able to construct the new Bauhaus building (1925–26) when his school moved from Weimar to Dessau. This structure was quite asymmetrical; built according to function, it linked a workshop area and a living area with a floating bridge that housed the administration. It is now hard to realize how revolutionary this building was, how freely it shrugged off gravity. One story above the

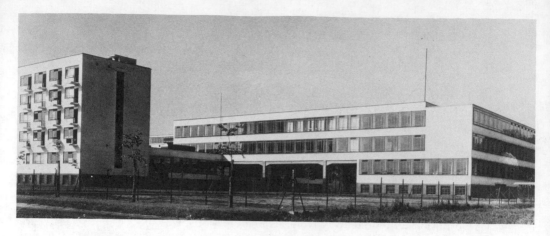

ground Gropius established a broad white band that seemed to hold the building afloat. The glass walls dimly exposed the interior at the same time that they reflected further sections of the building, making visible the Gropius ideal of related indoor and outdoor space.

It is unfair to Gropius that the school housed in this building has been dealt with elsewhere in deference to the importance of his artist teachers, for Gropius' goal was always a large unity under a comprehensive architectural formula, and school and building were one.

Gropius left Germany in 1934 for a brief stay in England, and in the following year the Museum of Modern Art in New York devoted an exhibition to his conceptual achievements, "The New Architecture and the Bauhaus." If this exhibition celebrated a modern architecture at the peak of its accomplishment, the catalogue gave it a name, "the international style," that was a source of irritation to Gropius for many years. For him, the international style was classical architecture.

In 1937 Gropius accepted an appointment at the Harvard School of Design. Here in America he could not repeat his spectacular organization of the Bauhaus, but he did organize a firm, The Architects Collaborative (1945), staffed by the pick of his students, in which he struggled with the fiction that he was one among equals. He was at Harvard for years before the university gave him a chance to build. Finally he designed the Graduate Center (1949–50), a relaxed and livable complex of dormitories surrounding a commons, with wall decorations by Albers, Arp, and Miró. Then larger commissions came his way: the American Embassy in Athens, and buildings for Baghdad University, his turn at building for the East.

He was involved in city planning in Chicago. His plan for the City Center in Boston's Back Bay (1953) unfortunately never materialized. And he collaborated on the Pan Am building in New York, which unfortunately did.

The careers of Mies and of Gropius present curious alternations. In Germany Mies had less opportunity to show what he could do, while Gropius was establishing an early record. In America, Gropius the humanist had little support, while Mies the purist had a brilliant career, leaving superb if uncomfortable monuments in our cities. Gropius aspired to serve humanity; Mies served corporations, and after Le Corbusier he is the modern world's most influential architect. The Seagram building in New York (1964), built with Philip C. Johnson, set a pace. This structure is unsurpassed in its kind, and it turns all the other glass buildings of Park Avenue into poor relations as it haughtily draws itself back from the street. Of all high-rise buildings, it is the most beautiful. (Or is it Ponti's Pirelli building in Milan?) If this is a monument to a corporation, perhaps a corporate entity is more alive than all the worker bees humming inside its hive, and this may be the reason for the architect's success: he understood his time.

Mies van der Rohe (1886–1969)

Mies was the son of a master mason. Delight in polished stone stayed with him, and transferred itself via elegance to the smooth gleam of glass and metal. His surfaces always seem more finished, more right, more precise than any others. He is the classicist of modernism.

He must have learned something from the use of glass in Gropius' early Fagus Factory. He made plans for two glass-walled skyscrapers between 1919 and 1921. These conceptions were never realized but they had their influence. They were a goal that was understood.

The Stuttgart Werkbund Exhibition of 1927, the Weissenhof development in which Gropius and Le Corbusier took part, was under his direction, and he had an opportunity not only to plan but to build.

He had a further opportunity to carry out his ideas when he built the German Pavilion for the Barcelona Exposition in 1929. Here he created architectural space with a number of vertical thin stone slabs that duplicate in their perfect and smooth reality the surface of the water in the adjacent pool. The only right figure for an existence in this rarified environment was a well-placed sculpture.

Mies' next luxury opportunity was in the Turgendhat

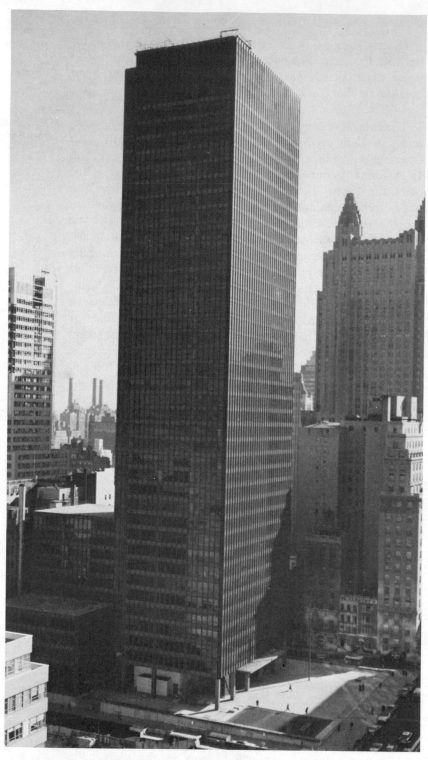

Mies van der Rohe, Philip C. Johnson.
Seagram building, New York. 1954–58. [Sandak.]

house in Czechoslovakia (1930). This time money was no
concern. Walls were of marble and onyx and polished steel
columns supported the roof. Thin stone partitions curved to
diagram space. Chairs beautifully designed by Mies, of
leather and chrome-plated steel, were set in precise patterns
like chessmen—if they were moved at random the game was
lost. Velvet curtains were white. Mies had a phrase for his
stark ideal: "less is more." In this case, it meant austerity is
luxury.

He inherited the Bauhaus in 1930 for a brief while; he
moved the school to Berlin before he was constrained to
give it up. When he came to America in 1937, in the same
year as Gropius, he chose Chicago, and here he had an
opportunity to realize his ideas. His great commission was
the Illinois Institute of Technology, planned by 1940, real-
ized by 1956. His buildings here are steel-and-glass cages.
A school of technology met the architect more than halfway,
and his austere instincts were appropriate and rewarded.

He had a chance to realize his early plans for glass sky-
scrapers in 1951 in the twin apartments on Lake Shore

Mies van der Rohe.
National Gallery,
Berlin. 1962–68.

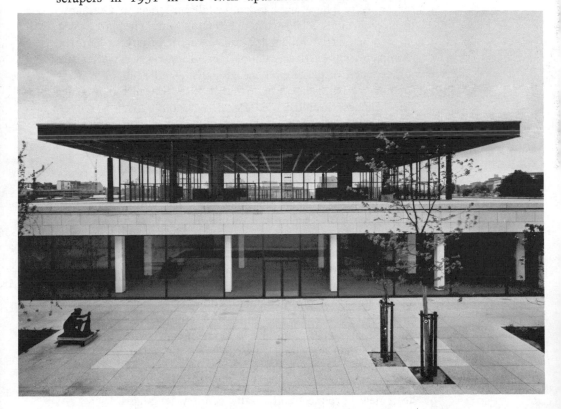

Drive. They are not exactly built for people, but they are
nonetheless beautiful. Which brings us to the Seagram build-
ing, and then to the National Gallery, Berlin (1962–68), a
great slab of roof floating high above its platform and far
overhanging its glass walls. It is an extremely beautiful event,
and beautiful in being extreme. But how do works of art
make out in space that suggests an airport? Less happily
than people, for they can never depart. But then, Mies was
housing an idea, which is what architecture is about.

Gio Ponti The very name International Style tells us that its charac-
(1891–) teristic buildings exist elsewhere, in Europe, and in major
cities the world over. They need not be high-rise, but since
Le Corbusier, since Mies, the monuments in this style are
likely to be towers; and high-rise buildings are likely to be in
the International Style. Such buildings are out-rising each
other at the present day, but we have seen them before and
they no longer astonish.

London does not really care for such towers; in Paris they
are resisted noisily, although they are going up on the edge
of the city. There are handsome tall buildings in Germany,
a land of cities reconstructed after the war. They are loved
in new industrial Milan, the most American city in Europe,
complete with a dense smog. Here they rise one after the
other, each displaying an individualism and zeal for experi-
ment. The handsomest of them all is the Pirelli building, by
the Milanese architect Gio Ponti, who built his tower over
an armature designed by the engineer Pier Luigi Nervi.

Ponti had neoclassic beginnings, restrained as he was by
the starchy neoclassicism of the fascist regime. Later he
moved toward something more baroque. His walls may over-
lap without meeting, so that the building has vertical corner
slots for light. The result sometimes has the weakness of
a theater set, and again is sheer magic.

The Pirelli building is a high, rectangular tower with ends
that are beveled, so that in plan it is boat-shaped. These
ends are slotted. The tower rises from a broader foot, like
the United Nations building. The Pirelli escapes the monotony
of the box, and has great distinction.

Ponti has also been a builder of churches. He has used
this same concept, the beveled rectangle, with the same
slots for lighting, and for surface has designed a gray tile
that glitters gently in the sun.

We shall encounter a turn from a classic architecture
to a new baroque trend as the century lengthens.

GIO PONTI. Pirelli
building, Milan.
1956–59.

POP ART

The Abstract Expressionist movement generated a great deal of critical writing in support of the artist. This defense tended to become an integral part of the movement, as though Abstract Expressionism were a sport, and there was in fact something sport-like about an art that was a personal gesture. The audience was forced to visualize Pollock, Kline, or Hofmann in the *act of painting*. This arena aspect of Action Painting led all the more quickly to the moment when the "action" was unexpectedly past. Suddenly the field was swarming with anonymous Abstract Expressionists who were unable to realize that the style had scored and won, and that the game was over.

What was to follow? We only need to take a backward glance at the alternations between Romanticism and Classicism, between Cubism and Dada-into-Surrealism, to expect a commitment to something directly contrary to Abstract Expressionism's loose, highly personal style. A new emphasis on the impersonal was now in order and duly arrived. On the side of theory, an analytic clarity of statement would succeed impulse: color was to be color, and form was to be pure form, progressively simpler as it approached geometry. The new pure impersonal painting had a name, *Color-Field Painting;* the simplified sculpture had a name or names, *Minimal Art,* or *Primary Structures.*

Meanwhile, the art world had a political upset, and the program had to wait. Another contrast to Abstract Expressionism could be—and was—built out of the facts of daily

life. Certain painters and sculptors, acting as if on a common impulse, seized on our mechanized, brash environment for their very raw material. They built with the manufactured objects that deck out our commercial mythology, and with the advertising that whips up an appetite for these objects. They returned to the recognizable image. They resold what had already been sold, and it is not surprising that many of them had themselves been producers of advertising.

This outburst had a name: Pop Art. The name itself came from England; it is a characteristically British abbreviation of the word "popular." The movement actually began in England, but as American Pop Art was more dominant, we are following American developments, and add the British and European contributions to the total.

It should be pointed out that Pop Art did not need to be created. It existed; it was only waiting to be recognized. There it was in such representational buildings as the Brown Derby (a restaurant in the shape of a hat); or in Disneyland, (whether in its castles or a talking Abraham Lincoln), on the calendars in the offices of lumber yards, or in the pornographic film.

Two painters led from Abstract Expressionism to Pop Art, figures who had the strength to sustain a transition: Robert Rauschenberg and Jasper Johns. We cannot reach Pop Art without considering their contribution.

Robert Rauschenberg (1925–)

Jasper Johns (1930–)

Rauschenberg apparently sensed that *art* was in need of contact with *life*. He seems to have set himself the task of breaking down the barrier between the two. Failing that, he chose to take up a position between them.

He came from Texas; he had been to Paris before he came to New York. He had had an extraordinary and unconventional schooling at Black Mountain College, North Carolina, in 1948–49, where he studied with Josef Albers, and perhaps more to the point, made contact with the composer John Cage, a breaker-down of barriers in the arts; and here he came to know a fellow student, another Southerner, Jasper Johns. Rauschenberg and Johns were to have studios in the same building in New York, and enter on the New York scene at the same moment.

If the barrier between *art* and *life* were to go, perhaps a mocking of the procedures of art was needed, the turning of technique to farce—something that should only be undertaken by a man like Rauschenberg who had technique to

spare. He went far beyond Pollock when he poured paint in some bulk over his bed, successfully gluing down his quilt. Thus Rauschenberg came up with a painted object of living as an object of art. And he managed a further breaking down of barriers by overriding the limitations of art forms. A work of art could be such a conglomeration of objects as we rarely experience in art and frequently experience in life. As an example of the second endeavor, *Monogram* (1959) provided a stuffed goat with an automobile tire around it as a centerpiece in the midst of a number

ROBERT RAUSCHEN-BERG. *Monogram*. 1959. Moderna Museet, Stockholm. [Photo courtesy of Leo Castelli Gallery, New York.]

of assorted objects. Such a stream-of-consciousness experience has all the jumbled incoherence of memory itself. By offering *fact* as *art,* Rauschenberg had solved his problem.

Combine is Rauschenberg's word for these arbitrary bringings-together, which have included earth and a seed planted in it. Art as an act of the artist's will can even have a negative sign before it. A white canvas, a painting that has *not* been painted, can nonetheless be treated as a painting; a drawing by de Kooning which Rauschenberg erased (with the artist's permission) is nonetheless a work of art, now signed by Rauschenberg.

Johns is a highly intelligent painter, and he also undertook to bridge, or at least reduce, the gap between life and art. As symbols presuppose that one world refers to another, it was logical to attack the symbolic nature of art. To do this, he chose objects that were already familiar signs or symbols, so that they resisted being made symbols all over again by the act of painting. His early subjects were targets—on which we naturally focus—and he painted them repeatedly. At much the same time he began a series of American flags. A piece of cloth painted as a flag is not a painting of a flag, it simply *is* both a flag and a painting. The meaning is not only in the painting, it is in the flag.

The same things can happen with paintings of other objects with a symbolic life. The two major symbol systems by which we all live are the twenty-six letters of the alphabet and numbers one through nine. Johns painted a long series of letters and another series of numbers. In these paintings, his technique is still quite Abstract Expressionist; he works

JASPER JOHNS. *Three Flags.* 1958. (Collection of Mr. and Mrs. Burton G. Tremaine, Meriden, Connecticut.)

with bold, visible strokes over a collage mulch of newspaper that provides his paintings with a solid surface that stops the eye—the very opposite of perspective. Here numbers and letters are simply stockpiled. And we are offered not only a painting of letters and numbers, but letters and numbers.

In a further effort to fuse realities, Johns "created" a flashlight, a light bulb, and a couple of beer cans (1958–62). He offered these objects as sculptures; and as if to prove the contention, they were bronze castings. The beer cans were carefully painted as beer cans, but being bronze they were museum cans. With Johns the work of art declared its new self-sufficiency as fact.

Hard-Core Pop Art

Andy Warhol
(1930–)

A small club within the Pop Art movement has enjoyed the title Hard Core. Here Andy Warhol is the best-known name. Warhol is to Pop Art what Dali was to Surrealism, and for the same reason: his art is essentially theater, in his case film. His repetition of images is in effect a series of motion-picture frames. Such a program calls for objects that gain through repetition, two being twice as valuable as one, and Warhol produced pictures of money, and Coca-Cola bottles in bulk, and then he was inspired to celebrate Campbell's Soup cans. He began with paintings of cans, but soon he went over to silk screen so that identical cans could be *processed,* as cans should be. He achieved an impersonal, machine-made image—Warhol has said that he would like to *be* a machine. To complicate matters, he has had the whim to sign an actual can. When his cans first appeared in 1960, they were in their natural red and white colors, but later he translated them into such colors as he chose.

Repetition fuses "fine" art and commercial art. If this can happen with soup cans, it can happen with people, especially famous people who exist for us as multiples, not only on film but in magazines and newspapers. Warhol chose to celebrate the heads of women, beginning with Marilyn Monroe after her death—the year was 1962. A single canvas contains twenty-five of her heads; a panel of lips and teeth contains eighty-four of her smiles.

Warhol also favored other women, Jackie (then) Kennedy, and Elizabeth Taylor among them. Scores of heads of three or four women, is this not more interesting than heads of scores of women, more essential, more visible? Warhol makes the point himself with the title, *Thirty Are Better Than One*—the thirty are all Mona Lisa. These heads grow large, in splashes of color that fit loosely on the photograph-based silk screens, and they have a spongy color-on-newspaper

vitality. Like Rauschenberg, Warhol strives for a middle ground between art and reality, hence the Campbell's Soup cans that are so like cans, and the women who convince because they are like publicity.

Understandably, his sequences took him over to the motion picture itself, and here in his desire to duplicate fact he avoided condensation into theatrical time. His film of eight hours of weather in the life of the Empire State building takes precisely eight hours to view, and could only be expected to hold the attention of a meteorologist.

As director-producer—for now he has a new employment—he has substituted sex for talent. He produced a Western in this vein, allowing us to get to know cowboys without Indians.

What is his central contribution? Warhol has pointed to a disturbing truth about existence as we now find it: identical objects follow each other like identical moments. The familiar has to repeat itself, or how would it be familiar? The passage of time is uncontrollable: it controls us. It is not strange that he comes through to an ultimate *Death and Disaster* Series (1965) in silk screen on canvas, and here his most famous image is that of the electric chair.

ANDY WARHOL. *The Six Marilyns (Marilyn Six-Pack).* 1962. (Collection of Mr. and Mrs. Melvin Hirsh, Beverly Hills.)

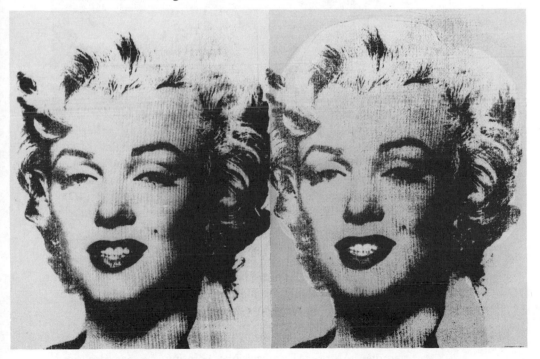

Roy Lichtenstein
(1923–)

After Warhol the outstanding names in Pop Art are Roy Lichtenstein and Claes Oldenburg. Lichtenstein has his own method of bringing art and life together. About 1962 or 1963 paintings began to appear that were apparently blow-up images of comic-strip scenes complete with balloons for captions. The images Lichtenstein chose as prototypes were not caricatures, they were the serious comic-serial illustra-

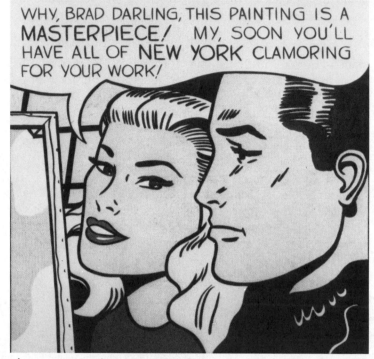

ROY LICHTENSTEIN.
Masterpiece. 1962.
(Collection of Mr. and
Mrs. Melvin Hirsh,
Beverly Hills.)

tions representing acts of wartime violence by a hero of the navy or air force, or moments of romantic turmoil in the life of the emancipated young American woman, typically a secretary or an airline hostess. The comic-strip technique he took over bodily, including the dots of Ben Day for halftones, blown up until they suggest dotted-Swiss fabric. Outlines were bold and heavy, colors sharp and vivid. On the differences between Lichtenstein's paintings and his sources, a great deal of critical ink has been spilt. The official view is that Lichtenstein has subtly transformed what he has appropriated, and has given the composition some abstract unity or simplicity beyond the reach of the cartoonist.

Lichtenstein went on to many other themes. He imitated, or translated, other artists, Piccaso among them; he has parodied Abstract Expressionist painting; he has produced landscapes and seascapes, mostly in belts of Ben Day dots.

For all these works he has stayed with his enlarged comic-strip technique. His paintings one and all maintain a highly special sophisticated satire of his own.

Oldenburg has created an art in which the ideas are compulsive, the objects that project them inventively chosen. Two dimensions were insufficient for the freedom Oldenburg needed and he soon was manufacturing things that were both recognizable and vastly changed. They were blown up enormously and tended to be of soft materials such as cloth stuffed with kapok: they had the consistency of pillows. Oldenberg's two overriding ideas, largeness and softness,

Claes Oldenburg (1929–)

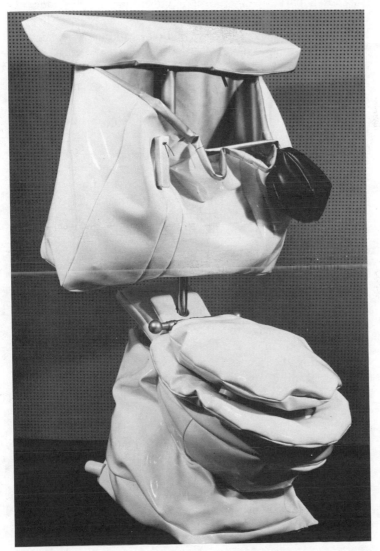

Claes Oldenburg. *Soft Toilet.* 1966. (Collection of Mr. and Mrs. Victor Ganz, New York.)

create an infant's impression of the world it discovers, the first in terms of sight, the second of touch.

What objects is Oldenburg impelled to magnify? Food, first and foremost. A popsicle, a slice of cake, a hamburger, become objects some three or four feet high. To match these, Oldenburg created clothes that could be worn by giants, and for the softening process, a typewriter comes out as pliable as a typewriter cover, a porcelain toilet as limp as a diaper.

By means of drawing Oldenburg carries his vast expansion of the familiar to extremes of architectural fantasy well beyond the possible: a museum floating in the sky in the form of a pack of cigarettes; a mushroom cloud made of cement to house a restaurant and other facilities; tall city buildings in the shape of two figures walking, or designed as half a kneeling woman. Letters appear the size of a city block; objects such as a baked potato on a gigantic scale are offered as city monuments. Such sculpture or architecture is sketched out with a deadpan facility.

He had an opportunity to realize his fantasy in reality at Expo '70 in Japan: he was able to create an icebag on a more or less monumental scale. Not on such a scale as his sense of the bizarre suggested: for a moment he visualized such a bag, with its rubber pleats descending from its stopped, as the dome of Saint Peter's Cathedral in Rome.

Nothing is more serious than farce. Oldenburg has been able, like Samson, to tumble the man-made temple. He has exercised his imagination with glee, an activity obsessive yet wholesome.

James Rosenquist
(1933–)

Tom Wesselmann
(1931–)

Robert Indiana
(1928–)

Jim Dine
(1936–)

George Segal
(1924–)

James Rosenquist supported himself by painting billboards that use enormous figures. He maintained this scale in paintings that have the blue-lavender tonalities characteristic of the originals. He has produced a painting that extends eighty-six feet. Tom Wesselmann also enlarged commercial products, but he is primarily associated with his *Great American Nude* series—strong outlines, flat colors —that he reinforced with actual properties for a backdrop; a real curtain and window, a real chair, a wall telephone that rings. Robert Indiana relied on sign language, and offered slogans or legends as challenges. "Eat," "Love," "Die," come through as commands. These signs have the precision of traffic signs. Jim Dine (a little earlier, a little nearer Abstract Expressionism) also introduced reality as a property: a wrench attached to the canvas, or enlarged clothes.

George Segal made white plaster casts of actual people. They are inevitably rather rough: the exact individual is forever hidden within. They describe their employment via gesture in a clumsy, compelling way, and their environment is built of real objects.

Edward Kienholz has a more imposing art. He has a way of creating visual figures of speech. His themes are intrinsically important: they are social injustice, or human cruelty and folly, and he can be terrifying. It is his weakness that these themes are literature made visible, but for sheer power he must be equated with Jonathan Swift. He invites you to look through a hole into a cell in an insane asylum where you see two naked figures on a double-decker bed, one the idea of the other, and both with goldfish bowls for skulls containing live fish.

Edward Kienholz
(1927–)

Consider again: the reproduction of a whole bar in Los Angeles, *The Beanery*. The congested interior, the bartender, the clients on stools, it is all here including the jukebox sounds built in, and the smells. Only the clients' heads happen to be clocks, and as time ticks, they tick. These people can only run if they run down.

EDWARD KIENHOLZ.
The Beanery. 1965.
(Stedelijk Museum,
Amsterdam.)

European Pop

The British pop artist had no Abstract Expressionism to revolt against. His revolt was against the conventional art or less-than-art of the nineteenth century, still an active, or at least obstructive force in England; and curiously it was also against modern art in the sense that in England modern art has been discouragingly alien and remote. What we must expect then is art locked to contemporary events, which have had the power to refresh the British artist.

Richard Hamilton
(1922–)

Peter Blake
(1932–)

Allen Jones
(1937–)

The most interesting figure, the most determined to build upon the new quality of everyday life, is Richard Hamilton. For his commentary he is prepared to use photography, often with a black-to-white inversion. The objects photographed or drawn make his point, or illustrate a point already made in the title. The use of a title as a literary point of departure seems essentially British.

Blake's factual painting technique lends itself to meticulous satire that appears to accept commonplace values. He has a topical, self-centered world of pretended innocence that is actually rather gamy. Blake has a billboard factualness; he exploits the naive with great effect.

British pop, being the last of the revolt against the nineteenth century, has a desire to shock and hence a special use for sex. Jones deals in impending revelation, so a minimum of clothes is needed. For American eyes his paintings are close to advertisements of women's wear—stockings and garters are at work. But some liberation has been achieved.

Martial Raysse
(1936–)

A. F. Arman
(1928–)

Yves Klein
(1928–62)

Three figures on the French side are significant: Martial Raysse is a manipulator of blown-up photographs; they are stained with arbitrary colors and studded or ornamented with applied objects. Half the art is in the choice, the rest is in decoration that may include illumination, for he likes to strew neon lights around. We are asked to assume that the photograph is reality itself and the effect is of a childlike celebration.

Arman is a figure of greater importance. His art too is built out of a single idea which lends itself to endless illustration, the idea of repetition, the Warhol idea. But Arman's repetitions deal with almost any small object, gadget, or implement which a magpie irrational avarice might collect, typically bottlecaps, paintbrushes, empty rifle shells. The container is likely to be a transparent plastic case. Once an indefinite number is accounted for, Arman's effect is achieved; there is no more need of composition than there is in a button box. Arman has even left the composition up to the public by offering a container with an inviting slot for random contributions.

A full collection plate is an Arman. Arman's appeal is to avarice. Wealth and art are not the same, but there is a connection. We are the century of the identical spare part. Which raises the question: Are we identical spare parts too?

Yves Klein carried to an extreme the Rauschenberg idea

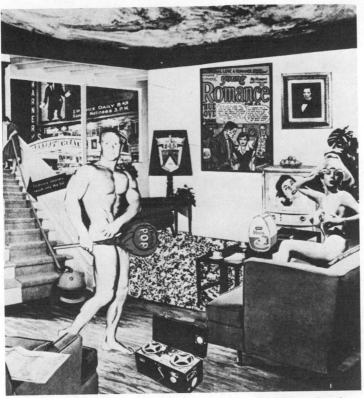

RICHARD HAMILTON. *Just What Is It That Makes Today's Homes So Different, So Appealing?* 1956. Photographic collage. (Collection of Edwin Janss, Jr.) [Photograph courtesy of The Solomon R. Guggenheim Museum.]

that the work of art resides in the artist's imagination. This was an idea of Duchamp's earlier, and for that matter akin to an idea of Plato's: what the artist produces is only the projection, or shadow of the "art." Thus Klein projected ideas. He floated helium-filled pillows (before Warhol), he opened an exhibition where nothing was, and he made paintings of a single color, his piercing ultramarine blue. He spread paint on living models and rolled them on canvas —the spots appeared rather like certain prehistoric images. He jumped out of a window for the experience of personal flight. He was everything within himself, and in this sense, his early death can be seen as his ultimate work of art.

All this raises a question: not, why Klein? but a somewhat larger question, why everything else in art? Can values spiritual and commercial survive mockery? If Klein is a "put on," are museums anything more than anthropology, a record of odd behavior in a warlike species? We can answer for Klein that a philosophy that sees art as farce calls for a great deal of art too.

One more human desire has found its current means of expression, not only to possess but to package. Christo Christo (1935–)

(Christo Javachef) has tirelessly wrapped up objects, from women to storefronts to whole buildings to a rugged section of Australian seacoast: only infinite cloth and rope are required. He undertook to stretch a curtain across a gorge in Colorado, at a cost approaching half a million dollars, which was easily raised. Everything man may desire can become more desirable if it is gift-wrapped. This is a theatrical activity, a happening, a striptease in reverse, a dramatization of a throwaway culture.

Happenings

Pop Art began with the obvious, which insured it a short life, for all art movements can only grow more obvious still. It was not quite as simple as it seemed, for as it subsided it split two ways: on the one hand, into a defiant realism—the integrity of the commonplace; on the other, into Happenings.

Art so far has been a fervent making of something *to last*. But suppose nothing is left, which will undoubtedly be the case, give or take another twenty or fifty thousand years. Is not the end product of art simply an experience? This is a theatrical idea. We are reminded that the great Greek dramas were created for only one performance—it was a great privilege if they were accorded a second. An art that leaves nothing behind is a happening.

It is not surprising that Rauschenberg and Oldenburg became involved with Happenings. The true Happening calls for a theatrical producer temperament. Here an outstanding talent is Allan Kaprow. His art is that of a motion-picture director with a special bent; he is able to organize the impulses of his actors and to get the best out of them or at least leave them the happier for getting something out of themselves. If Kaprow was able to persuade his troupe to lick jam off an automobile, he created joint participation in an implausible, irrational, uneconomic endeavor. Furthermore, he pushed people back to such an early age that the differentiations that have come with their later lives seem quite beside the point. Was this an enlargement or a contraction of personality? We have to say it was both. As in the movies, the end was a smacking of lips.

In general, Pop Art was a refreshing movement. It had a bad taste for the tastemakers. It interrupted the larger trend to which we return, for in the 1950s and 1960s art was not really in pursuit of life, it was in pursuit of ideas.

AMERICAN COLOR-FIELD PAINTERS

When Action Painting was still an activity, Rothko could still pass for an Abstract Expressionist. In his large canvases color gathered the beholder into one enveloping experience. When a sequel to Abstract Expressionism appeared (leaving out of consideration the intrusion of Pop Art) it was clear that Rothko had been a painter who looked toward the future, for the experience of color was the coming event. Events on canvas grew simpler until even Rothko's contrasting areas appeared complex. Single colors were now meant to speak for themselves. Sam Francis, one of the younger, later Abstract Expressionists, could speak of "saturation" in color. A number of new painters were now to develop each his special contribution to the new immersion in color. We limit ourselves rather arbitrarily to seven.

Louis was early; he too had a definite if indirect relationship to Abstract Expressionism. He had an outstanding talent, and those who see him as the greatest painter since Jackson Pollock cannot easily be argued down. Technically, he resembles Pollock in that neither is limited to the brush; where Pollock poured on lines and dripped, Louis drenched, soaking unprepared duck through and through. His stains have all the surface brilliance of watercolor plus a sense of depth, for the cloth was actually permeated with color, with pigment plus quantities of turpentine. The color came in a flood.

 Morris Louis
 (1912–62)

These new paintings came out of Washington. Louis was a

close friend of Kenneth Noland, who lived in Washington in those years, and the two painters influenced each other. Noland appears as the cooler, the more cerebral of the two. Apparently they were outside the influence of the dominant figures in New York, in particular of the liberators of color whether Rothko or Newman. What did affect both of them directly was an early experience of the remarkable painting of Helen Frankenthaler who had already embarked on the area-staining that Louis was to develop, a procedure which was her own development out of Pollock.

Over the last eight years of his life Louis evolved four distinct patterns or "configurations." His first was his *Veil* paintings. Here the floods of turpentine wash spread out in deltas to be overlaid by another color and then still another, so that their margins remain pure and prismatic. When such a painting is turned upside down these floods rise like fountains; and the *Veil* paintings often have the imposing and expanding shapes of elms.

MORRIS LOUIS. *Samach, Veil Painting.* 1958–59. Collection of Robert A. Rowan, Pasadena.)

The next configurations were the *Florals*. These petal or morning-glory formations have centers that seem to well out or to draw color back into their depths.

The third, altogether breath-taking group of configurations was the *Unfurleds*. Here large, horizontal canvases show two diagonal floodings of parallel strips of contrasting colors that begin on the side and seek the center of the bottom as

they descend—or begin at the bottom and slant outward toward the sides as they rise. These free yet closely controlled and symmetrical patterns are resplendent events; the bare canvas, like silence in music, comes alive and plays its part.

The final series was Louis' *Stripes*. These paintings are smaller and narrower. The colors pour down in rivulets that join each other to produce a long, vertical prism. At the last, some of these were mounted horizontally.

Louis was not shown in New York until five years before his death. The outburst of his art gives a sense of authority to the whole movement of color that blazed through the 1960s.

Helen Frankenthaler has given us very beautiful large canvases that support large color stains, color areas that were generally pale and clear and now are stronger and more broken. These paintings belong to a new time, and if they recall Pollock, it is only because they seem such personal expressions.

MORRIS LOUIS. *Nu.* 1960–61. Collection of Robert A. Rowan, Pasadena.)

Helen Frankenthaler (1928–)

Kenneth Noland
(1924–)

KENNETH NOLAND.
Seventeenth Stage.
1964. (Carter Burden
Collection.)

Noland, like his friend Louis, turned to patterns or con-
figurations in series, occupying himself with one theme after
another until it exhausted his interest. He began with a
Target Series from 1958 to 1960 in which the color is
stained in; but if the target circles are precise, the surrounding
colors have rugged frontiers. His second series is his
Chevrons. Here sharp wedges of color, one inside the other,
intrude into a clear field, first entering from the bottom of
the canvas, then, later, descending from the top. These
paintings remain relatively large; the color is strong, and

the effect is as stark and arresting as in the *Targets.* By 1964 Noland turned to a *Diamond Series,* generally on a narrow, vertical, diamond-shaped canvas support, with a surface divided by a series of stripes that parallel one of the sides. The effect is calmer, the format smaller; much of the emphasis has gone over into the nonrectangular form.

KENNETH NOLAND. *Saturday Night.* 1965. (Private collection, New York.)

Finally came the *Horizontals,* large cool paintings to which Noland has given the longest span of time and which seem to concern him most profoundly. Here horizontal lines in different colors and of different widths strike across the pale ground with all the silent insistence of laser beams. As these paintings grow progressively wider these horizontal lines lose themselves—to follow them to their end means turning the head, and taking on a new experience altogether. Thus the sides of the canvas—the only verticals with which Noland has to contend—are removed from the confrontation, and the *Horizontals* are felt to offer infinity. Noland consciously distinguishes between the horizontal, which is abstract and endless, like the sea horizon, and the vertical, which is a specific event like a mast.

Frank Stella Frank Stella came on the art scene in 1959 when he was
(1936–) twenty-three. His austere, highly abstract art was contem-
porary with the Pop Art movement and could hardly be more
remote from it. He concerned himself with variations in
form soon to be fed by variations in color. He began with a
Black Series. The canvases are evenly covered with a pro-
gression of parallel blackish stripes with lines of bare canvas
showing between them. These lines parallel the outer edge
and carry the form of the canvas down inside the mono-
chrome field: the intention appears to be the scaling down
of the importance of the edge by repeating the edge lines
indefinitely and so absorbing them into the painting.

As Stella experimented, the inner parallels tended to be-
come a problem in proportion as they approached the
center, and to avoid this, Stella made a central geometric
hole in the canvas. He also cut off corners, or notched the
sides—anything to subdue the basic rectangle. Meanwhile
the black color gave way to silver paint and then to copper.

By this time Stella was experimenting with highly colored
stripes which he offered as an alternative to the monochrome
pattern. He set up a format of a double square, one mono-
chrome, the other colorful. From here on the trend to color
grew stronger, and the scale increased until the double
squares reached a 10- x 20-foot expanse. The stripes became
FRANK STELLA. *Pro-* still broader and large central star patterns arrived. Finally,
tractor Variation. 1969. arcs of circles took over, a quarter-circle, a half- or even a
(Collection of Dr. and full circle. These *Protractor Paintings,* like the parallel stripe
Mrs. Charles W. Hen- paintings before them, have had a Baroque way of breaking
drickson, Newport loose from their symmetrical beginnings to sweep along a
Beach, California.)

wall in irrepressible gyrations. The wide stripes are of pale acid tones, often of luminous paint, and from the beginning Stella has built his paintings off the wall on a canvas support of some depth, so that they are three-dimensional, almost architectural events. Increasingly the color grew stronger: luminous reds, yellows, greens are set off by blacks.

Still more recently, his canvases have taken on sharp angles in conformations that recall Kandinsky. By now we have to ask whether change is geared to inner growth or to public expectation.

It seems to be a law that a pictorial procedure pursues the extreme that lies within itself. A color encouraged to be the subject of a painting gradually dominates the scene until all subordinate colors are quite defeated. At this point, we no longer have contrast, we have a single experience. This is the ultimate that Olitski has approached in his spray-gun paintings. Originally working with large contrasts like Rothko, he moved on to an unbroken extension of a color field. Jules Olitski
(1922–)

This does not mean that this single color is unblended. Having saturated an area with color, Olitski reattacks the surface with a spray gun, overlaying one color with another. Color showing through color produces a blurred complexity that resembles memory, a present with a special quality because the past shows through. Olitski's colors tend to reddish hues with lavenders and yellows for variants; the surface of a ripe-dark peach offers the nearest experience.

Olitski, like Stella, like Noland, has a problem with canvas edges; he does not wish to be the victim of fixed dimensions. Characteristically, he finds an area in the surface he has been working over that seems to come through to him for its special core of subtlety or vitality, and that is the area he selects for preservation. The rest is cut away. But even so, the problem of edges hovers over the artist, and he has reemphasized them with bold stripes of color that serve as a frame. But actually these stripes have a contrary purpose: by constituting a color framing Olitski denies the function of the actual edges of the painting; he sets up his own limits.

The effect of Kelly's painting is of extreme simplicity, a bold red shape over against an equivalent blue shape on a white field, or reds and blues, yellows and blacks set forthrightly side by side. Actually infinite subtleties are at work. Ellsworth Kelly
(1923–)

How much of a certain red balances what area of a certain blue? Is a red an area on a green painting or is a green an area on a red ground? When the borderline is a sweeping curve, is a black intruding upon a white or is a white yielding to a black? And often a series of canvases constitutes a single work, each canvas a color entity and all set in a deliberate sequence. Here too subtleties are to be discovered: one canvas is minutely larger, in order to sustain a balance of tones. The colors are never pure, they are simply uniform.

ELLSWORTH KELLY. *White-Blue,* 1961. (Collection of Irving Blum, Los Angeles.) [Frank J. Thomas.]

What we have been saying of Kelly is true in varying degrees of all the Color-Field painters: when great simplifications are accepted, the sensibility of the artist becomes in consequence very intense in the narrow area that remains to it. Subtleties that are almost undreamed-of in more obvious paintings become an acute concern.

RECENT SCULPTURE IN
ENGLAND AND AMERICA

British Formalism

Sculptors are active in England. If it seems reasonable to credit this continuing outburst to Moore, who is himself still highly productive, he must then be credited, strangely, with the deliberate turning away from his vision. Brancusi said of Rodin that "nothing grows under great trees," and British sculptors have been impelled to abandon the lingering Surrealism that hovers over Moore—curiously, Freudian art now no longer seems deep enough—and they have lost interest in the warm imprecisions of humanism. Their sculpture has grown increasingly abstract.

Anthony Caro (1924–)

No one has made this break, has taken on this new dimension, more successfully than Anthony Caro, himself originally an assistant to Moore. His earliest works were anatomical, congested struggles with mass in a search for bold form. He seems to have escaped from the insoluble through the influence of David Smith; he too turned to a welded-steel technique, which offered him a bridge to a constructed art. But this was only part of a change that at least timed with his contact with Americans and America. He was encouraged by the critic Clement Greenberg, who was to play a role in the appreciation of the Color-Field painters. He came to America in 1959; he got to know Kenneth Noland among others, and Noland's taut, flat, colorful geometry also seems to have been liberating to Caro.

The early abstract Caros are typically sections of great

ANTHONY CARO. *Halfway*. 1970–71. Steel. (University of California, Los Angeles, Franklin D. Murphy Sculpture Garden, gift of Edward and Jama Bensinger.) [Courtesy of John Swope.]

I-beams welded or locked together, the whole mysteriously vivified by one brilliant overall color. In such a work as *Mid-Day* (1960), it is not too difficult to see one of Moore's reclining figures lurking. But these great steel slabs announced a new freedom; they had a muscular independence. They were soon followed by a greater change, an independence from mass itself, which gave place to wayward spatial diagrams.

Early One Morning, two year later, presents an assortment of forms and directions, whether planes or lines, that seem to have only the slightest acquaintance with each other. But it is a civilized acquaintance. A random casual quality was to grow in Caro. Along with the absence of monumentality went the absence of pedestal or platform. Instead the work simply sat on floor or ground, and the endless surface allowed the sculpture to extend, to rove. The encounter between forms (planes, lines) resembles the encounter between individuals on a pavement. In *Span* (1966), forms appear simply to catch each other's attention; the variety is in the forms, the unity in the color. This quality of abstract independent forms, not being captive to, but captivated with each other, creates a whole new dimension in art, the open, the civilized encounter.

Among the newer men, King is perhaps the most original. He studied with Caro; he too was an assistant to Henry Moore. The moment of change came from a trip to Greece in 1960. Greek architecture impressed King as a form of abstract sculpture, a cultural outcropping, and it pointed the way out of subjective art. Add to this an American experience. He taught for a term at Bennington College in Vermont, which is Kenneth Noland territory. Caro had been here, and David Smith was near, over at Bolton Landing in New York.

Philip King (1934–)

An intensely experimental artist, King has produced few works. He is preoccupied with the relation between form and color. When his pieces are colored, he has a perverse liking for tones that are as hostile as possible to mass, or to any sculptural solemnities. Purples, baby pinks, blood reds, light blues are favorites. Black-and-white reproductions of his work seem much more conventionally sculptural. In general, his pieces are animated rather than heavy. This feeling is related to his choice of materials: he has preferred plastic to metal. His surfaces are smooth, impersonal, and

designed to convey form-ideas. His sculptures do not ask to be admired as the work of human hands. It is difficult to generalize about works that are so separate and distinct; but we can see a cone, a form that has great importance for King, gradually clarify itself. The red slots in the cone in *Through* decorate it with a series of hyperbolas.

Nile (1967) offers a rudimentary and stark geometry of bent planes that has served King a number of times over. Later, rectangular shapes emerge at an angle from ground or floor with a lurch that draws on gravity for the tension they convey. Still more recently, color has yielded to a sense of

PHILIP KING. *Through*. 1965. Fiberglass. (Rowan Gallery, London.)

form, as the forms themselves grow more complex. King talks of a sculpture's "identity" as it develops its own life.

William Turnbull (1922–)

Turnbull, a Scot, is an austere, unrelenting sculptor whose originality lies in a bold appropriation of whatever has gone before that lends itself, he seems to feel, to a further or conclusive development. This in itself is a trait which recalls Picasso. He begins with the icon or totem aspect that lurks in the sculpture of Brancusi and Giacometti. To work from such sources does him no harm whatever, for he is able to go further. He achieves the monumental and gives his forest of totems a menhir, Druidical impact.

From here he takes over where David Smith left off.

Turnbull's *Gate* (1972) has a finality about it with which Smith might have been content. The same sense of further advance applies to Turnbull's large canvases, for he is also a painter. Ultimately they are of a single uniform tone, with or without a border stripe. They recall Barnett Newman, but they leave Newman's paintings in a pioneer, exploratory state. Turnbull's work draws nourishment from the most advanced activity of the twentieth century.

Paolozzi, another Scot, played a part in Pop Art in his beginnings. He used anything at hand to create freestanding icons out of junkyard material. A remarkable capacity for embedding life in strange objects has stayed with him. Soon he was working with aluminum, and larger, coiling tubes took over with a python life of their own. The next stage was an art of bright, smooth surfaces: shining silver objects now looked like enlarged cross sections of moldings. Such a trend from Surreal ironware to formal aluminum resembles the development of David Smith, and with the same inevitability. Paolozzi seems to have begun with the gift of animation, and with maturity to have sought form.

Eduardo Paolozzi (1924–)

Primary Structures in America

With Primary Structures we again take up where David Smith left off, or rather where his rapid late development was broken off by accidental death. It is as though Smith's art, part geometry, part machine in mint condition, had been set up to manufacture a formal art of mid-century. It was to be a highly simplified art in which basic forms became arresting objects of wonder. These objects are generally without pedestals or fixed sites, and what they lose in context they gain as philosophical events.

Three sculptors, Tony Smith, Donald Judd, Robert Morris, have carried this new trend to what must seem its ultimate conclusion in terms of architectural detachment and simplicity. We are almost back with the pyramids where we began.

Tony Smith (1912–)

Tony Smith, the earliest, has gone furthest in scale. He was and is an architect, and thus comes rightly or naturally by his big geometric forms. For all their monstrous size, they long remained somehow hidden or unappreciated. His geometry grew out of teaching design, and he came ultimately

WILLIAM TURNBULL.
Aphrodite. 1958.
Bronze. (Waddington
Gallery, London.)

to the most reduced possible form, the cube. What is special about a cube? It has thrown a spell over the modern sculptor as has the square or circle over the painter; it represents all space—like its opposite curvilinear number, the sphere. In a cube every direction is at right angles to every other and they only meet once in all infinity. A cube then is infinity packaged, and if a sphere is a skull, a cube is an idea. By the time we have reached a cube as sculpture the sculptor does not have to *create* anything, he merely has to summon something into concrete existence. It can be done by telephone, by calling a machine shop. Smith's cube is of steel six feet on a side and its title is *Die*.

Tony Smith's other sculptures are large, more complex, and most still remain in plywood for lack of purchasers or patrons. Such purchasers would need to be corporations one assumes; the sculptures suggest the servicing of large commercial enterprises. They appear as great industrial conduits; they seem to rise foursquare from the ground, entering space at an angle, only to turn horizontally, then descend, reach the ground, and again turn back upon themselves. Painted black, they are convincingly solid. They are epics in architecture.

Tony Smith. *Cigarette.* 1961–66. (Collection of The Museum of Modern Art, New York.)

Donald Judd
(1928–)

Donald Judd, half a generation younger, is that much more impersonal in his work. He too creates cubes, but cubes in series, introducing the contemporary notion of serial repetition. He is willing to line up these cubes at equal intervals and hang them above the ground so that they become a sequence floating in space. Or he will create a series of boxes or slabs that climb the wall in sequence, often with edges of metal and the larger square sides of plexiglass.

The detachment which Judd seems to desire depends not only on the absolute aspect of a geometric fact, but on its repetition. A single structure is somehow an opposite number to the observer, but in a series of identical objects, sequence itself becomes the abstract subject. A sequence of perceptions is a sequence in time, so what is the unifying element in a series of identical objects? How do objects differ from hours? Such philosophical queries probe the very nature of awareness, of reality.

DONALD JUDD. *Untitled.* 1966. (Norton Simon Museum of Art, Pasadena.) [Frank J. Thomas.]

Robert Morris
(1931–)

Morris has his own favorite forms that belong in the same geometric family. He has created low polyhedrons set out in a pattern of four, and a square-sided ring split in two so that it is "glowing with mild-white light from its gaps," and a "doorway," and a "square donut." These forms tend to be painted a bland impersonal gray and vaguely suggest naval equipment.

At an opposite pole from his geometric forms are his later sculptures made of thick strips of felt. They have no fixed shape, but they have a nature to which they conform. They have a personality; they are as instantly recognizable as a coat is recognizable whether it is worn or hanging on a peg.

ROBERT MORRIS. *Untitled*. 1969. (Norton Simon Museum of Art, Pasadena.) [Frank J. Thomas.]

ADDED DIMENSIONS

For the painter, intensity has led on to the overwhelming, the saturated as an experience, the determination not to be submerged. It is not strange that painting at this point has cried out for still another resource, the need to possess actual light, not reflected light, but a light that can be switched on. And sculpture has asked for another dimension, actual motion. We must follow these significant new drives.

Approach to Motion and Light

Before we come to an actual light source in art, or actual motion, we should consider several artists as they approach these goals while they do not as yet provide their own light and their creations do not move. They only suggest illumination; they approach motion via light effects and work in illusion. They still deceive the eye.

Richard Lippold Working with wires in tension, the American Richard
(1915–) Lippold has created three-dimensional images of radiating light. His silver or gold lines in space are seen under hidden illumination against black, as we actually see the moon. With such radiating mazes he created a moon, and went on to create a sun, or a sunburst of dazzling complexity that comes close to capturing the sun as a focus of religious emotion. Such an outburst is still static and still shines with

reflected light, but it has become intangible, an object that cannot be reached or touched, and this is sculpture as we have not known it before.

In due course, Lippold went on to incorporate movement.

RICHARD LIPPOLD. *Variation Within a Sphere No. 10: The Sun.* ca. 1953–56. (The Metropolitan Museum of Art, New York, Fletcher Fund.)

Victor Vasarely
(1908–)

A Hungarian who has worked in France, Vasarely is a theorist as well as a performer. He has undertaken to alter basic definitions. For him art is no longer painting or sculpture nor is an artist a man who produces one unique work. For Vasarely art can and should be multiple, and the distinction between two or three dimensions is meaningless. The one remaining division seems to be between simple architectural fact and illusion. Accordingly, Vasarely explores the illusory, and approaches motion via distortion. His work is largely black and white, typically checkerboard patterns that seem to expand or contract to create an inescapable impression of swellings or dents on a flat surface. He has also worked with transparent overlays which cause fluctuations of pattern as they are moved, and he has transferred his

VICTOR VASARELY.
Vega Anneaux. 1969–
72. (Courtesy of Gallery Denise René,
New York.)

already complex black-and-white problems into vivid, flat color.

BRIDGET RILEY. *Fall.* 1963. (The Tate Gallery, London.)

He is enormously resourceful. His mass-production interests recall the Bauhaus and an art for social benefit. He has animated the static, and his influence is wide.

Perhaps the most successful artist to be content with illusory effects, the British Bridget Riley disturbs the habits of eyesight, creating paintings with patterns that swim and ripple. This is accomplished by subtle rhythmic changes either of shape or value. Such modulations adjacent to each other, or such fadings of tone, set the wall swaying before us. These effects were obtained for a long while solely with blacks, whites, and grays. But like most artists who accept the black-and-white discipline, she broke out of it in due course, in time for her exhibition with Philip King at the Venice Biennale of 1966. The method is deliberate and calculated, the result lyric. A new experience has been acquired.

Bridget Riley (1931–)

Larry Bell
(1939–)

Sculpture that contains light could be the title for the long series of glass boxes created by the Californian, Larry Bell. These transparent cubes, often mounted on rectangular glass pedestals, were at one moment beveled and in their ultimate form were simple geometry, made of a glass that carried a prismatic staining on its inner surface, an effect produced by a vacuum process that contributes a metallic deposit. Bell has been able to modulate this effect and can progress smoothly from transparency to a mirror surface. These boxes have something compelling about them that is all the more mysterious in that they are visibly empty.

LARRY BELL. *Untitled.* 1972. (Artist's collection.) [Photograph courtesy of Norton Simon Museum of Art, Pasadena.]

Of late, Bell has worked with much larger sheets of plate glass set at right angles. They reflect each other—illusion again—and reflect the beholder with varying degrees of transparency. This is not as much of a change as it appears, for the box is now large enough to open for the beholder. In effect, Bell has escaped from his box, and left the beholder trapped inside. With this development, Bell has greatly strengthened his hold on conditioned space.

Robert Irwin
(1928–)

Irwin, another Californian, has moved from painting to or through the third dimension, and it is now obvious that his concern is not with making an art object but with breaking down the barrier between art and environment—the task Rauschenberg had at one time set for himself. But Irwin's approach is profoundly philosophic. He is not intent

on mocking art, but on devising a method that minimizes the border or edge of an art object in order to marry art to reality.

Irwin mounts a curved, white disc at some little distance from a white wall and plays four lights upon it from four directions, projecting a four-leaf clover of shadows on the wall behind. These shadows, realities in their own right, destroy the edge of the disc, which is already curving away from the spectator. By such means Irwin approaches intangibility.

Changing his method, he has placed a ceiling-to-floor prism in a white room, an object hardly visible except for a vertical flash of color as the beholder moves; and he has sealed off a white architectural space with white translucent diaphragms, creating dim pale alcoves in which we hardly believe. As a creator in space, he dreams of a world in which every act is an art act, every experience an art experience, in which the universal medium is light itself.

Irwin's discs have been widely exhibited, and never reproduced with his permission.

Motion

Mechanisms in motion are a constant experience for modern man. Not surprisingly they arrest attention and the talents of designers have been lavished upon them. Ships, the largest of moving objects, have always compelled admiration. Originally, as their figureheads made clear, they were objects of feminine personification. They were designed to live with wind and weather and adapt to the motion of the sea. But with the coming of steam, ships took on more masculine characteristics: metal in place of wood led to harder, more assertive lines and ships were now designed to dominate the forces of nature rather than to invite their help.

In the nineteenth century a similar admiration was expended on railroads, on locomotives: coal, fire, steam spelled life. Trains themselves took on personalities and great trains had their names; the Empire State, the Twentieth Century, the Santa Fé Limited, the Silver Chief. These admirations have now been transferred to the automobile and the airplane, and the ultimate triumph for motion comes with the rocket in orbit. A victory over gravity somehow takes the place of that other overwhelming human goal, a triumph over death.

George Rickey
(1907–)

It is strange, with all these objects of mechanized worship, that art has been so slow to take to motion. For a decade or more, Alexander Calder's mobiles were virtually alone as moving sculptures. After Calder comes Rickey, who has created sculptures that swing and balance in the wind. He has worked on quite a different principle, that of the pendulum. He began with simple lines, long straight metal wands of stainless steel balanced with lead on the short end. He developed these lines into planes that swayed, and eventually rectangular moving planes became three-dimensional objects, such as cubes with wavering sides. Like Calder, Rickey has worked with great range in scale, but far more strikingly this has resulted in an equally great range in pace of movement, for these mobile lines or planes swing with a different pace or rhythm according to their size.

GEORGE RICKEY. *Two Lines Oblique Down, Variation II.* 1970. (University of California, Los Angeles, Franklin D. Murphy Sculpture Garden, gift of UCLA Art Council.) [Courtesy of John Swope.]

Jean Tinguely
(1925–)

With Tinguely, a Swiss, we return to a world of toys, now of a raucous and obstreperous nature. Tinguely has been obsessed with mechanisms that leave room for chance; in effect, humanized machines that perform drunkenly and counterfeit impulse. His machines are activated by electric motors. They range in appearance all the way from broken clockworks to farm machinery on the loose; they appear to be thrashing in their last agonies. Tinguely's American

debut at the Museum of Modern Art in 1960 was with a machine whose function was to destroy itself, a suicide managed with the assistance of the New York Fire Department.

His machines create noise, and the effect when an exhibition of his works is assembled and operative is of a mechanized zoo at feeding time. He reflects in all seriousness a twentieth-century response to the machine which can range from delight to alarm. His satire is aimed not so much at the machine as at man, its inventor.

JEAN TINGUELY. *M. K. III.* 1964. (Museum of Fine Arts, Houston, funds donated by David J. de Menil.)

Bury, a Belgian, represents electric motion that is far gentler and more controlled. His devices are precisely machined geometry: he brings together plane surfaces, cubes, and above all spheres or balls, whether of metal or wood. These objects move with the most restrained restlessness. They create a hypochondriac disturbance—as of concern for our heartbeats—while we wait for his spheres to decide to move.

Pol Bury (1922–)

POL BURY. *15 billes d'acier sur un cube*. 1968. Steel. (Katherine White Collection, Los Angeles.) [Frank J. Thomas.]

Jesus Rafael Soto
(1923–)

With Soto, a Venezuelan, we come back to random movement dependent on air. Soto relies on a very simple effect. He hangs fine rods in front of a plane composed of horizontal lines or ribs; as the free lines move or sway gently in front of the fixed lines, the eye is teased and tricked, and the fixed lines become as animated as those that move—the so-called moiré effect. Here again, restlessness speaks to the sensibilities.

Mark Di Suvero
(1933–)

An art permitted to sway or dangle on an entirely different scale, a Pop Art or junk art that swings, is the work of an American, Di Suvero. He chose wrecking-yard material. Heavy joists hung from a steel crane, a few lengths of massive chain, a suspended automobile tire produce a random composition that can solemnly lurch or sway. The juvenile imagination that throbs to the opportunities in a wrecking-yard, or follows the action of cranes loading the hold of a freighter, all this is in play. We love machinery not because it produces something but because its action fulfills us.

Lately the pop aspect, the motion, has tended to depart from Di Suvero's inventions, and the tensions of structural steel to remain.

MARK DI SUVERO. *Praise for Elohim Adonai.* 1966. Steel and wood. (The St. Louis Art Museum, gift of Mr. and Mrs. Norman B. Champ, Jr.) [Photograph courtesy of Richard Bellamy.]

Beyond these examples of modern forerunners extends a field of experimentation that is growing rapidly, a development in constant motion itself. Vibrations, whether random out of delicate balance or dependent on intermittent electric impulse, account for any number of rhythms and activities. Objects can whirr, race, creep, rock, or sway. It is obvious that artists converted to motion look out on endless possibilities, inviting more and more subtle methods, and in turn they look back on the drabness of fixed relations. And motion in art, like machinery itself, has left behind nationalism in art once and for all. Conceivably we might have imagined motion to be a characteristic of American art, but it is not so.

Light

An equally broad future can be foreseen for direct light in art as opposed to reflected light. A pioneer here was Thomas Wilfred (1889–1968) who created a color organ,

the Clavilux, a device for projecting on a screen a series of light forms that resemble Northern Lights. He gave a Clavilux concert in 1922. Amazing in itself, the instrument did not lend itself to further development and remained an event relatively isolated in history like Muybridge's early stroboscopic photographs.

Dan Flavin
(1933–)

In the last decade electric light has been suddenly seized on as a basic element in a composition, and here the neon tube competes with the bulb. The most forthright of the employers of light, Flavin has used neon tubes as spaced vertical columns or horizontal bars to create visual rhythms and an architecture of light.

Chryrssa (1933–)

Chryssa has created a vocabulary of colorful, repetitive light forms or diagrams that comes nearer to the neon-tube art of the electric sign. She has tapped the cold purpose of the machine.

Otto Piene
(1928–)

Piene, now in America, has been infinitely resourceful in the manipulation of light. His compositions depend not only on the position of the bulb, but on the changing intensity of the current, so that his theatrical lighting effects can be programmed.

Julio Le Pare
(1928–)

Le Pare, an Argentinian living in Paris, has swept together an aurora borealis of motion and sheen. Under his hand light lives and breathes.

A NEW BAROQUE

ARCHITECTURE

What has modified the international style with its international skyline? Something less monotonous—a feeling for masonry, or at least for the opaque; a willingness to admit delight in curves. We can say that the ideas of Mies are subsiding and the ideas of Wright returning, along with a hunger for individuality.

Three of the more interesting American architects in this new phase are Marcel Breuer, Eero Saarinen, and Louis I. Kahn. Breuer was a younger associate and one-time partner of Walter Gropius. When he left Gropius, he threw off the older man's stark austerity, and indulged his imagination with buildings that can only be seen as sculpture in reinforced concrete. If they still remain geometrical, they are no longer mere boxes. Such expressive architecture is with difficulty commercial, and lends itself to religious or educational buildings, churches or universities, which says something about its more human intention.

Marcel Breuer (1902–)

With Saarinen, this architectural freedom or fantasy reached a further flight. His TWA building at Kennedy Airport almost suggests the beating of wings. More successful is his Dulles Airport building in Washington, D.C., which succeeds in being a national monument. The suspended roof, as of a hanging tent, is not unique with Saarinen. If a ceiling is an indoor bridge, the suspension bridge has the longest span, so why not a suspension ceiling? The Saarinen example is beautiful and impressive.

Eero Saarinen (1910–1961)

MARCEL BREUER. St. John's Abbey and University, entrance with campanile, Collegeville, Minnesota. 1961. [Photograph courtesy of The Museum of Modern Art. New York.]

EERO SAARINEN. Dulles Airport building, Chantilly, Virginia (Washington, D.C.), 1958–62.

Kahn has done something still simpler, starker, and more timeless. He has managed to offset glass with blank windowless towers, and to give these towers a function, so that the open is sustained and supported by the closed. He has, in short, recaptured the wall (in the Richards Medical Research building in Philadelphia) that the international style strove so hard to demolish. Having accomplished so much, Kahn went further, in the Salk Institute building in La Jolla, California, and created a veritable medieval fortress, a wall braced with towers. The building faces on an inner court, and the court in turn opens toward the sea. All along this court, windows are set at an angle and look out to sea like so many theater boxes looking across each other.

In the new Kimball Art Foundation in Fort Worth, he has created a design at once highly personal and functional, with a series of galleries with arched ceilings, slotted down the middle of the arch for their source of light. With Kahn buildings, it is not only the solidity that gives monumental reassurance, it is our awareness of the personality of one man.

Louis I. Kahn (1901–1974)

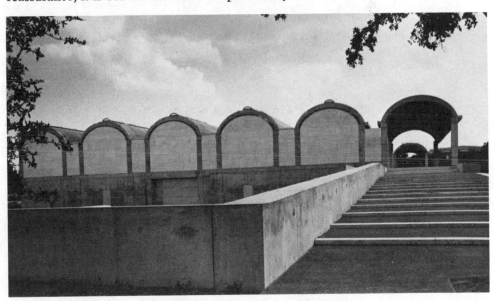

Louis I. Kahn. Kimball Art Museum, Fort Worth. 1972.

This quest of the personal has been carried further. As the original Baroque flourished in South America, so has a new Baroque. The complete example is Brasília, the new capital of Brazil. Designed by Oscar Niemeyer and conjured out of nowhere in the central plateau of South America, the city is an administrative outpost only to be reached by plane. Cities have been built by command before: Petrograd was

Oscar Niemeyer (1907–)

built by Peter the Great as a capital facing Europe, and certainly there will be more cities built from scratch as soon as we have the courage to abandon cities that have failed. But Brasília, a city without a populace, with buildings that are spectacle, fantasy, and whim, reminds us that cities are more than shelter.

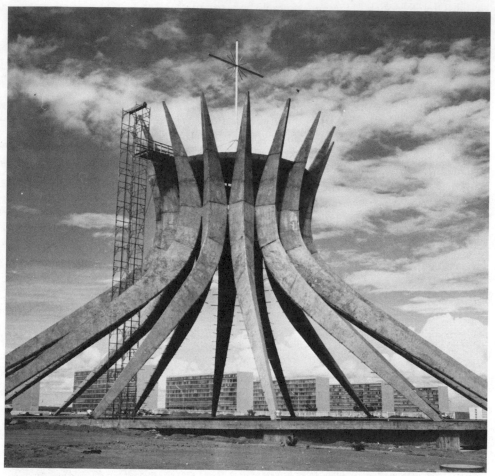

OSCAR NIEMEYER. Cathedral, ministries in background, Brasília, Brazil. 1962.

Pier Luigi Nervi (1891–)

This brings us to an extraordinary modern designer, the Italian Pier Luigi Nervi, an engineer whose conceptions are at the service of architecture. They are conceptions that seem to be one long and successful contest with the force of gravity. He is famous for his unsupported ceilings that typically cover a sports palace (in Rome) or exhibition hall (in Turin), poised shells of a honeycomb pattern seen from below. There is an air of the miraculous in Nervi's work. He does the supposedly impossible with reinforced concrete.

Rightness and fitness counter the self-consciousness in his achievements, and then he has willingly put himself at the service of architects and architecture—for instance he produced the structural core that made the Pirelli building possible.

Such a triumph over gravity leads us to a further wizardry on which we have already touched: the work of the inventor and designer who has created the geodesic dome. Buckminster Fuller has built these domes out of interlocking triangles. They are formal triumphs from without, and containers of climate from within.

Buckminster Fuller (1895–)

Frederick Kiesler, inventor of a form too radical for general realization, conceived of an "endless house," in the form of a coiling tube. If Fuller's dome is a skull, the endless house is an intestine. This is cave-dwelling all over again, and it may well stir long-forgotten memories in human experience.

Frederick Kiesler (1892–1965)

PIER LUIGI NERVI. Ceiling of Small Sports Palace, Rome. 1957.

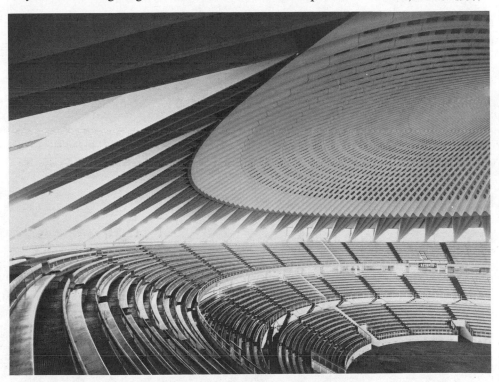

Even Kiesler realized an opportunity when he built a repository for the Dead Sea Scrolls in the museum in Jerusalem as a successful complex of low domes and underground

passages. Here the scrolls continue their centuries-old existence in a cave.

Must we contemplate underground living, where temperature is forever even, where there are no towers to totter, and we are safe? Safe from what? Even to raise the question is to reject it. Yet we have come too close to such a way of life. Too many people in our cities live and work hidden from the light that shines for us all.

Alvar Aalto
(1898–1976)

Another way of putting it: have we lost sight of simplicity? Simplicity need not be primitive: it is a question of reconsidering our demands. We can see simplicity at work in the Scandinavian countries. We can observe it in Finland, where the architect Alvar Aalto has built with modesty and restraint. His buildings come as close to the bodies that require them as a healthy body is close to its bones. His down-to-earth art cannot be expanded without losing its beauty, and there is a moral for us here.

ALVAR AALTO. Villa Mairea (garden side), Noormarkku, Finland. 1973.

This is a simplified account of a long history—our own—and a clue, perhaps, to some of the meanings in the appearances that surround us. We have looked back in order to know ourselves. In thumbing through our family album, the genealogy of Western art, we have of course missed many splendid sights. And we should remind ourselves that there is a whole other side of the world on which we have not touched, the arts of Asia: of Persia, India, Indochina, China, Japan. These worlds we have only half glimpsed throughout our long history, and they have only half glimpsed us. Yet they have influenced us more and more over centuries, and suddenly we have greatly influenced them. It is late now for a two-sided world; in our own time men have seen the other side of the moon.

The same is true of the arts that have grouped themselves around the equatorial regions, the great arts of Africa, of pre-Columbian America, of Polynesia. These arts—like the art of Egypt—tell us emphatically that man began as an artist. His art is his imagination made visible; it embodies his past, which he has a right to cherish, and will embody his future, for which he has a right to hope.

BIBLIOGRAPHY

GENERAL BOOKS:

Gombrich, Ernst Hans Josef. *Art and Illusion: A Study in the Psychology of Pictorial Representation*. Bollingen Series. New York: Pantheon, 1961.

Pevsner, Nikolaus. *An Outline of European Architecture*. 6th ed. Baltimore: Penguin, 1960.

ANCIENT ART:

Bianchi-Bandinelli, Ranuccio. *Rome: The Center of Power, 500 B.C. to A.D. 200*. The Arts of Mankind. New York: Braziller, 1970.

————. *Rome: The Late Empire, Roman Art A.D. 200–400*. The Arts of Mankind. New York: Braziller, 1971.

Boardman, John. *Pre-Classical from Crete to Archaic Greece*. Style and Civilization, Baltimore: Penguin, 1967.

Böethius, Axel, and Ward-Perkins, J. B. *Etruscan and Roman Architecture*. The Pelican History of Art. Baltimore: Penguin, 1970.

Carpenter, Rhys. *The Esthetic Basis of Greek Art of the Fifth and Fourth Centuries B.C.* Rev. ed. Bloomington: Indiana University Press, 1959.

Charbonneaux, Jean; Martin, Roland; and Villard, François. *Archaic Greek Art*. The Arts of Mankind. New York: Braziller, 1971.

————. *Classical Greek Art*. The Arts of Mankind. New York: Braziller, 1972.

————. *Hellenistic Art*. The Arts of Mankind. New York: Braziller, 1973.

Cook, Robert Manual. *Greek Painted Pottery.* 2d ed. London: Methuen, 1972.

Dorigo, Wladimiro. *Late Roman Painting.* New York: Praeger, 1971.

Frankfort, Henri. *The Art and Architecture of the Ancient Orient.* 3d rev. ed. The Pelican History of Art. Baltimore: Penguin, 1963.

Hanfmann, George Maxim Anossov. *Roman Art: A Modern Survey of the Art of Imperial Rome.* Greenwich, Conn.: New York Graphic Society, 1964.

Lawrence, Arnold Walter. *Greek and Roman Sculpture.* New York: Harper and Row, 1973.

L'Orange, Hans Peter. *Art Forms and Civic Life in the Late Roman Empire.* Princeton: Princeton University Press, 1965.

Maiuri, Amedeo. *Roman Painting.* The Great Centuries of Painting. Geneva: Skira, 1953.

Richardson, Emeline. *The Etruscans, Their Art and Civilization.* Chicago: The University of Chicago Press, 1964.

Richter, Gisela Marie Augusta. *A Handbook of Greek Art.* 6th ed. New York: Phaidon, 1969.

————. *The Sculpture and Sculptors of the Greeks.* 4th ed., newly rev. New Haven: Yale University Press, 1970.

Strong, Donald Emrys. *Roman Imperial Sculpture: An Introduction to the Commemorative and Decorative Sculpture of the Roman Empire down to the Death of Constantine.* New York: Transatlantic Arts, 1971.

Woldering, Irmgard. *The Art of Egypt: The Time of the Pharaohs.* The Art of the World. New York: Crown, 1967.

MEDIEVAL ART:

Branner, Robert. *Gothic Architecture.* The Great Ages of World Architecture. New York: Braziller, 1961.

Conant, Kenneth John. *Carolingian and Romanesque Architecture 800–1200.* The Pelican History of Art. Baltimore: Penguin, 1966.

Demus, Otto. *Byzantine Mosaic Decoration: Aspects of Monumental Art in Byzantium.* Boston: Boston Book and Art Shop, 1955.

Dupont, Jacques, and Gnudi, Cesare. *Gothic Painting.* The Great Centuries of Painting. New York: Skira, 1954.

Focillon, Henri. *The Art of the West in the Middle Ages.* Vol. 1, Romanesque Art; Vol. 2, Gothic Art. Ed. and introduced by Jean Bony. 2nd ed. New York: Phaidon, 1969.

Grabar, André, and Nordenfalk, Carl Adam John. *Romanesque Painting from the Eleventh to the Thirteenth Century.*

The Great Centuries of Painting. New York: Skira, 1958.

Harvey, John Hooper. *English Cathedrals.* Rev. ed. London: B. T. Batsford, 1961.

Hubert, Jean; Porcher, Jean; and Volbach, Wolfgang F. *The Carolingian Renaissance.* The Arts of Mankind. New York: Braziller, 1970.

Katzenellenbogen, Adolf. *The Sculptural Programs of Chartres Cathedral: Christ, Mary, Ecclesia.* Baltimore: Johns Hopkins Press, 1959.

Krautheimer, Richard. *Early Christian and Byzantine Architecture.* The Pelican History of Art. Baltimore: Penguin, 1965.

L'Orange, Hans Peter, and Nordhagen, P. J. *Mosaics.* Methuen's Handbooks of Archaeology. London: Methuen, 1966.

Mâle, Emile. *The Gothic Image: Religious Art in France of the Thirteenth Century.* New York: Harper and Row, 1958.

Panofsky, Erwin. *Gothic Architecture and Scholasticism.* Latrobe, Pa.: Archabbey Press, 1951.

Rice, David Talbot. *Art of the Byzantine Era.* London: Thames & Hudson, 1963.

Saalman, Howard. *Medieval Architecture: European Architecture 600–1200.* The Great Ages of World Architecture. New York: Braziller, 1962.

Simson, Otto Georg von. *The Gothic Cathedral: Origins of Gothic Architecture and the Medieval Concept of Order.* 2d rev. ed. The Bollingen Library. New York: Harper and Row, 1964.

Swarzenski, Hanns. *Monuments of Romanesque Art: The Art of Church Treasures in North-Western Europe.* 2d ed. Chicago: The University of Chicago Press, 1967.

Volbach, Wolfgang Friedrich. *Early Christian Art.* New York: Abrams, 1962.

RENAISSANCE AND BAROQUE ART:

Ackerman, James S. *The Architecture of Michelangelo.* Rev. ed. 2 vols. Studies in Architecture. New York: Viking, 1966.

Baldass, Ludwig von. *Jan van Eyck.* London: Phaidon, 1952.

Bergström, Ingvar. *Dutch Still Life Painting in the Seventeenth Century.* London: Faber, 1956.

Blunt, Sir Anthony. *Artistic Theory in Italy 1450–1600.* Oxford: The Clarendos Press, 1956.

Burckhardt, Jacob Christoph. *The Civilization of the Renaissance in Italy.* 3d rev. ed. London: Phaidon, 1950.

Châtelet, Albert, and Thuillier, Jacques. *French Painting from Fouquet to Poussin.* Geneva: Skira, 1963.

Clark, Sir Kenneth McKenzie. *Leonardo da Vinci: An Account*

of His Development as an Artist. 2d ed. Cambridge, England: The University Press, 1952.

Cuttler, Charles D. *Northern Painting: From Pucelle to Bruegel: Fourteenth, Fifteenth and Sixteenth Centuries.* New York: Holt, Rinehart and Winston, 1968.

Freedberg, Sydney J. *Painting of the High Renaissance in Rome and Florence.* 2 vols. New York: Harper and Row, 1972.

Friedländer, Max J. *Early Netherlandish Painting from van Eyck to Bruegel.* Rev. ed. London: Phaidon, 1965.

Friedländer, Walter F. *Caravaggio Studies.* New York: Schocken Books, 1969.

———. *Mannerism and Anti-Mannerism in Italian Painting: Two Essays.* New York: Columbia University Press, 1957.

———. *Nicolas Poussin: A New Approach.* New York: Abrams, 1965.

Hartt, Frederick. *History of Italian Renaissance Art: Painting, Sculpture and Architecture.* New York: Abrams, 1969.

———. *Michelangelo: The Complete Sculpture.* New York: Abrams, 1969.

Janson, Horst Woldemar. *The Sculpture of Donatello.* Princeton: Princeton University Press, 1963.

Kubler, George, and Soria, Martin. *Art and Architecture in Spain and Portugal and Their American Dominions: 1500–1800.* The Pelican History of Art. Baltimore: Penguin, 1959.

Lopez-Rey, José. *Velásquez' Work and World.* London: Faber, 1968.

Meiss, Millard. *The Great Age of Fresco: Discoveries, Recoveries and Survivals.* New York: Braziller in association with the Metropolitan Museum of Art, 1970.

Müller, Theodor. *Sculpture in the Netherlands, Germany, France and Spain: 1400–1500.* The Pelican History of Art. Baltimore: Penguin, 1966.

Osten, Gert von der, and Vey, Horst. *Painting and Sculpture in Germany and the Netherlands: 1500–1600.* The Pelican History of Art. Baltimore: Penguin, 1969.

Panofsky, Erwin. *Albrecht Dürer,* 3d ed., 2 vols. Princeton: Princeton University Press, 1948.

Pope-Hennessey, John. *Italian Gothic Sculpture.* 2d ed. New York: Phaidon, 1972.

———. *Italian High Renaissance and Baroque Sculpture* 2d ed. New York: Phaidon, 1970.

———. *Italian Renaissance Sculpture.* 2d ed. New York: Phaidon, 1971.

Rosenberg, Jakob. *Rembrandt, Life and Work.* 3d ed. London: Phaidon, 1965.

———; Slive, Seymour; and ter Kuile, E.H. *Dutch Art and*

Architecture: 1600–1800. The Pelican History of Art. Baltimore: Penguin, 1966.

Shearman, John K. *Mannerism.* Baltimore: Penguin, 1967.

Stechow, Wolfgang. *Dutch Landscape Painting of the Seventeenth Century.* 2d ed. New York: Phaidon, 1968.

Steer, John. *A Concise History of Venetian Painting.* World of Art. New York: Praeger, 1970.

Waterhouse, Ellis Kirkham. *Italian Baroque Painting.* 2d ed. London: Phaidon, 1969.

Wethey, Harold Edwin. *El Greco and His School.* 2 vols. Princeton: Princeton University Press, 1962.

White, John. *Art and Architecture of Italy: 1250–1400.* The Pelican History of Art. Baltimore: Penguin, 1966.

Wilenski, Reginald Howard. *Flemish Painters 1430–1830.* 2 vols. New York: Viking, 1960.

Wittkower, Rudolf. *Architectural Principles in the Age of Humanism.* New York: Random House, 1965.

———. *Art and Architecture in Italy: 1600–1750.* The Pelican History of Art. 3rd rev. ed. Baltimore: Penguin, 1973.

———. *Gian Lorenzo Bernini: The Sculptor of the Roman Baroque.* 2d ed. London: Phaidon, 1966.

Wölfflin, Heinrich. *Classic Art: An Introduction to the Italian Renaissance.* New York: Phaidon, 1953.

EIGHTEENTH AND NINETEENTH CENTURY ART:

Barker, Virgil. *American Painting: History and Interpretation.* New York: Macmillan, 1950.

Chassé, Charles. *The Nabis and Their Period.* New York: Praeger, 1969.

Elsen, Albert Edward. *Rodin.* New York: The Museum of Modern Art, 1963.

Fleming, Gordon H. *Rossetti and the Pre-Raphaelite Brotherhood.* London: Hart-Davies, 1967.

Friedländer, Walter F. *David to Delacroix.* Cambridge, Mass.: Harvard University Press, 1964.

Gaunt, William. *The Great Century of British Painting: Hogarth to Turner.* London: Phaidon, 1971.

Gauss, Charles Edward. *Aesthetic Theories of French Artists 1855 to the Present.* Baltimore: Johns Hopkins Press, 1949.

Goodrich, Lloyd. *Winslow Homer.* New York: Macmillan, 1944.

Gowing, Laurence. *Turner: Imagination and Reality.* New York: The Museum of Modern Art, 1966.

Larkin, Oliver W. *Art and Life in America.* Rev. and enl. ed. New York: Rinehart, 1960.

Levey, Michael. *Painting in XVIII Century Venice.* London: Phaidon, 1959.

————. *Rococo to Revolution: Major Trends in Eighteenth Century Painting*. New York: Praeger, 1966.

Lucie-Smith, Edward. *Symbolist Art*. New York: Praeger, 1972.

Madsen, Stephen Tschudi. *Art Nouveau*. New York: McGraw-Hill, 1967.

Morrison, Hugh Sinclair. *Early American Architecture: From the First Colonial Settlements to the National Period*. New York: Oxford University Press, 1952.

Myers, Bernard Samuel. *Goya*. London: Spring Books, 1964.

Nochlin, Linda. *Realism*. Style and Civilization. Baltimore: Penguin, 1972.

Novak, Barbara. *American Painting of the Nineteenth Century: Realism, Idealism and the American Experience*. New York: Praeger, 1969.

Pevsner, Nikolaus. *The Sources of Modern Architecture and Design*. World of Art. New York: Praeger, 1968.

Rewald, John. *The History of Impressionism*. Rev. and enl. ed. New York: The Museum of Modern Art, 1961.

————. *Post-Impressionism from van Gogh to Gauguin*. 2d. ed. New York: The Museum of Modern Art, 1962.

Richardson, Edgar Preston. *Painting in America: From 1502 to the Present*. New York: Crowell, 1967.

Rosenblum, Robert. *Transformations in Late Eighteenth Century Art*. Princeton: Princeton University Press, 1967.

Schapiro, Meyer. *Paul Cézanne*. 3rd ed. New York: Abrams, 1965.

Summerson, Sir John Newenham. *Architecture in Britain: 1530–1830*. 1st paperback ed. The Pelican History of Art. Baltimore: Penguin, 1970.

Thuillier, Jacques, and Châtelet, Albert. *French Painting from Le Nain to Fragonard*. Geneva: Skira, 1964.

Valsecchi, Marco. *Landscape Painting of the Nineteenth Century*. Greenwich, Conn.: New York Graphic Society, 1971.

Whinney, Margaret. *Sculpture in Britain: 1530–1830*. The Pelican History of Art. Baltimore: Penguin, 1964.

TWENTIETH CENTURY ART:

Alloway, Lawrence. *Systemic Painting*. New York: Solomon R. Guggenheim Museum, 1966.

Arnason, H. Harvard, *History of Modern Art: Painting, Sculpture, Architecture*. New York: Abrams, 1968.

Ashton, Dore. *Modern American Sculpture*. New York: Abrams, 1969.

————. *The New York School: A Cultural Reckoning*. New York: Viking, 1973.

Banham, Reyner. *Theory and Design in the First Machine Age*. 2d ed. New York: Praeger, 1967.

Barr, Alfred Hamilton. *Matisse: His Art and His Public.* New York: The Museum of Modern Art, 1951.

————. *Picasso: Fifty Years of His Art.* New York: The Museum of Modern Art, 1946.

Barrett, Cyril. *Op Art.* New York: Viking, 1970.

Battcock, Gregory, ed. *Minimal Art: A Critical Anthology.* New York: Dutton, 1968.

Bowness, Alan. *Contemporary British Painting.* New York: Praeger, 1968.

Brown, Milton Wolf. *American Painting from the Armory Show to the Depression.* Princeton: Princeton University Press, 1955.

Carrà, Massimo. *Metaphysical Art.* Compiled by Massimo Carrà with Patrick Waldberg and Ewald Rathke. The World of Art Library—Modern Movements. New York: Praeger, 1971.

Chipp, Herschel Browning. *Theories of Modern Art: A Source Book by Artists and Critics.* With contributions by Peter Selz and Joshua C. Taylor. Berkeley: University of California Press, 1968.

Cooper, Douglas. *The Cubist Epoch.* London: Phaidon, 1970.

Crespelle, Jean-Paul. *The Fauves.* Greenwich, Conn.: New York Graphic Society, 1962.

Dorival, Bernard. *The School of Paris in the Musée d'Art Moderne.* New York: Abrams, 1962.

Fried, Michael. *Three American Painters: Kenneth Noland, Jules Olitski, Frank Stella.* Cambridge, Mass.: William Hayes Fogg Art Museum, 1965.

Geldzahler, Henry. *New York Painting and Sculpture 1940–1970.* New York: Dutton, 1969.

Giedion, Sigfried. *Space, Time and Architecture: The Growth of a New Tradition.* 5th ed. rev. and enl. Cambridge, Mass.: Harvard University Press, 1967.

Goldwater, Robert John. *Primitivism in Modern Art.* Rev. ed. New York: Vintage, 1967.

Gray, Camilla. *The Russian Experiment in Art 1863–1922.* The World of Art Library—Modern Movements. New York: Praeger, 1971.

Gray, Christopher. *Cubist Aesthetic Theories.* Baltimore: Johns Hopkins Press, 1967.

Greenberg, Clement. *Post-Painterly Abstraction.* Los Angeles: F. Hensen Co., 1964.

Grohmann, Will. *Painters of the Bauhaus.* London: Marlborough, 1962.

Hammacher, Abraham Marie. *Modern English Sculpture.* New York: Abrams, 1966.

Hess, Thomas B., and Ashbury, John, ed. *Light in Art.* New York: Collier, 1971.

Hitchcock, Henry Russell. *Architecture: Nineteenth and Twentieth Centuries.* 3rd ed. The Pelican History of Art. Baltimore: Penguin, 1968.

——, and Johnson, Philip. *The International Style.* New York: Norton, 1966.

Hunter, Sam. *Jackson Pollack.* New York: Simon and Schuster, 1957.

Jaffe, Hans Ludwig C. *De Stijl, 1917–1931: The Dutch Contribution to Modern Art.* New York: Abrams, 1971.

Kaprow, Allan. *Assemblage, Environments and Happenings.* New York: Abrams, 1966.

Kozloff, Max. *Renderings—Critical Essays on a Century of Modern Art.* New York: Simon and Schuster, 1969.

Lippard, Lucy R. *Pop Art.* With contributions by Lawrence Alloway, Nancy Marmer and Nicolas Calas. New York: Praeger, 1966.

McShine, Kynaston. *Primary Structures.* New York: The Jewish Museum, 1966.

Martin, Marianne W. *Futurist Art and Theory 1909–1915.* Oxford: Clarendon Press, 1968.

Myers, Bernard Samuel. *Mexican Painting in Our Time.* New York: Oxford University Press, 1956.

O'Hara, Frank. *New Spanish Painting and Sculpture: Raphael Canogar and Others.* New York: Museum of Modern Art, 1960.

Popper, Frank. *Origins and Development of Kinetic Art.* Greenwich, Conn.: New York Graphic Society, 1968.

Raymond, Marcel. *From Baudelaire to Surrealism.* London: Methuen, 1970.

Read, Herbert Edward. *A Concise History of Modern Sculpture.* World of Art. New York: Praeger, 1964.

Rickey, George. *Constructivism: Origins and Evolution.* New York: Braziller, 1967.

Ritchie, Andrew Carnduff, ed. *The New Decade: 22 European Painters and Sculptors.* New York: The Museum of Modern Art, 1955.

Röthel, Hans Konrad. *The Blue Rider.* New York: Praeger, 1971.

Rose, Barbara. *American Art Since 1900: A Critical History* New York: Praeger, 1968.

Rosenberg, Harold. *The Anxious Object: Art Today and Its Audience.* New ed. New York: Horizon, 1966.

Rosenblum, Robert. *Cubism and Twentieth Century Art.* New York: Abrams, 1960.

Rothenstein, Sir John Knewstub Maurice. *British Art Since 1900: An Anthology.* London: Phaidon, 1962.

Rubin, William Stanley. *Dada and Surrealist Art.* New York: Abrams, 1968.

Russell, John. *Henry Moore*. New York: Putnam, 1968.

Selz, Jean. *Modern Sculpture: Origins and Evolution*. New York: Braziller, 1963.

Selz, Peter. *German Expressionist Painting*. Berkeley: University of California Press, 1957.

Tuchman, Maurice. *American Sculpture of the Sixties*. Sponsored by the Contemporary Art Council of the Los Angeles County Museum of Art. 1967.

Wingler, Hans Maria. *The Bauhaus: Weimar, Dessau, Berlin, Chicago*. Cambridge, Mass.: MIT Press, 1969.

INDEX